E. H. Gombrich

The Sense of Order
A Study in the Psychology
of Decorative Art

THE WRIGHTSMAN LECTURES
Cornell University Press

E. H. Gombrich

THE SENSE OF ORDER

A Study in the Psychology of Decorative Art

THE WRIGHTSMAN LECTURES delivered under the
auspices of the New York University Institute of Fine Arts

Cornell University Press Ithaca, New York

*This is the ninth volume of the Wrightsman Lectures,
which are delivered annually under the auspices of the
New York University Institute of Fine Arts*

© 1979 by Phaidon Press Limited, Oxford
Text © 1979 by E. H. Gombrich

First published 1979 by Cornell University Press

Printed in Great Britain
Text printed by BAS Printers Limited, Over Wallop, Hampshire
Plates printed at The Alden Press, Oxford

Library of Congress Cataloging in Publication Data

Gombrich, Ernst Hans Josef, 1909–
The Sense of Order.

 (The Wrightsman Lectures)
 Bibliography: p.
 Includes index.
 1. Art, Decorative—Psychological aspects.
I. Title. II. Series.
NK1520.G65 745'.01 77-83898
ISBN 0-8014-1143-2

Contents

Preface

When I was privileged to give the Wrightsman Lectures under the auspices of the Institute of Fine Arts of New York University in the Metropolitan Museum of Art I warned my audience at the end of the first lecture that they would be attending this series at their own risk. Usually we walk through life without paying much attention to the infinite variety of patterns and decorative motifs which we encounter all around us, on fabrics and wallpaper, on buildings and furniture, on tableware and boxes – on almost every article which is not self-consciously stylish and functional. Even this last category, as we shall see, derives some of its appeal from the absence of decoration, which we expect, or once expected, to see everywhere. To see but not to notice. For normally the decorative motifs which fill our world with such profusion are outside the focus of our attention. We take them in as background and rarely stop to analyse their intricacies. Even more rarely do we ask ourselves what it is all about and why mankind has felt this universal urge to expand vast amounts of energy on covering things with dots and scrolls, chequerboard or floral patterns.

It is only too likely that the reader of this book will for a time at least share the experience of its writer. He will start to see the patterns and ask questions about them. Whether this book will also provide him with answers which will satisfy his curiosity it is not for me to say. Clearly the main problem in tackling a subject of this kind lies in its very generality. There is no tribe or culture which lacks a tradition of ornamentation. Theoretical concern with design, on the other hand, is a comparatively recent development and only the 20th century has witnessed the final elevation of pattern-making into the autonomous activity of 'abstract art'.

There may be some readers who will be puzzled by my taking up this subject because they associate my work with a special interest in problems of representation in art. My previous book *Art and Illusion* (1960) dealt with the emergence and perfection of representational skills in the history of painting and sculpture. It was perhaps inevitable that this interest was sometimes identified with a championship of figurative as against non-objective art, all the more as I have criticized certain theories advanced in favour of these 20th-century experiments. I do not want to deny that I was needled by the assumption that I wished to equate 'art' with 'illusion' though my critics could not possibly know that in point of fact my interest in problems of pure design goes back much further in my life than my interest in the psychology of illusion. It is only by hindsight that I have come to realize how closely my own fascination with the art of ornament was bound up with the history of taste in these matters.

My mother loved and collected Slovak peasant embroideries. We eagerly waited for the visits to Vienna of a Slovak trader by the name of Matonicky, who used to come to the door and unpack his splendours of embroidered waistcoats, jackets, blouses, bonnets and ribbons. My mother's means rarely extended beyond the latter two items, but we learned to admire the beauty of colours and the immense decorative tact and skill displayed in these embroideries (Col. Plate I). I well remember wondering why such works were not esteemed as 'art' in the same way as great paintings were. I also recall hearing that these pieces were doubly precious since they could never be produced again. The tradition was rapidly fading because modern aniline dyes had replaced the natural dyes and in any case the style of life which supported these homecrafts was disappearing. I could not know at that time that the nostalgic discovery of these treasures owed a good deal to William Morris and that the English periodical *Studio* had published at that time a volume on *Peasant Art in Austria and Hungary*. I believe in fact that Mr Matonicky had been sent to my mother by a relative whose villa had been built by the progressive Czech architect Jan Kotěra, who had 'discovered' him.

I mention these links because I have come to wonder whether another interest I developed whilst still a schoolboy was also connected with contemporary movements in Austria. Early on I had come to notice, to compare, to contrast and even to draw the decorative details of Viennese buildings. I well remember the phase when I found to my own surprise and that of my elders how very frequently the irrational motifs of the urn formed part of architectural decorations, perched somewhere on the roof. The curious reader may find a pair of them flanking the gable of the 18th-century church façade of St Michael in Vienna (Plate 2). The same illustration also shows a house façade quite devoid of decoration and may remind us of the fact that this was a time when ornamentation had become an issue in Austria. The designer of that façade, Adolf Loos, had campaigned against it, but at the same time public taste had rediscovered the beauty and vigour of Austrian Baroque architecture, which somehow became identified with the specifically Austrian heritage. I do not know whether any echoes of these discussions had influenced me, but as a teenager I certainly searched for the charming relics of this style in the suburbs of Vienna.

Having taken up the study of the history of art at Vienna University I was given a welcome opportunity to develop this early interest. My teacher Julius von Schlosser presided over a seminar in which students were asked to read papers on general problems of method. He proposed that someone should report on Alois Riegl's *Stilfragen* of 1893, since he had known the author and had always been intrigued rather than convinced by his bold speculations. I no longer remember whether I was assigned this project or volunteered for it, though I suspect the latter. In any case I was soon engrossed in this masterpiece (discussed in Chapter VII), in which the history of the acanthus scroll is turned into an epic of vast dimensions. I began to notice acanthus motifs everywhere, in the waiting rooms of railway stations and on municipal lamp-posts, and surely made a nuisance of myself by drawing the willing or unwilling attention of my companions to these commonplace features. I began to share my teacher's ambivalent fascination with Riegl, whose theories were a favourite topic of discussion among the younger generation of art historians. Understandably therefore my own interests also turned to the art of late antiquity, which Riegl had made his province, and when a friend and colleague, the late J. Bodonyi, wrote his doctoral dissertation on the origins of the Golden Background in early Christian art I assisted him in a detailed analysis and critique of Riegl's *Spätrömische Kunstindustrie*. Both these books will inevitably figure prominently in the present volume. I mention the personal experiences which led to my involvement with Riegl because I cannot but regret that my continued interest in the theories of one of the most original thinkers of our discipline has earned me the reputation of being hostile to this great man. It is quite true that I have not been able to accept all his findings, but I still believe that one can pay no greater tribute to a scholar or scientist than to take his theories seriously and to examine them with the care they deserve.

The scholarly assignment to which I turned after my graduation brought me into fresh contact with problems of decorative art. Ernst Kris, who was at that time Keeper of the department of applied arts at the Vienna Museum, had invited me to join him in research on the history of caricature, a topic which had grown out of his increasing interest in the psychoanalytic theory of art. I paid tribute in *Art and Illusion* and elsewhere to my intellectual debt to Kris, but I may still add here that our book was also to contain a discussion of various forms of the grotesque, with which Kris was particularly familiar through his professional concern with 16th and 17th-century goldsmith work.

Thus it may seem natural that after *Art and Illusion* was safely out of the way I returned to the earlier preoccupations. In 1963, during my tenure of the Slade professorship in Cambridge, I devoted an experimental lecture to the subject of the grotesque, and being invited to give the Northcliffe lectures at University College London in 1967 I gave four lectures under the general title of *Rhyme and Reason in Pattern Making*. I eagerly seized on the

welcome opportunity of expanding and developing this research when I received the invitation to give the Wrightsman Lectures delivered under the auspices of the New York University Institute of Fine Arts in the Autumn of 1970, choosing as my title *The Analysis of Ornament* and giving six lectures. I cannot adequately express how grateful I am to the generosity and forbearance of Mr and Mrs Charles Wrightsman, who allowed me to take my time—and how much time!—in turning these lectures into the present volume rather than to print them more or less as delivered. In doing so I followed the precedent of my Mellon lectures at the National Gallery of Art in Washington, which formed the basis of *Art and Illusion*. As in that previous instance, I have tried to incorporate into this volume more or less everything I said in the lectures but I have recast and expanded them. Chapters III and VIII deal with topics not touched upon in the lectures.

Despite this expansion I must still claim the privilege of the lecturer to be severely selective in the examples on which he wishes to comment. How could it be otherwise where the theme itself is the pursuit of infinite variety? I had to resist the claims on my attention of any number of styles, procedures and solutions and to console myself with the words of the great Flinders Petrie in his *Decorative Patterns of the Ancient World* (London, 1930), in which he assembled several thousand motifs from one epoch alone: 'The subject is boundless, and to wait for completion would bar any useful result.' In short, the reader must not hope to find illustrations of his favourite type of decoration, any more than anyone interested in figurative art could expect to find any particular painting in *Art and Illusion*.

Though I have nearly followed the injunction of Horace, who wanted revisions to go on for nine years, I have had to be selective in my reading. Like the motifs of ornament, the literature on the crafts, practical, historical, and theoretical, is also 'boundless', and so are the discussions of the psychological issues broached in these pages. Had I waited till I had mastered either, I would have had to give up the attempt to bring the two fields of enquiry into contact.

I am fully aware of the fact that speculations, as yet unsupported by controlled experiments, cannot qualify as psychological theories. But what starts as a mere 'hunch' can sometimes be turned into a scientific hypothesis in expert hands, and I have been so fortunate as to see this happen with informal suggestions I have put forward in the past. Such evidence from experiments and computer models as I have seen published is referred to in the notes.

As in *Art and Illusion*, I have kept the notes out of sight, hoping that readers who look for 'chapter and verse' will find them with the help of a headline and the pagination. Given the scope of the book, I had to be sparing with references to specialized investigations, restricting myself to a few titles which may offer a point of entry to the problem discussed for anyone who wished to pursue or contest a particular argument.

Thus the resemblance of this volume to *Art and Illusion*, both in the subtitles and in the organization, is intended to underline the complementary character of the two investigations, one concerned with representation, the other with pure design. I hope that the book on *Symbolic Images* (1972) and other matters I have written on narrative and illustration can now be seen as fragments of an even more ambitious project: to study some of the fundamental functions of the visual arts in their psychological implications.

Such an ambition has its dangers. In particular I am aware of the risks I have been taking in inviting a comparison between this volume and *Art and Illusion*. The problem I set myself in *Art and Illusion* was relatively well defined. It basically concerns the process by which the rendering of the visible world was seen to change from schematic to naturalistic styles—a process which can be observed twice in the history of art—in classical antiquity and again in the Renaissance. There are many utterances by artists and critics who were involved in this story which can be used as evidence, and even though naturalistic methods may be under a passing cloud in our art schools we still know something about the teaching of this skill.

Though the thrust of that book has sometimes been misinterpreted, it is one of its points that the skill of imitation can be judged by objective standards; it presents limited problems capable of clearcut solutions.

The problems of this book, problems of design and decoration, would seem to lack such touchstones of success or failure. The art of ornament rose to a number of awe-inspiring summits in the Far East, in the Islamic world, in Anglo-Irish illumination and in late Gothic. There are any number of other peaks in the tribal arts of the Maoris or the American Indians of the north west, in the Plataresque style of Spain and its Mexican derivations, in the Rococo and in certain products of Art Nouveau. They all appear to follow different roads to different goals and yet we have no difficulty in seeing their family likeness.

Such difficulties arise only when we feel obliged to offer verbal definitions. It so happens that the English language is both too rich and too poor in related terms to permit such a definition. In German the term *Ornament* would serve quite well, and it will be seen that Victorian critics transferred this usage to England, but to most speakers of English, 'ornament' conveys some knick-knack on the mantel-piece, and to the musician a technical term for certain flourishes. The word 'design' tends to relate to technology and the term 'decoration' rather begs the question whether the practice with which I deal is simply one of adornment. There remains that jack-of-all-trades, the term 'pattern', which I shall use quite frequently though not with a very good conscience. For the word is derived from Latin *pater* (via patron), and was originally used for any example or model and then also for a matrix, mould or stencil. It has also become a jargon term for a type of precedent and has therefore lost any precise connotation it may have once had.

Luckily it is a mistake to think that what cannot be defined cannot be discussed. If that were so we could talk neither about life nor about art. I certainly would not venture to define the concept of order I use in the main title of this book, but I trust it will bring out the feature which interests me in decorative design. The arrangement of elements according to similarity and difference and the enjoyment of repetition and symmetry extend from the stringing of beads to the layout of the page in front of the reader, and, of course, beyond to the rhythms of movement, speech and music, not to mention the structures of society and the systems of thought.

There was a time when it was thought that all these manifestations of the sense of order were a distinctly human prerogative. Plato said so explicitly in a passage in *The Laws*: 'all young creatures . . . are perpetually breaking into disorderly cries and jumps, but whereas no other animal develops a sense of order of either kind, mankind forms a solitary exception'. One wonders whether Plato ever noticed the chirping of a cricket or the tail-wagging of a dog. Be that as it may, it means no derogation from man's unique achievements to look for their roots in our biological inheritance. Thus, in considering the question of order and rhythm, I had to step even farther back than I did in studying the problem of representation. I can only hope that from such a distance the outlines do not get too blurred even though, in contradicting Plato, I have had to preface my study with biological speculations. There is a respectable precedent for seeing decorative art in this wider context. The earliest and still one of the best books on the aesthetics of design is Hogarth's *Analysis of Beauty* (1753). Brought up in the empiricist climate of the eighteenth century, Hogarth took it for granted that the student of man could appeal to the example of animals. Connecting the pleasure he found we all take in the wavy 'line of beauty' with our biological heritage, he wrote, 'This love of pursuit, merely as pursuit, is implanted in our natures, and design'd, no doubt, for necessary, and useful purposes. Animals have it evidently by instinct. The hound dislikes the game he so eagerly pursues; and even cats will risk the losing of their prey to chase it over again. It is a pleasing labour of the mind to solve the most difficult problems.'

Correct or not, I can only hope that the reader will be ready to embark on such a hunt endeavouring to solve 'the most difficult problems'.

The illustrations should serve as guide-posts in pursuit of the argument, but also supplement it. They have been placed as close as possible to the relevant comment in the text, except where it was found that the examples discussed could be shown to greater advantage on plates. Maybe the conspicuous variety of their sequence will convince the enquiring reader at once that the 'sense of order' which manifests itself in so many ways has a claim on our attention.

It only remains for me to express my sincere gratitude first and foremost again to Mr and Mrs Charles Wrightsman. I should like to thank Dr Marian Wenzel for her self-denying work on the drawings she contributed for this book and Dr A. R. Jonckheere for his kindness in commenting on the drafts of the chapters dealing with psychological issues. Mr Stuart Durant generously placed his collection of books on design at my disposal. Miss Hilary Smith assisted with the preparation of the original lectures and Mrs Anne Gaskell with the multifarious tasks of getting the manuscript ready for press and preparing the index. My former colleagues at the photographic department of the Warburg Institute were as helpful as ever. Last, but surely not least, I should like to thank the members and associates of Phaidon Press, Dr I. Grafe, Simon Haviland, Teresa Francis and Keith Roberts, who joined in the work far beyond the call of duty.

London, February 1978 E.H.G.

INTRODUCTION

Order and Purpose in Nature

> It was first in animals and children, but later also in adults, that I observed the immensely powerful *need for regularity*—the need which makes them seek for regularities.
>
> K. R. Popper, *Objective Knowledge*

1 Order and Orientation

My belief in a 'Sense of Order' derives from the same theory of perception on which I drew in the analysis of representation. Briefly, this theory rejects the conception of perceiving as a passive process, the theory which Sir Karl Popper has dubbed the 'bucket theory of the mind'. Like him I believe in what he has aptly called the 'searchlight theory of the mind', a conception that stresses the constant activity of the organism as it searches and scans the environment. The terms in which I have just formulated this theory should tell the reader that it is based on an evolutionist view of the mind. I believe with Popper that such a view has become inescapable since the days of Darwin. Even so, much of textbook psychology still carries the traces of a conception which ultimately goes back almost two hundred years before Darwin to the empiricist theories of John Locke. It was Locke who launched the 'bucket theory' with his postulate that the mind of the new-born baby must be viewed as a *tabula rasa*, an empty slate; nothing could enter this mind except through the sense organs. Only when these 'sense impressions' became associated in the mind could we build up a picture of the world outside. There are no 'innate ideas', man has no teacher except experience.

Kant made the first breach in this theoretical edifice when he asked how the mind could ever order such impressions in space and in time if space and time had first to be learned from experience. Without a pre-existent framework or 'filing system' we could not experience the world, let alone survive in it. But however important Kant's objections were for philosophers, he was so much concerned with 'pure reason' that he never asked how the other organisms got on in this world. These were largely conceived as mechanisms driven by 'instincts', but whatever may have been meant by this vague term, it should have been clear from the outset that an animal must seek its goal in a complex and flexible way, avoiding dangers, seeking food, shelter and mates. Thanks to the researches of ethologists during the last few decades more is known about inborn reactions for which animals are undoubtedly 'programmed' than even Darwin could have surmised. To speak schematically, an organism to survive must be equipped to solve two basic problems. It must be able to answer the questions 'what?' and 'where?'. In other words it must find out what the objects in its environment mean to it, whether any are to be classified as potential sources of nourishment or of danger, and in either case it must take the appropriate action of location, pursuit or flight. These actions pre-suppose what in higher animals and in man has come to be known as a 'cognitive map', a system of co-ordinates on which meaningful objects can be plotted.

It should go without saying that in the lower stages of evolution these capacities cannot depend on that elusive entity we call consciousness. Even in man they are not so coupled. One of the most elementary manifestations of our sense of order is our sense of balance, which tells us what is up and down in relation to gravitation and therefore to our perceived environment. Yet we are only conscious of this achievement when it goes wrong, and the

organ of this sense, located in the inner ear, had to wait for the scientists to be discovered and isolated. Nor is our response to meaning always accompanied by full awareness. An example I have discussed elsewhere is our response to eyes. We are very sensitive to any configuration that can be interpreted as eyes, but it needs a good deal of conscious observation and training to become aware of the exact form and positioning of eyes in their sockets. The thing is perceived but the form is not. It is different with the location of eyes. We are well equipped to sense in what direction anybody looks and we have no difficulty in looking into the eyes of our fellow humans. Our spatial orientation, which governs our movement, is equally instinctive but distinct. It must imply the perception of ordered relationships such as nearer and farther, higher and lower, adjoining and separate, no less than of the temporal categories of before and after. Without wanting to put too much weight on the terms chosen, I would therefore propose to distinguish between the perception of meaning and the perception of order. It appears that these basic categories play their part throughout the range of the visual arts. Needless to say the perception of meaning can never be switched off, but for the understanding of decoration we have initially to concern ourselves with the perception of order. It is here again that modern evolutionist thought has modified and enriched the abstract system in which Kant had formulated the problem of space and time.

To quote Konrad Lorenz, the father of ethology, on this point: 'Even the primitive way in which *paramaecium* (one of the *infusoria*) takes avoiding action when it collides with an obstacle by first reversing and then swimming forward in another direction determined by accident suggests that it "knows" something about the external world which may literally be described as an "objective" fact. *Obicere* means to throw against; the "object" is something that is thrown against our advance, the impenetrable something with which we collide. All that the *paramaecium* "knows" about the "object" is that it impedes the continuation of its movement in a particular direction and this "knowledge" stands up to the criticism which we are able to exercise from the point of view of our richer and much more detailed picture of the world. True, we might be able to advise the creature to move in more favourable directions than the one it took at random, but what it "knows" is still quite correct: "the way straight ahead is barred" '

I have quoted this vivid passage, not only for its emphasis on the need for orientation at any stage of organic life, but also as an example of the need for circumspection in these matters. Strictly speaking, as Popper would remind us and as Lorenz knows, the creature's reactions are not based on knowledge but on a hypothesis; they rest on the implicit assumption that the object which gave it a jolt would continue to remain at that point, for otherwise a change of course might bring the animal into collision with the same obstacle. It need scarcely be added that the term 'hypothesis' is here used in a less specialized sense than in scientific research. Its use has been extended because some students of perception have found a close resemblance between the progress of knowledge in science and the acquisition of information all along the evolutionary ladder. 'We think of perception', writes Richard Gregory in his *Eye and Brain*, 'as an active process of using information to suggest and test hypotheses.' It is this approach which the reader will encounter throughout this book, though my homegrown ideas have also been fertilized by other schools of psychology, notably that of J. J. Gibson, who has rejected this terminology at least in relation to normal processes of visual perception. Luckily I can now refer the reader to the recent book by Ulric Neisser on *Cognition and Reality* (1976), which is based on the conviction that 'both J. J. Gibson and the hypothesis-testing theorists are right about perception.'

In pursuing the analogy between biological learning and the logic of scientific discovery, however, I rely more explicitly on Popper's methodology than any of the authors referred to. Accordingly the reader will find that I place less emphasis on the verification of a

hypothesis than on its 'falsification' or refutation. Popper has convinced me that a theory can never be established with certainty by any number of confirming instances, but that it can be knocked out by a single observation which disproves it. I venture to think that what might be called the *Popperian asymmetry* between confirmation and refutation has not yet been fully assimilated by the psychology and philosophy of perception. It is easy to illustrate this asymmetry by means of the example in hand. We have seen that the simple organism described by Lorenz learns through collisions, through jolts. We can interpret them as refutations of the hypothesis that it can continue on its path. Exaggerating the point for the sake of emphasis I would identify the built-in hypothesis with the sense of order, the jolt with perception. I hope however that the reader will not close the book on collision with this formulation: it will be considerably modified.

Still, if we wanted to simulate the actions and reactions of our primitive organism by a self-moving robot it would certainly be profitable to programme it for orderly movement, making it normally advance in a straight line and only change course either temporarily or permanently on impact with another object. The task becomes more complex, but, as we know, not insoluble, if the robot is to be programmed for another organic function, i.e. for pursuit or escape, for in that case the built-in assumption must also comprise the most profitable hypothesis about the moving target. Again we find that this aim is best served by an assumption of simple continuity; if the prey or target continues on a straight course it can be intercepted at a calculable point in space. It is for the same reason that the avoidance of pursuit is best served by random deviations from the predictable course. The hunted creature zigzags and backtracks to shake off the pursuer, and thus makes its course less predictable.

It will be remembered that William Hogarth tried to explain our alleged predilection for his 'line of beauty', the sinuous line, by reference to animal behaviour: 'This love of pursuit, merely as pursuit, is implanted in our natures, and design'd, no doubt, for necessary, and useful purposes.' He may well have been right, though I believe he spoilt his case by moving too quickly from biology to aesthetics. In any case I am not concerned at this stage with the question of pleasure, but with the instinct 'implanted in our natures, and design'd . . . for necessary, and useful purposes'. That ordered frame of reference which alone makes it possible for the organism to seek and to avoid objects is logically prior to the individual stimuli to which it reacts.

It is here that the 'searchlight' metaphor comes in useful, for it reminds us of the activity that is inseparable from the most primitive model of perception. The organism must probe the environment and must, as it were, plot the message it receives against that elementary expectation of regularity which underlies what I call the sense of order. The methods which emerged in evolution are legion, but they all have this in common—that they extend the creature's power of anticipation. Lorenz's primitive organism has to wait till it bumps into things. The specialized senses give due warning for avoidance or pursuit. Bats find their way in the dark around obstacles and towards their insect prey by a kind of sonar device. They emit ultrasonic directional cries, which bounce off solid matter and tell the animal about the location and movement of things in its path. 'Horseshoe bats', we read, 'squeak through the nose to give a narrow beam on a constant frequency, which can be swept back and forth like a searchlight . . . At the same time it moves its ears forward and back alternately sixty times a second, as direction finders.' Even more dramatic is the discovery of groping methods, using a radar-like device, employed by certain electric fishes: *Gymnarchus niloticus* 'uses its electric field as a mechanism of incredibly fine sensitivity to locate obstacles in its path . . . or to find its way into crevices, backwards as well as forwards. Using the same equipment it can also locate prey, be made aware of enemies, even recognize other members of the species, including a potential mate . . .'.

Yet the example of this astounding creature does not simply duplicate what we know of the bat. It leads us further towards the understanding of that link between perception and order I am anxious to illustrate. 'Although it is usual to speak of Gymnarchus using radar, this use of an electric field has little in common with it ... the electric field provides information by the distortion of its lines.' Exceptional as is this curious device, it seems to me to offer a perfect illustration of the Popperian asymmetry, the use which our sense of order must serve in the business of survival: it allows the organism to discover deviations from the order, departures from that norm which is somehow encoded in the nervous system. We are only now beginning to understand the degree to which our visual orientation in space also depends on such a norm. It might be called the norm of changing aspects. It was J. J. Gibson, above all, who drew attention to the hidden order implicit in the transformations we experience as we move around the environment. Whether I sit down at my table or turn a book in my hand, the flow of visual information which I receive will suffice to make me perceive the 'invariant' shape of the table or the book across the melodies of change. Only if this lawful transformation failed to occur, if the table moved by itself or the book shrunk in our hand, would we receive a jolt. The bearing which this extension of our sense of order may have on the theory of decorative design will be discussed in its proper place. Here it should help me first of all to define my position towards the *Gestalt* theory of vision, to which we owe such important insights into the perception of patterns and which is nevertheless generally agreed to be in need of revision.

2 *The Gestalt Theory*

The *Gestalt* theory was the first theory of perception which systematically opposed the 'bucket theory' of a passive registration of stimuli. It denied the possibility of an 'innocent eye' which I was at such pains to combat in *Art and Illusion*. We cannot see any configuration neat, as it were, because the tablet on which the senses write their messages has certain inbuilt properties. Far from leaving the arriving stimuli intact, it puts them into pre-arranged slots. There is an observable bias in our perception for simple configurations, straight lines, circles and other simple orders and we will tend to see such regularities rather than random shapes in our encounter with the chaotic world outside. Just as scattered iron filings in a magnetic field order themselves into a pattern, so the nervous impulses reaching the visual cortex are subject to forces of attraction and repulsion.

The alternative hypothesis I proposed in *Art and Illusion* converged, as I said, with an explanation mooted by Julian Hochberg. It appeals to the use we can make of order for the discovery of deviations. Take a man in the dark trying to gain information about the unseen environment. He will not grope and thrash about at random, but will use every finding to form a hypothesis about the meaning of his encounters, a hypothesis which subsequent gropings will serve to confirm or refute. The first and almost automatic assumption with which he is likely to operate is that hypothesis of a relative stability of objects which must also guide the movements of the lowly organism (or lowlier robot) described above. In a nightmare situation, in which every feature of the environment silently and unpredictably changed shape and place between his gropings, he would be forced to give up. But if the environment exhibits any regularities to be discovered, his only strategy would be to test it for orders of his own creation, modifying his tries in a progression from simple to more complex configurations.

Taking a further clue from Popper's methodology of scientific research I argued that: 'Without some initial system, without a first guess to which we can stick unless it is disproved, we could indeed make no "sense" of the milliards of ambiguous stimuli that reach us from our environment. In order to learn, we must make mistakes, and the most

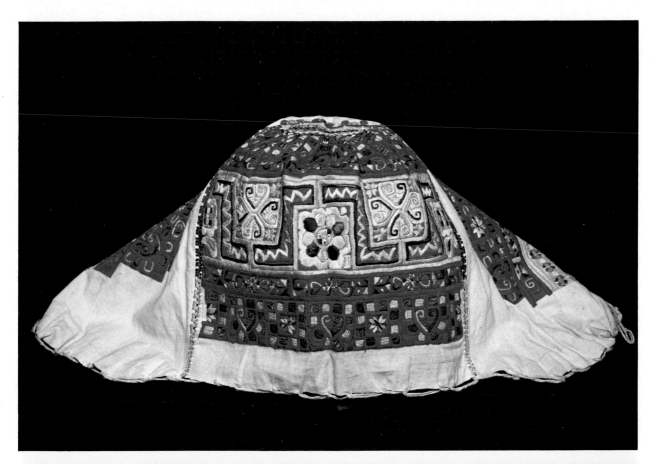

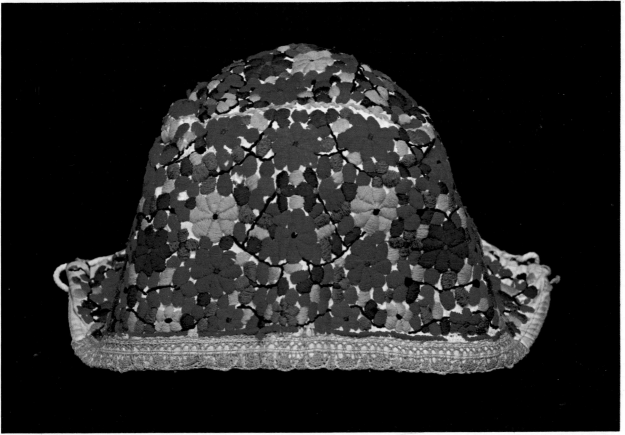

I. Two bonnets from Slovak folk costume. 19th century. Oxford, Private Collection. See pp.vii,73,159

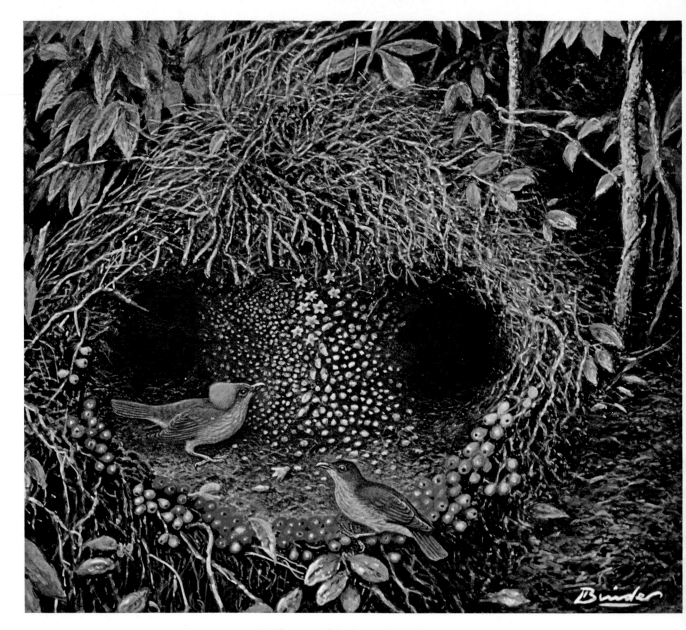

II. The nest of the bower bird. See p.6

III. Bark cloth from Tongatabu, Friendly Islands. From Owen Jones,
The Grammar of Ornament, 1856. See p.51

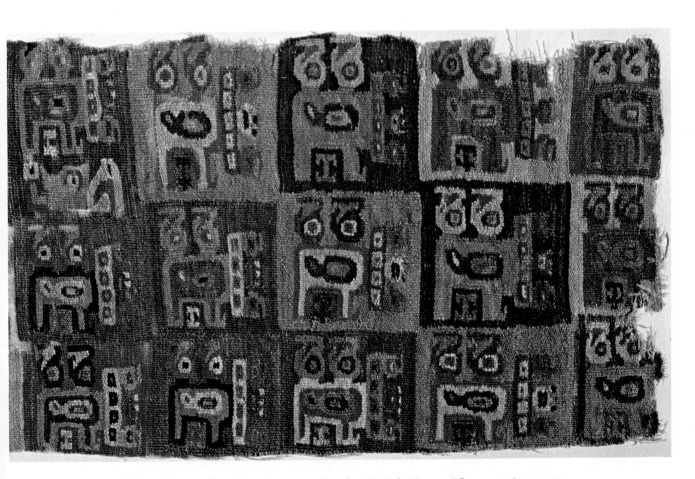

IV. Peruvian textile. 6th–11th century. London, British Museum. See pp.72,82,292,301

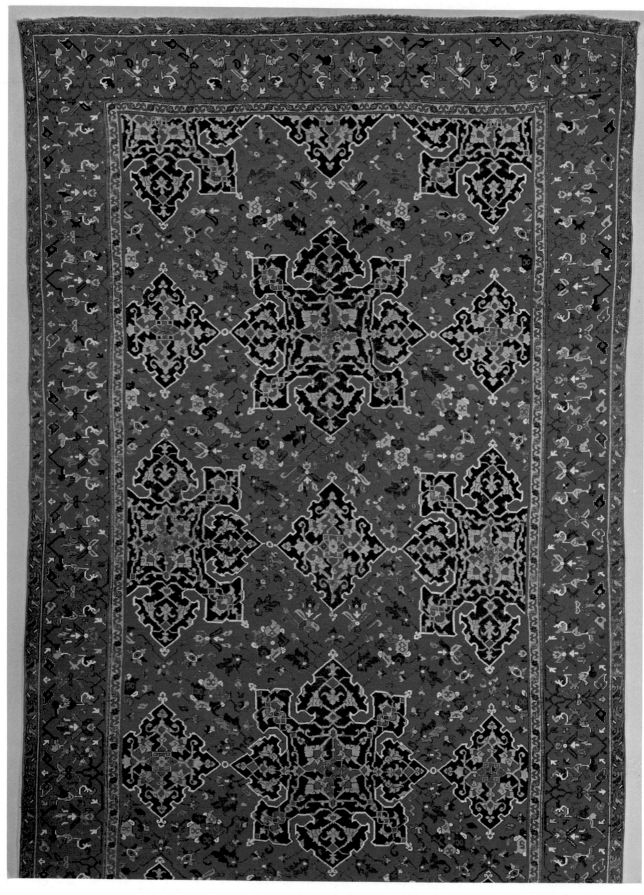

V. Detail of Star Ushak carpet. Persian, about 1600. New York, Metropolitan Museum of Art. See pp.73,78,190,292

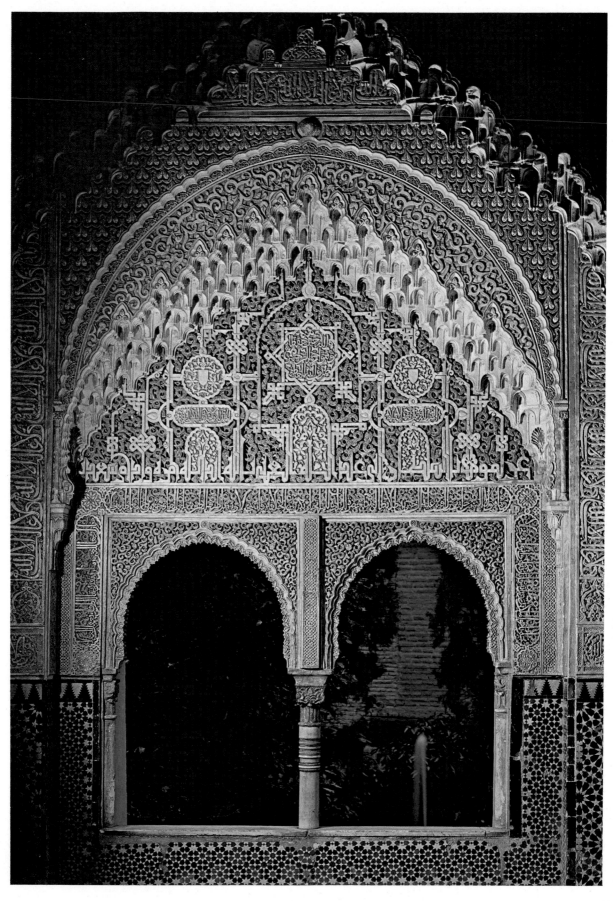

VI. Mirador de Lindaraja, Alhambra, Granada. 14th century. See pp.95,157,164

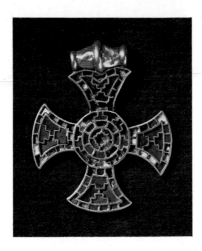

VII. The Ixworth Cross. Anglo-Saxon, about A.D. 600.
Oxford, Ashmolean Museum. (Slightly enlarged.)
See p.196

VIII. Kaleidoscope patterns. See p.151

IX. From M. E. Chevreul, *The Laws of Contrast of Colour,* English edition, 1861. See p.142

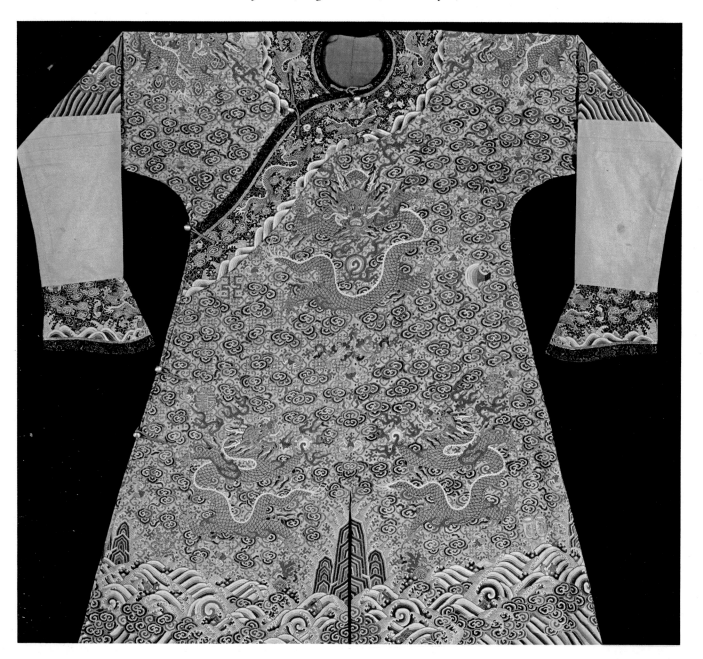

X. Detail of Imperial dragon robe. Chinese, late 18th or early 19th century. London, Victoria and Albert Museum. See p.241

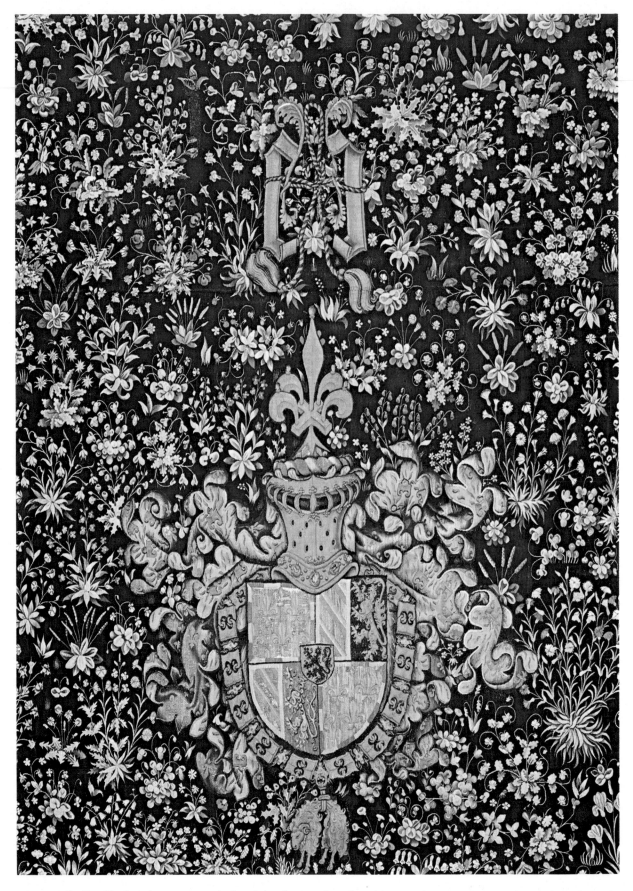

XI. Detail of 'Mille-fleurs' tapestry made for Philip the Good, Duke of Burgundy. 1466. Berne, Historisches Museum. See pp.159,232

fruitful mistake which nature could have implanted in us would be the assumption of even greater simplicities than we are likely to meet with in this bewildering world of ours. Whatever the fate of the *Gestalt* school may be in the field of neurology, it may still prove logically right in insisting that the simplicity hypothesis cannot be learnt. It is, indeed, the only condition under which we could learn at all.'

In *Art and Illusion* I was mainly concerned with two aspects of this learning process. We have a tendency to probe both the real world and its representations with a hypothesis of regularity which is not abandoned unless it is refuted. The way we see the sky, the infinite void above our heads, as if it were a flattened dome or vault is an example of such an unrefuted hypothesis. We assume that the stars up there lie in one plane at a right angle to our line of vision and there is nothing to undeceive the naked eye. We make the same assumption also for a sky represented in a picture, or indeed for any silhouetted feature on the horizon. But important as are these symptoms of the activities that go with perception, the theme of *Art and Illusion* demanded more emphasis on the other effect of the simplicity principle—its role in representation. It is well known that the variety of the visible world is reduced in the schematic renderings which are usually described as 'conceptual images'. I interpreted these images as minimum models of the objects they are intended to represent and I emphasized throughout the book that 'making comes before matching'; the minimal schema is first constructed before it is modified or corrected by matching it against reality. If I were asked to sum up the theory underlying this book in a similar formula it would be that groping comes before grasping or seeking before seeing. In contrast to any stimulus-response theory I would wish to point to the need to regard the organism as an active agent reaching out towards the environment, not blindly and at random, but guided by its inbuilt sense of order.

3 *The Patterns of Nature*

In the study of representation the tendency to make simple shapes requires attention only as a background to their subsequent modification. The decorative shapes and patterns which form the subject of this book testify to man's pleasure in exercising the sense of order by making and contemplating simple configurations regardless of their reference to the natural world. The world which man has made for himself is, as a rule, a world of simple geometric shapes, from the book my reader holds in his hand to nearly all the features of our artificial environment. Not all these features were created for the sake of beauty, but all of them stand out against the pleasing medley of the natural environment.

So deeply ingrained is our tendency to regard order as the mark of an ordering mind that we instinctively react with wonder whenever we perceive regularity in the natural world. Sometimes, in walking through a wood, our eyes may be arrested by mushrooms arranged in a perfect circle (Fig. 1). Folklore calls them fairy rings, because it seems impossible to imagine that such regularity has come about by accident. Nor has it—though the explanation of the phenomenon is far from simple. But why are we startled in any case? Does not the natural world exhibit many examples of regularity and simplicity—from the stars in their courses to the waves of the sea, the marvel of crystals and up the ladder of creation to the rich orders of flowers, shells and plumage?

The brief answer to this complex problem is that order in nature comes about where the laws of physics can operate in isolated systems without mutual disturbance. We are not surprised to see circular waves spreading on a pond after we have thrown a stone. We know the water to be uniform and that the impulse will travel uniformly in all directions unless there are obstacles or other influences, such as a current or a breeze, which will progressively complicate the order till it may elude not only perception but even computation.

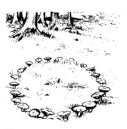

Fig. 1

What arrests our attention in the fairy ring is precisely the unexpected presence of order in what appears to be an environment of countless interacting forces: the random medley of the natural earth with its trickles of water through moss, its twisted roots and fallen leaves. Only a magic agency, so we conclude, could impose an order on such wild confusion.

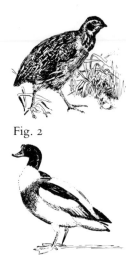

Fig. 2

Fig. 3

In other words, it is the contrast between disorder and order that alerts our perception. There is ample proof that this principle applies throughout living nature. For the distinctive designs exhibited by the flora and fauna of the world suggest that there must be some advantage to the organism in the emergence of certain visible patterns. They must have arisen from evolutionary pressures which favoured the bearers of certain types of markings. It is well known that there are two opposing tendencies, both of which are significant in our context. There is the camouflage pattern, aimed at making the creature invisible to its predators (Fig. 2), and the marking that makes it conspicuous (Fig. 3).

The camouflage pattern imitates a random distribution of elements such as occur frequently in the habitat of the species. It looks like an average, haphazard array of stones, sand or twigs without any outline or edge that could give the animal away when it freezes into its background. The camouflage artist imitates this procedure when he assembles the characteristic features of an environment and jumbles them in the same doses. The success of this device in nature and in war suggests that in scanning the world for novelty we soon learn to apply a similar law of averages. As long as the relative frequency and distribution of features is not changed we do not register novelty.

This observation extends beyond the device of camouflage to any kind of design that makes use of random elements – whether it is a mottled surface of coloured dots or a mixed tweed. The degree of randomness can now be controlled by computers, and experiments with such random patterns have confirmed the sensitivity of the mind for averages. In this respect even disorder is experienced as order.

The principle of conspicuous marking drives home a different point. In many situations the survival of the species will obviously depend on its members recognizing each other for feeding, mating and group formation. The design must therefore stand out clearly and visibly against the background. It should be as unlikely as possible to have come about by chance. The luminous colours and regular patterns of blossoms which must signal their presence to pollinating insects, the rich plumage used by birds in such displays as the peacock's fan, the distinctive markings of beaks recognized by the young, all these have been described as configurations of high improbability, that is of high information value.

Seen in this light it is perhaps a little less surprising that some kind of actual pattern-making can also be observed in the animal world. The small bower bird makes a stage or display arena for his courting (Col. Plate II). He clears an area of dead leaves and other debris and decorates it every day with fresh leaves of selected species of trees, which he saws off with his beak, serrated for this function. These leaves are placed with the light underside visible, and if reversed he will turn them back. Some broken snail shells are usually added. In this way the area is set off against the random world of his usual habitat as a signal to the female. It creates a little island of order, which corresponds in the visual realm to the patterned call with which the bird accompanies this display.

I use the comparison advisedly because biologists have stressed for some time that the regularity of animal calls not only serves the obvious purpose of specific recognition signals for the species, but is also apt to defeat the random noise which may fill the air.

4 Man-made Orders

It is never without danger to draw analogies between nature and culture, but I believe that here, as elsewhere, such dangers must be faced if progress is to be made. Clearly culture can

derive analogous advantages from the creation of orders which proved themselves in the process of evolution. Here and there the very unlikelihood of regularity having come about by accident may serve as a starting point for signalling.

Take one of the most widespread and possibly one of the earliest applications of pattern—tattooing, the incision of ornamental scars. It is clear from the outset that such ordered cuts differ from the wounds received in combat. Such wounds may also be borne with pride, as they were, or perhaps still are, by the duelling students of German universities, who displayed them as marks of their status. But even the most ritualistic sabre duel is unlikely to result in regular scars. The regularity is a sign of intention; the fact that they are repeated shows that they are repeatable and that they belong to culture rather than to nature. Scars of this kind can be developed into a complex system of tribal marks and social signs indicating rank or status in an unambiguous fashion (Fig. 4). They may also be used for decoration without any ulterior motive: to display the care and attention devoted to the body which has thus been marked. They are formations echoing and stabilizing the activity of a constructive mind.

Early students of ornament and of the beginnings of art sometimes wondered how man could ever achieve the degree of abstraction that they supposed to be inherent in the construction of a straight line. Even that great investigator of tribal art, Franz Boas, who was so much aware of man's enjoyment of mastery, still asked himself why geometrical elements occurred so frequently in man-made order, since, as he says: 'They are of such rare occurrence in nature, so rare indeed that they had hardly ever a chance to impress themselves upon the mind.'

The conclusion to which we are driven suggests that it is precisely because these forms are rare in nature that the human mind has chosen those manifestations of regularity which are recognizably a product of a controlling mind and thus stand out against the random medley of nature.

That they do, there can be no doubt. Do we not increasingly feel the contrast between the modern human habitation, with its grid of streets and its matchbox buildings, and the surrounding countryside? But has this contrast anything to do with the topic of this book, which is decoration? Is not the preference for straight lines and regular shapes a matter of convenience rather than of creativity? No doubt it is, but I also believe that the contrast between rationality and creativity is ultimately unsound. We shall see that it was Ruskin who bequeathed to us this opposition between the untamed exuberance of life and the dead perfection of engineering. His hostility to the machine certainly alerted him to a vital problem which no student of ornament can disregard, but I believe it also blinded him to the kinship between rational and organic orders. Once we realize what advantages rational man derives from the application of the simplicity principle, from his preference for straight lines and standardized geometrical shapes, we may be better placed to study the emergence of analogous behaviour along the whole evolutionary scale. We are no longer afraid in such matters to use teleological arguments and to ask why our mental make-up favours simplicity both in perception and in making. If these tendencies did not have a strong survival value they would not have come to form part of our organic heritage.

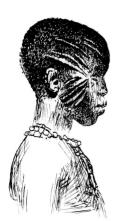

Fig. 4

5 *The Geometry of Assembly*

Intuitively it is clear that there are types of simplicity which go together with ease of assembly. The principle is illustrated no less in the normal brick wall than it is in the crystal that results from the close packing of identical molecules. In the organic world we find such standardized constituents in the cell assembly, or in the larger units making up a sea urchin (Fig. 5), a pomegranate or a maize cob. Many of these assemblies, moreover, also

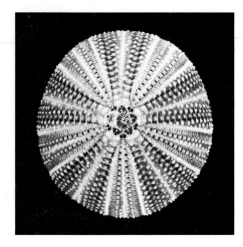

Fig. 5. Sea Urchin

demonstrate the advantages of the hierarchical principle—units being grouped to form larger units, which in turn can easily fit together into larger wholes.

All these inherent advantages of standardization are available to man as soon as he is ready to plan his activities in stages—first shaping bricks, then building the wall, and finally roofing the house. Such a planned sequence requires a certain amount of organization. What the Greeks called 'cyclopean walls' were made from irregular blocks, each of which had to be put into a place where it would fill a gap (Fig. 6), and what we call 'crazy paving' is composed of irregular slabs which have to be selected as the work proceeds (Fig. 7). There may be more charm in this than in the regular flagstones bought readymade from a builder (Fig. 8), but the technical advantages of the latter method are worth considering.

Our pre-shaped standardized slabs are interchangeable. We can take any one from the pile and start laying the pavement and we can also quickly count and see how many we shall need to cover a given area. Laying a crazy pavement, by contrast, may be more fun; selecting the fitting piece and constructing an irregular but pleasing network of joints will have greater charm than the regular grid of the flagstones.

Why would the champion of irregularity condemn the latter as dreary or monotonous? Is it not because it can be taken in so easily that it leaves our perceptive process without enough work to do, while the crazy pavement presents so much variety that we could never fully grasp it, let alone memorize it?

Figs. 6, 7 and 8

6 Monotony and Variety

This is the insight which the ancients summed up in the proverb '*variatio delectat*', variety delights. We look at the grid and take it in at a glance as soon as we have grasped the underlying rule that all the flagstones are identical. But the very ease of perception also

accounts for the boredom that is caused by such monotony. When the expected happens in our field of vision we cease to attend and the arrangement sinks below the threshold of our awareness.

In this respect the new intellectual discipline of the theory of information appears to hold greater promise for psychology than the earlier accounts of the *Gestalt* school. For in this technique of the communication engineers the information is measured by its degree of unexpectedness, while the expected becomes in their terminology the 'redundant'. There is much we can learn from this approach but the discussion of its technical difficulties is better left to a later chapter. Suffice it to say here that we must beware of the identification of the simple with the probable and redundant. The flagstone pavement, we shall find, is neither more nor less probable in any measurable sense than the crazy pavement; it is only more easily constructed and therefore remembered.

But however we analyse the difference between the regular and the irregular, we must ultimately be able to account for the most basic fact of aesthetic experience, the fact that delight lies somewhere between boredom and confusion. If monotony makes it difficult to attend, a surfeit of novelty will overload the system and cause us to give up; we are not tempted to analyse the crazy pavement. It is different with hierarchies which we can master and reconstruct (Plate 3). In these arrangements we can take the subordinate as read while we concentrate on the larger forms. The very ease of reconstruction allows us to go on and to enjoy that unity in complexity that has always appealed to paviours and other pattern-makers.

There are many relatively simple shapes which can be assembled or packed in different ways resulting in novel configurations, a trivial example being the parquet floor in which the rectangular boards are joined into interrelated zigzag lines (Fig. 9). Here, too, nature demonstrates the variety and indeed the infinity of configurations that can result from such joining of elements—the most varied and startling being snow crystals, though their beauty was not discovered before they could be studied under a magnifying glass (Plates 23, 24). We shall encounter many examples of such hierarchical structures designed by man which illustrate the principle of 'unity in diversity' that has always been connected with aesthetic configurations.

There must be a link, then, between ease of construction and ease of perception, a link that accounts both for the tedium of monotonous patterns and for the pleasure we can obtain from more intricate constructions, from configurations which are not felt to be boringly obvious but which we can still understand as the application of underlying laws. But why should this give us pleasure? What theory of perception would be needed to make this correlation between construction and perception intelligible?

Fig. 9

Pursuing the lines of thought of this Introduction, it is clear that Hamlet's 'the readiness is all' must be the motto of life. No jolt should take us unawares. The organism has often been compared with a homoeostatic device striving for equilibrium with the environment. Such equilibrium always requires action. There must be a 'feedback mechanism' (of the type of a thermostat) registering and counteracting any deviation from balance. In other words, even in a state of rest the organism cannot be allowed to remain passive. It must harness its sense of order to carry out the required adjustments, as we have to do when we try to stand still and shift our weight imperceptibly to one side or another. But these corrective movements have become automatic and do not demand attention. What reaches our awareness are only disturbances which affect the whole system. Not necessarily for long, however, for if the disturbance recurs at regular intervals the homoeostat is adjusted to accept it as part of its new environment. Adding the power of anticipation to our primitive model, we can picture the organism making ready for coming jolts, preparing to parry, to yield, or simply to brace itself. The child on the swing or, better still, the horse-back rider who learns to

adjust to the rhythmical jolts of the canter, the trot or the gallop must build a parallel internalized structure of innervations to match the regularities of the external movement. I propose to describe this adjustment as 'forward matching'. One might object that the term 'forward planning', from which I have derived this coinage, is bad enough since all planning must be forward, but that 'forward matching' is worse, since we cannot match what does not yet exist. It is this paradox, however, which has prompted my choice of the term, because it underlines the hypothetical nature of the reaction. If the gamble comes off 'forward matching' becomes automatic and sinks below the threshold of awareness; where it fails, the 'mismatch' will provide the rousing jolt, as when we reach a platform on walking downstairs, before we expect it.

It is worth pursuing this simple example for what it tells us about the links between spatial and temporal orders. If the stairs had not been all of equal height, we would not have adopted the routine of forward matching, but would rather have looked out before every new step. If after the unwelcome bump we find ourselves on level ground, we have another routine ready, that of walking, which is again nearly automatic. The transition back to our example of regular flagstones is easy. They are effortlessly perceived as a simple order to which we need hardly attend.

Ease of perception must thus be coupled with ease of construction—the production of internal models regulating our expectations. Take any regular body, a plain cube or a sphere; walking around it or merely turning it in our hands we have no difficulty in anticipating the aspects which will come into view. The same would not be true of a random shape such as a lump of coal. Here our expectations can never be more than approximate. The decorated object, a building or a box, stands somewhere in between these extremes. Our expectations will be borne out as far as the over-all form is concerned, but pleasantly upset within this major framework by the varieties of design.

7 Order and Movement

Everything, then, points to the fact that temporal and spatial orders converge in our experience. No wonder language speaks of patterns in time and of rhythms in space. Much of what has been said about the rational and aesthetic aspects of geometrical orders also applies to temporal events. The nineteenth-century author K. Bücher, who wrote a book *Work and Rhythm*, in which he derives music from the need of workers pulling loads or rowing together, certainly overstated his case. But he was right in his insistence on the need for timed movement in the execution of joint tasks. And here again it is not only the simultaneous movement that is ensured by rigid timing. Even more important is the possibility inherent in any order of constructing a hierarchy of movements or routines to ensure the performance of more complex tasks. Whether it is loading bricks onto wheelbarrows which are moved when full, or more complex movements executed on the parade ground, the need for dovetailed hierarchies is obvious. The gear or the cogwheel has made it easy for such timed interaction to be translated into mechanical operations, and any machine, from a pendulum clock to a motorcar, provides examples of this basic principle. In the machine the basic order is rooted in natural law. The pendulum, as we know, would go on swinging in the absence of interfering friction, because of the constant relationship between the forces of attraction and those of inertia. There are many regularities in nature which rest on such simple interaction. The tap will go on dripping regularly as long as the even trickle of water results in a cohesive drop which must fall when it becomes too heavy to adhere to the tap. There may be similar regularities of saturation and rhythmical discharge in organic rhythms, where reflex actions come into play, but it is one of the achievements of modern biology to have shown that such quasi-mechanical explanations are inadequate to

account for the rhythmical activities which pervade life. We all know of organic rhythms from the heart-beat and breathing to the complex actions of locomotion by swimming, crawling, flying or running, but scientists have only recently begun to unriddle the devices in the nervous system that enable a fish to coordinate its moving fins at any speed through impulses from the spinal chord. They have shown that more is involved here than a simple reflex mechanism. An organism can be interpreted as a complex team, a hierarchical structure of interacting forces, and this interaction could never be secured without some basic timing device, a sense of order. What distinguishes organic rhythms from the mechanical timing of the machine is their greater flexibility and adaptability. The hierarchies are so adjusted that the interaction can proceed at varying speeds without upsetting the desired result. Nature around us is throbbing with complex rhythms, and these rhythms serve the purpose of life.

Even in man most primitive body-reactions are geared to these rhythms. The baby's cries, the adult's laughter are rhythmical. Under the stress of emotions the simpler, more reflex-like rhythms easily take over, as when the child jumps for joy or the angry adult drums on the table with his fingers in irritation. Those mental states which psychoanalysis describes as 'regressive' seem to favour simple rhythms, and exposure to such simple rhythms in its turn seems to favour regression. We rock the baby to sleep, while in other contexts the rhythmic beat of the band may produce a kind of regressive frenzy.

We call such rhythms 'primitive' because the regular recurrence of units in time is so easily grasped. We know when to expect the next thump or stress and we can fall in without effort. Vary the elements and the subdivisions and it will need more attention to keep step; some complex sequences, such as those of Indian ragas, are hardly accessible to Western ears because it needs training to hold these varied relationships in mind. As in visual patterns, therefore, we have the same range in temporal rhythms from the monotonous to the varied, each with its own psychological correlates and effects.

It is in the acquisition and development of motor skill that we can best study the transition from primitive automatic rhythms to more complex hierarchical structures. For what goes for the perception of visual patterns also goes for their production. The monotonous may fail to register while the intricate may confuse. The expected tick-tock of the clock disappears from our awareness while any change in the rhythm or even the stopping of the noise may alert us. In a similar way the simple rhythms of our breathing or walking allow the movements to become automatic till they are only monitored for disturbances. It is the purpose of any learning of skills to make the constituent movements equally automatic. Whether we use a typewriter, ride a bicycle or play the piano, we first learn to 'master' the basic movements without attending to them all the time, so that our conscious mind is left free to plan and direct the over-arching structures; we think of the sentence we type, we guide the bicycle round an obstacle or we attend to a complex rhythm in the right hand while the even configuration of the accompaniment played by the other hand can be left to look after itself.

There is no craft which does not demand this breakdown of the skill into elements which are steered by the larger movement; mastery of plaiting (Plate 4), weaving, stitching or carving demands this structure of routines collectively guided by a conscious mind. It does not seem far-fetched to think that this mastery is achieved precisely by hitching the movement to that powerhouse that directs our organic rhythms. The work of the master craftsman goes 'with a swing' as his hands move in unison with his breath and perhaps with his heart-beat. No wonder that the product he carves or paints is imbued with this spirit of a living rhythm, that mark of the craftsman that Ruskin never ceased to exalt over the 'soulless' perfection of the machine.

Whatever we think of his valuation, the distinction is illuminating—we may call it the

contrast between rational and irrational creation. It would perhaps be tempting to group historical styles with these polarities in mind, contrasting the planned, measured and crystalline form of one extreme with the spontaneous, freely flowing rhythms of the other. But though one or the other principle may occasionally dominate, we have seen that we must not overplay the contrast between structural planning and the advantages of rhythmical movements which tap the inherent laws of the organism itself. Far from typifying exclusive procedures, we shall find that it is the tension between the two that gives life to historical styles. The work with ruler and compass is no less part of the art of pattern-making than are the curving line and the flourish of the master's pen. The pleasure we experience in creating complex orders and in the exploration of such orders (whatever their origin) must be two sides of the same coin.

8 Play and Art

> Christopher Robin goes
> Hoppity, hoppity
> Hoppity, hoppity, hop.
> Whenever I tell him
> Politely to stop it, he
> says he can't possibly stop.
> If he stopped hopping, he couldn't go anywhere,
> Poor little Christopher
> Couldn't go anywhere . . .
> That's why he *always* goes
> Hoppity, hoppity
> Hoppity,
> Hoppity,
> Hop.

It is a case where the pleasure in creation was obviously greater than the pleasure in perception. But A. A. Milne's little boy was not altogether wrong when he pleaded for his game. At least it may be remembered that I have argued that it must profit the organism to have a variety of routines at its disposal for matching and anticipating the regularities of the environment. We learn by switching on these routines in playing Christopher Robin's kind of game and we also learn to lock in on any such rhythm with compulsive persistence.

For the child, the way to break the monotony is not to stop, but to enhance the interest of the routine by introducing a new element. Christopher Robin might willingly have accepted a skipping-rope to accompany his hopping. Watching almost any solitary game we can find this tendency to step up the task after it has become too easy to require attention. Bouncing a ball, the child may alternate between the right and the left hand, or clap hands, once, twice, or any fixed number of times between the bounces till he can do it without a mistake. In thus filling in the interval between the peaks of the movement, the child discovers the dual satisfaction of holding on to the rhythm while avoiding monotony. It is this procedure, which I shall call 'graded complication', which most easily reveals its psychological kinship with ornamentation in the visual arts and in music.

Contrary to Plato's view which I quoted in the Preface, we now know that such manifestations of the 'sense of order' are not confined to human beings. In Desmond Morris's monograph about the young chimpanzee Congo, we encounter a description of graded complication which must make us pause.

'When Congo was given a piece of gymnastic apparatus and allowed to play with it, he would first make erratic exploratory actions, and then, out of this confusion, would come a

pattern of movement. This he would repeat over and over again, until, after a while, he would vary it slightly. Then the variation would grow and grow until the first rhythm was completely lost and a new one replaced it.'

The description even more than the drawings of the young primate appears to justify the title of the book, *The Biology of Art*, for it could be claimed that Congo here anticipated the whole of the history of styles. The first pattern having lost its charm by having become automatic, a new one was needed to experience the pleasure of mastery. It might still be objected that, after all, Congo lacked the awareness of what he was doing and the power to communicate it to others. The enjoyment of mastery need not have been accompanied by a capacity to objectivate the achievement which enables the child to set itself goals and to tell others of the grade it had reached, courting their admiration or even their envy. But it would be rash to conclude that the first germs of this capacity which leads to art is entirely lacking in the play of the primate. For Congo's play with brush and pencil came close to the edge of this decisive stage. At first his productions were dominated by a fixed sequence of movement which produced what Morris called the fan pattern (Fig. 10); he made strokes in the direction of his body. But Morris observed a dramatic change in this procedure which we can only describe in terms of intention movements. It was the moment when Congo drew the same pattern, but from the opposite side, by starting close to his body and drawing the lines away from him (Fig. 11). The visual product seems to have become more important than the enjoyment of production. Later he discovered the joy of making loops, but here the pleasure in sheer motor activity got the better of him and he tended to obliterate the shapes he had created (Fig. 12). The product counted for nothing. Congo did not

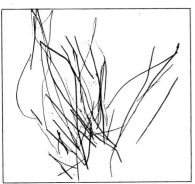 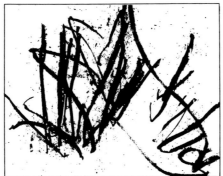 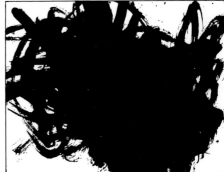

Figs. 10, 11 and 12. Drawings by Congo

become a simian pattern-maker, for he became altogether too unruly to carry on with his brushwork. Whether or not another ape may one day discover the pleasure of building more complex hierarchies we cannot tell. After the achievements of the Gardners with their chimpanzee, Washoe, nothing seems impossible.

Man would not be man if he did not put his mastery of movement to the use of ulterior purposes. The plaited basket, the woven cloth, the chipped stone or the carved wood, records and preserves that pleasure in control that is inseparable from the rise of decorative art. At the same time the pattern itself is made to serve cultural aims; tradition claims the right to restrict the freedom of play as motifs acquire meanings. The need for the standardized and the repeatable makes itself felt in the sign that must be fully controlled. But even the production of signs—the art of writing and the art of drawing—rarely severs its link with those organic rhythms which I have compared to an inner engine. Watch a child making the transition from rhythmical scribbling to the shaping of forms that require increasing coordination, and notice the shapes building up from those subunits or subroutines, like regular downstrokes or loops, which no longer require attention. Graphologists claim to discern something of the internal engine, the permanent rhythm of

the body, even in the handwriting of the adult and they are very likely right, for it is only through this integration that fluency in writing can be achieved. We shall see in fact that the urge for playful movement, for the discharge of motor impulses, is rarely far from the surface in the formation of signs and letters, and results in those flourishes and scrolls which are an essential aspect of decorative art.

The student of pattern will not be surprised to see these products of playful exuberance frequently assigned a relatively low rank in the hierarchy of the arts. The shaping of a flowing script is a higher achievement than the doodling of flourishes, and drawing, in its turn, a more complex skill than lettering. But even the art of drawing, as so many critics have stressed, is still rooted in the soil of natural organic movement. If every draughtsman did not have his own personal rhythm, his own handwriting, the connoisseur's effort of attributing drawings to masters would be hopeless. No doubt these traits are also connected with the process of learning that must be personal to every artist. The way he breaks up the task into individual chunks or subroutines will depend both on traditions and on individual dispositions. A simplified example of what I have in mind is provided by two methods suggested by Walter Crane for those who want to draw a horse (Fig. 13). Those to whom loops come easily should build up their forms from loops, while those whose natural rhythm is more jerky may try the alternative path. The historian of art, including the connoisseur, may profit from this analysis.

It is here, indeed, that the analysis of ornament, which is the purpose of this book, links up with the psychology of pictorial representation, the topic of my book on *Art and Illusion*. In stressing that 'making comes before matching' I was led to consider the role of visual formulae or schemata in the acquisition of drawing skills. I even referred to the link between drawing and writing in the Chinese tradition, where the learner practises drawing an orchid while chanting the instructions for movements. But I failed to generalize on this example and to bring out the close link between such acquired schematisms and those rhythmical propensities of the organism which reach from the subhuman level of Congo's brushwork to the sublime feeling for rhythm and form that makes a master such as Raphael ride his circling movements which are both schemata and patterns (Fig. 14).

The transition seems natural from the contemplation of these rhythmical marks to an awareness of that free-flowing movement that pervades all Raphael's compositional drawings, where every figure and every group is envisaged in terms of melodious interaction (Fig. 15). Whatever task a great artist is set, he will seek to attune it to his sense of rhythm and order, whether he is planning a building (as Raphael is seen doing on this sheet) or creating an image such as the *Madonna della Sedia* (Plate 1), for which the idea is seen emerging alongside. Having devoted a study to the analysis of this particular masterpiece of composition, I cannot find it surprising that critics over the centuries have focused their attention on devices of spatial organization and on the traditions of symbolism that

Fig. 13. Walter Crane: Two drawing procedures. 1902

Fig. 14 (*left*). Raphael: Studies of the Virgin and Child. About 1505

Fig. 15. Raphael: Part of a sheet of studies. About 1508

converge in such a classical formulation of a venerable theme. Compared to these highest reaches of art, the work of the humble weaver who thought out the pattern of the Virgin's scarf or that of the turner who fashioned the throne may indeed seem nugatory. But those who have seen the painting in its present setting in the Sala di Saturno of the Palazzo Pitti will not have been allowed to forget man's perennial urge to show off his skills in the creation of decorative patterns. We should permit our eyes once in a while to stray from the picture to the frame and to wonder at its function.

It is this, in brief, I propose to do in the following chapters. But this is the moment, also, to prepare the reader for the sacrifice involved in any discussion of greater generality. The individual example will tend to get submerged in the tides of the argument. This must serve as my excuse for not pausing to investigate the history of this particular frame, which is not, of course, contemporary with Raphael's painting. It must date from around 1700, from the time that the painting was first exhibited in the Palazzo Pitti.

But whatever the exact date or the name of the carver and designer, it must be admitted that, on the face of it, it seems an extraordinarily pointless activity to expend so much skill and labour on carving and gilding these festoons with laurel leaves and berries, stretched between fictitious curly brackets of extraordinary elaboration, which fasten them between shell-shaped forms. There are the four masks in the corners framed by plaits tied under their chins, their flowery head-dresses merging with whirling scrolls, which are sprouting leaves and serve as frames for the two cartouches in the central axis; finally there is the circle of curly acanthus leaves, thirty-one of them, which must have been measured with great care to make them fit.

At this point the twentieth-century reader is likely to ask whether such a monstrous piece

of decoration is at all worthy of attention. Would it not be more charitable to forget about it, or, better still, to plead with the Director of the Pitti Palace to disencumber the painting of this ostentatious vulgarity and to show it plain, preferably without any frame, as the paintings in the Gallery of Genoa are now displayed?

I would almost hope for some such reaction if it helps to involve the reader in the problem from the start. At any rate I have thought it right to devote the first section of this book (Chapters I and II) to the criticism of ornament and the debate on decoration that culminated in the virtual identification of ornament with crime, associated with the Austrian architect, Adolf Loos, at the dawn of the functionalist era.

I am old enough to view the passing of this era with regret, but by now there is plenty of evidence all around us that decoration is no longer taboo. We can ask again what prompts the craftsman to create his complex orders and what methods he can use (Chapter III) and conversely how these intricate structures are intended to be perceived (Chapter IV). Since we are not meant to examine the frame piecemeal, what, if anything, is the function it is intended to serve? How does the mind deal with ordered profusion and what can we say about the effects and their psychological causes? (Chapter V). How do such elements as the masks in the corner and the leaves encircling the opening enter into systems of decoration? (Chapter VI). Chapter VII looks at one of the elements which went into the making of this composition, the acanthus leaf, to exemplify the history of decorative motifs, which can be compared to the history of words in language. The comparison also raises the question of style in ornament, the subject of Chapter VIII, after which the question of meaning, which has loomed so large in recent iconological studies, has to be confronted (Chapter IX). The apparently meaningless flourishes and grotesques which we find luxuriating on the frame prompt further questions about the origin and function of these traditions (Chapter X). An epilogue on patterns in time briefly considers the analogies and metaphors which link the spatial arts of design with the arts of time, notably music, which 20th-century kinetic art has challenged to an interesting contest. It is more than a conventional flourish if I stress that the purpose of these chapters is merely to formulate problems. Many others will come to the reader's mind when he turns the pages and looks from the frame of the *Madonna della Sedia* to other illustrations in this book. My ambition has been to open questions, not to close them.

Part One
Decoration: Theory and Practice

I Issues of Taste

Less is more. Maxim attributed to Mies van der Rohe

1 The Moral Aspect

'The world is still deceived with ornament.' The warning occurs in the fairy-tale scenes of *The Merchant of Venice* where the suitors are tested by hiding the prize of the lady's portrait and of her hand in the leaden rather than in the golden or silver casket. But if the right suitor is made to declare that 'ornament is but the guiled shore to a most dangerous sea' we need not conclude that Shakespeare would have preferred the look of a leaden casket to that of an ornamented golden box. He only expounds the old doctrine that what matters is not outward show but inner worth.

Ornament is dangerous precisely because it dazzles us and tempts the mind to submit without proper reflection. The attractions of richness and splendour are for the childish; a grown-up person should resist these blandishments and opt for the sober and the rational. In this sense the warnings against displays of decoration are a tribute to its psychological attraction. We are asked to be on our guard because they may work only too well.

Few civilizations were disposed to deny that inner worth should be acknowledged by an appropriate display of outward show. Not only the splendours of kings and princes, but also the power of the sacred has been universally proclaimed by pomp and circumstance. Once in a while a preacher may have protested through deeds or words against such expenditure of skill and of resources, but this reaction in favour of renunciation is not necessarily linked with aesthetic revulsion. To my knowledge no contemporary member of the culture criticized an Indian temple (Plate 5), a Moorish Palace, a Gothic Cathedral or a Spanish Baroque Church (Plate 6) as 'over-ornate'. The concept did not exist, for there can never be too much of love and sacrifice expended on respect and veneration. The sneer 'it looks like a wedding-cake' is not on record in early civilizations. For why should not a wedding-cake (Fig. 16) celebrate the great occasion with all the frills and artifice of which the confectioner is capable?

In tracing the objections to decoration to their psychological and historical sources we must therefore be aware of different motivations. Where decoration is seen as a form of celebration it can only become objectionable when it is inappropriate. Pomp becomes pomposity, decoration mere gaudiness when the pretensions of decoration are unfounded. The 'brightest jewel' of the real crown can never be too precious, but precisely because it is so precious its use in other contexts may constitute a 'breach of decorum'—a concept to which we shall have to return. Moreover the link between the prized and the priced has as its corollary the taboo on imitation. The expenditure must be real and not sham. 'All that glisters is not gold' is a moral maxim, but it easily glides over into the critical maxim that what is worthy of glister must be worked in real gold. Cheap imitations, tinsel and glass, gilding and stucco become metaphors for any kind of eye-catching deception. Their easy appeal moreover shows the need for the discriminating eye, which can distinguish the

Fig. 16

genuine from the false and the hallmarks of devoted craftsmanship from shoddy short-cut methods.

It would be the task of a sociology of taste to tell us when and where such powers of discrimination mark the member of the élite and set him off from the vulgar and the childish, who fall for the gaudy bauble. In such a society the standards of craftsmanship and the choice of material can become so esoteric as to escape the perception of the uninitiated. Nowhere has this cult of refinement been carried to the same length as in Japan. According to William Watson, 'In China we do not encounter to the same degree the cult of rusticity which in Japan goes by the name of *shibui*, "astringent", then "tasteful, sober, quiet". If the Japanese scholar of the old school retires to the country to use the roughest utensils with relish (especially if a famous worthy can be said to have used them before him), his Chinese equivalent will be found fondling an antique piece of bronze or porcelain, which may be corroded or cracked, as befits its age, but is of the choicest quality without taint of the sophisticated-rustic.' But the triumph of an esoteric aesthetic does not necessarily go hand in hand with a rejection of splendour (Fig. 17). Even in Japan a masterpiece of the rustic style which can only be appreciated by sensitive fingers may still be placed in a precious setting, a pouch of brocade and a lacquered box, proclaiming its worth, much as a Raphael could be surrounded by a gleaming frame.

Fig. 17. Japanese bowl. Stoneware, 17th or early 18th century

2 Classic Simplicity

Whatever may be true of the Far East, in the history of Western Art the aesthetic ideal of restraint is inextricably interwoven with the classical tradition. The confidence with which we speak of 'barbaric splendour' betrays our deep-seated conviction that non-barbarians have other standards of excellence. A deliberate rejection of ornamental profusion has always been a sign of classical influence. Where this influence becomes a matter of pride, as in the Italian Renaissance and in 18th-century neo-classicism, the emphasis on form rather than decoration becomes a sign of self-conscious artistic virtue. Alberti's desire to see the interior of churches white is reflected in the interior of the Badia in Fiesole (Plate 7), which relies for its effect entirely on proportion. In a paper entitled 'Visual Metaphors of Value in Art' I tried many years ago to lay bare the psychological roots of this cult of restraint and to show how closely aesthetic condemnation remains linked with moral qualms. If we try to follow the explicit formulation of this ambivalence towards decoration to its source we are led from the criticism of art to that of speech. It was in the ancient schools of oratory that these critical issues were first articulated and debated.

If we can believe Plato, it was Socrates who constantly urged his disciples to be on their guard against the attractions of fine speech precisely because he was aware of their powers of seduction. The tricks and ornaments of sophistic oratory could easily deflect the hearer from

the argument in hand. Once again there is an obvious transition from the conviction that the charms of ornament can be used for a base purpose, to the suspicion that a profusion of such charms is likely to conceal a base purpose. The old proverb that 'a good wine needs no bush' has its correlate in what advertisers call 'sales resistance' to conspicuous bushes.

In the history of Greek rhetorical theory such 'sales resistance' developed into an aesthetic prejudice on the part of purists against all forms of verbal fireworks. These purists, who called themselves Atticists, decried the artifice of so-called Asiatic oratory with its rhythmic cadences and its far-fetched imagery. Their cult of the plain and simple threatened indeed to subvert the whole tradition of rhetoric with its panoply of tricks and devices. It was for this reason that Cicero expended much energy towards the end of his life in countering their arguments while conceding the limited validity of their case. Briefly, he acknowledged the force and value of the plain or Attic style where such a style was appropriate. But he urged that there were also occasions to which more solemn and artificial diction was appropriate. This is the influential doctrine of *decorum*, which lays down the conditions under which display is admissible and even necessary, while appealing to good taste to set it limits and to be aware of its pitfalls.

This doctrine, together with the metaphors Cicero used to commend the Attic style, never quite lost its power over the critical conscience of the classical tradition.

'The . . . Attic orator . . . is restrained and plain, imitating common usage, though he really differs more from the untrained than it seems . . . At first sight that plainness of style seems easy to imitate, but once you have tried it you know that nothing is less so . . . In his speech he should be free from the fetters of rhythm . . . these should be used in other styles of speech but should here be quite abandoned. It should be loose, but not rambling, to move freely but not wander about. He should also avoid, so to speak, cementing his words together too smoothly, for the hiatus and the clash of vowels has something agreeable about it and shows the not unwelcome negligence of a man who cares more for the subject than for the words . . . however, there is such a thing as a careful negligence.

'For just as some women are said to be more beautiful when unadorned, because this suits them, so this plain style delights, even though it lacks embellishments. For there is something in both cases that adds beauty without appearing to do so. In such a case every conspicuous ornament, the pearls, as it were, will be removed, no curling iron will be applied, cosmetics, white and rouge, will be rejected, all that remains will be neatness and cleanliness. The language will be pure and Latin, limpid and straight, always aiming first at propriety. Only one quality will be lacking, the one that Theophrastus enumerates as the fourth excellence of style, namely the sweetness and richness of ornament.'

Note that Cicero does not state that a lack of adornment is always preferable or that he would censure a queen for wearing pearls and even using cosmetics, but through his authority the aesthetic merits of simplicity had become firmly enshrined in the traditions of criticism. It had been established that apparent simplicity demanded much skill and that the absence of artifice could be a special merit. In this canonic passage, moreover, aesthetic and moral issues are hard to separate. What constitutes the chief merit of the style is its refusal to use methods of seduction—it is chaste and it is rational. It spurns rhythms and make-up.

These metaphors were always close at hand wherever ornament came under attack. For it was never hard to interpret decoration as a form of indulgence in sensuality and childish delights. Cicero especially singles out the absence of rhythm as a feature of plain and factual prose, and we have seen that the enjoyment of simple rhythms and exuberant flourishes is closely associated with what psychoanalysts call regression. Their charm may be linked with that of the curls and ringlets and sparkling pearls which may seduce the unwary.

In this way the hostility to decoration could easily be defended on rational grounds. Decoration was not only a wasteful indulgence, it was an offence against reason. Moreover,

and this proved a powerful argument, it was an unnecessary offence, because rationality by itself was productive of beauty. We tend to connect what is called functionalist aesthetics with the radical reform movement of the 20th century, but the case for the beauty of the efficient machine had also been made in antiquity and can be found in Cicero's writings on oratory.

Taking his cue from the beauty of the healthy human body, and of other organisms including well-grown trees, Cicero reinforces his case by the example of human design: 'In a ship, what is so indispensable as the sides, the hold, the bow, the stern, the yards, the sails and the mast? Yet they all have such a graceful appearance that they appear to have been invented not only for the purpose of safety but also for the sake of giving pleasure.'

'In temples and colonnades the pillars are to support the structure yet they are as dignified in appearance as they are useful. Yonder pediment of the Capitol [Fig. 18] and those of the other temples are the product not of beauty but of actual necessity; for it was in calculating how to make the rain-water fall off the two sides of the roof that the dignified design of the gables resulted as a by-product of the needs of the structure. . . .'

Fig. 18. The Temple of Jupiter on the Capitol. From a Roman coin, about 37 B.C.

Like the argument of the beauty of the healthy country girl who wears no make-up, the beauty of the well-built ship remained a commonplace in the armoury of the critics of ornament, to be brought out of storage whenever the occasion required it. But the most influential criticism of the irrationality of certain forms of decoration was sanctioned by the authority of Vitruvius, the law-giver of all architecture in the classical tradition. Vitruvius was directing his attack against a particular fashion in murals which had gained ground at the time of Augustus. It aroused his ire precisely by its capriciousness and irrationality. He had nothing against murals provided they made sense, such as the fictitious addition of architectural forms that created the illusion of a real or at least a possible extension of the interior.

'But these imitations based upon reality are now disdained by the improper taste of the present. On the stucco are monsters rather than definite representations taken from definite things. Instead of columns there rise up stalks; instead of gables, striped panels with curled leaves and volutes. Candelabra uphold picture shrines, and above the summit of these, clusters of thin stalks rise from their roots in tendrils with little figures seated upon them at random, or slender stalks with heads of men and animals attached to half the body . . .

'. . . Such things neither are, nor can be, nor have been. On these lines the new fashions compel bad judges to condemn good craftsmanship for dullness. For how can a reed actually sustain a roof, or a candelabrum the ornaments of a gable, or a soft and slender stalk a seated statue, or how can flowers and half-statues rise alternately from roots and stalks? Yet when people view these falsehoods, they approve rather than condemn.'

It is generally agreed that the type of decoration Vitruvius here attacks belonged to a late phase of what is known as the second style of Pompeian wall painting. However, there is not one decorative scheme extant which combines all the features he criticizes. A drawing by Giuliano da Sangallo after murals in the so-called Golden House of Nero (Fig. 19) combines many of these motifs; there are 'monsters' (sphinxes and gryphons), 'stalks instead of columns' and 'curled leaves instead of gables'. 'Slender stalks with heads of men and animals are attached to half the body', just as 'flowers and half statues rise from roots and stalks which would be unable to support them'. One wonders whether the Renaissance architect thought of Vitruvius' passage when he copied these motifs.

3 Polemics around the Rococo

I have shown elsewhere how adaptable Vitruvius' text was found to be whenever a critic of architecture wished to condemn any departure from the strict path of rationality. It was used

against the Gothic style and against what we call the Baroque. It was the text, again, to which the critics alluded who fought against the whimsicalities of the Rococo style in decoration. In a way this uniformity of argument presents a problem to the historian, for it rather looks as if there were nothing new under the sun and as if all change was only apparent. Just as all sermons can be summed up in the famous phrase that they are 'against sin', so all criticism will be found to be against transgressions of the rules of reason and of nature. It was quite possible in the 18th century as in other times to pay lip-service to the virtues of simplicity and yet to enjoy playful frivolity. The Marquis of Marigny, brother of Madame de Pompadour, for instance, who, as a young man, was appointed Director General of Public Buildings and retained this influential post for twenty-two years from 1751 to 1773, showed in his private patronage a marked predilection for the eroticism of what we call the Rococo, decorating his boudoir with pretty nudes by Boucher and similar painters. But this did not prevent him from extolling the 'simple wisdom' of the ancients and from preaching to the artists of the Royal Academy the virtues of sublimity and grandeur. We need not call these dual standards hypocrisy. The feeling was widespread after the middle of the century that the pleasures of playfulness had begun to pall and that it was time to remember the grandeurs of the *Roi Soleil*.

It fits well into this context that one of the most outspoken and wide-ranging attacks on the Rococo fashion in France came from the pen of the Secretary to the Academy, Charles Nicolas Cochin the younger. His *Supplication aux Orfèvres*, published anonymously in the *Mercure de France* in December 1754, takes the form of an ironical plea to goldsmiths and other designers not to contravene the rules of reason too outrageously. As always the echoes of Vitruvius are unmistakable. In decorating the lid of an oil cruet or some other work with an artichoke or a piece of celery of natural size, would the goldsmiths please not place by its side a hare no larger than a finger, or show figures supposed to be of natural size supported by ornamental foliage which could hardly support them without bending. I do not know a goldsmith's work which exactly corresponds to this description, nor need one ever have existed, but a soup tureen at the Musée des Arts Décoratifs in Paris (Plate 10) indicates that

Fig. 19. Giuliano da Sangallo: Drawing after Roman grotesques in the *Domus Aurea*. About 1505

Cochin did not exaggerate, at least as far as the disregard of scale is concerned: the hare and the lobster are not very different in size.

But from these Vitruvian strictures Cochin turns to functionalist considerations. His first targets are obvious absurdities such as curved chandeliers which look as if someone had bent them, and, worse still, drip guards which, instead of the convex shape that catches the wax, are concave, letting it drop on the table-cloth. A set of chased and gilded bronze wall lights from the Wrightsman collection (Plate 8) gives a good idea of the extravagance he had in mind. But these are only the opening skirmishes. His real plea is for a return to straight lines in furniture and architecture. Technological and aesthetic advantages go together. If architects were to respect the natural beauty of straight and square building stones they would not only save us from a public display of madness, they would also make life easier for the carpenters and glaziers, who would be spared having to fit the window panes into these 'baroque shapes'. The right angle is in any case always more beautiful than an obtuse or a pointed one, and even in decoration regular shapes, whether straight, square, round or oval, are preferable. Being more difficult to execute with precision, they will also enhance the designers' reputation more surely than all the foliage, bats' wings and other miseries which are *en vogue*. Cochin concludes by saying he knows very well that in such matters rational arguments are of no avail, but there is still hope. The fashion will run its course. 'It looks as if the time was at hand. The desire for novelty will bring about a return to the old architecture.'

What Cochin describes and predicts is really the coming of the style known to art historians as *Louis XVI*, the style of elegant severity of which the Petit Trianon (Fig. 256) is an outstanding example. The studied simplicity of Marie Antoinette's library (Fig. 20) marks the triumph of the ideas of which Cochin had made himself the spokesman.

Fig. 20. Marie Antoinette's library at Versailles. About 1783

The history of decorative styles and fashions as such lies outside the scope of this chapter, and indeed of this book. What concerns us in the polemics against the Rococo is only the degree to which decoration lost its innocence in the course of these arguments and required justification before the Courts of Reason and of Taste. Not that these justifications were ever very consistent, let alone compelling. They were often no more than what psychologists call rationalizations of preferences fed from less conscious sources. The rise of Neo-classicism was certainly the result of many converging trends, in which the revulsion against Rococo irrationality was only one element. Fiske Kimball in his classic history of the Rococo fashion has rightly stressed the growing influence of English culture on the continent of Europe as one of the main sources of the new outlook. The example of the

gentleman of taste with his Palladian country house and his landscape garden certainly helped to undermine the authority of the earlier style. Whatever the reasons, English taste had been averse for a long time to the caprices of French courtly fashions. When Christopher Wren went to Paris in 1665 in preparation for his architectural enterprises he wrote in these words about a Palace of Versailles which preceded the one we know:

'The Palace, or if you please, the *Cabinet of Versailles* call'd me twice to view it; the Mixture of Brick, Stone, blue Tile and Gold makes it look like a rich Livery: Not an Inch within but is crowded with little Curiosities of Ornaments: the Women, as they make here the Language and Fashions, and meddle with Politicks and Philosophy, so they sway also in Architecture; Works of Filgrand, and little Knacks are in great Vogue; but Building certainly ought to have the Attribute of eternal, and therefore the only Thing uncapable of new Fashions. The masculine Furniture of *Palais Mazarin* pleas'd me much better where is a great and noble Collection of antique Statues and Bustos . . .'

This is Neo-classicism *avant la lettre*, the identification of crowded ornament with feminine taste, the rejection of fashion in favour of what is unchanging; all this expresses and anticipates convictions which few educated Englishmen would have challenged in the eighteenth century.

It is only an apparent paradox that Cochin's attack against the sinuous line of the Rococo coincided so closely in time with the rational defence of this line in Hogarth's *Analysis of Beauty* of 1753. I believe that Hogarth's links with the Rococo can be overstated. His verdict on Wren's St. Paul's Cathedral (Fig. 21) shows him to be a perfect spokesman of the English tradition:

'There you may see the utmost variety without confusion, simplicity without nakedness, richness without taudriness, distinctness without hardness and quantity without excess.' Wren would have approved of this judgement. Hogarth was a great grinder of axes, but his discussion of the line of beauty lacks a polemical edge. He is out to explain in psychological terms why the human eye takes pleasure in curvature, but he is not out to advocate a particular style of decoration. Within the structure of his highly original book, references to decorative motifs are no more important than illustrations of various types of wigs or stays. His is the first consistent attempt to establish a theory of design on the foundations of perceptual psychology, soon to be followed by Edmund Burke's even bolder *Philosophical Enquiry into the Origin of our Ideas of the Sublime and Beautiful* of 1756. The effect of these books was long-term rather than short-term. They were not intended to impose restrictions

Fig. 21. St. Paul's Cathedral, London
(Christopher Wren, *Parentalia*, 1750)

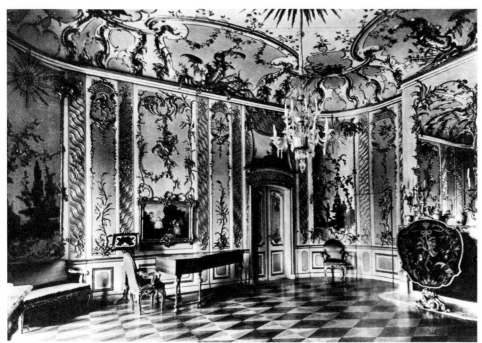

Fig. 22. Music room,
Sanssouci, Potsdam

on the variety of designs offered by cabinet-makers or gardeners nor did they result in any immediate stylistic revulsions.

In this respect there may still be some truth in the old simplistic idea that the gospel of Neo-classicism received its real impetus through the propaganda of J. J. Winckelmann. For maybe it was only in Germany that the Rococo had become what I have called a 'polarizing issue'. The opposition was enhanced by the national grievance which Germany nursed at the time against French fashions and French dominance. In a period when the German middle classes were looking for a national identity, the King of Prussia, Frederick the Great, made no secret of his admiration for French culture and his contempt for things German. His palace of Sanssouci (Fig. 22) at Potsdam, erected from 1746 onwards, embodied all the excesses of Rococo extravagance. We can feel the tensions generated by these issues in two German pamphlets directed against the Rococo fashion which also throw indirect light on the background of Winckelmann's reform movement.

As early as 1746, eight years before Cochin, one Reiffstein published an anonymous article in Gottsched's *Neuer Büchersaal der schönen Wissenschaften und freyen Künste* ostensibly criticizing the *style rocaille* or shell-work exemplified in a series of prints published in Augsburg and Nuremberg (Fig. 23). His strictures are the expected ones of asymmetry, irrationality and departure from nature. He does not forget to insert the Vitruvian criticism of figures resting on a support too weak to carry the load. But the real sting is in the tail. Is it an accident, he asks, that the artists who invented these designs all have foreign names? Germans are warned against aping French fashions, all the more since 'the decline of good taste in various arts among several of our neighbours is coupled with a decline in the decency of manners'. An editorial note appended to these nationalist remarks is even more outspoken:

'At this point the author touches on the true source of these strange decorations. It is not Germany but France, the mistress of so many absurd fashions, which is the inventor of this corrupt taste. The dislocated and lopsided curvature of these decorations is also a French whim, which is rightly abhorred by several great artists in Germany, for instance by Herr Giese in Berlin. Despite the fact that noble patrons have more than once asked him to accommodate himself to this fashion he had the greatness of mind to decline. This is the

mark of the true artist.' The reference to Giese in this context is not without interest, for Giese is known to art historians as a sculptor employed by Frederick the Great on the decoration of Sanssouci.

Thirteen years later, in 1759, Friedrich August Krubsacius published an anonymous pamphlet in which he trained the heavy guns of parody against the prevailing taste for capricious and asymmetrical design. His illustration of a cartouche (Plate 9) is intended to look like a typical product of the fashion, but the lettering of the motifs leads the reader to an elaborate key purporting to show the design is composed of nothing but refuse and rubbish. These *Thoughts on the Origins, Growth and Decline of Decoration in the Fine Arts* are an important document for the change of style and its source, for the author tells his readers that in France the tide of taste has turned:

'Monsieur Gabriel, Beaufranc, Sufflot, Carpentier, both the Blondels and other great architects, indeed the whole of the royal team of architects, opposed the spread of this evil and achieved at least so much that the new royal and public buildings and many houses of the Great within and outside Paris were not flawed in this way. Among them all, however, the Chevalier Servandoni has made a great contribution to the restoration of the good old taste out of love for the ancient Greek and Roman style of architecture and decoration, by his annual shows in front of the Louvre, through his new façade of the Church of St-Sulpice [Fig. 24] and several other buildings.

Fig. 23. Designs by F. de Cuvilliès, engraved by Lespilliez. About 1740

Fig. 24. The façade of Saint-Sulpice, Paris, by Servandoni and others, begun 1733 (J. F. Blondel, 1752)

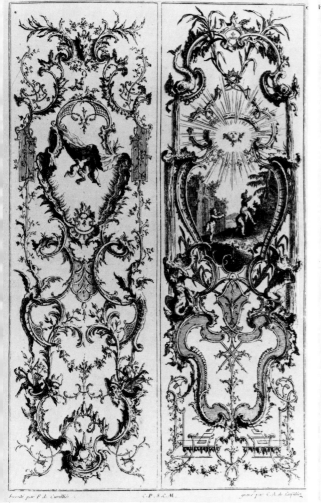

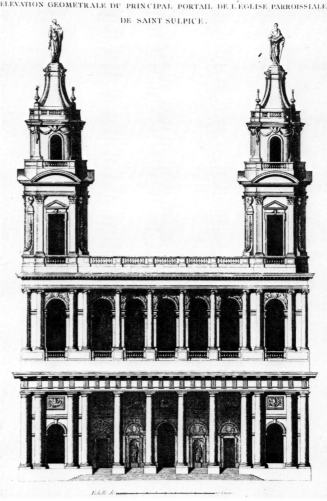

'Everyone who saw the Dresden performances of musical comedies (*Singspiele*) in 1755 and 1756 for which he personally made the designs will have felt for himself the effect of a grand, serious, natural and symmetrical decor.'

The year and the place mentioned by this eyewitness must interest the student of the Neo-classical movement, for it was in Dresden in 1755 that Johann Joachim Winckelmann had published its manifesto, his famous *Thoughts concerning the Imitation of Greek Works*. In unfurling the banner of 'noble simplicity and quiet grandeur' Winckelmann had again not omitted to draw on the Vitruvian argument: 'Our flourishes and that dainty shell-work without which no decoration can be produced have sometimes no more of Nature than Vitruvius' candelabras carrying small castles and palaces.'

But the main thrust of Winckelmann's attack is against lack of meaning in decoration, a fault he wants to remedy by the use of more symbolic motifs. He knew that he was laying himself open to the rejoinder that Greek decoration was not symbolic either, and following the use or abuse of his time he himself published an anonymous criticism defending the right of the decorator to emulate the variety and profusion of nature. He did so only to provide himself with an opportunity to write another attack on irrationality in decoration, denying that the ancients had ever failed to give meaning to their decorative design.

'In decoration one has to proceed as in architecture. Its style is grand when the articulation of the principal members of the orders consists of few parts and when these receive a bold and powerful mass and curvature. Remember in this context the fluted columns of the temple of Jupiter at Agrigento, where a man can stand within one of its curves. These decorations should not only be few, they should also consist of few parts and these parts should move grandly and freely.'

There is nothing here, as yet, about the superiority of straight lines over curves, but the reference to one of the newly discovered Doric Greek temples is characteristic. It heralds another polarizing issue, the conflict between Greek and Roman authority.

The pamphlet by Krubsacius provides another pointer. His uncompromising ridicule of Rococo motifs serves as a foil to a profession of functionalism which must surprise:

'Buildings can be made much more noble if one refrains altogether or at least as much as possible from decorating them. They have their essential beauty and need no extraneous assistance. . . . the only purpose is to indicate to passers-by the use of a building or the status and dignity of its owner and so to make them view its true beauty with attention.'

What is not surprising is that the author finds it necessary to insert in his pamphlet a complete translation of the Vitruvian strictures. But the use he makes of it again deserves attention. The sensational finds of Herculaneum had only just become available, and so he added an appendix on the folio publication *Le Pitture Antiche d'Erculaneo*, Naples, 1757. Much as he admires these unknown relics of antiquity, he finds on at least one of the plates (Fig. 25) an example of all the vices which Vitruvius had castigated. His careful analysis of all architectural errors displayed in this ancient design leads him to conclude that maybe it was not the Goths after all who were responsible for the spread of an illogical style, but the Romans.

'And so they reveal the truth of much Vitruvius said, but most of all one thing—that architecture and decoration had already begun to decline at that time and that true art was only to be found among the Greeks.'

It is customary to connect the rise of Neo-classicism with the discovery of Herculaneum and Pompeii. But this discovery also presented the admirers of antiquity with a problem. What they found did not always conform to the standards they had been taught to follow and so the ideal of artistic perfection receded in time and in place. In Winckelmann there arose the prophet of classical Greece. His message became, in its turn, a polarizing issue.

It was the new preference for things Greek over things Roman which provoked

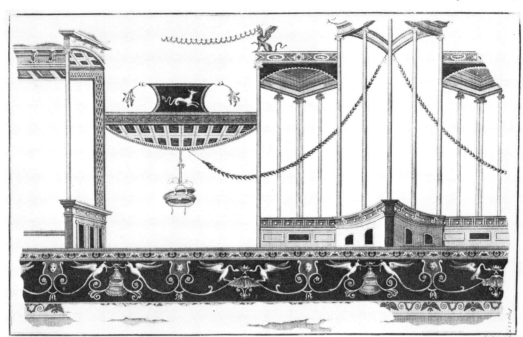

Fig. 25. Wall
decoration from
Herculaneum,
engraved 1757

Giovanni Battista Piranesi in these same years to champion the ideal of Roman grandeur in
his polemical writings with their somewhat muddled texts and their magnificent
illustrations. Piranesi was certainly no functionalist, no enemy of decoration as such. On the
contrary, he provoked the critics who preached restraint with his exuberant designs for
chimney pieces (Fig. 26) in which Egyptian and classical motifs are closely packed into
crowded assemblies. His introduction to this series of designs, published in Italian, French
and English as if he were conscious of his international clientèle, shows him very much

Fig. 26. Piranesi:
Design for a chimney
piece. 1769

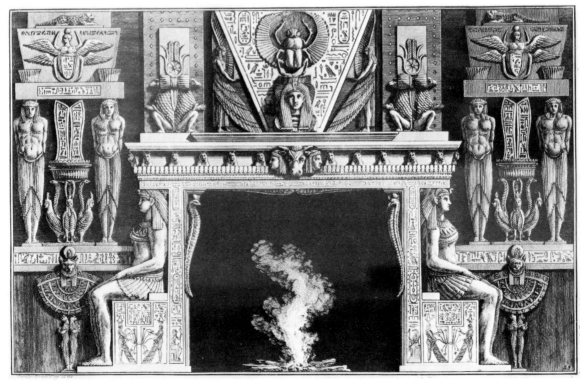

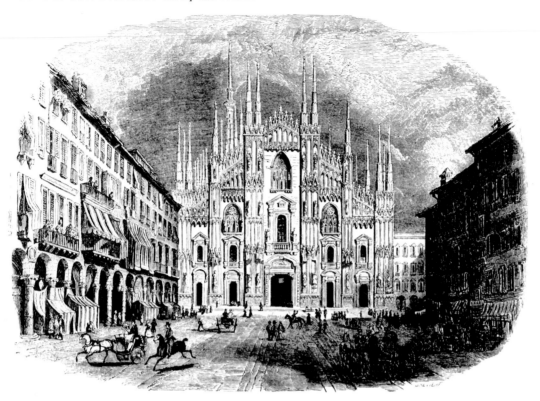

Fig. 27. Milan
Cathedral, founded
1386 (R. Töpffer,
1855)

aware of the reception these extravagances were likely to have: 'It is easy to say that the *right*
consists in keeping the medium between *too little* and *too much*; but to determine this
medium *hoc opus, hic labor est*' (this is the task, here is the effort). Piranesi here pointed to the
weakness of much criticism—and not of eighteenth-century criticism alone. But efforts
were made to remove the advice outside the range of well-meaning tautologies. 'Too much'
meant more than the eye could comfortably take in. This is the proposal of the influential
architect Francesco Milizia in the *Saggio sopra l'Architettura* of 1768 with which he prefaced
his Lives of the principal architects. 'Anything must be sufficiently simple to be taken in by
the eye and sufficiently varied to be seen with pleasure. Gothic architecture appears to be
extremely varied, but the confusion of ornaments fatigues because of their small size, hence
one cannot distinguish one from the other, and because of their large number there is not
one on which the eye could rest, so that it displeases precisely because of the features which
are chosen to make it more pleasant. A Gothic building is a kind of enigma for the eye of the
beholder. Greek architecture, by contrast, looks uniform, but since it has sufficient divisions
the mind can take it all in without tiring, and that variety is sufficient to cause delight.'

Like Hogarth, in other words, Milizia, who must have had Milan Cathedral in mind (Fig.
27), appeals to the psychology of perception and like Hogarth, also, he rationalizes his taste
for classical restraint by expressing his disapproval of too much decoration. His strictures
would certainly apply to Rococo profusion no less than to Gothic. But they are not directed
against ornament as such. No eighteenth-century critic advocated a complete abandonment
of decoration. The extensive exhibition of the Age of Neo-classicism mounted in London in
1972 under the auspices of the Council of Europe served as a reminder of the distance that
separated the practice of the period from its theory. In the writings of some critics,
functionalism sometimes seems to be just around the corner, but the polemics against the
Rococo achieved little more than a change of tune, a new principle of exclusion. For a time,
at least, the sinuous curve was taboo.

The change is epitomized in the career of the engraver Johann Esaias Nilson (1721–88). In

the 1750s he had achieved a deserved popularity with his gay inventions in the *style rocaille* (Fig. 28). Around 1770 he followed them up with a Neo-classical recantation (Fig. 29): beside a monument of severe design, which the eye can easily take in, we see a man tearing up sheets of paper, one of them inscribed MUSCHELWERK (*rocaille*). High seriousness had triumphed over frivolity.

Fig. 28. J. E. Nilson: 'Neues Caffehaus'. 1756

Fig. 29. J. E. Nilson: 'Tearing up the Rocaille'. About 1770

Fig. 30. Marian
Wenzel: The
Apothecary's Grotto

The extent of this triumph is memorably illustrated in Goethe's idyll *Hermann und Dorothea*, published in 1797 and describing events of two years earlier, in which the poet subtly interweaves the effects of the French Revolution with the impact of the new purist dogma on the taste of the middle classes. The worthy apothecary of a provincial German town is heard to complain about the spoilsports who had deprived him of all pleasure in what had once been his pride, a garden pavilion, which we may imagine as a minor version of more famous German Rococo pleasure houses, complete with painted dwarfs, sparkling shell-work and a frescoed parlour with pictures of high life (Fig. 30).

> 'Every traveller paused to look through the red-coloured trellis
> At the beggars of stone and the painted dwarfs in the garden.
> But, when coffee I served to my guests in the wonderful grotto
> —Covered with dust it is now and nearly a ruin in my life-time—
> Dear, how much they enjoyed the colourful sparkle of shell-work
> Beautifully set out—and even the expert was dazzled
> By the gleam of the lead and by the intricate corals,
> Nor did they fail to admire the painted walls of the parlour
> Where such elegant men and ladies were seen promenading
> Daintily holding or handing a flower with delicate fingers.
> True—but who would now but give it a glance, yes, I rarely
> Go there myself, for they want it different now, only "tasteful"
> As they describe it, the trellis be white and so should the benches.
> All must be simple and flush without any carving or gilding—
> Now it is the wood from abroad that is the most costly . . .'

With this reference to the expensive imported wood used for these 'simple' panellings, Goethe surely and subtly points to the sociological qualifications of the new purism. The

lack of decoration and ornamentation must be compensated for by noble materials and exquisite craftsmanship which proclaims at once that discriminating simplicity is a matter of choice and has nothing to do with a lack of means. One might almost say that the more simple the shape the more careful must be the handling of the surface and the more choice the material (Fig. 31). These are qualities out of reach for the vulgar and undiscriminating and so they become the hallmark of true refinement. Something of this law of compensation, as we have seen, has been implicit in the classical tradition from the start, but it only surfaced completely from time to time.

4 Design and Fashion

It was a decisive event in the history of the decorative arts, therefore, when the industrial revolution with its processes of manufacture upset this well-established relationship. We find a clear awareness of these changing social conditions in the preface to a well-known collection of designs for interior decoration in the *style empire*, the *Recueil de décorations intérieures*, by C. Percier and P. F. L. Fontaine, published in Paris in 1812. The authors make a point that there is no intrinsic difference between style and fashion. Interior decoration is just as much a matter of fashionable taste as is dress. They attribute the power of fashion in these matters to three main causes. The first is the love of change, which they call a moral, and we would describe as a psychological, cause. They see the second, social, cause in the increasing contacts among people, resulting in a greater desire to create an impression. The third, the commercial, lies in the advantage which producers derive from the rapid obsolescence of *objets de luxe*. The authors are convinced that only the first of these causes operated in antiquity and that not very strongly because the ancients were wise enough to preserve the essential and rational forms of their products. It is only in modern societies that fashion

Fig. 31. Writing table. Inlaid satin wood. About 1780

reigns supreme and makes the masses imitate the small number of those who set the tone, thereby prompting the minority to abandon any usage that has become general.

'To do everything for a reason, to do everything in a way to make that reason apparent and to justify the means towards the end is the first principle of architecture, while the first principle of fashion is to do everything without any reason except to do otherwise. . . .

'What spreads the inventions and the forms of such works universally is not a feeling for what is right nor a more enlightened taste . . . things are not desired because they are found to be beautiful; they are found to be beautiful because they are desired. In this way they soon suffer the fate of all fashionable products. Industry gets hold of them and reproduces them in a thousand economical ways to place them within reach of the least affluent. All kinds of falsifications debase their value. Plaster takes the place of marble, paper plays the part of painting, stencils imitate the work of scissors, glass substitutes for precious stone, tinfoil replaces solid metal, varnish fakes porphyry.'

One of the effects of this industrialization, the authors find, is that even the most beautiful things are found to have lost something of their beauty because they have been prostituted through vulgarization. More seriously still, the cheap imitations are bound to lack that perfection of craftsmanship which is really inseparable from good design. The habit of seeing a mass of *objets d'art* produced by mechanical routines discredits the whole genre.

The authors see no other way out of these dilemmas than a return to sound functionalist principles: 'Among all the forms of a chair there are some which are dictated by the shape of our body, the needs of convenience . . . what is there that Art could add? It should purify the forms dictated by convenience and combine them with the simplest of outlines, giving rise from these natural conditions to ornamental motifs which would be adapted to the essential form without ever disguising its nature. . . .'

Turning from these wise precepts to the plates of the book (Fig. 32) will produce a shock. The authors were evidently more slaves to fashion than they themselves realized or wanted to admit. But precisely because of these contradictions their book, with its shrewd preface and its fashionable plates, sounds the keynote of nineteenth-century debates.

Fig. 32. Chair designed by C. Percier and P. F. L. Fontaine. 1812

II Ornament as Art

> You whose hands make those things that should be works of art, you must be all artists, and good artists too, before the public at large can take real interest in such things; . . . the handicraftsman, left behind by the artist when the arts sundered, must come up with him, must work side by side with him . . .
> William Morris, *The Lesser Arts*

1 The Menace of the Machine

'The hypocrisy of virtue is of every age, but the hypocrisy of luxury is peculiar to democratic centuries. To satisfy these new cravings of human vanity the arts have recourse to every kind of imposture.' In these words Alexis de Tocqueville sums up his chapter 'In What Spirit the Americans Cultivate the Arts' in his classic *Democracy in America*, published in 1835. He thus accepts and develops the analysis of industrial society and its effects on the standard of workmanship made by Percier and Fontaine in 1812. What worries him, as it had worried his predecessors, is the idea of cheap imitations which give an object 'a look of brilliance unconnected with its true worth' and thus enables its owner to 'appear as something he is not.' If proof were needed of the close interaction between social and aesthetic hierarchies, this response to the new possibilities of industrial processes would provide it. Our admiration for any object of beauty can rarely be separated from our estimate of its material worth. Its uniqueness or rarity, its preciousness and its cost in labour and skill all enter into our attitude. We need only visit one of the Stately Homes and listen to the way the guide hopes to arouse the attention of his audience to realize the continued power of these motivations. We are frequently reminded that a piece of decoration is all made by hand. Every panel or carving is different from every other, but each is perfect in its own way. This indeed is a feature which mechanical processes cannot easily emulate and so it serves as a reminder of the care and imagination expended on the object. The public's reaction confirms the importance of the idea of toil and sacrifice that is originally inseparable from decoration. From this point of view a machine-made decoration is an absurdity.

To be sure mechanical aids have come to the assistance of craftsmen at least since the invention of the potter's wheel. Decorators have long used stencils and moulds and weavers' devices for pattern-making, which as early as 1725 included that modern tool of automation, the punched card. They prepared the way for the famous Jacquard loom of 1805. But however important these developments were, they were not felt to undermine the whole edifice of craft ethics. The hypocrisy of luxury was not felt to be a menace. It must be acknowledged that the cheap mass production of what had once been luxury goods presented a great opportunity. The comforts and even the 'status symbols' of the wealthy now appeared to be within reach of almost everybody. The nineteenth century prided itself, and rightly so, on having spread the advantages of civilization much further than they had ever been enjoyed before. We tend to think more of the misery and squalor caused by the Industrial Revolution than of these benefits, but we must not forget to what an extent the machine was a social leveller. It was not only the wealthy mill owner who could boast of a best parlour with heavy upholstered furniture, brim-full of pictures and ornaments. The moderately successful tradesman could acquire slightly less expensive versions of these coveted items, and even within my own memory the more humble dwelling would reflect this predilection. We have gained sufficient historical distance from that period to avoid the automatic epithets of vulgarity and complacency which were so invariably levelled against Victorian taste in the earlier decades of this century. The scattered contents of the best

parlour have now found their way into the antique shops frequented by our sophisticates, who often hide their own insecurity of taste behind the screen of patronizing amusement.

It is true that the nineteenth century witnessed a crisis of good taste, if by taste we mean a sense of standards and a sensitive discrimination responsive to nuance, but it is equally true that it was the Victorians themselves who made us aware of this crisis. In this respect nineteenth-century critics differed conspicuously from those of the twentieth century— they showed a truly critical attitude towards their own age.

Quite early in the century, politicians took sufficient note of these questionings documented in the *Report of the Select Committee of the House of Commons appointed to enquire into the best means of extending knowledge of the Arts and of the Principles of Design among the people*, published in 1836. The resulting debates, which may be said still to continue, have been admirably surveyed in a number of standard works. I mention particularly Sir Nikolaus Pevsner, *Pioneers of the Modern Movement from William Morris to Walter Gropius* (London, 1936), and *High Victorian Design* (London, 1951); Alf Bøe, *From Gothic Revival to Functional Form* (Oslo, 1957); and Quentin Bell, *The Schools of Design* (London, 1963). Even so, a large body of literature produced during this period remains to be evaluated. To do so would go beyond my competence and the aims I have set myself in this chapter. I shall only be concerned with the basic positions emerging in this momentous debate and with the lasting contributions to the theory of decoration made by some of the leading minds of the period, particularly in England, where the problems caused by the industrial revolution were most acutely felt.

2 *Pugin and the Reform of Design*

Ideological as well as economic factors entered into the discussion. The opening shots were fired by the romantic champion of the so-called Age of Faith, the young Augustus Pugin (1812–52), a Roman Catholic convert from a family of French émigrés, who figures prominently in the history of Victorian architecture as a pioneer of the Gothic revival. No doubt it was this bias which made him discern the problem inherent in the use of illusionistic motifs for decoration. Vitruvius, it will be remembered, had commended the addition of fictitious architectural features to interiors because he saw nothing illogical in this practice. Pugin detected such an illogicality at least when illusionistic design was used for wallpapers. For if a naturalistic representation in light and shade is repeated all around the room the shadows in the design will inevitably be found to conflict somewhere with the real fall of light from the windows. Better select a purely flat design, where such risks are not incurred (Fig. 33). It was even worse, in his opinion, to use 'highly relieved foliage and perforated tracery for the decoration of a floor' on which we are supposed to walk. For here illusionism came into conflict with the function of the pavement. The mediaeval craftsmen knew better: 'The ancient paving tiles are quite consistent with their purpose, being merely ornamented with a pattern not produced by any apparent relief, but only by contrast of colour.' (See Plate 3.)

Pugin goes on to say that the same principle should be applied to carpets and he therefore commends Turkish rugs because 'they have no shadow in their pattern but merely an intricate combination of coloured intersections.' This objection to three-dimensional representation in the decoration of walls or floors soon developed into a dogma among Victorian reformers of design. Dickens was to make fun of it in his novel *Hard Times* in 1854, in which he introduced 'a government officer . . . who had it in charge from high authority to bring about the great public-office Millennium, when Commissioners should reign on earth'. It is he who asks a class of youngsters whether they would use a carpet having a representation of flowers upon it (Fig. 34). The girl who says she would because she

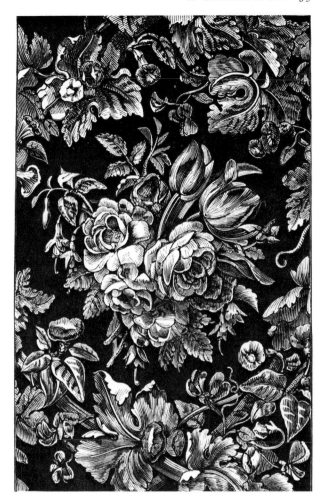

Fig. 33. A. W. Pugin:
Wallpaper design.
About 1848

Fig. 34. Carpet from
the Catalogue of the
Great Exhibition,
1851

is very fond of flowers is sternly asked whether in that case 'she would put tables and chairs upon them and have people walking over them with heavy boots'. ' "It wouldn't hurt them, sir. They wouldn't crush and wither, if you please, sir. They would be the pictures of what was very pretty and pleasant, and I would fancy . . ." "Ay, ay, ay! But you mustn't fancy", cried the gentleman, quite elated by coming so happily to his point.'

Dickens had clearly spotted the element of nineteenth-century rationalism in this advocacy of flat pattern and had effectively used it against the type of reformers, such as Henry Cole, he regarded as self-important meddlers. As a writer of fiction he resented what he took to be an inability to distinguish between fiction and fact. He was right because we have seen that there is indeed a line that links this criticism of ornament with the Vitruvian injunction 'you must not fancy'.

The very success of Pugin's simple rule may be regarded as a symptom of that insecurity of taste that is so characteristic of the Victorian era. For the population explosion and the unprecedented expansion of production that had gone hand in hand with the mushroom growth of towns had long undermined the last safeguard of traditional standards in design. Percier and Fontaine in 1812 had merely worried about the rapidity with which fashions adopted by the élite travelled down in the shape of cheap imitations. Now it was no longer a question of such imitation. The 'fancies' flourished, spontaneously catering for all tastes. In a sense it is this exuberance of fancy that has caught the imagination of our Victorian revivalists. To the contemporary critics there was nothing admirable in this riot of inventions.

As early as 1841 Pugin had attacked 'those inexhaustible mines of bad taste, Birmingham and Sheffield: staircase turrets for inkstands, monumental crosses for light-shades . . . and a cluster of pillars to support a French lamp' are among his examples of 'Brumagem Gothic' (Fig. 35), in which 'neither relative scale, form, purpose, nor unity of style is ever considered by those who design these abominations'. Pugin's method of teaching by concrete examples follows the tradition of Hogarth, but his purpose is more specific. His is one of the first attempts to characterize what became known in Germany as *kitsch*, the vulgarity appealing to an uneducated taste. It was to become the great bogy. The whole movement of reform which resulted in the Great Exhibition of 1851 might be said to have sprung from the bad conscience caused by such lapses. One of its champions was the Keeper of the National Gallery, Ralp Wornum, who published a series of lectures he had given between 1848 and 1850 at government schools of design under the general title *Analysis of Ornament*. Wornum singled out another type of 'aesthetic monstrosities, ornamental abominations' (Fig. 36): a gas jet in the form of a flower, a basket supposedly designed to hold liquid, poised on an animal's head, and a bell made of leaves. His objections are based exclusively on the rational idea of fitness. How can a flower produce a gas jet without wilting at once? How can a basket hold water, or soft leaves produce metallic sounds? The aesthetic pillory, trying to teach by example what vulgarities should be avoided, became part of the scene of nineteenth-century art teaching.

When the 'Department of Practical Art' arranged a display in its museum of '*Articles of Ornamental Art . . . for the use of Students and Manufacturers and the Consultation of the Public*' with a printed catalogue in 1852, a section was added to show '*Exhibition of False Principles in Decoration*'. In the catalogue Pugin, Dyce and Redgrave are duly quoted for the conviction that the direct imitation of nature was 'the chief vice' in the decoration of Europe in the present day. There were carpets, chintzes and wallpapers as warning examples of this 'vice'. One of the paper hangings (now lost), for instance, is accompanied by the Vitruvian strictures: 'Natural objects in unseemly position; horses and ground floating in the air: objects much out of scale.' But there were also patterns for trousers with 'geometrical forms

Fig. 35. 'Patterns of Brumagem Gothic' (A. W. Pugin, 1841)

Fig. 36. 'Ornamental abominations' (Ralph Wornum, 1856)

totally unfit for the garment for which they are intended; interfering with the form of the wearer'.

More interesting perhaps are the remarks about the display of glass, for here Redgrave is quoted for a new application of the principle of decorum. What he desires is the principle which later became known as 'truth to material': articles made of glass should respect and preserve its quality of lightness, brilliance and transparency. Hence the practice of cutting glass should only be resorted to in handles, stems and bases. When the practice is carried to an extreme it tends to vulgarize the simple and beautiful material and to interfere with the beauty of blown forms. Thus the vase illustrated in Fig. 37 is accompanied by the observation: 'the general outline entirely destroyed by the vertical cuttings'. The catalogue also notes with regret that 'one of the most popular jugs ever manufactured is a rude imitation in blue earthenware of the trunk of a tree, on which are applied figures, vine and leaves and grapes all out of scale with one another'—echoes of Vitruvius and Cochin!—and totally disregarding the general form.

We learn from a contemporary, however, that this 'chamber of horrors' was dismantled within a year of its opening. Gottfried Semper, one of the reformers, whose theories will concern us later, reports that it was found to be a mistake to set up such a pillory right at the entrance of the 'Museum for Practical Art and Science' at Marlborough House. Even unbiassed visitors felt provoked to criticize not the exhibits but rather the alleged laws of design which had not been observed. Moreover the designers whose work was exposed to public censure were turned into bitter enemies of that great institution, the future Victoria and Albert Museum, and thus impeded its influence.

It stands to reason that the short-term effect of this well-intentioned propaganda effort might be described in modern jargon as counter-productive. But the long-term effect can hardly be overrated. Remembering the analysis of the social situation of the 19th century in its relation to design that we found in Percier and Fontaine and in de Tocqueville, we cannot be surprised that one of the most powerful words in the armour of criticism of that time was the term 'vulgar'. To tar a certain method of design or decoration with the brush of 'vulgarity' was to condemn it most effectively, for who wanted to be regarded as vulgar? It was precisely because the industrial revolution had resulted in such a novel degree of social mobility that the contrast between respectability and vulgarity became one of the polarizing issues of the period. The doctrine that it was vulgar for decorations to look like pictures was easily grasped and easily applied; there was but one step from here to the conviction that paintings which did not conform to the laws of decoration were also vulgar. Illusionism in art had had its day.

At the time of the Great Exhibition of 1851 this development, like others which will concern us, still lay in the future. The more immediate problem in the theory of design was to arrive at a proper demarcation between the fine arts, which should imitate natural appearances, and the industrial arts, which should avoid that trap. It was this need for an alternative theory of design, a theory which strangely enough had never been attempted in the past, which stimulated reflections about the nature of ornament as an abstract play with pure forms. The same Ralph Wornum who ridiculed the excesses of decorative naturalism also meditated in his book on the kinship between ornament and music in a passage which sounds like a pre-echo of later speculations.

'I believe the analogy between music and ornament to be perfect: One is to the eye what the other is to the ear; and the day is not far distant when this will be practically demonstrated.

'The first principle of ornament seems to be repetition . . . a measured succession in series, of some detail, as a moulding . . . this . . . corresponds with melody in music . . . the system of both arising from the same source, rhythm . . . (Fig. 38)

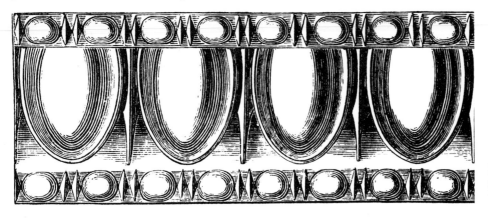

Fig. 38. Egg-and-dart moulding (Ralph Wornum, 1856)

'The second stage in music is harmony, or a combination of simultaneous sounds or melodies; it is also identical in ornamental art: every correct ornamental scheme is a combination . . . or measured succession of forms . . . called in the first counterpoint, and in the other symmetrical contrast.' I shall return to this comparison in the Epilogue.

3 John Ruskin and Expressionism

The proposal to regard the art of ornamental design as a sister art of music rather than of painting was to have enormous consequences for the status of decoration. But this retreat into a theory of pure form was opposed by the greatest of the Victorian critics, one who took decoration at least as seriously but approached it from a very different angle—John Ruskin.

The importance of Ruskin's theories has been obscured for some time by the vehemence of his rhetoric. The positions he wished to defend are expressed in a prose which resists paraphrase almost as much as would poetry. The expedient of quotation, which anyone has to adopt who wants to do justice to Ruskin's ideas, also has its drawbacks because the changes of tone disrupt the chain of argument. But for the reader who perseveres even the most strident of Ruskin's utterances will reveal his mental stature and his intellectual power.

It was a power wrested from despair. For while Wornum and the other Victorian reformers of design were optimists who believed in the possibility of improving the state of the arts in industrial England, Ruskin wrote against a background of apocalyptic forebodings. He had interrupted work on his *Modern Painters*, that hymn to the greatness of Turner and the beauty of Nature, to turn to the theory of architecture and decorative design in the *Seven Lamps of Architecture*, published in 1849, a year after the Communist Manifesto. The introduction strikes a note of doom: '. . . the weight of evil, against which we have to contend, is increasing like the letting out of water . . . the blasphemies of the earth are sounding louder, and its miseries heaped heavier every day' (VIII, p. 25).

The last chapter of the book leaves us in no doubt about the nature of the catastrophe he sees coming. The 'horror, distress, and tumult which oppress the foreign nations'—the revolutions of 1848—were to him the direct consequence of a false ideal of Liberty having supplanted the old values of Loyalty and Obedience. 'I am not blind to the distress among their operatives . . . the chief thing they need is occupation. I do not mean work in the sense of bread—I mean work in the sense of mental interest . . . it would be wise to consider whether the forms of employment which we chiefly adopt or promote, are as well calculated as they might be to improve and elevate us' (pp. 261–3).

Ruskin's famous denunciations of the machine stand in this context: '. . . at all events one thing we have in our power—the doing without machine ornament and cast-iron work [Fig. 39]. All the stamped metals, and artificial stones, and imitation woods and bronzes, over

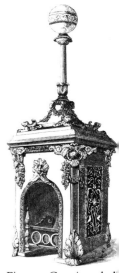

Fig. 39. Cast-iron hall stove from the Catalogue of the Great Exhibition, 1851

the invention of which we hear daily exultation—all the short, and cheap, and easy ways of doing that whose difficulty is its honour—are just so many new obstacles in our already encumbered road. They will not make us happier or wiser—they will extend neither the pride of judgment nor the privilege of enjoyment. They will only make us shallower in our understanding, colder in our hearts, and feebler in our wits. And most justly. For we are not sent into this world to do any thing into which we cannot put our hearts' (p. 219).

For a prophet with this message the attempts of the reformers were bound to look petty and ineffectual; for 'We shall not manufacture art out of pottery and printed stuffs: we shall not reason out art by our philosophy' (p. 256).

And yet this is precisely what Ruskin was also trying to do in going back to first principles. Having come to the study of architecture from that of landscape painting, he took it to be axiomatic that the only standard and source of Beauty was Nature, God's creation, and so, in his view 'forms which are *not* taken from natural objects must be *ugly*'. The passages in which he attempts to justify this axiom are strange exercises in special pleading.

The Greek egg and dart moulding (Fig. 38) is praised in Ruskin's most poetic prose, 'because the form of which it is chiefly composed is one not only familiar to us in the soft housing of the bird's nest, but happens to be that of nearly every pebble that rolls and murmurs under the surf of the sea, on all its endless shore'. The best Greek examples even share with the pebble a delicate flattening of the surface without which 'the moulding is vulgar instantly' (p. 144).

Now 'since there is hardly any common natural form in which it is possible to discover a straight line' (p. 145), geometrical patterns would seem hard to justify, and indeed the Greek fret is condemned as a 'vile concatenation of lines'. Ruskin concedes that some such configuration does occur in nature because bismuth crystals resemble it, but they are too rare to excuse the design. In his view it is different with the pattern of inscribed squares and triangles frequent in his beloved Lombard architecture (Fig. 40) because they resemble the crystals of salt, a more common mineral than bismuth. As it happens, however, the ban on forms not taken from nature is much mitigated in Ruskin's critical practice because in his chapter on the *Lamp of Power* he allows for the impression created by serial forms such as a succession of squares (p. 110). In his discussion of colour, moreover, he departs even more deliberately from naturalistic standards. Here he advocates simple shapes which allow the spectator to take pleasure in the coloured area. 'Curved outlines, especially if refined, deaden the colour, and confuse the mind' (p. 141).

But these concessions—such as they are—are not allowed to interfere with Ruskin's message. That enjoyment of purely formal relationships which had been a cornerstone of aesthetics since the days of Plato could only occupy a very lowly position in his scale of values:

'Ornament . . . has two entirely distinct sources of agreeableness, one, that of the abstract beauty of forms, which, for the present, we will suppose to be the same whether they come from the hand or from the machine; the other the sense of human labour and care spent upon it. How great this latter influence we may perhaps judge, by considering that there is not a cluster of weeds growing in any cranny of ruin which has not a beauty in all respects *nearly* equal, and, in some, immeasurably superior, to that of the most elaborate sculpture of its stones [Fig. 41]: and that all our interest in the carved work, our sense of its richness, though it is tenfold less rich than the knots of grass beside it; of its delicacy, though it is a thousandfold less delicate . . . results from our consciousness of it being the work of poor, clumsy, toilsome man' (pp. 81–2).

Read in isolation, Ruskin's statement does not appear to say much more than does the visitor to the country house who remarks on the patience and care bestowed on a work of

Figs. 40 and 41.
J. Ruskin: From *Seven Lamps of Architecture*, 1849

craftsmanship; and seen in this light even his angry rejection of machine-produced ornament as a 'downright and inexcusable lie' merely recalls the conventional warnings against cheap imitations. It would be grievously to underrate Ruskin's originality to stop at this parallel. For while the conventional admirer would marvel at the precision and exactness of which human hands are capable, Ruskin rebelled against this mechanical standard of excellence. He did not deny that 'it was possible for men to turn themselves into machines, and to reduce their labour to the machine level, but so long as men work *as* men, putting their heart into what they do, and doing their best, it matters not how bad workmen they may be, there will be that in the handling which is above all price' (p. 214).

What is 'above all price' for Ruskin in this chapter, which is headed *The Lamp of Life*, is precisely the traces or symptoms of a living being at work. Commenting on the work of masons at Soissons (Fig. 42) he writes: 'It will be plainly seen that some places have been delighted in more than others—that there have been a pause, and a care about them; and then there will come careless bits, and fast bits; and here the chisel will have struck hard, and there lightly, and anon timidly; and if the man's mind as well as his heart went into his work, all this will be in the right places, and each part will set off the other; and the effect of the whole, as compared with the same design cut by a machine or a lifeless hand, will be like that of poetry, well read and deeply felt, to that of the same verses jangled by rote' (p. 214).

This is an instance where the very beauty of Ruskin's writing has deprived him of the

credit for a real discovery. I mean the discovery of the importance of organic rhythms in the creation of artistic orders. I have referred to this issue in my introductory chapter in connection with the link that can be found between rhythmical movement and skilled performance. The orders created by life are indeed more flexible, more varied and elastic than those normally achieved by mechanical repetition. It was this evidence of life that mattered to Ruskin. For him the existence of the machine had resulted in a new 'polarizing issue', far more fundamental than the old issue of the costly versus the cheap. He identified the monotony of the machine with death and was therefore led to regard all deviations from mechanical precision as manifestations of life.

His bias had certainly sharpened his eyes to a problem that was even more topical in his days than it is in ours. He had asked himself why restoration killed the beauty of old buildings and why the Neo-Gothic churches, which had begun to spring up everywhere, lacked the vigour and vitality that he loved in the creations of the past. To him they looked dead precisely because they were the product of our industrial society, which turned men into machines. In his romantic picture of the mediaeval builders Ruskin envisaged the finished edifice emerging from a free and flexible teamwork of equals. He carefully measured and drew some of his favourite Italian churches such as the Cathedral of Pisa to demonstrate that what he called living architecture was not in fact composed of identical standardized units but of subtly varied elements. He did not claim that these workmen introduced variations deliberately:

'I believe they built altogether from feeling, and that it was because they did so, that there is this marvellous life, changefulness, and subtlety running through their every arrangement; and that we reason upon the lovely building as we should upon some fair growth of the trees of the earth, that know not their own beauty' (p. 209).

As a tract for the times the *Seven Lamps* failed to achieve Ruskin's aim of bringing the conditions of the Middle Ages back to industrialized England. In the Preface to the edition of 1880 he calls this book 'the most useless I ever wrote', and his bitterness comes out in many of the notes he appended to his text: 'What good this wretched rant of a book can do still, since people ask for it let them make of it; but I don't see what it's to be. The only living art now left in England is Bill-sticking'.

But whether he saw it or not, the new polarity he had established in art had an immense

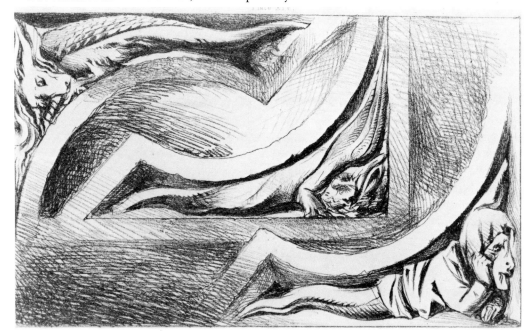

Fig. 42. J. Ruskin: From *Seven Lamps of Architecture*, 1849

influence on subsequent developments. In *Art and Illusion* I tried to show to what extent Ruskin's book on the *Elements of Drawing* of 1857, with its doctrine of the 'innocent eye', prepared the ground for Impressionism. Strangely enough I think it can also be shown that the turbulent pages of his architectural criticism contain the seeds of Expressionism. It was implicit in the shift from the product to the producer as the object of the aesthetic response.

Let us recall how this shift occurred. If all true beauty derived from God as the creator of Nature the machine could only produce counterfeits. But even man, we remember, could not aspire to rivalling the beauty of God's creations, and so the only justification for looking at human handiwork was that it was seen to be human, the creation of a created being, an individual soul. Hence it was quite consistent for Ruskin to base his architectural criticism in the *Seven Lamps* on the axiom that 'the right question to ask, respecting all ornament, is simply this: Was it done with enjoyment? Was the carver happy while he was about it?' (p. 218).

The sober answer to this question must be that we shall never know. But Ruskin had to believe that it was the carver's enjoyment that communicated itself in the manner of the making. We have seen that he sought contact with the mason through his work and felt he could sense the craftsman's mood much as a graphologist gains an intuitive picture of a writer whose individuality is not concealed by the drill of the copybook.

In his famous chapter on the Nature of Gothic of 1853, which forms part of *The Stones of Venice* (X, Ch. VI), Ruskin made this criterion the touchstone for his judgement on the styles of the past. Greek ornament, no less than Ninevite and Egyptian, is pilloried as 'servile' because here 'the execution or power of the inferior workman is entirely subjected to the intellect of the higher'. In other words the craftsman is enslaved by the master whose design he is asked to carry out. In Ruskin's view the height of this indignity was reached in the Renaissance, when the whole building becomes 'a wearisome exhibition of well-educated imbecility'.

But in the mediaeval, or especially Christian, system of ornament, 'this slavery is done away with altogether; Christianity having recognized, in small things as in great, the individual value of every soul. But it not only recognizes its value; it confesses its imperfection, in only bestowing dignity upon the acknowledgement of unworthiness. . . . it is, perhaps, the principal admirableness of the Gothic schools . . . that they thus receive the results of the labour of inferior minds . . . betraying that imperfection in every touch, indulgently raise up a stately and unaccusable whole' (X, pp. 189–90).

On these grounds Ruskin launches a sermon against the ideal of perfection which is to him an ideal of degradation. He ignores the marvels of precision of which the human hand showed itself capable in such essentially Christian works as the Lindisfarne Gospel and the Book of Kells (Plates 32, 82). For his dislike of an imposed discipline blinds him here to the miracle of self-discipline to which these and other masterpieces bear witness.

He is so obsessed with the fallen state of man that he identifies precision with inhumanity:

'You can teach a man to draw a straight line, and to cut one; to strike a curved line and to carve it; and to copy and carve any number of given lines or forms, with admirable speed and perfect precision . . .

'Observe, you are put to stern choice in this matter. You must either make a tool of the creature, or a man of him. You cannot make both. Men were not intended to work with the accuracy of tools . . .' (X, pp. 191–2).

It would be most interesting to follow the line which leads from this devaluation of manual skill to the commonplaces of twentieth-century art education. The contrast between death, as symbolized by the machine, and life, as symbolized by the traces of the human hand, soon turned into an opposition between drill and spontaneity, imitation and expression. Before the century was out, the designer Godfrey Blount wrote in a book 'for

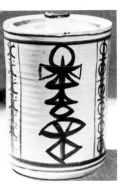

Fig. 43. Biscuit barrel.
English, about 1965

teachers, handicraftsmen and others' characteristically entitled *Arbor Vitae*: 'A mathematical pattern is always a bad pattern . . . Let us rid our minds of the idea that there is any abstract virtue in Art apart from expression. Expression is the all-in-all of every kind of art, patterns included.' Things could never be the same again after precision and finish had been so violently denounced as inartistic and indeed wicked. Even though we no longer hate the machine and have learnt to enjoy the mathematical perfection which it can give to functional products, we are still under the spell of the polarities introduced by Ruskin and like to see the handmade article display those signs of happy carelessness which he praised as a sign of life.

If one were asked to name one criterion by which to recognize works of twentieth-century craftsmanship it would be their often studied absence of mechanical precision (Fig. 43). Needless to say the machine has long caught up with this taste and can also produce the handmade appearance as in printed fabrics which imitate the daubs of rapid brushwork. To Ruskin this would have been the ultimate of the vile lie, but where is the line between lie and fiction?

I have pointed to this basic weakness inherent in all expressionist theories of art—the conviction that expression is identical with communication. From the start Ruskin never wavered in his conviction that he knew how to diagnose the mental and moral states manifested in the works of the past. His response to Gothic ornament is a case in point. Regarding the style as the antithesis of the regimentation and degradation which so deeply outraged him in his own age, he vicariously enjoyed what he took to be the freedom of the individual workmen which he saw manifested in the grotesque carvings of gargoyles (Fig. 41) and drolleries. The very irrationality of these monsters, which would have offended the tidy mind of Vitruvius, appeared to him as a symptom of healthy creativity and 'savageness'. But he also believed that the pride and perfectionism of Renaissance aesthetics could not have subdued the spirit of Gothic craftsmen if this spirit had not been sapped from within through 'over-luxuriance and over-refinement' (XI, p. 6).

We are familar from the previous chapter with the moral condemnation of ornament as over-luxuriance; Ruskin rejects it on different grounds. It is not barbaric splendour he criticizes, nor is it restraint as such he wishes to enforce. His criterion again can almost be described as graphological, the diagnosis of a mental state through its manifestation in lines and forms: 'I do not mean by *luxuriance* of ornament quantity of *ornament*. In the best Gothic of the world there is hardly an inch of stone left unsculptured. But I mean that character of extravagance in the ornament itself which shows that it was addressed to jaded faculties; a violence and coarseness in curvature, a depth of shadow, a lusciousness in arrangement of lines, evidently arriving out of an incapability of feeling the true beauty of chaste form and restrained power . . . We speak loosely and inaccurately of "overcharged" ornament . . . but without any distinct detection of the character which offends us . . .' (p. 6).

Ruskin attempted to demonstrate this contrast between good and bad in a plate (Fig. 44) showing what he called 'temperance and intemperance in curvature'. We are to admire the 'reserve of resource' in the first: 'how easy it would have been to make the curves more palpable and the foliage more rich, and how the noble hand has stayed itself, and refused to grant one wave of motion more'. The other, by contrast, is described as 'wholly unrestrained, and rolling hither and thither in confused wantonness' (XI, p. 9).

The exaggerations of this verdict need not detain us. If we want to practise graphology we must first distinguish the convention of a particular script from the individual's idiosyncratic transformation of his models. It was not the particular craftsman who produced the second scroll who was guilty of 'wanton' excess any more than it was the noble restraint of the earlier master that prevented him from turning the very conventional form into a chain of vortices. In fact—and here lies the rub—the type of diagnosis beloved of Ruskin and other

Fig. 44. J. Ruskin:
'Temperance and
intemperance in
curvature'. *The Stones of
Venice*, 1853

expressionist writers on style down to our own century is only valid on the assumption that
the conventions adopted by a period reflect the collective mind exactly in the way the
expressive movements of the individual reflect his psychic dispositions.

It may be more interesting to ask whether something could be preserved of Ruskin's
analysis when it is shorn of its naive expressionism. What he describes here as elsewhere is a
process of decline due to an inflation of effects. Now inflations—economic or otherwise—
are not really due to a lack of moral fibre (even though politicians sometimes talk as if they
were). They are the consequence of situations in which outbidding has become necessary.
The notorious follies of fashions are of this kind, and even here the moralist who chides the
individual for following fashion misdirects his efforts. But while the fact that wage earners,
designers or artists can be caught up in situations which are not of their own making
disproves the type of accusation in which Ruskin liked to indulge, it may not exclude the
possibility that certain formal conventions or styles can serve as convenient metaphors for
moral qualities. In a way we all react to styles in some such way. Take the case of music.

There may be many who find in the chromaticisms of post-Wagnerian styles a similar lack of restraint when compared to the period of Bach as Ruskin found in the contrasting shapes of scrolls, and such a verdict might be defended even though we would not mean to imply that Bach's contemporaries were less sensuous than those of Debussy.

Ruskin's diagnostic approach to ornament received a severe jolt only a few years after the publication of the *Stones of Venice*. The Indian Mutiny confronted him with an agonizing question: how could acknowledged talent in the decorative arts go together with what he saw as utter moral debasement? The episode is interesting for the new twist which Ruskin gave to his theory of the links between ornament and collective psychology. Briefly, he found in this apparent contradiction yet another confirmation of his prejudice against conventional, geometric pattern. Love of nature, of God's creation, was to him part of the Greek, and particularly the Christian, tradition. Hence, so he thought, all truly great art derived its decorative forms 'from above'. It studied nature first and applied this knowledge to ornament. This was the right path, which he contrasted with the one he abhorred, the path of the large mass of the nations which 'get at it from below by refusing all natural art whatsoever'. Among these he counts the Arabs and the Indians, who 'seek mere relations of colour and line' (XVI, p. 348).

It is in this character of oriental art that Ruskin finds the answer to the riddle that has been tormenting him. Indian art 'never represents a natural fact . . . It will not draw a man, but an eight-armed monster—; it will not draw a flower, but only a spiral or a zigzag (XVI, p. 265).

'It thus indicates that the people who practise it are cut off from all possible sources of healthy knowledge or natural delight; that they have wilfully sealed up and put aside the entire volume of the world, and have got nothing to read, nothing to dwell upon, but that imagination of the thoughts of their hearts, of which we are told that "it is only evil continually" . . . They lie bound in the dungeon of their own corruption encompassed only by doleful phantoms, or by spectral vacancy.'

Since Indian art is second only to Chinese painting in the rendering of flowers (Fig. 45) it is impossible that Ruskin derived his view from any study of Indian monuments. It is more likely that he caught an echo of Hegel's interpretation of the Indian mind, which represents the spirit of mankind entirely turned inwards, like in a dream, refusing all contact with reality. One cannot but wonder what Ruskin would have written if the atrocities he

Fig. 45. Floral ornament from the caves of Ajanta, India, 6th century A.D.

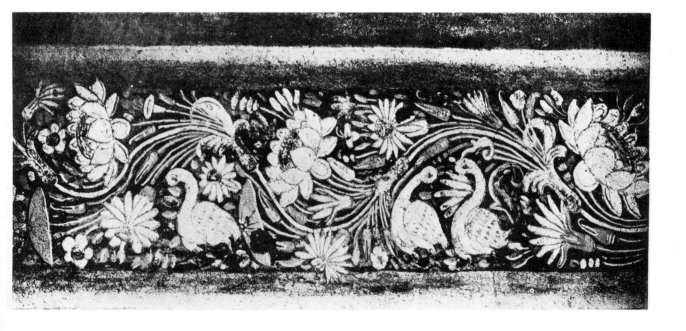

attributed to the Indians had been committed instead by Chinese or Japanese mutineers? Their art, after all, could not be accused of failing in attention to natural forms.

It would be wrong, however, to overlook in Ruskin's condemnation that element of ambivalence which he obviously felt towards England's cruel enemies. After all, he himself had praised the 'savageness' of the Gothic mediaeval craftsmen and so he comes to the reluctant conclusion that a decorative gift of what he calls the 'lower kind' is inseparable from cruelty and that civilization has an adverse effect on this form of artistic talent. The restraint of aggression (we might add all repression) has to be paid for in a loss of spontaneity and sensuous enjoyment:

'The fancy and delicacy of eye in interweaving lines and arranging colours—mere line and colour, observe, without natural form—seems to be somehow an inheritance of ignorance and cruelty . . . I do not profess to account for this . . . I merely assert the fact. Get yourselves to be gentle and civilized, having respect for human life and a desire for good, and somehow or other you will find that you will not be able to make such pretty shawls as before . . . You will find yourselves, as you make yourselves more kind and good, more clumsy in that sort of ornament. If you want a piece of beautiful painted glass at this moment, you do not find that any benevolent Christian can produce it; you have to go back to the thirteenth or fourteenth century, to the days . . . when the Black Prince killed two thousand men, women and children before breakfast because he got into a passion' (XVI, p. 307).

We know to our cost that the inability to produce fine stained-glass windows does not betoken a lack of cruelty. Yet even in perverse passages such as this Ruskin will be found to have anticipated ideas of the twentieth century. None other than Thomas Mann attempted to counter French accusations of barbarism when Germans had shelled the Cathedral of Rheims by the claim that such barbarism was part of true culture, to which the Cathedral belonged. The whole attitude which Ruskin betrays can in fact be found to have particularly appealed to the Expressionists. They shared his general nostalgia for a primitive mentality, as yet unspoilt by the corroding influences of civilization, and even Ruskin's specific theory concerning the rejection of nature by primitive man. It was on the polarity between the flight from nature and the trust in nature that one of the most influential books on Expressionist art theory was based, Wilhelm Worringer's *Abstraction and Empathy*, printed as a doctoral thesis in 1906 and published as a book in 1908. The title reflects exactly Ruskin's two paths. What Worringer calls empathy, the identification with natural forces, is to him a comparatively late product of civilization and this accounts for the peculiarity of Greek and classical art. It manifests an exceptional confidence, because most cultures live in dread of nature and resort to magic and spells to placate its mysterious forces. Abstraction in all the arts is a symptom of this anxiety, an anxiety with which the twentieth century has again become acquainted.

Worringer's sympathies were with primitive man. We may be sure that Ruskin would have repudiated his ideas as he would have repudiated all other manifestations of Expressionist theories. Maybe without the 'graphological' approach we would not have had the trend of action painting that turned art into a pure trace of the artist's movements. No doubt there is irony in this possible link between Jackson Pollock and the critic who had accused Whistler of having thrown a pot of paint into the face of the public, but would Ruskin not also have been astonished by his greater disciples—Tolstoy and Gandhi?

4 Gottfried Semper and the Study of Function

I have suggested in the introductory chapter that the polarity Ruskin bequeathed to us, that between organic rhythm and mechanical precision, rests on a misleading over-simplification.

Fig. 46. Design for a punchbowl
(Gottfried Semper, 1860)

Fitness for a purpose is important for organic and mechanical structures alike. This point of view was represented by another participant in the Victorian debate on ornament, the architect Gottfried Semper. Born in Hamburg in 1803, Semper taught architecture in Dresden till he became involved in the Revolution of 1848, which forms the background to Ruskin's *Seven Lamps*. As a refugee in England, Semper helped to arrange the Great Exhibition of 1851, but left later to move to Zurich and then to Vienna. He died in 1879.

Thanks to his views on the importance of the material in architecture and in the crafts, Semper has become a kind of father figure for the modern movement, but owing to the same bias he also became tarred with the brush of 'materialism', mainly through the writings of Alois Riegl, which will engage our attention in another chapter. Those who come to Semper with the expectation of finding a functionalist and materialist will in any case be somewhat bewildered. In his own buildings and designs he certainly was a true Victorian, witness his design for a punchbowl (Fig. 46) dating from his London years. His writings are even less easy to reconcile with his posthumous reputation. To tell the truth, they are almost unreadable. Where Ruskin is rhetorical and rousing, Semper is pedantic and soporific. It is not always easy to know what his two volumes of 1860, *Der Stil in den technischen und tektonischen Künsten*, are about. They are certainly not intended as an attack on decoration as such. Semper was looking for the proper relationship between decoration and purpose. The punchbowl, for instance, is intended to demonstrate the need to emphasize function by various degrees of decorative emphasis. The plain body of the tureen is gilded and polished and so is the ground of the lid. The decoration is in mat silver, to ensure that the structure is not visually smothered.

It may help to explain Semper's approach to know that in his youth he concerned himself with what was then a revolutionary archaeological discovery—the discovery that ancient buildings were polychrome and that the whiteness of the marble so beloved of the neo-classicists of his time was largely the result of the gaudy paint having disappeared. Some of the pundits, such as Franz Kugler, had attacked him and he wished throughout his life to defend and explain the decorative treatment of the wall in ancient architecture. Unlike Ruskin, Semper remained convinced that classical architecture was the model for all times. The Greeks should never be charged with breaking the laws of taste. It was in pursuit of this argument that Semper came to observe the duality between the support and the covering of the wall. In many building styles the raw wall is covered with matting, panelling, hangings, stucco, murals and wallpaper, in short everything Semper discussed under the term of

Fig. 47

Wandverkleidung (wall dressing). The investigation of this practice seems indeed a far cry from functionalism, but Semper's rather scholastic mind was led from there to consider the relation between structure and decoration on *a priori* principles. He aimed at a kind of axiom-system of the decorative arts in which these basic interactions could be described and classified.

In a lecture of 1856 on the function of body decoration or *Schmuck* through dress, jewellery, tattooing and coiffure he distinguishes three fundamental categories of adornment, which he calls the pendant, the ring, and the directional ornament, *Richtungsschmuck*. The aesthetic effect of the pendant depends on the laws of gravitation; ear-rings, nose-rings and all kinds of tassels move and sway with the body and emphasize its slant (Fig. 47). The term ring is used for all encircling forms such as wreaths, crowns, belts and bracelets which can be used to articulate the body and to enhance the effect of its swelling forms. Directional ornament accentuates a particular dimension: the plumed helmet or the towering coiffure make for greater height (Plate 14) and unlike the heavy pendant this adornment also indicates the direction of the wearer's movement, because ribbons, veils and even flowing hair are transformed by the pressure of the air so that they will flutter in rapid movement. It is this function of adornments which aroused the interest of Aby Warburg in his early studies of Botticelli and Ghirlandaio and attracted his attention to Semper. For Semper, however, this analysis was relevant only in relation to his system. His essay continues with speculations about organic form which were later incorporated in *Der Stil*. Like Ruskin he wished to appeal to nature, but in a very different spirit. Art should apply the laws of nature rather than imitate nature. The basic laws of form with which nature operates are symmetry, proportionality and directionality. In the organic world perfect symmetry is for him related to the closed forms of floating organisms which have no directional accent, no vector (Fig. 5). The growing plant, on the other hand, is extended between the pull of gravitation and its upward thrust, productive of symmetry and proportionality, while the higher animals, from the fish upwards, are organized in the direction of their movement; they have a front and a back and therefore a strong vectorial accent. I suspect that what Semper was groping for was something like D'Arcy W.

Thompson's classic book *On Growth and Form* (Cambridge, 1942), but he got stuck in *a priori* speculations derived through Goethe from the Aristotelian tradition. Aristotle distinguished between the material cause and the final cause, and it is not far-fetched to see Semper's further theorizing about the arts in this light, for he insisted on paying proper regard to the relation of purpose, material and technique.

It may well be that Semper would have remained entangled in generalities if he had not come to England. The debates he found in progress had resulted from a comparison between European and non-European designs. Pugin, it will be remembered, had commended Turkish rugs for their absence of naturalistic motifs and even Ruskin was forced grudgingly to admit the exquisiteness of Indian craft products.

In a lecture on textile design Semper accepted the orthodox line that 'we stand in no need of perspective nor of light and shade, but very much of regular composition. Wherever there are figures in the design they must be shown as much as possible in profile, since profile results much more in the impression of a flat plane than a frontal view' (Fig. 48).

It is from this alleged law of aesthetics that Semper proceeds to his more interesting diagnosis of the reasons for the greater artistic health of exotic art. 'The law of regular symmetric repetition is being observed by the uncivilized nations, possibly for the reason that they lack the means of deviating from it. Thus nature preserved them from sin. We on the other hand are the masters of enormous means and it is this abundance of means which is our greatest danger. Only by reasoning are we able to get some kind of order into this matter since we have lost our feeling for it.'

There is disappointingly little of this 'reasoning' in *Der Stil*, but where it comes to the surface it foreshadows indeed the ideas and practice of a later generation. Take Semper's remarks about the role of stitching in textile design. In his view it can exemplify the most important first axiom of applied art—the law of making a virtue of necessity. He admires the tact with which 'near-savages', who are still bound by the laws of necessity, apply this stylistic rule. 'We admire the artistry and the taste with which the Iroquois and other North American tribes contrive to join badger furs or doeskins with feathers, guts, animal sinews

Fig. 48. Indian embroidery,
18th century

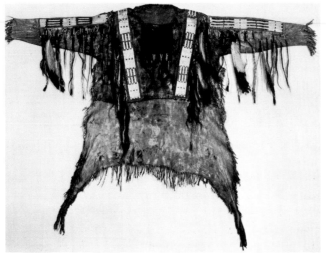

Fig. 49. Shirt of the Blackfoot Indians

Fig. 50. Modern leather garment

or artificial threads and the way this patchwork results in tastefully multicoloured embroidery, a decorative principle which might have led to a characteristic artistic development but was unfortunately nipped in the bud' (Figs. 49, 50). Maybe it was Semper's advocacy and that of his fellow reformers which transferred this tradition to modern leathercrafts, for today the principle of visible stitching has become commonplace in design.

We find a more detailed application of this principle of parsimony in Semper's discussion of woodwork. He deplores the invention of the brothers Thonet in Vienna of bending wood for the manufacture of furniture as doing violence to the material (Fig. 51). The carpenters of ancient Egypt knew better. They separated the *Necessarium* (the Necessary) from the *Commodum* (the Convenient) and expressed this duality in the shapes of their furniture. In the two Egyptian chairs he illustrates this separation is perfect (Fig. 52). The legs are angular and vertical to conform with the principle of structure and this structural kernel remains visible beneath the decorative lions' paws. The backrest, too, is made up of two parts; the structural member is vertical, doing no violence to the wood, which remains strong. The backrest proper is a softly curving inclined board adapted to the sitter's back. It is precisely because it does not belong to the structure that it can become the carrier of decoration, inlaid work adapted to the purpose since relief would be uncomfortable. The road from here to the Bauhaus is still a long one, but it is ultimately one road.

Fig. 51 (*far left*). Chair by the Thonet brothers. 19th century

Fig. 52. Two Egyptian chairs (Gottfried Semper, 1860)

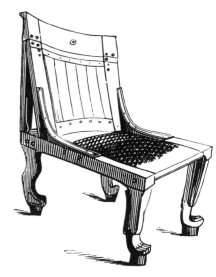

5 *Owen Jones and the Study of Form*

Whether the deplorable state of European design was to be found in a lack of discriminating taste, as Pugin and the reformers believed, in the ravages of the machine, as Ruskin thought, or in an imbalance of ends and means, as Semper shrewdly suggested, the need to go back to school and to learn the principles of decoration from foreign traditions was almost universally felt.

It was this need that was to be served by that classic of our field, *The Grammar of Ornament*, published by Owen Jones in 1856; the original edition is a sumptuous work of a hundred mainly coloured plates with some 1000 examples of the ornamental arts (Plate 11). Jones was born in 1809 and like Semper had a share in the arrangement of the 1851 Exhibition; he had published a standard work on the Alhambra in Spain and had been commissioned to decorate the Khedive's Palace in Egypt. His portrait in the R.I.B.A. (Plate 12) shows him against a background of moorish ornament.

In the *Grammar of Ornament*, however, he cast his net much wider, acknowledging from the start his purpose of perpetuating the lessons of the Exhibition: 'Whilst in the works contributed by the various nations of Europe ... there could be found but a fruitless struggle after novelty, irrespective of fitness ... there were to be found in isolated collections ... all the unity, all the truth, for which we had looked elsewhere in vain, and this because we were amongst a people practising an art which had grown up with their civilization ... united with their faith, their art had necessarily a common expression ...'

We have seen that this sentiment was common enough, and indeed Alf Bøe, to whose book I have referred, has criticized Owen Jones for a certain lack of originality. The 37 Propositions with which he prefaced the work as constituting '*General Principles in the Arrangement of Form and Colour, in Architecture and the Decorative Arts, which are advocated throughout this Work*' are admittedly somewhat vague and even vacuous, but this fault is amply made up in the analysis of individual designs. Jones brought to the debate a criterion which had been lacking in Ruskin and in Semper: the psychology of perception. His approach stems ultimately from that of Hogarth, who was the first to experiment with empirical methods in his search for the 'line of beauty'. It may sound a little empty when we read in Owen Jones' *Principles* that 'the essence of beauty is a feeling of repose which the mind feels when the eye, the intellect and the affections are satisfied by the absence of any want', but if we turn to its applications we may well be surprised. The series of examples opens with three plates illustrating '*Ornament of Savage Tribes*'. The very first example must have come as a shock to any Victorian reader. It shows a tattooed head from New Zealand in the Museum in Chester (Fig. 53) which, in Jones' words, 'is very remarkable as showing that in this very barbarous practice the principles of the very highest ornamental art are manifest, every line upon the face is the best adapted to develop the natural features'. In analysing cloth from Tongatabu in the Friendly Islands group (Col. Plate III) the author speaks of the 'admirable lesson in composition which we may derive from an artist of a savage tribe. Nothing can be more judicious than the general arrangement of the four squares and the four red spots. Without the red spots on the yellow ground there would have been a great want of repose in the general arrangement; without the red lines round the red spots to carry the red through the yellow, it would have been still imperfect. Had the small red triangles turned outwards instead of inwards, the repose of the pattern would again have been lost, and the effect produced on the eye would have been that of squinting; as it is, the eye is centred in each square, and centred in each group by the red spots round the centre square. The stamps which form the pattern are very simple [Fig. 54], each triangle and each leaf being a single stamp, we thus see how readily the possession of a simple tool, even by the most uncultivated, if guided by an instinctive observation of the forms in which all the works

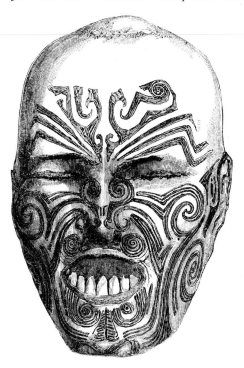

Fig. 53. Tattooed head from New Zealand
(Owen Jones, 1856)

of Nature are arranged, would lead to the creation of all the geometrical arrangements of form with which we are acquainted. On the upper left-hand corner . . . the eight-pointed star is formed by eight applications of the same tool; as also the black flower with sixteen pointing inwards and sixteen pointing outwards. The most complicated patterns of the Byzantine, Arabian, and Moresque mosaics would be generated by the same means. The secret of success in all ornament is the production of a broad general effect by the repetition of a few simple elements.'

Owen Jones' conclusion is memorable as a portent of things to come: 'The ornament of a savage tribe, being the result of a natural instinct, is necessarily always true to its purpose; whilst in much of the ornament of civilized nations, the first impulse which generated received forms being enfeebled by constant repetition, the ornament is oftentimes misapplied, and instead of first seeking the most convenient form and adding beauty, all beauty is destroyed, because all fitness, by superadding ornament to ill contrived form. If we would return to a more healthy condition, we must even be as little children or as savages; we must get rid of the acquired and artificial, and return to and develop natural instincts.'

It is not inconsistent, therefore, for Jones in his survey of ornamental styles to commend in particular the decorative system of ancient Egypt for its combination of a strong sense of order with a love of symbolism that much appeals to him. The lotus and the papyrus, he

Fig. 54. Extract from Owen Jones, *The Grammar of Ornament*, 1856

centred in each group by the red spots round ◆ the centre square. The stamps which form the pattern are very simple, each triangle ▲ and each leaf ◆ being a single stamp, we thus see how readily the possession of a simple tool, even by the most uncultivated, if guided by an instinctive observation of the

forms in which all the works of Nature are arranged, would lead to the creation of all the geometrical arrangements of form with which we are acquainted. On the upper left-hand corner of pattern No. 2, the eight-pointed star is formed by eight applications of the same tool; as also the ❘ black flower with sixteen pointing inwards ❛ and sixteen pointing outwards ❟ The most complicated patterns of the Byzantine, Arabian, and Moresque mosaics would be generated by the same means.

says, symbolize 'the food of the body and mind' and thus are most fitting elements of this lucid and severe decoration. It is this ingredient he misses in classical ornament, for which he displays only lukewarm admiration, dismissing Roman forms as nearly totally decadent.

And yet when he comes to exemplify the true principles of ornamental composition his standard of perfection turns out to be the Alhambra. True, it lacks 'the charm of symbolism', but this 'want' was more supplied by the inscriptions so frequently interwoven into the arabesque. For Jones, therefore, the Alhambra is the work 'most fitted to illustrate a Grammar of Ornament ... Every principle which we can derive from a study of ornamental art of any other people is not only ever present here, but was by the Moors universally and truly observed.'

Once more it is in the analysis of these principles that Owen Jones displays his psychological acumen. His diagrams (Figs. 55, 56) demonstrating what he thought to be the greatest ease of perception look forward to the empirical work of *Gestalt* psychology: 'All transitions of curved lines from curved, or of curved lines from straight, must be gradual. Thus the transition would cease to be agreeable if the break at A were too deep in proportion to the curves, as at B. Where two curves are separated by a break (as in this case) they must, and with the Moors always do, run parallel to an imaginary line (C) where the curves would be tangential to each other; for were either to depart from this, as in the case of D, the eye, instead of following gradually down the curve, would run outwards, and repose would be lost.'

It may be worth while, for a moment, to cast our minds back to Ruskin's comparison of curves (Fig. 44) to appreciate the gulf that separates Jones' perceptual approach from Ruskin's graphological expressionism. But then, Ruskin execrated the decoration of the Alhambra as an abomination. He hated that 'perfection' and even the 'repose' Jones admired most. It was achieved, in the view of Jones, by a systematic procedure which Ruskin's impulsive artist would have found inhibiting.

'The general forms were first cared for; these were subdivided by general lines; the interstices were then filled with ornament, which was again subdivided and enriched for closer inspection ... When seen at a distance, the main lines strike the eye; as we approach nearer, the detail comes into the composition; on a closer inspection, we see still further detail on the surface of the ornaments themselves.' As in the earlier example, Jones here explains with a few diagrams how this gradual enrichment leads to that 'harmony of form' which he finds in the 'proper balancing and contrast of the straight, the inclined and the curved'. '... any arrangement of forms, as at A, consisting only of straight lines, is monotonous, and affords but imperfect pleasure; but introduce lines which tend to carry the eye towards the angles, as at B, and you have at once an increased pleasure. Then add lines giving a circular tendency, as at C, and you now have complete harmony. In this case the square is the leading form or tonic; the angular and curved are subordinate.'

The musical metaphor harks back to Wornum and will interest us later. But now we must hear Jones further: 'We may produce the same result in adopting an angular composition, as

Fig. 55 (*above*) and Fig. 56. From Owen Jones, *The Grammar of Ornament*, 1856

A B C D E F

at D: add the lines as at E, and we at once correct the tendency to follow only the angular direction of the inclined lines; but unite these by circles, as at F, and we have still more perfect harmony, i.e. repose—for the eye has now no longer any want that could be supplied.' The same ease of perception resulting in repose requires in Jones' view that 'all lines flow out of a parent stem: every ornament, however distant, can be traced to its branch and root'.

He attached great importance to this observation, because like Semper he was convinced that the designer should follow nature not by imitating appearances but by applying its inherent laws. The principle of radiation like that of subdivision is for him perfectly realized in a leaf in which the sap is distributed from the stem in such a satisfying pattern (Fig. 57). Moreover he found that leaves and also feathers generally accord with the law 'that all junctions of curved lines with curved, or of curved with straight, should be tangential to each other', which he is inclined to call 'the melody of form'. But the 'repose' achieved by this impression of coherence and articulation should not be identified with simplicity. That balance between the straight and the curved that he had demonstrated in surface divisions was clearly not enough. 'All compositions of squares or of circles will be monotonous, and afford but little pleasure, because the means by which they are produced are very apparent. So we think that compositions distributed in equal lines or divisions will be less beautiful than those which require a higher mental effort to appreciate them.' Indeed he postulates that 'those proportions will be most beautiful which it will be most difficult for the eye to detect . . . In the best periods of art, all mouldings and ornaments were founded on curves of the higher order, such as the conic section; whilst, when art declined, circles and compass-work were much more dominant.' He is here anticipating an idea which Birkhoff was to elaborate in his book on *Aesthetic Measure*, the idea, that is, that pleasure in perception derives from the right mean between monotony on the one side and confusion on the other.

We cannot follow Jones into the similar 'laws' he derives from the principles of colouring found in Moresque decoration, where again he stresses the harmony arising from the balanced use of all primary colours. Like other writers on this topic he drew on Chevreul's findings about colour contrasts and he suggested that 'The various colours should be so blended that the objects coloured, when viewed at a distance, should present a neutralized bloom' (Proposition 22).

If some of these general rules strike us as a little disappointing we must realize that they arose from the need to offer an alternative to the two guidelines previously offered to artists and designers—the study of nature and the acceptance of tradition. The first had been severed by the reformers, the second by industrialization. No wonder designers floundered and looked for a saviour. The moan, 'we have no style', was so universally heard that Ruskin complained in 1857 'of the perpetual, empty, idle, incomparably idiotic talk about the necessity of some novelty in architecture' (XVI, p. 346).

Here, too, Jones took a less eccentric line. He realized, as he said in the introduction to the *Grammar of Ornament*, that his collection of examples would be used by many 'to borrow from the past those forms of beauty which have not already been used *ad nauseam*', but he hoped 'to arrest this tendency and to awaken a higher ambition'.

This ambition was to found a better style, based on the principles he had expounded, principles he believed were found in organic nature but could not be realized by the slavish copying of natural forms. It was to drive home this lesson that he appended to his book ten plates with his own drawings of leaves (Fig. 57) and blossoms. They were to show the unity in variety that characterizes creations of Nature and to give heart to those who asked how the creative instinct was to be revived. 'How . . . is this universal desire for progress to be satisfied—how is any new style of ornament to be invented or developed?' Some, he concedes, will think that a new style in architecture must first be found, but he suggests that,

Fig. 57. From Owen
Jones, *The Grammar
of Ornament*, 1856

Fig. 58. William
Morris: 'Acorn'
wallpaper design.
1880

on the contrary, 'a new style of ornament would be one of the readiest means of arriving at a new style; for instance, if we could only arrive at the invention of a new termination to a means of support, one of the most difficult points would be accomplished'.

The opinion that such means of support—columns or pillars—had been exhausted was blatantly untrue. 'Could the mediaeval architect have ever dreamed that his airy vaults could be surpassed, and that gulfs could be crossed by hollow tubes of iron? Let us not despair; the world has not seen, most assuredly, the last of the architectural systems . . . From the present chaos there will arise, undoubtedly, (it may not be in our time), an architecture which shall be worthy of the high advance which man has made in every other direction towards the possession of the tree of knowledge.'

His work culminates in a peroration of almost Ruskinian fervour in praise of God's Creation:

'See how various the forms, and how unvarying the principles. We feel persuaded that there is yet a future open to us; we have but to arise from our slumbers. The Creator has not made all things beautiful, that we should thus set a limit to our admiration; on the contrary, as all His works are offered for our enjoyment, so are they offered for our study. They are there to awaken a natural instinct implanted in us—a desire to emulate in the works of our hands, the order, the symmetry, the grace, the fitness, which the Creator has sown broadcast over the earth.'

In thus contriving to combine an optimism about the March of Progress with an equally optimistic faith in the Goodness of Creation, Owen Jones certainly must have appealed to a generation which believed in the possibility of reform. After all this was the time when a new type of artist appeared on the scene, the designer. The greatest of them, William Morris, is generally regarded as a disciple of Ruskin, but it is also known that he owned the *Grammar of Ornament* and he may well have drawn inspiration from its pages (Fig. 58).

6 The Japanese

One nation is conspicuously absent from Owen Jones' wide survey of decorative traditions—the Japanese. There are four plates devoted to Chinese ornament, which, as he reminds his readers, 'is so familiar through the numerous manufactured articles of every kind which have been imported into this country'. Familiarity, it is said, breeds contempt and Jones' treatment of the Chinese tradition is not very far from contempt. 'The Chinese are totally unimaginative, and all their works are accordingly wanting in the highest grace of art—the ideal.'

This is not the place to chronicle the growth of Europe's awareness of the artistic traditions of Japan, which in turn led to the revaluation of Chinese art. At the very time when Owen Jones was writing, in 1854, Commander Perry had forced the Japanese to re-open their country to European merchants and the effects, direct and indirect, soon made themselves felt. The first British Ambassador to Japan, Sir Rutherford Alcock, took a fancy to Japanese products and sent a consignment of specimens, which he had bought in the Bazaars of Yedo, to the International Exhibition held at South Kensington in 1862, where the 'Japanese Court' caused a considerable stir. When in the subsequent year John Leighton devoted a lecture at the Royal Institution to Japanese art he emphasized the superiority of the Japanese over the Chinese, who 'toil and spin but lack inventive powers'. While he has little patience with Japanese painting he admits that their 'patterns are handsome in the extreme', and ends with an appeal for the nation to devote the modest sum of one thousand pounds to obtain 'a really good collection presenting the arts and industry of Japan'. When Sir Rutherford Alcock himself lectured in the same year at the Philosophical Society at Leeds to commend the study of Japanese art to manufacturers, he used the occasion to proclaim an entirely Ruskinian message: 'That only those who love their work and find satisfaction in its excellence can see true pleasure in anything they undertake.'

It was indeed easier to come to terms with Japanese products for a Ruskinian than for a follower of Owen Jones and his group of reformers. For the Japanese certainly excelled in the loving imitation of God's creation, but in doing so they frequently contravened the rules the reformers had been trying to drive home—the rule that nature must not be imitated but should be conventionalized in order not to offend against the law that decoration must be essentially flat.

As Japanese works became known and artists and critics were captivated by the exquisite beauty and refinement of a tradition that was still alive, the embarrassment of the new dogmatist grew. In 1867 the once powerful Shogun, the factual ruler of Japan, had sent his treasures—real collectors' pieces, not bazaar ware—to the International Exhibition at Paris, in the hope, it is said, to prepare for their sale and thus to obtain much needed funds. His power did not last long enough for him to profit from the proceeds but the dispersal of these treasures brought Europe for the first time face to face with real masterpieces of Japanese crafts. In 1871 Théodore Duret, the friend of the Impressionists, went to Japan together with Cernuschi to lay the foundation of their rich collections. By then the opinion was firmly established that 'as a nation of artists' the Japanese were a match for the Greeks.

When Ernest Chesneau published his book on the education of the artist in the late 70s, in which he heavily drew on the tradition of the English reformers, he appends a characteristic footnote to the conventional warning against 'rugs with landscapes or vases with concave sides'.

'At the same time it is so true that there is no hard and fast rule in matters of art, that some modern specimens of Japanese pottery are curiously and intentionally deformed—crooked, twisted, or bulging like a sack of potatoes—and, nevertheless, in the most refined taste . . . [Figs. 59, 60]. Genius cannot be a slave to syntax. Do what it will, it does not violate laws; it

Figs. 59 and 60. Japanese bottle and bowl
(L. Gonse, 1885)

creates them . . . and Japan is, of all lands, the most gifted with the genius of decorative art.'
It was in these very years that the most ardent champion of Japonism among the artists,
Whistler, asserted the right of genius to break the rules of propriety by overpainting the
precious leather tapestry of the Peacock Room with his Japanese decoration.

When, in the next decade, the influential teacher Lewis F. Day, on whom the mantle of
Owen Jones had fallen, published his various text books of ornamental design, his works
reflected the uneasiness which the mounting fashion caused in the schools. The Japanese, of
course, were no respecters of symmetry (Figs. 61, 62) nor of the conventional laws of frames

Figs. 61 and 62.
Japanese designs
L. F. Day, 1890)

and orders. And Lewis Day concedes that 'One appreciates the freak of the Japanese as a relief from the monotony of absolutely formal disposition . . . but the license needs always to be justified by some excuse other than the artist's impatience of order. We have to be on our guard against a certain spirit of anarchy which appears to have taken possession of so many modern artists. There is a class . . . which will repudiate, not only the laws of art, but the need of all law whatsoever. Urgent need there may be of reform in our ideas of art, perhaps even of revolution; but sobriety recognizes in the artistic anarchists only the enemy of art.'

Day certainly tried to find out what merits there were in what he calls Japanese perversity. He grants it charm because 'one does not readily grasp all that is in it: there is always something to find out; which is just what there would not be in a simple and orderly geometric pattern of the European type.'

Indeed, in the end he concedes that despite their eccentricities the Japanese usually arrive at balance because their instinct in this respect is unlikely to err. The tide of *art nouveau* with its strong Japanese ingredients was not to be stemmed. The revolution was on the march.

7 *The New Status of Design*

The revolution justified Owen Jones' prophecy, that decoration might become the spearhead of a general renewal of style. It did so both directly and indirectly. Directly by the self-conscious display of novel forms and novel motifs on buildings, furniture and fabrics which proclaimed their difference from all that had gone before in Europe; indirectly by making the designer increasingly self-conscious, claiming equality with the painter, if not superiority.

There is ample evidence that this claim was accepted by the leading members of the aesthetic movement. Nothing can be more characteristic of this change in valuation than Oscar Wilde's remarks in his essay *The Artist as Critic*:

'The art that is frankly decorative is the art to live with. It is, of all visible arts, the one art that creates in us both mood and temperament. Mere colour, unspoiled by meaning, and unallied with definite form, can speak to the soul in a thousand different ways. The harmony that resides in the delicate proportions of lines and masses becomes mirrored in the mind. The repetitions of patterns give us rest. The marvels of design stir the imagination. In the mere loveliness of the materials employed there are latent elements of culture. Nor is this all. By its deliberate rejection of Nature as the ideal of beauty, as well as of the imitative method of the ordinary painter, decorative art not merely prepares the soul for the reception of true imaginative work, but develops in it that sense of form which is the basis of creative no less than of critical achievement.'

One of the most striking consequences of this rise in the status of decorative art was the desire of representational painters not to be outdone by their new rivals. In 1893 Maurice Denis, who was to acquire a rather disproportionate fame in the history of criticism for his discovery that pictures are flat, wrote: 'I think that above everything else a painting should be an ornament. The choice of subjects for scenes means nothing. It is through coloured surfaces, through the value of tones, through the harmony of lines, that I attempt to reach the mind and arouse the emotions.'

The quotations could easily be multiplied. I am old enough to remember the generation of art lovers who insisted that a test of a good painting lay in what they called its 'decorative' quality. It should not matter much whether you hung it the right way up or upside down.

It is interesting that an early protest against this use of the term 'decorative' came from one of the most prominent of the champions of Japanese art, the Portuguese-American, Ernest Francisco Fenollosa, who had been a teacher in Japan. In a meditation on 'The Nature

Fig. 63. 'The Fenollosa system of Art education' (W. Beck, 1928)

of Fine Art' which he published in one of America's short-lived 'little magazines', *The Lotos* of March and April 1896, he seeks for 'the synthetic quality' which painting shares with music and poetry and takes exception to 'this false employment of the word *decorative* . . . it crept into our language . . . because at the middle of the century, we made the astounding discovery that full oil paintings in shadow and perspective were not the best sort of ornament to put upon our saucers and cups. We found that we must try . . . to get a little farther away from the literalness of nature'.

Fenollosa's influence carried Japanese ideas into art teaching and if the diagram illustrating his method is anything to go by, he must be counted among the indirect teachers of Mondrian (Fig. 63). The time was evidently not far off when the word decorative was no longer good enough for the pioneers of a new style.

This emancipation of design from its servile status reacted back on the evaluation of decorative art. An apologetic note crept into the textbooks of the subject and contrasts markedly with the missionary tone of the previous generation. The preface to a book on Design by Richard G. Hatton published in 1902 opens with the words:

'There is at present a strong desire among persons of taste for plain objects, for objects devoid of complication of form, although beautiful in shape, delicate in proportion, and good in colour. Such a demand as this excludes decoration, or ornament, as an unnecessary addition, as much on the score of beauty as for any other reason . . .

'But simultaneously with the rise of a demand for plain objects of good form and colour has arisen a deeper regard for pattern. That patterns are a rhythmical form of art, with a justification of their own, is now admitted. Some have not hesitated to ascribe to them a deeper, more mystical and more symbolic significance than pictorial Art can itself claim . . . Lifted thus into a rather more exalted region, the works of the decorator become more definitely works of Art.'

8 Adolf Loos: 'Ornament and Crime'

The emancipation of pattern design into an independent art with growing pretensions foreshadowed the divorce between decoration and functional fitness. Among the advocates of this divorce none is more characteristic and articulate than Adolf Loos, whose essay of 1908, *Ornament und Verbrechen*, was distilled into the slogan that ornament is crime. Loos, who had returned to his native Vienna after a spell in the United States and England, assumed the role of a missionary in his polemical writings on design, which he later collected in book form. He never ceased to goad his fellow Austrians by telling them of the superiority of Anglo-Saxon taste and civilization over the self-conscious artiness of Austrian designers. His message must have sounded paradoxical to artists and critics who had prided themselves on having adopted the latest fashions propagated by such English journals as *The Studio* and who derived so much inspiration from designers such as Mackintosh. Yet it is true that many of the most radical ideas of Loos can be traced back to the English reformers even though he rarely referred to them by name in his dogmatic pronouncements. It has been pointed out that Sullivan, with whom Loos was associated in America, had written as early as 1892 that 'it would be greatly for our aesthetic good if we should refrain entirely from the use of ornament for a period of years in order that our thought might concentrate acutely upon the production of buildings well formed and comely in the nude.'

The moral overtones of this statement cannot be missed. The healthy naked body had served Cicero as a metaphor for Caesar's literary style and we have seen that the lack of meretricious adornment always appealed to the classical tradition as a sign of aesthetic superiority. Even Ruskin, who did not share this bias, would not have disapproved of Sullivan's remark and it may well be that there is more of Ruskin in Adolf Loos himself than

at first meets the eye. For Ruskin's very respect for the work of human hand had made him condemn the debasement of decoration; he laid it down in the *Seven Lamps* that 'you must not mix ornament with business.'

'The most familiar position of Greek mouldings is these days on shop fronts . . . How pleasurable it would be to have the power of going through the streets of London, pulling down those brackets and friezes and large names, restoring to the tradesmen the capital they had spent in architecture, and putting them on honest and equal terms, each with his name in black letters over his door . . . and each with a plain wooden shop casement . . .' (VIII, p. 157–8).

When Loos came to design a shop in Vienna for Goldmann and Salatsch on the Michaelerplatz (Plate 2), he did not put the front in wooden casements, but he removed all the traditional mouldings from the façade.

Loos also shared with Ruskin a distaste for ornamenting utilities, ventilators or railway stations. 'Railway architecture,' Ruskin had written, 'has, or would have, a dignity of its own if it were only left to its work' (p. 160). Loos, too, looked for this dignity, but not in the spirit of the Romantic technologists, who exulted over the beauty of engineering work. Like Ruskin he believed that utilities should be seen but not noticed. It was his conviction that the ordinary craftsman still knew perfectly well what made a good chair or a good saddle, but that the last vestiges of this healthy tradition were threatened by meddling professors of design, who wanted to 'apply' art to objects to which it did not belong.

Reporting on a Munich exhibition of 1898 Loos takes issue with the artificiality of *Art Nouveau* such as it was propagated by Liberty's in London and Bing's in Paris. He challenged the claim that this new style was the style of his time. There were plenty of objects that bore the style of the time, including clothing, railway carriages, bicycles and engines. These we like very much but we do not make much fuss about them. If the Greeks had had bicycles they would have looked like ours. The best chair will not be one that looks original but the most comfortable one. The postures of sitting, of resting, cannot have changed much, and if there can be improvements they would have to be minute ones hardly noticeable to the human eye. 'How hard it is to find a good chair and how easy to find a novel one.' Following the tradition of pillorying abominations, Loos describes an umbrella stand he saw at the exhibition. If a Greek or an Englishman had been asked to design such a stand he would have first of all thought of its function. Not so the German designer, who was only out to invent a fitting symbolic reference to rainy weather. 'Water plants wind upwards and on each one of them there sits a frog. That the pointed edges of the leaves might easily tear the umbrella does not trouble the Germans.' Few crafts were as yet untouched by this conscious striving for artiness though Loos acknowledged that Austrian leather craftsmen and silversmiths had profited from the English elegance with its stress on simplicity.

The aesthetics propounded by Loos certainly harked back to the Neo-classical tradition, which saw in any surfeit of ornament a symptom of vulgarity. But his convictions were also reinforced by the very emphasis which both Ruskin and the reformers of design in England had placed on the superiority of barbaric and exotic craft traditions. Ruskin, it will be remembered, had sung the praises of Gothic barbarism and had even been led to acknowledge the superiority of uncivilized savages in matters of design, however much he abhorred their moral degradation. It was but a step from this conviction to the assertion that the inferiority of the industrial age in matters of ornament is in fact a symptom of its higher civilization. We find the germ of this idea in an article by Loos of 1898:

'The less civilized a people is, the more prodigal it will be with ornament and decoration. The Red Indian covers every object, every boat, every oar, every arrow over and over with ornament. To regard decoration as an advantage is tantamount to remaining on the level of a Red Indian. But the Red Indian within us must be overcome. The Red Indian says: That

woman is beautiful because she wears golden rings in her nose and in her ears. The civilized person says: this woman is beautiful because she has no rings in her nose and in her ears. To seek beauty only in form and not to make it depend on ornament, that is the aim towards which the whole of mankind is tending.'

It must interest the psychologist that here, as so often, the rights and wrongs of ornament are discussed in terms of feminine adornment—here too we may remember Cicero's remarks about the superior beauty of the unadorned woman.

When Loos came to develop and expound his identification of ornament with barbarism and with crime he drew even more heavily on the erotic associations of decoration. In fact, he identifies ornament with primitive eroticism and, at least by implication, the absence of ornament with purity and chastity.

Written in the era of evolutionism and the aura of Freud, the article presents the development of mankind as the story of moral evolution: 'The child is amoral. The Papuans are equally so for us. The Papuans slaughter their enemies and eat them. They are not criminals. If, however, a man of this century slaughters and eats someone he is a criminal or a degenerate. The Papuans tattoo their skin, their boats, their oars, in short everything within reach. They are not criminals. But the man of this century who tattoos himself is a criminal or a degenerate. . . . The urge to ornament one's face and everything within reach is the very origin of the visual arts. It is the babbling of painting. All art is erotic.

'The first ornament that was ever created, the cross, is of erotic origin . . . The horizontal stroke is a reclining woman; a vertical stroke the man penetrating her. The man who created this experienced the same urge as Beethoven, he was in the same heaven in which Beethoven created his Ninth Symphony, but the man of this century who feels the urge to cover the walls with erotic symbols is a criminal or a degenerate . . . I have found the following law and presented it to mankind: the evolution of civilization is tantamount to the removal of ornament from objects of use. I thought this would give joy to the world but it did not thank me . . . What oppressed them was the realization that they were unable to produce a new ornament . . . They walked sadly among the show cases of their museums and were ashamed of their own impotence. Every age has its own style and our own should be denied one? When they said style they meant ornament. To those I said: Do not weep! Learn to see that the very greatness of our time lies in the fact that it is unable to produce a new ornament. We have overcome ornament, we have struggled free from ornament. Lo, the time is nigh and fulfilment awaits us. Soon the streets of the city will gleam like white walls; like Zion, the Holy City, the capital of heaven. This will be the consummation.'

Loos may have been trailing his coat when he thus echoed the prophetic accents of Ruskin, but he certainly meant what he said when he insisted on the separation between art and utility: 'We possess the art that has replaced ornament. After the stresses and strains of the day we go to hear Beethoven or *Tristan*.'

9 Ornament versus Abstraction

There was indeed something prophetic in this manifesto against ornament. For though nobody would claim that our cities now look like the capital of heaven, the divorce of functions between art and design was accepted by subsequent generations. Not only did it become an article of faith that the ornamentation of houses, furnishings and household goods was fundamentally in poor taste, it was also admitted that the formal imagination which had thus lost its traditional outlet had to be given a new playground. It was in the period when the creation of decorative forms was increasingly suppressed in favour of functional utility that what is called abstract art made its entry into the preserve of painting and sculpture.

Admittedly this is a sensitive, not to say a neurotic point in twentieth-century criticism. There is nothing the abstract painter used to dislike more than the term 'decorative', an epithet which reminded him of the familiar sneer that what he had produced was at best pleasant curtain material. The abstract art of the twentieth century looks for an ancestry far removed from the humble craft of decorative design. One is reminded of Michelangelo, who rebuked a correspondent for addressing him as sculptor. The successful and those who have arrived tend to deny their poor relations.

The relations between decoration and abstraction are too complex to be summed up in any formula, but the reader of the chapter will realize that the theory of twentieth-century abstract painting owes indeed more to the debates on design that arose in the nineteenth century than is usually allowed. Ruskin's emphasis on the expressive, 'graphological' characteristics of spontaneous handiwork, Wornum's comparison of ornament with the art of music, and most of all the growing devaluation of illusionism in favour of a purely formal ordering of elements, not to speak of the frantic search for an authentic new art expressive of the new age, all these are elements in the story of the rise and acceptance of abstract painting. During these times of ferment around the turn of the century the words ornament and decorative were not yet dirty words in the criticism of painting.

There are signs today that the estrangement between the two camps has subsided and that the new interest in problems of the painting surface has prompted abstract artists to look across the fence into the compound of the decorators. The decorators in their turn had never felt any compunction against raiding the workshops of the abstract artists. There was no movement in twentieth-century art which failed to influence design. Given the organization of art teaching, it would be surprising if it were different. Any number of Ph.D. theses await being written about the influence of Cubism, of Tachism, of Op or Pop art on fabrics and wall paper and about the decreasing time lag with which these inventions are taken up and spread throughout industry.

We shall have to return to this interaction, which makes the very distinction between fine art and applied art increasingly problematic. But one decisive difference surely remains—it is the difference in function. What we call art in our society is presented to us in a particular context, to be received with a particular kind of attention or, to use the technical term, with a particular mental set. We could never devote the same degree of attention to all the myriad products of the decorative imagination which surround us. But to appreciate their wealth and variety in their own context we must look more closely at the realities of pattern-making.

III The Challenge of Constraints

If to the Infinite you want to stride
Just walk in the Finite to every side.
Goethe

1 Realities of Pattern-Making

Looking back on the history of taste and theory surveyed in the two preceding chapters one factor stands out: decoration, once the domain of the craftsman, became the concern of the self-conscious designer. The efforts of the Arts and Crafts Movement were directed towards reversing this shift, but in this respect the movement largely failed. If anybody was a designer in the modern sense of the term it was William Morris. Even so it would be a mistake to infer that the lamentations about the demise of crafts were entirely justified. As so often, the critics failed to see what was going on in front of their noses. I am referring to the ubiquitous needlewomen in their own circles, many of whom spent their ample leisure hours knitting, crocheting, lacemaking or embroidering. In the preface I referred to my early admiration for the Slovak peasant embroideries which my mother collected. I had much less interest in the work I could myself have watched, as these ladies deftly manipulated threads whilst taking part in the conversation. There is less leisure now and I believe that a certain split has meanwhile occurred between such crafts as knitting, which serve an immediate practical purpose, and distinct leisure activities such as pottery, which are felt to be an outlet for what is called creativity. Whether or not we accept the extension of the term from the prerogative of the deity to the pastimes of children in the nursery, I believe that those of us who lack the patience and the aptitude for any of these activities must at least have the humility to seek information from those who have. There is no shortage of books on the crafts written by practitioners for those who want to learn the elements or perfect their skills. Browsing in this varied literature we soon discover how much the theoretician can learn from encyclopedias of home crafts or from primers by nursery school teachers. Take the introductory remarks in a delightful primer on *Straw Stars* by Gretl Zimmermann, from which I take Figs. 64 and 65:

Figs. 64 and 65

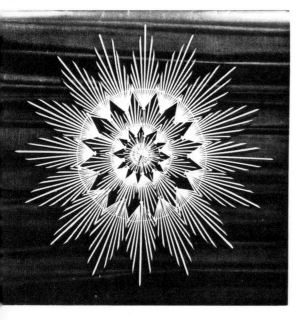

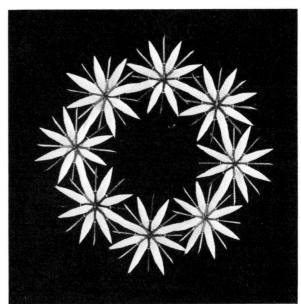

'The possibilities for inventing new designs are virtually without limit, and this booklet offers a number of examples to stimulate your own creativity. By following the instructions given in these pages, you will acquire the familiarity—one might even say 'sympathy'— necessary for the proper control over the material. For example, both grass and straw are limited in length, and both are very slightly tapered, so that they can be joined by inserting one into another. Part of the challenge of this—and, in fact, of any—craft lies in exploring and exploiting all the possibilities inherent in the material. The success of your efforts will depend largely on your sensitivity to form and proportion, and on care and precision in your work.'

The teacher is concerned with what the practitioner should do. The student of theory likes also to look at the implicit limitations which define the skill.

The first and perhaps the most important derives from the nature of the medium. There are limits to what you can make with straw. The second is alluded to in the appeal to 'sensitivity to form and proportion'. This sounds like vague aestheticism, but there is a solid core of fact which restricts the possibilities open to any pattern-maker—I am referring to the laws of geometry. The eight stars of Fig. 65 neatly fit into an octagonal wreath, but similar patterns could not be made with an arbitrary number of elements. The craftsman need not know the propositions his work exemplifies. He finds them not only by 'sensitivity', but by trial and error. The needs of method constitute the third important constraint within which the pattern-maker operates. They derive from the limitations of the human mind, of the span of attention and of foresight. Our booklet takes cognisance of this psychological limit by detailing the procedure in various 'simple steps', and adds this warning:

'Only when you are able to construct a simple star that looks elegant, neat, and well made should you go on to the more complex stars. Always remember that an unhurried attitude and a steady hand are prerequisite for the success of your craft.'

It must be a delight to reach proficiency in the making of straw stars. Whether it is also a delight to have made them is a different matter. Even if we produce them as presents, the grateful recipients may wonder what to do with them. Creativity also creates problems. It is here that the traditional crafts scored because they were firmly tied to a purpose. Decoration had to be subservient to utility and as soon as it strayed too far from this path there were sure to be protests such as that of Cochin against the goldsmiths of his age. Like all games of ingenuity, pattern-making could only thrive on these limitations. The demands of functionalism, as we have seen, threatened ultimately to lead to the demise of decoration, and so did the abolition of all restrictions which transformed pattern-making into 'abstract art'. Some of the realities we have found discussed in the little book on the making of straw stars have however confronted the crafts since the dawn of history. We may describe them as the constraints of material, of geometry and of planning.

2 *The Mastery of the Material*

In the study of decorative art the so-called doctrine of materialism has been in bad odour ever since it was attacked by Alois Riegl in his seminal book *Stilfragen*. It was Riegl who pointed out that it was naive to explain such simple patterns as the chequerboard by the technique of plaiting or weaving with two types of blade, because the decision to use such varied material must have preceded the finished product. No doubt he was right. What I have called the 'sense of order' underlies all human creations and many activities lower down on the evolutionary scale as well. But once this is granted it is all the more important not to be frightened by the label of materialism into the opposite fallacy. Man can only be creative in relation to problems which he seeks to solve. The idea of the artist as a divine being turning chaos into any kind of order in a free display of creativity is a Romantic myth.

Even a Beethoven was a 'com-poser', he worked within an established medium and within a firm tradition, com-posing his tones in marvellously new patterns which are, of course, modifications of patterns he had learned and studied.

We cannot know how the first pattern was made, but we can be sure that it could not have been made out of nothing. Flowers, feathers, shells, shiny stones or beads are universally used, but before they are used they must be searched for, collected, selected and frequently also prepared. There is no rigid dividing line between the sorting of such elements and their ordered arrangement. In *Art and Illusion* I stressed that in the making of representations 'making comes before matching'. I might have added that in all cases sorting comes before making. The craftsman has to have the material handy which is to serve him as a 'medium'. In thinking of elementary pattern-making we tend to think of certain orderly forms of arranging these elements. They may be bunched for greater effect, or spaced for wider distribution, they may be scattered or aligned in straight or undulating rows, combined into simple shapes or composed into intricate networks. In any case, if the arrangement is to last it has to be fixed in some way or other. The beads or claws have to be strung (Plate 13), the coloured feathers, shells or earth applied to a support.

Where this support is given we speak of decoration. The term 'applied art' usefully brings out this frequent dependence of pattern-making on a given structure, whether natural or man-made. It is certain that one of the earliest forms of pattern-making is the decoration of the human body. It modifies the body by cosmetic devices, by paint, tattooing, jewellery, headgear, or clothing, in a variety of combinations and with spectacular effect (Plate 14).

In adorning the body an order is superimposed on an existing order, respecting or sometimes contradicting the symmetries of the organic form. The same applies to the decoration of technical products. Whether he decorates a canoe or a house, a weapon or a pot, the craftsman is confronted with a given shape he must 'adorn'. Such adornment always means modification of the original structure, by incising, carving, painting or covering. We have seen that this modification caused the critics no little worry. Was it not better to leave well alone, to enjoy the natural charm of the body beautiful, to respect the 'truth' of the structure rather than to transform it arbitrarily? These qualms, as we know, arose quite early in the history of criticism, but they did not lead to the rejection of decoration as such until the machine had triumphed. The slogan of 'truth to material', which implies that timber should look like timber and stone like stone, owed much of its appeal to the proliferation of substitutes, which made it impossible for the public to appreciate and assess the process of production. In the past the situation had been radically different. Anybody could see that the modifications imposed by the craftsman on his material were the fruit of immense skill and labour, but nobody was disposed to question the value of such displays of virtuosity.

An extreme example will best be suited to bring out the difference in attitude which separates us from past centuries. The Victoria and Albert Museum possesses a showpiece of the sheer super-human skill of the great woodcarver Grinling Gibbons (1648–1721), a lace cravat carved in wood (Plate 16). We are prone to regard such displays as tasteless and I am not out to defend them. But Gibbons was a real master of considerable taste and tact, and having enjoyed his skill in rendering the delicacy of flowers and the suppleness of leaves in this inert material (Plate 15) he obviously took pleasure in entering into a contest with the most subtle of human crafts, that of the lacemaker. What we admire in lace is the ability of hand and eye to compel the finest of threads into intricate orders (Plate 17); Gibbons wanted to go one better and to make such threads out of wood.

There are examples in the history of all crafts of this desire to press against the limitations of the material as far as is humanly possible and to put the victory of mind over matter to the test. The Gothic craftsmen who carved the stalls of Lancaster Priory (Plate 19) must have shared Gibbons' outlook. The more recalcitrant the material the greater the triumph. Add

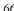

Fig. 66. Locksmith's sign.
German, about 1750

the ambition to defeat even the forces of gravity in constructions which are so delicately poised that one wonders how they can hope to stand up, and you come closer to understanding the aims of those Bavarian Rococo carvers who dissolved a balustrade into waves of dancing curves (Plate 20).

The Gothic mason's way with stone parallels such efforts. Some traceries look as weightless and delicate as lace. Adam Krafft's *Sakramentshäuschen* of 1496 at the church of St. Lorenz in Nuremberg (Plate 18) reaches from the floor to the vault, where its top bends like a supple plant. This may not appeal to modern taste but the fully documented history of this tabernacle for the Host gives much food for thought. One would think that it must have taken a lifetime to work out its immensely intricate detail of statuary and tracery, but this is to underrate the resources of skill and the effect of steady, concentrated teamwork. In the contract signed in April 1493 the master promised to finish the work, for which he had submitted drawings, within three years. He and at least three apprentices were to spend all their time on the enterprise, for which they would receive 700 gulden. In fact the work was completed four months earlier than stipulated, which prompted Hans Imhoff, the patron, to give the master a bonus of seventy gulden, and his wife a coat costing 6 gulden, 2 shillings and 6 heller. True, the work is not all carved of solid material. There is much use of coated wire made to look like stone—but then such workshop secrets are also part of the trick.

Not invariably. We shall have occasion to consider the pride of the blacksmiths of all ages in bending and forging the iron to their will (Fig. 66). Whether a craftsman works in iron or gold, silver-wire (as in filigree) or ivory (Plates 21, 22), we must acknowledge that only the most intimate familiarity with these materials can lead to that 'feel' for their needs and their limits on which these crafts could thrive. We may not want the material to deny its identity, wood being turned into a semblance of lace or needlework into painting, but the craftsman's ambition to effect such miraculous transformations cannot be left out of the history of art.

There are forms of pattern-making in which construction and decoration enter into an even more intimate marriage because the making of the support and the making of

Tetrahedron

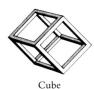

Cube

Octahedron

Dodecahedron

Icosahedron

Fig. 67. The five
Platonic bodies

III *The Challenge of Constraints* 67

ornament coincide. The process of plaiting, on which Riegl commented, is a case in point, and so, of course, are weaving and the other textile arts from their simplest to their most complex forms. The warp and woof by themselves form a pattern, and it is open to the craftsman to modify it by varying the threads in any order he chooses and interlacing them in any number of graded complications.

In the textile crafts the flexibility of the material is essential to the creation of both the support and the pattern. It is where the elements of construction are rigid that the craftsman is bound to become aware of the constraints imposed on his choice by the laws of geometry. In the introduction we have briefly considered the technical advantage of uniform elements in the building of larger units, whether we think of the stacking of standardized bricks or the joining of regular paving stones. As soon as the craftsman begins to use the elementary tools of geometry—the ruler and the compass—he learns about the limits within which he must work, if he aims at the composition of a continuous structure.

3 Laws and Orders

There is evidence that this basic problem of packing stimulated the rise of theoretical geometry to no small extent. The cosmological speculations in Plato's *Timaeus* about the ultimate constituents of the world start from the proposition that no void exists. The world as we know it is a pattern of closely packed atom-like solids and each of the four elements corresponds to one of the five regular bodies (Fig. 67). When God undertook to create the universe out of chaos he began 'by first marking them out into shapes by means of forms and numbers.' The operations described in great detail are those of a pattern-maker whose ultimate elements are triangles. From these God composed the cube for earth, the tetrahedron or pyramid for fire, the octahedron for air and the icosahedron for water, leaving the last, the dodecahedron, 'for the universe in his decoration thereof'.

We no longer imagine the elements to be composed of regular standard shapes, but the problem of packing such shapes into larger units has continued to engage the scientist ever since it was perceived that the shapes formed by crystals must be due to their regular composition. Crystallographers were the first to explore the geometry of regular solids and the intrinsic possibilities of their symmetrical arrangement. It was in the pursuit of this line of thought that the great mathematician Andreas Speiser investigated the geometrical laws of pattern-making. Even the non-mathematician can follow his analysis a certain distance if he remembers the basic operations used in geometry for the construction of shapes by means of compass and ruler. The pair of compasses will be used in two ways: one is called 'translation', the carrying over of a given distance between points from one place to another; translation of an interval along an axis produces a rhythmic row. Fixing one point of the compass we also use it for drawing a circle, in other words for 'rotation'. Rotating a shape by a hundred and eighty degrees produces 'reflection' (Fig. 68). Ninety degrees permits us to draw the axis relative to which these reflected shapes are symmetrical. We all remember from childhood how we can use the compass for dividing the circle into six parts and create the pattern of overlapping rosettes which turns up in Phoenician ivories (Fig. 69) and Assyrian pavements (Fig. 180). There is no limit to the subdivisions of the circle in the

Fig. 68 Translation Rotation Reflection

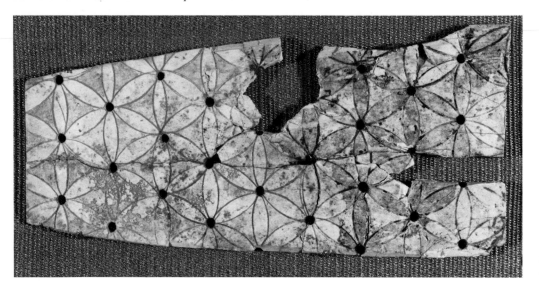

Fig. 69. Phoenician ivory. About 9th century B.C.

making of stars, wheels or rosettes which exhibit symmetries, though not all of them can be similarly constructed. The restrictions are more obvious in the case of uniform grids or 'lattices' which are confined to triangles, squares, rhomboids or hexagons (Figs. 56, 70). It is characteristic of these lattices that they can be infinitely extended on all sides in a continuous pattern. Filling their shapes with elements we can now study the number of symmetrical relationships we can produce by translation and rotation. Starting from an elementary asymmetrical unit and proceeding to the generation of further symmetries we learn that there are exactly seventeen such possibilities as illustrated in Fig. 71. Speiser also analyses the number of 'translations' along an axis or vector within a stripe or band and illustrates the seven main types (Fig. 72).

Fig. 70. From L. F. Day, *The Anatomy of Pattern*, 1890

Fig. 71. The seventeen
symmetries
(Speiser, 1937)

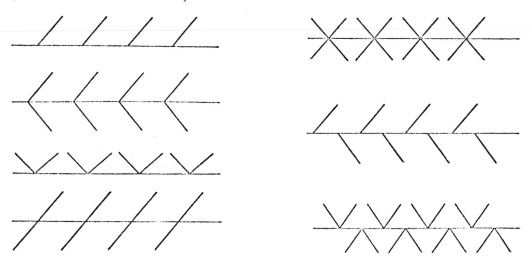

Fig. 72. Seven border types. (Speiser, 1937)

These complete the possibilities if we decide to stay strictly within the two-dimensional plane, but in practice, as he reminds us, decorators rarely accept this restriction. They add the resource of 'interlace', imagining their lines to cross over or under another line, thus introducing the fiction of a mirroring plane. Taking this further possibility of symmetry into account, Speiser arrives at 80 possibilities, which he does not, however, illustrate.

Whether or not we can follow the theorist in his demonstrations, there is one misunderstanding we must avoid at all cost. We must not confuse the analyses of geometrical symmetries with the mathematics of combination and permutation. There is no danger whatever that the resources of the pattern-maker will ever be exhausted by the constraints of geometry because any one of the groups and devices described by Speiser can be combined with others in an infinity of combinations and permutations.

The earliest (and perhaps the rarest) treatise on the theory of design drives home this insight with marvellous precision. This book, of which I owe the knowledge to Mr Stuart Durant, has the lengthy title *Méthode pour faire une infinité de desseins différents avec des carreaux mi-partis de deux couleurs par une Ligne diagonale, ou observations du P. Dominique Douat Religieux Carme de la Province de Toulouse sur un mémoire inséré dans l'histoire de l'Académie Royale des Sciences de Paris l'année 1704, présenté par R. P. Sebastien Truchet Religieux du même ordre, Académicien honoraire* (Paris, 1722). The first plate explains the method and the symbolism. By rotating the divided two-coloured square, four variants are produced; these are marked with the first four letters of the alphabet (Fig. 73). In the second table, sets of two such variants are shown to result in sixteen possibilities, also explained in symbols on the adjoining page (Fig. 74). Sets of three result in 64 permutations, sets of four in 256, which need four plates of which the last are here reproduced (Figs. 75, 76). Taking each of these as units to be further combined, we arrive by doubling them at 256 to the power of 2 which is 65536, and so on *ad infinitum*. Seventy-two such systematic variations are shown on a number of plates of which I show the first and the last (Figs. 77, 78). The system is set out in further tables with the permutations of the first letters, which must recall to the modern reader the methods of demonstrating the genetic code as discovered in the 'double helix'. We have learned to appreciate that the number of properties which can thus be encoded is infinite.

In the sphere of design this fact can be exemplified by means of the most astounding of nature's patterns, the snowflake. Its constituents are the hexagons and needles resulting from the laws which order the molecules when the water drop freezes. The shape of these minute crystals is determined by the tensions within the drop resulting from size and temperature.

Figs. 73 and 74. Douat's method of permutation (S. Truchet, 1722)

The variations resulting from the underlying laws of geometry have provided endless fascination to scientists since the days of Kepler, and have also interested designers since the nineteenth century. It was for the benefit of the latter that W. A. Bentley and W. H. Humphreys published in 1931 a book with 2,453 different examples of snowflakes (Plates 23, 24). And yet this figure is less than minute compared to the one which has been computed for the range of possibilities. Apparently there are so many of them that the whole universe (as presently estimated) could be packed with crystals of this kind without a single duplication.

CONTINUATION DE LA TABLE de 256 Permutations.

193 DDDD	209 DAAD	225 DBAD	241 DABB
194 DDDA	210 DBBD	226 DACD	242 DCBB
195 DDDB	211 DCCD	227 DCAD	243 DACC
196 DDDC	212 DDAB	228 DBCD	244 DBCC
197 DDAD	213 DDBA	229 DCBD	245 DABA
198 DDBD	214 DDBC	230 DAAA	246 DACA
199 DDCD	215 DDCB	231 DBBB	247 DBAB
200 DADD	216 DDAC	232 DCCC	248 DBCB
201 DBDD	217 DDCA	233 DAAB	249 DCAC
202 DCDD	218 DADB	234 DAAC	250 DCBC
203 DDAA	219 DBDA	235 DBBA	251 DABC
204 DDBB	220 DADC	236 DBBC	252 DCAB
205 DDCC	221 DCDA	237 DCCA	253 DCBA
206 DADA	222 DBDC	238 DCCB	254 DBAC
207 DBDB	223 DCDB	239 DBAA	255 DACB
208 DCDC	224 DABD	240 DCAA	256 DBCA

Continuation de la Table de 256 Permutations.

Figs. 75 and 76. Douat's method of permutation

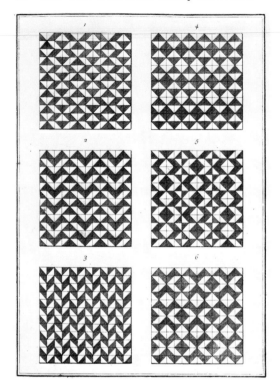

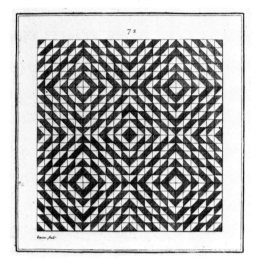

Figs. 77 and 78.
Douat's method of
permutation

In contemplating this unimaginable number it is well to remember that it merely counts the geometrical possibilities of one simple family of forms. Yet it is easy to multiply the conceivable variants by another sheer infinite factor if we include size or colour among the variables. Even disregarding size, the primary colours of the rainbow would alone permit us to multiply by seven, but if we decided to apply colours to the individual elements of each crystal we would mount the ladder towards infinitude with surprising ease; turn each of these multicoloured stars into an element of your grid pattern and arrange them serially or symmetrically around the possible axes, and you lose all chance of estimating the number of permutations.

The exercise is not an idle one, if it reminds us of the artificiality of the purely geometrical approach. Pattern-making in its most general form may be characterized as an ordering of elements by identity and difference. The pattern-maker often enjoys creating classes of motifs which are like in one respect and different in another. Colouring is his most elementary device in achieving this end. The squares of the chequerboard are identical in shape but not in colour, and the designer is free to vary this difference across the board in any combination he chooses. Again there is no limit to the permutations; he may inscribe circles into some of his squares and reverse the colour relationship, some circles red on blue ground and others blue on red. Using an asymmetrical motif instead of the circle he may also vary or reverse its orientation systematically. Once more there is no limit set to the exponential growth of variants. Examples abound in practically any style of ornament but it appears that the Peruvian weavers and embroiderers excelled all others in this subtle game. Some of their achievements have been analysed in the book on primitive art by Franz Boas, starting from a simple specimen of a border consisting of a series of diagonal bars of identical shape. The sequence of colours is 1. Bright red with brown dots; 2. Blue with pink dots; 3. Dull yellow with brown dots; 4. White with pink and brown dots; 5. Dark green with red dots; 6. Red with green dots. To analyse the textile from the Museum of Mankind (Col. Plate IV) in similar terms would overtax the patience of the reader. In principle these

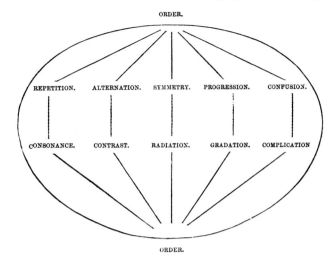

Fig. 79. From Charles
Blanc, *Art in
Ornament and Dress*,
1877

patterns can be analysed because they confine variations within identical motifs. But this possibility recedes as soon as the pattern is made up of looser and more flexible classes and subclasses, forming interlocking hierarchies. The Slovak embroideries mentioned in the Preface (Col. Plate I) display a pleasure in variation similar to the Peruvian textiles, but the changes in colour, orientation and arrangement are less rigidly controlled; they look more spontaneous, more imaginative, but they still keep within the orders of the over-arching system. When we turn to the larger hierarchies of a Persian rug we will find it even harder to specify the interplay of similarity and difference which governs the design. The stars and lozenges of the rug on Col. Plate V are related in colour and scale, and the characteristic shape of their outline recurs in the border in a very different context. Its motifs, in their turn, are also distributed over the ground of the central field with colours symmetrically altered. It would be futile to go on listing the correspondences and differences, because the idea of pressing all designs into one rational system is a will-o'-the-wisp. Geometrical shapes are definable, similarity is not. The element 'a' may be similar to 'b' in one respect and to 'c' in another—in fact it must be if the design is to become varied and interesting. Classification is always the product of the ordering mind, and the search for the 'logical' system in which a unique place can be assigned to any ornamental motif is doomed to failure. As long as the study of ornament was linked to historical styles, categories were easily at hand. But the search for basic principles of design which had already inspired Truchet and Hogarth also gave rise to a large body of books, good, bad, and indifferent, ultimately derived from the Euclidean model, and progressing from the elements of the point and the line to a classification of shapes. I have had to leave them on one side, because they too often suffer from an uncertainty of aims—unlike Speiser in his rigorous analysis, their authors find it hard to steer their way between a purely objective and an aesthetically dogmatic approach.

This is not to say that nothing can be learned from some of these attempts to reduce the infinite variety of decorative effects to a system. A seductive example is contained in the writings of Charles Blanc, the critic whose theories were to influence Seurat and other post-impressionists. He sums up his system in a diagram which almost speaks for itself (Fig. 79). The line on top lists the basic devices of the decorator, that below subsidiary resources which fall under the same main heading as those above. Thus 'consonance' is a weaker form of repetition as when an architect applies similar forms varied in scale; contrast is a method of strengthening alteration; radiation from a centre a special form of symmetry; gradation a regular form of progression; and complication explains the puzzling label of 'confusion', which in the text is qualified as 'balanced confusion'—as is certainly necessary if the principle is still to be accommodated under the general heading of 'order'.

The Triquetra

The Interlacement and Its Variants

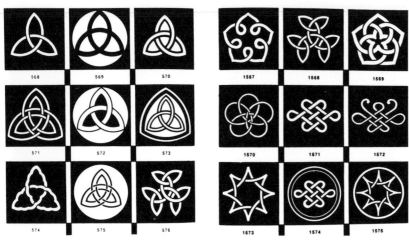

Fig. 80. From C. P. Hornung, *Handbook of Designs and Devices*, 1932

There is much that is tempting in Blanc's system, but it does not fare too well when we try to apply it to our last three examples, the Peruvian textile, the Slovak embroidery and the Persian rug. The reason is plain: it omits from its categories the basic characteristic of orders, the notion of hierarchical arrangements. Each of Blanc's categories may be found to apply to one level of the design, but not to the next. The study of elements does not really illuminate the whole. The criticism applies to most of the studies written in our century when the guidance of tradition disappeared and the need for exploring the principles of 'basic' design became more pressing.

One simple example must suffice to point to this inherent weakness of all systems of ornament. I take it from Hornung's *Handbook of Designs and Devices* (1932), offering 1,836 basic designs and their variations to the student of design who will turn the pages of this book with profit and admiration (Fig. 80). Nor will his pleasure be diminished by the observation that occasionally identical configurations can turn up under different headings—the triquetra 576 is also grouped with Interlacement and its variants (1568).

Perhaps the most handy classification for the practical purpose of the historian is offered in the brief book by Wolfgang von Wersin, *Das elementare Ornament und seine Gesetzlichkeit* (Basic patterns and their underlying laws) (Ravensburg, 1953), which contains a table of categories recalling the Linnean system of plants (Fig. 81).

His first distinction is between what he calls 'closed orders' (such as the star or the rosette), based on purely rotational symmetries, and serial orders of unlimited rhythmical sequences based on 'translation'. Here he starts with the serial order or row and distinguishes between the *simple sequence*, the *alternating sequence*, and the *cross-linked sequence* based on the shift of an alternating sequence relative to two framing sequences (Fig. 81). Each of these configurations can occur on borders or on areas where they form a lattice. In each of these three cases he also wants us to distinguish two main types of motif, those composed of *lines* and those which are basically *dots* or patches. This is a distinction he sees running across the whole range of the four sub-classes of his three main categories, that is three basic themes plus the three variations on each (which I have italicized). The three types of variations he enumerates are *enrichment*, *combination* of various elements, and the introduction of *representational* elements such as floral motifs. His categories thus total twenty-four genera and species which can be signified by symbols.

More ambitious, but less handy, is the book by K. Lothar Wolf and Robert Wolff, *Symmetrie* (Münster and Cologne, 1956). Its subtitle (which can be rendered only roughly) describes it as an 'attempted instruction in organized vision and meaningful design systematically presented and elucidated with many examples.' The two-volume work (which

incorporates Speiser's results) abounds in mathematical tables and symbols as well as diagrams and photographs of natural and artistic forms. One useful term we have not yet encountered is worth noting, the term *stretch-axis* for the arrangement of similar motifs increasing in scale along an axis as in Fig. 147. But on the whole the work has confirmed my conviction that there are limits to the usefulness of a purely morphological system.

What mainly interests us in this chapter are the constraints which the designer must accept or overcome in creating his infinite hierarchy of forms, and this we may never appreciate as long as we start from the finished product. It is only by reconstructing in our mind the possible sequence of operations which resulted in the final design that we may come nearer to an understanding of this aspect of craftsmanship.

This is the moment, then, to return to the insight stressed by Ruskin as well as by Franz Boas, that design is rooted in movement, and that its formal hierarchies frequently come about by what I have called 'graded complication'. Let us remember Christopher Robin's 'hoppity' step as a variation of the tedious way of setting one foot in front of the other, or the child's self-imposed task of clapping between the bounces of a ball. The first, in the terminology of this chapter, corresponds to a composition of elements, the second has the character of 'decoration' since it adjusts its hierarchies to the given realities of the game. Composition of a simple repeat pattern is achieved by joining, as in stringing beads or laying a tiled floor.

But any hierarchical arrangement presupposes two distinct steps, that of *framing* and that of *filling*. The one delimits the field or fields, the other organizes the resultant space. Where the design is applied to a given support, being drawn or painted on a surface, as in the example given by Owen Jones (Fig. 56), the framing grid and the filling motif together constitute the ornament. Where it must be 'self-supporting', as in lace, tracery, or wrought iron, another form of joining is needed to give coherence to the structure. We may describe it as *linking*. Like the first two steps, linking, too, can take many forms; where it proceeds from the frame inwards we may often speak of *branching*, whereby the subdividing or curling branches may be used as motifs to fill the remaining void (Plate 20). Alternatively the link can be felt to originate from the centre of the motif *radiating* outward to the framing device as in the tracery of Lancaster Priory (Plate 19). Admittedly it is often a matter of interpretation how we see the link.

Take the frame of the Madonna della Sedia (Plate 1), which has served us as a paradigm before, and will do so again because it is such an average piece of decoration. The delimitation of the field is achieved by various framing devices which are reiterated for emphasis, the moulding on the outside of the frame being the most elementary form of this reiteration. Though our designer had to allow the final 'filling' to be achieved by Raphael's masterpiece, he still had the choice of areas to be organized by filling motifs such as his four masks in the corners, which radiate branching and curling scrolls. Further links tie some of the elements together in the forms of the fictitious brackets which fix the laurel wreath, and these, in their turn, are filled with subsidiary motifs.

It does not need much experience to realize that a scheme of such divisions articulating the panel must have been established by the craftsman before he planned the detail. He could not have established their shape and scale without resorting to measurement, notably in determining the size and number of the leaves within this central circle. In other words there must have been a number of auxiliary lines drawn on the panel which might be described as framing devices destined not to show up in the final product. For the next operations, much would depend on whether the frame was carved by one master craftsman or by a team. In the first case one would tend to assume that he proceeded in order, drawing and carving identical motifs serially, spending some time on the acanthus and some on the laurel leaves. But we cannot exclude the alternative—the master drawing or carving only one quarter of

Table demonstrating the internal affinity between different ornaments and the relation of a basic ornamental form to possible variations.

Note: The ornaments shown as variations (in the three lower rows) are merely examples of many possible variants of the same order.

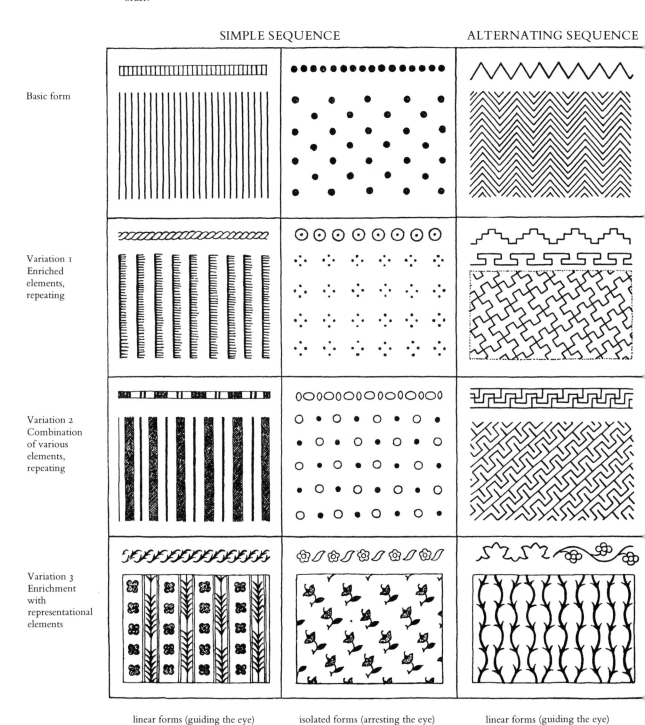

Fig. 81. Tabulations from Wolfgang von Wersin, *Das elementare Ornament*, 1953

Note: The ornaments shown as variations (in the three lower rows) are merely examples of many possible variants of the same order.

ALTERNATING SEQUENCE CROSS-LINKED SEQUENCE

			Stripe
			Lattice
			Stripe
			Lattice
			Stripe
			Lattice
			Stripe
			Lattice

isolated forms (arresting the eye) linear forms (guiding the eye) isolated forms (arresting the eye)

Fig. 82. Doric order, north-west corner of the Parthenon

Fig. 83. Doric order, Roman version

the whole frame, leaving it to apprentices to copy his handiwork and to complete the design. It is this 'slavery' of precision work to which Ruskin objected so passionately. It wholly effaces the process by which the work came into being. He was right in stressing that it is imperfections in the design which give us insight into the work of the living craftsman.

Ruskin happened to dislike the Greek fret as a lifeless ornament but he would have had to approve of the signs of life which surface in the framing device of an Attic cup in the British Museum (Plate 25). Like most of his fellow craftsmen, the painter of the cup clearly had not troubled to measure and divide. He started with the rhythm of four units framed by a subdivided square, but having repeated this rhythm four times, he must have noticed that he would get into difficulties, reduced the next to three units and even so landed with an incomplete fret at what I take to have been his starting point. He may well have found it more satisfying to draw the beautiful garland on the outer rim, where he could afford to be flexible without being caught out.

To be sure, our vase painter could have avoided inconsistencies even without elaborate measurements by first subdividing his cup and then adjusting the design by eye; his fellow workman on the Acropolis was less well placed. The Doric frieze seems a simple design based on the alternation between the triglyphs (triple slit beam ends) and the metopes (square slabs) (Fig. 82), and yet it turned out that there was no way of taking it around a building without awkward inconsistencies. According to Vitruvius there were Greek architects who avoided the Doric order altogether since it resulted in 'wrong and inconvenient correspondences'; these, it turns out, are inseparable from the geometrical nature of the task. It was natural to expect the beams, and therefore the triglyphs, to be placed directly over the columns, and to fill the intervals with metopes. But how is this sequence to continue at the corner? Either the metopes had to be stretched to get closer to the corner column, or the distance between the columns narrowed at this point; neither looks good. Vitruvius proposes a compromise solution for this notorious 'corner-triglyph conflict' which differs from that generally found on Greek temples (Fig. 83). It was his authority which prevailed in the Renaissance, but once our attention has been drawn to the dilemma we cannot help noticing the artificiality of any compromise.

This may be a somewhat complex example, but there are many more instances where the revenge of geometry is more obtrusive. In the case of the beautiful Chinese couch (Plate 26), the lattice work of the border fits perfectly into the frame, but the imaginative design of the larger field could never be accommodated to any rectangular framework. It is meant to clash.

When we come to the designs of Islamic rugs we are again confronted with richer hierarchies. Taken in isolation, the principal motifs of the rug discussed above (Col. Plate V)

certainly illustrate the operations of framing, filling and linking. It is hard to imagine that they were not planned from outside inwards. But in turning each of these designs and the smaller alternate units into repeat motifs the designer soon came to the end of the field and had to cut them short. While he preserved the symmetry along the main axis he did not do so at the upper and lower end. It is all the more interesting to see that he was consistent in showing the protruding angle of the motifs jutting out from the border. The implication is that the repeat pattern continues infinitely but that we are only shown an arbitrary section, as if the foreman had told the weaver to stop the central design and now start on the border. Far from being exceptional, this method of composition is quite frequent in Islamic art.

In principle, the two contrasting procedures which have emerged, that of planning from outside in (by sub-division) and that of building the pattern from inside out by repetition and extension, correspond to the distinction I made above between decoration and composition. The decorator starts with a given field, which he is expected to organize; the designer who composes an abstract pattern (as for a wall paper) starts from his motifs. We have seen, however, that in practice any motif can be decorated further and any resultant void in the interstices be filled in. There are many designs, therefore, where these distinctions become arbitrary, but there are others where they are helpful. In analysing the rich variety of Egyptian patterns used for ceilings and walls, for instance, Milada Vilímková has found it useful to distinguish the various repertories of form and their function. In my terminology I would say that the framing and linking devices tend to be geometrical, the filling motifs representational. In Fig. 84 there is also a gradation of realism involved. The central motif between the spirals is derived from an Egyptian Lotus column with volutes reminiscent of Ionic capitals; the frontal cow's head with a solar disc is the symbol of Isis, marvellously fitted into the irregular field; and in the remaining spandrels we find quite naturalistic locusts confronting each other.

One might easily imagine these locusts to have been an afterthought of the designer when he found that the area called for another filling. Not that it is ever easy in art to distinguish between a thought and an afterthought. Creative work usually proceeds in stages with the

Fig. 84. Egyptian ceiling pattern from Thebes, 19th dynasty, 1348–1315 B.C.

artist watching the emergent form and considering where to go next. What distinguishes this 'feedback' in ornament from the painting of a picture, is the fact that any such afterthought commits the designer to a series of operations; he must repeat what he has done to restore the correspondences on which his pattern rests—one locust may mean fifty.

It is this element of commitment which is likely to commend to the craftsman certain procedures and to make him avoid others. Even the most elementary task such as the stringing of beads for a necklace will favour a step by step method. Theoretically it is open to the maker to pick out from a random heap a sequence of coloured stones which he may then want to repeat in order or in reverse after he has reached the middle. But he will be more likely to adopt what might be called an even-handed method, starting from his centrepiece and adding one unit here and the corresponding one there, always balancing his moves till he has filled the length of the string. It is a method which not only requires less concentration, but also allows for easy correction of mistakes at every step.

This method of successive enrichment or elaboration is applicable both to outward and inward planning. It is well illustrated in A. H. Christie's instructive book on *Pattern Design* (Oxford, 1929), which reconstructs the framing, filling and branching procedures leading to a simple design from a textile pattern in 'an early Italian picture in the Museo Civico, Pisa' (Fig. 85).

It may be useful at this point to reduce the principle to a simplified diagram of an extremely monothematic design (Fig. 86): starting from an equilateral cross a further such cross can be placed between each of its arms and the procedure continued for as long as the sharpness of the pen and the grain of the paper permit. It would be equally possible to continue outward, framing the first cross by another one, both procedures extending infinitely. Clearly it is the first alternative, that of inward articulation of any remaining field, which has the nearest parallels in decorative style. The urge which drives the decorator to go on filling any resultant void is generally described as *horror vacui*, which is supposedly characteristic of many non-classical styles. Maybe the term *amor infiniti*, the love of the infinite, would be a more fitting description.

Framing, filling, linking. Any of these procedures of 'graded complication' can point the way towards infinity, with framing and filling taking the lead in a remarkable gold cup from the Crimea (Fig. 87 and Plate 27) dating from the fourth century B.C., in which Greek workmen adapted their native motifs to the taste of their 'barbarian' hosts. The round of the disk is divided in a floral pattern into twelve lobes, each of them filled with gorgons' heads, surmounted by stylized volutes. The petals in between are filled by slightly smaller gorgons' heads with a shorter scroll above; the further spaces of this 'artichoke' show 24 bearded heads of a more exotic cast, alternating with 48 boars' heads and, on the rim, with 96 bees. Twelve panthers' heads along the lower border face the other way; the rim with its classical egg-and-dart motif frames an inner border of sixteen dolphins accompanied by smaller fish. The diameter of the whole bowl is merely 23.1 cms ($9\frac{1}{8}$ inches). Had it been larger, no doubt the space between the 192 wings of the bees would also have been filled.

If such 'filling in' is the immediate response to the *horror vacui*, linking is the most sophisticated. Any regular lattice or symmetrical design is always capable of further development by the creation of links between its constituent elements. In this process a rich network of progressive intricacy can be seen to emerge, for it is in the nature of any geometrical periodicity that it can serve to generate fresh periodicities in a hierarchy of forms.

The greatest explorers of these graded periodicities achieved through linking by straight lines or curves were the Islamic craftsmen. In recent years a number of theories have been proposed about the motivation and methods of their linking procedures. It is as well to remember, however, that any kind of regularity can become the starting point for the

Fig. 85. From A. H. Christie, *Pattern Design*, 1929

Fig. 86. Progressive filling in

Fig. 87. Golden cup from the Crimea, 4th century B.C. See Plate 27

creation of further regularities—witness that simple contraption, the Kaleidoscope, which does the trick with mirrors.

The combination of framing and linking naturally lends itself admirably to the decoration of structures where mechanical and aesthetic considerations react. The stalactite domes of Islamic architecture (Plate 28) and the fan vaults of Gothic churches (Plates 29, 72) exemplify this principle.

It must be the exigencies of structure which suggested a further method of enrichment to the craftsmen of many styles, the form of linking known as interlace, in which the linking lines or ribbons are shown to cross above or below each other in a three-dimensional arrangement (Fig. 88). Islamic craftsmen excelled in such virtuoso performances, which we shall encounter again. They were capable of further enrichment by departing from the monothematic principle and decorating the geometric interlace with floral designs or stacking the ornamentation with the links emerging from under the motifs and crossing further framing devices (Plates 30, 31).

But surely no style manifests that *amor infiniti* more perfectly than that of the Anglo-Irish illuminators. No other work can rival the Book of Kells in sheer wealth and intricacy of invention. It would be futile to attempt an analysis of the resources used by the designer of the famous Chi-Rho page (Plate 32, 33), the frames within frames, the fillings within fillings, the branching and radiating links, the unexpected appearance of representational

Fig. 88. Tile facings in the Hall of the Ambassadors, Granada (A. Speltz, 1910)

Fig. 89. Lace pattern
(J. Foillet, 1598)

motifs within the tangle of the interlace and outside it; even less can a description do justice
to the role colour is made to play to keep forms apart or bring them together.
Contemplating the page one realizes that the distinction I have proposed between the
constraints of the material and those of geometry cannot always be upheld. The *amor infiniti*
aims at surmounting all constraints. The same noble urge which makes the craftsman
subdue his material also makes him stretch the bounds of inventiveness.

In the Book of Kells the two motivations combine; the display of virtuosity in filling
every area with unimaginably complex configurations also testifies to an exuberant formal
imagination. In other works the search for variety need not involve the craftsman with the
infinitely small. This pleasure in sheer variety in place of repetition was the feature of Gothic
workmanship which Ruskin exalted so much, though other styles were more systematically
concerned with variety. The Peruvian textiles mentioned earlier (Col. Plate IV) provide an
early and intriguing example of sheer pleasure in permutation. The decoration of the choir
of Monreale (Plate 34) is another instructive instance because the style is here austere rather
than rich; each of the roundels, which provide the accents, shows a fresh variant of the
design, giving us a feeling of an inexhaustible imagination at work. Some lace patterns (Fig.
89) from the end of the sixteenth century illustrate the same principle of variation in unity.
The identical squares around the central motif are all filled with star patterns, but each of
them is different.

It is not surprising that the game of playing variations on simple themes, which we also
know from music, attracted the interest of more self-conscious centuries. A Victorian
architect, Robert William Billings, published an enthralling book entitled *The Power of
Form applied to Geometric Tracery*. It contains one hundred designs based on a single simple
diagram of three circles inscribed in a circle (Fig. 90). Far from being monotonous, the many
variants he produced are so entertaining that one regrets that they cannot all be illustrated

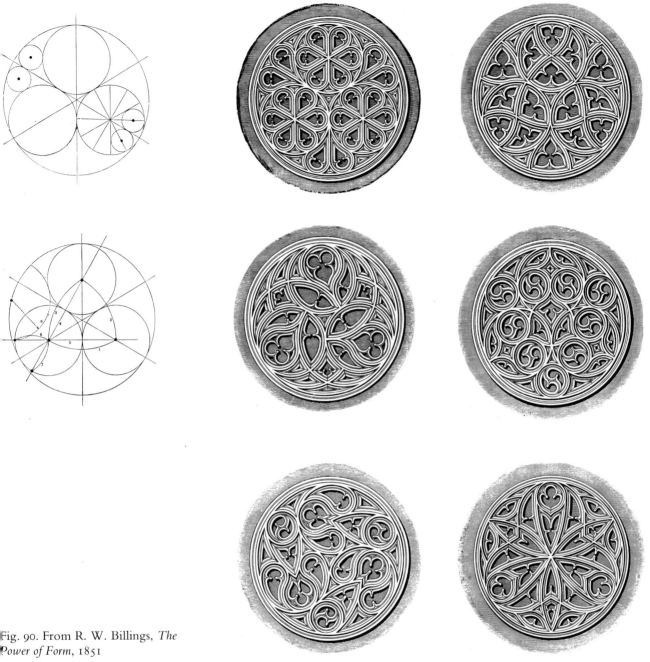

Fig. 90. From R. W. Billings, *The Power of Form*, 1851

here. Not long ago Josef Albers, a twentieth-century pioneer of non-objective art with a strong theoretical bent, responded to the same challenge in his series of designs entitled *Trotz der Geraden* ('Despite the straight line'), demonstrating that even the simplest of elements allowed him to invent permutations rich in ambiguities and surprises (Fig. 91).

4 The Limits of Foresight

Seen from the vantage point of history there are interesting correspondences between the development of decorative and that of representational styles. Discussing the latter in *Art and Illusion*, I stressed the rhythm of 'schema and modification' which we have seen paralleled in the operations of enrichment and variation responsible for the emergence of more complex designs. In both cases the freedom of the individual artist is severely limited by the

Fig. 91. From J. Albers, *Trotz der Geraden*, 1961

weight of tradition and the difficulty of the problems involved. Admittedly the nature of these problems is more easily defined in the case of representation than it is in that of decoration. So far we have singled out two such challenges which both limit and stimulate the craftsman—the recalcitrance of the material and the inexorable laws of geometry. Neither one of them alone nor both combined would suffice to explain the psychological obstacles in the way of complete innovation. There may be several such obstacles, but the one which is germane to the concerns of this chapter lies in the limits encountered in planning a complex order out of nothing.

I owe an instructive example of this intrinsic problem to the admirable studies by George Bain. On the first page of his *Methods of Construction in Celtic Art* we are shown what looks like a relatively easy lesson in designing what the author calls 'Simple Celtic Knotwork Panels' (Fig. 92). His text explains what is far from simple in these configurations: 'Numbers with no common factor produce an endless line when used with half-sizes at the four corners. Example, top and bottom, [of the line framing the inscribed panel] 4 and 2 halves, sides, 3 and 2 halves. Eoghan Carmichael, son of Dr. A. Carmichael, first discovered that the Pictish artists used this method to produce a continuous line. J. Romilly Allen first discovered that knotwork was based on Plaiting. It took him 20 years research to do this.' To

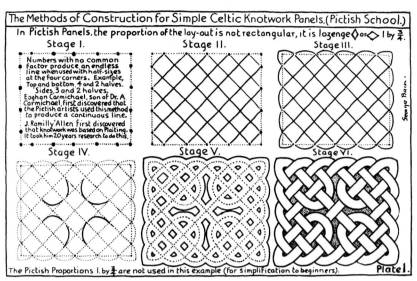

The Methods of Construction for Simple Celtic Knotwork Panels.(Pictish School.)

In Pictish Panels, the proportion of the lay-out is not rectangular, it is lozenge ◇ or ◇ 1 by ¾.

Stage I. Stage II. Stage III.

Numbers with no common factor produce an endless line when used with half-sizes at the four corners. Example. Top and bottom, 4 and 2 halves. Sides, 3 and 2 halves. Eoghan Carmichael, son of Dr. A. Carmichael, first discovered that the Pictish artists used this method to produce a continuous line. J. Romilly Allen first discovered that knotwork was based on Plaiting. It took him 20 years research to do this.

Stage IV. Stage V. Stage VI.

George Bain.

The Pictish Proportions 1. by ¾ are not used in this example (for simplification to beginners). Plate I.

Fig. 92. Construction of a knotwork panel (G. Bain, 1944)

the outsider the first discovery seems perhaps more startling than the second, but one must have tried to match these knots by plaiting to appreciate the difficulty.

Be that as it may, Bain's illustration, which constitutes a 'simplification for beginners', makes it as clear as one single instance ever could why there must be limits in evolving a complex design. Nor should it be thought that it is only beginners who are in need of precedents. Leonardo da Vinci, who urged the apprentice to draw from the work of other masters, was interested in the problem of continuous interlace as he was interested in everything. He published a series of knots which he proudly labelled 'The Academy of Leonardo da Vinci' (Fig. 93). It looks as if he had wanted to counter the pride of the Platonic Academy in Florence by demonstrating his manual skill. This interpretation would chime in well with the note which Leonardo added to a drawing of twisting headless snakes: 'body born of perspective by Leonardo da Vinci, the disciple of experience' (Fig. 95). Experience, for him, comprising the work of both the mind and the hand. Purely abstract speculation he held in contempt. His dazzling pieces of interlace are certainly not the fruit of abstract calculations. They must have been his response to the challenge of complex interlace patterns which had been adapted by Italian craftsmen from Islamic examples (Fig. 96). The history of these exercises in ingenuity illustrates the step-by-step principle of development with which I am concerned. If, as has been suggested, the pattern of the Italian dish is a modification of a more angular Islamic type, Leonardo's knots in their turn are enrichments of his presumed model. It is well known that these designs aroused the ambition of the craftsman in Albrecht Dürer, who copied and modified Leonard's engravings in a series of woodcuts (Fig. 94). Their lesson was not lost on other Renaissance designers. No wonder— to work out such a knot design from scratch would certainly tax the patience and knowledge of any mathematician. To modify it on the other hand by simplification or elaboration cannot be very difficult.

A collection of drawings in the Victoria and Albert Museum once owned by a nineteenth-century Persian decorator, Mirza Akbar (Plate 36), includes a scroll wrapped in leather which the craftsman could easily carry with him as a pattern book. It contains a series of thirteen squares in which the centre and a few axes are scratched onto the surface and various lines traced in ink. We can see where the point of the compass went in, and where the ruler was applied. The designs are rather simple but they could easily be adapted or elaborated as occasion required.

It is unlikely that the owners of this or of earlier such pattern books were leading masters, but while we must grant that others were more imaginative and more skilful I see no reason

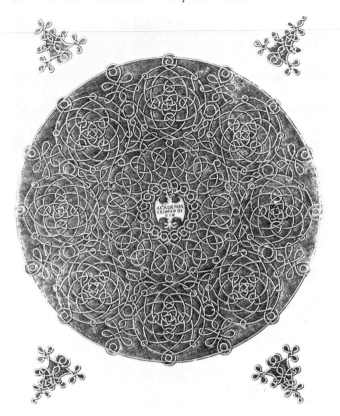

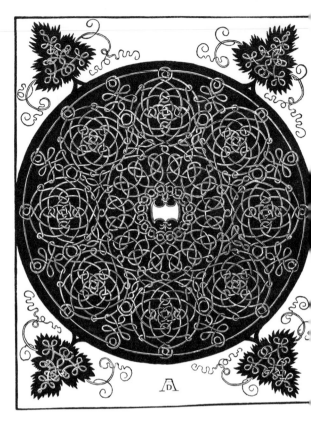

Fig. 93. Engraving after Leonardo da Vinci. About 1495

Fig. 94. Woodcut by Dürer. 1507

Fig. 95 (*below*). Leonardo da Vinci: Drawing from the *Codice Atlantico* with the note '*corpo nato della prospettiva di Leonardo da Vinci discciepolo della sperientia*' (reversed for legibility)

Fig. 96. Venetian-Saracenic bowl. Early 16th century

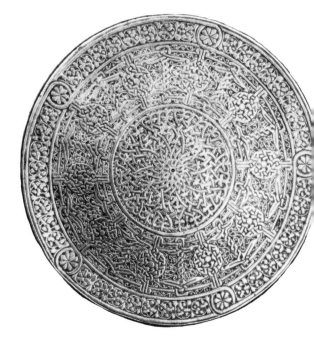

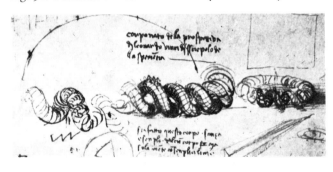

to postulate that they must have planned their designs from scratch, solely possessed of the laws of geometry. Much has been written in recent years on the mathematical basis of Islamic art and its possible link with Platonic metaphysics, but there is no evidence to suggest that these ideas were discussed in the workshops. It is one thing to analyse a complex configuration in geometrical terms, as Speiser did, or as we find it done on a more empirical

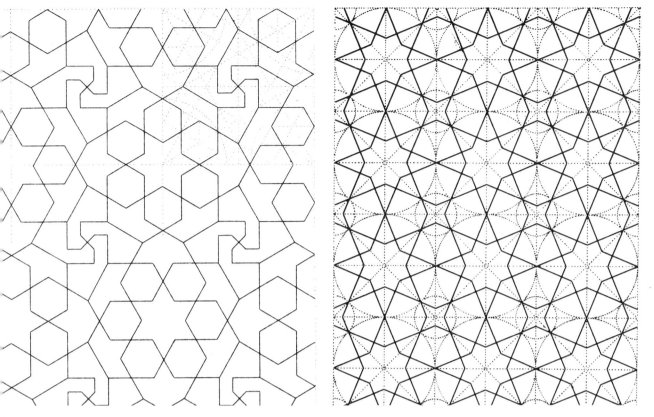

Fig. 97. Arabic
interlace (J. Bourgoin,
1879)

basis in the book of 1879 by J. B. Bourgoin, *Les Éléments de l'art Arabe: le trait des entrelacs*, which classified these lattice patterns according to their elements (Fig. 97). It is quite another thing to generate such miracles of complexity. I find it less likely that those who were initiated into these mysteries were interested in their classification than that they were shown how certain procedures with compass, ruler or strings, led to certain results. The need for planning was reduced by the lessons of experience.

It is this conclusion which is suggested by the tendency to conservatism which the history of decoration shares with that of the other arts. They all partake of the rhythm of trial and error, the Darwinian process of mutation and the survival of the fittest. It is excellently summed up by A. H. Christie in his book on *Pattern Design*, to which I owe so much. 'The slightest change in a pattern suggested others, either to be pursued at once by the same worker, or at some future time by another who might by chance pick up the thread. Thus, in the course of ages an infinite number of cognate designs, derived from a root idea, have been logically evolved, step by step, by the united efforts of many minds . . .'

We have seen in the preceding section what it means for an order to be 'worked out' and that working out is a process requiring both circumspection and also a bit of luck. If that were not the case we could not have games such as solitaire or patience, which set the player the problem of arriving at a given pattern of correspondences meeting a given set of constraints. In trying to meet this challenge we often find that we lack the foresight which would be required to solve the problem without creating new obstacles elsewhere. Composing a satisfactory pattern is bound to run into similar difficulties. The motif which is to be repeated may disintegrate in a sequence much as a word does when it is repeated. Put the word art into a continuous line and you find that you have also written 'tart', 'tartar'. Some books on design warn the practitioner against such untoward accidents and exhort him to try out repeats systematically to see what happens on every side in the joining.

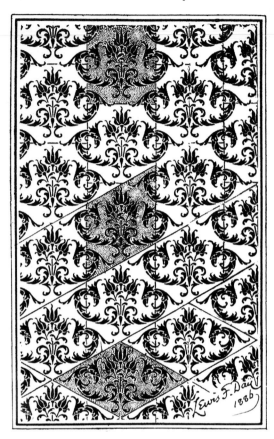

Fig. 98. 'The drop' (L. F. Day, 1890)

Even the designer of wall papers is warned by the practised craftsman to guard against unwanted effects by adopting certain simple safeguards. The Victorian designer Lewis F. Day characteristically recommends a useful trick to protect the beginner against unforeseen mishaps. He advises the student to base his 'repeat' on a diamond shape which permits what he calls 'the drop' (Fig. 98): 'The drop is a device by means of which the designer is enabled, without reducing the scale of his work, to minimise the danger of unforeseen horizontal stripes in his design, a danger which is imminent when the repeats occur always side by side on the same level . . . the design may be so contrived that each succeeding breadth has to be *dropped* in the hanging.' He explains that a slight drop would eliminate unwanted horizontals, but we might get instead unwanted diagonals 'with even more unfortunate effect . . . this difficulty is avoided if you make the "drop" just one-half the depth of the pattern, so that every alternate strip is hung on the same level. Then the horizontal lines correct themselves.'

It is the kind of advice which the experienced master may have given any number of times to the apprentice before textbooks of design were ever thought of. For this 'know-how' is more indispensable than a knowledge of geometry. Patterns emerge more often than they are thought of. We have noted in a different context that the criticism of the so-called materialist theory of ornament rather misses the mark. The question is not whether patterns are simply due to technical processes such as plaiting or weaving, but rather whether such techniques suggested forms of decoration. No doubt they did. We have seen the force of these suggestions in discussing the processes such as linking and vaulting. The decoration of textiles offers an even greater variety of examples. The pattern-maker is always grateful for geometrical guide lines which he can use for his elaborations. The fabric he uses as his support can often save him the trouble of drawing and measuring. There is a kind of needlework characteristically called 'counted thread embroidery'. It illustrates to

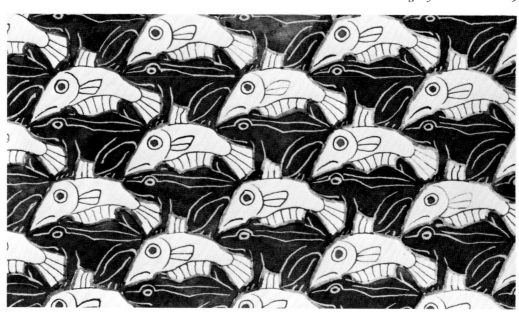

Fig. 99. M. C. Escher: Counterchange of fish and frog. About 1942

perfection the usefulness of an existing grid for the creation of further links. Where the support has to be created together with the pattern, as in knitting or crocheting, the sequence of moves has to be memorized or preferably written down as it is in the modern knitting pattern.

If there is one example which illustrates both the technical roots of a device and its triumphant emancipation as a piece of virtuosity it can be found in the development of counterchange. The trick has attracted particular attention since the Dutch artist M. C. Escher harnessed it to his fantastic inventions, which dazzle the eye and the mind by their astounding complexities (Fig. 99). What strikes the layman who contemplates these designs is again the difficulty of planning them. Even the non-artist can imagine what it is like to draw a fish or a frog with reasonable precision, but how can one attend to this task while at the same time watching out for the space one creates on the other side of the line, as it were? In other words, how can the artist think of the positive form of his repeat motif, and yet so shape it that the void created by the boundaries results in a different repeat motif which also represents an animal. In attempting to answer this question we tend to discover that most of us have 'one-track minds'. We cannot attend to two things at once and yet this is what the trick demands.

Now counterchange, the correspondence between positive and negative shapes, is certainly in its origins the simple consequence of commonplace technical procedures. It will emerge in matting or basket work whenever two varieties of cane or leaves are used to create nothing more surprising than a chequerboard pattern or a Greek fret (Fig. 100). The correspondence so created must have appealed to decorators all over the world. It occurs among the patterns of Amazon Indians (Fig. 101) and in a more complex form in ancient Mexico (Fig. 102). But the supreme masters of counterchange were no doubt the Islamic designers who modified their grid patterns till figure and void corresponded in the most surprising way (Fig. 103, 104). To achieve this kind of correspondence the designer must again use the step-by-step method of 'Graded Complication'. There must always be a give and take in the modification of the figure and the ground. Proceeding in this way, the Islamic masters designed their show-pieces, which Escher is said to have studied with passionate interest. He needed the stepping-stones towards the solution of his problem of representational counterchange. Once the trick has been shown to be possible it is certainly easier to repeat it. Escher has found imitators in Japan (Fig. 105) and elsewhere.

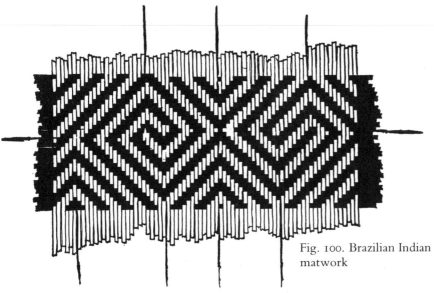

Fig. 100. Brazilian Indian matwork

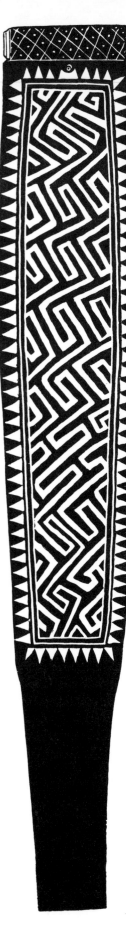

Fig. 101. Amazon Indian club

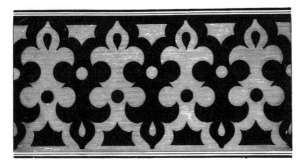

Fig. 102. Ancient Mexican stamp

Fig. 103. Islamic counterchange (C. B. Griesbach)

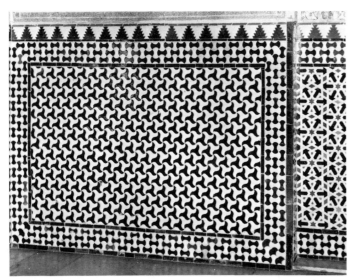

Fig. 104. Wall decoration in the Hall of the Ambassadors, Seville, Alcazar. 14th century

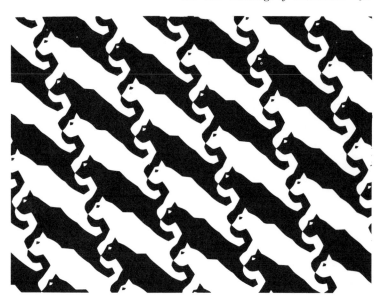

Fig. 105. Michio Kubo: Counterchange. 1968

5 *Tools and Samples*

The history of pattern design would be inexplicable without the existence of patterns. This is more than an idle play on words. We remember that the term pattern originally meant a parent form including such mechanical aids as a stencil used for the production of repeated shapes. The history of such aids has still to be written. The making of tools for textile painting, of moulds for plastering, even of stencils, must have occurred to craftsmen in many parts of the world. Blocks from which elementary motifs could be printed in various colours are discussed by Owen Jones in connection with bark cloth designs (Fig. 54) and a Mexican stamp is shown in our Fig. 102. More sophisticated are the methods of turning a random configuration into a pattern by reversal, as when marble slabs are cut in two and turned into reflecting designs (Plate 35) or similar processes are used for grained wood-panelling. Other procedures of this kind which are known today to every schoolchild may have had to wait for the availability of cheap disposable material such as paper. I am referring to the production of patterns by folding and cutting out, which can result in such pleasant surprises (Fig. 106).

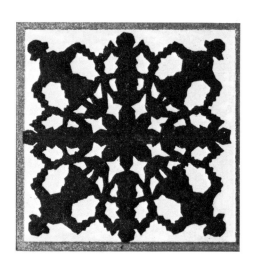

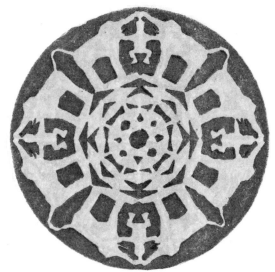

Fig. 106. Cut-out patterns by pupils of F. Cižek. 1916

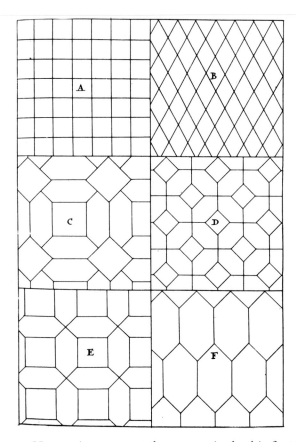

Fig. 107. Glass panels (Félibien, 1676)

Here as in every art the creator is also his first beholder and critic. But maybe pattern-making differs in practice from other arts in that the beholder is traditionally allowed a much greater choice. In our society at least, it is characteristic of the situation that we want a large range for selection. Whether we choose a wallpaper or curtain material, we look at many products, though the experienced customer will be aware of the pitfalls of judging a design from a small sample. Once more the limits of prediction make themselves felt and doubly so in a context where the range of possibilities has expanded as much as it has today.

The needlewomen we encountered at the beginning of this chapter certainly exercised their choice before they used a particular pattern as a guide. All books on needlework illustrate the finished products as well as giving instructions on the choice of material and the step by step operation.

What is more interesting in our context than these instructional handbooks are the devices for the systematic exploration of possibilities. They may be termed instruments for expanding the range of inventions by permutations and combinations. It is here I believe that geometrical and mathematical methods find their proper place in our story: not as the original inspiration of craftsmen but as the expression of the desire to widen the ranges of their skills. The plates in Félibien's *Treatise on Architecture* illustrating the arrangement of window panes in configurations of ever increasing complexity (Fig. 107) are still close to the orthodox tradition of pattern books, but entirely new ground is broken by the system of permutations devised by Douat discussed above (Figs. 73–8).

It was more than a century later that a scientist called in aid a mechanical device to trump this method. I mean Brewster's Kaleidoscope, which does not lead to a finished product but merely to evanescent mirror-reflections, which will engage our attention in another chapter. Investigating the potentialities of regular repeat patterns the German scientist

Fig. 108. Moiré effect
(H. W. Franke, 1971)

Wilhelm Ostwald, best remembered for his attempt to systematize the classification of colours, launched a formidable enterprise by which he hoped to map out the 'world of forms' for the benefit of designers. It consists of folders holding loose transparent sheets of equal size on which the basic lattices are printed, starting from a standardized net of equilateral triangles followed by squares, hexagons and more complex configurations. The ingenious idea behind this sequence of 62 sheets was to show the number of permutations to be achieved by the superimposition of these various nets. Maybe the theoretical interest of this demonstration of formal hierarchies is greater than its practical value. What has proved of more fascination for designers is the method of superimposition resulting in what are called moiré effects (Fig. 108). Basically the effect is one we observe when walking past two identical fences consisting of equally spaced uprights. Sometimes the supports and interstices are aligned, sometimes the supports of the nearer fence will occlude the interstices of the second, and the result will be the familiar flicker. Superimposing more complex grids, the resulting pattern will increase in complexity and in interest, like criss-crossing wave patterns on the surface of the pool.

It is in these effects that mechanical methods score over freehand techniques. Machines for the production of controlled lines and curves have been in existence for some time, starting from the guilloche, commonly used on bank notes because it is hard to imitate (Fig. 109), to various pastimes such as the spirograph. The advantage of all these and similar devices is the ease of production and variation, which allows us to eliminate the failures and select the best.

In more recent times these prospects have been thrown wide open by the computer, the most formidable competitor to the craftsman. The consequences of computer techniques in this field cannot yet be estimated but already we have learnt a great deal from the ease of programming the creation of almost any kind of order and studying its effects. Maybe the

Fig. 109. Guilloche
from a bank note

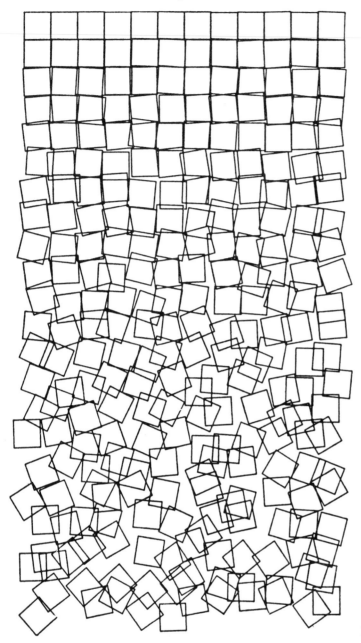

Fig. 110. Georg Nees:
Gravel stones (H. W.
Franke, 1971)

greatest novelty here is the ability of the computer not only to follow any complex rule of organization but also to introduce an exactly calculated dose of randomness (Fig. 110).

The configurations resulting from this technique of giving latitude to chance within a fixed framework of predetermined moves not only exhibit features of aesthetic interest, they also offer unrivalled insights into the operations of our sense of order in the perception of complex patterns.

Part Two
The Perception of Order

IV The Economy of Vision

> What is seen depends on how the observer allocates his attention; i.e., on the anticipations he develops and the perceptual explorations he carries out.
> Ulric Neisser, *Cognition and Reality*

In the spring of 1956 I had the privilege of spending a few hours with that great student of perception, Wolfgang Koehler, who was a guest of the Institute for Advanced Studies in Princeton. I was giving the Mellon Lectures in Washington which turned into *Art and Illusion* and I was most grateful for the opportunity of discussing these problems with the famous pioneer of *Gestalt* psychology. I scrawled a face on the blackboard and asked him what was going on in our minds when we looked at it. He shook his head. 'Remember,' he said, 'psychology is a baby, this is far too complicated a problem for us to solve as yet.' What would he have said if I had asked him what was going on in our minds when we looked around in the Alhambra (Col. Plate VI)?

I am aware of the foolhardiness of trying to confront these problems, but I feel that something may be gained even in drawing attention once more to what J. J. Gibson has described as the 'awe-inspiring intricacy of vision'.

1 Varieties of Vision

Art educators sometimes try to make us feel guilty for our failure to use our eyes and to pay attention to the riches which the artists spread out before us. No doubt they are occasionally right, but their strictures do little justice to the difference between seeing, looking, attending and reading, on which all art must rely. Even a perfunctory study of the psychology of vision tells us that seeing must be selective from the start and that the way the eyes respond to these selected samplings depends on many factors both physiological and psychological. It is easy in this modern world of ours to demonstrate the fallacy of equating 'seeing' with the totality of light energies that impinge on our retinas. What we see on the television screen is notoriously different from what is actually going on there—the rapid variations in the intensity of one scanning dot—and even what we see in any normal black and white illustration dissolves into a variety of dots under a magnifying glass. The examples prove what we all know from daily life: that there are strict limits to the powers of resolution even of the normal eye. These limits may be said to determine what we can see and scrutinize as elements in a given visual array if we wish to focus on it, and what will elude this scrutinizing examination. Like the elements of the screen in the print, so the pebbles of a beach, the bricks of a wall or the leaves of a tree will fuse at a certain distance into larger areas, which are experienced as 'textured' depending on the way the elements reflect the light. The relevance of this experience to our subject of pattern and decoration is not far to seek. For in those combinations of elements which we have analysed in geometrical terms, all which are too small, too densely spaced, or too distant from the observer, will inevitably merge into an impression of texture, which, in its turn, can dissolve into its elements under a close scrutinizing glance: the motley cloth will show as a random mixture of many-coloured threads.

But interesting and important as are these extremes of perceptual fusion, they present fewer problems to the student of design than the all-important middle zone, which extends between the two. In walking through the Alhambra with its infinite varieties of patterns we neither see mere texture nor can we possibly take in the whole of any design unless we sit down to scrutinize and possibly copy it. How, then, should we account for our experience in perceptual terms?

2 The Selective Focus

It was William Hogarth who first appealed to the psychology of vision to explain his preference for what he called 'intricacies'.

'Intricacy in form . . . I shall define to be that peculiarity in the lines, which compose it, that *leads the eye a wanton kind of chase*, and from the pleasure that it gives the mind, intitles it to the name of beautiful.'

Hogarth based his idea of pursuit on what appears to be an irrefutable fact of visual perception, which he illustrated in a diagram (Fig. 111) 'which represents the eye, at a common reading distance viewing a row of letters, but fix'd with most attention to the middle letter A. . . . if the eye stops at any particular letter, A, to observe it more than the rest, these other letters will grow more and more imperfect to the sight, the farther they are situated on either side of A, as is express'd in the figures; and when we endeavour to see all the letters in a line equally perfect at one view, as it were, the imaginary ray must course it to and fro with great celerity. Thus though the eye, strictly speaking, can only pay due attention to these letters in succession, yet the amazing ease and swiftness with which it performs this task, enables us to see considerable spaces with sufficient satisfaction and one sudden view.'

Fig. 111. Hogarth: The reading eye. 1753

Hogarth was right in reminding us of the limited span of focussed vision. The *fovea centralis*, which is alone capable of sharp definition, covers less than one degree, while the remainder of our visual field appears progressively indistinct the further it is removed from the fovea. Unlike the limits of resolution, this unevenness of our vision rarely obtrudes on our awareness, because we can always fix on any point that interests us, and since the eyes are very mobile we can build up a detailed picture of any object we wish to inspect. We do so all the more readily as our visual impressions do not fade immediately but stay with us for sufficiently long to enable us to turn the mosaic of small snapshots into a coherent and continuous image. But however this image may ultimately come about, it is really a construct. This is the reason for the observation which I mentioned in the Introduction, that ease of perception corresponds to ease of construction. We remember the contrast in this connection between the regular grid of flagstones and the crazy pavement. The first is surely more easy to take in than the second.

The relevance of these considerations to our perception of decorative design is as great today as it was in the days of Hogarth, but here as always the progress of research has only served to remind us of the complexity of the problem involved. Hogarth could still write as if focussing and attention were one and the same thing, and it is certainly true that the two are normally coupled. We tend to turn our eyes automatically in the direction of something to which we want consciously to attend. Perhaps it is only detectives who have trained themselves to observe 'from the corner of their eyes' without looking. There are other experiences, however, which all of us share, which justify making this distinction between fixation and attention. The example of reading used by Hogarth is a case in point. It is certainly possible to focus on a printed page without attending to it, and therefore without reading it. We may see a newspaper lying somewhere and become aware of the fact that a given word such as our own name was printed somewhere on the page though we may have

subsequently to search for it with our conscious attention. In discussing decoration, this distinction between seeing and attending is certainly not an idle one; we know that we rarely attend to the details of design, but if we did not see them at all, decoration would fail in its purpose.

3 Loss of Definition

Now the question of what things look like while we do not look at them is sufficiently abstruse to be dismissed by commonsense as absurd. And yet we have seen that Hogarth and others thought they knew the answer to this teaser. He thought he could represent the unfocussed letters of the page by blurring them slightly. We have all had this experience of blurring and we are ready to accept the device. Being presented at the oculist's with his rows of letters we can tell which we can recognize and which are fading into a blur before they become merely textured lines. But while it is easy to say what we see, the question of describing the letters we cannot properly make out leads us back to our predicament. Artists have endeavoured for a long time to reproduce this impression. There are many paintings showing the page of a book or a letter covered with squiggles indicating writing or print. As long as we do not attend to them they strike us as fully convincing; even so we must not fall into the trap of identifying the precise squiggles on the page with the way we see letters from a distance. The reason is simple; these squiggles could stand for any letter. There must be a range of different shapes all of which we might accept to be equivalent before inspection, and this range would naturally include the real letter forms as well.

There are a number of situations in various arts where such perceptual generalizations are used. When theatrical producers want to give the general impression of a muttering crowd they ask the actors on the stage to repeat some nonsense words such as 'rhubarb, rhubarb'. When Charlie Chaplin was forced to make the painful transition from silent films to the talkies he looked at first for an idiom that would be acceptable to all audiences and composed a song of nonsense words which convincingly sounded like a real text in an unknown language. Saul Steinberg is a past master of doing the same with script. He likes producing spoof documents and signatures which look at first like real writing but turn out to be a mere sequence of loops and strokes so cunningly distributed that they capture the general appearance without containing any genuine letter form. This process of perceptual generalization is also used by typographers who want to demonstrate the appearance of a printed page without distracting the customer by meaningful letters (Fig. 112). The artist who covers the pages of an open book in his painting with abbreviated dots and dashes does so largely for the same reason, that he does not want to distract our attention. But visually he can also use real letters just as a muttering crowd might also use real conversation if they could think of anything to say and could be sure they would not be understood.

Fig. 112

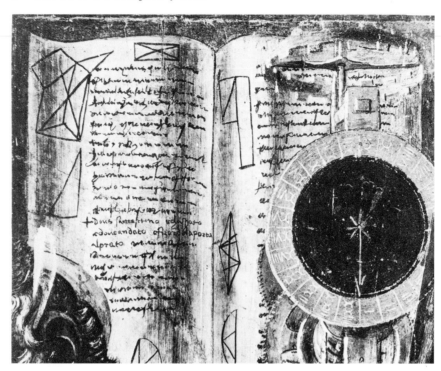

Fig. 113. Botticelli: Detail from
St. Augustine. 1480

Botticelli actually made use of this licence in the fresco illustrated. His picture of St Augustine in the church of Ognissanti in Florence shows an open book (Fig. 113). Relying on the altitude of the fresco and its distance from the normal beholder, he covers the page with squiggles; but there is also a real sentence to be read there, ending *e dove andate fuor de la porta al prato* (and where you go outside the Porta al Prato). He had not counted with the photograph and the prying eyes of the art historian using binoculars.

The fact that people with normal eyesight cannot make these letters out at that distance is far from surprising, it is obvious. What must be probed, to repeat, is only the obverse question of what it is they see instead. Not surprisingly the first artist who reflected on this elusive question was Leonardo da Vinci. His primary concern was very properly with the question of what we cannot see at a distance. He spoke of the 'perspective of disappearances' (*perspectiva de' perdimenti*) and took great pains to investigate the exact sequence of these disappearances with increasing distance. First we lose the shape, then the colour and finally the mass of the body so that 'when you see a man close to you you will discern all these three elements, with increasing distance you will first fail to recognize who it is, from further away you cannot tell his colouring but see him simply as a dark body, and in the end he will appear as a tiny dark round spot'. Note the transition from the negative description (what we no longer can see) to the positive characterization of the percept. Leonardo looked for an explanation of this tendency towards simplicity in the structure of the eye and in its power of resolution; he was mistaken in the first, but right in the second argument, which to him accounts for the fact that a horse will lose the legs before the neck and the neck before the body, after which only an oval form would remain.

He certainly knew that his advice to painters was somewhat schematic and that different colours and different contrasts of colour and illumination would influence the sequence of 'disappearances' with distance. But he was basically right in his observation that the characteristics of any such objects elude description. Was he equally right in his description of what would remain? Does a man become a circle and a horse an oval? The rule may be helpful for the painter who has to put down something on the panel without specifying more than can be seen—as Botticelli did in his painting of the Adoration in London (Plate

39a)— but we must remember that when we inspect his 'dark round spot' we see something clearly and from close quarters which he saw vaguely and from afar. If we in our turn step back far enough we can also lose detail, but then the roundel and the oval will lose definition as well. If we can still make sense of it, this will be due to the guidance given to us by the context, which makes us search and test the indistinct forms till we find a reading that fits our expectations. It is one of the principal points of *Art and Illusion* that this kind of activity is inseparable from perception and that the ideal of an artist faithfully recording the sensations of his 'innocent eye' rests on a misunderstanding. We cannot switch off the part of the brain that interprets the visual stimuli playing on the retina without ceasing to perceive altogether.

Among the resources of interpretation which I discussed in *Art and Illusion* the most relevant for our present context is what I called 'the etc. principle'. Looking at a crowd or a troop of horses we will be less aware of the exact loss of detail because we will tend to expect that the members of this mass will be identical and read them accordingly—finding it difficult, if not impossible, to tell at any point where we see elements and where texture (Plate 39b); where we are reading and where we are 'reading in'. It is different if an unknown object heaves into sight from afar. In that case we project a variety of readings onto the indistinct shape and decide, maybe, that it might be any of a variety of things. Up to a point, however, as I have tried to show elsewhere, this reading will affect our visual experience; the blob may be a man or it may be a bush, but while we wonder, we tentatively transform it.

I found it useful to recapitulate these observations before returning to the 'perspective of disappearances' in our 'middle zone' of proximal vision, the loss of definition outside the focussed area. Leonardo does not seem to have occupied himself with this phenomenon, but Hogarth was here anticipated early in the eighteenth century by that intelligent critic Roger de Piles, whose allegiance to the Rubénistes made him sensitive to the more 'painterly' aspects of representation. '. . . the eye is at liberty to see all the objects about it, by fixing successively on each of them; but when 'tis once fix'd, of all those objects, there is but one which appears in the centre of vision, that can be clearly and distinctly seen; the rest, because seen by oblique rays, become obscure and confused, in proportion as they are out of the direct ray'.

The terminology used by de Piles (which is dependent on traditional optics) need not concern us. He is convincing when he demonstrates by means of a diagram (Fig. 114) that of a number of spheres placed at the same distance from the eye only one would be seen clearly at a time, while the remainder would 'decrease both in force and colour in proportion as they recede from the straight line, which is the centre of vision'.

But de Piles' illustrations and further remarks also show that he, too, underrated the complexity of the problem. While he represents the 'decrease in force and colour' that occurs outside the fixation point, he fails to render the more interesting way in which the other spheres would 'become obscure and confused'. Nor is this important point due to his draughtsman, for de Piles explicitly equates this lateral lack of definition with the perspective of disappearance. 'Their only difference is, that the latter decrease in magnitude, according to the rules of perspective, as they go off from the said centre; and the former, which only extend on the right and left of the centre, grow fainter by distance, without losing the form or bigness.'

The difficulty in testing de Piles' assertion derives again from that interaction between seeing, knowing and expecting which so frequently intervenes in our observation of visual processes. If we were confronted with his spheres as they are arranged in his illustration we would quickly take in the fact that they are all identical spheres; the 'etc. principle' would be sure to operate and so we would be unable to tell how the loss of definition affects

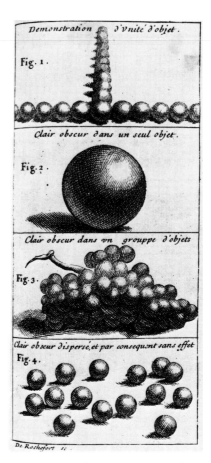

Fig. 114. Focus and definition (Roger de Piles, 1708)

them. We also remember how hard it is to concentrate on the appearance of an object outside the foveal area without automatically shifting the eye and thus spoiling the experiment. A controlled experiment has to use shapes not previously inspected and has to secure the direction of the observer's gaze by artificial means.

It is likely that such a series of experiments designed to investigate the 'perspective of disappearances' from various angles share with other experiments the fate of yielding a number of unsurprising results. Disappearance through distance, through lack of illumination, through dazzle, faulty eyesight, or distance from the fovea depends on a large number of variables such as size, colour, contrast with background, simplicity, familiarity, movement and perhaps training. But I think that de Piles' equation between disappearance through distance and through lateral angle cannot be confirmed. There is a difference in quality between the two experiences which we all know, however difficult it may be to describe it. That reduction of complex shapes into simplified patches which Leonardo characterized in his discussion of the way a man or a horse shrinks into a blur as it recedes has no direct parallel in unfocussed vision. If my self-observation can serve as a guide, certain distinctive features stand out in a jagged and somewhat incoherent way. Here, as in the distant view, it is the break in visual continuities which is noticed most easily, a contrast in colour, texture, form or, most of all, movement which suggests the presence of a separate object or an event meriting attention. In following such indications and shifting our eye we will inevitably look for confirmation of our confused impression: sometimes a mere sampling glance will suffice, while other situations will demand prolonged scrutiny.

Maybe it is this possibility to check that distinguishes the experience of peripheral vision so markedly from that of the distant view. The perspective of disappearance described by Leonardo causes us to give up. We may strain our eyes to make out more than the fusing

elements of a distant sight but, as a rule, we are not disposed to question it too much. We know that the detail is lost and that only the main contrasts are presented to us—the blue distant hills present no special problem to the landscape painter, who has every right to present them as pale blue wavy shapes. It is different for painters who want to explore that twilight region between seeing and not seeing which is connected with the visual span of proximal vision.

4 Testimonies of Art

I take Fig. 115 from the book by an assiduous student of design, Walter Crane's *Line and Form*, where it serves him to 'illustrate the value of different quantities in Persian rugs'. He certainly achieves this by a gradation of tone and density of texture, which might be all we notice at a first glance. But he also reminds us cleverly of the varying distinctness of motifs, such as the pomegranate design in the main border zone, which is reasonably clear at one point, incoherent further below and standing out in bold but asymmetrical outlines on top, possibly indicating a change of colour. What remains intact in this sketch is the straight lines delimiting the zones, and this, too, corresponds to our experience though the purely visual impression we receive is probably less tidy—at least if we have a trace of astigmatism. In any case, the example of such artistic methods of abbreviation confirms the existence of different 'perspectives of disappearance'. The same rug seen at a greater distance, where motifs can no longer be made out, would have to be rendered differently and a loss of illumination would result in yet another variant.

We are entitled to use this testimony of art, but only on one condition: we must never forget that one difference between a representation and reality lies in the simple fact that in reality we can always go on looking and exploring, if necessary with artificial means such as binoculars or magnifying glasses, while the image as image is strictly finite. Magnify it too much and it will cease to be an image and become a piece of textured matter. In a photograph the information conveyed to a normal eye will be restricted by the resolution of the lens, the grain of the film and the size of the image; in an illustration, as we have seen, the 'screen' sets further limits to the detail that can be recorded.

But with these cautions in mind it is still interesting to study the way artists attempted to cope with the wealth of detail which characterizes such masterpieces of decoration as the Alhambra. A sequence by J. F. Lewis, *Sketches and Drawings of the Alhambra*, made during a

Fig. 115. Walter Crane: Rapid sketch of a Persian rug. 1902

Fig. 116. Inscription from the Alhambra, 'There is no conqueror but Allah' 14th century (Speltz, 1910)

residence in Granada in the year 1833, offers food for thought, for Lewis was no mere hack and his views are both informative and pleasing (Plates 37, 38). Like all artists with a sound naturalistic training, he has no problem with the 'disappearance' through distance, showing the gradual loss of detail and of contrasts of which Leonardo speaks. Nor is he troubled by the similar reduction of information which results from lack of light. The shadows 'blot out' the patterns more abruptly than does distance. Even in proximity, however, he cannot give us a full inventory of all the motifs on the walls because their infinite complexity would defeat his medium and his patience. He confines himself to a more summary design, increasing the sketchiness as he is approaching the margin to indicate that centrality of focus which de Piles had been one of the first to advocate. Like Walter Crane he preserves the principal outlines, however, though it is doubtful that we would see rather than expect them.

If proof were needed of this role of expectation and knowledge it could be found in the way Lewis renders the Arabic inscriptions, which abound in the decorative system of the Alhambra, repeating everywhere the praise of Allah as the only monarch (Fig. 116).

Remembering our discussion of generalized lettering we may say with confidence that Lewis had no knowledge of the script and was not even interested in its beauty. He has missed the characteristic 'duct' of Islamic writing. It is most unlikely that anyone familiar with this tradition would have attempted to suggest the inscription through these forms, let alone that he would have perceived them in this way. Here as elsewhere it is impossible to separate perception from knowledge or expectation. What F. C. Bartlett called 'the effort after meaning' enters into the process of vision as soon as we open our eyes. From this point of view we cannot separate the problem of the perception of form from that process of conditioning that comes from repeated exposure to a certain style. Milizia probably reported the truth when he complained that he found Gothic decoration confusing and classical decoration easy to see. He lacked the perceptual skill that comes with familiarity and allows us to proceed from the overall form to the detail. Taking a leaf out of Hogarth we might say that he found it difficult to read.

Maybe we are now better equipped, however, to assess both the limitations and the value of Hogarth's comparison between the inspection of letters and the viewing of decoration. He implied (though admittedly he did not say) that the eye is similarly employed in both cases, whether reading a line of script or pursuing a line of ornament, and this assumption was taken up by Owen Jones, who postulated that we feel discomfort if we are frustrated in this pursuit by a jagged line (Fig. 55). But this is not the case. It seems to me distinctive of the way we look at decoration that we do not normally fix on every motif one by one. If we stick to Hogarth's comparison, we rather perceive it as we see a printed page before we read it. We are aware, in the Alhambra, of the delights that await us wherever our eye may wish to settle, but we do not start pursuing or unravelling every scroll. It is for this reason that the

problem of undifferentiated or unfocussed vision has loomed so large in this account of the general impression created by intricate designs. To expect that we read every motif in the Alhambra as we read a book is not only unrealistic. It is contrary to the spirit of decoration, which offers us a feast for the eye without demanding that we should taste of every dish. The pleasures of anticipation and of memory may largely be subliminal, but they are none the less real. And yet I hope to show that Hogarth had the right intuition when he brought the problem of reading into the discussion. The very difference between these modes of seeing may be important. Moreover more research has gone into the study of reading than into any other aspect of form perception. It is one of the areas which has undoubtedly profited from the new intellectual tool that has also been applied to the study of pattern perception—the theory of communication of information, which I mentioned in this context in the Introduction.

5 *Visual Information*

A good deal of circumspection is always needed in transferring techniques and terminologies developed for the solution of a particular problem to other fields of research and it is notorious by now that this circumspection has occasionally been wanting when the new tool of information theory became a new toy. Terms such as 'redundancy' or 'random' became words of critical parlance which left a certain amount of confusion in their wake. The confusion is not surprising when we remember that the origin of these preoccupations lies very far outside the field of artistic activity. They arose in the scientific study of the transmission of messages in which electrical engineers investigated the most economical way of sending and receiving information by signals. The basic situation with which they were concerned was that of communication along a relatively noisy channel and all channels are 'noisy' in the sense that some random electrical interference is likely to occur. The purpose of any message in this idealized model is to reduce the state of doubt in which the recipient had found himself, and it is this state of doubt first of all that can be expressed in terms of uncertainties and probabilities. Imagine the situation of the anxious father waiting for the message whether it is a boy or a girl. Before its arrival his bet would be roughly fifty-fifty or more exactly dependent on the statistics of live births. All that would be needed to remove his doubt would be one of two signals if a prior code had been arranged. In such ordinary life situations the prior code is offered by the language which is in common to the sender and transmitter. Strictly speaking all the economical engineer would have to transmit to a speaker of English in this situation would be a 'b' or a 'g', which would resolve this particular doubt. He could save himself the rest of the letters since they do not add any fresh information. If he still transmits the whole word it is precisely because the channel may be noisy and he can only defeat such random interference by making doubly sure. If 'g' is obliterated there is still 'irl' to resolve the father's uncertainty. If the context were less defined by the situation more additional letters would be needed to ensure safe reception. This technique of making sure by including features which could be expected and which therefore do not convey additional information is what engineers call the use of redundancy. We may regret the choice of this term because it has become the source of unnecessary confusion in aesthetics. For most people the term redundant carries the connotation of the superfluous, if not the more sinister one of being declared redundant. In the theory of communication of course there are no such overtones of valuation. Redundancies are not superfluous because the message must get through the noise and the simplest form of redundancy is that of the straight repeat, familiar from such calls as 'testing, testing, testing' or more seriously from the message of distress, s.o.s., s.o.s., which attempts to ensure that the random listener will pick it up.

THE 🐈 MUST GET DONE

\\ ᴜ \\

Fig. 117

It is easy to understand how our grasp of ordinary language profits from high redundancies. We can afford to miss or mishear individual sounds or even words without losing the meaning. In speaking or writing we may slur forms and articulations and omit dotting our 'i's and crossing our 't's without fear of becoming unintelligible all at once. In reading we sweep our eyes in abrupt, so-called saccadic movements from fixation point to fixation point to pick up the meaning, and much guessing and anticipation is going on all the time as we 'follow' our author. It is easy to demonstrate the role of redundancies in our grasp of a text through a guessing game. If you present a subject with an incomplete message you can find out how much of it he can guess through his knowledge of what is likely in a given context. Anybody can try such an experiment by covering up part of a printed text and guessing at its completion. The better we know the language and the context the more easy the game will become, and the more letters of an individual word are in view the more the guess converges towards certainty—provided, of course, our partner plays the game honestly and does not confront us with a misprint or a nonsensical sequence.

The illustration which I take from a textbook of psychology (Fig. 117) brilliantly demonstrates the force of these principles. Few of us would find it difficult to read the word partly obliterated by a blot, but most of us will be surprised by the demonstration of the scanty evidence on which our reading was based. Up to a point all rapid reading resembles such a guessing game. We draw on our stored knowledge not only of the individual letters but also of the language and of the expected sequence of words and meanings. On the whole we glide along these pre-established rails with so little care that we even fail to notice gaps or misprints. We owe this assurance precisely to the redundancies. A message in code where every character counts cannot be read at speed, and lists of numbers have to be attended to in a very different way again.

These commonsense observations explain why it appears so tempting to apply the new discipline of information theory to the study of perception. Nor is it hard to see why these attempts ran into difficulties. The theory as originally conceived is a mathematical theory designed to measure the amount of information necessary to reduce the receiver's doubt concerning given alternatives. To apply it we must be able to state the number of existing alternatives and the kind of signal necessary to reduce their number. It is well known that this can be done by a simple series of yes or no answers which allows a questioner to locate an item on a given grid as in the game of Twenty Questions. In applying this theory to messages in ordinary language it had to be considerably stretched, but language at least has the advantage, as we have seen, that it operates with a finite set of rules and within the limits of its vocabulary. An English speaker who sees a word starting with the letter 'q' knows that the next letter must be 'u' and he also has a reasonable range of expectations of the words which he is likely to encounter. Every additional letter will reduce this range and if the message reads that the meeting was suspended for lack of a q.u.o.r.u.m. every successive letter can be said to be increasingly redundant. Even in this case, however, we have moved out of the strictly measurable to a more subjective conception of what a particular reader is likely to find redundant. Not everybody knows the expression 'a quorum' and you might dispute whether it is even part of the English language. There can be no strict mathematical theory of this kind of previous knowledge and expectation, we have to resign ourselves to a

looser analogy between the perception of language in everyday life and the transmission of information within closed systems.

If this approach has yet proved fruitful the reason is simple: it has helped to get the theory of perception away from another vague analogy, which has turned out to be even more misleading. I refer to the comparison of the eye with the camera. It proved so misleading precisely because it seemed so plausible. After all the camera is constructed on the model of the eye and there is a strict analogy between the photographic plate and the retina since both react to the distribution of light energies which together form the image. The comparison is also responsible for the ready acceptance of the idea of the 'innocent eye', which I was at such pains to combat in my book on *Art and Illusion*. It postulates that we can, and possibly should, attend to all messages which the eye receives from the visible world with neutral impartiality because to be selective in our attention introduces a bias and therefore a distortion of the objective truth. We have now seen why this demand is quite unrealistic. Our visual apparatus has in common with the camera that its focus of sharp vision is limited and that it can only sample part of the light distribution in a more precise way at any one moment. Whether we want to or not, we have to be selective because our eyes are. But quite apart from the structure of our eye we now know that much further selection, more sifting and processing of messages, is going on at various stages on the neural pathways from the retina to the visual cortex, the part of the brain that receives the messages from the visible world. Nor can this possibly be the last stage in this transformation of light into percepts. For just as there is a physical focussing at the moment of intake, there is something like a mental focussing in the mysterious process of attention, which psychology has not yet quite unriddled. Without this final selection we would be flooded by messages to the point of distraction. We could not find our way through the world if we could not, at any moment in time, take very much as read.

It is because of this characteristic of perception that the analogy with the processing of messages investigated by the theory of information has proved fruitful, however careful we must be not to overwork it. For it is a fact that much of our environment can be regarded as so fully expected that the scrutinizing eye can treat it much as it treats the redundant parts of a text. J. J. Gibson has proposed to investigate those characteristics of our world which we can normally take for granted as part of 'ecological optics'. We usually accept it as natural for instance that light comes from above or that areas of still water are level. These and similar expectations with which we approach the visible world provide opportunities for tremendous economies in reducing the amount of information to which we have specially to attend. These economies increase progressively as we are confronted with a familiar environment, where the objects we encounter conform to expectations.

6 Expectation and Extrapolation

There is no reason why this structure of our expectations should not be investigated by the same techniques which have proved so powerful in the theory of information. We can play the same kind of guessing game with pictures of things as we can with texts, covering up part of the representation and asking the subject to complete it. To make the process more systematic Professor Attneave used simplified images forming black silhouettes of familiar objects on a white ground. Imposing a grid on the picture and uncovering one square at a time, he asked subjects to bet on whether the next square would be black or white, filled or empty. He found that these bets are naturally far from random because we have certain justified expectations when confronted with images of familiar things such as a house, a tree or an animal. Where such expectations are not fulfilled we register surprise, and the degree of this surprise can be equated with the amount of information in the sense of the theory. We

would be less surprised to discover that the roof of the house is steeper than we expected, than we would be to discover that it terminates in a flower.

Where thing-perception is concerned we might explain this reaction easily by the previous knowledge of the guessing person who may be said to know human beings, houses or trees much as he knows the words of his language. But what about our capacity to perceive abstract shapes and forms, that capacity which concerns us in this book? There is no theoretical limit, as we have seen, to the combination and permutation of purely formal designs. It is true that in a given culture some designs or motifs will be more familiar than others. There are styles of ornament which exhibit a certain analogy to language. If that were not so, restorers could not fill in missing pieces of a string course or of a decorative motif with such confidence. The Alhambra would look very different if it were not for this ease with which repeat patterns can be restored (Plates 37, 38). No doubt this effect of familiarity also plays a part in our reactions to different styles of ornament, but the question we have to ask is a much more fundamental one. How do we perceive the elements of patterns which we have never seen before? What role, if any, can expectation play here in the necessary selectivity we must exercise?

Psychologists have found that we do indeed approach them with certain expectations, however hard it may be to justify them rationally. Using the same guessing game once more, Attneave has shown that if a subject is presented with a simple pattern such as a sequence of alternations, *a,b,a,b,a,b*, the tendency will be to gamble on the continuity of the same sequence and therefore any alteration will cause more surprise. It is tempting to use the same term of redundancy for the continuation of the sequence though it must be admitted that here the analogy wears dangerously thin. After all there really is no reason in logic to believe that the alternation will go on indefinitely.

It is precisely because of this objection that the experiment takes us right into the centre of the problem of pattern perception; I refer to the role which we must assign to extrapolation in our commerce with the external world. The concept of extrapolation is sufficiently crucial here to pause for its definition given in the Oxford Dictionary: 'The action or method of finding by a calculation based on the known terms of a series, other terms, whether preceding or following.' A number of sightings of a comet, for instance, establishing its location at given points, may thus be used to construct its path in between these locations and to predict its further appearances. (Strictly speaking, the 'filling in' of the path between observed points should be described as 'interpolation', but this term has so many meanings that it may cause confusion.)

Now it may be somewhat unexpected to attribute to our perceptual system the ability to perform this kind of calculation, but anybody watching a game of tennis will have to admit that the players must be able to do by instinct and by training what astronomers do by calculation. They must extrapolate from their observations of the ball where it will be at a future moment, and must know by experience whether they can reach that point with their racket. Both instinct and training, inborn and acquired abilities must have a share in the skills required of the player. The necessary refinement of perception and of movement must build on a reaction with which we are endowed from birth. There is a gradation from the baby's first tentative movements of eye and hand to those of the clumsy player and further to the champion, whose anticipations will be increasingly precise. It may sound a little paradoxical also to speak of his 'anticipations' of his own movements, but a little self-observation will convince us that normally we cannot and do not predict exactly how we shall carry out an intended movement. Nor need we do so. Reaching for a pencil we can guide our hand visually just sufficiently to be sure it will not miss its aim. It is only a failure to reach it which is signalled to the brain as a breakdown needing attention. Refinement of skills consists in narrowing down the latitude allowed to our initially vague extrapolations.

Fig. 118. Guardi: Venetian scene

Learning to perceive proceeds in the same direction. It depends on the purpose how far this process is carried out.

In a chapter on 'Illusion and Art' which I contributed to a volume jointly edited by the psychologist Richard Gregory and myself, I have argued at some length in favour of the 'prognostic character of perception'. I used the example of an imaginary creature equipped with a perfect registration apparatus capable of completely mapping the environment at any given moment, but lacking the power of extrapolation. How could it even cross a road without danger of being run over? What I should have added—remembering the Popperian asymmetries—is that for crossing a road it is only important to predict where no car will be at the crucial time. Some of us prefer to take no chances while others are confident that their anticipations are precise enough to make a dash through the traffic.

Neither in our movements nor in our perceptions are we normally aware of the calculations underlying our anticipations. If they enter our consciousness at all, they do so in the shape of phantom percepts. We see where the tennis ball or the car will be, and it is on this power of expectation that conjurers often rely to trick us. Not only conjurers, though. What we call the artist's power of suggestion, his ability to mobilize what in *Art and Illusion* I called 'the beholder's share', relies on this perceptual mechanism. Maybe the refinement necessary to respond in this way to a rapid sketch or an impressionist picture is also an acquired skill, but a skill which develops an inborn capacity. A few deft penstrokes in one of Guardi's drawings of Venice suffice for most of us to 'see' a gondolier because we understand from the context that this is what they must stand for (Fig. 118).

But in all these cases it could be argued, and indeed it must be argued, that it is experience which developed this skill of interpretation. We know about drawings and about gondoliers and if we did not, the suggestion would fail to work. If that is granted we can pinpoint the problem of this book more precisely. For there is no doubt that we also extrapolate, expect and anticipate in cases where this kind of experience must be lacking. Thus Kanisza has shown that an incomplete shape is turned into a phantom triangle precisely because we extrapolate or interpolate the missing outlines between the gaps (Fig. 119). Why do we do this? Why do we see a continuous contour which is not there?

Fig. 119

It might be answered that as products of a technological civilization we have become so much conditioned to the straight lines and geometrical shapes of our artificial environment that we extrapolate or 'fill in' the triangle from past experience of similar forms. But this kind of explanation turns out to be inadequate to account for the universal tendency with which we are concerned, the tendency which in the most general terms may be described as the assumption of continuity. We expect things not to change unless we have evidence to the contrary. Without this confidence in the stability of the world we could not survive. Our senses could not cope with the task of mapping the environment afresh every moment. They rather serve our internal representation, on which we enter certain observations and assumptions, with which we operate unless and until they are disproved. This is the

application of the 'Popperian asymmetry' which I foreshadowed in the Introduction. Our whole sensory apparatus is basically tuned to the monitoring of unexpected change. Continuity fails to register after a time, and this is true both on the physiological and the psychological level. Fixing the eye on a given configuration—as can now be done by means of a device attached to the eyeball itself—the percept will fade in the absence of the incessant oscillations we carry out. Any continuous body feeling, sight or sound, will sink below the threshold of attention. The rush of wind and water, the rustling of leaves, the ticking of the clock and even the roar of traffic outside the window become mere background and will be ignored unless they interfere with other sounds. The best proof we have, however, that we still hear what we no longer notice comes from the well-known observation that we realize it when the sound changes or stops. We must have been 'monitoring' it unconsciously all the time. This monitoring for continuity can be set by the system in various ways. The trained pilot will notice the unusual change in the pitch of the engine noise, the anxious mother the change in the breathing of the sick child. On the other hand, the discontinuities in their turn can be taken as read as soon as they are expected; the quarterly chimes of the village clock may soon pass unnoticed. It appears in fact that expectation can have a dual result according to the way we are 'set'. Discontinuity may arouse us and give us a jolt, when it clashes with our forward matching (as in the stairs–platform shock). But it may also cause us to fill in from our imagination what we have come to expect. There are such experiences in the sphere of listening, as when we are made to fill in an imaginary continuous bass which the instrumentalist cannot really play; maybe the sense of vision is more prone to this kind of projection, which approximates a hallucination. The phantom contour of Kanisza's figure is a case in point. I have mentioned its kinship with the way we complete a sketchy figure, but we may now also see why the two similar phenomena must not be confused. The expectation of continuity is not learned; it is the result of what I have called continuity monitoring. Without this monitoring, as we have seen, we could not survive, but naturally this economy of effort also involves risk. Having to save our attention for the appearance of novelty we gamble on continuation wherever the monitor receives no message to the contrary. It is for this reason, I believe, that we 'see' non-existent lines. They appear because there is an empty screen that allows us to project our provisional expectation. Introduce positive evidence of discontinuity, and the spook will disappear.

7　The Probable and the Surprising

It is not difficult to connect the principle of continuity-probing with the basic idea of information theory without using technical language. For on this very general level the theory of information has really taught us to grade information according to the degree of surprise a message may cause us. Conversely the more a message is unsurprising and the more it could be done without, the more we can regard it as redundant. We may advance a little further here if we remember that we tend in our own lives to equate the surprising with the unlikely and the expected with the probable. We have seen before that this commonsense equation leads to difficulties which need sorting out before we can hope to profit from the new approach. For in what sense can we say that any particular event is 'improbable'? Important as this question clearly is for our quest, we must be careful lest it takes us into a labyrinth of controversial speculations. I do not think we need enter that labyrinth if we keep our purpose firmly in mind, which is the clarification of the principle of perceptual surprise.

　　At the time when 'random' had become a vogue word among artists, and the extremists among action painters had taken to throwing their paint at the canvas, a humorist drew a sequence in which the frenzied throw resulted in an exact replica of Whistler's 'Mother'

Fig. 120. Drawing by W. Miller; © 1961 The New Yorker Magazine Inc.

(Fig. 120). The painter certainly had reason to be surprised, for we must agree that it would be infinitely improbable for this disaster to befall him. But in what sense is this event surprising or improbable? It is here that we must watch our step, for strange as it may sound at first, any other blot would also have been infinitely improbable. Imagine for instance that it had turned out that the artist had unintentionally made a replica of a Jackson Pollock or indeed of one of his own earlier masterpieces— the shock would or should have been the same, provided of course we had spotted the coincidence. The word coincidence is helpful here, for it indicates that the surprise arises from the correspondence of two events or configurations. There being any number of variables intervening when the artist throws his paint—the viscosity of the medium, the distance from the canvas, the direction and force of the throw—we rightly feel that the result will be random. Any discovery of a law governing the configuration must therefore strike us as greatly surprising—whether the structure can be defined in terms of meaning or in terms of geometry. There would also be cause for surprise at the coincidence if the splash had taken on the form of a perfect ellipse. Why? Simply because among the innumerable possibilities of configurations only very few would fall into some category we could name and recognize in any terms.

This is obviously the first point to remember here. It can now be stated a little more precisely by using the standard example of the elementary probability calculus, the tossing of a coin. It is well known that the probability of heads or tails turning up is one half, if the coin is true. This applies to every throw, because previous throws naturally do not influence

Fig. 121

the result. Nevertheless we also know that, the longer the series, the less likely is it to consist of heads or tails only. After a time of identical results we would rightly question whether the coin was in fact true. To work out what the probability is of ten throws in succession being heads, we have to find the number of possibilities there are in the game. With one throw there are two possibilities, h and t. With two throws there are four, i.e. h.h., h.t., t.h. and t.t., that is, two to the power of 2. With ten throws the number of possible permutations is two to the power of 10, which is 1024, and thus the answer to our question is that the probability of the series of heads is one divided by 1024. So, of course, is the probability of any other sequence.

What, then, becomes of our impression of a striking coincidence? Once more it must be due to our bias in categorizing these events. Among the one thousand and twenty four permutations most would look more or less the same to us insofar as they exhibited no recognizable order. It is perhaps worth trying this out by using real coin tosses to 'programme' the threading of beads—white standing for heads and black for tails. Our illustration (Fig. 121) shows the result of ten such sequences. Few of them can be described as a pattern such as tribal artists or children have made from time immemorial when arranging two elements of this kind. We are right in our feeling, therefore, that where we encounter such a pattern, a regular alternation or a symmetrical arrangement such as the last two rows, it is less likely to have come about by chance. But this observation of the greater likelihood of disorder rather than order does not yet explain the visual effect of an ordered arrangement which must be the main concern of the student of design. What, if anything, has this reaction to do with that principle of continuity-probing, the role of expectation and extrapolation, which has led us to consider the theory of chance?

8 Breaks as Accents

The answer must be sought not so much in any principle of order itself, as in the effect of discontinuities, the jolt we receive when passing from order to disorder or vice versa. It was suggested in the Introduction that any such change in the degree of orderliness attracts attention. The disturbance of regularity such as a flaw in a smooth fabric can act like a magnet to the eye, and so can an unexpected regularity in a random environment such as the mysterious fairy rings in wild woodlands. Both reactions testify to the tendency of the sensory system of economizing attention in accordance with the Popperian asymmetry principle by probing merely for that change in the distribution of stimuli that may call for fresh alertness. Our Figs. 122 and 123 illustrate the bearing which these observations have

Fig. 122

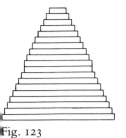

Fig. 123

on the perception of patterns. In the case of the necklace it is the missing bead, the gap between the equal units, which obtrudes on our attention. In the case of the pyramid (an example I take from Wolfgang Metzger's book *Gesetze des Sehens*) the progressive diminution in the width of the steps is taken for granted. Now it is the identity of the two in the middle which breaks the sequence and attracts attention.

What we call a 'visual accent' must always depend on this principle. Its placing and its strength is due to a break in continuity, whether in the density of texture, the direction of the elements or other noticeable irregularities which elude enumeration. Any illustration in this book of an organized design will exemplify this effect. At the same time we can observe that the response to these visual jolts greatly varies. A departure from geometrical regularity which one observer will scarcely notice will strike another as an obtrusive accent. Much depends on what we look for, on what is called our 'mental set'. Testing an instrument for its performance will make us attend to deviations which will be only globally perceived as pleasant variety in a decorative design.

In any case, our scrutiny will narrow down progressively from the general to the particular, from the large to the small. We are thus well attuned to the discovery of primary and subsidiary accents in design, for most patterns, as we have seen, are constructed on hierarchies of orders within orders. What is experienced as a continuous field broken by a border reveals itself on closer inspection as a grouping of discontinuous motifs which may exhibit different orders within their outlines. The systematic aspect of this 'graded complication' was briefly reviewed in Chapter III. The psychological effect will engage our attention in the next chapter. What matters here is that 'continuity-probing' is also graded to register changes between order and disorder on many different levels.

Luckily it has become easy to demonstrate this capacity by means of computer-made arrays. The inventor of this technique, Bela Julesz, has designed many elegant experiments to investigate both the capacities and the limits of our perceptual equipment. Using a computer to distribute the filled and empty spaces in a narrow grid in a genuinely random way, he has shown that stereoscopic vision has no difficulties in responding to small changes of these overall textures unless the instruction to the computer comes to exceed our analytical faculties. Clearly we were not endowed by nature with this divining rod for discontinuities in order to satisfy the curiosity of psychologists or even to enjoy the complexities of decorative designs. Thanks, mainly, to J. J. Gibson, we know in fact what vital part the response to certain continuities must play in our perception of the visual world. He stressed in particular the role of textures and of gradients in our orientation. By texture he means the uniform grain of materials, the sand of the beach, the grass of the lawn, the ripples of the sea or the weave of the cloth. These continuities make us attend to edges and contours. Moreover the perspective effect, resulting in the regular diminution of these repeat elements, gives us vital clues for our spatial orientation. It was not for nothing that Renaissance painters first demonstrated the laws of perspective by means of a chequerboard floor. The identical units so structure the surface that we have no difficulties in seeing the recession. An extension of such a pattern over walls, ceilings and furnishings also demonstrates how texture gradients give us information about objects and their outlines even in a uniform environment (Fig. 124). Victor Vasarely (Fig. 125) has turned this fact to good account in his witty rendering of a clown. Just as a chequered object will stand out, so a hillock in the sand will be set off from the surround by its difference in perceived texture, a discontinuity that will be much enhanced when we move and notice the different rate of transformation the two surfaces will undergo.

It was Gibson also who emphasized what I have called in the Introduction 'the order of changing aspects, the effects of movement on the appearance of the world around us'. He has shown that the mathematical regularities described in the analysis of pattern occur in our

Fig. 124. Marian Wenzel: Perspective of an interior

Fig. 125. Victor Vasarely: *Harlequin*. 1935

everyday field of vision. Moving towards an object it will appear to expand concentrically while the shapes we pass swing around us in regular rhythms. We do not have to attend to these patterned movements and transformations, for we are programmed to expect them as the concomitants of our locomotion. What matters to us is what Gibson calls the invariants, the real shapes of objects which, in his view, we pick out through the information which our senses can process. Whatever our attitude to this particular interpretation may be, his results and those of other students of perception have certainly made it amply plain why the camera model of visual perception must be laid to rest for good and all. We could not function if we were not attuned to certain regularities. This tuning, moreover, could never have come about by learning; on the contrary, we could never have gathered any experience of the world if we lacked that sense of order which allows us to categorize our surroundings according to degrees of regularity, and its obverse.

9 Order and Survival

But whence can we have derived this order? The question is as old as philosophy itself. It plays a decisive role in one of Plato's most moving dialogues, the *Phaedo*, where Socrates in his death cell tries to persuade his disciples not to grieve, because the soul is immortal. He introduces this particular argument by asking one of his pupils whether he knows what 'likeness' is. And yet, how can he know? Had he ever seen two things which were absolutely alike—for instance two pieces of chalk or of wood which could be so described? If not, his knowledge of the idea or the concept of likeness could not derive from sense experience. It must come from elsewhere. We must have seen or experienced mathematical equality before our soul ever entered into our bodies, and it is this memory that provides us with the standard by which we judge whether things in this world are more or less alike.

I once had a student who cried when she read this poignant scene because she could not bear the thought of Socrates having grounded his hopes of immortality on a fallacy. It is true that as a proof of personal survival the argument will not hold water, but if we replace the notion of the individual's memories of a former state by the more modern-sounding idea of our biological equipment Plato was surely right that we are endowed from birth with the capacity to judge our experiences by such prior categories as identity or difference, similarity or contrast. We distinguish the familiar from the unfamiliar and the simple from the complex. Moreover Plato was certainly right intuitively in his claim that there is some kinship between our reactions to remembered sights and to simple shapes. The familiar, as we have seen, becomes the expected and thus we take it as read, unless an unfamiliar context arouses our attention. Geometrical simplicity can also become monotonous and fail to register except where it contrasts with less ordered surroundings.

In modern times the investigation of this response to order has been the principal concern of the *Gestalt* School of Psychology. One of the main problems it attempted to solve was our tendency to extrapolate from discontinuous shapes regardless of our previous experience. This phenomenon of 'closure' is most easily observed during brief exposures of such configurations as an incomplete circle which is confidently seen as continuous. It is understandable that the great pioneers of this line of research, notably Wolfgang Koehler, looked for an explanation of this tendency in those physical forces which result in regular shapes—whether we think of crystals, of the configurations produced by sound waves on vibrating plates, or the patterns made by iron filings in a magnetic field. Koehler postulated that 'closure' and similar reactions to simple shapes have such a basis in the physical events which must accompany perception in our central nervous system. The electrical impulses arriving in the visual cortex of the brain must result in some such ordered distribution of charges which make us see what is not there. I have indicated in the Introduction that these

bold theories are no longer accepted by most students of brain functions. This does not mean that the large range of observations which were made in the laboratories of the *Gestalt* School about our reaction to ordered shapes are no longer of any account. On the contrary, they await a fresh interpretation if and when an alternative theory can be devised.

It certainly would be premature to claim that such a theory lies now at hand, but I have expressed a bias for the solution towards which a number of psychologists have been moving. This is the direction which I owe to Popper's philosophy of science because Popper has always stressed the close links between the methods of science and the activities of the perceiving mind. All hypotheses—whether perceptual or scientific—can be formulated as tentative principles of exclusion, ruling out certain possibilities. Take the illustration of calculating the orbit of a planet from isolated observations. There would be no point even in starting on such an operation if we thought that the planet might dance about in wild loops and jumps. We must begin with the narrow assumption that its course was not random but continuous and regular, hoping that further observations will either confirm or refute this. Should the latter be the case, we will not give up but move to another conjecture next in complexity to the simplest one. In plotting the path of a star, we may replace a straight line by a circle and the circle by an ellipse, the last providing the required fit. The procedure has yielded such spectacular results as Kepler's discovery of the laws of planetary motion and Newton's theory of gravitation not because it was ever probable that the universe around us is simple. Nature rarely is. But the less probable a theory is, the greater will be its information content. If such a theory is corroborated by subsequent observations it tells us much more about the world than a less specific, more general conjecture and thus it leads to a real growth of knowledge.

In recent years the psychologist Julian Hochberg has used the approach of information theory to arrive at a similar interpretation of the facts observed by the *Gestalt* School. He too has linked the simplicity principle with the needs of a successful perceptual strategy. Wherever we have to resort to trial and error in puzzling out the messages transmitted by the senses it pays to start with assumptions of simplicity and to hold on to them till they are refuted, after which we must try another tack only slightly less simple. Hochberg also appends a salutary warning that it is far from easy to specify in every case which assumption should be regarded as the simplest—a warning which also applies to the term continuity I have favoured. We shall see in fact that what I have called the continuity probe may present us with the need for a choice though not necessarily with a conscious one. But at least it is agreed now that without some principle of selection, some way of sorting the incoming stimuli into hierarchies of relevance, the organism would be flooded by an uncontrollable mass of information and perception. I have mentioned in the Introduction that such selectors operate in relation to impressions which have a bearing on the survival of the organism. Certain configurations are pre-coded in the central nervous system and release a chain of reactions when they are encountered in nature. I have suggested in the Introduction that these biological dispositions could hardly stand alone. They must be set into the framework of devices allowing the organism to orient itself in space and in time— and these devices must of necessity relate to general geometrical relationships. Students of perception have discovered what they call 'feature extractors': these operate in the visual system of certain animals such as cats, and respond to particular arrangements such as horizontal or vertical lines, which must thus stand out in the environment. Experiments demonstrating the degree to which certain 'simple' forms guide the orientation of homing insects suggest moreover that for these creatures no less than for us the geometrically simple pattern is more easily coded and remembered than the more complex or random configuration. Whether or not man is also pre-wired for such coding is still a matter for debate. Maybe it could be argued that man is less in need of specifically inbuilt responses

because he can code and hold simple forms in his memory, in language and in art. We have a rich store of categories, concepts and configurations on which we can draw in testing and interpreting the messages from the external world. What is experienced as continuity and what as change depends, among other factors, on our capacity to hold and to remember. We can learn to cope with what Hogarth called 'intricacy', and even to enjoy it, precisely because we are flexible enough to acquire a greater range of expectations which modify and articulate our awareness of continuity during our visual pursuit, our scanning of the environment.

10 Global Perception

Let us return to the permanent record of such scanning—not the instantaneous photograph but the artist's sketch (Fig. 126). Looking over his shoulder as he draws an architectural and decorative ensemble, we shall see his perceptual hierarchies at work as he starts from the relationships he finds easy to code in a few lines, re-constructing rather than recording the main divisions of walls or pavements, and passing on to the more complex shapes he can still set into this framework as he scrutinizes their shape to hold and remember during the brief passage from the eye to the drawing surface. Beyond these shapes, it is true, there will always be others too complex and too elusive for reconstruction and these he can only put down as impressions of continuous or discontinuous textures.

His procedure, I believe, provides an analogue to the way we take in our environment, not in a flash but in stages, sorting and grading our impressions according to the dual principles of meaning and of simplicity.

We thus come back from a somewhat unexpected angle to one of the leading themes of *Art and Illusion*—the use of the 'schema' for the rendering of the visible world. Readers of

Fig. 126. Marian Wenzel: A rough sketch

that book will remember the role geometry played in the construction of these schemata, which are applied and modified in the portrayal of reality. The systems of mathematical proportions, the workshop tricks for the construction of a human head from an egg-shape solid, that cruelly misunderstood advice of Cézanne to Bernard to look at the world in terms of cylinders, cones and spheres—all confirm the importance of these basic structures for our domination of the visual world. If from this point of view the history of representation is the history of the modification of geometric shapes, the history of ornament shows us mankind taking them for what they are, and making them combine and interact in countless permutations for the delectation of the eye.

In analysing this pleasure we must not forget the distinctions mentioned at the outset of this chapter—the distinctions between seeing, looking, attending and reading. Remembering my own normal reaction to decoration before I had embarked on this investigation, I was tempted to call this book 'The Unregarded Art'. The wallpaper, the pattern on the curtains, the scrolls on the picture frame do not impart information and therefore rarely invite conscious scrutiny. True, we also may fail to notice a picture in a room or see it merely as a patch on the wall, but we know all the time that it is meant to be focussed and contemplated. Painting, like speaking, implicitly demands attention whether or not it receives it. Decoration cannot make this demand. It normally depends for its effect on the fluctuating attention we can spare while we scan our surroundings.

In entering one of the courtyards or halls of the Alhambra we react at first as we would react in any environment—we seek to orient ourselves. Such orientation takes time, but a very short time only because there is so much we feel entitled to take 'as read'. We do not have to focus on every pillar or window, for we rapidly and almost subliminally take in the continuities and the redundancies of the principal elements, their order and their position. It is here that we come back full circle to the problem of our visual span and of peripheral vision discussed at the beginning of this chapter. Our confidence in the orderly arrangement of the interior allows us to make use of peripheral and provisional inspection where there is no contrary evidence in sight. And perceiving the further orders of decorative enrichment we can continue in the same way, narrowing the visual span while still relying on the continuities vaguely perceived on its periphery. We have seen that the progress of inspection will generally correspond to the principle of graded hierarchies, as we become aware of further levels of framing, filling and linking down to the final flourish or scroll. Standing in the Alhambra we know that we cannot sample all these infinite elaborations, but we do not have to, either. They do not obtrude, but they will repay attention if we are so inclined.

We must resist the temptation to regard global perception as no more than careless perception. Thanks to the principle of progressive complication, we are able to absorb much more of the general character of a decoration than we can ever consciously analyse, let alone describe. Those critics who feel overwhelmed by the assault on their senses made by the profusion of ornament and have therefore condemned it as tasteless and barbaric may have misunderstood what was expected of them. The skill and inventiveness of the master craftsman is not only aimed at our conscious awareness. It rests on the experience that we can sense the all-important distinction between confusion and profusion without piecemeal examination. We are confident that we are facing orders within orders which would respond to our probing for regularity without making us lose the feeling of infinite and inexhaustible variety. These may be large claims for an art form which is mostly and even rightly relegated to the lower ranks of aesthetic creativity. But history shows that some of the great traditions of ornamental styles transcended the limitations of pure decoration and were able to transmute redundancy into plenitude and ambiguity into mystery.

V Towards an Analysis of Effects

The organism is continually comparing the prognosis of the continually changing new external events with his determined frame of significances.

If they conform, i.e., 'work', he is no longer interested; but in so far as they do not, he has to take stock of the situation.

There are three possibilities—either his frame of significances may be wrong, or his immediate sense response may be wrong, or both. In any case, he has a problem to solve.

The Morning Notes of Adelbert Ames, Jr.

1 The Limitations of Aesthetics

The creation of orders is based on the laws of geometry. The perception of orders must bring other factors into play. The geometrical structure of a visual design can never, by itself, allow us to predict the effect it will have on the beholder. In one respect this is obvious: structure is independent of scale while perception is not. Merely enlarging or reducing a pattern may change the effect dramatically. I could have shown Fig. 127 in Chapter III as an example of counterchange. With diminution below the threshold of resolution the design appears as mere texture. With enlargement, conversely textures reveal underlying orders as in the case of the snow crystals. Colour like scale can influence the effect of any order by making the elements more or less conspicuous through contrast or brightness. But apart from these and other variables which operate on the objective response of the eye, the visual effect of any design must also depend on such factors as familiarity or taste. An unfamiliar script looks different from one we can read with ease. We have seen that taste is the most elusive of the ingredients which together make up the subjective reaction to decorative design. What strikes one critic as richness and splendour may repel the other as a vulgar medley. Milizia in the eighteenth century saw nothing but confusion in the Gothic style and for Ruskin the Alhambra was an abomination.

It is this subjective element in the visual effects of pattern which seems to me largely to vitiate the attempts to establish the aesthetics of design on a psychological basis. There is a large literature reporting on experiments arranged to study preferences. Subjects are asked to rank a variety of elementary designs so as to find out the optimal balance between monotony and confusion—assuming that either of the extremes will be rejected as unappealing. No doubt something can be learned from these investigations, but by and large the result seems to me to be incommensurate with the effort. 'Some like it Hot' as the film title had it, and any observer of the changing scene of fashion knows that preferences in designs and colour schemes can fluctuate with extraordinary rapidity. Where *Art Nouveau*

Fig. 127. Texture with counterchange pattern (C. P. Hornung, 1976)

Fig. 128a. *Art Nouveau* design. 1898

Fig. 128b. *Art Deco* fabric design. About 1920s

relished the sinuous line, *Art Deco* went in for angularity (Fig. 128 a, b). In addition there may well be another source of error affecting these laboratory studies: reaction to design is largely determined by context. Benedetto Croce dismissed the experimental psychology of his day with the remark that if he were asked which shape of a rectangle he preferred for an envelope he would have to know whether it was to contain a love letter or a business letter. He was right, but only partly so. In fact few people care about the shape of the envelope unless their attention is drawn to it. It is only after they have been asked that they may discover their preferred choice. I have mentioned the frequent complaint among art educators that so few people attend to design, but this complaint cannot change the psychological fact that there is a limit to the visual information we can take in and process. Decoration is rarely scrutinized with the same kind of attention which we devote to a painting, let alone to the words on a printed page which we are reading. If it affects us it affects us less consciously, as does the frame of a painting. To what extent can the student of decoration probe these fluctuating reactions without destroying the effect which really interests him?

There is no easy answer to this question, but it seems to me that we must start by acknowledging these limitations. What we wish to investigate are not the inherent qualities of form, invariable properties of visual configurations, but rather the potentiality of design to arouse certain responses. It is the advantage of this more modest programme that it avoids the pitfalls of brainwashing. We do not claim, as do so many books on the aesthetics of design, that certain combinations of shapes or colours should or must be seen in any particular way. We remain aware of the fact that we are frequently asking leading questions and that these inevitably affect the subsequent response. Why should they not? They are part of the previous experience the subject brings to the pattern, but the answer may still tell us something worth knowing.

I have drawn attention in some earlier writings to one such method of using leading questions for the analysis of aesthetic response—the method developed by Charles Osgood and his associates in their book *The Measurement of Meaning*. What Osgood found was that

Fig. 12

we are all ready to answer any question, however absurd, about any experience when we are asked at pistol point as it were, and that these answers will not be random. This comes as no surprise when we are asked, for instance, to grade colours along a scale from warm to cold, for most people experience red as warmer than blue and critical parlance has adopted this terminology. It turns out, however, that we are almost equally willing to assign other sensory qualities to colours, for instance weight, sweetness, roughness or loudness. From here the investigator may proceed to expressive characteristics such as mildness or fierceness, strength or weakness, even goodness or badness in a moral sense. The reader may take any such polarity and try to grade the current designs of Fig. 129 along a seven-point scale in both directions, from neutral to some, more, most; little, less, least. It would certainly be misleading to conclude that such responses are always part of our experience. They are not. It is the method of investigation which brings the experience to the fore. The method probes potential meanings, not experienced ones. It really seeks to determine acceptable metaphors for the description of certain reactions. It is here that I see the value of Osgood's work for aesthetics, for it is notorious that there really is no way of conveying an aesthetic response except by metaphor. Look into any list of wines and vintages with their attempts to convey the distinctive flavours of certain growths, or into any similar descriptions of perfumes. Look at the vocabulary of critics, which has so often struck the uninitiated as pretentious nonsense. Of course it is nonsense when taken literally but taken as metaphor it may occasionally be acceptable to those who are able to test it against their own experience.

Can we go further? Can we justify metaphors in objective psychological terms? In other words, can we explain our feeling that certain colours are warmer than others or certain sounds darker? It could be argued that only a complete mapping of our brain could give us an answer. We would have to know how we are 'wired' and how and where the input from various senses comes together so that our responses to sights, sounds or smells converge in this intrasensory centre. If such connections could be found we might be relieved of the task of explaining visual effects in any but physiological terms. But since this day has not arrived, we may still venture to look for explanations within the modality of vision to account for some of the basic reactions to patterns.

2 Restlessness and Repose

Owen Jones pivoted his aesthetics of ornament on the idea of 'repose'. In a sense the term can only be a metaphor because designs neither move nor rest. Nevertheless we all know spontaneously what is meant by a restless design or its opposite. How does this reaction arise? Introspection suggests that we call a pattern restless when we feel pulled about. The extreme of such a sensation would be caused by an array of irregularly spaced and intermittent flashing lights which for various reasons we must not ignore—for instance if they are all meant to function as signals for action. Our attention would be overloaded, we should no longer know where to look, but feel distracted to the point of helplessness. It is easy to imagine how such a situation could be made worse or better. How the intensity of the lights could make them more conspicuous and contrasts in colour more confusing or how, on the other hand, we could learn to cope if we got the hang of the underlying rhythms and succeeded in forming such firm expectations that we only needed to attend to any unexpected signal. The first alternative offends against our sense of order, the second adjusts to it.

I have chosen an initial example where the restlessness is real rather than metaphorical, because I believe that these effects of movement are not different in principle from those of stationary arrays. The reason lies in the nature of our visual apparatus, which was discussed in the preceding chapter. Our eyes are so constructed that we can only focus on a very

Fig. 130 a and b

ig. 131 a and b

limited area at a time and if we are asked to take in more we have to shift our focus. Where many signals compete for our attention we will not know where to look first and again feel pulled about, without our gaze ever finding rest (Fig. 130a).

It is easy to counteract this effect by the method which tidy people have used from time immemorial—there are ten circles and ten triangles in the field and we need only sort and arrange them in some specifiable order for the spook to disappear (Fig. 130b). It was on this basic fact that *Gestalt* Psychology built its imposing edifice and so I should explain once more in what respect my emphasis differs. In accordance with the preceding chapter I would say first of all that the tidy arrangement has more continuities and fewer breaks—in other words fewer accents. Thus while the *Gestalt* approach fastens on our perception of order I would draw attention to the reverse, our response to disorder. This may look like a mere verbal quibble, but I believe the shift of emphasis has real consequences. Take the effect of 'masking' which plays a part in the arguments of the *Gestalt* School. Rudolf Arnheim in his book on *Art and Visual Perception* makes the point that order wins over experience in configurations such as Fig. 131, for almost nobody will notice that it contains the familiar shape of the figure 4. He is right, no doubt, but how could we recognize it in the absence of those breaks which alone constitute its distinctive features? We would have a hard life if we had to test every continuous line for other lines it may contain. We have seen that on the contrary our eyes are attracted to points of maximal information content. There are also more such points in the restless figure than in the ordered one, hence it demands more attention.

Summing up the discussion of this approach, which was developed in the preceding chapter, we might indulge in a little science fiction and imagine an instrument we could call a 'break-spotter'. It is an instrument programmed to search the environment for discontinuities of stimulation. If we want it to perform this feat we would not only have to endow it with a 'sensor' reacting to light (that is, an eye), but also with a rudimentary storage facility (that is, a memory). We remember that the area of foveal vision is very narrow; a succession of fixations on a repetitive wall paper would not, therefore, inform us of its continuities unless the previous fixation had left a trace in our immediate or 'echo' memory. Our robot would also need such a device to make the impression linger after the stimulus had disappeared, something like a bell which continues to vibrate after it has been struck, or like an after-image which fades only gradually. A mere renewal of the identical stimulation would cause no external reaction, but the greater the difference between the recent stimulation and the new one, the more our break-spotter would be made to react. In other words it would pass continuous arrays but in accordance with the Popperian principle of asymmetry, it would stop and flash at breaks. Such an arousal system might give the user of the instrument the kind of sensation I have described—the sensation that the break is a magnet to the eye and that too many such magnets competing with each other in an unexpected way would result in uncoordinated movements. Objectively speaking, it is not the breaks which attract the eye but the eye which seeks the breaks. Since, in our simplified

Fig. 132. Records of eye fixations (G. T. Buswell, 1935)

model, the 'break-spotter' emits no signal during its automatic scanning of continuities, it must give its users the subjective feeling that it moves purposefully towards certain points.

We could improve our mechanical model to justify this feeling even better and to correspond more closely to the construction of the eye. Visual perception is not an all-or-nothing affair. The focus is narrow but the visual field is wide, and a conspicuous break is perceived even at the edge of the visual field, thus alerting the instrument and initiating a move to inspect the spot. Such a possibility should make it most economical for our 'break-spotter' to sample the environment in a number of rapid random movements which are likely to lead to the detection of significant breaks. Up to a point this is indeed how our eyes appear to be functioning. They dart around in 'saccadic' movements, during which they transmit no information to the brain. Only when they come to relative rest do they resume their function. It will be remembered that William Hogarth and Owen Jones took it for granted that the eyes perform what might be called continuous tracking movements along the lines drawn by artists. We still read in many popular accounts that the artist thus leads the eye, but this comfortable notion had to be given up as soon as techniques were evolved to photograph eye movements during reading or during the inspection of pictures. Not that these photographs disprove the existence of a subjective feeling that we do run our eyes along continuous lines. The feeling arises from the processes of extrapolation and interpolation, of filling in, which was also discussed in the preceding chapter. We are always ready to expect and supplement continuities unless the opposite is proved. We behave, in other words, as if we could regard continuities as relatively 'redundant' while breaks will yield the information we seek.

The conclusion is less abstruse than it may sound. Long before the theory of information was ever thought of, illustrators of books on design acted accordingly. To represent a particular type of column it was deemed sufficient to show the distinctive terminations, i.e. base and capital with just enough of the shaft to indicate its shape (Fig. 83). Not surprisingly therefore, photographs of eye movements and fixation points show that continuous contours appear to have been less thoroughly inspected than those parts of the design which cannot simply be 'taken as read' (Fig. 132).

We remember from the preceding chapter that this tendency of our perceptual system is so marked that it also assumes continuity where none may be present. This is the case, for instance, with the Kanisza triangles (Fig. 119) where we see phantom lines, which are not there, extending between the breaks. To simulate this reaction in our apparatus we would clearly have to endow it with an 'extrapolator', a device which goes beyond mere registration of continuities to the production of continuous shapes.

Once more it is easier to envisage such a mechanism for temporal rather than spatial patterns—in fact it appears that in this form my break-spotter hardly belongs to the realm of pure fiction. As continuity monitoring of biological rhythms serves a vital need in medicine, an instrument appears to have been developed for use in intensive care units which registers the heartbeat of the patient. Since, however, a 24-hour cardiogram would also take long to read the machine can be instructed to pay attention only to arhythmical sequences. Whatever precise form this wizardry may take, it must in principle be based on a tuning device which matches the normal rhythm of the pulse but starts up as soon as a 'mismatch' occurs, when its own rhythm and that of the patient get out of step. It must be in line, therefore, with the speculations put forward in my Introduction. I there stressed the need of the organism for the production of orderly sequences in the service of the detection of disorder—my examples ranging from the generation of electric impulses by certain fishes to the capacity of 'forward matching' I attributed to the horseback rider who falls in with the rhythms of his mount and will attend only to unexpected jolts or changes.

Remaining within the temporal modality, it is not hard to imagine how such a matching device could be designed. It would have to possess a repertory of rhythms and speeds to which it could switch much as a dancer can pick up the music and adjust his steps accordingly. The simplest of these repertories could not continue long without a break till it has sent us to sleep; it would be productive of both 'repose' and of 'boredom', while the other extreme would certainly deserve the description of 'restlessness'.

To pursue the analogy between the perception of temporal and spatial patterns we would have to postulate a repertory for shapes which corresponded to that for rhythms. Our 'break-spotter', then, would have to generate a series of patterns and test them against the incoming stimuli. In conformity with recent discussions along such lines we might call these generated patterns 'templets' though they would naturally not be rigid shapes but rather flexible patterns of waves used for the scanning of the environment. It seems to me that many of the observations of *Gestalt* psychology could be accommodated to such a notion— both that of 'closure' discussed in the previous chapter, and that of 'masking' mentioned in this one.

We certainly know that the brain can and does spontaneously generate visual patterns of much greater complexity, though we rarely see them except in abnormal states. I am referring to the dazzling and sometimes beautiful configurations which can interfere with our vision during attacks of megrim and are a frequent effect of hallucinatory drugs—from which the so-called 'psychedelic' fashions of decoration took their cues. It has been suggested that such flickering visions are always potentially available, but are normally suppressed by the activities of conscious perception. It would be tempting to see in these morbid manifestations a run-away effect of our active sense of order. Whether, and in what respect, they may be regarded as an analogy to the 'templets' with which our 'break-spotter' had to be fitted out, I would not dare to say.

We do not have to resort to such wild speculations to explain how such templets might function as a counterpart to the internal rhythms facilitating 'forward matching' in time. It has been shown that our visual system is attuned to the detection of spatial regularities, however this detection may be achieved. A straight line of evenly spaced dots is detected even beyond the narrow span of foveal vision and in the presence of much visual 'noise' (that is of random dots scattered around them). Such tasks of detection can be graded by difficulty. A series of dots arranged in a straight line is more easily found than a curved or angular one, and regular spacings are more easily discovered than irregular ones. The student of pattern could not wish for a better confirmation of the laws of simplicity. We have seen that this kind of simplicity can be interpreted as a form of redundancy. The regular row of dots, once defined and matched, merely repeats and brings nothing new. The more a

system or set of shapes is dominated by specifiable laws the less information will be needed to reconstruct any element that may have been missed.

The psychologist W. R. Garner has used this trend of thought to suggest that configurations which *Gestalt* theory described as 'good' can thus be defined mathematically as members of a small subset of regular systems. His analysis may not be free of artificiality, but what matters here is the intuitively obvious finding that forms of maximal regularity can be most easily specified and produced. To describe a sphere you need only one variable, the radius: however you turn it, it remains invariant. A random lump of rock could never be exhaustively described and there can be no 'templet' to match it.

But however difficult it may be to define simplicity in a way which suits every purpose, it is clear that belief in the existence of a sense of order must also presuppose a criterion of simplicity and its opposite. Our 'break-spotter' would not only probe the environment in a sequence of graded complexity, as if the 'templets' were pre-arranged for this routine; the accuracy of these probes would also vary according to the calibration for which the instrument is set at any given moment. By and large, as we have seen, it would scan any shape somewhat like a draughtsman who roughs out the main outlines before filling in and refining the detail (Fig. 126).

We have learned in recent times that this tendency of our 'break-spotter' to leave internal lines unexamined can be used to trap it into overlooking glaring inconsistencies of design. I am referring to the so-called 'impossible figures' which have attracted so much attention of late, since M. C. Escher and Josef Albers (Fig. 91) took them over from the psychologist's laboratory. No account of perceptual illusions is up-to-date without the so-called 'devil's tuning fork' (Fig. 133a), the three-pronged configuration which turns out not to be three-pronged at all. What matters in this context is the role here played by illicit extrapolation. Unlike the non-existent lines of Kanisza's triangles (Fig. 119) the lines of the tuning fork design are real enough. It is their function in the representation of a three-dimensional object which changes surreptitiously. Starting from the prominent three ovals which indicate the termination of three rods represented in the drawing, we take the lines to be intended as contours of three solids, and switching our fixation to the other side we also find the base to which they should be attached. Normally it would be redundant to follow such outlines all along from tip to base, and so we fail to see that in the interval between fixations what was the outline of a rod became the boundary of a void—something that could not happen in a real object. It is the absence of a break which lulled our 'break-spotter' into reporting 'continuity'. The mistake is all the more intelligible as there is no particular point where it should have signalled the switch. It reports correctly, however, as soon as we do introduce a break anywhere between the two sides of the drawing (Fig. 133b). I have suggested in another context that we can also clear up the paradox if we reduce the scale of the design so that it can be taken in at one glance (Fig. 133c). For the explanation of visual effects extended between repose and restlessness the devil's tuning fork is only of marginal importance, demonstrating a disquieting puzzlement which has rarely been consciously aimed at by pattern-designers before this century. There are 'impossible objects' resulting from inconsistencies of design in Hellenistic and Roman mosaics (Fig. 134), but it is hard to tell how far they were intended to bemuse.

The tuning fork effect proves that it is possible to deceive our 'break-spotter', but this fallibility does not deprive it of its usefulness. We all use it whenever we are engaged even on

Fig. 133

a

b

c

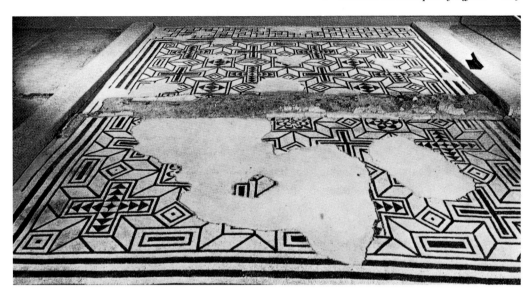

Fig. 134. Mosaic floor
from Fishbourne,
Sussex. A.D. 75

the most humble task of design, decorating a Christmas tree or arranging pictures on a wall. Distributing our elements, we step back to see where a 'break' demands to be filled. Another candle on the tree, another picture on the wall, will restore the repose. True, if we then go on enriching a particular area we create gaps elsewhere which have to be seen to in their turn. We have watched this kind of procedure in Chapter III when discussing the tendencies of the *horror vacui* or *amor infiniti* in decoration (Figs. 85, 86). Once we are caught in 'break-spotting' it is hard not to go on 'framing, filling and linking'.

I have placed 'framing' first in this sequence because it is the frame or border that delimits the field of activity both for the decorator and the viewer. The border or frame may be described as a continuous break which sets off the design from its environment. It matters little how this break is achieved; it may be done by a contrast in shape or colour, a change of direction, or even by a blank space (Fig. 135). Suffice it that some firm disruption of regularity alerts the viewer. Discovering such an enclosed field we expect an area that repays scrutiny (Plate 1). Once we are engaged in this inspection, the border will function like a barrier seen from the corner of the eye. It tells us where to start and end and it will do that all the more efficiently the simpler its shape. By contrast a playful Rococo frame will exhibit that restlessness which will invite the eye to linger and search. It presents an inversion of the norm (Fig. 22).

Normally most man-made objects in our environment are constructed on simple lines.

Fig. 135

The decorated object is therefore automatically provided with a frame or limit beyond which the eye need not stray. Admiring a Persian rug we have no difficulty in confining our gaze. Oscillating between global attention to the principal 'breaks' or accents and focussing on individual areas with their finer articulations, as did Walter Crane in Fig. 115, we quickly take in correspondences between areas, which will therefore offer no further surprises, and contrasting fields, which promise fresh delights. Though we know we cannot exhaust the design we do not feel 'pulled about' as we did in front of the 'restless' medley.

There is no doubt that familiarity contributes to such a feeling of repose, much as novelty may create difficulty in sorting out the design. But even without such prior conditioning we respond to the degree of simplicity or complexity exhibited by a design. We again remember the contrast mentioned in the Introduction between the 'crazy pavement', which defies analysis, and the paving with flagstones, which is so easily remembered. The realm of decoration extends between these extremes of confusion and monotony; the one will send the 'break-spotter' spinning, the other will perhaps cause it to switch off.

3 Balance and Instability

There is one visual effect which clearly occupies a privileged position in our field of study, and which must therefore offer an important test case for any explanatory hypothesis—I am referring to bilateral symmetry and the impression of 'balance' it creates spontaneously. If repetition is a form of redundancy (as in S.O.S., S.O.S.), it is easy to see that symmetry must be a special form—it mirrors the arrangement on one side of the central axis on the other side. But why, we may ask, is such a reversed sequence favoured by our perceptual system? That this is indeed the case is easily shown by any arrangement of typographical signs. Take a succession of such signs, such as the following alternation between repeated brackets and the letter O: ((((O(((O((O(O((((O(((O((O(O. It takes a moment to see the underlying rule of diminishing numbers of brackets and to spot the redundancy. But if we do not repeat but reverse the sequence, the impression of palindromic regularity is immediate: ((((O(((O((O(OO)O))O)))O)))). Speaking in geometrical terms, 'translation' is less easily seen than 'reflection'.

We should not be unprepared for this effect if we remember the bias of our 'break-spotter'. For in bilateral symmetry the central axis must offer a 'magnet to the eye' since it is the only area which, by definition, is not repeated in the array. Instead of being 'pulled about', our imaginary device therefore remains suspended between two equal attractions and locks in on the point of maximal information. Taking up this vantage point and starting to test for simplicity is bound to establish the redundancy of the proximal elements, for it will receive the same sequence of messages whether it veers to the right or to the left of the axis. Having thus formed the preliminary hypothesis that this form of redundancy may prevail throughout, peripheral vision will rapidly confirm it.

It is this confidence in the break-spotter's ability to cope with the information presented on either side of the focal point that may account for the fact that symmetry appears to expand our field of vision, our visual span. Compare the asymmetrical design of a rich Baroque structure, showing two different aspects on either side of the axis, with a symmetrical arrangement (Figs. 136 a, b). In the latter we feel that we can detect the many mirroring features on either side of the foveal area without having to scrutinize them in succession. The effect increases with scale. Remembering the experience of orienting ourselves in a regular building, discussed in the previous chapter, we appreciate the ambition of architects to organize a whole complex or piazza symmetrically so as to give us the feeling of an expanded horizon (Fig. 137).

At the same time the role of peripheral vision in the global impression of bilateral

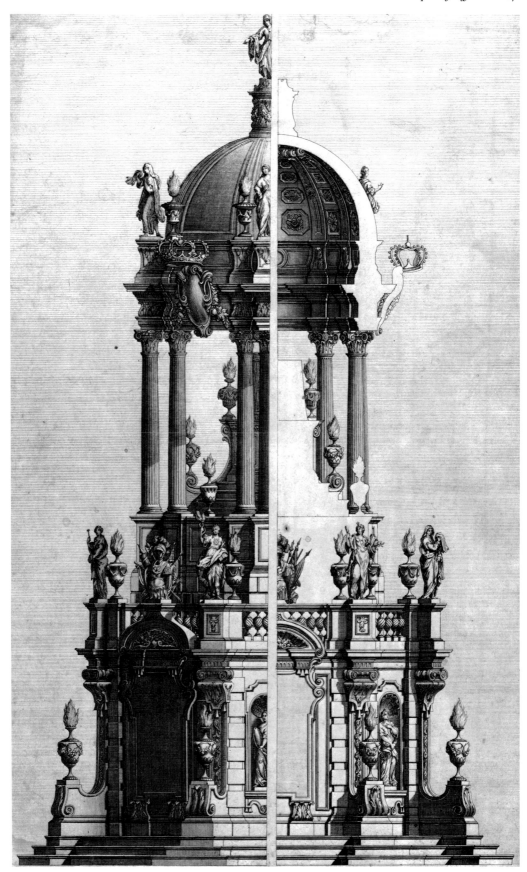

Fig. 136a. Joseph Galli de Bibiena: Design for a catafalque. About 1715

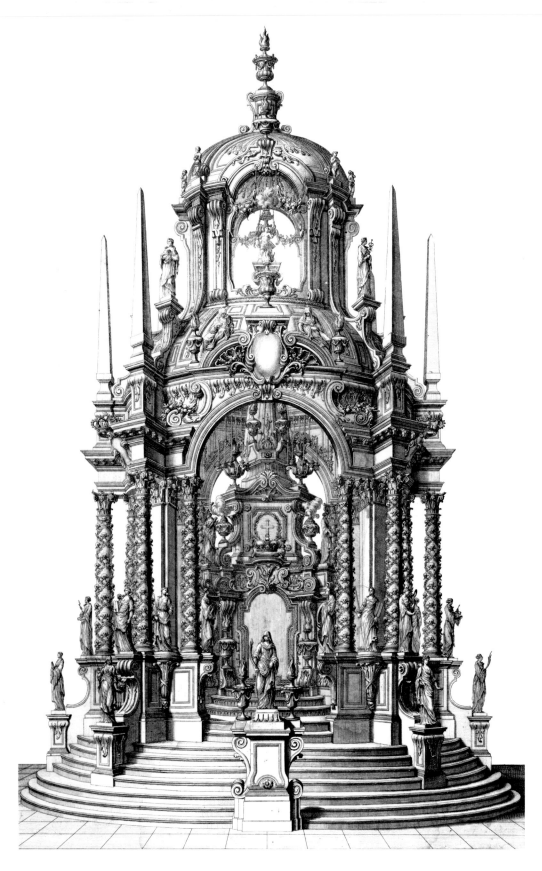

Fig. 136b. Joseph
Galli de Bibiena:
Design for a
catafalque. About
1715

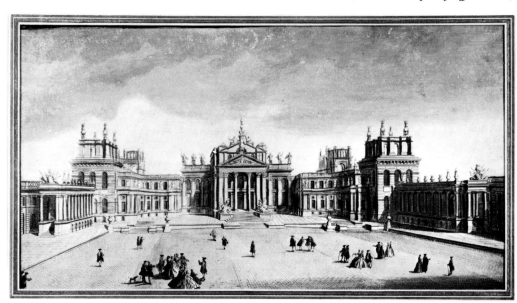

ig. 137. Sir John
'anbrugh: Blenheim
alace. 1705–24

redundancy also helps to explain why we rarely notice minor deviations from symmetry, unless we are set to discover them (Fig. 138). It is well known that we pay little attention to the asymmetries of the human face as long as the expected features are roughly in their place. Only when our attention has been drawn to these irregularities do we find it hard to disregard them.

The tolerance we extend to such minor departures from symmetry also accounts for the success of Ruskin's plea against precision. Precision can look 'dead', because of the surfeit of redundancies. If our hypothesis is everywhere confirmed and no fresh jolts are administered to our apparatus the effect is one of monotony.

The student of visual effects does well in taking metaphors seriously, for they must tell us something of the way our experiences are categorized. The equation of symmetry with balance is a case in point. No doubt it seems obvious if we think of elements of identical weight and equal size being placed on opposite scales (Fig. 139). We do not expect such an arrangement to be unstable and we transfer this confidence to the symmetrical design. But neither in mechanics nor in design is balance always dependent on such identity. There must be an added reason for the privileged position which bilateral symmetry appears to hold in our perceptual reactions. I believe that it is a mistake in these matters to confine the analysis of effects to static configurations. Our perceptual systems, and therefore our 'break-spotter', must be attuned to the needs of the organism in motion. This is the area in which J. J. Gibson has revolutionized the study of perception. He has drawn attention to the way the visual system guides us in our movement through the transformations which our environment undergoes. Walking or driving towards an object on level ground and fixing our eyes on the 'target', we not only see it increase in size, we also perceive what Gibson calls the 'panoramic flow' of the surround which opens up before us and swings round in a regular pattern. In this situation asymmetry of the flow will either denote that we have swayed from our course and must adjust it, or that the ground is not level. In other words the 'balance' of symmetrical patterning of peripheral vision is involved in the basic experience of monitoring our own balance and movement.

It fits in well with these considerations that the 'balance' of the symmetrical design demands as a corollary a firm frame or another means of isolating the configuration. In particular any further repetition will threaten the repose; because it destroys the uniqueness of the central axis. The sequence ATA is symmetrical, but if it is repeated as ATAATAATA, rival

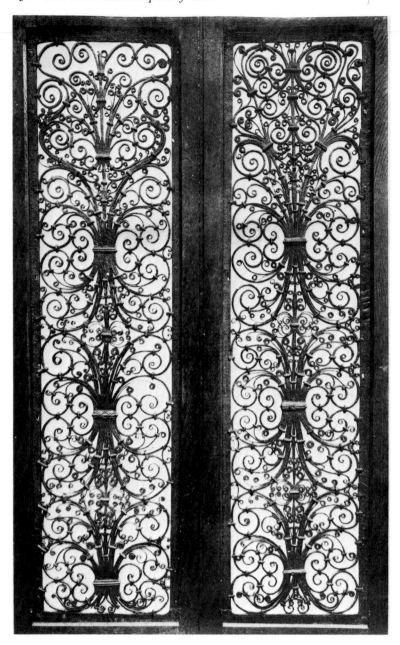

Fig. 138. Altar grille
from the Abbey of
Ourscamp, France.
12th century

symmetrical orders of TAAT and AATAA are created which extend on either side and threaten the restfulness of the single reading (Fig. 140). A variety of 'templets' fit the case and so the search cannot come to a successful conclusion.

The most striking effect of this multiplicity of reading is connected with the alternation between 'figure' and 'ground', discussed in the third chapter. The more the two are 'balanced' the more the total configurations will conform to a variety of hypotheses. Hence that form of restlessness which derives from the alternation of readings—often illustrated by

Fig. 139 Fig. 140

the cruciform design inside a circle (Fig. 141) which tends to change from a black shape on a white ground to a white shape on a dark one. Both readings 'fit' and there is no way of deciding between the two.

The clearest example of such instability is also one of the most frequent and widespread designs—the chequerboard pattern (Fig. 142). Test the field for continuities of colour, and the diagonal rows of black or white squares will dominate the impression. Focussing on a white square and regarding it as a centre of a black cross, you can test the rest of the field for redundancies and see that there is no contradiction; identical black crosses can be found anywhere. Let the eye stray to a black square and you will find the configuration of white crosses around a black centre repeated. If, finally, you are tempted to look for a cross along the diagonal axes of a square, such a figure of fivesquare (a quincunx) will obediently come into prominence either in black or in white. Up to a point the experience suggests that we are in control of the apparatus and can switch to various test patterns at will, but it turns out that this control is limited. We cannot hold our readings for long, because the 'break-spotter' is designed in such a situation to probe for alternatives and so the pattern will appear to fluctuate in front of our eyes.

Discussing the activity of probing and testing which I attributed to visual perception in *Art and Illusion*, I spoke somewhat daringly of 'tentacles of phantom colours and phantom images which always flicker around our perception'. We rarely notice these probes, this 'forward matching', for if the anticipation comes true we need no longer distinguish between expectation and perception; if it does not, on the other hand, they are rapidly erased. The chequerboard makes the phantoms visible because it neither contradicts nor fully confirms our visual forecast.

Testing for simplicity, our apparatus matches its templets against the redundant rows of repeats, but a highly redundant design of identical elements offers no easy anchorage for our apparatus on which to 'lock in'. It drifts and loses its place. If we want to count a series of identical visual features we tend to use our finger and count by pointing, because they are too slippery for the unaided eye. As soon as we shift our gaze we may have lost the figure and landed on the ground so that another 'templet' comes into prominence. The larger the area and the more elusive its features, the more it will exhibit this subjective kind of restlessness, fluctuating in front of our eyes and offering any number of readings as in the case

Fig. 142 a and b

of the Chinese lattice design (Plate 26). At the same time it will resist any grouping for which the apparatus is not programmed.

There is a little poem by the German mystic and humorist Christian Morgenstern which neatly describes what happens when we attempt to counter the pull of existing continuities in gazing at a repeat pattern such as a flowered wall paper but trying to use it for an imaginary game of chess.

Tapetenblume bin ich fein,	I am the flower in your room
Kehr wieder ohne Ende,	That always comes again
Doch, statt im Mai'n und Mondenschein,	Not just in spring my blossoms bloom
Auf jeder der vier Wände.	But yet and yet again.
Du siehst mich nimmerdar genung,	See, I am everywhere the same
So weit du blickst im Stübchen,	Just look your fill, my lad,
Und folgst du mir per Rösselsprung—	But don't you try the knight's-move game
Wirst du verrückt mein Liebchen.	For then you will go mad!

What drives the victim of the wall paper crazy is not the redundant pattern, but his vain attempt to read it for once in an unexpected way. He tries to focus on the motifs in the sequence of 'knight moves' and predictably loses the spot from which he just started, unless, perhaps, he risks spoiling his walls by marking every spot on which he wants to alight. The result of such a track of 'knight moves' would still look somewhat restless, but it might well do as a wall paper design.

Like all psychological mechanisms the compulsion for our eyes to run along the established rails of redundant repeats can be used by the designer for contrasting effects. He can use it to enforce a reading or to unsettle our perception in a most disturbing way. The first possibility is brilliantly demonstrated in the book *Gesetze des Sehens* by the *Gestalt* psychologist Wolfgang Metzger. He shows us two geometrically identical grids with different terminations (Fig. 143). Where the stars are jutting over the edge they acquire a prominence that makes us notice the stars throughout; where the squares stand out from the field it is they which dominate the appearance of the pattern.

We are reminded once more of the tendency to read any shape from outside in. It takes a

Fig. 143. The effects of the border (W. Metzger, 1975)

moment therefore to realize that the two patterns of Fig. 144, taken from a French nineteenth-century handbook of decoration, are also identical except in their tilt. Predictably the edge offers the strongest articulation and where this is echoed by the transversal lines it is these which come into prominence, while the different edge of the other example makes us aware of the axes of the crosses which run parallel to it.

We have seen that the 'extrapolator' of our system is so thoroughly biased for the establishment of continuities that we assume their existence between fixation points, as in the Tuning Fork illusion. In Gordon Walters' painting (Fig. 145) the white strips curl into visual accents on the left, the black ones on the right, leaving the zone between them to oscillate between figure and ground according to where we look first. An even more

baffling trick is played on our 'extrapolator' by the so-called Fraser Spiral (Fig. 146), which is not a spiral at all, but a series of concentric circles superimposed on vortex lines. These lines, it turns out, tend to deflect our searching gaze so that we always lose our place and settle for the most plausible 'templet', the continuous spiral. The tracing pencil will convince us of our perceptual error, and so will the device of covering up half of the field which permits us to see the concentric semicircles as parallels. As with the tuning fork illusion, lightening the load of information helps our grasp of reality.

In recent years the systematic overloading of our perceptual apparatus has been adopted as a legitimate means of art—I am referring to the interesting experiments which became known as 'op art'. Though the results transcend the scope of decorative design they are of great theoretical interest as an extreme of 'restlessness'. What the study of these effects confirms is the difficulty our 'extrapolator' can encounter when the designer sets it a variety of 'traps' it was never constructed to cope with. It is good in recognizing continuities and redundancies, but bad, as we have seen, in 'locking in' on a particular feature of repeated elements. If, in addition, the fields of the chequerboards are not identical but get progressively smaller as in Fig. 147, there comes a point when two different continuities

Fig. 146. The Fraser Spiral

Fig. 147 (*opposite*). Spyros Horemis: Op art design. 1970

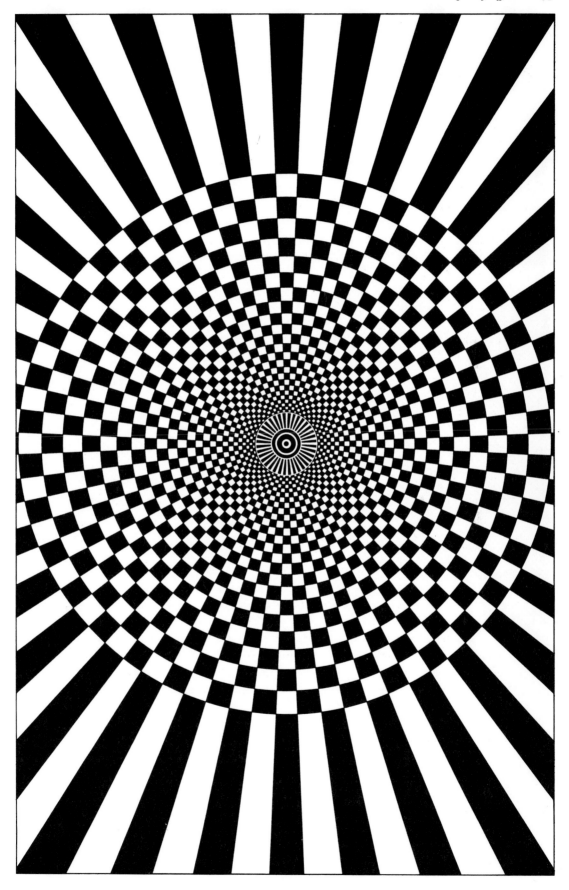

struggle for dominance. Near the circumference of the circle, where the squares are large and prominent, we tend to follow their alternation along the straight line towards the middle. But when we lose the individual squares we mainly see the continuities of black or white sequences along the diagonals which curve in intersecting arches from the centre. Which of the two alignments wins over the other depends on our initial fixation and on the distance from which we view the pattern, but there is always a zone of conflict where various readings (including a circular one) will clash and fluctuate. There is no contour to hold on to, no obvious point of transition, and thus we oscillate in our search for a reading we can grasp. Moreover our visual apparatus is somewhat slow in adjusting itself to brightness differences—a dazzling contrast produces an after-image which shifts as we shift our focus. Hence the inspection of a complex grid may become confused by after-images of the same grid which become superimposed and produce the moiré effect mentioned in Chapter III (Fig. 108). And the effects of fatigue due to overloading, and we are nearer an explanation of that uncontrollable flicker which often settles on the images of 'op artists' (Fig. 148a). I

Fig. 148a. Reginald Neal: *Square of Three Black and Yellow.* 196

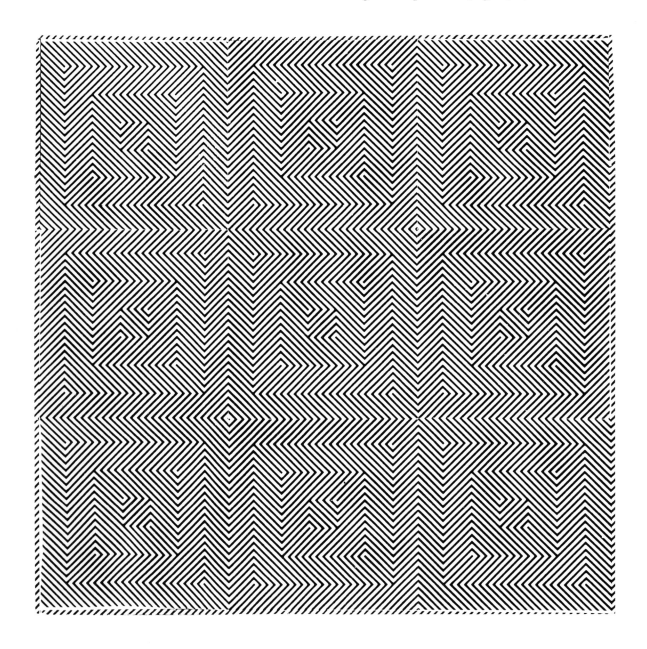

Fig. 148b. Detail of Fig. 148a

believe that even here introspection and experiment can help us to come closer to an understanding of the matter. Nothing is more instructive than to watch what happens when we cover up part of the field till the eye is quite capable of analysing the pattern (Fig. 148b), or to resort to mirrors and magnifying glasses to stalk the effects even further. The elimination of surplus redundancies from the unfocussed part of the field immediately stills the pattern and makes them look rather ordinary.

4 *Waves and Vortices*

The flicker effects of op art show that there are at least two distinct causes of restlessness. One is the result of the movements of a 'break-spotter' which is subject to various pulls, the other of its internal mechanism, which sets it searching for the right templet it can never produce. We may describe the first alternative as psychological, the second as physiological. But other factors enter as soon as meaning comes into play. I have mentioned the danger of taking metaphorical descriptions of visual experience too literally, but it may well be asked whether the element of metaphor, that is of comparison, can ever be fully eliminated from our experience. These reflections are prompted by the effects of what we call 'wavy lines' and 'vortices', motifs which are experienced by most observers (if not by all) as undulating or turning, and the question must be asked how far associations play a part in these reactions.

It was William Hogarth who first suggested that the pleasure he found in what he called the 'line of beauty', the wavy line, derived ultimately from our searching mind and eye: 'The serpentine line by its waving and winding at the same time different ways, leads the eye in a pleasing manner along the continuity of its variety, if I may be allowed the expression; and which by its twisting so many different ways, may be said to inclose (tho' but a single line) varied contents.'

We have seen that we need not dismiss Hogarth's idea of visual pursuit, though we no longer attribute this pursuit to tracking eye movements. Whatever the ultimate cause, the wavy line will be found by all observers to suggest motion more easily than a straight line (Fig. 149). It may well be that the impression is derived from the confluence of several factors. One of them is the fluctuation we experience in any configuration where figure and ground are evenly balanced. Searching for similarities we find that each bulge corresponds to the next bulge, but also to the negative bulge it leaves on the other side. Indeed, comparing the mirroring forms along their 'gliding axis', we have to switch our reading from positive to negative shapes. What is part of the 'figure' in one reading is part of the 'ground' in the next, but there is no real break or border which would help us to settle any interpretation. Our 'break-spotter' will not be pulled about as in a violently restless pattern, but it is unlikely to come to rest.

This is the point to remember that our fictitious instrument would present a very imperfect analogy to our real equipment if it were designed to function only in a stationary environment. Our world is in constant motion and our instrument must be adjusted to keep track of and to anticipate the changes resulting from our own movements and those of the objects with which we interact. In other words the message 'here is a wave' would set up an anticipation of movement, much as the sight of an unbalanced configuration would produce the signal of an imminent fall. It is hardly profitable to speculate whether we are

Fig. 149

a b c

Fig. 150

born with a disposition to react like that or whether our imaginary device would here have to incorporate the results of experience.

The same applies to the impression we receive from radiating lines (Fig. 150). Most people will tend to see the schematic picture of the sun with its black lines as rays shooting outwards. Association and learning no doubt have a share in this reaction, but here, as with other symmetrical designs, we should not neglect the effect of our own movement. The expansion corresponds to the effect we could anticipate when approaching the disk. Detaching the lines enhances the impression, for now they seem to hover in space. But an enclosing line inhibits it, since it turns the rays into the spokes of a wheel.

There may well be a combination of these factors in the most striking of 'dynamic' effects in design, that of the so-called 'vortex' or 'whirl' motif (Fig. 151 a–b), of which the name once more suggests an association with forms in real motion. The best known motif of this type is the swastika of evil memory (Fig. 151c), which has always been felt to be endowed with a certain dynamic energy. Whence does this energy derive? Why do we experience the symmetrical Greek cross (Fig. 151d) as balanced while the crooked cross seems ready to rotate? There is no sanction for this impression in mechanics, for if either were pivoted on an axis the four arms of both constructions would weigh the same.

I would suggest that this dynamic derives from the way we test our primary impression for redundancies. If the crooked cross were really in motion there would be no difficulty in such tests, because each of the arms would quickly be seen to be identical with the others when it comes into the same position. In the Greek cross we don't have to wait for rotation because, as we have seen, all axes are alike when scanned from the centre. In the vortex motif we have at least to carry out an imaginary rotation to see that they are invariant. True, from the geometrical point of view there is no reason why this rotation should be clockwise. It is here that the impulse to continuity-probing appears to make itself felt. Each of the arms points in a particular direction and seems to chase the next; we follow, I believe, not with the eyes but with the mind.

It is doubtful whether this reaction to rotated forms can altogether be explained in terms of vision alone. Our preference for bilateral symmetry has its obvious counterpart in our body movement. Asked to perform a certain movement with both hands we are more likely spontaneously to make mirroring gestures. After all, our hands themselves are felt to be mirror images of each other, and if we make parallel movements the thumb will lead in one and the little finger in the other. Hence it is easier to write mirror writing with your left hand while you write the same words normally with your right. Perhaps it is for the same reason that children easily confuse letter shapes with their mirror image and write И instead of N. Bilateral symmetry around a vertical axis is felt to be close to identity. The same is not true of symmetrical forms turned upside down. At least it seems to me that ⌐ is much more likely to be confused with L than with Γ. Hence, perhaps, the compulsion to test by mental rotation these puzzling forms which are both alike and different. Rotational symmetry represents an order which is visually less easy to grasp. I hope it is a pardonable exaggeration to say that it is not the motif which is unbalanced but that it upsets the balance of our mind. Random shapes do not produce this effect, it rather arises from the clash between our sense of order and a visible regularity which eludes the basic laws of simplicity, the first for which we test our environment.

a

b

c

d

Fig. 151

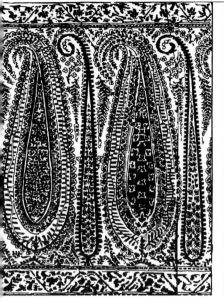
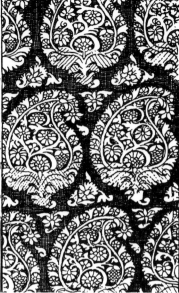

Be that as it may, any designer of geometrical patterns knows that he has it in his power to adjust their balance in one way or another by his setting of visual accents and that, conversely, the weight of these accents can be assessed by the degree to which they affect the balance. He will be equally skilled in introducing a counterpoise to keep his pattern dynamic without becoming restless. The popularity of the 'Paisley pattern', for instance, depends to no small extent on the ease with which the asymmetry of the motif can be adjusted by varying the relation of the 'fruit' and the 'stalk' (Fig. 152). Moreover the directional pull of a row of these motifs can be counteracted by turning the pattern the other way in the next line, thus restoring a kind of symmetry productive of 'repose'.

There is every reason to believe that craftsmen encountered and solved this 'dosage' of asymmetry independently in many diverse traditions. I have in mind such masterpieces as the early Celtic mirrors (Plate 40), Maori paddles (Fig. 153) or American Indian pottery (Fig. 154). A more systematic investigation of the effect can be found in the variations on the Gothic rose pattern, some of which are illustrated in Fig. 90. They show that asymmetry need not lead to a loss of that quality Owen Jones called repose. But the past masters of 'dynamic symmetry' are surely the designers of China and Japan. Here that famous symbol

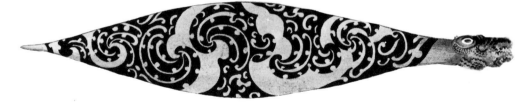

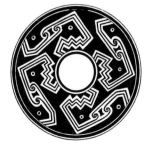
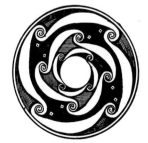

Fig. 153. Maori canoe paddle.
Late 18th century

Fig. 154. Pottery designs of the
Mimbres Indians of New Mexico.
A.D. 900–1100

of harmony, the unity of 'Yin' and 'Yang', sets the key with its asymmetrical halves so perfectly fitted into a restful circle (Fig. 155). Just as *Chinoiserie* gave the Rococo designers the courage to depart increasingly from bilateral symmetry, so the example of the Japanese, as we have seen, opened the eyes of the late nineteenth century to the possibilities of more complex harmonies (Plate 42).

Fig. 155. Yin Yang symbol

5 *From Form to Meaning*

It must have become increasingly evident that the distinction I have attempted to maintain between the perception of geometrical orders and the perception of things can never be clear-cut. We would be hard put to decide in which of the categories to place one of the most frequent devices of ornamental design—the interlace. The device defies any tidy classification, for interlace can be, and often is, a solid reality, the result of plaiting, knotting or weaving, but it is no less frequently used as fiction in three-dimensional lattice or relief as well as in flat design. What must interest us in the context of the perception of form, however, is not so much the exact boundaries of these media as the degree to which the appearance of overlap imposes a reading on forms and lines. Once more it is the 'continuity assumption' which comes to the fore in this universal effect. Take the simple pattern of alternating rectangles such as occurs on the tiled floor of a mediaeval German church (Fig. 156). It is not a design which is in any way difficult to specify for what it is, but even so, we

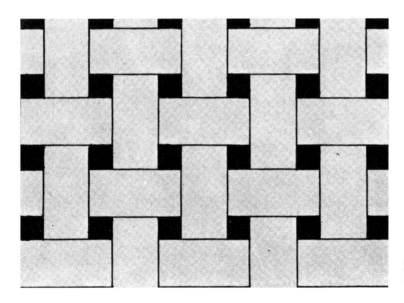

Fig. 156. Floor-tile pattern (Kier, 1970)

tend to interpret it in defiance of reason as a three-dimensional pattern. In other words we follow the pull of continuity and simplicity, which suggests a reading in terms of crossed bands. If this is the case where no formal indications suggest the presence of solid ribbons, the suggestion becomes irresistible where the contours of the bands or ribbons are indicated. Indeed, there is no better way for the designer to clarify ambiguous shapes and to still a restless configuration than by thus escaping into the third dimension. Christie has shown in telling examples how the fiction of interlace can help to facilitate our grasp of a system of forms and narrow down their instability; we understand how it all hangs together, how it is made and how it can be disentangled (Fig. 157).

There are also more strictly illusionistic devices which add to the resources of the designer. If the flat key pattern oscillates between 'figure' and 'ground', the illusion of solid

Fig. 157. Flat and
interlace patterns
(A. H. Christie, 1910)

depth can clarify their relative role (Fig. 158). But we also know that such illusionistic shapes can be used in their turn to introduce fresh forms of ambiguity, as in the popular pattern of ambiguous cubes which can be read as solid or hollow according to the way we imagine the light to fall (Fig. 159).

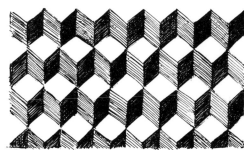

Figs. 158 and 159

Fig. 160

More interesting, because less frequently discussed, is the ambiguity of simulated transparency, which again permits us to observe the continuity principle baffled by ambiguity. We can imagine Fig. 160 to represent a transparent white cross superimposed on a black rectangle or a transparent black material laid upon an opaque cross. Which of the readings we adopt often depends on accident, but once we settle for one we may not notice the alternative. It was not before Cubism had discovered the potentialities of these ambiguous layers that designers used them systematically in the creation of restless shapes. True, the tartan pattern is an exception to this rule, but here we remain so much aware of the technical reasons for the shifts in colour that we are not even tempted to ask which lies on top and which below (Fig. 161).

Fig. 161. Tartan

6 Colour

There is a serious limitation in restricting any analysis of effects to geometrical forms while omitting colour. It was in the field of colour that the psychological laws of perceptual interaction were first studied with scientific rigour. The story of Chevreul's discovery of the laws of simultaneous contrast is well known but it loses nothing in the retelling. As an expert in chemistry Chevreul had been appointed superintendent of the dyeing department of the Royal Gobelin Manufacturies and found himself confronted with unexpected difficulties. He received complaints about the quality of certain pigments used and discovered that only some of them were well founded. In other cases the dyed wool used in the offending specimens was exactly the same as that which had caused no complaint in other pieces. It was then that he discovered that for instance 'the want of vigour complained of in the blacks was owing to the colour next to them, and was due to the phenomena of contrast of colours'. Announcing his discovery in a lecture in 1828, he proceeded throughout his long life to extend and refine his research, which also had a great influence on painters. Summing up his law at the beginning of his book he writes: 'In the case where the eye sees at the same time two contiguous colours, they will appear as dissimilar as possible, both in their optical composition and in the height of their tone' (Chapter 2). In our terms we might say that the break-spotter tends to exaggerate. Disliking uncertainty it accentuates differences. But this is only one possible reaction to colour change. The 'spreading effect' I discussed in *Art and Illusion* exemplifies a more global reaction to colour combination in which the feeling of difference is transferred from the individual colour to the whole pattern. In his book, which is richly illustrated (Col. Plate IX), Chevreul rightly insists that his findings should not be oversimplified. The field of colour interaction is rich in surprises: unfortunately there is a strict technical limit to the possibility of demonstrating them. Coloured illustrations of a scale, number and fidelity necessary to exemplify them are disproportionately expensive. We have seen in the third chapter, moreover, that for the mathematician the intervention of colour means a reduction of the purely formal relationships existing in the geometrical pattern. Thus colour can be used singly or in combinations to emphasize or to disrupt existing orders, but in any case there must be more identities, and therefore axes of similar elements, in a design of uniform colour than in a multicoloured one. It is easy to see, therefore, that colour can be used to still the restless fluctuations of a chequerboard, just as unexpected contrasts in colour can upset the balance of a symmetrical design.

What is more intriguing is the use of colour nearly or totally divorced from form. I have in mind the cloudy shapes of undefined boundaries which can result from certain techniques such as 'tie dyeing', glazing, or the mottled and marbled blots traditionally used by Western bookbinders since the seventeenth century. As soon as we attend to such designs we also look for shapes and boundaries. The 'extrapolator' comes into its own, though in certain sophisticated designs it will be stalled by the frustrations of the search. But then such endpapers were even less intended to be contemplated than are normal decorative designs. They are there to suggest a precious textured material which forms the transition between the tooled leather-binding and the reading matter.

7 Representation

The meanings associated with colours have taken us beyond the subject of this chapter, the consideration of purely formal effects. It is time to remember that few ornamental styles are entirely free from representational elements, plants, animals, humans or implements. It remains to show that the introduction of representational meanings poses altogether different perceptual problems. The difference springs from that duality of our perceptual

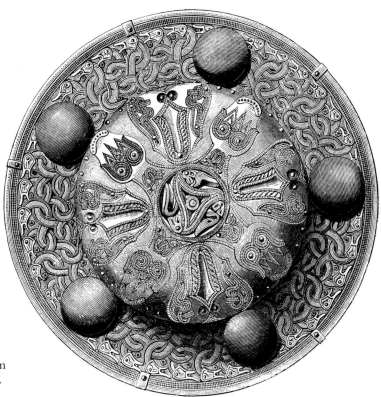

Fig. 162. Iron umbo from
Ultuna, Central Sweden.
7th century A.D.

equipment, which has already been mentioned in several contexts—the sense of order and
the sense of meaning. The first, it will be remembered, enables us to locate a stimulus in
space and time, the second to respond to it in the interest of our survival. The organism must
identify mates as well as predators, sources of food and sources of danger. Here recognition
is at a premium and the focussed glance a necessity. Hence looking at an object is not the
same as scanning our environment for order. We must be able to make head or tail of the
impression—quite literally—if we encounter a creature that may be hostile or friendly.
There is all the difference in the world between a wavy line and a snake—for we had better
look out where the snake has its head (Fig. 162)!

I have suggested that even our reaction to the wave pattern may be influenced by a
residual anticipation of movement associated with this form. But wavy lines have no
orientation in space, no determinable range of size or volume. Snakes have. Thus the effect
of interpretation on the way we see a shape will extend over a broad spectrum. To see the
line as water, mountains or, perhaps, a fluttering ribbon might be described as 'reification',
to see it as a living serpent as 'animation'. Either process can endow it with a new kind of
'presence' and even a halo of space. It is a process which is all but independent of the degree
of naturalism employed. It depends at least as much on what I have called 'the beholder's
share' as on the artist's wish to portray reality. Recognize the schematic ostriches on a pre-
Dynastic Egyptian jar (Fig. 163) and they begin to run around the vessel. Moreover, one
such interpretation may suggest another. The border motifs of Gafsa rugs from Tunisia (Fig.
164) are easily recognized as a row of camels, soldiers standing to attention, and (somewhat
less easily) as fish in a canal. Recognition determines orientation, scale and potential
movement. To see a shape as a camel means to look out for the features of the creature, such
as the head and the legs. The parts which make up the motif will automatically cohere, while
the residue will turn into mere 'background' or 'filling', until, that is, somebody points out
to us that these shapes we regarded as meaningless also have their representational function.

Fig. 163. Egyptian jar. About 3400 B.C.

Thus the element of conditioning and skill which we have seen to influence the reading of all complex forms can also determine our reaction to representational motifs. The effect can best be illustrated by the standard example which philosophers like to use in the discussion of

Fig. 164. Detail from a Gafsa rug pattern

visual interpretation or 'seeing as'—the notorious 'rabbit or duck?' figure (Fig. 165). Take a blot of its approximate shape, use it for a variety of patterns, and then substitute the ambiguous figure for it. Using it as a serial motif we can watch what happens as we switch from one reading to the other. Every interpretation leads to a new sense of direction. All the ducks look towards the left, all the rabbits towards the right. What is hard—at least for me— is to swap readings in mid-course and read the design as alternating rabbits and ducks. The difficulty confirms the role which scanning for redundancies plays in the perception of order. We do not read every single motif separately, we only confirm their identity. It is not without further interest to vary the configuration and make the creatures confront each

Fig. 165. Rabbit or duck?

other, tending either towards the axis or away from it and thus, perhaps, even expanding and contracting ever so slightly as our focus shifts. No doubt a wallpaper of this kind would be even more maddening than the one which provoked Christian Morgenstern's warning. In any case it would convince us of the complex forces which the interaction of order and meaning brings into play. How the designer wishes to harness these forces will depend on another variety of factors, among which the purpose of his design will be foremost. It is for this reason that the analysis of perceptual effects can never suffice for the construction of aesthetic norms. Even if such an analysis were carried much further than was attempted in this chapter it could, at best, explain the means at the disposal of the designer. Their use must depend on the function his culture and tradition assign to his activity.

8 Form and Purpose

I have often suggested that the formula familiar from architectural theory that 'form follows function' also offers a guideline to the historian of the other arts. It is not the aim of this book either to justify or to qualify this assertion. But it so happens that the reader has one of the applications of perceptual theory in front of him. I am referring to the form of the printed page developed by the art of typography. We have a reasonably clear picture about the way the reader's eyes sample a line of print in a familiar language in saccadic movements, constantly drawing on stored knowledge to fill in familiar words from the merest indications. But the sense of order is no less relevant to this process than the sense of meaning. The words are set out in lines and the lines grouped in paragraphs. The way a text is laid out on the page makes a considerable difference to the ease with which we can pick up the meaning.

The German language and some of its cognates have a useful term to describe the effect typographers aim at. It is the ordinary term 'übersichtlich', which means literally

'surveyable'. By an accident of language which is not without psychological interest the word in English corresponding etymologically to German 'über-sicht' is oversight, which usually means almost exactly the opposite, a failure to attend rather than ease of attention. Maybe these are two sides of the same coin. We remember that continuity-probing is almost automatic and therefore leads to a relaxation of attention. Hence both the ease and the danger. Where we have to attend to a medley of letters we are less likely to 'overlook' a misprint. It is clear that the typographer like any other artist must attune his design to the characteristics of the break-spotter. The separation of words, the setting out of paragraphs, the means of emphasis through capitals or change of fount all confirm the role of discontinuity in the setting of accents and the attraction of attention. Different cultural traditions have responded differently to these possibilities. The poster and the banner headline shout at us from a distance, and sometimes shout so loudly that we decide to ignore this distraction. The sacred page of a Koran needs no such methods because it is designed for readers who probably know the text by heart. It is all the more remarkable that there is one constant which appears to be common to all scripts and must have developed independently in several cultures—I am referring to the crucial device of the line. Whatever the direction in which characters are arranged, from left to right, from right to left, in alternation, or from top to bottom, even—exceptionally—in a spiral, any formal script facilitates the picking up of sequential symbols by arranging them in some such simple way. Order and meaning interact. Compositors and textual critics know of an undesirable side-effect which an excess of order can have for the perception of meaning. If identical words or even letter sequences happen to stand directly below each other on the page for several lines in succession, this rival continuity will result in an unintended configuration and may deflect the eye from its business of moving along individual lines. The effect can be so disruptive that students of textual traditions in mediaeval manuscripts have often found that passages were lost and nonsense intruded when the copyist lost his place on the page and his eye was shunted to another line.

In types of script where geometrical regularity is less easily achieved than in calligraphy or print, the compensating device of ligatures or cursive writing is often introduced, linking the individual letters of a word, and once more care is needed not to introduce false continuities by lines becoming entangled above or below. These are cases where our automatic break-spotter stalls because it is not quite sufficiently instructed to follow meaning rather than form. Yet, all in all, the development of script in any of its varieties perfectly illustrates the approach to perception which is advocated in this book. The sense of order which accounts for the appearance of the line and the page also enables the eye to pick out with the least effort the small deviations from regularity which constitute the distinctive features of characters, punctuation and paragraphing. The contrasting ways in which these characters in turn can be transformed by the decorative urge will be discussed in another context.

It is the fascination and difficulty of the study of decoration that it concerns a human activity which is almost divorced from an ostensible function. Here the sense of order is given free rein in generating patterns of any degree of clarity or complication. We cannot prescribe to the designer whether he should aim at restlessness or repose. The West generally preferred symmetry, the Far East more subtle forms of balance. There are styles, like those of Egypt or ancient Greece, which impose a lucid reading even on complex and varied elements. Others explore the instability derived from the wealth of different interpretations the design offers to the searching eye. Such effects add charm to Hellenistic mosaic pavements and were especially sought by the Islamic designers, who knew how to keep the mind busy without allowing variety to turn into confusion (Fig. 166). The same is true of certain forms of Gothic tracery which are apt to dissolve and re-form in front of our eyes, as

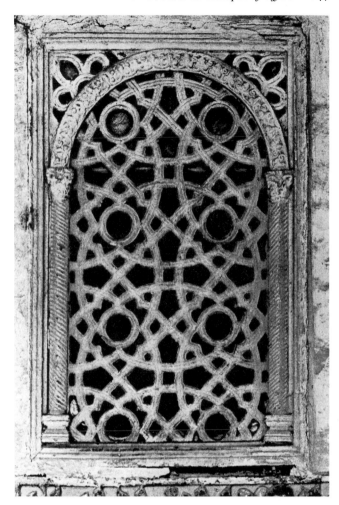

Fig. 166. Marble window
grille from the Great Mosque,
Damascus. About A.D. 715

shown in an instructive diagram drawn by Peter Meyer (Fig. 167). We shall encounter other
resources of ambiguity explored in other styles, which will bring home to us that it is our
search after meaning, our effort after order, which determines the appearance of patterns,
rather than the structure described by mathematicians.

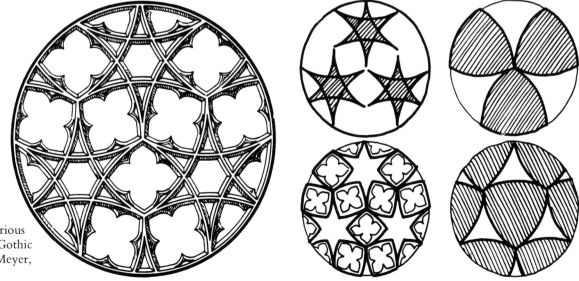

Fig. 167. Various
readings of Gothic
tracery (P. Meyer,
1944)

This is the moment, then, to return to Plato and his faith in the objective existence of geometrical relationships. The soul undimmed by the body was able to take them all in in a flash, and there is indeed a long tradition of metaphysical thought deriving from Plato which ascribes this capacity to God and the higher Intelligences. These, we are told, are not in need of piecemeal perception in time, but can apprehend the whole of Truth in the immediacy of direct intuition. Such beings, we might say, would see the configurations in terms of all existing correlations, while we can only use our more limited mind to apprehend these in succession. But for once this limit of our capacity is not a liability but a gain. For such higher Intelligences who take in the whole of the pattern at once it could not possibly have the same interest and beauty as it can have for us. There is something in being human after all.

VI Shapes and Things

The sense organs receive patterns of energy, but we seldom see patterns: we see objects. A pattern is a relatively meaningless arrangement of marks, but objects have a host of characteristics beyond their sensory features. They have pasts and futures; they change and influence each other, and have hidden aspects which emerge under different conditions.

Richard Gregory, *Eye and Brain*

1 The Kaleidoscope

In 1819 the Scottish scientist, Sir David Brewster (1781–1868) published his *Treatise on the Kaleidoscope*, describing an invention he had made in the preceding year. He owed the inspiration to a number of experiments on the polarization of light, which he had been conducting since 1814 and which involved the use of mirrors set at an angle. Having found the position of the mirror and the peephole which would result in a perfectly symmetrical pattern, he decided to patent his invention, which he proposed to call 'beautiful-image viewer' in Greek, that is Kaleidoscope. But, as he tells us, 'in consequence of one of the patent instruments having been exhibited to some of the London opticians, the remarkable properties of the Kaleidoscope became known before any number of them could be prepared for sale. The sensation excited in London by this premature exhibition of its effect is incapable of description and can be conceived only by those who witnessed it. . . . According to the computation of those who are best able to form an opinion . . . no fewer than two hundred thousand instruments have been sold in London and Paris during three months. Out of this immense number there is perhaps not one thousand constructed upon scientific principles and capable of giving anything like a correct idea of the power of the Kaleidoscope.'

Brewster had tremendously high hopes of this power. One of the chapters of his little book is devoted to the application of the Kaleidoscope to 'the fine and useful arts'. He was sure that his instrument would not only save the labour of designers but would do much better than designers: 'It will create in a single hour, what a thousand artists could not invent in the course of a year; and while it works with such unexampled rapidity, it works also with a corresponding beauty and precision'. He goes through the various arts, from the design of Gothic rose-windows to that of carpets, but also recommends his instrument to the bookbinder, the wireworker and the paper stainer. In fact, Sir David hoped that the Kaleidoscope would give rise to an entirely new art, the art of colour music. We shall have to come back to this aspiration in another chapter. Here we may well pause to ask why even the more modest hopes he had for the development of design turned out to be rather naive. After all there is no doubt that we do enjoy looking at the regular configurations presented to us by the Kaleidoscope. I am myself a devotee of this instrument and I like to share my pleasure with others. They usually respond with delight, but after a few exclamations of 'ah' and 'oh' they put it aside and talk of other things. Various reasons might be adduced for this disappointing reaction. The first arises from the considerations to which the last chapter was devoted: the view through the Kaleidoscope, with its multiple mirrors resulting in multiple symmetries, exhibits maximal redundancy. The configuration, as such, shows that 'repose' and balance which make for a certain degree of monotony. It is true that Brewster's instrument overcomes this failing because we can always change the pattern at will by shaking the Kaleidoscope. Naturally we enjoy the surprise of the new picture but it soon wears off. When we have seen one segment we have seen them all. There is little left for the eye to explore.

But in a way this interpretation explains too much. Was not the inventor right when he recalled Gothic rose-windows (Plate 45) as configurations of the kind produced in his machine? Would anyone call these miracles of design monotonous? It is true that some rose-windows, as we have seen, counteract the effects of perfect symmetry by some dynamic element of the vortex variety, which is inaccessible to the Kaleidoscope, but that is still not the whole answer. The answer is surely that the idea of a pure form is always an artificial abstraction. The rose-window in a Gothic cathedral is not, of course, the result of chance produced in a pretty toy. We cannot divorce the impression it makes from our knowledge of the craftsman's skill and from awareness of meaning. The failure of the Kaleidoscope to live up to the hopes of its inventor should offer food for thought to the advocates of computer art.

Not that either computers or even the Kaleidoscope should ever be dismissed as instruments of exploration when it comes to investigating the visual effects of order. Originally Brewster used simple line drawings for his experiment (Fig. 168). It is indeed most interesting to see how what looks in isolation like a senseless squiggle, loses its identity in the larger shape and merges into the overall star patterns. Breaks and gaps alert us to the presence of objects in our field of vision, and where these gaps are closed, such objects fuse into larger wholes. What is even more interesting is that the breaks themselves are devalued, as it were, when they become part of the overall pattern. Redundancy appears to drain the individual element of much of its meaning and character. We can see this best by looking at the classicizing figures Brewster recommended for his instrument (Fig. 169). These figures merge into the pattern of the five-spoke arrangement he illustrates and become mere counters in the game of mutual reflection.

The Kaleidoscope is therefore an ideal starting point for the exploration of this mutual

Figs. 168 and 169. From Sir David Brewster, *Treatise on the Kaleidoscope*, 1819

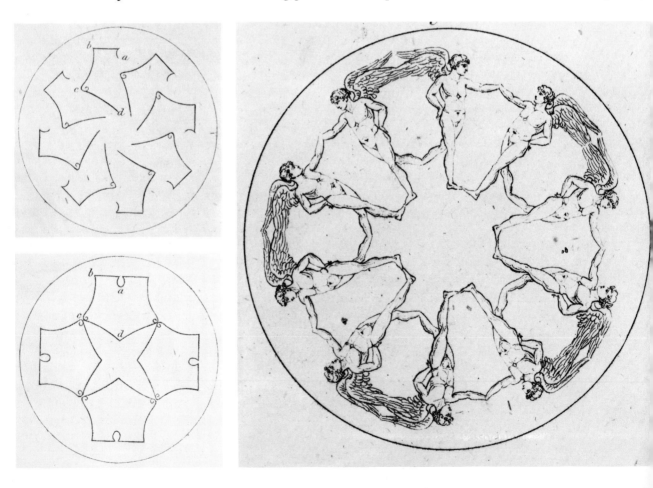

interaction between things and patterns. The type we had as children could be filled with odds and ends, beads, buttons or threads, and much of its magic depended precisely on the way in which these mean and trivial little objects were transfigured into things of beauty by becoming constituents of unexpected patterns.

The most entrancing and most instructive version of the Kaleidoscope has only recently come on to the market. It contains a slit through which we can look out into the real world, and allows us to watch how our messy environment is transformed into a thing of lawful beauty by the multiple mirrors inside the tube. It is possible to photograph the effect and to show how an ordinary city street or an object no more romantic than a telephone box can be metamorphosed into a star (Col. Plate VIII). This effect is indeed striking. Instead of the world that floods us with information too varied and too confused for us to handle, we look into a realm of simple order, which we can probe with ease. But we have purchased this order at the expense of meaning. Even where the individual things visible through the opening are not fragmented by the slit they lose their identity as thoroughly as Brewster's figures, if not more so. There must be a conflict, or at least a tension, between the two functions of perception to which we referred at the outset, the perception of things and the perception of order. By things I here mean elements in our environment which have a meaning for us in terms of our survival and our interests. Things can be obstacles or goals, they can present dangers or attractions. In every case they have meaning. What I have called the sense of order may be said to serve us first and foremost to orient ourselves in space and time and to find our way in relation to the thing we seek or we avoid. It was in the service of this function that we found the 'simplicity hypothesis' of such immense use to the organism. It allows it to take things as read and to attend selectively to individual meanings. The perception of regularity, of repetition and redundancy, presents a great economy. Faced with an array of identical objects, whether they are the beads of a necklace, the paving stones of a street, or the columns of a building, we rapidly form the preliminary hypothesis that we are confronted with a lawful assembly, and we need only sample the elements for redundancies by sweeping our eye along the whole series and just taking in one repeating component.

2 Repetition and Meaning

'Pop artists' have recently exploited this effect with direct reference to the depersonalizing tendencies of the multiplying media. Put a portrait of Marilyn Monroe in a series (Fig. 170), and what should have been an individual becomes a mere stereotype or counter. Individual after all means indivisible, but the repeat invites us to disregard this very characteristic. Instead of making us concentrate on the unique image by scrutinizing the features of the portrait, it tempts us to single out any element, be it the eye, the mouth, or a mere shadow, which fuses into a new pattern as in the Kaleidoscope. A row of repeated eyes are no longer anybody's particular eyes.

A similar experience is known to psychologists of language and many of us have discovered it independently in our childhood. If a word is repeated long enough it appears to be drained of meaning and becomes a mere puzzling noise. Try to pronounce the word 'meaning' some fifty times in a row and you will begin to wonder how you could ever operate with this strange sound. One of the reasons for this experience is the disintegration of the sound pattern through repetition. Instead of the two syllables coming in their right order we will also hear them grouped in the reverse, 'ningmea', and this, of course, makes no sense. Seeking for order is testing for alternative groupings, as we have amply seen in the last chapter. This tendency will pounce on any kind of redundancy at the expense of meaning.

Order and meaning appear to exert contrary pulls and their interaction constitutes the

Fig. 170. Andy Warhol:
Marilyn Monroe. 1962

warp and woof of the decorative arts. For the designer no less than the beholder must
experience the degree to which repetition devalues the motif while isolation enhances its
potential meaning. No wonder that any object that becomes an element in a repeat pattern
almost asks to be 'stylized', that is simplified in geometrical terms. I know no wittier
illustration of this effect of redundancy than a drawing by Max Beerbohm ridiculing the
vanity of Henrik Ibsen (Fig. 171), in which even the wall paper echoes the great man's
portrait in a decorative flourish.

Joking apart, the duty of the decorative artist to subdue the individual forms of plants and
animals by reducing them to 'stylized' motifs was a central dogma of the Victorian schools
of design. We encountered this hostility to naturalism in the discussion of mural, textile and
other ornaments which orthodoxy demanded to be flat so as not to disturb the eye by
fictitious depth (Fig. 34). Moreover, living nature will never repeat itself so exactly as the
pattern-designer demands. He must reduce its variety in his floral or animal designs,
though the length to which he should go towards geometrical abstraction was a matter of
taste and usage (Fig. 172). It is well known that the advocates of conventionalized designs

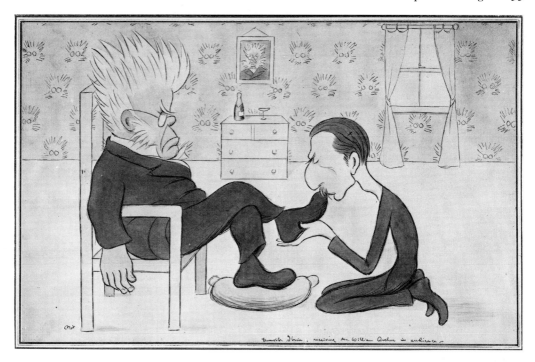

Fig. 171. Max
Beerbohm: Henrik
Ibsen receiving
William Archer. 1904

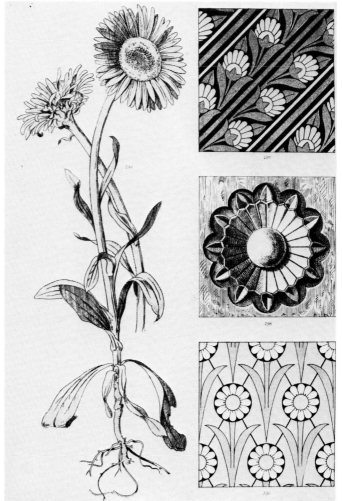

Fig. 172. *Aster
Alpinus* and its
ornamental
treatment (F. E.
Hulme, 1874)

had a formidable opponent in John Ruskin, for whom Nature could never do wrong. Rather than devaluing and killing living forms for their degraded use as ornament, he wanted shapes to be animated and imbued with a life of their own. Hence he had nothing but admiration for the grotesque monsters created by Gothic masons, and nothing but contempt for the neat floral repeat patterns of Renaissance decorators.

Ruskin tells us of a memorable debate between the defenders of decorative orthodoxy and himself. The passage occurs in *The Two Paths*, where he discusses the conventional style of the savages, which he could not but admire though he associated it with moral degradation. He does not name his opponent, but we know from his notes that it was R. N. Wornum, author of *The Analysis of Ornament* and a prominent figure in the reform movement.

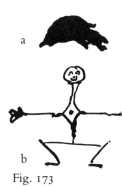

'My friend had been maintaining that the essence of ornament consisted in three things:— contrast, series, and symmetry. I replied (by letter) that "none of them, nor all of them together, would produce ornament. Here [Fig. 173a]—(making a ragged blot with the back of my pen on the paper)—"you have contrast; but it isn't ornament: here:—1,2,3,4,5,6,"— (writing the numerals)—"you have series; but it isn't ornament: and here [Fig. 173b],"— (sketching this figure at the side)—"you have symmetry; but it isn't ornament". My friend replied:— "Your materials were not ornament, because you did not apply them. I send them to you back, made up into a choice sporting neckerchief." ' (Fig. 174.)

Fig. 173

Needless to say, Ruskin was not one to give up his position so easily. He rightly remarked that Wornum's design showed more than a mere mechanical application of his three principles, nor could he refrain from a derogatory sneer at sporting neckerchiefs.

Some fifty years later a Birmingham drawing teacher, Frank G. Jackson, still found the experiment sufficiently interesting to extend it in his textbook of *Decorative Design* (London 1897). Trying to answer Ruskin's points one by one, he observed that 'we are not to assume that the friend's adaptation of the materials supplied to him was perfect, admitting of neither change nor variation . . . On the contrary, . . . it was one only of the many ways in which they might have been put together' (Fig. 175).

By clever manipulation of his unpromising material Jackson even managed to turn the blots into the suggestion of leaves and to transform Ruskin's mannikin into something like a

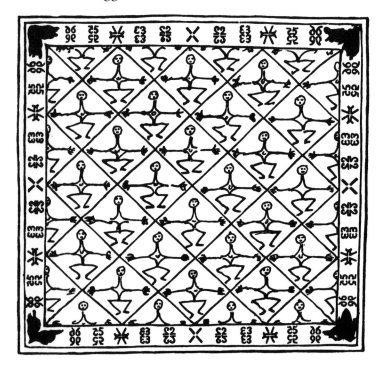

Fig. 174

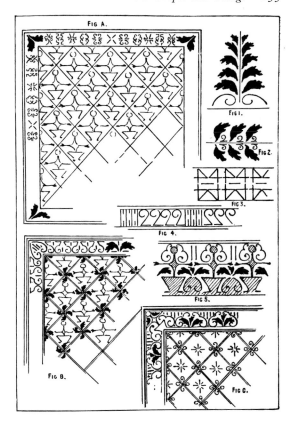

Fig. 175. From F. G. Jackson, *Decorative Design*. 1897

flowerpot—demonstrating that power of 'reading in' which is inseparable from the processes I have called 'reification' and 'animation'. But what concerns the student of form in this sequence most of all is the complementarity between meaning and pattern. Place Ruskin's scrawl in the centre of an empty field, and it will form the focus of attention with all the comic effects which contribute to the intended meaning. Add symmetrical elements on either side, and any central motif, no longer camouflaged by repetition, will stand out and demand attention.

3 'Fields of Force'

It looks indeed as if the eye—or rather the mind—were attracted by the line of least resistance and gave up scrutinizing for meaning in order to take in the arrangement. We have observed something in the last chapter of these dynamics of ordered configurations. No wonder that the first theory to explore these characteristics sought to find evidence here of the existence of a real physical field of force in the brain. Having opted for an alternative theory, the 'field of force' has for us become no more than a metaphor, but as a metaphor it illuminates the powerful effect of symmetries and correspondences. In the Kaleidoscope the radial symmetry pulls the eye towards the centre from which the redundancies are most easily surveyed. Conversely, the repeated elements, as we have seen, lose something of their identity as they merge in the overall form.

If terms are needed to describe these familiar effects of the 'field of force', I would suggest 'positional enhancement' for the move into the privileged centre, and 'positional attenuation' for the opposite device. Language acknowledges this distinction in describing one matter as of 'central importance' and another as merely 'marginal' or 'peripheral'. The number of decorative arrangements which apply these twin effects is legion. Whether we think of gardening, architecture or nothing more solemn than housekeeping, we can find

examples wherever we look. We garnish a dish with a row of cucumbers or hard-boiled eggs, we decorate a cake with a pattern of cherries (Fig. 176). Every time the individual morsel has thus been made to serve a visual order, its culinary identity has become slightly attenuated, its flavour matters less than its looks. Strangely enough it is different with the centre of the dish which is so garnished. Here the very fact that it is framed enhances its particular quality, one might almost say its dignity. It serves as a focus of attention and expectation. The cherry in the centre of the cake is very much a cherry.

Fig. 176

We can observe instinctive reactions to this field of force in any activity that relies on arrangement. We take it for granted that in a ceremony the important personage will be in the centre, flanked by figures whose identity or dignity is less important and mainly serves to enhance that of the protagonist (Fig. 177). Whether in ritual or in the theatre, on the parade ground or on a platform, we know very well what it means to move to the centre of the stage, though we rarely ask why the centre has acquired this strong emotional and perceptual accent.

We here come back yet again to the strange object we considered at the outset of this investigation—the ornate and sumptuous frame of Raphael's *Madonna della Sedia* (Plate 1). Without a frame there can be no centre. The richer the elements of the frame, the more the centre will gain in dignity. We are not meant to examine them individually, only to sense

Fig. 177. A sacrifice to Isis. Mural from Pompeii

them marginally, and once more 'marginally' here oscillates between a mere metaphor and a literal description.

The frame, or the border, delimits the field of force, with its gradients of meaning increasing towards the centre. So strong is this feeling of an organizing pull that we take it for granted that the elements of the pattern are all oriented towards their common centre. In other words the field of force creates its own gravitational field. What is up or down outside the frame is a matter of comparative indifference within the enclosed world of the pattern. The masks and acanthus leaves around the Raphael turn with the frame, and we feel no discomfort in seeing these heads upside down. They are the right way up when viewed from the centre.

What all these examples indicate is the way order works towards cohesion. There is no more obvious example of the importance of such correspondence than architecture. The flanking spandrels of an arch will mirror each other in their decoration and will thus give us the feeling that the arch is well held together (Col. Plate VI). We here come back to the metaphor of the feeling of balance given by 'balancing designs'. This appeal of symmetry is so universal that architects have submitted to its demand in most styles of building all over the globe (Plate 5). Indeed it was not really before this century that a conscious protest arose against the tyranny of the symmetrical façade, the dominance of order over the demands of practical considerations in the arrangement of rooms and of windows. The asymmetrical house appeared to earlier centuries as a piecemeal makeshift affair, the product of accident rather than of planning.

4 Projection and Animation

It is precisely by draining the individual elements of their identity that the overall order makes them fuse into a larger unit which tends to be perceived as an object in its own right. If the Kaleidoscope permits us to study these contrary effects of fragmentation and integration, there is another experimental tool at hand to illustrate the power of the fields of force in creating meanings of their own. I am referring to the so-called Rorschach test, originally devised for psychological diagnosis. The test uses ink blots which are given to subjects to test their interpretations of these random forms (Fig. 178). What matters in our context is not the diagnostic value of this procedure but the fact that it was found advantageous to use symmetrical ink blots to elicit interpretations. Very likely the random splash looks too much like what it really is, an ink blot, to stimulate the imagination. But any such splash of ink or paint can easily be turned into a predominantly symmetrical shape even without the Kaleidoscope, simply by folding the paper while the ink is wet. It is such double shapes which are generally used in the Rorschach tests. The symmetrical configuration loses its

Fig. 178

accidental look and therefore invites us to search for a meaningful description. Maybe it is relevant here that so many objects in our environment exhibit symmetries. Nearly all organisms do and it is not surprising that butterflies or faces are frequently seen in these blots. But maybe there is more to this tendency of projecting some overriding meaning into the symmetrical blot. Symmetry, as we have seen, implies cohesion. The whole shape or field must be ruled by one inherent principle or law, and it is this instinctive conviction which makes the ordered shape stand out as a candidate for scrutiny. Since it is unlikely to have come about by a mere accidental shuffling of shapes and colours, it must be classified as an object in its own right, and as such we must be able to give it a meaning and a name. What must interest us here is the fact that this process of identification, which is technically known as projection, invariably affects the way the blot is seen.

We have encountered this effect near the end of the preceding chapter where I used the 'rabbit or duck' figure (Fig. 165) to justify the distinction between pattern perception and thing perception. The distinction is one of 'mental set' rather than of the shape in view. In the case of the Rorschach test, we are asked to see the random configuration in terms of things, and in playing this game in our imagination we can also attend to the way the scale and the orientation of the shape appear to fluctuate as we try out different readings. We can see Fig. 178 as an insect with outspread wings, from above; turn it upside down and it can easily become a face with bushy eyebrows and heavy whiskers. It is always amusing to think of other interpretations, which will once more alter the orientation of the blot. As soon as a shape is identified as a thing or a creature it becomes transformed. No wonder non-figurative artists fight the tendency of looking for representational elements in their shapes and colours, for such projections can have the most disruptive effect on the intended dynamics of form. Meaning can subvert order, just as order can subvert meaning.

It is the advantage of the concept of projection that we do not have to ask too insistently where in pattern designs geometrical motifs end and representational ones begin. The very names we tend to give to some basic configurations indicate that there is a no-man's land between abstract and figurative design. We speak of star-shapes, of wavy lines, vortices, radiating forms, of networks, chequerboard patterns, egg-and-dart, rosettes, without implying any representational intention. We shall have to come back to the problems of symbolic meanings assigned to such different motifs in various styles. What concerns us here is the perceptual effect of our projection, which goes further than the mere recognition of an individual motif. Our response to different decorative styles is governed by the way we read their motifs.

I have referred to the idiom that we 'cannot make head or tail' of a perplexing sight. The addition of heads and tails not only offers the explanation, it turns what was a mere medley of lines into a writhing knotwork of fighting dragons such as we know from Celtic and Scandinavian art (Fig. 179). Where vegetal motifs predominate, as in the arabesque, we are differently guided. Plants may not have a head or a tail, but they have roots and branches or shoots. We can see them grow, turn, intertwine, spread or squeeze into corners.

We need not ask why floral motifs were so frequently used by decorators all over the

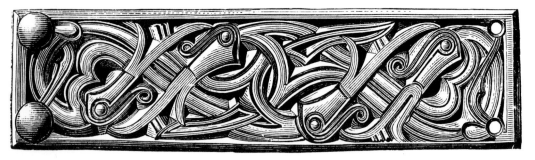

Fig. 179. Part of a harness in gilt bronze from Vallstena, Gotland. 7th century A.D.

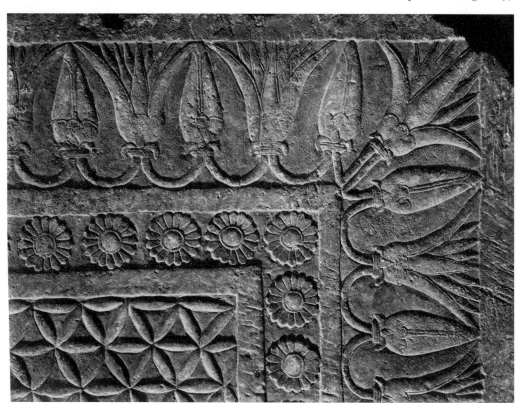

Fig. 180. Pavement from Nimrud. 9th century B.C.

world. The appeal of the flower and the wish to perpetuate its rapidly fading beauty speak for themselves. What may more easily escape our attention is the effect which the representation of flowers can have on the degree of formal organization. That it is not a necessary effect is demonstrated by the styles of the ancient Orient, where flowers, buds and leaves are strictly formalized and standardized into repeat patterns (Fig. 180)—but then this treatment is in accord with the comparative rigidity of all figurative art in these cultures. The other extreme is reached in Far Eastern decoration, where the freely growing plant is allowed to make its effect without the aid of symmetry or repetition, of framing, filling, and linking (Plate 41). The measure of freedom accorded to floral motifs as distinct from geometrical shapes would surely resist tabulation. We have observed the contrast on the Greek dish between the fretted border and the undulating wreath (Plate 25). There is less freedom in the persistent and influential tradition of designs for silk and other textiles which favour repeat ornaments also for technical reasons, though the plant motif in form of a 'pomegranate' usually retains its orientation, its sense of growth, particularly when it is combined with a vase (Fig. 181). But here as in the earlier instance greater naturalism also leads to greater freedom as in the 'Mille-fleurs' motifs of Gothic hangings (Col. Plate XI). It has certainly been tempting for designers in many cultures to scatter flowers over the whole field in a profusion and variety which would not have been conceded to uninterpreted shapes (Fig. 182 and Col. Plate I).

We can test this interaction between shape and meaning by taking the pattern which served us in the preceding chapter as an example of a restless design (Fig. 130a). Interpret the circles and triangles as floral motifs and we no longer feel pulled about in the same way (Fig. 183). We know that flowers are exempt from the demands of tidiness. One of the advantages of scattering blossoms rather than growing flowers (Fig. 182) has often appealed to designers of fabrics—the cloth can be used in any orientation without looking topsy turvy.

In more formal designs it depends very much on the choice of motif and context how the

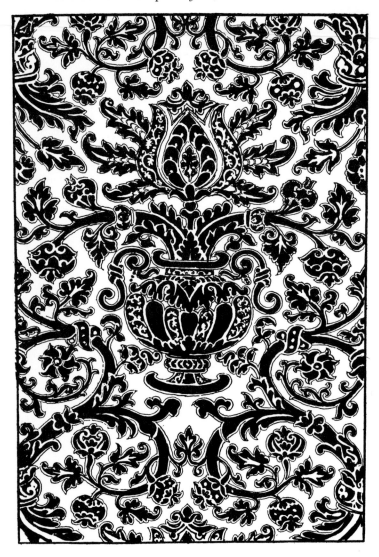

viewer will react. Noticing the birds perching on the leaves in the fifteenth-century Lucchese damask (Fig. 184), we read the whole field as a network of plants and berries obeying gravitation. But in the Sicilian silk of Fig. 185 the birds become subordinated to the 'field of force' created by the symmetry. The skill and tact of the designer can make representational motifs, whether stylized or naturalistic, respond to these and other natural pulls, counter them, or even play with them. The Gothic crocket and finial generally follows the upward direction of the decoration even where the leaves are curling back (Fig. 186). In later styles the swags hang heavily, the ribbons flutter in the wind, tassels are dangling on chords, and strapwork is curling as if it followed the laws of some imaginary material. Within the representational context even the geometrical frames and links can become 'reified', we endow them with sensory qualities such as smoothness or roughness, springiness or inertness, pliability or rigidity. Spiralling terminations suggest the curling of elastic matter (Fig. 138), angularity looks sharp and brittle. The glazing of a Chinese pot is seen to spread or to drip from one area into another (Fig. 187). Even inanimate motifs, in other words, begin to partake of our experience of movement and touch. We perceive what J. J. Gibson calls their 'affordance', their potential response to being handled.

Glancing back to our standard example, the frame of Raphael's *Madonna della Sedia* (Plate

Fig. 181 (*left*). Italian fabric design with vase pattern. Late 15th or early 16th century (R. Glazier, 1923)

Fig. 182 (*top*). Flowered material

Fig. 183. Flower-scatter design

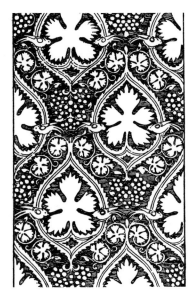

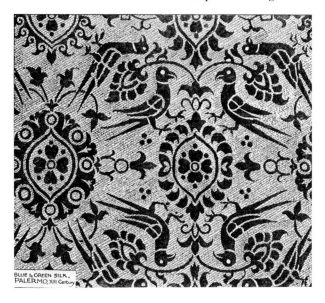

Figs. 184 and 185.
Lucchese damask,
15th century, and
Sicilian silk, 13th
century (R. Glazier,
1923)

1), we can confirm this effortless transition from representation to decoration. The painting conveys to us quite naturally the surface and character of bodies in rest and motion, the texture and pliability of the drapery and fringes, the solidity of turnery and the intangible orb of the halo. If we switch our attention to the frame, we are also left in no doubt about the tactile qualities of its motifs. The laurel wreath is tautly stretched, the acanthus leaves in the inner circle curl within their grooves, and even the shapes which lack a clear representational identity are felt to spiral and turn elastically as wood-shavings might do. Here too the introduction of representational elements affects the way in which we regard the whole configuration. Animation spreads to all but the most geometrical lines.

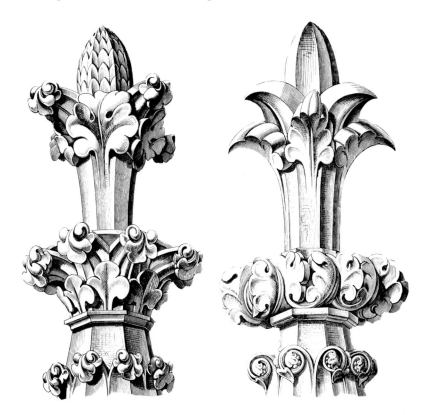

Fig. 186. Gothic crockets and finials (C. B. Griesbach)

Fig. 187. Chinese stoneware jar.
8th–9th century A.D.

It is this oscillating interplay between representation, fiction and pure form which establishes yet another dimension for the decorator in his construction of hierarchies. There are fictions within fictions, representations within representations, all of which can singly or in combination serve to clarify or to transform the structure which is to be decorated. Take the eighteenth-century plasterwork over the chimney in a house in Scotland (Fig. 188) (now

Fig. 188. Stucco work
from Fullarton
House, Ayrshire.
Attributed to J. Enzer
About 1730

alas demolished), with motifs ranging from purely geometric fretwork to naturalistic flowers, fruit and even putti. Our reaction is inseparable from our past experience. The geometric motifs look rigid, the leafage soft and pliable. The symmetrical scroll flanking the conch-like motif spreads and curls, the festoons hang lightly, the tassels more heavily. The cornucopiae are filled to overflowing, the urn with the busy children is understood at once as a representation within the representation. Observing ourselves we find that our response depends altogether on our grasp of the various degrees of reality implied in this decorative fantasy. The framework of the chimney-piece is more solid and permanent than the motifs arranged around it, which thus gain the air of temporary decoration for a festive occasion. Temporary, and yet lasting, they perpetuate the floral tribute and the joyful mood.

Here is the moment to recall the conviction of Victorian designers that there was an unbridgeable gulf between naturalistic representation and decoration. Their reasons for banning naturalism lay precisely in the effect we have observed of turning the ground into background or space. They experienced a conflict between the real thing in space, be it a vase, a wallpaper or a rug (Fig. 34), and the fictitious or virtual space of the pictorial motifs. We need not deny that such a conflict can be jarring, particularly if our attention is drawn to it. But up to a point this tension is common to all decoration. Decoration, almost by definition, is applied to the things and objects of our environment. We see them as things and we also see the decorative pattern. The two processes will inevitably interact and it is to these interactions we have to turn.

5 Decoration

In the third chapter of this book, decoration has been described as a special case of superimposing one pattern on another. Man-made things are usually articulated in some predictable way according to structure and function. Some of the reasons for this preference were mentioned in the Introduction. They lie partly in the ease of assembly of standardized simple units and consequently also in their adaptability to team work. Harking back to our standard example of flagstones versus crazy pavement, we may also remember that ease of construction and ease of perception frequently go together. Having just stressed the role which habituation and routine play in our perception of decorative forms, we may thus find another point of contact between the way a thing is made and the way it is seen.

In the development of skills engineers speak of 'chunks', the units of movements from which a larger skill is built in hierarchical orders—thus the five-finger exercises teach the beginner 'chunks' of piano playing which he can use or modify in a future performance without having consciously to attend to them. Are there 'chunks' also in the perception of structures? The example of reading seems to suggest that there are, and so does the experience of looking at buildings in a familiar style. We can take in the constituent elements, the doors and windows, the columns and the pilasters, with much greater ease than we could absorb exotic buildings.

There is an interesting passage in the *Optics* by Ptolemy, dating from the second century A.D., which can be read as a subtle confirmation of this role of perceptual habits in our reaction to buildings. In discussing visual illusions arising from erroneous inferences, the author observes that the parts higher up tend to look wider than they are—so that doors or façades which are true rectangles appear to be diverging upwards. He suggests that this illusion is due to our expectation of finding the opposite arrangement, for normally the base is wider than the top so that the building tapers. Maybe the fact that he was writing in Egypt gives a clue to this strange passage, for in ancient Egypt not only the Pyramids, but also pylons were normally built on this pattern. I am not sure that this reasoning (which is also said to underlie the so-called optical corrections of the Parthenon) is universally valid.

Nothing is harder to pin down than the way we 'see' objects of which we know the shape. But though we cannot prove that the visual training of Ptolemy's contemporaries in ancient Alexandria invariably resulted in this distortion, there is little doubt that perceptual habits make for visual comfort or discomfort. I still remember the reaction of an elderly gentleman to the invitation to sit down on a cantilevered chair. He apologized profusely that, while he knew that no trick was being played on him, he preferred the assurance of a four-legged support.

Ptolemy, too, linked our reaction to the habit of expecting a broadly based structure. The functional has aesthetic consequences. In the first chapter I quoted Cicero's comments on the beauty of the Capitoline Temple which was grounded in utility—the pitched roof allowing the rain water to drain off. The history of architecture and decoration amply proves that the form of the gable persists as an upper termination much as the base is made to look solid, whether or not there are structural reasons for this arrangement. The shapes have become indicators of orientation. Not only buildings as a whole, but the individual members as well are endowed with these visual labels indicating 'this way up'. The forms which these terminations take in columns, pilasters, finials or turrets are legion, but they have this in common: that they are not easily reversible. Maybe it is in this direction that I could have found the answer to the question which puzzled me in my youth: why decorators so liked putting urns on roofs. Used as a crowning feature (Plate 2, Figs. 136 a, b), they function like the rounded knobs on the chair of Raphael's Madonna (Plate 1) and give the structure an appearance of greater stability.

Architecture must be the test case for any theory concerned with the decoration of man-made structures, for it is here that the fruitful tension between functional and ornamental hierarchies can be studied on any number of levels. The key word here is 'articulation'. Where structure and decoration are in harmony, as in the classical tradition, the parts of the building, doors and windows, roofs and towers, are kept distinct by structural and decorative means. Wren's St. Paul's (Fig. 21) or Servandoni's St-Sulpice (Fig. 24), mentioned in the first chapter, are as good examples as any of this principle. It is a far cry indeed from these severe creations to the Baroque exuberance of the Sacristy of the Cartuja at Granada (Plate 6) or to the dreamworld of the Alhambra (Col. Plate VI), but it needs no elaborate analysis to show that the main articulations of the building still serve as the frame for the decorator. We know that framing and linking can be elaborated into decoration as in Islamic domes and Gothic vaults (Plates 28, 29), but this use of the framework does not exclude a further articulation of parts—as is beautifully exemplified by the half-timber houses of Tudor England in which the 'black-and-white' patterns of beams are sensitively varied to mark the principal divisions of the house (Plate 44).

As long as there has been a theory of design, the need for consonance between structure and ornamentation has been stressed. For those, however, who are less interested in prescription than in description the question remains to be answered why these sermons were ever necessary. The advantages of a clear structure are not hard to divine. We have touched upon them in discussing the lucid lay-out of a page, the visual aids given by alignment and paragraphing, in short all the elements which make an object *übersichtlich*, visually easy to grasp (Chapter V). A featureless room in uniform colour without visible edges might well produce visual discomfort. One is reminded of the effects of 'sensory deprivation' when absence of stimulation causes hallucinations. Even absence of accents makes us project them where none are to be found—this is notoriously so in hearing, where a uniform tapping tends to be grouped by the mind as if to create those 'chunks' that can best be handled and compared. A row of identical dots also invites grouping but these subdivisions are less stable than their auditory counterparts, and so the desire for marked accents is intelligible. Even a uniform pattern, however, can serve our orientation through

Fig. 189.
Camouflage (M.
Luckiesh, 1922)

the perspective effect of diminution which indicates the slant of the textured wall or floor
(Fig. 124). Different texturing, as we have seen, can serve the needs of explanatory accents as
well as any other form of decoration.

There is an added advantage to such texturing, moreover, which any housewife can
appreciate. A plane surface shows up any speck of dirt and any flaw. We have seen that such
breaks in continuity act invariably as 'magnets to the eye' and thus it is imprudent to court
disaster, which can so easily be averted by multiplying the breaks. How much more difficult
would it be to fashion a pot with a wholly smooth surface without the slightest finger mark,
than to cover it intentionally with rows of such prints. We may here remember the
complaint of Goethe's apothecary that the smooth surfaces demanded by Neo-classical
taste go together with the use of expensive wood. Purity is costly.

There is no conflict, however, between richness and what I should like to call
'explanatory articulation', a notion that is best illustrated by its opposite—camouflage. In
camouflage the elements of the object and its outlines are obscured by conflicting
information painted on the surface (Fig. 189). What we need for visual comfort, however, is
to gain an easy grasp (mental or physical) of the way a thing is put together (Fig. 190). We
want to see where the lid begins or where the vessel can be held. Beyond this it is a matter of
taste how far we want to indulge the decorator. Today most people prefer the lucidity and
elegance of the Neo-classical tureen by Boulton and Fothergill (Plate 43) with its subtle and
restrained differentiation of shape and texture to Gottfried Semper's over-rich design (Fig.
46), but we remember that Semper himself was proud of having respected and enhanced the
structural articulation of the vessel.

There are many examples in the history of decorative art in which structural articulation
leads to further ornamental articulation without our being able to say exactly where one
ends and the other begins. Thus the iron hinges on wooden doors and coffers serve to secure
the wooden board and will certainly perform this function more efficiently if they are
spread further to make sure that nothing can 'give' (Fig. 191a). But this process of elaboration

ig. 190. Spanish box

ig. 191a. Hingework
: Montréal, Yonne.
2th century
. Starkie Gardner,
907)

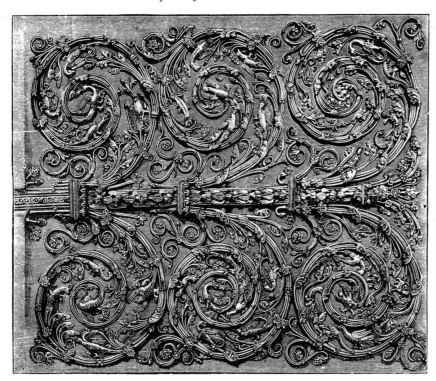

Fig. 191b. Hinge from the Porte Sainte-Anne, Notre-Dame, Paris. Early 13th century (J. Starkie Gardner, 1907)

continued until the hinges themselves became showpieces of the blacksmith's craft, as on the Porte Ste-Anne of Notre-Dame, Paris (Plate 46).

What are the psychological forces which appear to drive ornament forward towards such enrichment or—if you side with the classicists—excess? Is it simply hard to give up any activity as long as there is no external pressure to stop? Going on, the craftsman can outdo his rival and show his infinite resources of skill and inventiveness. Why should he relinquish work as long as it gives him pleasure to modify it even further? But underlying this pleasure there must be further urges—the urges described in Chapter V as break-spotting and break-filling. We all know from our experience and observation that in our civilization, at any rate, the smooth surface acts as an invitation to idle hands. It asks to be modified, articulated, filled in or even defaced, as if man found it hard to resist such an easy option of exercising his power over things. The pleasure in exercising this power may well have deep roots in the evolution of *homo faber* (man the maker).

It was that great Dutch interpreter of human culture, Jan Huizinga, who reminded us that *homo faber* must also be associated with *homo ludens*, man who enjoys playing. It is the charm and attraction of decoration that it transforms an object without really changing it. Like the child who turns a stick into a hobby horse or a leaf into a boat, the decorator can indulge his

Fig. 192. Egyptian palette. Pre-Dynastic, before 2900 B.C.

Fig. 193. Egyptian column (A. Speltz, 1910)

g. 194. Bed of the Divine Cow.
om the tomb of Tutankhamun.
bout 1361–1352 B.C.

g. 195 (*below*). Egyptian vessel
the form of a fish. 18th dynasty,
51–1306 B.C.

g. 196. Egyptian
otus chalice. About
00 B.C.

fancy by re-interpreting the things around him and make others share his pleasure. Victorian critics were outraged at inkstands turned into turrets and gas-jets into flowering twigs (Figs. 35, 36), but there never has been a time when craftsmen did not sometimes follow the suggestion of a shape and complete the interpretation. Egyptian art is especially rich in such examples. Even in pre-Dynastic times the so-called 'palettes' used for make-up were shaped as animals (Fig. 192), columns were turned into the semblance of papyrus or lotus plants (Fig. 193), and the couch in Tutankhamun's tomb (Fig. 194) was shaped like a sacred cow, ready to carry the pharaoh into the other life.

It may be objected that the last example is one of religious magic rather than playfulness, but it is not always possible in these matters to tell where fancy ends and ritual begins. The many vessels in the form of animals or fishes (Fig. 195), the beakers shaped like chalices (Fig. 196), look more like objects made for amusement and delectation than with magic intention.

There is no shortage of parallels in other styles up to and including the precious trinkets fashioned by Fabergé. In short the tendencies to projection, reification and animation which could be observed in our reaction to motifs also make themselves felt in the reinterpretation of objects. Where is the difference between the festoons on our frame (Plate 1) or the decoration of the chimney discussed above and the transformations suggested by the designer of our tureen (Plate 43)? He shaped the handle and the base like bundled reeds held together by twisted ribbons, in allusion to the lightness of basket work, and crowned the lid with a floral bud. Earnest critics from Vitruvius to Wornum objected to this negation of reality in favour of fiction. No doubt Cochin had every right to complain of the playful distortions which led the goldsmith of his time to twist candleholders into such unsuitable

shapes that they give us the feeling that they could not keep the wax from the tablecloth. But the ambition which drove them to these excesses was the same which prompted Grinling Gibbons to carve a lace cravat out of wood (Plate 16). What we are supposed to enjoy is going to the brink without actually falling over.

6 Modifying the Body

There is no field in which such excesses of 'brinkmanship' are more conspicuous than in that of fashion. I do not propose to survey the psychological armoury of fashion design any further than I discussed architectural decoration. The power of visual accents to articulate and modify the structure of bodies and buildings need not be spelt out, but there are certain perceptual effects mentioned in any book on dressmaking which are far from self-explanatory. I refer to the rule according to which horizontal stripes tend to broaden the figure, while vertical stripes will make it look slimmer—if that is found desirable.

Characteristically it was a Frenchman, Charles Blanc, who elaborated these and similar rules into a system. Blanc's interest in the perceptual and emotional effect of elementary forms is remembered by art historians because he influenced the art of Seurat, whose friend he was. His own researches had led him back to the Dutch mystic Humbert de Superville, who had based a fantastic philosophy of art on what he called the 'unconditional signs' of lines and forms, the horizontal standing for rest, the vertical for energy.

'Women'—writes Blanc—'who in their dress are artists *par excellence*, have not consulted philosophers to know how to set off their beauty or hide their defects. They make use of *la vue-sentiment*, and are guided by it alone. You would never persuade a woman embarrassed by her height to wear a dress striped lengthways, nor a little woman to try to add to her stature by means of horizontal stripes. Women understand instinctively, in a wonderful way, that the attention should be drawn in a different direction to that of their defects.'

Blanc makes a bold attempt to reduce this instinctual law to first principles, anticipating to some extent the methods of twentieth-century psychology: '. . . given two surfaces equal in dimensions, two circles for example, the one divided by vertical lines will appear a little increased in height, because by repeatedly insisting on the idea of height, these lines will direct our thoughts towards that dimension. Both circles will have a slight tendency to an oval, each in the direction of its lines' (Fig. 197).

 Fig. 197

Maybe Blanc's untechnical explanation is as good as any that has as yet been put forward for this undoubted effect. Where he speaks of a line 'directing our thoughts towards that dimension' we might prefer to use the concept of expectation or hypothesis. We have seen that what we have called the economy of vision makes us operate with certain expectations and one of them seems to be that lines will go on in a given direction. We have also seen that the eye tends to go to the limits of a line to check this assumption; these are perceptually sensitive points. On the other hand the repetition of the parallels makes it redundant for us to scrutinize every line and we thus leave this dimension unexamined. I would not pretend that this crude analysis really explains the whole phenomenon. Undoubtedly, there is also

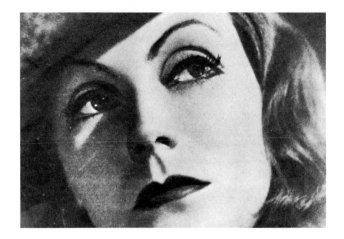

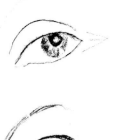

something in the traditional view that the vertical has altogether a different meaning for us than the horizontal. We associate height with effort and with dominance and we tend to think of this dimension in different terms from the way we think of length and breadth. Measurement, after all, is a great feat of abstraction. We very rarely are confronted in practical life with the need of comparing length with height. There is no advantage in knowing that on average our outstretched hands, from fingertip to fingertip, will span the same distance as the height from our soles to the crown of our head. Hence, perhaps, the mystical awe with which this observation was handed down in the figure of the Vitruvian Man.

Needless to say, the dressmaker's power to conjure with the figure and thus to contradict biblical authority, which tells us that we cannot add a cubit to our stature, is only one of many ways in which the body can be manipulated in its appearance. Even body-painting or tattooing, which may be the oldest form of decorative art, must have been practised with this aim consciously or unconsciously in mind (Plate 14). Perceptual and emotional reaction naturally cannot be separated in this wide field of expressive and erotic emphasis, which we do not propose to enter. The more meaningful a part of a body may be in these terms, the more sensitive it is likely to be to perceptual modification. We all know how easily the look of the eye can be transformed by make-up—as in the case of Greta Garbo (Fig. 198)—and what difference a change in hair-style may make to the appearance of the face (Fig. 199). The framing shapes transform the meaning of the object they enclose.

Fig. 199

Perhaps no one went further in this use of costume than Queen Elizabeth I of England, particularly later in life when she may have felt that her ageing features stood in need of such enhancement through a surrounding 'field of force' (Fig. 200). We must isolate her face to discover the human being behind the made-up mask, encircled by an awe-inspiring halo composed of spreading circles moving outwards till they reach the final fringe of the

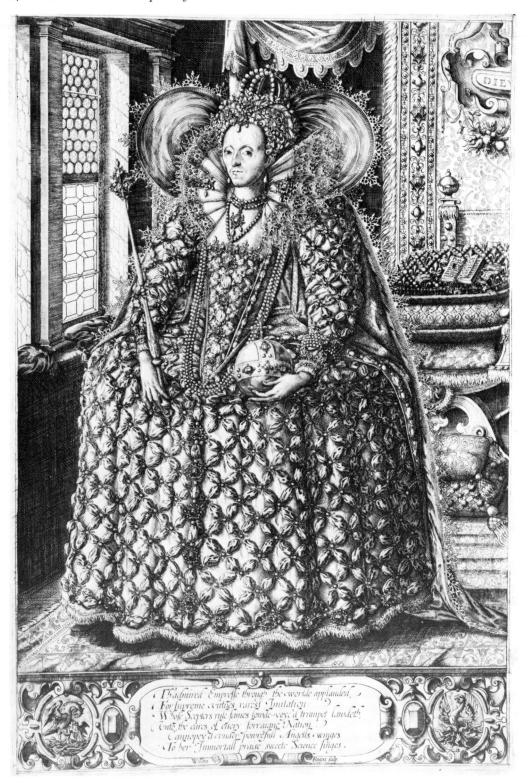

Fig. 200. William
Rogers: *Queen
Elizabeth I.* About
1595–1600

lacework. But much as she may have needed the support of artifice as a woman in a world of
men, even her power would not have sufficed to create it out of nothing. She drew on the
trend of fashion, which her dressmakers could modify but not ignore. It is time to turn to
this element of continuity in decoration.

Part Three
Psychology and History

VII *The Force of Habit*

> Progress, degradation, survival, revival, modification, are all modes of the connexion that binds together the complex network of civilization . . . Looking round the rooms we live in, we may try here how far he who only knows his own time can be capable of rightly comprehending even that. Here is the 'honeysuckle' of Assyria, there the fleur-de-lis of Anjou, a cornice with a Greek border runs round the ceiling, the style of Louis XIV and its parent the Renaissance share the looking-glass between them. Transformed, shifted, or mutilated, such elements of art still carry their history plainly stamped upon them; and if the history yet farther behind is less easy to read, we are not to say that because we cannot clearly discern it there is therefore no history there.
>
> Edward Burnett Tylor, *Primitive Culture*

1 *Perception and Habit*

The force of habit may be said to spring from the sense of order. It results from our resistance to change and our search for continuity. Where everything is in flux and nothing could ever be predicted, habit establishes a frame of reference against which we can plot the variety of experience. If the preceding chapters explored the relevance of our need for spatial order in our environment we must now turn to the manifestations of the temporal sense of order, the way the force of habit, the urge for repetition, has dominated decoration throughout history.

In the study of perception the force of habit makes itself felt in the greater ease with which we take in the familiar. We have seen that this ease can even result in our failure to notice the expected because habit has a way of sinking below the threshold of awareness. As soon as a familiar sequence of impressions is triggered we take the rest as read and only probe the environment perfunctorily for confirmation of our hypothesis. I have alluded to this role of perceptual habits in the preceding chapter when I referred to the notion of 'chunks', those units of skill which have become automatic and are thus available to us for the construction of further hierarchies of skills. It may be argued that what we call projection in the theory of vision or hearing is an aspect of that tendency, a manifestation of the force of habit. The ink blot vaguely resembling a familiar sight such as an insect (Fig. 178) will be seen in this habitual way. There are perceptual habits even more deeply ingrained than the sight of butterflies, notably the sight of the human face. Whether this habit has an inborn component or not, it is notorious that we are particularly prone to project faces into any configuration remotely permitting this transformation. The tendency may help to account for certain decorative motifs which must have sprung up independently in many parts of the globe. The bulging form of a vessel shaped to hold a liquid has often been endowed with eyes and other facial features to resemble a head, a bird or the semblance of a whole portly figure (Fig. 201). We shall find, in a later chapter, that these and similar habits of 'animation' are frequently reinforced by the belief in the efficacy of eyes, limbs or claws as protection against evil. What concerns us here is the power of inertia which contributed to the survival

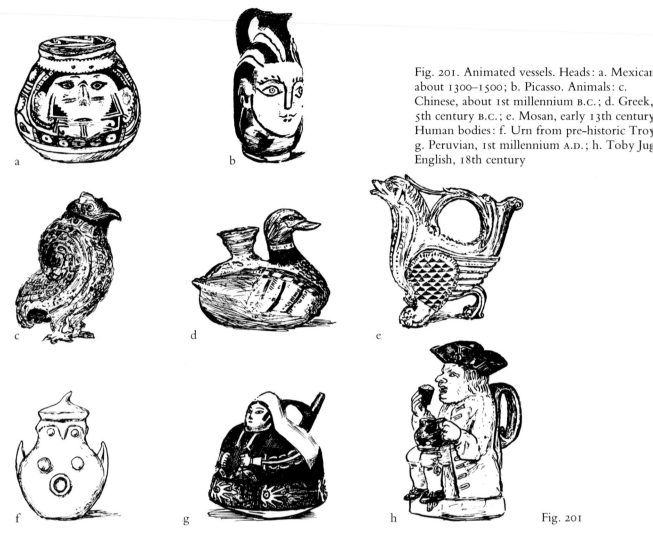

Fig. 201. Animated vessels. Heads: a. Mexican, about 1300–1500; b. Picasso. Animals: c. Chinese, about 1st millennium B.C.; d. Greek, 5th century B.C.; e. Mosan, early 13th century. Human bodies: f. Urn from pre-historic Troy; g. Peruvian, 1st millennium A.D.; h. Toby Jug, English, 18th century

Fig. 201

of such devices as the transformation of supports into clawed legs long after the magic connotation has been forgotten (Fig. 202). If it is true, as one sometimes reads, that in respectable Victorian homes the legs of the piano were draped (Fig. 203), this need not be interpreted as a symptom of excessive prudery. After all, once we adopt the perceptual habit

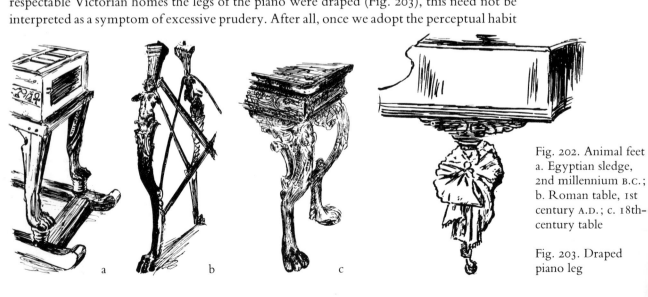

Fig. 202. Animal feet. a. Egyptian sledge, 2nd millennium B.C.; b. Roman table, 1st century A.D.; c. 18th-century table

Fig. 203. Draped piano leg

of looking at these props as legs they are not exactly beautiful legs. In other words, once a perceptual interpretation is set up for whatever reasons, it is likely to persist. From the operation of the force of habit in space we must pass to the consideration of its working in time.

2 Mimicry and Metaphor

In *Art and Illusion* I have tried to make a case for the view that art and artifice grow out of the same psychological roots. It is artifice first of all which is called upon in human culture to resist change and to perpetuate the present. Where things decay the craftsman can create the substitute that remains—whether we think of the cowrie shells serving as eyes in the Jericho heads of some six thousand B.C., or of nothing more solemn than the cosmetics industry. Artificial beards worn by the Egyptian Pharaohs, the wigs which have played such a part in human attire over the centuries, artificial eye-lashes or artificial teeth, all testify to the urge which makes man try to defeat nature and to go one better wherever possible.

In Chapter VI we have seen the floral motif taking over from the shortlived flower. Not that this translation from life into stone or paint must have been literal. It rarely was. But who can doubt that the decorator's repertory would be the poorer without his power to remind us of blossoms, leaves, gardens, wreaths, and festoons (Plate 15)?

And as with flowers so with furnishings. Real curtains fall to pieces, painted curtains are cheaper and more durable. In one of the earliest monuments of a settled civilization, the Neolithic site of Çatal Hüyük in Anatolia excavated by Dr Mellaart, we find walls covered with patterned paintings which the excavator considers to be imitations of woven rugs. It may be impossible to confirm this hypothesis, but when we come to the mural of the tomb of Hesire from the Old Kingdom in Egypt (Fig. 204) one cannot doubt that what is here reproduced is the pattern and appearance of a woven hanging. This convention of imitating a wall-hanging in paint is particularly widespread and tenacious. We find it in many mediaeval churches (Fig. 205) and even in the Sistine chapel, below the Quattrocento fresco cycle.

Fig. 204. Painted curtain. Egyptian, about 2700 B.C.

Fig. 205. Painted curtain. Yugoslav mural, A.D. 1252

Fig. 206

Fig. 207 Fig. 208

Modern designers have a term for this kind of imitation. They call it mimicry. The lino which imitates bathroom tiles or parquet flooring, the wallpaper which imitates damask or wood, the marbling of stuccoed walls, the false timber frontage—what Osbert Lancaster called 'stockbroker's Tudor'—there is no end to these devices all around us. Of course they are not exactly popular with modern designers.

We have observed the roots of this revulsion at the time of the industrial revolution when the power of the machine to simulate expensive handiwork and even costly materials threatened the established hierarchies of the earlier craft traditions. Mimicry was identified with the vulgar desire to keep up with the Joneses on the cheap, and was thus condemned in the name of honesty. But to some extent this criticism misses the point of an age-old tradition, for is there really much 'make-believe' involved? We all know that the painted curtain is not real and the lino parquet not made of wood; maybe therefore this habit of providing substitutes, cheaper and more adaptable than the original material, is not rooted in our wickedness. Instead we may see it as a feat of the imagination, the discovery of fiction, the liberation from literalness in a playful shifting of functions.

To the Puritan revolution of the 20th century, make-believe as such is a symptom of escapism, the refusal to adapt to change. I would agree with this diagnosis but I would plead for another psychological assessment of this force of habit. Mimicry can ease us into adaptation, the adaptation to new materials, new conditions, new tools, by providing that element of continuity for which there is so strong a need. It is well known that the first railway carriages imitated coaches (Fig. 206) and the first gas lamps candelabras (Fig. 207). Even in our fast-moving times, which discourage conservatism, examples of this craving for continuity are too numerous to specify. One can still see advertisements for electric heaters which imitate coal fires (Fig. 208) and even re-create the beloved cosy glow by means of a red lamp and an engine-driven device to produce the flicker.

Rather than mocking the man who had organized his life round the fireplace, where he liked to sit and relax, and who refuses to change his habits for the sake of technical change, we should consider the strength that comes from this capacity of adjusting the new to the old. To gain an estimate of the force and source of this strength we may do well to look from decoration to the greatest example of continuity in human culture, I mean the development of language. Many of the words we use can be traced by etymology to roots which can be found in Sanskrit texts dating from the second millennium B.C. But impressive as are these testimonies to the tenacity of traditions in language, etymology also demonstrates to us the capacity of the human mind to keep language a pliable tool. The meaning of the original root has sometimes changed beyond recognition, and yet it is often possible to make this change intelligible. As new concepts come in, old words have to perform new functions. Thus nearly all our abstract terms can be traced back to a more concrete usage. The terms for spirit started their career in nearly all languages as words designating the breath, and the term 'abstract' itself of course means pulled away—away from the concrete or literal meaning. In studying these extensions and transfers of meaning, etymology comes to concern itself with what the Greeks called metaphor, which really means transfer or carry-over. An old meaning is transferred and thereby transformed so as to designate a new concept. It is this capacity of the human mind for assimilating the new to the old which is also at work in the humble device of decorative mimicry. It is a form of metaphor.

Take the new element in our lives which is air travel. If anyone said of an aeroplane that 'the silver bird winged its way over a carpet of clouds', we would classify this as a metaphor and a poor cliché to boot. But let us go to the airport and look at the aircraft from its nose to its tail units with its fins and its rudders, its wings and its engines, of so and so much horsepower, and fuelled with a product of petrol which is, of course, 'rock oil'. Our boarding passes will take us on board, but not on any boards. We glance at that mysteriously named cockpit and pass down the aisle guided by the air hostess, who is no hostess and who tells us to fasten our seatbelts, which are no belts. Such derivations make the dictionary one of the most fascinating books on our shelves. Who could have guessed that the jumbo jet owes its name to an elephant in the London zoo famous for its size and that he in his turn was probably called after mumbo-jumbo, the alleged name of a West African divinity or bogey first recorded in 1738?

How merciful it is that language has retained this capacity of being stretched and changed to take in the new while linking it with the old. Naturally it would have been possible to invent new names for every fresh feature, just as the word gas was invented by van Helmont (d. 1644) to denote a novelty, though even he modelled it on the Greek word for chaos. There are fields nowadays in which new words proliferate and one sometimes suspects them to be used as status symbols, the esoteric language of a new tribe. Metaphor and extended meaning illustrate adaptation, the way of assimilation to which our mental apparatus is attuned. Our very process of growth, of learning from childhood onwards, extends, ramifies and assimilates new emotional and intellectual experiences by way of stretching the old system of classification. We learn about the emotional side of this continuity through psychoanalysis. Freud's concept of the symbol refers to the primal categories which are still close to our biological dispositions, the sexual symbol, the father-figure. All these can be interpreted as expressions of the force of habit, of continuities which can be extended and refined but will somehow remain alive in our minds.

3 The Language of Architecture

If these considerations have taken us a little far away from the topic of decoration there exists luckily a visual tradition of acknowledged importance which permits us to illustrate the

workings of the force of habit from a variety of aspects—the history of Western architecture from ancient Greece to the present century. In the introductory pamphlet to a series of Radio talks on 'The Classical Language of Architecture' Sir John Summerson has called this tradition 'the most comprehensive and stable manner of design the world has ever seen'. The origins of the language, the etymology of many of its motifs, can certainly be traced back to the elements of primitive timber architecture, the post and the lintel. It was Vitruvius himself who explained the salient features of the Doric order (Figs. 82, 83) as imitations of forms originally used in wood. If he was right, which it is hard to doubt, the origins of the classical tradition in architecture lie in 'mimicry'—only this time it is the more expensive but more durable material of marble which is used to simulate the traditional timber structure. What was it that made the ancient architects stick to such features as triglyphs and metopes which make obvious sense as part of a wooden rafter, but only cause additional work to the masons of a temple built of stone? Can it have been anything but the tenacity of perceptual habits which had come to expect certain structural elements? The triglyph, for instance, offered and still offers what I have called an explanatory accent. It showed where the transversal supports of the roof ended and how they were laid. True, other accents are not so easily explained in terms of mimicry. The entasis, the gentle swelling of the column, for instance, which contributes so much to the organic impression conveyed by Greek architecture, has less mechanical origins. We must accept the contribution here of what Wölfflin in his architectural studies describes as empathy, the habit of projecting life into inert shapes. The column seems to carry the load like a living shaft and indeed like a human being. The endowment of the various forms of columns, the 'orders', with human characteristics is an essential feature of the classical tradition and also goes back to Vitruvius, though the metaphor was not illustrated before the sixteenth century (Fig. 209).

Fig. 209. Doric and Corinthian orders (John Shute, 1563)

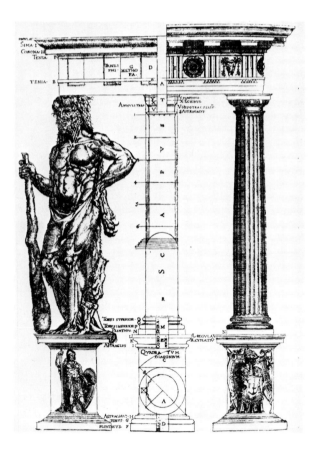

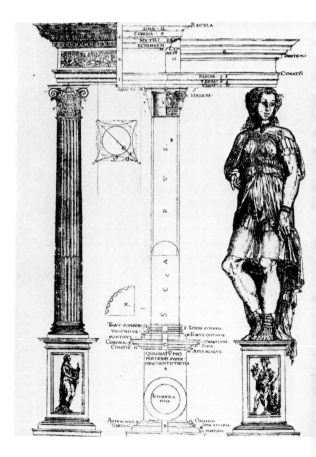

 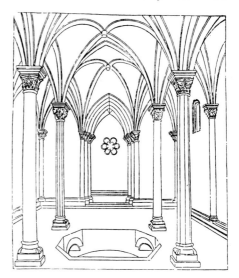

In the history of language there are two main factors making for change. One is the natural drift of language, the changes in usage and pronunciation by which Latin turned into 'vulgar' Latin and into the various regional dialects which became the Romance languages. In the eyes of the schoolmasters most of these changes were corruptions and so they saw it as their task to reform the language of the tribe. The efforts of the Renaissance humanists to restore Latin to its pristine purity are an example of the second kind of change, the deliberate reform from above. Both these factors have their exact analogue in the history of Europe's architectural language. Seen from the vantage point of the Renaissance theorists of architecture, the millennium extending from the decline of the Roman empire to Brunelleschi's reforms was an age of corruption in which the good laws of classical grammar were perverted by the barbarians. It is well known that the terms Gothic and Romanesque were originally connected with this interpretation. When it gave way to an appreciation of these styles on their own merits, emphasis centred on the distinctive features allowing for easy classification, the round arch, the pointed arch, methods of vaulting and forms of tracery. It may be argued, however, that these necessary classifications somewhat obscured that unity of tradition which is more relevant to my present context. Corrupt or no, distinctive or not, the Romanesque column (Fig. 210) is a development of the ancient column and even the slender columnettes and soaring piers of Gothic interiors betray this origin at first sight (Fig. 211). The history of architecture describes in detail what technical and social conditions accounted for these mutations; it also reminds us of their aesthetic potential. To make the support heavier or lighter than usual, to make it alternate with piers or introduce more complex rhythms, to imprison the supports in masonry or let them form a fictitious network, all these modifications are bound to affect the impression created by a building (Figs. 212, 213). It is here that the tenacity of traditions yields an unexpected advantage. It is only where expectations are formed that they can also be reassuringly confirmed, playfully disappointed or grandly surpassed. There is no period in European architecture in which these possibilities were not instinctively felt or exploited by builders of genius. And yet these masterpieces in the vernacular may somewhat differ in kind from the self-conscious products of the reform movement which we associate with the Renaissance theorists Alberti, Serlio, Vignola and Palladio, who reduced the Vitruvian rules to what Sir John Summerson called 'the architectural equivalent of the Latin tongue'. To continue the quotation from his masterly account: 'It has a strict grammatical discipline, just as Latin has, but also like Latin is capable of magnificent rhetoric, calm pastoral beauty, lyrical charm or sustained epic grandeur.'

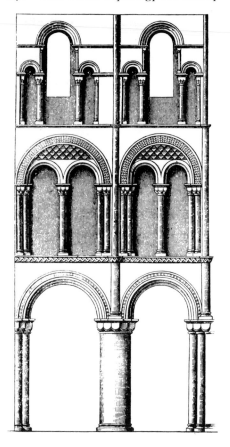

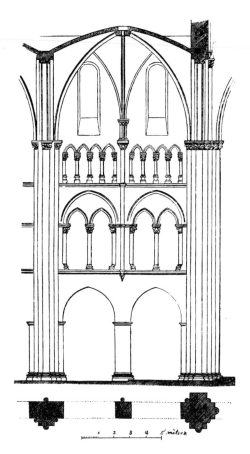

Figs. 212 and 213. Wall systems of Peterborough Cathedral, nave abou 1150, and Limburg Cathedral, begun 1213 (W. Lübke, 1858)

Such diversity in unity may only become possible where the designer works within strict alternatives which the public learns to appreciate. He knows which of the five orders will suit which type of building and which position within the building. It is against this background also that wilful deviations can make their effect. 'The giant orders' which Michelangelo introduced in his design of the Capitol (Fig. 214) presented such a bold departure because normally each storey of a building was assigned its own order. Well

Fig. 214. Michelangelo: Palazzo dei Conservatori, Rome. Begun 1546

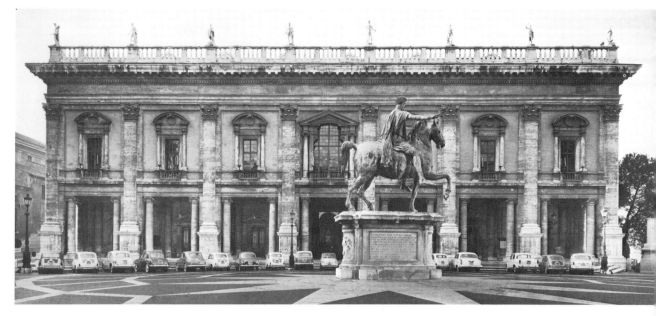

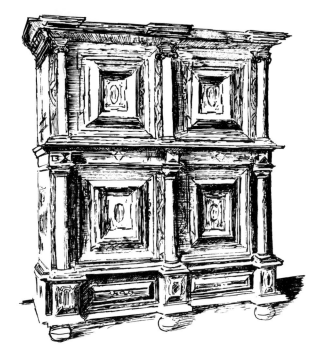

Menuisier en Batiment, Portes

g. 215. 17th-century
rman wardrobe

g. 216. *Menuiserie.*
om the *Grande
cyclopédie.* 1767

might Vasari say that Michelangelo's departures from the proportions, order and rule of common usage derived from Vitruvius and antiquity 'have placed artists under an infinite obligation because he broke the fetters and chains which kept them always on the common highway'. And yet nobody reading these words would guess that the classical tradition in architecture continued quite unbroken throughout the subsequent styles of the Baroque, Neo-classicism, the Greek Revival, right into the twentieth century. As in the past, the licence, even the extravagance, of certain solutions presupposed the coherent framework of an accepted language. The pliability of this language, its adaptability, poses a problem of aesthetics and of social psychology which might puzzle us more if we had not come to take it for granted. Not only the builders adopted the idiom as a matter of course, it spread from architecture to carpentry and cabinet-making, indeed to all forms of decoration which used the elements originally developed for the timber structures of early Greek temples (Fig. 215). The spread of these motifs can be traced in the manuals and pattern books of the various decorative crafts (Fig. 216); to master the rudiments of the orders and the shapes of mouldings was a necessity. It is in these less conspicuous forms that the force of habit makes itself felt. Look around in any house built before the functional revolution of the twentieth century and you will see shapes of door frames, of table ledges or of ceiling cornices, reflecting designs invented more than two thousand five hundred years ago.

No doubt there are many reasons for this conservatism of the crafts. We know that even in our fast-moving times the introduction of new models of machinery requires a period of 'tooling up', and the masons' and the carpenters' tools were necessarily adjusted to certain forms and unsuitable for others. It may soon become as difficult to get a door-frame with mouldings made as it would have been some decades ago to persuade the builder to leave the frame uncut. But here as often the conservatism of the craft may be due to a large variety of factors. An interesting suggestion in this respect has recently been made by Konrad Lorenz, who compared the tenacity of conventions in the traditional crafts with the process that students of animal behaviour call 'ritualization'. In both cases, so he argues, the rigid stereotype facilitates communication and preservation. The movements and actions the craftsmen perform must not only be performed correctly, they must also be correctly handed down to the next generation.

'It is hardly an exaggeration to say that every pattern handed down by tradition becomes, with time, endowed with those frills and embellishments which, by making it more impressive, facilitate handing-down. The apprentice of the ancient smith had to learn that a newly forged sword must be tempered while still red-hot, in cold water, but if he is taught to do it three times, twice in running water and once in the morning dew, according to the precept of Kipling's Weyland, smith of the gods, the procedure is so much more impressive . . . and what is more, that kind of embellishment *may* contain, irrespective of their non-rational origin, some very real improvements, which are consequently taken up and reinforced by natural selection.' Certainly the craftsman will not be inclined to 'reason why' his tools and patterns are adjusted to mouldings, and mouldings he will make.

Not that this tradition remains confined to members of the crafts. The ritual—if we so want to call it—carries over to the public in the form of perceptual habits. On the whole we only become conscious of these habits when we are asked to break them. Every traveller knows how often he is made aware of a habitual assumption only when it fails to work. If you want to switch on the light in England you press the switch down, in America you push it up. The resistance to change in technology and in art, so much deplored by critics and reformers, must be symptomatic of a deeply felt need. I know no better example of this link between conservatism and perceptual habit than the hostile reaction with which the public of Vienna greeted the first functional façade by Adolf Loos (Plate 2). It was dubbed 'the house without eyebrows', because the windows lacked the customary cornice or gables, with which normal windows of whatever style were marked in Vienna.

4 *The Etymology of Motifs*

The radicalism of Adolf Loos was a symptom of the malaise which decoration had caused for so long among the theorists of the nineteenth and early twentieth centuries. We have seen that this malaise, rooted in the decline of the craft tradition, also led to those reflections on the nature and origin of decoration which formed the subject of our second chapter. It is against this background that the most important work on the history of a decorative motif must be seen, Alois Riegl's *Stilfragen* of 1893. Born in 1858, Alois Riegl was trained in the strict and proud tradition of the Vienna *Institut für oesterreichische Geschichtsforschung* before, at the age of 28, he joined the staff of the *Oesterreichische Museum für Kunst und Industrie*, closely modelled on the Victoria and Albert Museum in London. These centres had been founded in the hope of fostering a new awareness of the laws of design among manufacturers and among the public.

As a Keeper in the textile department of the Museum, Riegl was in charge of one of the richest collections of oriental rugs anywhere in the world. It was to these treasures, therefore, that he devoted his first book of 1891, *Altorientalische Teppiche*, and his Preface shows that he was well aware of the topical relevance of his subject. Oriental carpets had become fashionable; and not only among the rich, but in much wider circles it had become 'a point of honour' to own at least one such piece. There was no doubt in Riegl's mind as to the source of this trend. It was the corruption of the industrial arts of Europe which had sparked off the reform movement calling for a return to simplicity. Citing Gottfried Semper and Owen Jones, who had specifically commended the unerring taste in design to be found in oriental rugs, Riegl reminded his readers that the sands were running out. Even in the East the conditions of home crafts under which these rugs were produced were about to disappear, and collectors would do well to hurry before commercialism had done its worst.

But Riegl was not only aware of the aesthetic problems of his time. He was also eminently responsive to the intellectual climate of these decades, which were still dominated

by the impact of Evolutionism. His historical training had acquainted him with the persistence of Roman Law in formularies, charters and other documents of the Middle Ages, and he had earned his spurs with a paper on mediaeval calendar illustrations, which likewise proved the unbroken power of the classical tradition. These were the years when Aby Warburg, born eight years after Riegl, took up the problem of the tenacity of the classical tradition, to which he devoted his life and his library, precisely because the universal demand for a New Style challenged the historian to ponder the relation between continuity and change. What Springer had called *Das Nachleben der Antike*—the 'afterlife' of the ancient world—was a potent factor wherever the historian looked.

It turned out that it was also a factor in the history of Oriental rugs. Dissatisfied with the vague talk which linked these products with the legendary splendours of the ancient East, Riegl began to analyse the principal motifs occurring in the designs of these regions. The result was startling. The vocabulary of these visual poems derived frequently from Greek roots.

Take the motif so often found on the borders of oriental rugs, which looks like a series of pomegranates linked by leaves (Fig. 217). Riegl was able to show that it could be traced back over more than a thousand years to the leaf-palmette of a type used, for instance, at the late antique temple of Split from the time of Diocletian (Fig. 218). The similarity of the arrangement of alternating directions in the flowers and undulating leaves confirms a common ancestry. By the time Diocletian's craftsmen used it in the fourth century A.D., however, the arrangement was in fact at least a thousand years old. A vase from Melos dating from the seventh century B.C. (Fig. 219) shows that the principle of alternating flowers with their scrolly links had been established in Greek art during the period of its dawn. Like the etymologist who traces the roots of a particular word through the history of various languages, Riegl was able to identify basic motifs behind changing appearances. His method triumphed in the demonstration that the typical arabesque, such as we find in the stucco motifs of Islamic Egypt, can be revealed as a transformation of a Greek palmette if only we alter the relation between figure and ground (Fig. 220). Thus the whole vast

Fig. 217. Border of a Persian rug. 16th century A.D. (A. Riegl, 1893)

Fig. 218. Two borders from Split. 3rd century A.D. (A. Riegl, 1893)

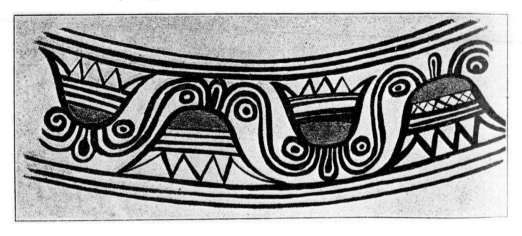

Fig. 219. Vase from Melos. 7th century B.C. (A. Riegl, 1893)

Fig. 220. The arabesque retranslated (A. Riegl, 1893)

growth of decorative ornament we associate with this form of the arabesque was in fact a development or transformation of the Greek style of ornament, just as French or Spanish is a development of the Latin language.

At the very time when Riegl was busy tracing the continuous development of the Greek palmette over 2,500 years to his own time, another scholar was digging on the other side of the tunnel, as it were, to lengthen the story in the other direction. He was the American, W. H. Goodyear, the Keeper of the Egyptian Collection of the Brooklyn Museum, whose book *The Grammar of Lotus* also appeared in 1891. Goodyear's background and motivation differed from Riegl's. His interest had been fired by the search for ancient symbols in the traditions of the East, a search to which I shall have to refer again. The purpose of *The Grammar of Lotus* is not only to show that the beautiful plant of the Nile was a symbol of the Sun, but that this sacred character of the flower explains its universal application in Egyptian art, on columns and on borders (Figs. 193, 221). Moreover Goodyear tried to show that this solar symbolism spread from Egypt to other Eastern civilizations, all of which adopted the Lotus (Fig. 180), and that it finally infiltrated ancient Greece, where the decorative forms of the palmette (Fig. 222) and of other elements turn out to be nothing but transformations of this solar flower.

Goodyear's theory of the ubiquity of solar motifs has not recommended itself to scholars, but his proof of the link between Greek and Egyptian ornament could not be gainsaid. This means that another 2,500 years could easily be added to Riegl's story, for the use of the Lotus certainly goes back to early Egyptian dynasties in the fourth millennium B.C. The discovery that so many of the decorative elements still in circulation in his time had such a venerable continuous history inspired Riegl to write his *Stilfragen*. He must have worked at surprising speed, for the book came out in 1893, only two years after Goodyear's publication.

I have called *Stilfragen* perhaps the one great book ever written about the history of ornament. It owes its greatness to the inspiring vision which rose up before Riegl's eyes when he realized that the study of ornament was a strictly historical discipline. The opening paragraphs of his Introduction indicate that he expected opposition to this point of view. The accepted orthodoxy among his colleagues regarded ornament as a by-product of technical procedures, and such by-products could arise spontaneously at any time and in any region. We remember that it was Gottfried Semper whose name had become associated

a

b

Fig. 221. Egyptian Lotus motifs (W. H. Goodyear, 1891)

with the so-called 'materialistic' explanation of decorative forms, though Riegl is careful to dissociate Semper himself from the thoughtless application of his original insights. 'Certainly Semper would have been the last to want to replace a freely creative will to art by an essentially mechanistic and materialistic imitative urge.' This is the polemical context in which Riegl first introduced his famous term *Kunstwollen* (will to art or will to form) and I have stressed in Chapter III that he was right in reminding his contemporaries of the limited explanatory power of any purely technical explanation. What Riegl may have underrated is the degree to which the sense of order also dominates technical artefacts, and further the force of habit which, as we have seen, makes for the survival of orders once created. Not that he denied the possibility of such survivals, of which the influence of timber construction on

Fig. 222. From the Lotus to the Greek palmette (W. H. Goodyear, (1891))

the Doric order is a classic example, he only turned against the lazy assumption that all geometrical motifs must arise spontaneously again and again from the techniques of basketry or weaving. It was this kind of assumption which blinded students of art to those continuities which he had observed, and he made it his programme to 'tie together the thread which had been cut into a thousand pieces'. It was the thread that linked the earliest Egyptian Lotus ornament with the latest arabesque.

There were two places only where loose ends needed knotting. One was the transformation of the Lotus ornament into the scroll, the other the origin of the dominant classical motif, the acanthus. It was his concentration on the scroll which had prevented Riegl in his first book from anticipating Goodyear's insights into the Egyptian origin of European plant ornament. For the Egyptians did not know the undulating scroll and neither did the art of Mesopotamia. The ancient Oriental styles with their tendency to lucid isolation and geometric rigidity could not, so it seems, accommodate the freely waving line as a link. Their decorative repertory included spirals (Fig. 84) but these were strictly confined to repeat patterns and never extended along borders. In searching for the origins of this linking device which proved of such immense consequence for the history of decoration, Riegl was of necessity restricted by the archaeological material known in his time. The art of Crete, for instance, with its wealth of decorative forms, had not been discovered yet, but Riegl knew of Schliemann's finds of Mycenaean pottery and it was there that he found the motif he was looking for, the wavy or undulating scroll either as a geometrical design or as a plant motif (Fig. 223). Whatever the ethnic origins of the Mycenaeans may have been, the fertile

Fig. 223. Mycenaean motif (A. Riegl, 1893)

invention of this design was made in the orbit of ancient Greece. As Riegl put it, 'a whole world separates the limited (*borniert*) artistic spirit of Egypt from that which manifests itself in the Greek vegetative scroll.'

As a child of his time, Riegl never doubted the influence of racial factors on stylistic development. Those of us who are disinclined to accept such explanations have to look for alternatives, provided explanations are ever possible. No doubt the absence of a motif which seems so natural and so useful as the wavy line from a style extending over several thousand years and over a large geographical area, presents a problem. It is not lessened by the fact that undulating lines of one kind or another can also be observed in the decorative repertory of other prehistoric styles which need not necessarily have had any connections with Mycenaean Greece. Maybe one element of the explanation would have to be sociological, that is, it might be found in the working procedures of the Egyptian decorative crafts. The strictly designed repeat pattern permits division of labour and the collaboration of large teams such as were undoubtedly needed for the colossal enterprises of the Oriental empires. There is a Greek anecdote illustrating the point. Two sculptors working in different places were each producing one half of a colossal figure; using 'the Egyptian system of proportion' they achieved such accuracy that the two halves were found to fit without the slightest flaw. Such precision requires rigidity; the elements of Egyptian (and Mesopotamian) decoration usually fit together like the blocks or tiles composing the building. Riegl was right when he felt that the undulating line was contrary to the spirit of these styles. It is essentially a motif suggesting a free-hand design which allows a certain amount of elasticity and irregularity (Plate 25). In fact, it is this elasticity which proved so invaluable to the decorator once the motif had been integrated into the repertory, because—as Riegl knew—the wavy line is infinitely adaptable to any area it is expected to fill, allowing for contractions or extensions, stretching along borders or masking a gap. There is no doubt that this adaptability and flexibility secured the success of the motif once it had been introduced. But maybe in considering its relatively late adoption in a developed form, we should not disregard the hidden complexity which we found when analysing its perceptual effect. Perceptually the wavy line (Fig. 149) is far from simple because of the fluctuating interactions between figure and ground which arise as we look from bulge to bulge or from hollow to hollow. Moreover, any diagonal configuration is perceptually less easy to grasp than the horizontal or vertical connection. Small children have considerable difficulty in copying a square with a diagonal because, if we may simplify a complex argument, it disturbs their rigid habit of expectations. It would be an abuse of such psychological results to suggest that the ancient Egyptians had not yet attained the degree of intellectual maturity necessary for the adoption of the wavy scroll, but they may have resisted it as a somewhat irrational element which contravened their own rigorous sense of order.

We have seen the way Greek art combined the motif of the lotus blossom with the wavy scroll, and we followed with Riegl the transformation of this design into the palmette as used in oriental rugs. But if Riegl wanted to be faithful to his programme of demonstrating continuity, one other important novelty had to be accounted for, a novelty more famous even in the history of Greek ornament than the wavy scroll—I refer again to that hallmark of ancient decorative art, the acanthus.

The ancients had certainly believed the acanthus to be a straight imitation of a real plant. Vitruvius had told the touching story of the origin of the Corinthian capital (Plate 48)—that it had been modelled by the sculptor Kallimachos on the chance find of a basket with toys which a faithful nurse had deposited on the tomb of a girl and which had become enclosed by acanthus leaves. Riegl could surely not be expected to believe this *ad hoc* invention, but he was altogether sceptical about the derivation of the plant motif from the particular weed which grows in such profusion all over Greece and Italy (Plate 47). Was the leaf all that

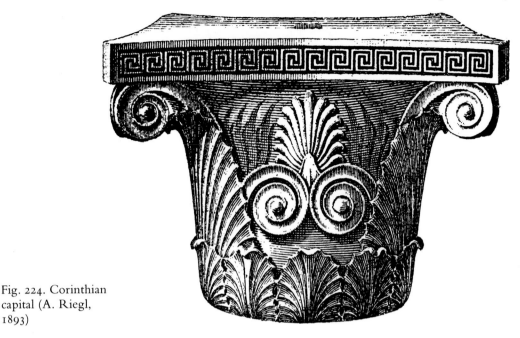

Fig. 224. Corinthian capital (A. Riegl, 1893)

similar to the leaf of *acanthus spinosus* which he found illustrated in Owen Jones? It was not. There really was no need to give up the hypothesis of continuity, for if you looked at certain early forms you could see that the so-called acanthus was really no more and no less than the old palmette turned into a leaf (Fig. 224). Nowhere does Riegl's forensic skill shine out more clearly than in this plea for continuity. He marshals most convincing comparisons between an indubitable row of palmettes (Fig. 225) and an early acanthus frieze from the Erechtheion (Fig. 226) to make his interesting case.

No doubt there was a good deal of special pleading in Riegl's presentation. He had to circumvent a number of inconvenient facts such as the naturalistic rendering of acanthus leaves on vase paintings representing funeral stelae (Fig. 227). Moreover, it is clear that the leaf he illustrated was far from being the closest example he could have chosen. The early examples do not represent the leaves of the plant. They resemble the supports of the chalice (Fig. 228). The Greek designers also place them in the corresponding positions to the stem (Fig. 229, Plate 49). It has been argued correctly that in these early versions it certainly is not the palmette which turns into a leaf. The palmette seems to be conceived as a blossom and the acanthus as the chalice (Fig. 230, Plate 50). Indeed, in all the early versions of the acanthus scroll the function of the leaf is to mask the divisions of the stem.

Maybe we can here recall another perceptual element which may have played its part in the adoption of this motif; I mean the tendency of searching for continuities. There is something slightly unsatisfactory in a wavy line from which other lines fork off. The change

Fig. 225. Row of palmettes (A. Riegl, 1893)

Fig. 226. Lotus-palmette frieze from the Erechtheion. About 415 B.C. (A. Riegl, 1893)

Fig. 227 (*left*). Design from an Attic *lekythos* (A. Riegl, 1893)

Fig. 228 (*above*). Acanthus (R. Hauglid, 1950)

Fig. 229. Detail of a frieze from the Erechtheion. About 415 B.C. (A. Riegl, 1893). See Plate 49

Fig. 230. Detail of a gold quiver. 5th century B.C. (A. Riegl, 1893). See Plate 50

of direction in the undulation can be taken in our stride, but the additional complication demands some kind of visual explanation. The joints conflict with continuity not only because a new direction is introduced, but also because the continuous width of the line is compromised at the joint. Should both be imagined to taper where they are joined, and if not, which of the two is continuous? In metalwork the joints have to be hammered or tied, introducing another discontinuity (Fig. 138). It can be masked if the scroll becomes an acanthus scroll (Fig. 66). It has been suggested that the Greeks observed this advantage in a different plant, *arum dracunculus*, which has stems growing out of blossoms in a similar way (Fig. 231). If that is true, it would strengthen rather than weaken Riegl's case because what he was after was the priority of formal requirements over purely imitative interest in a particular plant.

It would be a pity if the immense value of Riegl's observations were obscured by certain weaknesses in his method, weaknesses closely linked to his evolutionist background. Like Darwin he looked for 'missing links', links between the palmette and the acanthus. But the designs he identified as such links do not necessarily prove his case. Granted that there are motifs which can be interpreted as something between a palmette and an acanthus leaf, are we entitled to place them chronologically between the former and the latter? Is it necessarily the case that anything that looks like a transitional form must be evidence for a gradual evolution? We might put the question in the most abstract form. If we have a motif 'a' and another 'b' and we find a mixed form 'ab' does this necessarily show that 'a' developed into 'b' via 'ab'? Could not 'ab' be a subsequent hybrid or an assimilation of one form to the other?

The history of ornament knows many such cases, and some of them come very close to Riegl's example. There are Oriental rugs of the kind Riegl studied, in which the shapes of the scroll are assimilated to pheasants or parrots (Fig. 232). We could obviously not apply Riegl's criterion here and say that all parrots in Persian decoration are nothing but transformed scrolls.

It is important to stress, however, that these and other criticisms that could be made of Riegl's specific hypothesis concerning the origins of the acanthus motif in Greek art do not invalidate his basic postulate of continuity. For whether or not the palmette can be watched as turning itself into an acanthus, it is still likely that the plant motif was received into the

Fig. 231. *Arum dracunculus* (Carus Sterne, 1891)

Fig. 232. Pheasant border from a Persian silk carpet. 16th century

a

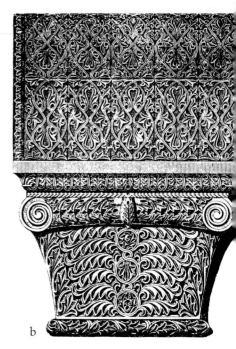

b

repertory of Greek ornament because it could so easily be assimilated to the traditional palmette. We see once more that force of visual habits at work which ensures the role of the 'schema' in the procedures of art. The schematic motifs which Greek designers had derived from the ancient Orient were returned to life in the great awakening that can be observed in all aspects of Greek civilization. The 'animation' of the scroll into a living plant with a resemblance to a familiar weed is part of that evolution which became a revolution.

It remains fascinating to follow Riegl as he takes us, in the last four sections of the book, through a further thousand years of stylistic change, to analyse with him the transformations of the Corinthian capital from the fourth century B.C. to the late antique versions of the motif in the Byzantine Church of St. John (Fig. 233a) and in the Hagia Sophia (Fig. 233b). He pays tribute to Owen Jones, who had recognized that this development led directly to the arabesque, but he criticizes the emphasis Jones places on the novelty of the design in which the distinction between stem and leaf is lost, observing that this same tendency makes itself felt much earlier in Greek ornament. Resuming his arguments from the book on Oriental rugs, Riegl completes the demonstration of the continuous development from Byzantine to Sassanian and Syrian variants of plant ornament, culminating in the developed forms of Moorish art, which still betray to the practised eye their origin from the Greek palmette and the acanthus (Fig. 234).

Riegl was perfectly aware of the fact—as he says in the Introduction to *Stilfragen*—that the history of the classical plant ornament could be continued throughout the Middle Ages and to the Renaissance, but strange as it may sound, nobody has yet written a worthy continuation of the book. Needless to say, it could only be written with Riegl's single-minded concentration on individual problems, for nobody could ever map out the ramifications and transformations of the acanthus scroll in all their surprising varieties. Once our eyes have been sharpened to these continuities of the motif we shall encounter it again and again. It luxuriates in Byzantine stonework (Fig. 235) and on Romanesque capitals (Plate 51), it turns into Gothic foliage, where it is metamorphosed into native plants. Indeed, one of the many urgent tasks for a new Riegl would be to investigate the apparent naturalism of Gothic leaf work in the light of his treatment of the acanthus. Were the craftsmen who fashioned the marvellous decorations of Rheims (Plate 52) and Amiens, so

Fig. 233a. Capital from the Church of St. John, Constantinople. 6th century A.D. (A. Riegl, 1893)

Fig. 233b. Capital from the Hagia Sophia, Constantinople. 6th century A.D. (A. Riegl, 1893)

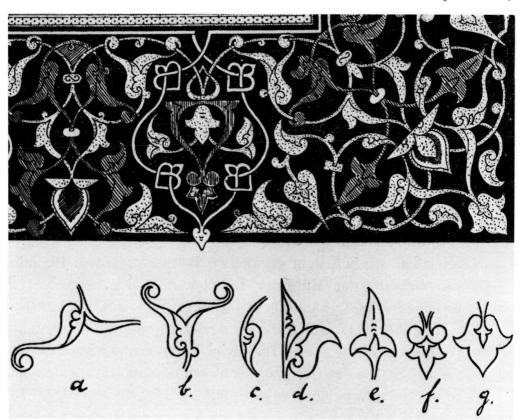

Fig. 234. Analysis of the arabesque (A. Riegl, 1893)

admired by Ruskin, or the famous 'Leaves of Southwell' (Plate 53), so lovingly described in a charming book by Nikolaus Pevsner, really and exclusively relying on a study of living plants, or can we sometimes, at least, still feel the schema of the traditional acanthus leaf behind the renderings of the native flora? Did the continuous tradition facilitate the reabsorption of classical forms in the Renaissance? What was borrowing and what independent growth in the heavier forms of the scroll favoured in the Baroque such as we encountered on the frame of Raphael's *Madonna della Sedia* (Plate 1)? And to what extent can Riegl's method be used for the explanation and analysis of the Rocaille? Are these playful shells (Figs. 23, 28) just another metamorphosis of the acanthus, or are those versions of the motif which suggest this affinity also hybrids which sprang from the unlikely crossing of two different motifs?

Fig. 235. Acanthus scroll on a stone relief from the Church of SS. Sergius and Bacchus, Constantinople. A.D. 527–36 (A. Speltz, 1910)

But tempting as it would be to linger over these questions, other problems posed by Riegl's researches might prove even more rewarding to any intrepid explorer who took up the etymology of motifs. I am referring to the astounding spread of the scroll across Asia into the Far East. It appears in China during the Han dynasty in the first centuries of our era, approximated to the Chinese idiom but still recognizable as the Greek scroll (Plate 54), and is finally adapted there to the great tradition of floral decoration without fully losing its Greek

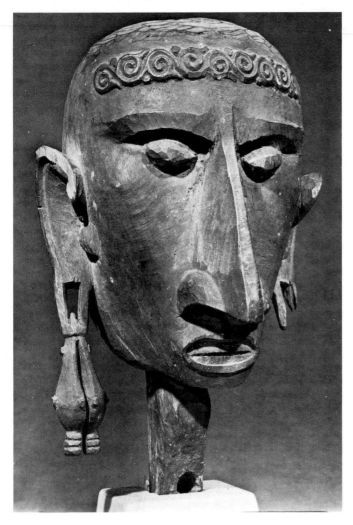

Fig. 236. Carved head from
Tanimbar, Moluccan Islands

accents (Plate 55). In India, where it seems to have been associated at first with Buddhist imagery as on the halo of the Buddha from the fifth century (Plate 56), it finally achieves in Hindoo sculpture a lush richness not rivalled anywhere (Plate 57). It also penetrates into the folk art of the South East, as witnessed by its appearance on what looks like a primitive tribal mask from a Moluccan ritual pole (Fig. 236). Clearly the etymology of motifs would still offer interesting problems for research and indeed for the demonstration of the interdependence of all civilizations of the Old World. Not that the flow was all one way. There are some motifs which developed in China and percolated to the West; one of them is the so-called cloud band (Fig. 237), which was assimilated into the vocabulary of Oriental

Fig. 237. Cloud band

rugs and sometimes crossed with the western scroll (Col. Plate V). More enigmatic in its derivation and spread is the so-called Paisley pattern (Fig. 152), for which many explanations have been suggested, none of which is wholly satisfactory.

5 Invention or Discovery?

But what would constitute a satisfactory explanation? We know that the force of habit is selective and survivals are often capricious. We also know from the example of language that it is frequently useless to ask why certain roots or forms lived on over thousands of years while others were eliminated without a trace. Any historian must surely approach such problems of explanation with diffidence and with scepticism but, speaking in the most general terms, it may still be accepted that the principle of the survival of the fittest is a useful guideline. Maybe motifs survive because they are easy to remember and easy to apply in diverse contexts. It was suggested in a previous chapter for instance that the Paisley pattern combines the advantage of distinctness with the possibility of introducing a directional element, a slight loosening of symmetrical rigidity which could easily be regulated or counteracted at will. Could not similar advantages be found in all motifs which remained successful over the centuries?

The manifold versions of the palmette in the textile motifs which reach Europe from the East (Fig. 238), variously described as pineapple or artichoke designs and also assimilated to the pomegranate or the carnation, must owe their survival to this adaptability. While the basic arrangement was given, it still allowed the designer subtly to adjust the relation between figure and ground and to lighten or increase the relative weights of the motif and the framing device.

One of Saul Steinberg's delightful covers for *The New Yorker* (Fig. 239) suggests the fantasy of a garden in which the traditional floral motifs of the decorator's repertory have reverted to the soil, as it were, and are tended by a grave feline gardener. Which of them is destined to grow and prosper, and which will fall victim to the voracious ornamental birds which haunt the plot? Does it make sense even to ask this kind of question in the harsher world of historical realities?

We certainly must not claim that we could ever have predicted the course of events and foreseen the road which led from the Lotus to the acanthus and beyond to the rocaille. But if the perpetual study of decoration is to benefit the historian it must at least be able to identify certain advantages which Riegl's animated undulating scroll enjoyed and which may therefore account for its survival and proliferation. Partial explanations of its perceptual appeal have indeed been offered in the past. Hogarth's discussions of the 'line of beauty' are entirely based on his idea of visual satisfaction, and so is Owen Jones' analysis of the arabesque in terms of eye-movements. I believe that both these authors were right in their contention that there are formal motifs which are not only inventions but also discoveries. By this I mean that they are found to fit certain psychological dispositions which had not been satisfied before. Medicine speaks of drugs which are 'habit-forming', and the history of such habit-forming drugs or spices is writ large over the face of the globe. No doubt it would be foolhardy to apply this idea uncritically to the history of art, but it is worth asking whether we may not speak of decorative motifs which, once invented, turn out to be habit-forming. Maybe the acanthus has a claim to our attention similar to that of the vine or the tobacco plant. If that is true it may still be impossible to specify exactly wherein lies the psychological attraction of the motif. But some tentative answers suggest themselves. First it has all the decorative advantages we found in the wavy line without the possible disadvantage of that abstract motif. The advantage, we remember, lies in its flexibility, which makes it applicable to any empty area, the disadvantage derives from the inbuilt ambiguity between figure and ground, which may introduce an undesirable element of visual complexity. The transformation of the line into a plant scroll firmly establishes the relation between figure and ground, introduces explanatory accents which allow subsidiary scrolls to grow out of the stem without visual discomfort and gives the decorator the option

Fig. 238. European textiles with palmette motifs. 16th century (R. Glazier, 1923)

of introducing as many additional directional accents as he wants, varying the symmetry and balance according to the demands of his task (Plate 58).

Thus the acanthus scroll offers scope for all the basic activities of the decorative designer which I described in Chapter III as 'framing, filling and linking'—the latter taking the forms of branching or radiation—, and combines them in so flexible and sensitive a way that it offers the perfect instrument for the organization of areas. Moreover, the animation of the line which turns it into a live organic motif offers many pleasant associations with flowers and greenery so closely linked since time immemorial with the habit of decoration. Last but not least, the restriction to particular motifs offers the same aesthetic opportunities we observed in the cases of the architectural orders. The trained public will come to sense the exact degree to which the plant is stylized or animated, lush or lean, and will respond to these variations with increasing sensitivity, if not necessarily as violently as Ruskin did when he distinguished between temperance and luxury in a scroll (Fig. 44).

I realize that any such analysis must, by its very nature, have all the faults of an 'ad hoc' hypothesis which cannot be tested. All we can ask is whether it may be an improvement on Riegl's explanatory hypothesis. Riegl, it will be remembered, had used the discovery of continuity to counter the 'materialist' theory of decoration which appealed to the authority of Gottfried Semper for the role played by technique in the spontaneous generation of decorative motifs. It was this materialism, this disregard of the aesthetic and psychological urges underlying artistic creativity, which Riegl wanted to put out of court by his demonstration of a millennial development. As he studied the vicissitudes of the lotus turning itself successively into the palmette, the acanthus and the arabesque, he began to think of it as if it were endowed with a life and will of its own. Thus we read that Hellenistic art brought the Greek scroll to the end towards which it had been consistently driving for centuries, or that it was its essential aim to unfold freely over large areas. In other words, he was more a Lamarckian than a Darwinist, or more precisely an Aristotelian who thought in terms of a 'final cause'. That 'will to art', which Riegl had conceived as an alternative to the mechanistic explanations of individual motifs, developed into a vitalistic principle underlying the whole history of art.

It is this shift of emphasis which also helps to explain Riegl's unwillingness to follow up *Stilfragen* with further studies in the history of motifs. Having proved his point he must have found it more important to consolidate his concept of the *Kunstwollen* by a different approach. It had to be shown that this inherent force pervaded all artistic manifestations of a particular period or style. Once it could be demonstrated that architecture and sculpture, design and ornament obeyed one unifying principle, the ghost of 'materialism' was surely laid for good and all.

The Swiss scholar Ferdinand de Saussure, who so greatly influenced modern linguistics, introduced the distinction between the 'diachronic' and the 'synchronic' study of language. The first deals with historical changes (e.g. the changing forms and meanings of the term 'pattern'); the second with language as it can be observed at any particular point in time (e.g. the current usage of the term). Applying this distinction, it is clear that *Stilfragen* is a diachronic study of ornamental motifs. To supplement it by a 'synchronic' account Riegl had to turn to the analysis of a particular stylistic period. An opportunity for this shift offered itself very soon when he was commissioned to publish the 'Works of late antique decorative art found in the area of the Austro-Hungarian Monarchy'. His work, entitled *Die spätrömische Kunstindustrie* (1901), presents a further stage in his interpretation of the place of the decorative arts within stylistic history.

Fig. 239. Drawing by Saul Steinberg. From *The New World* (Harper & Row). © 1964 Saul Steinberg. Originally in *The New Yorker*

VIII The Psychology of Styles

> How I am always overcome by fear whenever I hear a whole nation or age
> being characterized in a few words—for what an immense mass of varieties
> are comprised in such words as nation or the Middle Ages or the Ancient or
> Modern Times!
>
> Johann Gottfried von Herder, *Abhandlungen und Briefe über schöne Literatur
> und Kunst, Viertes Fragment*

1 Riegl's Perceptual Theory of Style

If Riegl's *Stilfragen* is the greatest book among studies of decorative design, his *Spätrömische
Kunstindustrie* may be described as the most challenging. One cannot ignore its thesis even if
one cannot accept it uncritically. There is a great difference between the two books in
the way the evidence is handled. The diachronic unity of stylistic developments which he
demonstrated in *Stilfragen* brilliantly survived the test of observation. The 'synchronic'
unity of style in any one period is much closer to a metaphysical postulate. It is doubtful
whether it can be tested at all. But this ambitious attempt to demonstrate what may be
undemonstrable also offers a clear-cut psychological theory of style. In a field as vast and as
varied as is the study and interpretation of style, it is only too easy to lose one's way. Riegl's
Kunstindustrie can serve as a landmark even for those of us who may ultimately wish to go in
another direction.

There are few episodes in the history of artistic theories which allow us to observe the
interaction between contemporary issues and intellectual arguments with greater clarity
than the genesis of Riegl's most famous work. Just as Goodyear's *Grammar of Lotus* was a
catalyst which permitted the great synthesis of *Stilfragen,* so *Die spätrömische Kunstindustrie*
constitutes Riegl's response to the book by the holder of the Chair of Art History in Vienna,
Franz Wickhoff, on the *Vienna Genesis* (1895). Originally conceived as the introduction to
the publication of a famous early Christian manuscript, this interpretation of late antique art
(published in English as *Roman Art*) set out to clear the stylistic development from Augustus
to Constantine from the stigma of decline. It does so quite explicitly by referring to the
topical issues of Wickhoff's period, notably the battle around Impressionism. Where
earlier critics had merely seen the corruption of Greek sculpture and painting in slovenly and
sketchy procedures, Wickhoff stressed the positive gains achieved by this development in
what he called 'illusionism'. What is important in our context is the attention he paid in this
analysis to works of decorative art. Among his prime witnesses were the beautiful slabs of
the tomb of the Haterii in the Lateran Museum, dating from the first century A.D. (Plate 59).
In his sensitive description Wickhoff stresses the refusal of the craftsman to imitate the roses
surrounding the pillar with all naturalistic detail. 'Only the impression was to be rendered,
the impression made by a rosebush full of buds, flowers and leaves trembling in the air.'
Referring to Riegl's *Stilfragen*, which had come out two years earlier, Wickhoff stresses the
continuity of stylistic development in the rendering of plant motifs. He asks how the
characteristic beauty of this decorative masterpiece could have been overlooked for so long,
and blames the orthodoxies discussed in Chapter II. While the academies of art taught
the painters to imitate reality to the point of deception, the schools of design warned their
students never to imitate the art of illusionistic periods, but rather to choose as their models
the decoration of those ages of European art which had not yet 'outgrown the charmingly
childish babble of stylized representation'. We also learn from Wickhoff that the inevitable
reaction against this dogmatism was connected with an event 'unprecedented in the History

of Art'—the impact of Japanese art on the West. According to Wickhoff it was this discovery which helped to remove the taboo on naturalism. 'In the wake of this development, we can now appreciate the beauty of such works as the rose pillar which a previous generation would have rejected as contravening the rules of design.'

Wickhoff's interpretation and advocacy naturally added a new element to the study of ornament, on which Riegl was to seize. The account in *Stilfragen* of the development of plant motifs had been mainly descriptive. Changes in treatment and style were attributed to the changing *Kunstwollen*, but no further analysis was given to explain why the artistic intention had changed. Wickhoff provided part of the answer. The change ran parallel to the one observed in the history of European painting from the Renaissance onwards. Close attention to detail had given way to the summary treatment we associate with a rapid visual impression. Here another book which had aroused much discussion in these years came to Riegl's aid, the book by the sculptor Adolf von Hildebrand, *The Problem of Form in the Figurative Arts*, which had been published in the same year as *Stilfragen*. Prompted by the same issues which had interested Wickhoff, but less sympathetic to Impressionism, Hildebrand set out to define the contrasting approaches to nature in terms of perception. Classical sculpture was essentially based on sensations of touch, Impressionist painting was purely visual—ignoring at its own peril the residues of tactile sensation which are invariably associated with visual perception. We are in the years when Berenson was to elevate these tactile sensations into an aesthetic principle, while Wölfflin used the polarities of Hildebrand for his even more influential analysis of stylistic developments since the Renaissance.

Riegl's *Spätrömische Kunstindustrie* of 1901 is the most consistent and uncompromising application of this perceptual theory of art. Its thesis can be briefly summed up: the history of art from ancient Egypt to late antiquity is the history of the shift of the *Kunstwollen* from tactile (Riegl says haptic) to visual or 'optic' modes of perception. This shift can be observed not only in the figurative arts, it also manifests itself in architecture and in the decorative crafts. Every architectural motif, every brooch or fibula of a given period, must and can be shown to obey the same inherent laws of stylistic development that drove art relentlessly from touch to vision. It will be remembered that Riegl's assignment had in fact been the publication and description of archaeological finds in the soil of the Austro-Hungarian Monarchy. The thoroughness and consistency with which he carried out his programme must command admiration even where it does not command acceptance. Here, as in his earlier book on Oriental rugs, his first aim was to reduce as far as possible the share claimed for other cultures and other tribes. The finds from the period of migration had to be shown to form part of the artistic development of the Graeco-Roman world if they were to be explained as the products of a late phase of the *Kunstwollen*, the outcome of one specific phase of perceptual bias. Three techniques are here analysed in succession—openwork (Fig. 240), chipcarving (Fig. 241) and garnet insets (Col. Plate VII). They show, in Riegl's view, the progressive abandonment of the isolated motif lucidly standing out against a neutral ground such as we know it from classical Greek art. Instead we get a blurring of the distinction between figure and ground. I have mentioned in an earlier chapter that it was Riegl who anticipated psychologists of perception in his discussion of the change between figure and ground that marks certain styles of ornament. The feature first emerged in certain types of openwork where the figure and the void balance each other visually. In the technique known as chipcarving it is even harder to tell whether it is the ridge or the groove that should be seen as dominant. In the garnet inlay of the dark ages the golden setting sometimes provides a pattern and the dark red stones impress us as ground. The reversal is complete. For Riegl this development runs exactly parallel to the changes in sculpture observed during that period. Instead of the careful tactile modelling of every individual feature, late Roman sculpture developed that summary treatment which gave it such a bad

g. 240. Openwork.
out 3rd century
D. (A. Riegl, 1901)

g. 241 *(far right)*.
iipcarving. About
n century A.D.
. Riegl, 1901)

name, the use of drills as distinct from chisels, leading to an exploitation of deep shadows and strong lights (Plate 60). Instead of that loving articulation of the individual element which we admire in the best products of Greek art, we get massed effects, more impressive from the distance than from close quarters. According to Riegl it is not only useless but also shortsighted to decry this change as a decline, because without this inevitable development art could not have progressed to the rendering of space and atmosphere in that second cycle which started in the Renaissance and culminated in Riegl's time.

That there is a certain amount of special pleading in this remarkable demonstration almost goes without saying. A careful reader of the book will find, for instance, that Riegl sometimes rejected the evidence of coins found with the objects, because they suggested a date too early to suit his sequence. Moreover, some of the perceptual effects he so brilliantly analysed as manifestations of a given phase in the evolution of the *Kunstwollen* are far from unique to this stylistic group. After all, there is no ornament which plays more teasingly with the switch between figure and ground than the Greek key pattern (Plate 25). A stroll through any collection of tribal art is also likely to produce intriguing parallels to Riegl's specimens (Figs. 100–102). Some tribal artefacts may be explained as the results of diffusion and imitation, but with others there is no such possibility, and we would have to attribute to various remote regions the same perceptual development which we found in the Western world.

Riegl would have found difficulty in admitting such pluralism because, like his earlier *Stilfragen,* the *Spätrömische Kunstindustrie* has a polemical edge. The demonstration of the 'synchronic' unities of artistic developments and of their intrinsic necessity was aimed— consciously or unconsciously—at the critics of modern developments who were trying in vain to stop the stars in their courses. Its message, popularized in Worringer's *Abstraction and Empathy,* was taken up by the revolutionary movements in the art of the early twentieth century, which strove to fashion a new art for the new age. The longing for such an escape from the stale round of historical styles inspired the movement of *Art Nouveau,* for which the unity of high art and applied art was so vital a demand. No wonder that the study of styles was coloured by this quest for inner cohesion and unity. Its roots lie in the artistic situation of the nineteenth century.

2 *The Pervasiveness of Style*

The idea of linking period styles with distinctive types of ornament was commonplace in nineteenth-century schools of design. Any number of books took the student through the repertories of forms associated with classical, Byzantine, Gothic or Renaissance ornament to enable him to design façades, interiors or furnishings in any of the period styles favoured by changing fashions and requirements (Fig. 242). Turning the pages of these books, we are immediately reminded of one of the principal sources of these unified repertories.

Fig. 242. Gothic
ornament (A. Speltz,
1910)

Architectural styles are in the lead and tend to determine the forms of furniture and of implements in a very direct way. We have seen this principle of unity at work in the preceding chapter. The classical orders and their subsidiary elements, such as mouldings, were applied by carpenters to wardrobes and chests, which were turned in this way into metaphorical buildings. We can observe the same process in Gothic furnishings with their blind arcades suggesting windows and mullions. Nor is it difficult to see how these elements of design spread from here to other media and other purposes whenever function invited decorative enhancement. The Gothic chalice or ivory diptych will exhibit Gothic designs, much as the Renaissance title-page or picture frame will display elements of the Renaissance repertory. The nineteenth century was obsessed with style precisely because it felt itself to be without a style of its own. The misguided efforts of restorers to rid buildings of later accretions and to return them to a fictitious purity of style are symptomatic of this preoccupation. But the very difficulties in achieving this desired cohesion also drew

attention to the fact that there is more to style than a mere repertory of forms. The Gothic churches of the Victorian age stubbornly refuse to look mediaeval. It may be no accident therefore that we find one of the greatest students of design, Viollet-le-Duc, whose name has become unjustly associated merely with radical restoration of Gothic cathedrals, postulating this principle of a higher unity in the article on style he wrote for his *Dictionnaire raisonné de l'architecture française* (1854–69). In this article he makes the very point which has so often been made against his restorations: 'We cannot adopt the style of the Greeks because we are not Athenians. We cannot recover the style of our mediaeval forbears because times have marched on. All we can do is to affect the manner of the Greeks or of the mediaeval masters, in other words, make pastiche. Instead we must do what they did or at least proceed as they proceeded, that is to say penetrate to the true and natural principles to which they penetrated, and if we do that our works will have style without our seeking for it.'

What Viollet-le-Duc, like Riegl, wanted to demonstrate was the logical cohesion of every great style. He saw such styles as vast deductive systems in which every form followed from the central principle adopted by the architects. In this sense style is 'a kind of unsought emanation of forms'. 'Whenever a population of artists and craftsmen are thoroughly imbued by the logical principles by which every form derives from the purpose of the object the style shows itself in all works issued from the hands of man, from the most ordinary pot to the exalted monument.'

But what is this logical calculus which could tell the Greek or the Gothic craftsman on the grounds of first principles what form he should give to an ordinary pot? Surely the Cartesian tradition here played a trick on Viollet-le-Duc in making him extend the principle of deduction much further than logic warrants. It is not hard to see that his assertion represents one of the many attempts to rationalize the intuitive feeling that the various manifestations of an age are not random, but exhibit a common character, a common spirit.

Having frequently criticized these rationalizations, particularly in their Hegelian versions, I feel reluctant to return to this elusive question once more, but no discussion of style can possibly evade it. I vividly remember a conversation with Erwin Panofsky when I accompanied him on Cape Cod as he was walking his dog in the summer of 1951. He told me how puzzled he had been in his student days by the expression 'Gothic painting'. He could understand the application to buildings or decoration, but in what sense could a painting be Gothic? I summoned my courage and asked 'Do you think that all this really exists?', to which he replied with an uncompromising 'yes'. Only later I realized that in his lectures on *Gothic and Scholasticism* he had just committed himself to another attempt to justify the Hegelian tradition of governing spirits. The intuitive feeling that there is an affinity between the structures of Gothic cathedrals and the philosophical system of the Scholastics need not concern us here, but the reasons which prompted Panofsky to set aside his initial doubts are surely relevant to the history of design. Reformulating Panofsky's question, we may ask whether there exists a link between a painting and its frame, or more specifically between all the elements of a Gothic altar (Plate 61), the shrine with its sculptures, the wings with their reliefs and painted panels and the architectural detail of its fretwork setting.

To deny this coherence would be to fly in the face not only of Hegelianism but of the most cherished conviction of aesthetics, which postulates the 'organic unity' of works of art. And yet it is hard to see how this conviction could be tested objectively. What could we say to a sceptic who objects that our feeling of unity is simply due to the force of habit? We have so often seen paintings of this style associated with Gothic shrines that the sight of one calls up the other—much as the sight of a friend's hat on a peg may call up his face, some imaginative people even seeing a kind of phantom head peeping out under it. No doubt, the sceptic might continue, this experience may lead to the subjective conviction that the hat

belongs of necessity to this man and to nobody else, and once this conviction is settled it can be rationalized in any number of ways. The sceptic certainly has a case there; and his case can even be strengthened—as I have argued elsewhere—where various features are seen as the 'expression' of one and the same spirit or mind. The sense of order turns out to be a somewhat disturbing element in the cool examination of what I might venture to call Panofsky's first problem. For nowhere is the integrative capacity of our mind more in evidence than in our physiognomic reactions. Every movement of our facial features, the smiling mouth, the wrinkled brow, is experienced as expressive, and any combination of movements sets the mind the task of deciphering their joint significance. So automatic is this achievement, that we find the reading almost inescapable even where we know it to be mistaken. We all extend this synoptic vision of our fellow humans from their facial expressions to their gestures, their gait, their voice and their habits—including their choice of a hat, and it is in the nature of things that we can never be refuted. If an old friend turns up wearing a strange hat we may register a momentary surprise, after which we adjust our picture of his character to allow for this whimsical aberration. It is only as a last resort that we decide something to be so much 'out of character' that we must attribute it to some external cause.

The sceptic might grant that such intuitions are not wholly fanciful. We do form a 'global' impression of our fellow humans which allows us to sense their character and their likely actions and reactions. Without some such faculty we could hardly get on in life. How far these feelings are open to rational analysis is a different matter, but the claims of graphology, which imply that it is possible from the traces of handwriting to infer other character traits, cannot be entirely dismissed.

At this point however, the sceptic may well remind us that the assessment of the expressive character of handwriting is only possible within a very firm pre-established context. What the graphologist may find symptomatic is the way a given writer modifies the traditional lettering he has learnt. He has not invented the script we are judging, and if he had, its diagnostic value might be less rather than more. It is precisely because we can trace the causative chain of tradition in the teaching and learning of writing that we may be able to plot and assess the slight individual deviations which we find symptomatic of a whole coherent system of character traits. To transfer this method by analogy to the study of styles may be illicit on at least two counts: first because such a transfer implies a belief in some kind of collective spirit or group mind which would permit us to speak of races, classes or ages in the terms we use for individuals, secondly because the styles and forms of visual arts may vary for a number of reasons entirely unconnected with their expressive force. We lack the clearcut context which may justify graphology.

Even so the history of art criticism shows that the temptation to treat stylistic changes as symptoms of changing spirits is almost inescapable. We remember how Ruskin turned 'graphologist' in inferring the moral decay of the age from the lush form of a scroll (Fig. 44). We may grant that the change in the form of the scroll is not an isolated phenomenon, but must it be symptomatic of everything else in art and society? If it is not, at what point would it be prudent to stop analogizing?

We need not go further than script to define this question. There is certainly a formal affinity between Gothic script and Gothic ornament (Fig. 243), just as we can appreciate why Renaissance humanists changed over to the clear forms of Carolingian minuscules, which they described as *all'antica* and which was adopted by their printers (Fig. 244). But is there also a special Gothic mentality behind Gothic lettering? Did not any scribe of the period have to learn and practise this kind of script, of which we can trace the evolution in a secular process? Does it make sense, therefore, to diagnose the spikiness of Gothic shapes by the same standards we might adopt when seeing such spiky forms in a contemporary hand?

ig. 243. Hans
chönsperger: From
e first German
w book. Augsburg,
496

ig. 244. Title page
y Erhard Ratdolt.
'enice, 1476

3 *Heinrich Wölfflin*

None of the great historians of art expended more energy on this type of question than
Heinrich Wölfflin. A master in conveying the physiognomic qualities of forms and of styles,
Wölfflin loved to exercise his skill. But unlike some of his less critical successors, he was well
aware of the sceptic looking over his shoulder. Throughout his life he was a physiognomist
with an uneasy conscience. This inner conflict is apparent even in his first book, *Renaissance
and Baroque*, published in 1888, thirteen years before Riegl's *Kunstindustrie*. Its famous chapter
on the causes of change in style opens with a confrontation between two theories then
current; one, the psychological hypothesis of a German architect Adolf Göller, who
regarded the sequence of forms from the Renaissance to Baroque as a result of blunted
sensitivity, of the need for stronger stimulation resulting from visual boredom; the
opposing theory prevalent in Wölfflin's day saw style as an 'expression of the age'. We are
once more faced with the duality between a diachronic or sequential explanation and a
synchronic or holistic one. Wölfflin was critical of the Hegelian type of holism, which lumps
together feudalism, scholasticism, spiritualism etc. as 'expressions' of the Gothic age. He
knew that little more was needed than a modicum of ingenuity to find affinities between
these disparate manifestations. What we must ask, he argues, is what characteristics of an age
are at all capable of being expressed in a visual form. It is here that he comes up with his
physiognomic theory of architecture, which is a theory of empathy. According to this view,
which enjoyed a great vogue at the end of the nineteenth century, we respond to shapes
much as we respond to music by dancing inwardly. The lean vertical shaft may make us
tense and stretch our muscles, the spreading horizontal shape will make us feel relaxed and
calm. It is in this body reaction that Wölfflin seeks to locate the mediating factor between
various aspects of the Gothic style.

Figs. 245 and 246. Gothic and Renaissance shoes (E. Viollet-le-Duc, *Dictionnaire du Mobil. Français*, 1858–75)

'There is . . . a Gothic deportment, with its tense muscles and precise movements; everything is sharp and precisely pointed, there is no relaxation, no flabbiness, a will is expressed everywhere in the most explicit fashion. The Gothic nose is fine and thin. Every massive shape, everything broad and calm has disappeared. The body sublimates itself completely in energy. Figures are slim and extended, and appear as it were to be on tip-toe. The Renaissance, by contrast, evolves the expression of a present state of wellbeing in which the hard frozen forms become loosened and liberated and all is pervaded by vigour, both in its movement and its static calm.

'The most immediate formal expression of a chosen form of deportment and movement is by means of costume. We have only to compare a Gothic shoe [Fig. 245] with a Renaissance one [Fig. 246] to see that each conveys a completely different way of stepping; the one is narrow and elongated and ends in a long point; the other is broad and comfortable and treads the ground with quiet assurance.'

This masterly characterization has become a *locus classicus*, but in Wölfflin's pages it is followed by qualifications. He does not intend to deny the validity of technical explanations in the history of architecture, nor does he think that style is always a mirror of its time. Sometimes, for instance, architecture has ceased to be responsive to the moods of an age, whose formal sensibility then finds an 'outlet' in the decorative arts.

Wölfflin never resolved the contradiction between his physiognomic and his formalistic approach to style. His *Principles of Art History* still aims at establishing identifiable categories for the description of the same stylistic transformation he had discussed in *Renaissance and Baroque*. But now he is less concerned with their expressive character than with basic organizational principles. Wölfflin likes to speak in this context of contrasting 'modes of seeing' which accompany (if they do not explain) the shift in artistic styles from hard-edged to soft-edged, from closed form to open form. His approach here has much in common with Riegl's but it is less unitary, less deterministic. Even so he felt moved in 1933 to publish an essay entitled *Revision* to clarify his position. The diagnostic tools he had sharpened in his first book had meanwhile become vulgarized and sensationalized in the writings of Worringer and of Oswald Spengler, and talk of 'Gothic Man' and 'Renaissance Man' had become the small coin of the market place. Wölfflin evidently wished to call a halt. Surely, he says, we must not overdo this. There are phases in the history of painting which exhibit their own logic. The development of Italian painting from the Early to the High Renaissance seems to him a case in point. 'It would be absurd to postulate that every step in this evolution corresponds to a distinctive nuance of "classic man", resulting in its own kind of art.' He warns his readers not to expect too much and not to demand an exact parallel between the 'history of seeing' and the general history of the human spirit. It looks as if his conscience was not only troubled by certain over-statements in the *Principles*, but quite especially by its sequel, the book *Die Kunst der Renaissance in Italien und das Deutsche Formgefühl* (rather misleadingly translated as 'The Sense of Form in Art'). For here Wölfflin had shown himself more responsive to the intellectual currents of the time and had exercised

his interpretative skill in the elaboration of national physiognomies, contrasting the classic lucidity of Italian Renaissance creations (Plate 63) with the intricate, dynamic and irregular shapes beloved of German art (Plate 62). What had driven him to this investigation was the difficulty of assuming that mentalities changed as rapidly as did styles. But these doubts led him to the even more dubious assumption of a racial theory.

'We have become too much used to identifying the history of art with a sequence of closed stylistic systems, allowing the idea to slip in that every style originates something entirely new. A moment's reflection suffices, however, to realize that in the various styles prevalent in a country there remains still one element in common to them all which stems from the soil, from the race, so that the Italian Baroque, for instance, does not only differ from the Italian Renaissance but also resembles it, since behind both styles there remains Italian Man, as a racial type which only changes slowly.'

Mercifully the sceptic and the humanist in Wölfflin kept him from further elaboration of this philosophy, and so we can examine his comparisons without *parti pris*. Maybe one should even be grateful for the fact that the sceptic did not prevent the exercise altogether. For though no reader will suspect me to be neutral in this matter, my scepticism, like Wölfflin's holism, is sometimes troubled by an uneasy conscience. No student of decorative art can deny that some of Wölfflin's confrontations are persuasive. His contrast between an Italian Renaissance chest and a Gothic wardrobe (Plates 62, 63) is certainly no less telling than is the comparison between Gothic and Renaissance lettering. The notion of an underlying sense of form which mediates between the various visual arts need not be a mere figment of the imagination simply because the explanations offered have proved so feeble. We all feel sure that a Rococo ornament would look out of place in an ancient Egyptian temple or a chinoiserie in a Renaissance church. It is a satisfying game to look for decorative motifs which seem to go together with other elements of a particular style. After all it was the Greeks themselves who stressed that the columns of their temples had something in common with human types; they were seen as visual metaphors (Fig. 209) and it is easy to understand the ground of this comparison. No doubt the same is true of Gothic forms and certain aspects of Gothic sculpture and painting. To the Romantics the comparison of Gothic architecture with northern forests was a commonplace and it is easy to see the kinship between Cranach's crozier and Cranach's tree (Plate 64). Many trees on German drawings (Fig. 248) seem to obey the same sense of form as a Gothic ornament (Fig. 247). Remembering Panofsky's early qualms, we may say that there is indeed some real coherence between the frame of the Gothic shrine and its figurative elements, the rich whirling drapery of Gothic sculpture certainly goes well with the fretwork of the crowning decoration. There are periods where this formal coherence between the arts is obtrusive, none more so than the period of *Art Nouveau* with its preference for sinuous lines in painting and decoration. But how pervasive are even these principles? Not all buildings or furnishings produced in the years when *Art Nouveau* was *en vogue* followed these laws; on the contrary, even among the advanced designers of the period there were opponents such as Adolf Loos, who preached a functionalism *avant la lettre*. Indeed, if the examples of such affinity can be multiplied, so can the counter-examples. Would we expect the decorative forms Giotto used in his frescoes (Plate 66), if we did not know them? Would the original frames of Dutch paintings strike us as visually fitting (Plate 65)? What decorative feature from Spanish seventeenth-century interiors could be set beside a Velazquez without a sense of strain?

Maybe a champion of Riegl's unitary theories would here object that our comparisons remained too close to the surface of the phenomena. If we dig deep enough we may still find the same *Kunstwollen* manifested in all of them. However they may differ in aesthetic qualities and status, they still show the same pointer readings when examined along the scale

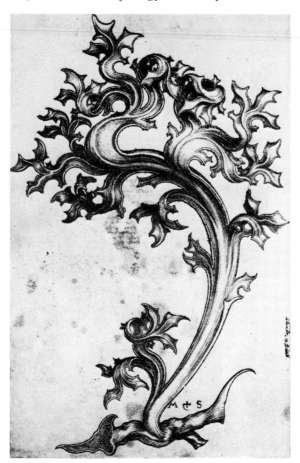

between the extremes of tactile and optic perception. But there are episodes in the history of art which make this postulate of perceptual unity extremely doubtful. One of them, as we remember, was actually mentioned by Riegl's predecessor Franz Wickhoff: Victorian theory insisted on the need for a clear separation between the forms of applied art and those of high art. The decorator should stylize, the painter should not. A flower on a wallpaper should be flat, a flower in a picture three-dimensional. And lest it is suggested that this late example is the product of an intellectual dogmatism alien to earlier periods, we may point at a similar cleavage in the early Middle Ages, though here the roles are reversed. Romanesque painting tends to be flat, emphasizing the plane and permitting the figures to stand out as lucidly legible shapes. In the decorative borders, however, the illusionistic devices of Hellenistic painting live on, as if the artists enjoyed showing their skill in these simple tricks (Fig. 249). They would not have done so, if their public had not shared this pleasure, which was no longer offered by narrative painting. Whatever the reasons for this division of skills, perceptual unity is certainly sacrificed wherever one craft tradition sticks to old patterns while the other transforms the models in a particular direction.

4 Focillon and the 'Life of Forms'

But do we need this postulate of uniformity for each style and period? The need has certainly been denied not only by sceptics suspicious of all generalizations of this kind, but also by schools of art history anxious to arrive at some underlying law. I am particularly thinking of Henri Focillon, whose brief book *Vie des Formes* made many converts to a stylistic pluralism, allowing every medium and art form its own pace of evolution.

Fig. 247. Martin Schongauer: Gothic ornamental leaf. Second half of the 15th century

Fig. 248. Wolf Huber: Pen drawing About 1520

'All interpretations of stylistic movements'—he writes—'must take account of two essential facts: several styles can live at the same time, even in closely adjoining or the same area; and styles do not develop in the same way in different technical domains.' Though Focillon acknowledged the temptation which always exists to 'demonstrate an internal logic which governs the forms', he asked his readers and pupils never to forget the contingent, the experimental and the creative elements in the history of art. But what concerns us here is that he all but exempted the study of ornament from this caution.

'It lies in the essence of ornament that it can be reduced to the purest forms of intelligibility, and that geometrical reasoning can be applied without hindrance to an analysis of its constituent relationships. . . . In such a field it is not illicit to assimilate style to stylistics and to establish a logical process which is forcefully and demonstrably at work inside the style—it always being understood, however, that the temporal or regional sequences may differ in speed and purity.'

The phases which a style normally undergoes in its development Focillon called 'Experimental', 'Classic' and 'Baroque', and it is clear that he found identical tendencies in the architectural decorations of late Romanesque and late Gothic. The parallelism is well brought out in the way in which, in *The Art of the West*, he described the final stages of both styles. He writes of twelfth-century Romanesque:

'By spreading itself with a lavishness which disregarded architectural discipline, and by overrunning members for which it was ill adapted or whose function it obscured or enfeebled, the decoration escaped from the strict regime which had confined it to definite situations and definite frames. . . . A network of flickering shadows, a scattering of excessively numerous and varied accents, compromise the balance and unity of the monumental block . . .' (Plate 67).

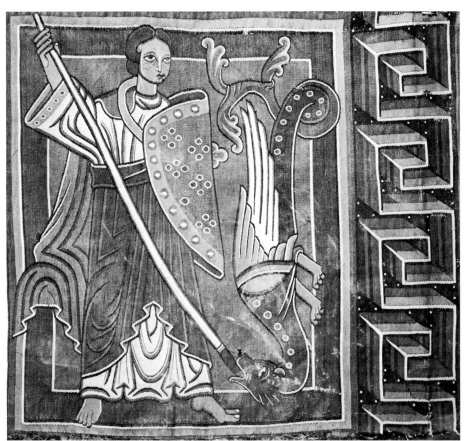

Fig. 249. Tapestry, St. Michael, Halberstadt Cathedral. Second half of the 12th century

And this on the Flamboyant style, the 'Gothic Baroque':

'This new instinct which ... assailed the fundamental principles of the structure, also undermined the strength and stability of external masses. ... This stippling of light and shadow, this undulating movement of the forms, these flames of stone are the most prominent features of the glistening cloak, an optical illusionism which conceals the annihilated masses' (Plate 68).

Focillon, of course, is aware of this affinity between the final stages of the two dominant mediaeval styles, and broaches the possibility of a deliberate revival, a cyclical theory in which like comes to borrow from like. What is even more interesting is the kinship between his description of styles he considered degenerate and those condemnations of similar developments we found in Vitruvius and in Vasari. Indeed Focillon's characterization of Milan Cathedral (Fig. 27) consciously or unconsciously echoes Vasari's condemnation of the 'Gothic' style. He calls it 'the masterpiece of all false masterpieces ... As an optical illusion, Milan Cathedral successfully produces an effect of grandeur and luxury. But the profusion of gables, pinnacles, finials, balustrades, statues and statuettes cannot conceal from the practised eye the poverty of the architecture and the extreme mediocrity of the technique'.

It is striking to what extent Focillon here continues the tradition of French mediaeval studies largely inaugurated by Prosper Mérimée, witness the opening of Mérimée's essay on mediaeval religious architecture in France published as early as 1838:

'Studying the buildings erected between the Roman era and that of the Renaissance, one will find that the history of every architectural style is the same, as if their progress and decadence followed a general law. Simple at first, the buildings gradually become adorned; as soon as they have acquired all the elegance and all the richness which belong to the style, without it being altered, the age has arrived at the perfection of that style or, if one prefers the formulation, at its greatest development. Soon, however, the tendency to decorate, to enrich the original repertory exceeds the bounds we have set. Instead of being accessories ornamentation becomes the principal aim.'

Given this ancestry, it is not unexpected that Focillon's analysis restates the very views against which Riegl had reacted so strongly. That 'inner logic' of which he speaks derives from the academic theory of art, based in its turn on the criticism of rhetoric in antiquity. The conquest of means, the perfect fit between ends and means, and the final display of virtuosity in which means become an end in themselves—all these are features of the traditional vocabulary of criticism which implied and justified that notion of progress and decline which was so abhorrent to Riegl. Moreover, in scrutinizing Focillon's accounts, we shall find the same emphasis on certain decorative features, the reliance on shadows, the exuberance of texture, which Riegl had placed into the centre of his analysis of late antique art while refusing at the same time to brand it with the stigma of 'decadence'. He did so in the name of scientific objectivity, which had no room for such notions as decline.

5 'Purity' and 'Decadence'

It is all the more surprising to find that Riegl's interpretation of late antique decoration shows a remarkable affinity with that of John Ruskin, who would have abhorred the intrusion of science into the study of art. The chapter on *The Lamp of Power* in Ruskin's *Seven Lamps of Architecture* contains a passionate appreciation of Byzantine ornament (which is meant to include what we call Romanesque) for its masterly exploration of light effects. This, as Ruskin stressed, was alien to ancient Greek art, for the Greek 'attention was concentrated on the one aim of readableness and clearness of accent. ... what power of light these primal arrangements left, was diminished in successive refinements and additions of ornament; and continued to diminish through Roman work'. He attributes the reversal of

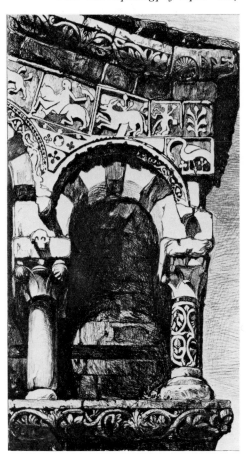

Figs. 250 and 251.
From J. Ruskin,
*Seven Lamps of
Architecture*, 1849

this technique to the introduction of the dome. 'Hence arose, among the Byzantine architects, a system of ornament, entirely restrained within the superfices of curvilinear masses, on which the light fell with as unbroken gradation as on a dome or column, while the illumined surface was nevertheless cut into details of singular and most ingenious intricacy. Something is, of course, to be allowed for the less dexterity of the workmen; it being easier to cut down into a solid block, than to arrange the projecting proportions of leaf on the Greek capital: such leafy capitals are nevertheless executed by the Byzantines with skill enough to show that their preference of the massive form was by no means compulsory, nor can I think it unwise. On the contrary, while the arrangements of *line* are far more artful in the Greek capital, the Byzantine light and shade are as incontestably more grand and masculine . . .' (Figs. 250, 251).

As so often in his great and enigmatic book, Ruskin all but drowns this important observation in a hymnic praise of the power of nature and the beauty of light falling on clouds, mountains and trees, 'that diffusion of light for which the Byzantine ornaments were designed'. 'Those builders had truer sympathy with what God made majestic, than the self-contemplating and self-contented Greek. I know that they are barbaric in comparison; but there is a power in their barbarism . . . a power that neither comprehended nor ruled itself, but worked and wandered as it listed . . . and which could not rest in the expression or seizure of finite form. It could not bury itself in acanthus leaves.'

In a footnote added later to this passage, Ruskin withdrew his slighting remark about the self-contented Greek. He had evidently been carried away by his own power of advocacy, but this recantation only enhances the kinship of his account with that of Riegl and even Wölfflin. Every style exists in its own right. The Greek style aims at legibility (Plate 49) and

a line executed with skill; late antique art worked in masses for powerful visual effects, sacrificing some dexterity for a grander impression of the whole.

Ruskin's account can dispense with the apparatus of perceptual psychology and the recourse to evolutionist determinism and yet successfully defend the later style against the charge of corruption. He can do so even without denying that some skill must have been lost in the transition from a linear to a summary treatment of forms. Whether he was right in his suggestion that this change was due to the introduction of the dome is a different matter. The idea that architecture must always be the leading art may have influenced his view; but taken in a more general way there may be some truth in this hypothesis. The tendency towards the grandiose and colossal which pervades the development of late antique architecture and culminates in the Hagia Sophia cannot be divorced from the changes in decoration. Nobody today would want to leave out of account the difference in the organization and workforce needed to build the Erechtheion on the Acropolis (Plate 69) as against the temples of Baalbek (Plate 70). The small band of Greek fifth-century masons would necessarily work differently from the armies of workmen needed for the vast architectural enterprises of the orientalized emperors. The gradual adoption of the mechanical drill instead of the chisel on decorative detail must be as much connected with this development as with a perceptual bias for deep shadows (Plate 71). But need one explanation exclude the other? Great art is great because it is resourceful. If the road is barred to one kind of perfection, the desire for excellence searches for a compensating move, turning a handicap into an unexpected advantage. To ignore or deny the existence of such handicaps may well block our understanding of stylistic change. It is for this reason that the replacement of the idea of skill by that of 'will' seems to me unhelpful. It can never do justice to that process of adaptation, that interplay between sacrifice and exploration which characterizes all successful developments in science, technology and art. To deny that representational skills declined in late antiquity seems to me as perverse as to withhold admiration from the marvels of Ravenna or the Lindisfarne Gospels.

Maybe it is precisely here that the study of decorative art can clarify some of the relevant issues. One of them engaged our attention in Chapter VI, where the Kaleidoscope introduced us to the effects of patterning and led to the conclusion that there are contrary pulls at work in our perception of things and of patterns. Repetition, we found, devalues the individual motif, isolation enhances it. The designer will accordingly tend to stylize the repeated elements and animate the enhanced representation. The dispute between Ruskin and his more orthodox opponent helped to bring out this opposition, which is equally relevant to our present concerns. That childish scrawl he had produced as a challenge (Fig. 173) turned out to serve quite well as a repeated motif, where its individuality was scarcely noticeable. It would have been wasteful and pointless to produce a masterpiece of figure drawing to function in this capacity, just as it would be ludicrous to employ no more skill than Ruskin used for this figure in a narrative composition.

Not that this illustration should be taken *au pied de la lettre*. What deserves consideration is merely that compensatory character between decoration and representation which the extreme example brings out. The isolation and the refinement of the Greek acanthus scroll are two sides of the same coin, as are the multiplication and the simplification of floral motifs in late antique art (Figs. 233, 234). Or observe the delicacy of the Rose pillar (Plate 59) which so enchanted Wickhoff. It could find no place in the rich design of late antique scrollwork, in which we cannot concentrate on the individual motif because of the pull of redundancies. We find a similar decline of naturalism in the development of late Gothic ornament which Focillon characterized as decadent. The reason for his charge here was not so much the summary execution, as the disregard of the architectural structure these motifs had originally been meant to enhance rather than obscure.

This phase also seems to be common to many styles. Discussing the same subject of French Flamboyant decoration, the popular handbook on *The Styles of Ornament* by Alexander Speltz says (in the English edition): 'The desire for greater lightness becoming now apparent, and the purity of design being neglected at the same time, it finally happened that the Ornament grew apace and masked the form, a fate which in the end overtook almost all styles of architecture.' There may be an element of overstatement here, but in any case one would like to describe this typical development in more neutral terms.

That subservience to structure which is so often identified with 'purity' corresponds, in our terms, to the use of 'explanatory articulation'. Ornament serves to facilitate the grasp of the object it decorates. We have observed this function in the extended application of the Classical orders, as when pilasters and friezes turn an otherwise amorphous wall into the semblance of supports and lintels. The most important instance of such explanatory articulation in the whole history of architecture, however, may turn out to be the Gothic rib and the other members of the Gothic repertory. At any rate there is a school of thought which denies the functional explanation of these features. Ribs do not necessarily add to the stability of a vault, nor, so it seems, do flying buttresses. It is likely that this denial of an old orthodoxy overstates its case, but in doing so it has brought into relief the articulating function of certain features formerly thought of as purely structural. What was it then that led to the loss of purity here and in the case of the orders? It is hard to know whether such a question permits an unambiguous answer, but here, as in the previous instance, we can at least remember the homely adage that you can't have it both ways. Articulation demands that 'magnet for the eye' that comes from discontinuity, it presupposes a paucity of accents enhanced by that 'field of force' we have observed in this context. The multiplication of accents and the complications of design which lead to enrichment and profusion cannot but detach the decoration from the structure and set up a rival attraction. This does not mean that, as with representation, a balance can never be struck between these conflicting demands—on the contrary, we speak of masterpieces precisely where we feel that this difficult feat has succeeded. But it is likely that the difficulty will increase with the complexity of elements to be handled and reconciled, and if this general statement is acceptable, it helps to justify not only the idea of decline, but also the conviction that styles come to an end when these developments have run their course and can go no further.

There is no intention of offering these remarks as an original contribution to the dynamics of stylistic change. They are no more than reformulations of ideas which are implicit in the whole conception of a 'logical development' with which most historians of design have operated. It should be the task of the future to turn this loose metaphor into a serviceable tool of historical analysis.

6 *The Logic of Situations*

The first step in such an analysis would consist of a clearing operation. We must acknowledge that it is individual people, craftsmen, designers, patrons, who are the subject of history, rather than the collectives of nations, ages, or styles, yet we must also recognize the limits of the individual and the strength of cooperative action in society and over time, for it is this aspect of human existence which entitles us to speak of evolution. The coral reef of culture was built by short-lived and weak human beings, but its growth is a fact, not a myth. Looking at any final achievement we can trace the contributions of individuals and understand both their greatness and their inevitable limits. The first child (if there ever was such a child) who cut a twig from a willow tree and made a whistle may have been a genius, but however great we may imagine him to have been, he could not have evolved the complex instrument of the organ and written Bach's organ fugues single-handed and within

the span of a human life. We have a right to say that both the instrument and the music evolved step by step from small beginnings, maybe from the whistle via the pan-pipe. Whether we call this a logical development is another matter. It is logical only in the sense in which K. R. Popper speaks of the logic of situations, the course of action a rational being would choose in pursuit of a particular aim. This approach offers a powerful tool for any historian of technology, for where the aim is given, the choice of means can be rational. The historian of the arts is in a less comfortable situation. The aims of art—if we can speak of such aims—may shift, and what we take to be the end-point of a logical evolution may only look this way by hindsight. The piping shepherd had no thought of church organs, and Bach's fugues would have left him cold.

It is important to face the fact that in this respect the history of figurative art differs radically from that of decorative design. In *Art and Illusion* I have tried to show 'why art has a history'. I gave psychological reasons for the fact that the rendering of nature cannot be achieved by any untutored individual, however gifted, without the support of a tradition. I found the reasons in the psychology of perception, which explains why we cannot simply 'transcribe' what we see and have to resort to methods of trial and error in the slow process of 'making and matching', 'schema and correction'. Given the aim of creating a convincing picture of reality, this is the way the arts will 'evolve'; the aim, in its turn, must depend on the function assigned to the visual arts in a particular culture such as that of ancient Greece. It should be clear even from this brief recapitulation why the logic of situations cannot yield a similar clearcut hypothesis for the decorative arts. Both the aims and the means are more diffuse. Even so we need not give up altogether, for we have seen that here, as in the case of pictorial styles, certain facts have been established against which we can test the tool of situational logic.

One of them was the subject of the preceding chapter: the tenacity of decorative traditions exemplified in the millennial history of Western architecture and in the evolutions of the plant motifs traced in Riegl's *Stilfragen*. What these observations confirm is the psychological fact that designers will rather modify an existing motif than invent one from scratch. The difficulties in the way of a radical innovation are both psychological and social. The number of truly original minds is small and those which exist are apt to be told by the public to stick to established traditions. Hence, as George Kubler, Focillon's disciple, says in his thoughtful book on *The Shape of Time*: 'The human situation admits invention only as a very difficult tour de force.'

Nothing comes out of nothing. The great ornamental styles could no more have been the invention of one man, however inspired, than could the organ fugue. Anglo-Irish ornament, the arabesque or the Rocaille come to mind as such typical 'end products' of a long sequence of what Kubler calls 'linked solutions'. We have seen why it is much easier to modify, enrich or reduce a given complex configuration than to construct one in a void. Hence certain formal sequences resemble the game of cat's cradle, with every craftsman taking over the threads from the hands of his predecessor and giving them an extra twist. Though we cannot trace these evolutions in detail, we are satisfied that the development must have taken its starting point from a less complex form, such as the interlace of late antique mosaics, and reached the end points through the collective efforts of generations of craftsmen. It is sequences of this kind which are most readily described as 'logical', but they are logical only if we assume that maximal complexity was the aim from the very beginning. If we shrink from such teleological language, we have to account for the observed sequence in different terms. It would be in accord with a logic of situation to say that it is rational for human beings to want to advance in the pecking order. In most societies some kind of competition is not only permitted but encouraged. Thus patrons and craftsmen vie to 'outdo' each other for the sake of attention, prestige and fame. I have

discussed elsewhere what profit the historian of fashions, trends and styles may derive from the analysis of such basic situations, what I have called 'The Logic of Vanity Fair'. The point to remember here is merely that once competition has settled on one particular feature, be it expenditure, pomp or refinement, it lies within the logic of the situation that this line will be followed as long as the game is worth the candle. If intricacy becomes a 'critical issue', it is in intricacy that artists and patrons will want to 'overtop' each other. Given the right conditions and the right craftsmen, the competition may culminate in such extremes as the Book of Kells (Plates 32, 33). Is it only hindsight which makes us call it an extreme?

The idea that a style becomes 'exhausted' must always be somewhat suspect, for how should we know what fresh possibilities a genius might still have discovered in a given repertory of forms? It is well to remember that, while the style of interlace came to an end at the time of the Book of Kells, there is no such dramatic termination of the arabesque. To be sure it may be argued that something of the zest and vitality of earlier periods was later lost in mere routine; maybe the spirit of competition declined after driving the style to its perfection, but having reached this plateau of excellence, it may have settled into a splendid convention which is still practised in the East.

Everything speaks against the existence of all-pervasive laws which would permit us to explain any such development as an inevitable sequence of events. Even those sequences which appear to be following an internal logic can be shown not to be fully determined. The course of Gothic decoration, the last phase of which was so brilliantly described by Focillon, is a case in point. In England, as is well known, the Decorated Style was succeeded by what is known as the Perpendicular Style. Focillon speaks of 'the revenge of the straight line, supplanting, with all its rigidity and purity, the capricious sinuosities of curve and counter curve'. Thomas Rickman, who gave these styles their names in the early nineteenth century, has a more down to earth explanation. He writes that the Decorated Style 'was very difficult to execute, from its requiring flowing lines where straight ones were more easily combined, and at the close of the fourteenth century' (in fact before its middle) 'we find these flowing lines giving way to perpendicular and horizontal ones, the use of which continued to increase, till the arches were almost lost in a continued series of panels, which, at length, in one building—the chapel of Henry VII (Plate 72)—covered completely both the outside and inside; and the eye, fatigued by the constant repetition of small parts, sought in vain for the bold grandeur of design which had been so nobly conspicuous in the preceding style' (Fig. 252).

If we are to believe the writer and other critics, there was no escape from decadence, whichever way the Gothic designer turned. Is this mere bias or can we justify this universal feeling in terms of logic of situations? Maybe we can, at least up to a point. We have seen that this criticism attaches to styles in which the play of forms acquires a certain autonomy, unconnected with its decorative purpose of serving as explanatory articulation. It is not hard to see how such emancipation can result from that very game of competition we have been considering. As soon as the need to trump the rival in one particular quality becomes paramount, all other purposes are forgotten or at least neglected. Not that such emancipation need result in genuine decline. After all, we have the example of music to show how an art form transcended its social setting to create a world of its own.

Up to a point this happened even to the art of ornament, at least as soon as a medium was at hand to allow the craftsmen to exercise their ingenuity divorced from any immediate purpose. I am referring to the flood of engravings with ornamental inventions which were produced between the fifteenth and the late eighteenth centuries. Ostensibly they are meant to serve as models and patterns, but few of them could be applied consistently without modification and simplification. They are autonomous products of the artist's creative imagination.

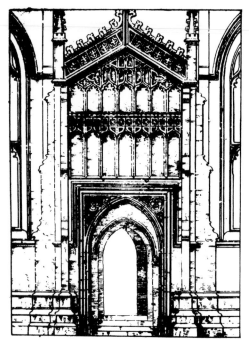

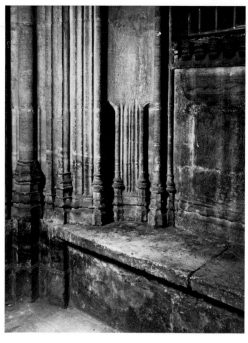

Fig. 252. Example of the Perpendicular style (Richman, 183(

Fig. 253. The Divinity Schools, Oxford. About 1440

There is evidence to show that the spirit of 'outdoing' sometimes passed from the patrons to the artists. Employers had to restrain their designers for fear of bankruptcy. There is a telling example still visible in the Divinity Schools at Oxford, where we know that the master Thomas Elkyn was instructed in 1440 to dispense with the 'housings of images, casements and fillets, and other frivolous and irrelevant elaborations' initiated by his predecessor Robert Winchcombe. As a result we can still see the transition from complex mouldings and traceried panels to the simpler forms (Fig. 253)—an episode for which there are any number of parallels in more recent University buildings. We do not know whether Thomas Elkyn submitted meekly or under protest, but evidence from later periods confirms that it was sometimes the artists rather than the patrons who were committed to the game of 'one-upmanship'. Writing about the extension of his country seat, which he had entrusted to Lucas von Hildebrandt, Count Harrach bursts out in his correspondence: 'That accursed Jean Luca properly wallows in the grandiose . . . whenever I suggest an omission or an economy Jean Luca raves like one possessed. It cannot be, it cannot be, my honour and reputation depends on it.' Much of the work discussed in that correspondence is lost, but the Lower Belvedere, which Hildebrandt designed for Prince Eugene at about that period (Plate 73) gives an idea of his ambition. There may be something in the frequent charge heard since the times of Ben Jonson that it was the architects who seduced their patrons to indulge in spending sprees they could not afford or justify.

Once more it may be in the 'logic of situations' that this urge to show off—whether on the part of the patron or of the artist—could lead to short-cut methods, cheaper materials, coarser craftsmanship, which invited the stricture of purists and accounts for the charge of decadence. Whether or not we share these misgivings, they are not entirely irrational. Nor is there any need to dismiss altogether the explanation of 'aesthetic fatigue' first proposed by Adolf Göller; it is based on the undeniable psychological fact that the familiar tends to register less than the unfamiliar, and that the public therefore demands ever stronger stimuli. The theory was rejected by Heinrich Wölfflin in his *Renaissance and Baroque* but is treated with somewhat greater respect by George Kubler. That it cannot express a universal law is obvious, for there have been great styles which changed very little. The ancient Egyptians do not seem to have tired of their decorative repertory for a very long time. It may be well to

remember in this context that where ritual is concerned there is no demand for novelty. Ritualistic art rests on the strong desire for re-enactment and preservation rather than for fresh stimulation. The opposite attitude, the search for novel impressions, may only arise in more fluid situations where competition establishes new hierarchies. Here lie the germs of that attitude which Harold Rosenberg has aptly called 'the tradition of the new'. Those caught in such a situation will look for 'originality', which means that they must implicitly compare what they see with what they have seen before. There certainly are different degrees of emphasis here, ranging from a mild interest in innovation to the impatient rejection of last year's model, and all of these attitudes may co-exist in one society. It would make sense, however, to suggest that where the demand for stimulation outruns the capital of inventiveness inflation sets in. There is such a thing as the debasement of coinage in art no less than in economics—and, as I had occasion to remark in discussing Ruskin's moral comments on Fig. 44, in neither case can the fault be laid at the door of the individual.

Thus, while we must give up the search for the laws of history which could explain every stylistic change, we are still entitled to watch out for sequences and episodes which we can hope to explain in terms of the logic of situations. For though a non-deterministic account must restore to the individual artist his freedom of choice between various rational options, this choice need not therefore be random. The aims of competition on which attention has become focussed at any particular moment may certainly influence his choice of a novel modification.

The movements of fashion show this selectivity in bizarre magnification. Whether the competition is in high hats, short skirts or small waists, those who join in the game must follow suit—at least for a while, till the folly reduces itself *ad absurdum*. There need be no such excess in design, but here, too, we can observe trends and directions in features which come to the fore while others are suppressed or neglected. How far can we identify these trends in terms of the perceptual factors analysed in Chapter V, factors such as 'repose' and 'restlessness', 'lucid' or 'blurred'? The temptation is great to identify the first with Wölfflin's 'classic' or Riegl's 'tactile' as against their 'baroque' and 'optic'. But we must beware of overstatements. A configuration can be clear and asymmetrical, indistinct but flat. What remains true is that any one of these features can become dominant, a focus of interest and competition.

7 The Rococo: Mood and Movement

We certainly must not fall into the trap of reducing the artist's choice to a few alternatives. Style in art, like style in language, is rather a matter of weighted preferences. It is only where there is a choice that those who aim at a plain style will go for the short word, whereas personalities manifesting predilections favouring polysyllabic alternatives activate opposite selectivities. In practice distinctions are less clearcut than in this example. In judging a style we judge a tendency. This, I believe, is one of the factors which account for the different interpretations which have been the subject of this chapter. We may discern a tendency 'globally' without being able in any individual case to pin it down. There is no better example of this difficulty than the most detailed investigation ever made of the origin of a decorative style—Fiske Kimball's masterly book *The Creation of the Rococo*. Where a student of Wölfflin might have conjured up for us the image of 'Rococo man', the product of the dancing master and the tailor, advancing with mincing steps and an air of frivolity, the author shows us the result of his work in the archives of the French court, analysing the contributions of individual designers who continued, developed and modified the decorative schemes of their predecessors. We are enabled to trace precisely the tendency towards asymmetrical designs which marks the second generation of these masters, and

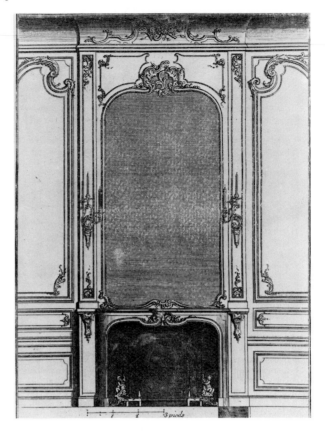

Fig. 254. Pierre Lepautre: Engraving of a chimney piece for Marly. 1699

Fig. 255. Chimney piece from P.-J. Mariette's edition of A. C. d'Aviler, *Cour. d'Architecture*, 1760 (first published 1735)

learn that their source was not so much the Chinoiseries which came later into fashion, as individual experiments of an earlier date. No wonder the author made short shrift of the generalizations of German art historians. His criticisms hit their mark, and yet, could it be that somewhere he failed to see the wood for the trees? Could it not be argued that the individual innovations introduced step by step have something in common, if only a revulsion from the heavy grandeur of the earlier style? The delicate flatness of Mansart's ornaments engraved by Lepautre in 1699 (Fig. 254) may be seen to move in the same direction as the subsequent introduction of playful asymmetries by Mariette in 1735 (Fig. 255). To be sure, I am enough of a sceptic not to attribute this tendency to a new all-pervasive body-feeling, but are we not entitled to speak of such global impressions as lightness and grace? Fiske Kimball was not unaware of this general quality. He twice quoted the famous minute by Louis XIV in which the ageing monarch criticizes the choice of subjects for the palace of a young princess—'Il me paroit qu'il y a quelque chose à changer, que les sujets sont trop sérieux et qu'il faut qu'il y ait de la jeunesse mêlée dans ce que l'on fera. Vous m'apporterez des dessins quand vous voudrez . . . Il faut de l'enfance répandue partout.' Referring, as it does, to the choice of subjects for paintings which were to have included such grave divinities as Minerva and Juno, the King, with his demand for 'childhood everywhere', may only have insisted on the principle of *decorum*, the fitting subject for the fitting place. Why does it produce such resonance in us as we notice the coincidence of its date, 1699, with the initiation of the new trend?

It is the theory of decorum itself which implies and demands a correlation of styles with emotive tones. For Vitruvius, as we recall (Fig. 209), Doric was robust and severe, Corinthian maidenly. I have generalized this theory in *Art and Illusion* to explain the links between formal and physiognomic qualities, drawing not on the theory of empathy, which was favoured by Wölfflin, but on the findings of Charles S. Osgood in his book *The*

Measurement of Meaning, to which I referred in Chapter V. They can reassure us at least that we are not talking plain nonsense when we attribute an overall physiognomic quality to a style. Fashion writers would not have needed this assurance. They know what they mean when they announce that the coming collection will have a feminine touch or an accent on severity. What is relevant to our quest in these loose global descriptions is that they characterize certain effects to be aimed at by whatever means. The unitary aim may influence the choice of colour schemes, of textures or of cuts—there is no demonstrable link between these various decisions except their desired end effect.

It is for this reason that I have declared myself a sceptic with an uneasy conscience. For if there are such global aims in styles which can be reached along different ways and in different media, the type of bias which Wölfflin described as *Formgefühl* may still be definable in psychological terms. There is even hope of making progress in the solution of what I have called Panofsky's first problem, the problem of why we can speak of Gothic painting. We all feel that a painting by Watteau aims at a similar range of feelings as does an ornamental design of his *ambiente*. Maybe there is also some affinity between a Gothic painting and its contemporary setting? To be sure, there are no laws imposing the same aim on any artist working at a given time, just as there is no compulsion for all to compete along the same lines. Any artist may strike out in a different direction and may start another bandwaggon rolling—or else he may not. The sceptic remains right in insisting on the role played by individual temperaments, talents and opportunities.

On one point in particular the sceptic must not be tempted into concessions to the collectivists. There is no need whatever to assume that a taste for robust effects in art must be the symptom of a robust mind, or that conversely a bias for the light touch correlates with a lighthearted disposition. There are any number of counter-examples which should dispose of these facile conclusions. It was the austere, harsh and rationalist Prussian Frederick the Great who surrounded himself at Potsdam with the most whimsical Rococo decorations (Fig. 22). On the other hand it was the flighty Marie Antoinette with her pastoral entertainments who inhabited the Petit Trianon (Fig. 256), one of the first buildings in France which showed the influence of Neo-classicism.

I have argued elsewhere that this absence of correlations would have to be expected if we replaced the Hegelian idea of a spirit of the age by the more concrete notion of movements. Movements may be started by individuals who find followers among whom a strong sense of identity develops. Sometimes they want to distinguish themselves from others in their dress, deportment and preferences. Sometimes they may even adopt a style as their badge.

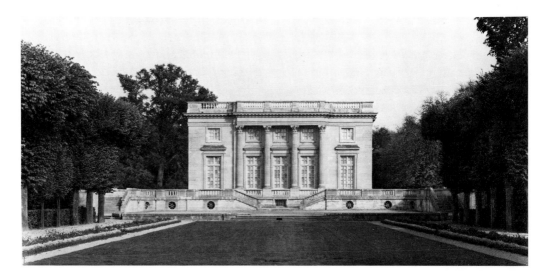

Fig. 256. Façade of the Petit Trianon, Versailles. 1762–8

CHAPEL ROYAL BRIGHTON

St GEORGE'S CHAPEL WINSOR

CONTRASTED ROYAL CHAPELS

Fig. 257. A. W. Pugin: Contrasted royal chapels. 1836

I have suggested that for a time, at least, the Renaissance was such a movement and that a building *all' antica* could proclaim the patron's adherence to its ideals. It could, but it need not. Inertia or lack of funds may have kept many a friend of the humanists in Gothic surroundings, conformism and fashion may have made a prince adopt the new style even though his outlook was thoroughly mediaeval. It would be the task of a future sociology of art to establish when and under what circumstances a style, a family of forms, was adopted as a badge. We must agree with Fiske Kimball that the Rococo was not associated with a movement. On his own showing, however, the reaction against the Rococo was. We have seen in the first chapter that it drew some of its arguments from the general ideals of the Enlightenment, the worship of Nature, the cult of Reason and the authority of the ancients. The political and cultural prestige of England, as Fiske Kimball has rightly stressed, also played its part in discrediting a fashion which had never been fully accepted by the British.

These and similar facts may suffice to explain why my troubled conscience has not led me to abandon my sceptical convictions. Maybe it is only *post factum*, by a process of hindsight, that styles can come to express the spirit of an age—an age which has acquired the quality of a myth. It was in this way that the nineteenth century used the historical styles of Gothic and Renaissance as symbols to proclaim political and ideological allegiances. A. W. Pugin, whose influence on design will be remembered from Chapter II, articulated this opposition in his *Contrasts or A Parallel between the Noble Edifices of the fourteenth and fifteenth Centuries and Similar Buildings of the Present Day* (1836) (Fig. 257). Henceforward the Gothic style was firmly identified with the Age of Faith and its ideals. Churches and Colleges were conventionally built in that guise while the advocates of progress and secularism preferred the Renaissance style. The subject as such lies beyond the scope of this book, but we must turn to the general role of symbolic meaning in design.

IX Designs as Signs

It is one of the most difficult tasks to establish the frontiers between ornament and symbol. This question, which has so far been little pursued, and that almost exclusively by amateurs, still offers a superabundant field for the exercise of human ingenuity, though it looks very doubtful today that it will ever be possible to cultivate it even in an approximately satisfactory manner.
Alois Riegl, *Stilfragen*

1 Motifs and Meanings

For most of the students of art whose ideas concerned us in the preceding chapter, problems of form and of style stood in the centre of interest. At the time of Ruskin, Riegl, Wölfflin, Focillon and even the young Panofsky the systematic analysis of meaning was of secondary importance. When Aby Warburg reintroduced the old term of 'iconology' he delimited a new area of interest, of which Panofsky was to become the acknowledged master. Yet even at that time the general science of signs, variously known as Semiotics, Semiology or Semasiology (from the Greek *sema* = sign), was merely a cloud no larger than a man's hand on the horizon of the humanities. Today the cloud has burst and the mists are rolling in, threatening to blur the outlines of once familiar distinctions. One of these is the distinction between designs and signs, between the merely decorative and the symbolic. Where it is proposed to treat everything as a sign, it becomes doubly important to re-interpret the old commonsense terminology, which had served the student of art for so long. We can visualize it in form of a scale extending from naturalist representation at one pole to 'pure' shapes or colours at the other, with pictorial symbols of increasing abstractness ranged between them. There is no reason to doubt that this scale still has its usefulness, even though we must admit that any visual arrangement anywhere along the line can also function as a sign—from naturalistic representations (such as labels on food packages) to merely formal arrangements (such as flags). We are familiar, also, with the interaction of these elements in the constitution of symbols. We know what it means when we speak of a red-letter day or say that a name should be inscribed in letters of gold on the roll of honour. The meaning attached to individual colours may differ from culture to culture. It is well known that our colour for mourning is black while among the Chinese it is white—though black and white share the absence of real colours. It goes without saying that the funeral decor will also embody other symbols in its design pointing to death and to the hopes of afterlife. The same goes for other ritualistic occasions, such as white weddings with myrtle, not to speak of all the epithalamic symbols which may find their place on the wedding cake. Keeping our eyes open, we shall find such interaction between decoration and symbolism in many places. Music stands are quite often designed in the shape of a lyre (Fig. 258), however unlikely it may seem that performers on that legendary instrument ever used a stand. Architects in particular have frequently embodied what might be called emblematic motifs into their decorative design, though few went as far as Miglioranzi, who in 1687 composed his Porta dei Bombardieri in Verona (Plate 74) entirely of instruments of war. Instead of columns he used images of gun-barrels which rest on drums of war, flanked by powder-barrels and coiled ropes. They are crowned by mortars and the decoration everywhere alludes to military equipment and the tools of the engineer. By themselves these motifs were standard. They are derived from the trophies of victory which figure on ancient monuments and were adapted to decorative use wherever allusion to military glory was felt to be appropriate (Fig. 259). It was from the instruments of war that emblematic decoration spread to musical

Fig. 259. Trophy
(A. Speltz, 1910)

instruments (Fig. 22) or Cupid's armament in the boudoir. The School of Tropical Medicine in London even sports on the outside the gilded images of the enemies it is dedicated to combat—bedbugs, fleas and mosquitoes (Fig. 260).

It was the age of Reason, the eighteenth century, which attached particular importance to significance in decoration. We remember the polemics against the Rococo and its playful irrationality. Nothing is more characteristic of this rationalist earnestness than the decision of the architect Benjamin Henry Latrobe to discard the traditional acanthus in the orders he designed for the Capitol building in Washington and to use instead American plants such as corn and tobacco (Fig. 261).

It is not surprising that this practice reacted back on the historical study of design. From the observation that decorative motifs can have a symbolic meaning, it was only too tempting a step to conclude that all motifs were originally conceived as symbols—though their meaning had been lost in the course of history. If that conclusion was justified a rich harvest beckoned to the historian who deciphered the symbolism of far distant ages. Once the meaning of these designs was established the monuments would again speak to us.

There is no spell more potent than that cast by mysterious symbols of which the meaning has been forgotten. Who can tell what ancient wisdom may be embodied in these enigmatic shapes and forms? The aura surrounding Egyptian hieroglyphs before they could be read is but one example of this appeal of the unknown to the human imagination. The search for origins, for primeval knowledge and wisdom, seeks the support of any visible token with which it can be associated. Students of culture may again be reminded of the comparison between the history of motifs and the history of etymology. They may find that the comparison is only too apt; for etymology had raised similar hopes and has had to resign

Fig. 260. The School
of Tropical Medicine
London. 1926–8

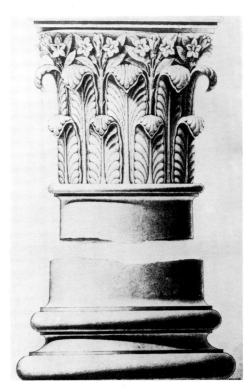

Fig. 261. B. H. Latrobe: Corn and Tobacco columns designed for the Capitol, Washington. 1809 and 1817

itself to a much more modest role in the study of languages. The hope that in tracing back the roots of any word we would arrive at the true and original meaning—its God-given meaning as it were—led to notorious fantasies and excesses. It turned out that there is no pet theory, however wild, which could not be supported by the use of etymological arguments.

As with etymology, so with designs. In both cases speculations were particularly aroused by religious issues. Fundamentalists, who accepted the literal truth of the Scriptures as the word of God, were prompted to search these sacred records for further revelation and inspiration. To this attitude, moreover, the claims to authority of Classical Antiquity were problematic if not blasphemous unless it could be shown that the Ancients derived their wisdom from revelation. A typical expression of this point of view is a book by John Wood published in Bath, 1741, characteristically entitled *The Origin of Buildings: or, the Plagiarism of the Heathens Detected*. The burden of his message is that Vitruvius is a plagiarist and that the laws of building are really laid down in the Old Testament, particularly in the passages concerning the building of the tabernacle and the temple. One brief sample will illustrate his mode of reasoning:

'. . . it seems evident, that the Volutes in the Capitals of the *Temple of Diana*, which was the Example cited by *Vitruvius* whereby the Ionick Order was constituted, were not there introduced to imitate the Curls of the Hair, as he suggests, but as Emblems to perpetuate the Memory of that Thing, which was the Occasion of removing the Difficulties the *Ephesians* lay under, on Account of the Stone for the Work, as well as the high Pitch of Glory those People were arrived to, to be capable of accomplishing such a stupendous Piece of Building; a Horn among the *Jews*, and other People in the Eastern Part of the World, signifying every Thing that contributes to a Sovereign, Sovereignty, and Power.

'For when *Moses* set fourth the Strength and Power of *Joseph*, his Expressions were, *The Horns of Joseph are like the Horns of an Unicorn*. (Deut. xxxiii, 17) *Hannah* (I Sam. ii, 1 & 10) after the Birth of *Samuel*, describes her Glory and Honour, in saying, *Mine Horn is exalted in the* LORD: *He shall give Strength unto his King, and exalt the Horn of his Anointed*.'

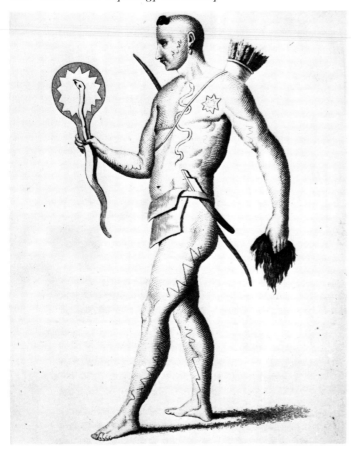

Fig. 262. Priest of the Solar
Ophite religion from north
west of Louisiana
(J. B. Deane, 1833)

Wood goes on quoting a string of further references to the horn not only in the Old
Testament but also in Greek mythology and in renderings of horned divinities and rams on
ancient coins. He concludes: 'Therefore as spiral Figures were represented in the *Ionick*
Capital, the Idea of them cannot be ascribed to the Curling of a Woman's Hair, as *Vitruvius*
would make us believe.' For good measure he lists any references to the ram he can think of,
including the zodiacal sign and even the 'battering ram', which brings him back to the
visions of Daniel.

The growth of information in the eighteenth century about an ever-increasing range of
exotic cultures and tribes presented Biblical fundamentalists with fresh problems because all
nations stemmed from Adam. Symbolism no less than language was searched all the more
eagerly for what it could tell us of the beginnings of the world. Not all arguments used in
these discussions were as ingenious as those of the Dutch mystic Humbert de Superville,
who used the ancient motif of the Medusa head as evidence for his theory that the moon had
only appeared in the sky very recently, causing a cosmic catastrophe of which he found
traces all over the world. The fact, or what he believed to be the fact, that the Maoris of New
Zealand paint their noses red could thus be explained as a memory of the outbreak of
volcanoes which accompanied this cataclysm.

Even in his own age Humbert was remarkable for his eccentricity but the basic idea that
the symbols and decorations of savage tribes should be scrutinized for what they could tell
us—or more precisely what they would confirm—pervades this branch of divinatory
literature. A work published in 1833 bears the significant title: *The Worship of the Serpent
traced throughout the world, attesting the temptation and fall of man by the instrumentality of a
serpent tempter*. The author was the Reverend John Bathurst Deane, whose labours recall
those of Casaubon in George Eliot's *Middlemarch*. Serpent-worship was devil-worship and

its evidence was to be found everywhere. Deane illustrates his book with the picture of an American Indian of the country north west of Louisiana (Fig. 262), whom he describes as a priest of the Solar Ophite Religion. The sun and the serpent tattooed upon his breast and the pictures upon the instrument in his hand are interpreted as illustrations of ancient customs. The former especially reminds the author of the 'stigmata' alluded to by Job and St. Paul, which the author believed to have been worn on the body of the priests of all religions, quoting in evidence the distinctive signs worn by Brahmins.

Deane's book did not escape criticism, but the method of looking for what Casaubon called a 'universal key' was not discouraged. After all, even the great philologist Max Müller thought that he could unlock the secret of practically all mythologies by postulating a universal solar religion. Here too the study of decoration could readily join the study of myth and of language to support this all-embracing theory. Thus J. B. Waring published in 1874 a book *Ceramic Art in Remote Ages*, in which he proved to his own satisfaction that the simple motifs of prehistoric pottery, which had just become the subjects of systematic study, could all be interpreted as solar symbols. Waring was a Swedenborgian and considered himself a prophet but he brought together an impressive mass of material from prehistoric tombs and exotic art to support his pet theory. The text to his collection of Circle Symbols (Fig. 263) is a fair sample of his method.

'In No. 1 we see the Sun in the centre of five concentric circles, possibly marking the course of the five planets round it, a theory held by several ancient philosophers, and from the external circle spread undulations, probably indicative of water. As this is an *oinochoe*, or wine jug, the allusion to the sun and water, as necessary to the growth of the Vine, is quite natural. The Solar symbol is seen again on the bronze paterae found in England belonging to the Roman period, and is equally applicable to Apollo, Mithras, or Serapis, all three favourite deities here during the Roman occupation. It occurs again on the underside of the cups from Cornwall and Wilts, and on the stone slabs found in the British tumulus. Indeed the ground plan of a tumulus itself among the Keltic races is, possibly, formed on the solar symbol . . .'

We have encountered this implicit faith in the explanatory power of solar symbolism in the book by Goodyear, whose researches on the lotus motif were of such importance for

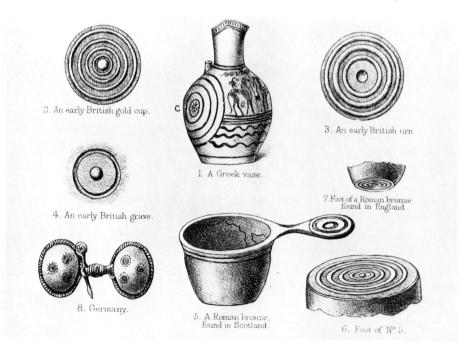

Fig. 263. Designs on prehistoric pottery (J. B. Waring, 1874)

Riegl. What makes Riegl great is the shift he effected from speculations about origin to historical research. He had rejected the 'materialistic' dogma of the origins of ornament in technical procedures but he kept an open mind about symbolism. It was his opinion that 'every religious symbol carries within itself the predestination of becoming in the course of time a predominantly or purely decorative motif, provided it is artistically suited'. Whether or not the lotus was a symbol, its success as a motif was only to be explained on formal grounds.

There are arguments from etymology which are convincing and compelling, and no doubt there are similar arguments from the etymology of motifs. In neither case should the excesses of the method be used as a ground for discrediting it altogether. But in making this point we should not overlook an essential difference between the study of language and the study of pattern. We know after all that the function of language must always be that of communication. How can we tell whether or to what extent designs were intended to function as signs?

Nineteenth-century scholars thought that an answer to this question was at hand. Steeped as they were in the evolutionist creed they were convinced that we had an easy access to the remote past of our civilization. The so-called primitive tribes of what today we call 'underdeveloped' areas represented that earlier phase in replica. The study of the decorative art of 'the savages' would therefore provide the key to our understanding of the origins of ornament.

It was a zoologist who saw the evolution of ornament exclusively in Darwinist terms. He was Alfred C. Haddon, whose book *Evolution in Art: as Illustrated by the Life-History of Design* was published in 1895. The main theme of the book is summed up in the statement that 'a large number of patterns can be shown to be natural developments from a realistic representation of an actual object, and not to be a mental creation on the part of the artist.' Haddon, in other words, is sceptical of 'purely formal' interpretations of designs. He prefers the assumption that most, if not all, geometric motifs are the end result of an evolution by which a naturalistic picture was simplified beyond recognition. It is not difficult today to recognize the link between this theoretical bias and the practice of Victorian art schools to which reference was made before (Chapter VI), that of teaching design as an exercise in 'stylized' composition. This parallel received a good deal of support from the study of scripts, which often evolved from pictographs into signs, and from the process of degenerative copying to be observed in the imitations of Roman coins by 'barbarian' nations, where the image tends to disappear in a welter of lines. Moreover, Haddon was understandably impressed by the reports of ethnologists who had asked native informants to explain to them the meaning of certain motifs. He was convinced that 'by no other method could we ever gain any idea as to what was the meaning of these particular patterns and designs', and urged collectors to gather such information, which was so rapidly disappearing even in his own time.

'What is wanted is an interpretation of the form, of the meaning of odd little details of contour, of indentation, or or projection. No apparently insignificant superfluity is meaningless, they are silently eloquent witnesses of a past signification like the mute letters in so many of our words. Almost every line or dot of every ornament has a meaning, but we are without understanding, and have eyes and see not.'

Haddon was rightly impressed by a study of W. H. Holmes on the variations on the

Fig. 264. Derivatives of an alligator, after W. H. Holmes (A. C. Haddon, 1895)

image of the alligator found in the art of Chiriqui, Colombia, in which the picture is seen to be conventionalized beyond any possibility of recognition by those who are not in possession of the series (Fig. 264). It has meanwhile been pointed out by Franz Boas that there is a fatal flaw in this reasoning no less than in the reliance on native informants which Haddon and his followers recommended. Few of the designs are dated, and there is no evidence that the more recognizable image must have been the original creation. We have seen in Chapter VII that the opposite can also occur. We remember the conventionalized scroll turned into naturalistic parrots on Persian rugs (Fig. 232), and, if Riegl was right, a similar transformation of geometric into naturalistic form accounts for the birth of the acanthus motif. What is sure in any case is that the meanings attributed to designs change from period to period and area to area. In a famous section of his book on *Primitive Art* Boas has shown that the meanings assigned by different tribes of American Indians to related elementary shapes depend very much on the preoccupations of their different cultures.

Using the motif of a triangle with an enclosed rectangle (sometimes provided with spurs at the base) as his example (Fig. 265), Boas shows that this configuration can be read as a tent with poles, doorway and pegs. At other times it may be drawn more flatly and represent a hill. 'It may be placed on a white background which signifies snow or sand; blue lines extending downwards from the base indicate springs of water and small triangles may be placed in the inner triangle. Thus it becomes a mythical mountain in which, at the

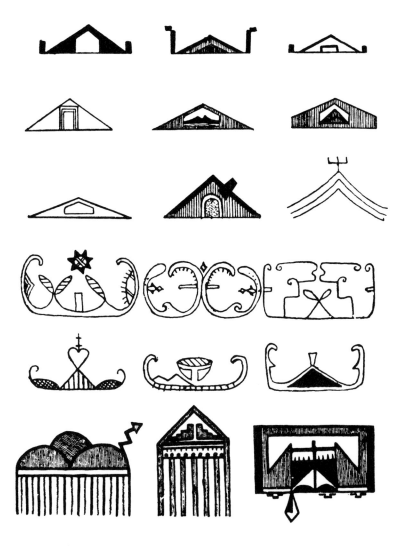

Fig. 265. Transformations of a motif in North American tribal art (F. Boas, 1927)

beginning of time, the buffaloes were kept and which is located on a snow-covered plain. On the slopes of the mountain grow trees.' Boas contrasts this interpretation with that of the Pueblo Indians, whose greatest need is rain and who accordingly interpret the symbol as a cloud from which the rain falls. 'Since their art is far less angular in style than that of the Plains Indians, they often substitute a semi-circle for the triangle and attain a greater realistic resemblance to clouds by superimposing three of these semi-circles from which flow down the rain lines.' Another tribe reads the obtuse triangle as mountain passes and a fort protected by palisades. 'Further to the north we do not find the enclosed rectangle, but the triangle and spurs at the base persist. These are explained as paws of a bear, the triangle being the sole of the foot, the spurs the claws.' Boas points to other vicissitudes of the same motif. In one case the triangle is stretched and vertical lines are added to the sides to make it conform to the interpretation of a fish tail. In another, curved lines are added on and the pattern becomes a symbol of the town or of the tribe and its chief.

What is so interesting in this example is the number of variables Boas brings into play. There is the basic motif comparable to a linguistic root, and there are the purely stylistic modifications comparable to the 'sound shifts' in various languages. Beyond this the changing cultural context makes for different readings, which in their turn will react back on the motif and lead to further changes. This too has its parallel in linguistics. The story has it that the Elephant and Castle district in London derived its name from an inn, 'The Infanta of Castille'. Folk etymology transformed the sound into 'Elephant and Castle', and a picture of this Indian chess piece replaced the original sign. Even where we know of a meaning attributed to a particular design at any one time, therefore, we cannot use this evidence in our quest after the original meaning—if ever there was one.

One of the most impressive and long-lived decorative motifs in the arts of China is the ferocious mask known as the *t'ao-t'ieh* (Plate 75). The term means 'glutton', and is only found in relatively late texts. One of these texts also offers an interpretation of what it describes (not quite accurately) as a monster without a body. We are asked to regard it as a moral sermon against greed, for the creature 'tried to devour men, but was unable to swallow them, and so damaged its own body'. It is agreed to be most unlikely that the Chinese bronze casters who so frequently employed versions of this mask on their magnificent bronze vessels thought of such an exhortation. But students of these enigmatic monuments are still divided: some feel that we must resign ourselves to ignorance while others hope that it should be possible to decipher the meaning of their decor. Since the character for 'thunder' in Chinese script is a spiral, for instance, they suggest that the spiral patterns on early bronzes must signify rain or thunder. This in turn has been used by Carl Hentze as a confirmation of his theory that the decoration of these ritual vessels exhibits a 'consistent iconographic programme' of cosmic symbols in which the *t'ao-t'ieh* is supposed to symbolize the earth, birds the heavenly light and reptiles the water realms.

It is not possible for the outsider to weigh the individual arguments brought forward for these interpretations, but it may be permissible to place them into their historical context. For though it must be invidious to compare the efforts of contemporary scholars with the flights of fancy of earlier amateurs, they share the basic assumption that designs must be interpretable as signs. Thus Lévi-Strauss was moved to endorse the elaborate theory of Carl Schuster according to which certain motifs frequently encountered in the peasant embroideries of South East Asia reflect complex diagrams of kinship relationships deriving from the hypothetical marriage rules of palaeolithic tribes. A famous Indologist of our days (F.D.K. Bosch) devoted a book to the analysis of Indian decorative motifs in terms of mythological categories without even mentioning the derivation of the Indian scroll from the classical world.

In the World of Islam exhibition in London in 1976 the following note on the arabesque

was displayed for the guidance of visitors: 'It derives from an abstraction of the patterns made by plant forms. It makes possible the creation of partially naturalistic designs with which there is no beginning and no end. Such a visible expression of infinite continuity within an ordered and unified system has religious symbolic connotations. The reference of arabesque to plant forms also touches on two other important aspects of Islamic thought: the very considerable interest in science and the notion of paradise as an enclosed garden of flowers and water.' The note is symptomatic of the tendency I have been discussing, the refusal to accept the autonomy of decorative design. The visitor must be reassured that there is more to the arabesque than meets the eye. The revelation of symbolic meaning resembles an initiation into the deeper mysteries of the tradition. It is clear from the wording of the passage that there is no concrete evidence for these interpretations. Certainly a contemplation of ordered systems could have 'religious symbolic connotations'. Whether these connotations would fit in perfectly with the tenets of Islam is a different matter because Islam stresses in particular the overriding power of Allah, whose omnipotence totally exceeds human thought and calculation. 'The very considerable interest in science' mentioned in the exhibition note sometimes came into conflict with this religious tenet. In any case such botanical treatises as existed had surely nothing to do with the stylized scroll of the arabesque. It may be less easy to disprove the link between vegetal decoration and the idea of paradise 'as an enclosed garden of flowers and water', but there were better means at hand of creating such an artificial paradise in the palaces of the mighty than the application of the arabesque.

Here the search for meanings coalesces with the tendency discussed in the preceding chapter, of looking for some principle of unity among all manifestations of a culture or period. Being characteristic of Arabic decoration the arabesque must also partake of the essence of 'Islamic thought'.

In linguistics the quest for the 'spirit' of a language has largely been abandoned and so has the search for the original meaning of roots as a guide to semantics. Instead interest has begun to centre on the synchronic analysis of how language actually functions in any one community. The student of design would do well to follow suit and to concentrate on the known function of design in the past and in the present.

2 *Marks of Distinction*

There is a famous and venerable passage in the Bible which may well be the earliest detailed description of a design; I am referring to the description of the holy garment ordered by Moses according to the command of the Lord as described in Exodus XXXIX.

'The ephod was made of gold, blue and purple and scarlet and fine twisted linen. And they beat the gold into thin plates and cut it into wires to work it in the blue and in the purple and in the scarlet and in the fine linen with cunning work. The robe and the ephod was all blue but they made upon the hems of the robe pomegranates of blue and purple and scarlet and twisted linen, and they made bells of pure gold, and put the bells between the pomegranates upon the hem of the robe, round about between the pomegranates; a bell and a pomegranate, a bell and a pomegranate, round about the hem to minister in, as the Lord commanded Moses.'

There is no explanation given of the motifs of pomegranates and bells, though naturally subsequent commentators have not been sparing in explanations. For the Scriptures it is quite sufficient that the Lord wanted the priest's garment so and not otherwise. What is stressed in the design element is the strong contrast of colours, blue, purple and scarlet, the preciousness of the material and the regularity of the pattern with its strict alternation of motifs, which makes the robe distinctive. The symbolism is rooted in the use.

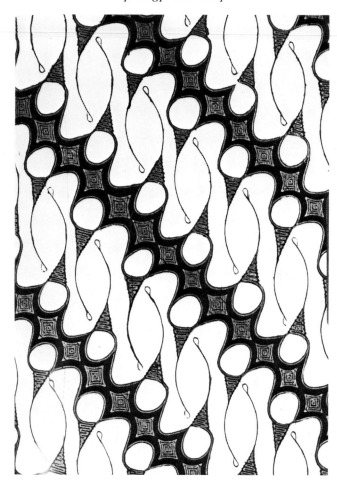

Fig. 266. Javanese batik
design

What specialists tell us of the great textile art of Java is well suited to bringing out this vital point. The term *parang rusak* used for a distinctive design (Fig. 266) literally means 'dagger point' or 'broken blade'. 'In explaining the term, some say that the diagonal repeat motifs derive from the stylized bird-head commonly featured on the hilt of the Javanese dagger (*kris*), others say it derives from the practice of using a dagger-blade to "cut" the design on a waxed cloth. The temptation to attach meanings and even religious symbolism to motifs of decorative art is strong in the East and especially in Java, but the fact that such interpretations are often contradictory or inconsistent encourages the assumption that invention of the forms sometimes preceded the meanings.'

But it is noteworthy that this uncertainty does not extend to the significance of the pattern in its social context. We know that in Central Java it was exclusively reserved for court wear, but we also read how these restrictions were gradually undermined. 'As part of the process of freeing "forbidden" patterns for common use, they were often combined with other motifs, the artistic success of such intermixing depending on the instinct of the batiker.'

It is in this light that we must see the strenuous efforts made in ceremonial contexts—old and new—not to allow distinctions to be blurred. One example must here stand for many: the register of colours and materials of robes, gowns and hoods for graduates in the University of Oxford. In 1636 Archbishop Laud ordered the Heads of Colleges and Halls to determine what were the correct robes for each faculty. Anyone who thereafter tried to introduce any novel form of robe was to be punished at the discretion of the Vice-Chancellor. Tailors were particularly enjoined not to depart from the prescribed patterns. Nor were these injunctions confined to the distant past. 'On 28th May 1956, a committee on

academic dress examined a book of patterns prepared and submitted . . . on behalf of the National Federation of Merchant Tailors, and recommended that the patterns be approved. This recommendation included the alternative for the lining of the M.A. hood and said that the use of nylon substitute fur for the hoods of Bachelors should no longer be allowed . . . the register of patterns was prepared, bound in leather and on parchment leaves, to which were affixed patterns of silks, materials and fur . . .'

Consulting the publication, which is fully illustrated in colour, we also learn that the gowns of the various degrees differ according to three degrees of formality. The Doctor of Letters (D. Litt.) for instance, should really have three attires, according to the occasion:

'FULL DRESS: A full scarlet robe with bell-shaped sleeves, of which the body is made from scarlet superfine cloth with facings and sleeves of neutral grey silk. A square cap is worn.

CONVOCATION HABIT: A sleeveless cloak of scarlet superfine cloth, part lined with neutral grey silk, fastened with two grey-silk-covered buttons in front. The back is gathered in a yoke. The hood is of scarlet cloth lined with navy blue silk.

UNDRESS GOWN: A black gown of silk or poplin with a form of black lace sewn on the collar, the lower part of the back, underneath the arms and down the sleeves, which are closed and cut straight, but have an opening just above the elbows.'

The intended significance must have come first and the various designs must have been produced through differentiation in order to reflect the various categories of degrees given by the University.

There is a recent investigation in which this process of differentiation has been studied in an area where it can be fully documented. I refer to the design of military uniforms, which must of course reflect the numerous divisions and sub-divisions of nations, arms, regiments and the whole hierarchy of functions to which the military mind attaches such importance. Otto Koenig had the ingenious idea of tracing these marks of distinction as far back as possible. Like other theorists of decoration he wants to use his rich material as evidence for his own hypothesis about the essentials of cultural development. He is fascinated by the parallels between the evolutionary processes in nature which account for the origin of species and those pressures of evolution at work in human civilization. As a disciple of Konrad Lorenz he is particularly interested in those processes of ritualization which, as we have seen, Lorenz himself has compared with the establishment of customs in human society. In pursuit of this comparison Koenig particularly stresses one direction of development, the change of function from practical usefulness to display. Many of the features of uniform which appear to serve purely decorative purposes owe their origin to very practical considerations in earlier warfare. The splendid ceremonial uniforms of pre-khaki days with all their gold braid and their shining buttons can be seen as the deposits of a long development which transformed a utilitarian outfit into a ritualistic object. What enhances the parallel between this development and that in the biological sphere is the tendency to exaggeration which goes with the change from a tool to a sign. The sign must above all be conspicuous and memorable, and so all the resources of visual emphasis are mobilized, till the military uniform of the proud commander bears a more than fortuitous resemblance to the plumage of a peacock or a bird of paradise. One of Koenig's examples (Fig. 267) is the lining originally given to buttonholes to prevent tearing and which is gradually allowed to spread luxuriantly over the whole tunic (much as happens to the hinges of mediaeval doors, Plate 46). The extremes were never suitable for combat, but ceremonial dress needed no such restraint. Koenig rightly emphasizes that no one would suspect the origin of their embroidered tunics to be traceable to the simple buttonhole.

The historian of decorative arts will study these demonstrations with interest but he will also remember some of the pitfalls to which an exclusive insistence on continuity is prone. I

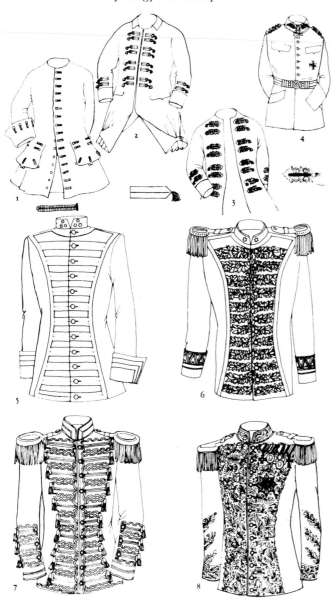

Fig. 267. Developments in
uniforms (O. Koenig, 1970)

have discussed this problem in connection with Riegl's analysis of the acanthus as a mere transformation of the palmette. The series of motifs he drew up to establish this derivation looks convincing, and yet it turned out that the existence of transitional forms could be explained in another way. There might have been a convergence of forms, a mutual assimilation of motifs of different origin. It so happens that similar developments also exist in nature. Not all 'phenotypes' which look similar are derived from a common ancestor. Maybe a parallel could also be found in the history of uniforms. The embroidered tunic must have other ancestors in embroidered coats or waist-coats, though this obvious affinity does not disprove the existence of the line traced by Koenig.

We have seen in the first chapter of this book that there is one general rule which pervades the marks of distinction in most social contexts—the gradation in the degree of costliness. Purple certainly became the royal colour because of the extreme rarity of the dye derived from the Tyrian shellfish, and the rarity of the ermine in winter lends distinction to the white fur worn by judges and peers. We have also seen in a previous chapter that the machine and its capacities were felt to be subversive in this matter of the significance of decoration,

which is why Oxford regulations forbid 'nylon substitutes' for fur. Before such surrogates were invented the more elaborately decorated article would also be the most costly—particularly if we include in this rule the labour and care needed to obtain and to work precious materials. Thus the decorated and the plain were categories by themselves which pervaded the whole of life. Hence the importance of the concept which shares its etymological root with decoration—that of decorum, which plays such a crucial part in the history of aesthetics, as mentioned in Chapter I. The term derives from the rules of rhetoric in antiquity which demanded that the choice of words should always fit the occasion. You would not use high-flown language in a petty lawsuit any more than you would use colloquialisms in a solemn oration. Modern usage has generally restricted the concept of decorum to the second type of example; we tend to speak of a breach of decorum mainly where distinctions are disregarded which should be observed.

There is another key word here which links the aesthetics of ornament with the social function of design—the word formality. The more 'formal' the occasion, the more emphasis is laid on the preservation of forms, both in the institutional and in the visual meaning of the term. The graduands in their processions, the soldiers on parade, the committee seated on the dais, the judges on the bench must observe formality, they must not only submit to the rules but they must also be seen to submit. From this point of view we need not be surprised about the role which the uniform plays on any such formal occasion. The uni-form adds formality by aiding symmetry and emphasis. It makes the individual merge in the pattern and thereby contributes to the extra emphasis on the personage in the centre of the stage whose attire is unique and especially splendid. In Chapter VI I have compared these perceptual effects to a field of force that modulates and modifies the meaning of any individual element that comes within its orbit. The study of formal occasions in any society confirms this observation. True, the degree to which any society can formalize an occasion depends very much on organizational factors. Uniformity needs a good deal of planning and discipline, and Ruskin was right in his intuition that it also needs authoritarianism. The military uniform is a fruit of seventeenth-century absolutism and the goose-stepping soldier has become a symbol of Prussian drill.

Even the uniformity of household implements, which we tend to take for granted, is a relatively late feature. To us a formally laid table must show uniformity in plates, cutlery and even the chairs arranged around it, and no hostess likes a piece of her set to be broken. But the production of sets of plates or cutlery may not go back further than the introduction of uniform. It, too, presupposes a strictly organized manufacture.

Here as always the 'set' of plates or dishes forms a subclass of a category which those who know the rules will recognize and respect whether or not their use can be rationalized—as in the case of fish-knives made of silver rather than steel—or is purely conventional as are the various glasses in use for various wines.

There is an episode in Bertrand Russell's autobiography which neatly illustrates the importance attached to these formalities in Victorian society. He remembered how, at the age of thirteen, he had met the great Mr Gladstone for the only time in his life.

'As I was the only male in the household, he and I were left alone together at the dinner table after the ladies retired. He made only one remark: 'This is a very good port they have given me but why have they given it me in a claret glass?' I did not know the answer, and wished the earth would swallow me up. Since then I have never felt the full agony of terror.'

The force and tyranny of that sense of order that ruled polite society could not be illustrated more succinctly. Conventional distinctions were accepted as a matter of course by all members of society, not only at table but also, and particularly, in dress and appearance. The famous painting *Work* (Plate 77) by Ford Madox Brown is intended as a moralizing panorama of the whole of society in mid-nineteenth century, from the top-

hatted city gent in the background to the navvies and the flower girl in rags. Lacking a knowledge of the required nuance we miss some of the painting's message carefully spelt out by the artist, but even I am old enough to remember a time when workers wore cloth caps and civil servants bowler hats and when it would have been unthinkable for the two to swap headgears. Gentlemen were worried that a tie was perhaps too drab for a particular occasion or—worse still—too loud to accord with their dignity. It is still a breach of decorum to wear a T-shirt with 'tails'—but for how long?

The sense of decorum reflecting social distinctions is on the wane, and remembering Bertrand Russell's ordeal this may not be too great a loss. In any case a certain resistance to these manifestations of the social sense of order is not a novelty. It is worth noting in this context that the Shorter Oxford English Dictionary lists under 'formal' the meanings: 'Rigorously observant of forms . . . ceremonious, usually *reproachful*', 1514, and 'wanting in ease or freedom', 1597. 'Formality' is equally stated to be used 'often *depreciatively*' 1647, and is defined, in one sense, as 'excessive regularity or stiffness', 1599.

Even so it would be rash to join in the complaint that the young no longer have a sense of decorum. Maybe they are still too much obsessed with it. The young men in England who liked, a few years ago, to flaunt uniforms from the Boer War were certainly in breach of army decorum, but one must assume that they and their contemporaries understood how they were categorizing themselves in adopting this apparel. In the most general way the flamboyance which may strike us today functions as a deliberate distinction from the drabness which is, or was, associated with respectability. Even anti-decorum is a form of decorum. Thus it was fashionable for a time to imitate the patched trousers of the erstwhile tramp by sewing conspicuous patches onto jeans or other garments. Some of these were even printed onto the material as a 'mimicry' of makeshift repairs, a poignant reminder of the fact that modern fabrics rarely tear and when they do are discarded even by the poor, whose womenfolk used to wear themselves out with darning and patching even in times within my memory. Now these signs or symptoms of distress have become the decorative badge of the anti-establishment, a badge which is of course worn by members of that non-existent institution.

Keeping our eyes open we shall soon find designs everywhere in our environment which have come to function as signs according to a new sense of order and decorum. When coffee bars first advanced into England in the wake of the armies returning from Italy they adopted a decor that was distinctly different from the traditional dark style of the pub (Figs. 268, 269). They have meanwhile been followed by the discotheque and the boutique. In all of these cases the decoration obviously aims at conveying the contrast with traditional emphasis on order and restraint by a jagged, loud and 'jazzy' medley which suggests the dynamics of a particular life-style. Clearly, therefore, symmetry and asymmetry, repose and restlessness in patterns easily become associated with particular moods and with the effort to create a certain atmosphere.

The new arbiters of these matters, the 'hidden persuaders' of the advertising industry, are always anxious to promote what they call the 'image' of a firm or a product. The showrooms, the offices, and even more the packaging must convey the social implications of a particular commodity. You are expected to acquire it as an expression and a display of the way you see yourself. There is a homely image 'as mother made it' and a daring one which 'your mother would not like'. The professed aim is to create an atmosphere, an aura, which is supposed to affect us subliminally, creating a mood rather than transmitting a meaning. Thus we must still insist on distinguishing this subtle social use of design from the function of signs and symbols. Decoration, as I have stressed, is generally perceived marginally; it must make its effect in the global impression we receive from it. Signs and symbols must be inspected focally to yield their distinctive meaning.

Fig. 268. Marian Wenzel: A coffee bar
Fig. 269. Marian Wenzel: A pub

Fig. 270. Marian Wenzel:
Christmas wrapping paper

It accords well with these dual functions of designs and signs that decoration is so frequently found to provide the appropriate setting for the sign or symbol. We here come back to the type of usage discussed at the opening of this chapter such as the colours associated with weddings and funerals. The interests of commerce have provided a wide field of application for the inventive designer, who must every year introduce new wrapping paper for Christmas or Easter, combining the appropriate robins, candles, stars, eggs or rabbits with suitably chosen colours and patterns (Fig. 270). He is the heir of earlier craftsmen whose more solemn task was to intermarry dynastic or heraldic symbols with a setting suitable for a particular occasion.

3 Heraldic Symbolism

Among the greatest treasures of late mediaeval chivalric art are the boastful displays of the Burgundian duke Charles the Bold which the Swiss peasants captured on the battlefields and in the camps of Grandson and Murten in 1476 when they routed the invader. Not only did the duke's coat of arms decorate shields, banners and the caparisons or trappings of the horses, it was accompanied by the device of the *pierre à feu*, which belonged to the symbolism of the Order of the Golden Fleece and which the duke is reported to have adopted to proclaim his power of kindling the fires of war—the power which cost him his life. The setting of these symbols varies according to the occasion. They appear on the vestments of the priests specially designed in black for the commemoration service for Philip the Good (Plate 76), they are surrounded by festive spring flowers on the tapestries which must have decorated the tent (Col. Plate XI). Here the coat of arms and the device of the firestone are supplemented by another device, the letters EE, which have not fully yielded their secret but may stand for *Eques Ecclesiae*. The artist must have ransacked herbals and also have studied flowers from nature to provide a sumptuous setting for the ducal arms. He was allowed to follow the bias of the late Gothic style with its enjoyment of natural beauty and variety and the gay mood of spring. Inside the shield, of course, such a licence was out of the question, for here he had to keep to the strict laws of a conventional system of signs, the laws of heraldry.

There is no tradition more suited to the study of this interaction between signs and design than that of heraldry. There are still experts in the esoteric lore of heraldry which survives from the age of chivalry. The student of pattern may envy the precision with which configurations can be named and described in this ancient tradition: there is the bend engrailed, invecked, embattled, counter-embattled, the bend raguly, dovetailed, indented and dancetted (Fig. 271). There are the same and others for the fess, including the fess wavy and the fess nebuly, and so to the cross and the saltire. It is hardly necessary to draw attention to the orderliness which the laws of heraldry impose on these designs, nor to the importance attributed to strong primary and contrasting colours for setting off the 'charge' against the 'shield'. What is striking is the way in which anything that enters this field of force is becoming formalized and transmuted into a motif. Heraldic flowers and beasts belong to a higher order of beings which obey the laws of rigid regularity as a matter of course. The heraldic rose and the fleur-de-lys are so stylized as to defy recognition and so is the heraldic lion whether it is shown rampant or couchant—the latter posture, being not quite befitting for a lion, turns it into a lioncel or leopard.

The habit of the nobility of embodying in their coats of arms those of their ancestors with all their reminders of title deeds and privileges presented designers with interesting problems of ordering and adjustments. Most of the shields we find accommodate or 'marshal' more than one heraldic device, they are 'impaled' or 'quartered' to show the whole array of devices which a herald would easily read. The most interesting formal consequence of this need to superimpose and to telescope many signs is the invention of a particular kind of counterchange. Where a lion rampant appears on a divided field the part on the light ground will be dark while that on the dark ground will be light (Fig. 272). We have all become so familiar with this expedient that it comes as a surprise to find that it was not used outside heraldry before the turn of the century.

g. 271. Heraldic rminology (A. C. ox-Davies, 1909)

g. 272. The alvasone coat of ms. Early 17th ntury

FIG. 65.—Bend.

FIG. 66.—Bend engrailed.

FIG. 67.—Bend invecked.

G. 68.—Bend embattled.

FIG. 69.—Bend embattled counter-embattled.

FIG. 70.—Bend raguly.

G. 71.—Bend dovetailed.

FIG. 72.—Bend indented.

FIG. 73.—Bend dancetté.

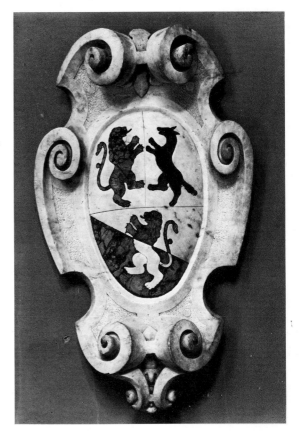

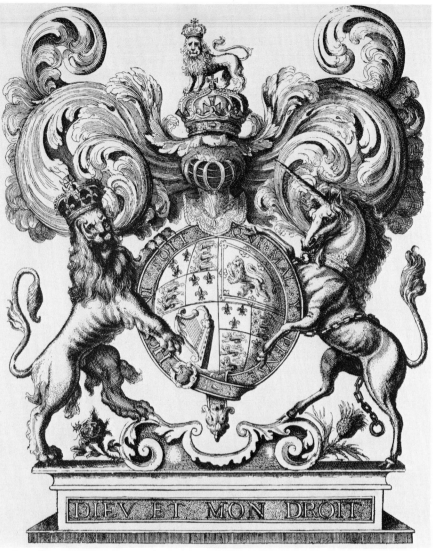

Fig. 273. Royal coat of arms
(R. Pricke, 1674)

But these consequences of strict formalization can only be observed within the confines of the shield itself. This shield is normally set in a wider frame, in which we can observe the gradual relaxation of rigidity. The coat of arms in isolation is normally held by so-called supporters. They can be beasts such as a lion and a unicorn familiar from the British royal arms (Fig. 273) or they can be human (Fig. 274). In their representation the laws of decorative order lose their sway; the supports can be naturalistic—or as the language of heraldry calls it, 'proper' in shape and colour. The shield tends also to be surmounted by a helmet which, in its turn, carries a crest. In tournaments the armoured knight in his vizor displayed his shield on his arms and his crest on his helmet with any other devices he might favour. In any display the treatment of the crest is more relaxed than that of the shield and the plumage is rendered with zestful flourishes. The whole combination can be surrounded by a mantle which is draped in freely falling folds. We thus get the whole gradation from the lucid and therefore conventionalized charge on the shield to the freedom of the setting, where the artist can give rein to his personal taste.

We here come back to the question posed at the outset of this chapter, the relation between signs and designs. It is the function of signs to attract attention, to be conspicuous and clear, and it is the business of the designer to enhance this effect by creating the proper setting.

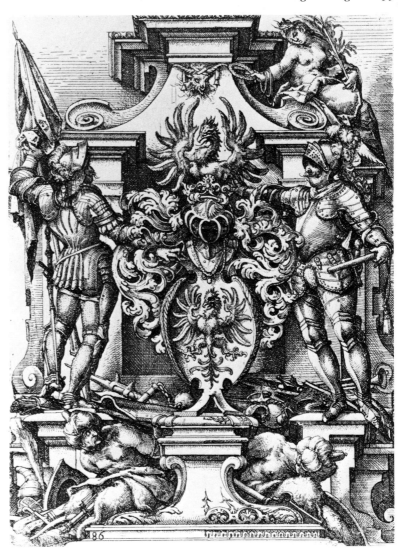

Fig. 274. Wendel Dietterlin: Coat of arms with human supporters. 1598

4 Symbol and Setting

Long before jewellers knew how to set a precious stone to the greatest advantage through judicious placement, isolation and supporting surround, Nature had arrived at these principles through evolutionary pressure. Wherever attention is to be enlisted for attraction or for threat, we find these means of geometrical simplification, isolation and the halo effect of a surrounding zone which sets off and enhances the centre (Fig. 150). In flowers the circle of petals helps to attract the insect, in animals a coloured surround may accentuate certain parts of the body for the purpose of threat or display—the 'magnet for the eye' is strengthened by what I have called the 'field of force'.

This is not the only instance in which our sense of order can be seen to influence the communication of meanings through signs. In the development of scripts, we remember, it is the device of the line which universally serves as a guide to the eye. Beyond this commonsense device, however, the use of such perceptual aids as lay-out, paragraphing, and other typographic devices vary considerably in the traditions of different cultures. What makes this particular interaction between order and meaning, sign and design, so interesting, is the variety of possibilities it reveals to the most cursory glance.

It appears that the scripts of the Middle East such as cuneiform were confined to

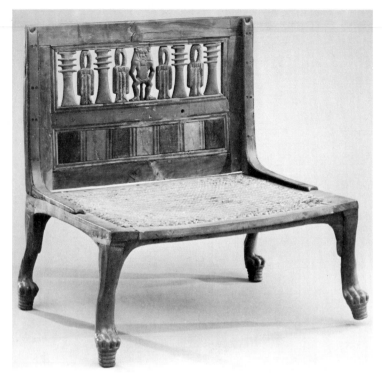

utilitarian principles of order without special means of emphasis or enhancement. Egyptian hieroglyphs, on the other hand, were easily adapted both to the functions of communication and to that of symbolization. The oval 'cartouche' which makes the Royal name stand out from the text is famous for the role it played in the decipherment of the script. The ideograms could also be used side by side with other symbols in a decorative setting which loudly and clearly proclaim an auspicious meaning. There is a beautiful chair in the Metropolitan Museum of New York from the 18th dynasty (Fig. 275) showing the figure of Bes, the gnome of good luck, and the hieroglyph of 'welfare' repeated several times. Among the treasures of Tutankhamun there are vases set between the Lotus and the papyrus, which together symbolize the union of Upper and Lower Egypt (Fig. 276). Flanking the zigzag row we find a ring and a stylized tadpole, the first the hieroglyph for eternity, the second for one hundred thousand, the whole meaning one hundred thousand eternities. The notched stems above the scroll represent palm ribs, the hieroglyphic sign for a year. The stand consists of a central support flanked by two signs of 'life' which are turned into human figures holding the hieroglyph for 'welfare'. Thus the setting of the vase and the inscription it carries derive from the same system of signs.

There is no exact parallel in Chinese culture to this fusion between symbolism and decoration. True, Chinese ideograms with auspicious meanings can also be found in a stylized setting, as in the combination of the bats with the longevity sign on Chinese screen doors of comparatively recent date (Fig. 278), but the most characteristic contribution of Chinese calligraphy does not so much formalize the sign as make it yield to the free impulses of the hand wielding the brush (Fig. 277). It is this infusion of life which is appreciated by the Chinese connoisseur, who makes a sign respond to the order of movement rather than to the laws of geometry.

The pliability of arabic letters permitted even greater diversification. There is the angular 'cufic' type (Fig. 279) and the more florid cursive script (Fig. 116); both styles have proved immensely adaptable to the decorative functions of Islamic ornament, merging easily with its geometric grids or its undulating arabesques. In this setting the inscription—be it a

Fig. 275 Egyptian chair. 18th dynasty, 1551–1306 B.C.

Fig. 276. Floral unguent vase. From the tomb of Tutankhamun (d. *c.* 1352 B.C.)

Fig. 277. Characters from a poem by Tao-chi (1640–*c.* 171

Fig. 278. Chinese lattice screen.
Chengtu Szechwan, A.D. 1900

prayer, a date or a proverb—could be turned into a design in its own right (Plates 78, 79). So close, indeed, became the intermarriage of script and decoration in the Islamic tradition that Western craftsmen who admired and adopted these motifs were unable to distinguish the designs from the signs. We sometimes see meaningless cufic letters, often copied from Islamic textiles, used as decorative borders on Renaissance works of art (Plate 80), the design having triumphed over the sign.

The Western alphabet, which we inherited from Phoenicia via Greece, has proved at least as elastic in the way the distinctive features of the characters can remain recognizable across a large range of transformations. Hence it offers another test case for the response of a system of signs to the fluctuations in the styles of design which make up the history of Western art. There is a humorous drawing by Saul Steinberg which neatly reveals our instinctive expectation of such interaction. It shows a Mondrian type of painting, severely linear, which the painter has signed with a tremendous flourish (Fig. 280). The clash between the two systems of form brings it home to us that a severe style of design demands an equally spare type of signature. The design and the sign are expected to draw on the same repertory of forms and if they do not the conflict results in discomfort because of the rapidity of

Fig. 279. Cufic script
from the Koran.
Mesopotamia,
7th century

Fig. 280. Drawing by Saul Steinberg from *The Passport* (Harper & Bros.). © 1953 Saul Steinberg. Originally in *The New Yorker*

adjustment that is demanded of us. It is only against a background of similarity that we can appreciate the distinctive variations in motifs. A word made up of characters from very different founts would be hard to read and ugly to look at.

It was in the Roman world that the beauty and force of a monumental inscription on a building was first discovered. The form of the letter was made to submit to the laws of architectural structure in the *littera quadrata* (Fig. 281). Clarity of form and spacing alone enhance the authority of the inscription with its 'lapidary' succinctness and its sense of decorum expressed both in the choice of words and in the form of lettering. It was an art much admired and emulated in the Renaissance and other periods of classical revival. The very concentration on the sign itself and the absence of any decorative flourish was experienced as a token of restraint, dignity and taste.

Other styles submitted the same letter forms to very different transformations. The initials of mediaeval manuscripts are turned into complex ornamental flourishes, which will

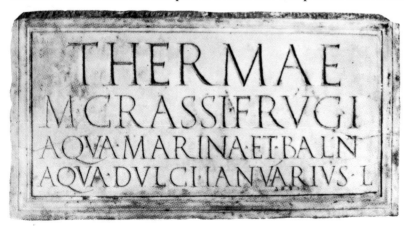

Fig. 281. Inscription from Pompeii

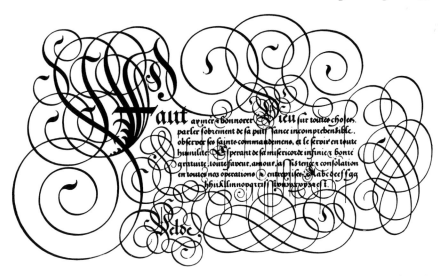

Fig. 282. Jan van den Velde:
Flourish. Rotterdam, 1605

engage our attention in the next chapter. The calligraphers of the 15th, 16th and 17th centuries, particularly in the north, knew nothing of the classical rejection of the flourish. On the contrary, they indulged this playful skill to the full whenever they wanted to show off their mastery and indicate the love and care with which a document had been written. To the student interested in the relationship between sign and design this convention is of paradigmatic importance: for the flourish exhibits that side of ornament which Ruskin valued above all, the expression of the joyful exuberance of a craftsman who displayed both his control and his inventiveness. It is as if, having formed a letter on constructive principles, there was still so much surplus energy which needed an outlet that the hand showed off its mastery of regular movement in the swinging scrolls and loops (Fig. 282).

One is reminded of the 'florid' gestures of the courtier we still see imitated in the acting of Elizabethan comedies—the way the hat is doffed or a curtsy performed. In fencing, the flourish accompanies both thrust and parry to dazzle and impress the opponent and the spectators, though not all duellists improvise a poem at the same time like Rostand's Cyrano. In any case the elaboration of an action into a display of virtuosity could lead to the

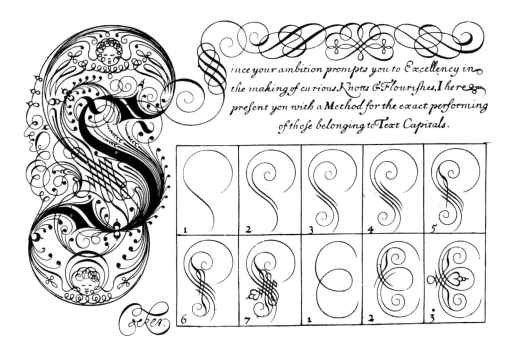

Fig. 283a. Edward Cocker:
Magnum in parvo. 1672

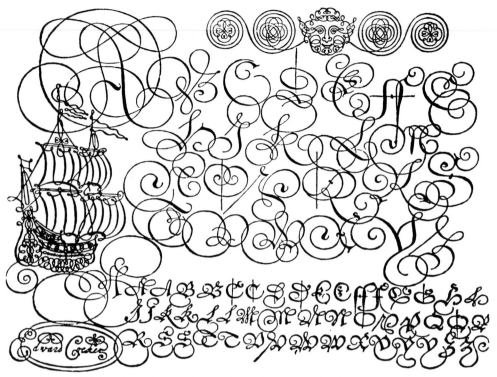

Fig. 283b. Edward
Cocker: Scroll.
London, 1657

Fig. 284

same kind of 'decadence' we discussed in the case of other ornamentation. There are examples of penmanship, such as the scrolls by Edward Cocker (Fig. 283), which defeat their own purpose; we could never see the flourishes as letters if we did not expect them to follow the sequence of the alphabet. The design all but obliterates the sign.

This fusion between the flourish and the letter-form can intentionally be taken beyond the limit of legibility: in the monogram (Fig. 284) the interlacing of letters can (though it need not) result in an ornamental cypher, to be used much like a personal device in decorative or heraldic contexts. It is there to be recognized but not read.

There is another function of the flourish more intimately bound up with the signature. Here it can be defended on rational grounds because its personal rhythm makes imitation difficult, but surely this is not its sole purpose. It also retains its character of display and self-assurance. Looking at the signature of Queen Elizabeth I (Fig. 285)—by no means an extreme example in its time—we may be reminded of her mode of dressing, illustrated in Fig. 200. Much as the jewellery and lace encircling her head was to create its own 'field of force', so the loops and guilloches of the pen render the large royal signature even more solemn and conspicuous.

In this respect the flourish, which leaves the sign intact and surrounds it with free elements of design, reflects the same distinction we observed in the conventions of heraldry. It is a distinction which matters in the context of this chapter precisely because it suggests the

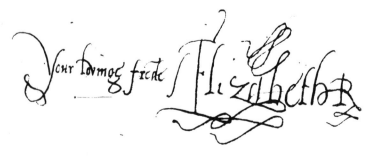

Fig. 285. Signature of
Queen Elizabeth I

degree of autonomy we must grant to ornament. It can, but it need not, fuse with symbolic meanings. Obvious as this may sound, the point needs stressing because the very irrationality of ornament has so often tempted observers to look for a symbolic root. The flourish is easily understood as a playful product, a paradigm of the relation between sign and design. Even where it enters into a symbiosis with the sign, serving as a means of emphasis or enhancement, it never quite surrenders its freedom from the constraints of signification.

5 *The Transformation of the Flourish*

The playful character of the flourish sometimes invites the metamorphosis I described as 'reification' and 'animation'. The undulating frame of our Greek cup (Plate 25) becomes easily elaborated as a wreath or scroll; indeed, once our attention is drawn to this aspect we can divine the movement of the designer's hand also in the magnificent scroll of the *Ara Pacis* with its beautifully balanced spiralling terminations (Plate 58). More often we see these animated flourishes return to their original function of setting off a sign or symbol, creating an effective contrast between the freely moving motifs and the emphatic device—as in the case of the brackets displaying trade signs (Fig. 66) or inn signs in many old cities of Europe.

 This mutual enhancement of the symbol and its setting can draw on any number of representational motifs. In the hands of a consummate master such as Bernini the hieratically shaped symbolic dove is set off by the whirling angels, clouds and expansive radiance that crowns the Cathedra of St. Peter (Plate 81). On the other side of the globe the potentialities of swirling 'cloudbands' were used to great effect in the Chinese tradition to reinforce the powerful motif of the Imperial dragon on such designs as the Emperor's robe (Col. Plate X). The visual effect of these cloudbands is strikingly similar to that of the flames on the Burgundian vestment (Plate 76).

 But the ultimate in reification is reached in that ubiquitous device of European decorative art since the Renaissance—the cartouche. I emphasize the 'reification' in the cartouche because in its origin it transforms the abstract heraldic field or shield into a real or fictitious object. Such a transformation is natural in the medium of sculpture, where the coat of arms is held or displayed as a real tablet or shield like a precious piece of metalwork (Figs. 29, 136, 272). In Renaissance painting this play with a fictitious support also led to a simulated piece of paper or parchment being affixed to the panel for the signature or some other inscription, and artists added realism to this playful device by showing the support frayed and coiling at the edges (Fig. 286). The word 'cartouche' derives from 'cartello', a little card.

 In his vast composite woodcut of the Triumphal Arch of Maximilian, Dürer placed inscriptions on fictive animal skins (Fig. 287). The engravers of patterns took up this and similar fancies and soon the cartouche, the shield-shaped writing support with its curling

ig. 286. Antonello
a Messina: 'Cartello'
om *Salvator Mundi*.
bout 1465

ig. 287. Albrecht
)ürer: Detail from
ιe Triumphal Arch
f Maximilian. 1515

Fig. 288. J. U. Krauss: *The Ascension of Enoch and the Loading of the Ark*. About 1700

framework, was in universal demand wherever inscriptions or symbols were to be inserted into a decorative ensemble. We also find it as a matter of course on our paradigm for such designs, the frame of the *Madonna della Sedia* (Plate 1), where it is centrally placed to take the title or number. It is surely not far-fetched to interpret its coiling frame as a reified flourish on a reified support. Wherever required, these motifs could effect an easy transition to the heraldic devices of the mantle, the crest and the plumage which might be made to move and twist in unison.

It is one of the great advantages of the reified or animated flourish around the cartouche that

Fig. 289. J. U. Krauss: *The Flood*. About 1700

it can so effortlessly absorb additional symbols or emblems within its swirling shapes. A German artist, Johann Ulrich Krauss, amply exploited this possibility in his *Historische Bilder-Bibel* (1696–1700), which has recently become available in a partial reprint. The engraving of the animals entering Noah's ark is even a double cartouche framing the ascension of Enoch, that of the Flood receding uses the clouds as a frame (Figs. 288, 289). Fully to appreciate the wrought-iron balustrade now installed on the stairs of the Wallace collection in London (Fig. 290) it is helpful to know that it was made for the coin cabinet of Louis XV. It is his monogram which forms the centrepiece while cornucopiae pouring forth coins allude to the original setting, and the sunflowers to the kings of France.

6 The Symbolic Potential

In looking at these transformations of the flourish in its function as a surround we are led back to the considerations of Chapter VI concerning the interaction between shapes and things. It was the Kaleidoscope which suggested to us that repetition devalues elements while isolation in the centre will emphasize them. In the 'field of force' we can observe the effects of 'positional enhancement'. The tensions between character and flourish, sign and design, suggest a further conclusion: there are designs and motifs which lend themselves to repetitious and rhythmical treatment, and these are likely to be incorporated in framing devices. For the symbol in the centre, other formal qualities will be suitable—geometrical simplicity, lucidity and symmetry. We recall motifs like the fleur-de-lys or Bernini's treatment of the symbolic dove.

Commercial designers of our own day have often endeavoured to create devices which exhibit the characteristic known in German as *Prägnanz*. One of them, the symbol of London Transport, served me as an example in *Art and Illusion* for the possibilities it offered to multiple reinterpretation. In publicity, in political life or in religious contexts symbols should be memorable and therefore repeatable. We may here remember symbols such as the winged sun-disk of Egypt (Fig. 291), the Lotus and the Wheel of Life of Buddhist India, the symbol of

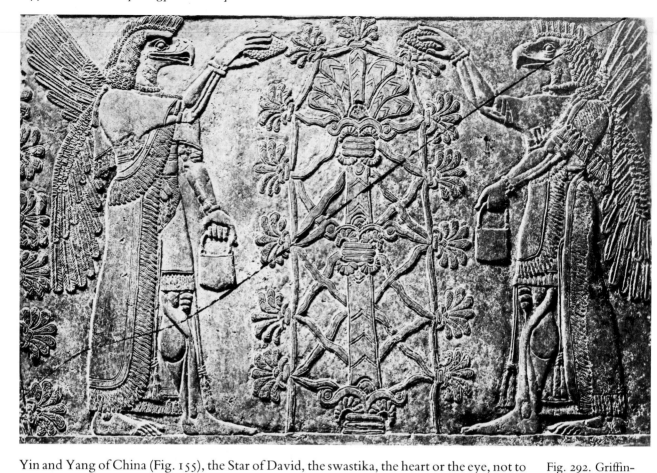

Fig. 292. Griffin-demons and sacred tree. Nimrud, 9th century B.C.

Yin and Yang of China (Fig. 155), the Star of David, the swastika, the heart or the eye, not to mention the Cross, which will be discussed separately. What makes them relevant here is not their meanings so much as their formal characteristics. It is these which give them what might be called a 'symbolic potential'. Paradoxically this formal potential can present an obstacle to interpretation where we lack any collateral evidence. I am referring to the tendency of looking for permanent meanings in certain traditional designs, a tendency which has played such a part in the history of our studies. Take one such motif, known almost universally as the Tree of Life, which consists of a central feature, usually in the shape of a symmetrical tree or plant, flanked by animals, humans or demons (Fig. 292). Trees have certainly been worshipped in many religions of the globe and the belief in a cosmic tree supporting or sustaining the Universe can also be documented from many regions. But the application of the Biblical term, the Tree of Life, to what is essentially a formal design need not always be justified. There is little doubt that some such configurations had a distinctive religious meaning in Ancient Mesopotamia, where they are frequently found on cylinder seals, but it has proved far from easy to interpret them unambiguously with the aid of contemporary texts. But need this meaning in any case have been carried along with the motif as it spread and proliferated in so many styles, including the folk art of Europe (Figs. 293, 294)? The stylized plant lends itself well to the role of marking the centre, and since animals are more easily drawn in profile than frontally, they are naturally paired to restore the balance. There is no reason to assume that this motif could not also have arisen spontaneously, though it must be granted that its symbolic potential may frequently have led to its being invested with meaning.

This point of view has found a persuasive advocate in Jurgis Baltrušaitis, who continued the line of research of his teacher Henri Focillon and insisted in several studies on the inadequacies

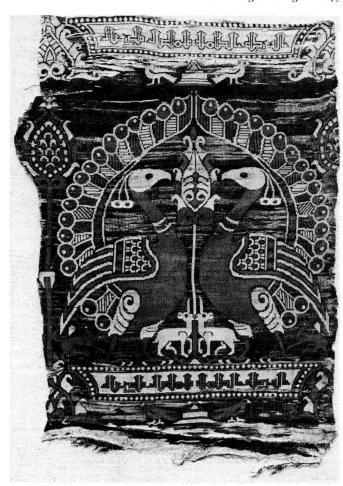

Fig. 293. Spanish textile
with Tree of Life motif.
12th century

Fig. 294. Transylvanian
cross-stitch design with
Tree of Life motif

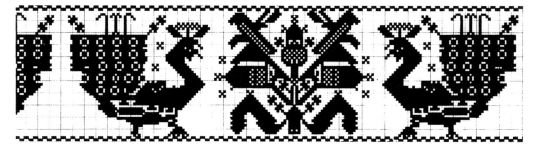

of both the iconographic and the purely formal approaches to the history of motifs. There are
certain 'formal themes' in the history of art which permit variations both in content and in
form and which still remain related, linking motifs first found in Sumerian art with
Romanesque and later designs (Fig. 295). His formula does not solve the problem of the
persistence of such motifs, but it points to the need of finding an explanation for their
undoubted potential to be invested with meanings.

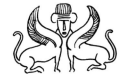
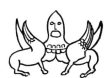
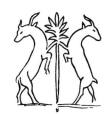
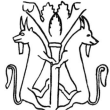

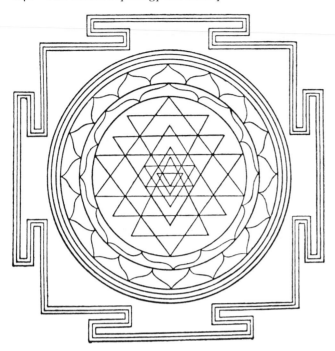

Fig. 296. Indian Shri-yantra
mandala (H. Zimmer, 1920)

The boldest attempt which has been made to account for this persistence takes us back to the beginning of this chapter. I am referring to the theories of Carl Gustav Jung. There is certainly something in Jung's approach to symbolism as a 'lost language' which recalls the various earlier attempts to recover the esoteric wisdom of the mysterious past through the interpretation of symbolic motifs. But for Jung the path to his revelation is not to be found in historical research alone. It must be guided and supplemented by the interpretation of dreams and fantasies, which in their turn can be better understood through the results of historical research. This is the doctrine of 'archetypes', which is relevant to our present topic because it concerns the intrinsic meanings Jung and his school attribute to certain simple geometric designs, notably the one they describe as 'mandalas'.

To quote from the authoritative introduction to Jung's Psychology by Frieda Fordham (1953): 'Mandala is a Sanskrit word meaning magic circle, and its symbolism includes all concentrically arranged figures, all radial or spherical arrangements, and all circles or squares with a central point. It is one of the oldest religious symbols (the earliest known form being the sun wheel) and is found throughout the world. In the East the mandala (whose form is fixed by tradition) is used ritualistically in Lamaistic and Tantric Yoga as an aid to contemplation [Fig. 296]. There are Christian mandalas, dating from the early Middle Ages, showing Christ in the centre with the four evangelists and their symbols at the cardinal points. Historically, the mandala served as a symbol representing the nature of the deity, both in order to clarify it philosophically, and for the purpose of adoration.

'Jung found the mandala symbolism occurring spontaneously in the dreams and visions of many of his patients. Its appearance was incomprehensible to them, but it was usually accompanied by a strong feeling of harmony or of peace.'

I have never found it easy to come to terms with Jung's psychology with its mixture of mystical and scientific pretensions. All the more do I find it necessary to put on record that I have myself experienced the vision described at the end of this paragraph. Even in the life of a cloistered academic there are moments when difficult decisions have to be made—for instance whether or not to move to another cloister. It was during such a crisis that I wavered a good deal, but when I went to bed at the end of the day on which at last I had made up my mind, I vividly saw in front of my eyes what is called a hypnagogic image, the visual experience that

can precede sleep. I remember it as a regular flower bed with a group of tulips in the centre. It was certainly accompanied by that feeling of harmony and peace described by Frieda Fordham.

I still would not be inclined to concede that this experience provides evidence for Jung's interpretation of a collective psyche. My bias prompts me rather to seek the explanation in that sense of order which is the subject of this book. Order can serve as a metaphor for order, particularly in the context of alternatives. What I experienced was the contrast between the dithering oscillations of my former state of uncertainty and the balance I had at last regained by a firm decision. In other words my explanation would appeal to the psychology of metaphor to which I referred in the fifth and eighth chapters in connection with Charles S. Osgood's research. There is no need to assume that our dreams and visions draw on a collective pool of archetypes. What may be part of our psychological make-up is rather the disposition to accept degrees of order as potential metaphors of inner states.

7 *The Sign of the Cross*

There is one motif and sign in the Western tradition in which all these forces seem to come together like the rays in a burning-glass—I refer to the sign of the cross, the most central symbol of the Christian world. Whatever the real shape of the instrument of torture on which Christ died, the visual symbol, which was only adopted after centuries, follows the laws of symmetry and order to such an extent that those early students of meanings to whose speculations I referred at the outset of this chapter were struck by the frequency with which this sacred motif occurs in pre-Christian decoration (Fig. 297). In fact, the cross has remained an almost inevitable design even where it is not intended to function as a sign, but now the religious meaning is always potentially present. In Dreyer's film *La Passion de Jeanne d'Arc* (1928), there was a sequence in which the cross-beams of the window in the prison cell of the Maid create a cruciform shadow on the floor on which the inquisitor brutally steps to drive home the symbolism. We can again draw on the parallel with etymology to illustrate these fluctuations in the intensity of meaning which is still felt to be present in the sign. The word cross derives from Latin *crux*, which really means pain or torture, but thanks to the transfer of the word to a particular configuration the original meaning has been forgotten. We speak of a

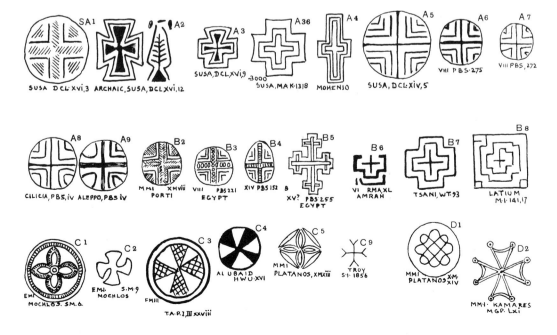

ig. 297. The cross-shaped motif before 000 B.C. (Flinders etrie, 1930)

Fig. 298. Golden gospel bookcover. Monza, Italy, about A.D. 600

street crossing or of crossing the street and we are cross when somebody has crossed us. The term cross-stitch indicates a shape, but when we say that we have a cross to bear we are closer to the original meaning. It is well known that Christian churches incorporated the shape of the cross in the plan of the building though this would surely not have happened had the symbol of the faith been a different shape such as the crescent.

What makes the history of this symbol particularly instructive is the belief in the power of the sign of the cross to ward off evil. A rapid gesture with the hand will banish the demon and so will an informal scratch made with chalk. But here as always we can watch the confluence of many motivations in the creation of traditions. The bookcover (Fig. 298) or the church door incorporating the design of the cross is certainly meant to afford sacred protection and to proclaim the holiness of the book or the place; but at the same time the designer will wish to

express the respect and awe due to the sacred with all the resources at his command. The precious materials, the gold, jewels and pearls, will enhance the power and dignity of the design and reflect the infinite splendours which are both signified conventionally and symbolized by analogy in these objects of supreme value. But besides the material itself, the workmanship must also reflect the infinite care and devotion due to the sacred symbol. There is no more astounding testimony to this conviction than the Cross page of the Lindisfarne Gospels with its infinitely rich and mysterious interlace (Plate 82), to which we shall return in the next chapter. What must interest us here is the response of the symbol to the exigencies of the design. The cross becomes a Greek cross rising above a support, thus maximizing symmetrical correspondences as far as was possible on a rectangular page.

But not only does the cross adjust to the field of force of which it becomes the centre, it also tolerates and indeed invites a decorative device that counteracts the rigidity of extreme formalization—the flourish. Any cemetery in central Europe contains examples of wrought-iron crosses with exuberant scroll work surrounding the sacred sign (Fig. 299). I

Fig. 299. Grave-cross.
German, 16th century

Fig. 300. Helmet of the
Household Cavalry

remember a procession in Lucca on the eve of the feast of the *Volto Santo*, the ancient crucifix
that is venerated in the cathedral. Members of congregations from other cities joined in to
pay their tribute to the famous image, among them a delegation from Genoa carrying very
large and heavy crucifixes which needed several men to support them. The image of the
suffering Christ on the Cross was honoured by elaborate goldsmith's work of flowers
decorating the ends of the crossbeams, and these delicate stalks, leaves and blossoms moved.
Once in a while the carriers would stop, plant the crucifix on the ground and shake it to
make the goldsmith's work rattle to the applause of the onlookers. Obviously their sense of
decorum differed from ours, but there was no mistaking the respect in which they held the
sacred sign.

It may be appropriate to draw together the various strands of this chapter with the help of an
example which is both a decorative design and a charged symbol—the design on the helmet
of the Household Cavalry (Fig. 300) familiar from the ceremony of the Changing of the
Guard. The centre badge is the Star of the Most Noble Order of the Garter formed by the
radiant cross surrounded by the garter itself, which is inscribed with its motto and rests on a
chalice of acanthus leaves, suggesting a relatively late date for the design. The device is
encircled by the chain of the Order, 'the George', dating from the period of Henry VIII. It
consists of roundels with Tudor roses alternating with love knots from which the image of
the Saint with the Dragon is suspended. On the helmet the design is further framed by
branches of laurel and oak leaves, presumably standing for glory and strength, the whole
being surmounted by the Royal Crown. The plumes on the helmet of the Life Guards are
white, those of the Blues and Royals red. The signs which make up the design may not be
visible in any encounter, but they perfectly merge with the function of the traditional
pageant. No wonder the helmet by itself is used on posters for tourists. Though the meaning
may be obscure to most of them, the significance of the whole strikes home.

X The Edge of Chaos

usciti paion fuor dal gran caosse
rivolto di vari modo sottosopra
(they look as if they had emerged from the great Chaos
turned upside down in various ways)

Paolo Lomazzo, *The origins of the Grotesque*

1 A Zone of Licence

In the year 1515, Albrecht Dürer was commissioned to design the decorations for a special prayer-book destined by the Emperor Maximilian for his newly founded Order of St. George. Fig. 301 shows one of its pages with a prayer to St. Apollonia, who is represented on the margin in the traditional way with the tools of her martyrdom and the palm of the martyr. But how are we to look at the rest of the design? Dürer represents her standing on a thistle-like flower with curly leaves and spiralling tendrils; an empty cartouche between swags and fluttering chords is shown above, and below a crane-like bird advances towards a tortoise. The left-hand margin is formed by a concatenation of the most heterogeneous motifs: a fruit (or is it an egg?) sending down gnarly roots and carrying an elegant vessel, the base decorated with acanthus leaves and the twin handles formed by dolphins. It is topped by a most puzzling monster, whose beak recalls that of the crane, but which sports two crossed antlers, on which a bird is seen to perch. Further up, the accompanying staff or rod sprouts leaves and tendrils which, on the right upper margin, lose their organic nature and turn into loops and patterns. Stranger still, the lower end of the rod connects with a tangle of lines forming a human mask.

Turning the pages of this extraordinary book we find the same mixture of the sacred and the profane, the serious and the playful. The prayer to the Virgin (Fig. 302) is graced by a lovely vision of Mary at her prayers visited by the dove and blessed by God the Father, while the devil shows his impotent rage smarting under the fire and brimstone raining down from the clouds. Above there is the curly sprig with tendrils surmounted by a cherub, and opposite there is another concatenation of motifs, this time the antlers of a creature with a ring in its nose sprout chalices from which human profiles emerge, and the pen-play on the upper border turns into rabbits and simplified human masks.

Dürer's prayer-book is a suitable point of entry into the topsy-turvy world of these enigmatic images, which are variously described as 'grotesques' or 'drolleries'—Dürer himself spoke of '*Traumwerk*' ('dreamwork'). 'Whoever wants to do dreamwork, must mix all things together.' He certainly did. For not only are his motifs mixtures of creatures, his composition draws on all traditions which could supply him with ideas.

It has been pointed out that he may have seen flourishes terminating in human faces in a manuscript by the French illuminator Mazerolles, owned by Maximilian (Fig. 303). This is a secular text, but the artist must also have known any number of religious books in which the sacred and the profane were mixed in bewildering confusion.

Much learning and ingenuity has been expended in assigning symbolic meanings to the marginal flourishes, monsters and other motifs created by Dürer and his mediaeval predecessors, and there is no reason to doubt that once in a while the text offered a starting point to the artist for his playful invention. But even when we are prepared to strain our credulity, the majority of inventions must still be seen as creations in their own right. We are not unprepared for this conclusion, because we have observed in the preceding chapter how

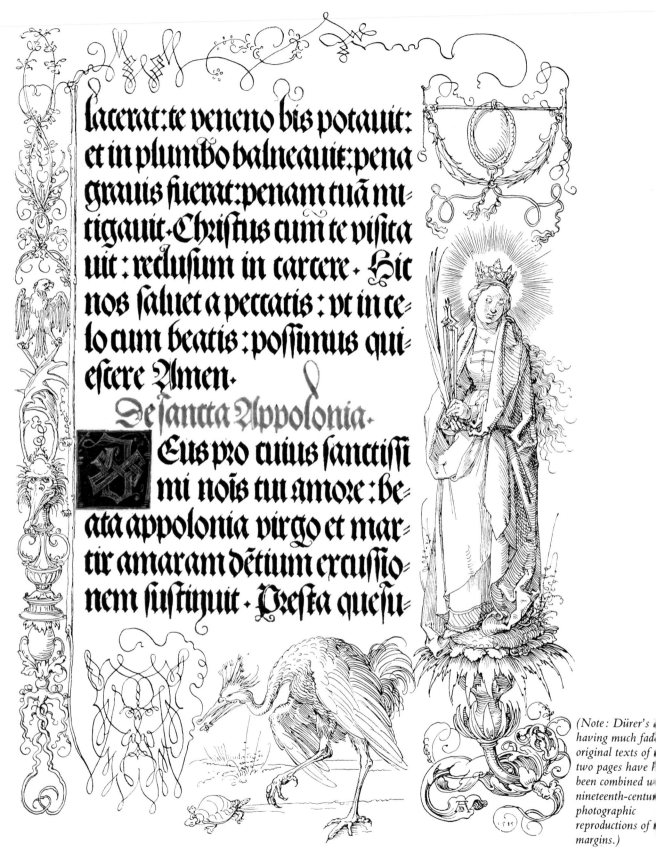

Fig. 301. Albrecht Dürer: Prayer to St. Apollonia. From the prayer-book of the Emperor Maximilian. 1515

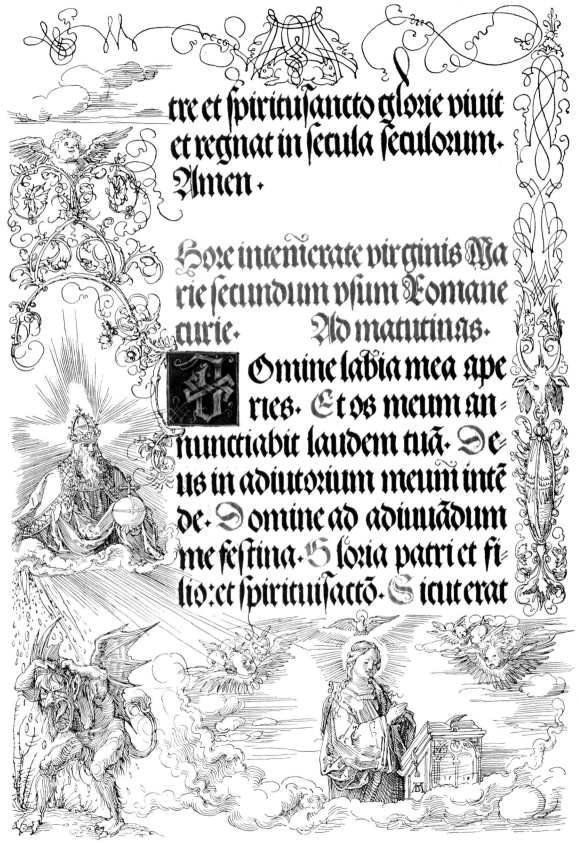

tre et spiritusancto glorie viuit
et regnat in secula seculorum.
Amen.

Hore intemerate virginis Ma
rie secundum vsum Romane
curie. Ad matutinas.
Omine labia mea ape
ries. Et os meum an-
nunciabit laudem tuã. De
us in adiutorium meum inte
de. Domine ad adiuuãdum
me festina. Gloria patri et fi-
lio: et spirituisacto. Sicut erat

Fig. 302. Albrecht Dürer: Prayer to the Virgin. From the prayer-book of the Emperor Maximilian. 1515

Fig. 303. From a manuscript by Philippe de Mazerolles. About 1470

the flourish can support and enhance the letter in the centre while exhibiting an increasing freedom. What I have called the 'field of force' varies in the character of its 'charge'; the 'shield' of the coat of arms obeys different laws from that of the crest, the mantle and the support, and even the flickering and tinkling goldsmith work surrounding an image of the crucified saviour was not felt to be an infringement of decorum.

Dürer certainly enjoyed a commission which gave him licence to display his virtuosity and inexhaustible inventiveness. For him the test of a good painter was to be 'inwardly full of images'. He freely drew on the repertory of the Northern tradition which is best described by the French term of 'drollery'. His other source was the classical style of decoration which became known at that time as the 'grotesque'—an allusion to the underground vaults or *grotte* in which most remnants of ancient mural decorations were found in Rome (Fig. 19).

Without assuming that Dürer can have known this particular instance, we may take as an example of the Northern tradition a page from the Luttrell Psalter of about 1340 (Plate 83) because the scale and quality of its marginal 'drolleries' exhibits a comparable mixture of fantasy, humour and realism.

What is characteristic of the Northern tradition here is the disregard of symmetry in the distribution of the motifs over the margin; Dürer does not go quite so far. His vertical borders only deviate occasionally from bilateral symmetry. This tribute to principles of order suggests contact with the classical tradition of the 'grotesque', a contact which is confirmed by individual elements. Basically Dürer developed the repertory of the classical 'candelabra' motif. There were many examples in Venice and the motif had meanwhile reached the North in such illuminated manuscripts as the Flemish Calendar in the British Museum (Plate 84). We recognize the vases with the suggestion of dolphins for the handles, the skull-like configuration, with its leafy antlers and wings, the egg-shaped forms and the tendrils assuming animal shapes. The predominance of hybrid creatures, shared by the 'drollery' and the 'grotesque', is the feature which attracted most comment whenever this tradition became the subject of critical attention.

I have quoted in the first chapter the complaints by Vitruvius about the fashion which had come into vogue at the time of Augustus, the taste for such 'falsehoods' as 'slender stalks with heads of men and animals attached to half the body' and other 'monsters'. There is an even more telling and, if possible, even more influential reference to this kind of invention in the opening lines of the *Ars Poetica* of Horace, like Vitruvius a canonical authority for later critics. Horace, no less than Vitruvius, grants that the artist like the poet can make use of make-believe. He has a right to invent, but in exercising this privilege he should not offend against the laws of decorum:

'If a painter chose to join a horse's neck to a human head and to make multicoloured feathers grow everywhere over a medley of limbs, so that what at the top is a beautiful woman ends below in an ugly dark fish—friends, at such a show, try not to laugh.

'Painters and poets have always had the prerogative of daring anything. We know it, and both demand and grant the same licence. But not so far as to unite the mild with the savage or that snakes should be coupled with birds, lambs with tigers.'

There is another justly famous text, written more than a thousand years later, which comments unfavourably on the 'ridiculous monsters' in the decorative stonework of cloisters—the 'Apologia' to William; Abbot of St.-Thierry, by St. Bernard of Clairvaux. The main thrust of the argument here is a condemnation of waste and frivolity, the useless expenditure of money which should rather have been given to the poor, and the distracting effect of these fantasies on the monks, who should think of higher things. Once more it is the hybrids which come in for particular strictures; those in the crypt of Canterbury Cathedral suggest that the Saint did not exaggerate (Fig. 304).

'But in the cloister, in the sight of the reading monks, what is the point of such ridiculous monstrosity, the strange kind of shapeless shapeliness, of shapely shapelessness? Why these unsightly monkeys, why these fierce lions, why the monstrous centaurs, why semi-humans, why spotted tigers, why fighting soldiers, why trumpeting huntsmen? You can see many bodies under one head, and then again one body with many heads, here you see a quadruped with a serpent's tail, here a fish with the head of a quadruped. Here is a beast which is a horse in front but drags half a goat behind, here a horned animal has the hindquarters of a horse. In short there is such a variety and such a diversity of strange shapes everywhere that we may prefer to read the marbles rather than the books.'

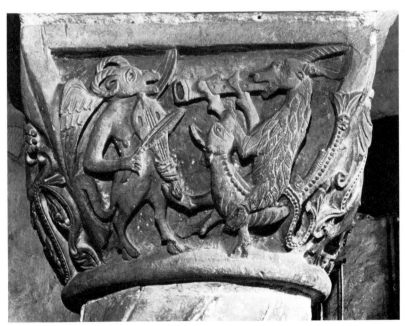

Fig. 304. Capitals from the crypt of Canterbury Cathedral. Early 12th century

What these texts have in common is the reaction of exasperated helplessness provoked by hybrid creatures, part plant, part human; part woman, part fish; part horse, part goat. There are no names in our language, no categories in our thought, to come to grips with this elusive dream-imagery in which 'all things are mixed' (to quote Dürer again). It outrages both our 'sense of order' and our search for meaning. I have often stressed in the course of this book that it is these two tendencies which dominate our perception. They alone enable us to form those expectations which can be subsequently confirmed or refuted and which thus permit us to 'make sense' of the information we pick up with our eyes. If that is true, we are in a position to reply to the rhetorical question constantly repeated by St. Bernard: 'What is the point?' The point is that there is no point. That each of these 'shapelessly shapely' motifs offers us surprise after surprise, just as the monster of Horace, which at the top is a beautiful woman and below an ugly dark fish. Normally, as we scan any configuration we have learned to 'extrapolate'; here we receive one shock after the other. Not only do the limbs of these composite creatures defy our classifications, often we cannot even tell where they begin or end—they are not individuals, because their bodies merge or join with those plants and tendrils mentioned by Vitruvius. Thus there is nothing to hold on to, nothing fixed, the *deformitas* is hard to 'code' and harder still to remember, for everything is in flux.

What is equally vital to our understanding of these effects is that the uncertainty of response carries over from the perceptual to the emotional sphere. Nobody has characterized this instability of reaction with greater acumen than John Ruskin in *The Stones of Venice*: '. . . it seems to me that the grotesque is, in almost all cases, composed of two elements, one ludicrous, the other fearful; that, as one or other of these elements prevails, the grotesque falls into two branches, sportive grotesque, and terrible grotesque; but that we cannot legitimately consider it under these two aspects because there are hardly any examples which do not in some degree combine both elements; there are few grotesques so utterly playful as to be overcast with no shade of fearfulness, and few so fearful as absolutely to exclude all ideas of jest.'

It should not be impossible to diagnose the cause of this ambivalence. It lies, I believe, in the ambiguous status of these motifs, which oscillate between decorative form and representational images. Seen as representations of 'real' monsters they inspire fear of the unknown and the demonic; seen as playful inventions they make us laugh. Nothing in art is more delicate and more elusive than the idea of pure 'fiction', that twilight realm which Plato characterized as a 'dream for those who are awake'. Vitruvius, we remember, refused to acknowledge this domain when he complained that 'such things neither are, nor can be, nor have been'. Horace, slightly more tolerant, warns the artist not to carry licence too far lest he become ludicrous. St. Bernard asks what the point should be of all these hybrid creatures.

It is not the representation of monsters or monstrosities as such which these critics castigate, but the free creation of impossible combinations. Their idea of what is impossible certainly differed from ours. The whole of the ancient and mediaeval world believed in the existence of monsters and illustrated them whenever they occurred in myth, fable or travel accounts. Some of these were fearful, others mildly funny. There are the fierce bogeys, dragons, devils, demons or the minotaur, half bull, half man, whom Theseus killed. There are also the naughty sprites and gnomes, the satyrs with horse's tails, Pans with goat's feet, fauns with pig's ears, whom the Greek world imagined as savage rather than malevolent, as they danced and revelled, fought and lusted after nymphs, enjoying the freedom of not being human and thus free from human constraints. The sea-horses drawing Neptune's chariot (Fig. 305) and the monsters surrounding it on a mosaic floor in Ostia belong to this world of half-belief, and so do the children who so frequently inhabit the vegetation in what

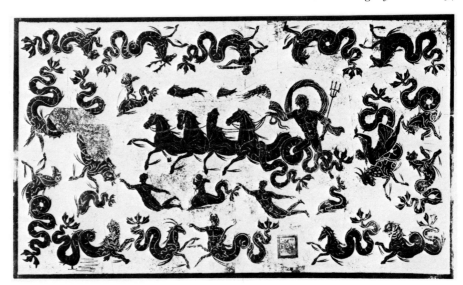

g. 305. Mosaic floor from
e Baths of Neptune, Ostia.
t century A.D.

are called the 'peopled scrolls' (Plate 85) of classical decoration.

Originally they may have been seen as the spirits of the plants; but in trying to ask every time what these sprites or monsters represent or what they mean, we are likely to fall into the same trap in which Vitruvius, Horace and St Bernard were caught. Should we not rather ask what function they were to serve as images? It is a useful rule of method to keep these questions distinct—the hobby horse, as I have urged long ago, is not so much the representation of a horse but a substitute for one.

2 Protective Spells

Nowhere is the function of the image to serve as a substitute more pronounced than in the figures of 'guardians' which serve in a variety of cultures to protect sacred precincts, temples or houses. What is needed there is efficacy, and if that efficacy is strengthened by combining the most powerful features of various beings, so much the better. The most venerable as well as the most famous of these guardians is the Great Sphinx of Egypt from the third millennium B.C., which combines a lion's body with the head of a king. We can only speculate about the meaning this image hewn from the rock originally held for its makers, but an inscription dating from a later period defines its role quite unambiguously: 'I protect the chapel of this tomb, . . . I ward off the intruding stranger. I hurl the foes to the ground and their weapons with them.' It is the image itself which is speaking. It does not portray a supernatural being, it *is* that supernatural being endowed with inherent power. In the case of the guardian bulls from Assyria (Fig. 306) which flanked the entrance of cities and palaces there is even a tell-tale feature which excludes the idea of portrayal—they are rendered with five legs, so that they are seen as 'complete' from whichever side they are approached. The demons should not make the mistake of thinking that a three-legged bull cannot do them much harm.

It was one of my teachers, Emanuel Loewy, a friend of Sigmund Freud (himself passionately interested in the symbolism of the ancient world), who proposed that this 'apotropaic' function could account for the purpose and origin of most if not all decorative motifs. He did not have to go far for evidence in ancient art. Having slain the fearful monster Gorgo (one of three unlovable sisters), Athene cut off her head and henceforth wore the *Gorgoneion* as a protective spell on her body and on her shield. With its hideous grin and its serpents as hair, the sheer sight of this head (like that of the Medusa's) turned every living thing into stone. Gorgons' heads and similar threatening masks are frequently seen on Greek

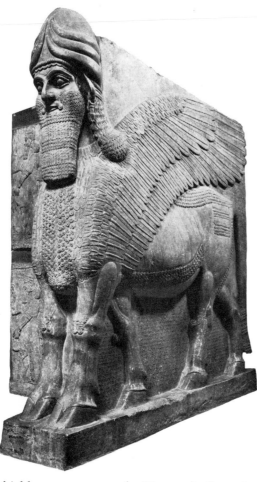

Fig. 306. Guardian bull from
Nimrud. About 800 B.C.

shields, arms or vessels (Fig. 307). Sometimes their role is taken over by eyes alone, sometimes by serpents. Observing the frequency of the octopus in Cretan art, Loewy suggested that this creature, too, with its snake-like arms must have been represented to serve as a protective device (Fig. 308).

Decoration frequently shades over into protective charms. Its function merges with that of amulets, using such motifs as claws (Plate 13) horns, the phallus, the gesture of a 'fig' to

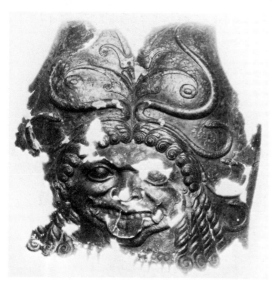

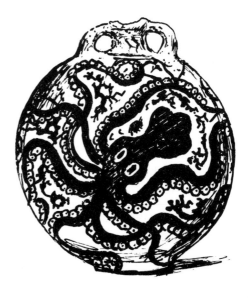

Fig. 307 (*far left*).
Breastplate. Greek,
late 5th century B.C.

Fig. 308. Cretan pot.
About 1500 B.C.

turn away one of the many malevolent influences which are still so widely dreaded—or why else should we say 'touch wood' when we feel we may have 'tempted the gods'? Maybe Emanuel Loewy went too far in explaining so many motifs by this one principle, but he deserves our gratitude for having broached the kind of psychological question which always turns up in new guises whenever we study the manifestations of human culture: are certain similarities which we observe among distant cultures due to culture contact, or should they rather be explained in terms of psychological traits all human beings may be presumed to have in common? The decorative arts pose this problem with particular urgency, and we might be spared many more strained explanations if we could attribute all intriguing parallels to the spontaneous generation of similar forms for similar functions. I do not believe that we are entitled to do this in every case, but I side with those who think that the reaction against the psychological bias of the generation of Frazer, Freud, Loewy and Jung has perhaps overshot its mark.

In this respect I cannot but agree with Claude Lévi-Strauss who, having acknowledged the danger of 'enthusiasts' jumping to conclusions from the observation of parallels, acknowledges the need for examining the possibility of genuine diffusion, but if there was no possible contact between cultures which used similar decorative motifs 'we must turn to psychology or the structural analysis of forms and ask ourselves if inner connections of a psychological or logical nature do not allow us to understand such frequent and simultaneous occurrences which cannot possibly be the result of the simple play of probabilities'.

The observations which prompted Lévi-Strauss to these reflections will concern us later. Here I should like to support his argument by illustrating two jugs which look strikingly similar though they stem from wholly disparate traditions—Fig. 309 coming from fourteenth-century London, Fig. 310 from New Guinea. For those of us who are ready to use psychological arguments the kinship is not hard to explain: we know that the tendency to 'animate' vessels is universal (Fig. 201). No doubt it is here reinforced by the equally universal belief in the apotropaic power of eyes or masks which must also have inspired the

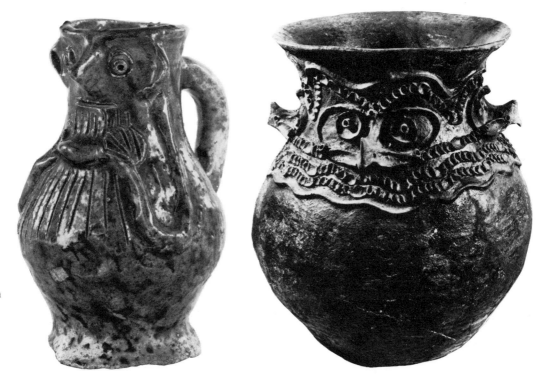

ig. 309. Jug found in
e City of London.
4th century

ig. 310. Pot from
New Guinea

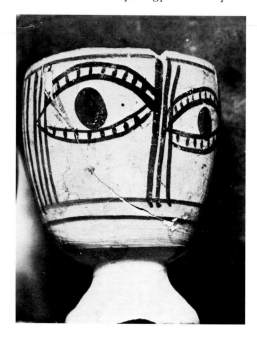

Fig. 311. Pot from Nubia

Fig. 312. Bronze ritual vessel (*fang yi*). Chinese, excavated at Furfeng, Shensi. 1st millennium B.C.

Fig. 313. Censer from Quen Santo, Mexico. Late Maya, 1st millennium A.D.

North African potter to endow his simple jug with such a forceful face (Fig. 311). The *t'ao-t'ieh* mentioned earlier (Plate 75) is generally believed to have originated in this function. Figs. 312 and 313 juxtapose a magnificent Chinese ritual vessel with a censer from ancient Mexico, which must have looked formidable indeed when smoke was pouring out of all its openings. Such forms must spring from the same impulse as the habit of endowing the

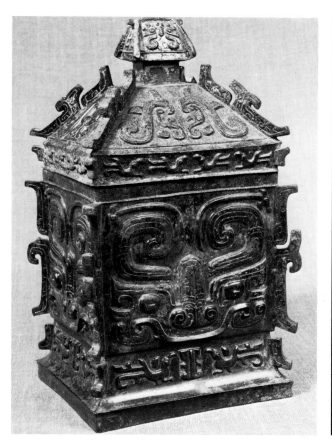

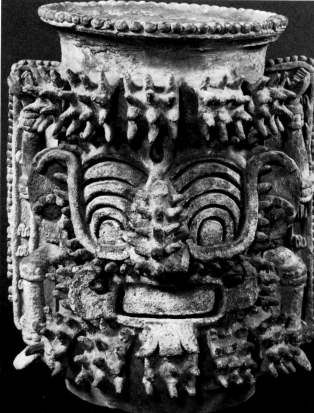

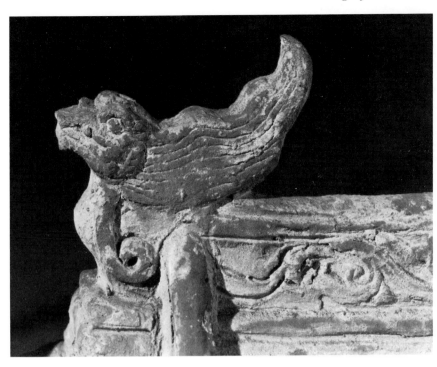

g. 314. Dragon termination from
e roof of a model house. Ming
nasty, 14th–15th century

termination of beams with threatening heads complete with eyes and jaws, such as we find
them in China (Fig. 314), in Mexico (Fig. 315), in Norway and in the folk art of Alpine
valleys (Fig. 316).

I have alluded to one manifestation of this tendency in the chapter on the Force of Habit,
where I discussed the power of metaphorical thought. We speak of the 'head' of a beam and
so we can easily give it a head, just as we speak of the 'legs' of a table and endow it with feet
or better still with claws, which will not only explain but also protect the structure (Fig.
202). The unexpressed assumption in this type of charm is that the demons are probably very
much like us and will therefore be frightened by whatever frightens us.

g. 315. Dragon's
ad termination
om a pyramid at
eotihuacán, Mexico.
arly 1st millennium
.D.

On this assumption it is quite rational to carve or paint menacing features on any object
that is to be protected. More than that, it makes sense to transform the object or any of its
parts into the semblance of a demonic being which might prove a match for any potential
aggressor. I have discussed in a previous context the principle of 'animation' in design, and
have contrasted it with that of stylization. The latter imposes order and approximates the
living form to geometric shapes, the former imbues the shapes with life and therefore with
movement and expression. That the principle of animation rules unchecked in the world of
the grotesque needs no demonstration. The potentially magic function of animation may

g. 316. Dragon's
ad termination
om the roof of a
ouse at Serfaus,
yrol

contribute to our understanding of these forms. For animation not only uses monsters, it generates them. If any termination is to be brought to life as a head, a leg, or perhaps a tail with a sting, there can be no full respect for organic cohesion. Nor need there be. The seven-headed hydra, the triple-headed Cerberus, are more frightening because of their accumulation of aggressive features. On a sword hilt from Ceylon (Fig. 317) every one of five ornamental terminations is transformed into an aggressive dragon's head.

The extremes are reached in the arts of the steppes, of which the so-called Luristan bronzes offer early examples, where the limits of organic form are everywhere transgressed. We find creatures with several heads or several bodies. In Fig. 318, as Henri Frankfort wrote, 'one may doubt whether the lower part belongs to the man in front or renders the hindquarters of the two animals'. Shapes which suggest horses end in beaked heads. Such combinations, as Frankfort reminds us, have aptly been called 'zoomorphic junctures', 'by which fish-tails are made to end in ram's heads, tines of a stag's antlers in birds' heads, and so on'. It sounds exactly like a description of Dürer's marginal drawings, or like the passage from Horace. Unfortunately there was no Horace about in ancient Luristan to comment on these strange forms. We do not know whether their owners found them funny, or frightening— or both. It may well be that in talking about the magic functions of images, writers have been somewhat too solemn. Neither the demons nor their victims necessarily lack a sense of humour.

Fig. 317. Sword hilt from Ceylon. 18th century

3 'A Great Dragon Force'

There are few relics of a lost civilization which appear to be charged with more numinous power than the magnificent ritual bronze vessels of ancient China. I have referred to the debates concerning the meaning of their elaborate decoration and to the likelihood of the central motif, the *t'ao-t'ieh*, having an apotropaic function. The great Swedish Sinologist Karlgren suggested a hypothesis to explain not so much the meaning as the function of the 'primary style' of these vessels (Plate 87), which he calls 'uni-decor' because no part of the vessel is left empty of a motif resembling a dragon. 'Its accumulation'—he writes—'was evidently meant to load the sacred vessel with a great dragon force, an enormous magical power.' Karlgren's classifications are not universally accepted by scholars working in the field today, but it seems to me that his interpretation remains convincing despite its speculative nature. I could not think of any better characterization of the astounding golden sword hilt in the British Museum (Plate 86), which dates from a much later period but illustrates the principle of 'dragon power' to perfection. While the sword hilt from Ceylon (Fig. 317) limits this protective animation to the terminal points the Chinese craftsman contrived to compose the whole of a sheer infinite whirl of these powerful monsters.

Fig. 318. Bronze fro[m] Luristan. Early 1st millennium B.C.

It would be surprising if, in offering his suggestion, Karlgren had not also thought of other products of the 'zoomorphic style', which extends in various forms from China across the steppes of Asia to Europe, where it flourished among the Celts, the Anglo-Saxons and finally the Vikings. The countless varieties and subdivisions of this form of animation have been analysed and tabulated by generations of archaeologists. They have classified the various forms the beasts and monsters take and the methods of their intertwining, and have distinguished not only local workshops but sometimes even individual designers. They have been less willing to answer the question of function. Of course we can only guess what prompted craftsmen to outdo each other in the creation of these teeming tangles of dragons or serpents, but Karlgren's formulation might well have appealed to a Viking chieftain. His suggestion of a magic motivation can perhaps be reinforced by an observation made by the late Walter Hildburgh in two articles on folklore which deserve to be better known. Hildburgh shows that in the beliefs of many peoples demons dislike nothing more than

being confused. Hence knots, mazes, tangles and other forms of 'indeterminability' are considered to be excellent protection against those evil influences which lurk everywhere. Counting as such has its dangers, for a knowledge of numbers may give the demon power over what has been counted. There is a poem by Catullus in which he tells his beloved to give him kisses by the thousands and hundreds; 'after we have come to many thousands we shall confuse the number so that we do not know it, and no malevolent person could harbour envy, knowing that there were as many kisses'. Hildburgh cites many beliefs in Italian and Spanish folklore which base the protective power of charms and plants on the inability of witches to count their grains, petals or threads. In Umbria the jawbone of a hedgehog was worn as an amulet in the comfortable conviction that before overcoming its power the witch would have to know exactly how many spines the hedgehog had.

Closer to our subject is a Tuscan belief quoted by Hildburgh after C. G. Leland (*Etruscan Roman Remains in Popular Tradition*, London, 1892), that 'when a family is afraid of witchery they should undertake some kind of *lavori intrecciati*—braided work—for witches cannot enter a house where there is anything of the kind hung up . . . (they) can do nothing, because they cannot either count the threads or the stitches . . . the boughs of mulberry trees should be plaited together so as to protect the silkworm from the evil eye, just as plants such as 'convolvuli' with their many confused tendrils will, it is hoped, bewilder the sight of sorceresses.' Hildburgh cautiously suggests that interlace and knotwork in ancient ornament may allow a similar interpretation and that, in particular, the mazes and maze dances were once connected with the hope of confusing pursuers.

I have acknowledged the fact that analogies of this kind no longer carry much weight among archaeologists and anthropologists, but I have also suggested that their justified scepticism may occasionally be due to a confusion between meanings and functions. We really must not interpret the meaning of a motif without support from contemporary evidence. Disregarding this caution has led to the flights of fancy I discussed in the preceding chapter. But in framing a hypothesis about the possible function of a tool we are entitled to rely on what Popper calls situational logic. Human hands and human aims do not differ so much that we have to hesitate before we call a spade a spade, even if there is not strict proof of its use. Human psychology, to be sure, is more volatile than human anatomy, but this book is grounded on the assumption that there are invariant dispositions in the human mind which account for the development of certain common features in decorative art no less than in language or culture. The sense of order is such a disposition and so is its corollary, the discomfort of visual confusion. There is only one step from this assumption to the hypothesis that this reaction tends also to be attributed to those unknown powers against which man everywhere wishes to find protection.

There is a certain affinity between this suggestion and the theory expounded by Worringer in *Abstraction and Empathy*, a theory which, as I showed in the second chapter, was largely anticipated by Ruskin. Worringer pictures 'primitive man' as fear-ridden, seeking refuge from hostile nature in the dream world of 'abstraction'. I have no wish to revive this theory, for I do not share the expressionist's image of man. I merely wish to propose that, given certain aims, men will resort to certain means—what I have called 'protective animation' is such a means, endowing artefacts with the potential to ward off evil. If it could be shown that there also exists a widespread disposition to attribute to hostile powers a dread of confusion and indeterminacy, we would come closer to an interpretation of the tangled dragons of Northern art. For here the two tendencies are combined or superimposed. The 'dragon tangle' (Fig. 179, Plate 82) can best be understood as an animated interlace. The ribbons or ropes are endowed with heads and are thus seen to twine and writhe, sometimes 'tying themselves into knots'. Maybe this combination offered another source of protection. Able to resist disentanglement by evil eyes and filled with dragon power, the fabulous beasts

are yet safely held in the maze of their own making. It is worth remembering that this kind of design flourished in an artistic environment which rarely cultivated naturalistic representation. If parallels are anything to go by—and I would use this one with all due caution—the ban on representation, known from the civilization of Islam, is connected with the fear of creation. The naturalistic image infringes on the prerogative of God. The dragon in its tangle is relatively 'safe'. The guard-dog will not escape from its chains.

4 The Elusive Mask

If there is one psychological disposition about which one can afford to be dogmatic it is our readiness to see faces in any configuration which remotely suggests the presence of eyes and corresponding features. It will be remembered that Dürer played on this tendency in the flourishes of his marginal drawings where a frontal mask emerges from the looping lines of Fig. 301 and two slanting profiles on the upper border of Fig. 302. I have suggested in *Art and Illusion* and also in this book that it is worth while observing ourselves during this process of 'reading in'. The rapid identification of some of the features is followed by the 'effort after meaning', which looks for further anchorage in the tangles of lines. We easily succeed in 'making sense' of some of the lines and accept others for what they are—mere flourishes. But the more intently we look the more we may also find that the image 'dissolves' and

Fig. 319. Bronze and iron scabbard found at Filottrano, Italy. Late 4th century B.C.

Fig. 320. Detail of bronze neck-ring from Barbuise, France. Late 4th or early 3rd century B.C.

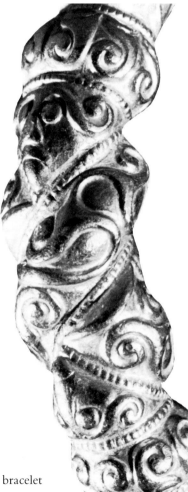

Fig. 321. Detail of hollow gold bracelet from Waldalgesheim, Germany. Late 14th century B.C.

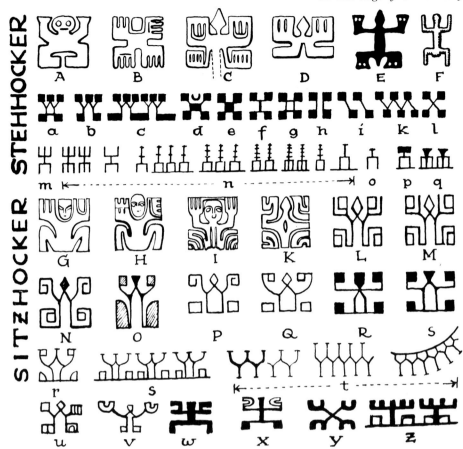

Fig. 322. Variants of the 'tiki' from the Marquesas Islands (K. von den Steinen, 1925)

recomposes itself according to various possible readings. In other words, we are engaged in a constant process of animation which can never quite come to a standstill.

The instability of these acts of projection naturally presents a problem to the interpreter of decorative styles—for how can he be sure that what he reads as a face was intended to represent one? The dilemma has prompted J. V. S. Megaw to subtitle his *Art of the European Iron Age* 'A study of the elusive image'. In particular there is a group of Celtic metalwork dating from the late fourth century B.C. in which the familiar classical motifs of the palmette and the scroll turn into such teasing images of faces that Paul Jacobsthal spoke of a 'Cheshire Cat Style'. The fragment of a bronze and iron scabbard found at Filottrano in Central Italy (Fig. 319) can certainly be read as a conventional palmette, but even so, the schematic head in between is almost inescapable. Sometimes the masks emerge more clearly out of the spiralling scrolls (Fig. 320) while at other times the suggestion is merely of a multitude of watching eyes (Fig. 321). Did the designers seek the elusiveness in the same spirit which has been postulated for the complex interlace—as a form which cannot be grasped and which can therefore defy and defeat the evil eye? We cannot tell. All we know is that the elusive mask or animal head surfaces and disappears in a variety of styles and a variety of forms, and often we are left guessing whether the configuration which reminds us of a face is the result of accident or design.

We should not be surprised to find analogies in other artistic traditions. In one of the earliest and most thorough studies of any system of ornamentation, Karl von den Steinen describes what he calls the formation of 'secondary faces' in the tattoo patterns of the Marquesas Islands. This time the mask does not emerge from a floral scroll. It turns out to be composed of the principal element of design used by the tribe, the figure of the cowering 'tiki', of which variants are shown on Fig. 322. Bearing a curious, though naturally

accidental resemblance to the primitive mannikin drawn by Ruskin in his polemics with Wornum (Fig. 173), the basic configuration is of uplifted arms and bent knees. Hands and feet are sometimes marked by crescents or squares respectively, the head is rarely elaborated. Even without following the author's detailed analysis of the constituent motifs of these designs, we can sharpen our eyes to recognize this basic form, which recurs in the mask-like features such as in Fig. 323. Given the fact that Tiki was worshipped as a divinity (familiar to modern readers from Heyerdahl's *Kontiki*), we may once more adapt Karlgren's formulation and suggest that through tattooing the body becomes charged with 'tiki power'. In any case the transformation of the tiki into a mask adds a further potency— though we must note that the informants of von den Steinen were both more detailed and less explicit in their accounts.

In returning to the Chinese monster, the *t'ao-t'ieh*, on this roundabout route, I have in mind the possibility that this famous motif may also have originated as a 'secondary face'. For it turns out on analysis that the early forms of the mask are composed of two confronting beasts, probably 'dragons' seen in profile (Figs. 324, 325). In discussing this

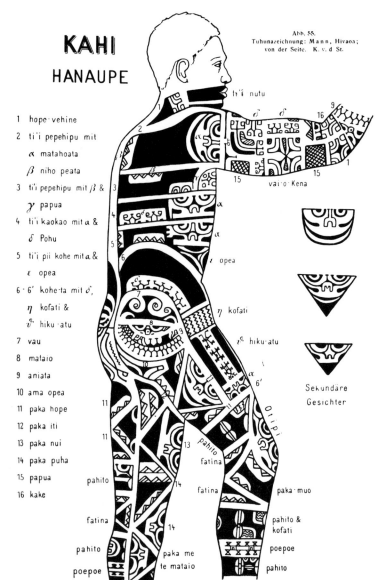

Fig. 323. Tattoo pattern from the Marquesas Islands (K. von den Steinen, 1925)

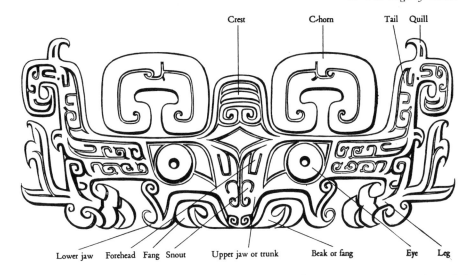

Crest C-horn Tail Quill

Lower jaw Forehead Fang Snout Upper jaw or trunk Beak or fang Eye Leg

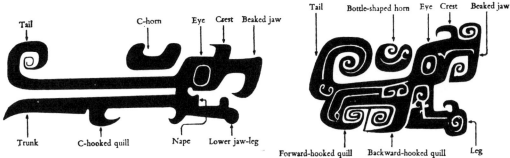

Tail C-horn Eye Crest Beaked jaw

Trunk C-hooked quill Nape Lower jaw-leg

Tail Bottle-shaped horn Eye Crest Beaked jaw

Forward-hooked quill Backward-hooked quill Leg

Figs. 324 and 325.
Diagram of a *t'ao-t'ieh*
and its composition
(W. Willetts, 1965)

strange visual pun William Watson is inclined to think that the face came first and the decomposition later. It is impossible to tell. What we can tell is that the face frequently exhibits that indeterminacy which may have such an important function in the protection of the vessel. Scholars have obliged the modern viewer by analysing the components of this body-less creature and assigning each motif a name, but visually the important fact is surely that we are at a loss to find its limits and its shape. 'In later versions,' we read, 'only the eyes betray their presence among the maze of spirals that form their bodies.' The search can never come to rest.

This may be part of the function of all visual ambiguity. For as William Watson acutely observes: 'It is impossible to see the t'ao-t'ieh simultaneously as a single mask *and* as two dragons standing nose to nose. An awareness of the two possible readings of the shapes disturbs a viewer as soon as they are pointed out to him. T'ao-t'ieh of large size, such as are known to have been made of wood with inlay of bone, would spread their disquiet rapidly through any place where they are displayed.'

There are few problems of cultural anthropology more tantalizing than the affinities which are found to exist between the arts of ancient China and those of ancient America. I have compared the Chinese and the Mexican ritual vessels (Figs. 312, 313) as examples of 'apotropaic motifs' which might have originated independently. Can the same be said of another analogy which is even more striking—the existence in Mexico of composite heads? The fearful idol of the Aztec Earth Goddess (Fig. 326) is a nightmare image if ever there was one; round her neck she wears a chain of cut-off hands and torn-out hearts and her garment is woven out of rattlesnakes. Even her head consists of two rattlesnakes confronting each other much as the dragons of the *t'ao-t'ieh*. Can this be explained on psychological grounds?

Maybe it can. For we also find the composite head in the art of the Haida Indians of North

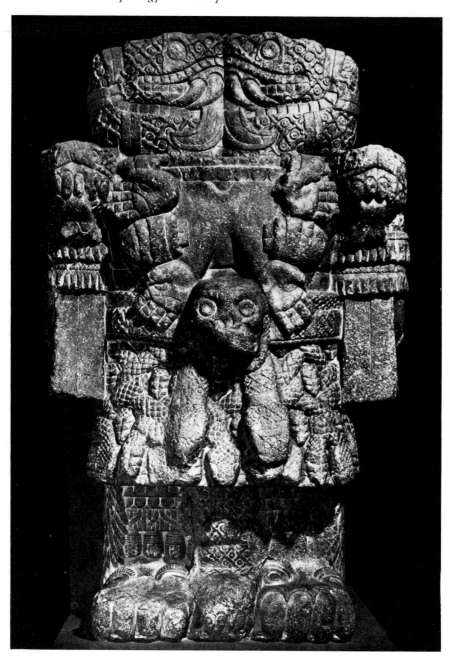

Fig. 326. Aztec Earth Goddess 'Couatlicue'. About 15th century A.

America, which has been so lovingly described and analysed by Franz Boas in his book on *Primitive Art*. It might be argued that contact between Mexico and Haida country is less unlikely than the transfer of the motif across the Pacific and over thousands of years, but the large material presented by Boas makes us see the double head in Haida art as an organic outcome of the native style. What matters to the Haida designer is not the real appearance of a creature but certain individual features such as the front teeth of the beaver, the claws of the bear. Given these carefully observed elements, the body can be dissolved in any number of ways and still remain recognizable to the tribesman, who attaches most importance to the heraldic or totemic significance of decoration. Boas reproduces a design on a bracelet (Fig. 327) representing a bear. 'The animal is imagined cut in two from head to tail, so that the two halves cohere only at the tip of the nose and at the tip of the tail. The hand is put through this hole, and the animal surrounds the wrist. . . . An examination of the head of the bear . . .

Fig. 327. Design on a Haida
bracelet (F. Boas, 1927)

makes it clear that this idea has been carried out rigidly. It will be noticed that there is a deep depression between the eyes, extending down the nose. This shows that the head itself must not be considered a front view, but as consisting of two profiles which adjoin at mouth and nose . . . the peculiar ornament rising over the nose of the bear, decorated with three rings, represents a hat with three rings which designate the rank of the bearer.'

This is in fact one of the examples which prompted the methodological reflections I have quoted above from Claude Lévi-Strauss, who was struck by the recurrence in several cultures of this device of 'split representation'. The explanation he sought in certain characteristics of social organization does not seem to me convincing, all the less since he neglected some of the parallels (such as the Mexican one) and included others (such as Maori art) which seem to me to be built on very different principles.

The direction in which I prefer to look for a solution to the enigma is in the function of the 'secondary face'. Convincing as I find Boas' analysis, I miss in it any indication of why the designer fused the heads of the two confronting animals in a way which is so reminiscent of the *tao-t'ieh* and of other styles. If we could assume that the secondary face, far from being fortuitous, provided one of the motivations for the designer, we might ask whether he was not intent on an apotropaic effect similar to that we associate with the Chinese motif. Admittedly we have to face a formidable methodological difficulty here. Such testimonies as we have from native craftsmen do not appear ever to mention this magic power of the frontal mask. If we accept the orthodox explanations in mainly heraldic terms we have to dismiss the apotropaic hypothesis or assume, as I do, the existence of an unconscious symbolism unknown to the craftsmen themselves. Why should sexuality, but not anxiety, be assumed to find an outlet in the unconscious symbolism of folk art? To me it seems likely that the power of the frontal mask is sensed by any human being, whether or not it is explicitly acknowledged. Looking through Boas' chapter, one is struck by the proliferation of frontal masks with large eyes on implements and blankets (Fig 328). Yet the native

Fig. 328. Design on a
Chilkar blanket
(F. Boas, 1927)

informants of the author and his predecessors remained strangely silent on that point. Their accounts are too contradictory to inspire confidence. All we learn is that, for all the distinctiveness of individual features, the masks are impossible to grasp and hold—a feature which would accord with the interpretation here proposed.

The blanket shown in Fig. 328 represents, according to Emmons, on top, a brown bear sitting up. On the body of the bear is a raven's head. The hind quarters are treated like a whale's head. The eyes are at the same time the hip joints, the mouth the feet of the bear. He was also given another explanation: the principal figure being a whale, the head of which is below. The body, which is turned up, is treated as a raven's head, and the tail as a bear's head. The side panels are the sides and the back of these animals, but represent at the same time an eagle in profile on top, and a raven in profile below. According to Swanton the design represents a halibut. The head is below. The whole large middle face represents the body; and the large face nearer the upper border the tail. The wing designs in the lateral panels, next to the lowest head, are the small pectoral fins and the rest of the lateral fields, the continuous border fin.

Whatever the individual explanations—which would have made Horace laugh—it must look to the outsider as if the elements of the design were less important than the presence of frontal masks. The creation of the double profile may well be rooted in the same unexplained preference.

The discovery that a 'secondary face' can so easily emerge from the representation of two confronting animals has been made in many parts of the globe. While some cultures exploited it in the service of magic protection, other craftsmen may have found the emotional charge of this unintended motif an undesirable by-product. If that is true we might find here an unexpected motivation behind the ubiquitous 'Tree of Life' (Figs. 293, 294), where a clear central axis prevents the meeting of the profile heads and thus keeps them from playing perceptual tricks. I realize that the two explanations appear to be contradictory. I do not think they need be. The student of the visual image and its power must never lose sight of the desire to avoid certain effects.

Admittedly this kind of speculation is unlikely ever to be substantiated or refuted; its only justification (and its main danger) rests on the multiplicity of phenomena it brings under one roof. Its scope is thus much wider than that of the theory of Jan B. Deregowski, who has also used a psychological observation to account for the double profiles in Haida art. He reminds us of the universal tendency among children and untutored draughtsmen to produce 'conceptual images' which aim at a complete enumeration of all distinctive features. The best way to show that a quadruped has four legs is to draw the body not in foreshortening but in a map-like diagram which is easy to design and easy to recognize. But is it not also the best way to convince the demon that somewhere hidden in the tangle there *are* four legs? Maybe a combination of the intellectual and the emotional tendencies will ultimately help to explain the appearance of such strange configurations in various parts of the globe.

5 The Migration of Monsters

The explanation of the convergence of motifs in terms of psychological tendencies can never be wholly satisfying, because it cannot be tested. But what are the alternatives? The explanations put forward in art history for the appearance and re-appearance of 'bicorporate' monsters—creatures with two bodies under one head—are hardly more convincing. I have mentioned in the previous chapter the theories which Baltrušaitis formulated to account for the similarities between such motifs in Sumerian and Roman-esque art (Fig. 295). He rightly stresses the analogies of procedure. We would say that Sumerian and Romanesque artists used similar methods of animation to bring certain

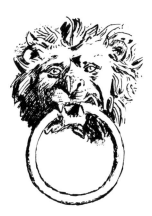

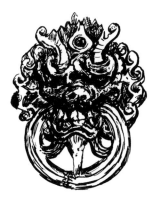

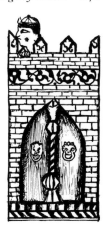

Fig. 329. Lion mask from Lake Nemi, Italy. 1st century A.D.

Fig. 330. Ceramic dragon mask. Chinese, 7th–8th century A.D.

Fig. 331. Lion's head on a fortified gate. Detail of an Islamic miniature. 1317

geometrical configurations to life. But when it comes to explaining this kinship the author falls back on obscure culture contacts, the survival of Sumerian motifs in the East and their migration to mediaeval Europe. A much more radical solution of the problem was put forward by the Danish scholar Vilhelm Sloman in his monumental publication *Bicorporates*. I once enjoyed the hospitality of that lovable man and remember the passion with which he explained his conviction that certain striking similarities between Sumerian fragments and mediaeval carvings on Danish fonts compel the conclusion that real contact had taken place. He proposed to fill the gap by postulating that the Crusaders must have been so impressed by work they considered to reach back to Biblical times that they took plaster casts and carried them home on their ships to their native villages. Can we believe this?

That imports of exotic textiles, metalwork or other treasures constantly stimulated the imagination of the craftsmen and helped to preserve and to spread certain inventions cannot be doubted. But it seems to me all the more urgent to distinguish between such instances of 'diffusion' and those of spontaneous generation.

I owe a perfect example of this difference to the erudition of Otto Kurz, who traced the spread of an unlikely motif from Greece via Rome (Fig. 329) to China (Fig. 330) and back into Islamic (Fig. 331) and Western decorative art (Fig. 346). I am referring to his paper 'Lion Masks with Rings in the West and in the East.'

'Some 2500 years ago'—Kurz sums up his riveting article—'a Greek artist conceived the strange idea of putting a movable ring into the mouth of a lion, or rather of combining two traditional elements, an artistic and a utilitarian one, by uniting a lion *protome* with a swinging handle. The new art form, once created, lived on everywhere and became almost immortal. It would never have been so successful if its appeal were so simple that it could be expressed in a short formula. As in every 'success story', there were many contributory factors and ambiguity played a considerable part. The figure of a lion was the traditional guardian of the dwellings and belongings of the living and the dead. Human pride could find immense satisfaction in imposing on the fiercest of beasts a most menial task. And in addition, a playful element slipped in. The *homo ludens* made the lion into a performing animal, frightened by it and at the same time showing his superiority over it.'

The psychological insights reflected in these conclusions are matched in the body of the article, which lists the significant parallels with the author's customary economy and wit. What concerns us most is his discussion of the Chinese reception of the motif. 'For it appears that the ground for such a reception was surprisingly well prepared in a tradition which can only be described as a spontaneous growth. As in so many styles all over the world, there existed, here also, a tendency towards a zoomorphic interpretation of abstract shapes. The upper half of the handle of some early Chinese bronze vessel received protruding eyes with eyebrows, nose and ears, and was thus transformed into a living being which seems to hold

the handle in its mouth [Fig. 332]. When movable rings made their appearance they were often joined to the masks of the t'ao-t'ieh, but were fixed to its protruding beak or nose [Fig. 333]—possibly a more logical way of fixing a ring to an animal.'

I can think of no better illustration of what I mean by the 'logic of situations'. The protective mask and the ring are both functional (in the eyes of the users). The specific combination of the ring with the mouth of the lion was due to a one-time invention, fixed by the force of habit.

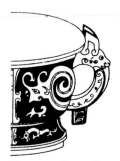

Fig. 332. Part of a Chinese ritual vessel. See plate 87

6 Domesticated Demons

Almost any doorknocker in our cities reminds us of the force of habit which makes for the continuity of motifs long after the memory of their original function has faded away. The mask of a 'guardian' has become the distinctive feature which the dwindling class of people who use or buy doorknockers still seem to expect. Few of them are likely to believe in their protective powers, but maybe there are some who feel that, if the traditional form does not help, it cannot harm, and is therefore better not omitted—much as they may keep their fingers crossed without positive conviction, but from a vague fear of leaving something undone.

Seen in this light the hybrids we encountered among Dürer's marginal drawings for the Emperor's prayer-book are the direct progeny of the monsters of yore. It would require a whole book to analyse this secular process by which the zoomorphic tangles of the Dark Ages merge in subsequent centuries with the inhabited scrolls of classical lineage, and develop into showpieces of lighthearted virtuosity on the margins of Gothic manuscripts. It would also be tempting to treat this development as a steady shift in function and meaning by which the threatening dragon turns by degrees into a comic goblin. But such a picture would be simplistic. We do well to remember Ruskin's words that 'there are few grotesques so utterly playful as to be overcast with no shade of fearfulness, and few so fearful as absolutely to exclude all ideas of jest'.

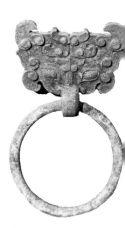

Fig. 333. Chinese coffin handle. 5th–4th century B.C.

I mentioned in the Preface to this book that my interest in the grotesque was first aroused through my collaboration with Ernst Kris on a history of caricature and comic art. It was Kris who initiated me into the psycho-analytic theory of the comic which he had helped to develop and apply. What he particularly stressed was the instability of the comic, its tendency to oscillate between the uncanny and the ridiculous. He saw the pleasure we take in the comic largely as a triumph over anxiety, the achievement of dominance over psychological forces which threaten our precarious control. In Freud's theory the enjoyment derives from the confluence of two distinct sources of pleasure. We like to 'regress' to the stage of the babbling child who playfully learns the use of language in nonsense chatter. We also gain satisfaction by lifting the repressions inhibiting us from giving vent to aggressive or erotic drives. In the successful joke the witty play on words serves as a bribe for the breaking of taboos. Generalizing on this model, Kris stressed the importance for art of a strong 'ego', mastering and ordering the instinctual urges through giving them the outlet of an acceptable shape.

Looking back at Dürer's marginal drawings we can appreciate the role which virtuosity played in the control of his 'dreamwork'. To put it simply, he can enjoy relaxing the rules and conventions of waking life by allowing his flourishes to turn into masks or rabbits and crowding his margins with the weird hybrids we described. There is no neat dividing line here between the sacred and the profane, the awesome and the comic. Dürer's devil himself (Fig. 302)—like that of many a mystery play—is both sinister and funny in his frustration and rage.

The mixture may have been different in various periods of Christian art, but the

ingredients were basically the same. More than seven hundred years before Dürer, we find the same elements in the Book of Kells, that astounding monument of piety and virtuosity which does not lack a playful element. One of the greatest authorities on the Hiberno-Saxon style of illumination, Françoise Henry, reminds us in her text to the Facsimile Edition that even here we must forego asking too precise questions. Commenting on 'the little lion-like creatures which prance so proudly in the intervals of the text' (Plate 88a) she writes 'Do they mean something, or are they just the liberated version of the animal-interlace with feline head? And are they lions, or at least the painter's notion of lions? Sometimes they seem to assume more familiar shapes: the cat gathered up on its haunches, watching a mouse-hole [Plate 88b] or an emaciated cat seen from above, lying on the floor and busily licking its back [Plate 88c]. Imperceptibly, we have come down from the dizzy heights of symbol and mystery to the most familiar of everyday realities, from transcendental theology to genre scenes. But caution is still necessary. The cats and kittens in the Chi-Rho [Plate 88d] are not engaged in homely comedy. Whatever their exact meaning, they are gathered around a cross-bearing disc which brings them into line with the other symbols on the page.'

The group referred to is indeed one of the most surprising anticipations of the more realistic drolleries of later centuries, as it is seen nestling snugly between the overwhelming intricacies of the whirling interlace. Are the mice nibbling the host and the cats holding them by their tails? Or are the cats helpless while the mice are dancing on their backs? Whatever the answer to this riddle, the likelihood that the scene has a meaning does not solve the puzzle of their presence as portents of things to come.

Perhaps we are wrong to be surprised. All great works of art gather up a rich variety of human experience. Homer and Shakespeare have given ample proof that humour and laughter will enrich rather than impair the universal significance of their creations. If we find it hard to come to terms with the tradition of drollery and the grotesque, the fault may lie in the way we have been taught to approach the visual arts. As long as we divide the field between formal analysis and iconography, the area which concerns us here will inevitably elude us. It is the merit of Focillon's approach to have pointed out the peculiar relationship between form and content in the ornamental tradition of the Middle Ages, but I believe further progress must depend on analysing a little more closely what 'game' it is these artists were playing.

I have attempted an answer in the preceding pages—it is the game of 'animation'. Like all games it hovers between believing and pretending. Need I again invoke my 'hobby horse' which is playfully turned into a 'pretend' horse by transforming the end of a stick into a head? Behind the game, I contended, is the desire to ride a horse. Behind the game of animation there is also the wish for protection against evil forces, but such habits rarely persist unless they satisfy more than one need. We have had occasion to observe how animation adds to the resources of the decorator by endowing the form with a direction and a dynamic of its own. Focussing on these functions may help to bridge that gap between form and meaning which has bedevilled the interpretation of these motifs. There is a noticeable difference between the kinds of life which the artist can choose to instil into any structure. He can endow the termination of a shape with the traditional gaping or threatening jaw and complete the image by adding fangs or tails; he can also transpose the form into the floral realm by adding a leafy crown or curling tendrils (Figs. 334, 335). The resulting difference is not only one of content or mood. The animal shape is experienced as mobile, it is about to jump unless, as we have seen, this potential threat is neutralized by interlace or by the dynamic device of representing the creature locked in combat with others or biting its own body. In any of these solutions the scanning eye will perceive the elusive menace which will reinforce the impression of movement all curling or rotating shapes tend to elicit. I have spoken in Chapter V of the designer's ability to impart the desired 'dosage'

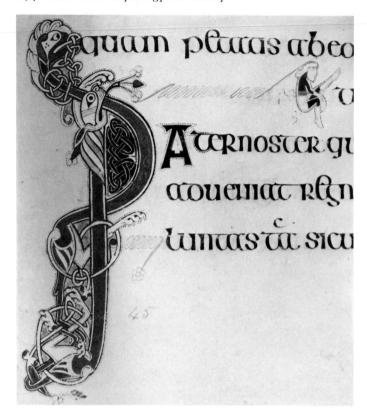

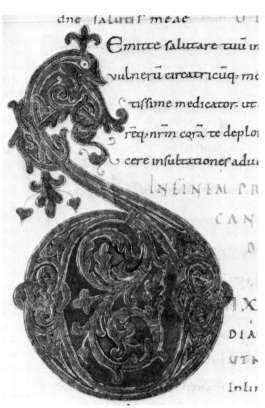

of movement or balance to his pattern. Animation immeasurably contributes to these resources, by achieving the right blend between the tense contortions of the animal and the relaxed flexibility of imaginary plants. Inevitably the head endowed with an eye will provide the visual accent while the lush scroll will need time to explore.

The device of mixed animation permits of any degree of fantasy or realism, solemnity or humour. In a splendid initial of an Ottonian manuscript (Fig. 336) the realms are neatly separated and yet combined, the letter I is transformed into a tree, which a man is seen to climb. Is this a joke or should we follow the commentators who see the image as a metaphor for upward striving? We shall never know, but we cannot doubt the admixture of humour in the initial of a manuscript from the School of Canterbury of Jerome's Commentary on Genesis, dating from the early twelfth century (Fig. 337). The letter A is formed by a ferocious dragon, who holds something like a pig in its claws, but the creature (whose tail ends in foliage) allows a man to ride on its neck, who apparently picks fruit or leaves from the scroll which winds around the other side of the letter. In its shelter we find a man berating a performing bear—he says 'A B C' while the docile pupil seems to repeat 'A'— the letter under which the dialogue takes place. Is it not likely that the scribe, in designing the initial, was reminded of his role in teaching another 'performing bear' to read or to write?

There is more fantasy and menace in the initial L from a French Bible of about the same period (Fig. 338). The creatures chasing each other through the foliage are impossible to classify. The bird-like dragon has an almost human head, and the human below a dragon's head. The lower end of the stem is turned into an ambiguous monstrous mask seen from in front but almost suggesting two profiles. The creature underneath sits on a bench formed by intertwining dragons.

It is hard to resist the lure of what T.S.R. Boase has graphically described as the 'haunted tanglewood', but even the few examples from the one field of figured initials may have sufficed to show that it was not only the force of habit that ensured the survival of multiple

Fig. 334. Page from the Book of Kells. Early 9th century

Fig. 335. Page from the Psalterium Aureum, St. Gallen. Late 10th century

ig. 336. Initial from a lectionary from Reichenau. 10th century

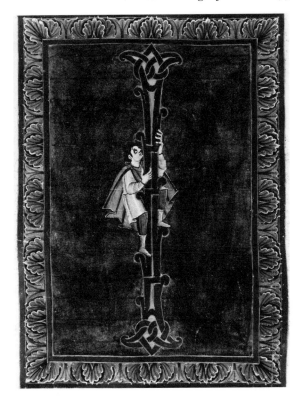

ig. 337. Initial from Jerome's Commentary on Genesis. School
f Canterbury, early 12th century

ig. 338. Initial from a French Bible. Early 12th century

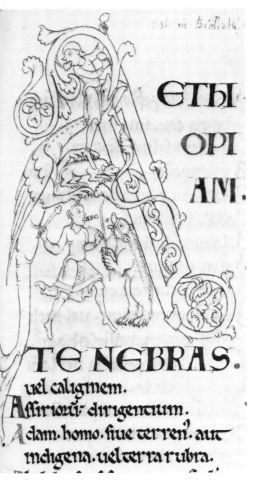

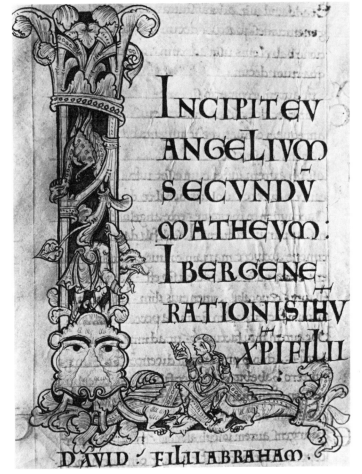

Fig. 339. Opening
from a Netherlandish
Book of Hours.
About 1300

animation. The perceptual surprises described by Horace are as nothing when compared to
the licence enjoyed by the mediaeval draughtsman. His exploitation of the unexpected helps
to create and maintain visual interest—and what could be more unexpected than the
whimsical creations which play hide and seek in the 'inhabited scrolls' of mediaeval art? No
doubt they allow the artist to give vent to his feelings of aggression and his sense of fun but
we must not neglect the primacy of aesthetic effects which outlast stylistic changes. Gothic
marginal drolleries are more anecdotal, more realistic even than their Romanesque
predecessors, while cultivating the ingredients of farce: the wild chase, the comic antics, the
confrontations of strange creatures, the tumblers and performing animals, the 'world upside
down' with its preaching foxes and listening geese are all elements of animation in the wider
sense of the term. No selection can give an idea of the richness and wit of this repertory, but
the opening of a Netherlandish Book of Hours of about 1300 (Fig. 339) gives a fair sample:
on the left side we have a satirical genre scene with a devil diving on a woman who sinfully
plays chess with a man; above, two hybrids, half knight, half scroll, are about to fight. The
lower border on the opposite page is more lively still with a dog and a man dancing to the
viol played by a woman. The scroll which supports the initial terminates in an animal head,
while the floral sprig is 'inhabited' by charming singing birds. Underneath, a knight
precariously perched on the scroll fights a lion, and an owl beneath completes the selection.

Fig. 340. English
sandstone corbel.
12th century

One can understand the objections of St Bernard and those who echoed his strictures, for
how is anyone to concentrate on the prayers while such counter-attractions compete for his
attention? But were these censorious clerics not lacking in charity? The hours of prayers
were long and the need for relaxation real. Would it not have been infinitely worse if the
counter-attraction had been a novel or even a picture story? These inconsequential images
would attract the eye but they would not hold it for long; they present a kind of 'side show'
which refreshes the mind but does not stay in the memory because they do not cohere.

We must not forget that both in its origin and function the drollery is an art of the
margin; it is so quite literally in the manuscript tradition, it is so in its function and form in
the decorative sculpture of buildings and furnishings, such as gargoyles, corbels, roof bosses,

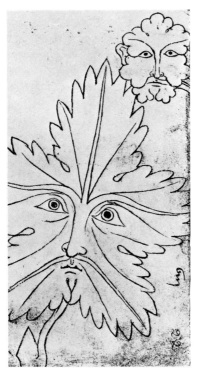

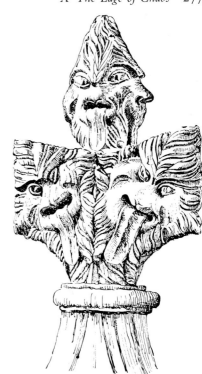

ig. 341a. Villard de
onnecourt: Foliate
eads. About 1235

ig. 341b. Stall
rmination from
attlesden, Suffolk.
4th century
M. R. James, 1930)

bench endings and misericords. The fearsome gargoyle (Fig. 340) preserves the 'apotropaic'
heritage of animation quite openly, while other features give more scope to playful
inventions—the elusive mask turns up again in the foliage, sometimes, no doubt, as a
'secondary face' to which a new meaning may be assigned (Fig. 341a). The motifs are
effectively and humorously combined into a three-headed monster with protruding
tongues on the stalls of the church in Rattlesden, Suffolk (Fig. 341b). On the 'misericords'—
the 'perches' under the seats which saved the monks from the rigours of endless standing—
the craftsmen were free to let their imagination run riot, to crack bawdy jokes or simply to
carve what they pleased (Fig. 342). Ruskin's 'element of fear' has largely disappeared from
their jolly imagery.

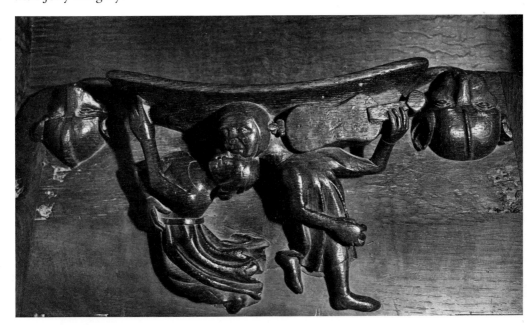

ig. 342. Misericord
om Chichester
athedral. About
30

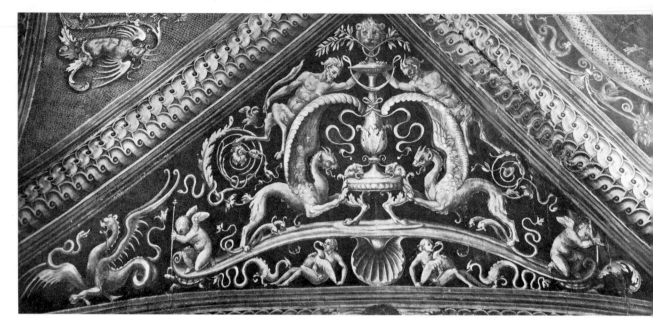

7 *The Revival of the Grotesque*

Fig. 343. Perugino: Spandrel from the ceiling of the Cambio, Perugia. About 1500

To the best of my knowledge there are no carved misericords in Italy. Whether this absence is due to the Italians being firmer on their feet, sterner in their discipline, or simply to a lack of tradition, I do not know, but what must strike anyone is the restraint of Italian craftsmen in the Middle Ages. Like the art of Byzantium, with which it had such close relations at times, the art or arts of mediaeval Italy refrained from the licence which we observed in the North. Wölfflin, it will be remembered, spoke of a radically different 'sense of form', and it is true that the leading school of mediaeval decorators in Italy, the *Cosmati*, concentrated on geometric forms. Not that the art of animation practised in antiquity was ever quite forgotten. We find animated foliage in between the frescoes of Giotto (Plate 66), and the 'animated candelabra' we have encountered among Dürer's models became a feature of Italian design *all'antica* even before the grotesque proper came into vogue around 1500.

It is well known that the richest source of these motifs was found in the rooms and corridors of the so-called Golden House of Nero (Fig. 19), which were buried so deep in the earth that they were known as the *grotte*. The spread of the grotesque can be traced almost step by step, and has been so traced in an admirable study by Nicole Dacos published by the Warburg Institute. One of the first painters to adopt the new mode was Pietro Perugino, an artist few of us would associate with light-hearted frivolities. Fig. 343 comes from his ceiling of the Cambio in Perugia, painted around 1500. It is worth looking at in some detail; the two dragons issuing in scrolls, flanking a candelabra topped by a lion's head, on whose wings are perched two satyrs. The whole contraption is based on a curved foil resting, as we discover, on two tortoises, which are just being stabbed by two ungrateful winged *putti*. Down in the shelter of the foil two naked women, Ledas, are disporting themselves with their swans, while dragons disturb their leisure by pinching them on the knee. There is more going on: serpents are coiled round the scroll on which a harpy sits, and in the corner a dragon fights with a swan, whose long neck is tied in a knot.

It is the affinity in content between the classical grotesque and the mediaeval drollery which enabled Dürer to admit them both into the repertory of his marginal drawings. The main distinction, as we noticed, was a formal one—unlike the drollery, the grotesque tends to submit to the formal order of symmetry and balance.

As we might expect, the added discipline does not remain without effect on the

psychological content. If anything, the grotesque shows more licence in breaking the taboos of convention and decorum than the drollery. The art of the North can be bawdy and coarse, but the grotesque shows an almost systematic play with human forms which is only just permissible because the creatures represented are not wholly human. No doubt this play with eroticism was facilitated by the authority of a style *all'antica*; it has its parallel in the elegant pornographic poems of Panormita and other humanists. The daring content is excused by the virtuosity of the form. Symmetry itself, as we remember from the Kaleidoscope, has a masking effect and repetition empties the individual motif of its emotional charge, by turning it into a pattern.

It took some time before artists found the right balance between the pattern and the licence. The grotesques of Signorelli (Plate 89), almost contemporary with those of Perugino, are so densely packed that they are nearly hidden in the pattern. The symmetry swallows up the curious creatures. In Raphael's *Logge* (Plate 90) with their countless stucco reliefs, floral scrolls and naturalistic fauna, it is most of all the profusion as such which impresses, that inexhaustible inventiveness, as the artist empties a cornucopia of images, of cupids and griffons, in light-hearted play. What earlier styles of decoration, the arabesque most of all, had achieved through intricacy and complexity of patterning the new style achieved through sheer variety—the feeling that there is more here than the eye will ever be able to take in.

The acknowledged master of the grotesque, Raphael's assistant Giovanni da Udine, used the motif of the hybrid monster with discretion (Plate 90), perhaps remembering the strictures of Horace. But paradoxically, it was these famous lines which brought the monster to the attention of artists. I know of no ancient Roman decoration which contains the exact creature described in the *Ars Poetica*, but there are a good many variants of the motif in Renaissance grotesques. An engraving of 1523 by Lucas van Leyden (Fig. 344) keeps close to the imagery of Horace's painter who chooses 'to join a horse's neck to a human head, and to make multicoloured feathers grow everywhere over a medley of limbs, so that what at the top is a beautiful woman, ends below in an ugly dark fish'.

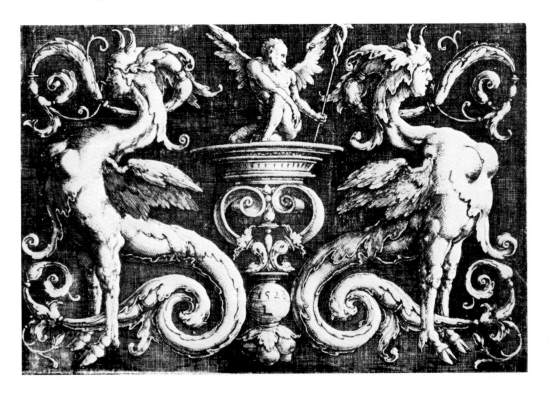

ig. 344. Lucas van
eyden: Grotesques.
523

Il poeta el pittor Vanno di pare
Et tira il lor ardire tutto ad un segno
Si come espresso in queste carte appare
Fregiare d'opre et d'artificio degno

Di questo Roma ci puo essempio dare
Roma ricetto d'ogni chiaro ingegno
Da le cui grotte ove mai non soggiorna
Hor tanta luce a si bella arte torna

Fig. 345. Master of the Die:
Grotesque. Early 16th
century

There is more evidence that this classical quotation was well remembered by artists who were pushing the fashion of the grotesque. A print by the Master of the Die (Fig. 345) shows an inhabited scroll *all'antica*, with relatively mild grotesque elements such as the female carrying the vase, which in its turn is covered by a lid, half lid, half face. It is accompanied by a little poem:

Il poeta e'l pittor vanno di pare	Poet and Painter as companions meet
Et tira il lor ardire tutto ad un segno	Because their strivings have a common passion
Si come espresso in queste carte appare	As you can see expressed in this sheet
Fregiate d'opre et d'artificio degno	Adorned with friezes in this skilful fashion.
Di questo Roma ci puo essempio dare	Of this, Rome can the best examples give,
Roma ricetto d'ogni chiaro ingegno	Rome towards which all subtle minds are heading
Da le cui grotte ove mai non soggiorna	Whence now from grottoes where no people live
Hor tanta luce a si bella arte torna.	So much new light on this fine art is spreading.

Whoever wrote these lines clearly remembered the passage in Horace in which the poet's licence is linked with that of the painter, albeit in a critical way. Soon artists all over Europe understood the spirit demanded by the genre. In the prints by Cornelis Bos (Fig. 346) the monster is linked with the enigmatic, the mysterious, through allusions to Egyptian or Oriental divinities, all caught up in the strapwork which has replaced the scroll, making it

Fig. 346. Cornelis Bos:
Grotesque. 1546

hard to disentangle the decorative from the organic. Real legs protrude through the eyeholes of a mask. Acrobatic satyrs have clambered through the openings in the festooned strapwork. But what of the woman with the Egyptian headdress? How did she ever get into the fantastic structure which emphasizes her nakedness? We are not supposed to ask.

It may be argued that the very possibility of reproducing and spreading these designs through the medium of engraving changed the status and function of the grotesque. There is something self-contradictory in a pattern for 'dreamwork', a guidebook to chaos. Moreover the type of print of which Fig. 346 is an example could well exist on its own. The grotesque has moved from the margin to the centre and offers its inconsequential riddles to focussed vision. With this growth of intellectual interest more and more opinions in the course of the sixteenth century rejected the criticism of the grotesque implicit in Vitruvius and Horace. These enigmatic designs must have had a meaning—they must hide the mysteries of 'Pythagorean' philosophy and the profound wisdom of the hieroglyphs. They are not mere designs, but signs. We stand at the beginning of the tradition we briefly surveyed in the preceding chapter.

8 The Dissolution of Form

Earlier in this chapter I have had occasion to stress two elements which can be observed in the history of decorative art—the force of habit, which makes for historical continuity, and

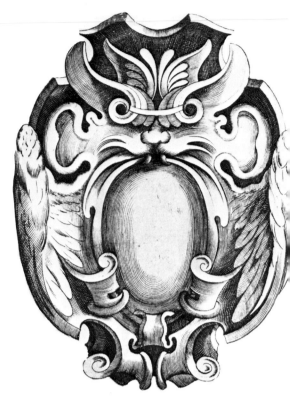

the invariants of psychological dispositions, which account for converging developments. There was more scope for the force of habit in the history of the drollery and grotesque than one might expect, for many individual motifs are variations on familiar themes. A fresh effect depended merely on changes being rung on the psychological reactions to be especially engaged.

These reflections are prompted by the return of that puzzling device which I have called the elusive face in the repertory of decorative art. The play between two confronting animals forming a face, which we found in China, in Mexico and among the Haida Indians, was not one of the motifs favoured by either the drollery or the classical grotesque, though I would not exclude its occasional occurrence. The engraving of a vessel dating from around 1600 (Fig. 347) shows what we would call an apotropaic mask formed of two dolphins touching each other. The possibility of foreign inspiration cannot be excluded but it is unlikely. The design fits wholly into the European trend in which the boundaries of forms are increasingly dissolved.

Characteristically these charms of ambiguity were discovered afresh in the development of those framing motifs I mentioned in connection with the cartouche (Chapter IX). The curling and swirling motifs I have described as 'reified flourishes' are unfocussed forms mainly serving to enhance the focussed centre. They thus provided an ideal vehicle for the grotesque, for the free play of inventions designed to display the unbounded inventiveness of the decorator's imagination. The temptation to 'reify' the shield into the open mouth of a gaping mask (Fig. 348) proved as irresistible as did the opportunity of turning spiralling volutes into suggestions of eyes. What is typical of the style which developed around 1600 is not, of course, the device of animation as such, but the careful 'dosage' applied by the designer. He prefers not to commit himself and to leave the responsibility of any reading to us, as in the cartouche by Adam van Vianen (Fig. 349), a Dutch goldsmith who also applied these forms to his vessels.

The systematic ambiguity of these shapes which are neither fish nor fowl, neither bone

Fig. 347. Hendrik Goltzius: Detail from an engraving of Bacchus with a cup. About 1600

Fig. 348. Federico Zuccaro: Cartouche About 1600

Fig. 349. Adam van Vianen: Title page. About 1650

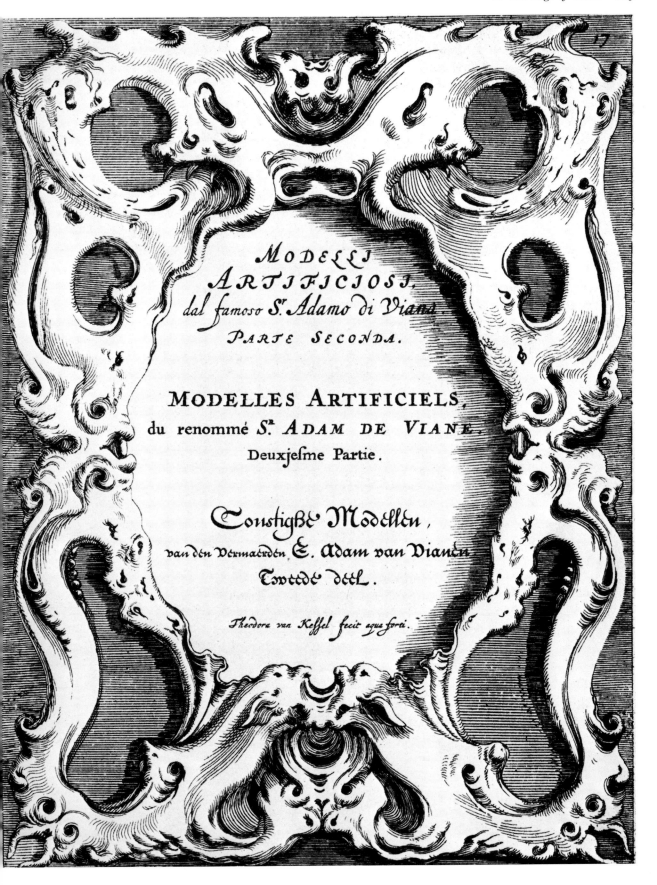

MODELLI
ARTIFICIOSI,
dal famoso Sr. Adamo di Viana.
PARTE SECONDA.

MODELLES ARTIFICIELS,
du renommé Sr. ADAM DE VIANE.
Deuxjesme Partie.

Constighe Modellen,
van den Vermaerden E. Adam van Vianen
Tweede deel.

Theodora van Kessel fecit aqua forti.

nor flesh, caused this style to be termed 'auricular', because its scrolls reminded critics of human ears. One might also think of skins or furs, still revealing in their shapes the underlying features of the animal. It is almost impossible, in looking at this frame, not to glide from one reading into another, seeing an animal mask with a trunk here (in the right hand upper corner), a gaping mouth on the side, and once more the suggestion of dolphin-like creatures whose fins are also the ears of a frontal mask; it is completed by the two curving crests of a cross-breed between a fish and a cockatoo.

From here it is but a step to those frivolous inventions of Rococo engravers which we encountered in the first chapter as the main target of classicist reactions. Relaxation or, as the psycho-analysts would call it, regression into fantasy, had gone so far that the cry arose in the Age of Reason for a return to control and discipline.

For a last time we may look back from here at our paradigm, the frame of Raphael's *Madonna della Sedia* (Plate 1). To the reader who has shared this journey with me it should have looked progressively less puzzling. We recognize in it a version of the cartouche with four animated motifs oriented towards the field of force they enhance. They are progenies of Gorgon's heads, apotropaic masks but transformed into smiling classical beauties endowed with most unclassical animated coiffures, which lead into the friendlier realm of exuberant vegetation. Further outward the florid flourishes harden into brackets crowned with shells and serving as fictitious fasteners for the stretched laurel garland running inside the classical moulding of the frame. The whole riot of gleaming forms flanking the two cartouches intended for the inscriptions is separated from the painting by a restrained circular acanthus border, proclaiming further allegiance to classical authority.

Far from wishing to distract from the precious painting which it encircles, the designer of this golden setting wanted to pay tribute and arouse attention like a flourish of solemn fanfares at the entry or departure of Majesty. In taking leave of the visual manifestations of the sense of order we must still pursue the implications of this analogy, which links the arts of space with the arts of time.

EPILOGUE

Some Musical Analogies

> Words move, music moves
> Only in time; but that which is only living
> Can only die. Words, after speech, reach
> Into the silence. Only by the form, the pattern,
> Can words or music reach
> The stillness, as a Chinese jar still
> Moves perpetually in its stillness.
> Not the stillness of the violin, while the note lasts,
> Not that only, but the co-existence,
> Or say that the end precedes the beginning,
> And the end and the beginning were always there
> Before the beginning, and after the end.
> And all is always now.
>
> T. S. Eliot, *Four Quartets*

1 *The Claims of Music*

'All art,' said Walter Pater in a famous passage, 'constantly aspires to the condition of music.' The existence of music, an art devoid of ostensible subject matter, an art not even serving a physical need like architecture nor rivalling nature through *mimesis*, rarely failed to excite wonder and jealousy. For without these supports music appeared to achieve pre-eminence both in its power over the emotions and in its appeal to the intellect. A book devoted to the 'Sense of Order' could hardly leave this greatest of its achievements out of consideration, but it cannot do it justice either. Music can only be discussed in musical terms. To explain to an outsider the purpose and beauty of a particular move in chess we would first have to initiate him into the rules and traditions of the game. Something like this also applies to the elucidation of tonal patterning in its developed form. Even a deaf person can see, when looking at printed music, that certain configurations recur in one form or another on the various lines of the score, but this would not give him much idea of the correspondence or difference between visual and tonal composition. The symbolism of musical notation does not reproduce these patterns except indirectly. The recurrent time intervals marked by bars are not printed at identical distances, nor are the distances between tones exactly reflected in the distance between notes—accidentals and other peculiarities of the system result in the fact that the same phrase often looks different when it starts with a different note. It would certainly be possible to devise an isomorphic notation—one in which like intervals look alike on paper—but this would not much help the tone-deaf, because it is precisely the point of the musical system as it evolved over the centuries that the sound of the notes also depends on context. I have therefore decided to do without musical examples. Even if I had the competence to discuss them (which I have not) the length of existing textbooks of musical theory would prove the futility of the exercise. My aims in this epilogue are much more modest. I must take it for granted that the art of tonal patterning has led to some of the most miraculous achievements of the human mind. Far from wanting to explain them I shall take them as given, and merely try to probe analogies and metaphors in other forms of pattern-making for their validity and limitations.

2 *The Rivalry of the Arts*

Among all the arts music has long been acknowledged as being most firmly grounded on theory, on a knowledge of numbers which, translated into sound, would sway the passions as if by magic. In the Middle Ages music alone was conceded a place in the noble ranks of the *Liberal Arts* in the curriculum and even placed above the linguistic skills of grammar, logic and rhetoric, the *Trivium*; it belonged to the more advanced *Quadrivium*, since it is based, like Arithmetic, Geometry, and Astronomy, on the security of measurement.

Music owed this position to the discovery of Pythagoras that the sensory qualities of sounds were related to mathematical ratios. The experience of consonance we sometimes have when we hear the tones produced by two plucked strings rests on their lengths being in simple proportions. Doubling the length of the string results in an octave, the proportion 2:3 in a fifth and so on in steady progression throughout the intervals of the diatonic scale.

Rudolf Wittkower has shown to what extent this discovery of the mathematical nature of harmony inspired the great architects of the Renaissance. They hoped that similar ratios in the dimension of rooms, for instance, would lead to similar psychological effects. The buildings which resulted were undoubtedly of great beauty, but the underlying theory could not survive scientific analysis. Once the 19th-century physicist Helmholtz had come up with an explanation of the experience of consonance in terms relating exclusively to the behaviour of sound waves, the analogy ceased to be persuasive. Briefly this explanation rests on the behaviour of a vibrating string creating the pattern of air impulses that reach the ear; doubling the length of the string results in a tone one octave lower, but does not otherwise interfere with the total pattern of wave motions—causing, we must assume, the feeling of identity in difference that characterizes the octave. Opinions differ about the validity of Helmholtz' approach in the case of more complex intervals and chords; but there is no physical analogue to acoustic effects in contemplating a room the shape of a double cube.

The search for the causes of colour harmonies did not fare much better. It had naturally been stimulated by Newton's discovery that there really was an analogy between colour and tones, insofar as colour, like pitch, depended on wavelength. But quite apart from the fact that the compass of wavelengths experienced as light is of a different order of magnitude to that of sound waves, the reactions of the eye differ fundamentally from those of the ear. The eardrum vibrates sympathetically with the plucked string, the retina is a composite organ. The light energies impinging on its rods and cones cause short-lived chemical changes which result, in their turn, in electrical discharges reinforcing and impeding each other along the complex pathways which lead to the visual cortex.

But though the comparison between sound-waves and light-waves proved fallacious this need not mean that there are no possible explanations of the experience of colour harmony in physiological terms. We know at least as much about the causes of contrasting after-images or the nature of 'primary' colours as we know about the laws of acoustics relating to music. But being specific to the workings of the eye, this knowledge can no more fulfil the hope of those who aspire to create a colour music, than the knowledge of musical laws could alone guide Renaissance architects.

Even so this hope dies hard. Attempts to build a colour piano may go back to the sixteenth-century Milanese painter Arcimboldo and were revived in the eighteenth century by the Jesuit P. Castel, on whose instruments the touch of a keyboard produced both tones and coloured ribbons—the primary colours corresponding to the triad.

The author of a poem on Painting which celebrates Castel's invention also shows himself aware of the fact that Newton had not succeeded in explaining the relation between sound and light: he appeals to the greatest French scientist of the age to make good this omission (in vain, as it turned out):

Mais quel est ce rapport du son à la lumière ?
D'Alembert, c'est à toi d'expliquer ce mystère.

When, a generation later, a Scottish scientist took up the idea of colour music, he characteristically left explanation on one side and concentrated on the effects he hoped to achieve. I am referring to Sir David Brewster, whose invention of the Kaleidoscope was discussed in Chapter VI. In the treatise about his new apparatus Sir David reveals himself as an early pioneer of what today is called 'kinetic art'.

'I venture to predict,' he writes, 'that combinations of forms and colours may be made to succeed each other in such a manner as to excite sentiments and ideas with as much vivacity as those which are excited by musical composition. If it be true that there are harmonic colours which inspire more pleasure by their combination than others; that dull and gloomy masses, moving slowly before the eye, excite feelings of sadness and distress: and that the aerial tracery of light and evanescent forms, enriched with lively colours, are capable of inspiring us with cheerfulness and gaiety, then it is unquestionable, that by a skilful combination of these passing visions, the mind may derive a degree of pleasure far superior to that which arises from the immediate impression which they make upon the organs of vision. A very simple piece of machinery is alone necessary for introducing objects of different forms and colours, for varying the direction of the motion across the angular aperture, and for accommodating the velocity of their motion to the effect which it is intended to produce . . .'

We may note in passing that Brewster does not claim to have experienced these thrills, he only expects them to come about. A generation later we find a similar optimism in the writings of Ralph Wornum, one of the reformers of design, whom we remember for his eagerness to distinguish the laws of decoration from those of pictorial representation (Figs. 36, 38) — a tendency which led to his clash with Ruskin. It was in the same context that he wrote the forecast I have quoted that the theory of design would one day be as firmly grounded as that of music, expecting, presumably, that this achievement would also enhance the status and value of the art.

Writing in the same year and in the same situation, Gottfried Semper went even further in this analogy between ornamental design and music though he also hinted at the reasons why it can never be perfect.

'The articulation of the eurhythmic configuration must conform to certain tendencies of recurrence with cadences and caesuras, with stressed and unstressed elements, which in their concatenation give rise to the completed device. In this respect musical configurations, in other words melodies, are subject to the same laws as are the visual ones, except only that the ear is able to follow and to resolve a much more complex order than the eye, which has to take in the whole simultaneously in one moment.'

Reading these opinions one can only admire the confidence with which their authors slide over the most perplexing issue of aesthetics — the question of where metaphors end and solid analogies emerge. Brewster remained firmly wedded to metaphor in linking the emotional effect of colours with that of sound. Language amply confirms this linkage. Colours can be described as warm, sweet, loud or cheerful, much as sounds can be characterized as bright, soft, harsh or sad. Granted that critical terminology can never do without recourse to metaphor, is it sufficient for the foundation of a theory ? This is what the eighteenth-century critic Wattelet implied when he wrote in comparing painting and music :

Ils ont tous deux des tons, des accords, des nuances.
Et leurs termes communs marquent leurs ressemblances.

But in a way he was begging the question. The existence of such common terms only proves the elasticity of the human mind, its ability to extend categories or to create fresh classes of experience, particularly at the point where the sense modalities converge. But such synaesthesia is an elusive and subjective reaction and cannot provide a firm foundation for the creation of new arts, whether non-objective painting or kinetic art. Are we on firmer ground with some of the other comparisons adduced by Wornum and Semper? Is the term rhythm, which the former uses, a mere metaphor when applied to spatial arrangements? Etymologically it certainly is. The term is connected with the Greek word *rhein*, to flow, and rhythm thus relates to the flux of time, or as Aristotle says, to any regular recurring motion. Unlike Wornum, Semper, it will be remembered, acknowledges this element of time in music by remarking that the eye has to deal with configurations simultaneously 'in one moment' while the ear perceives a succession of elements.

Very likely Semper was prompted to make this remark by the memory, from his schooldays, of Lessing's *Laocoon*, which tried to erect an unsurmountable barrier between the arts of space and the arts of time. Following the lead of the English critic James Harris, Lessing opposed the comparison between poetry and painting on the grounds that the one unfolds in time while the other is intended to be perceived at a glance. If he were wholly right the comparison between repeated sounds and repeated shapes would indeed be illegitimate and all attempts to find points of contact between design and music would have to wait for the realization of Brewster's machine, when configurations could recur in time rather than in space.

But we have seen in the preceding chapters that matters cannot be quite so simple. The fixating eye takes in only a relatively small area, and scanning a repeat design takes time. Where Lessing and those who followed him erred was in equating perception with sensation. They thought of the eye taking a snapshot and of the ear registering successive sounds like a gramophone record. But our perception can never be explained in terms of momentary stimuli. It is not the impression we receive at any particular moment in time which determines our experience, but its relation to our memory and our anticipation. Without these resources of our mind neither the arts of space nor those of time could ever have come into being. Even the perception of a regular row of dots depends on our ability to compare what we have just seen with what we are seeing at the moment and also with the continuation that we expect. There is a genuine analogy here with the perception of rhythmical sounds, since the idea of rhythm depends on the memory of a time interval, and our ability to hold this memory in anticipation of the next sound. This capacity of the human mind to defeat the flux of time and to perceive events which, strictly speaking, no longer exist, provoked St Augustine to some of his profoundest meditations on the nature of time. He realized that even in calling one syllable long and another short we are comparing sensations which have vanished. We are no doubt aided in this feat by what has been called the iconic or 'echo memory', the continued presence of a sensation in our consciousness before it fades and is filed in the long-term memory store. If this were not the case we could not have a mental image of a movement, a signal or a word. In this respect Wornum and Semper were not quite wrong when they compared recurrent shapes with recurrent notes.

Admittedly few experiences are more difficult to put into words than is our reaction to temporal patterns. Listening to a familiar piece of music we may feel or sense the next phrase appearing over the horizon as it were; we anticipate its shape and perhaps also its mood while still listening to the notes which strike our ears. It is impossible even to hint at these elusive matters without resorting to metaphors; we need not feel guilty about this, for without this device language could never be made sufficiently supple to describe what may be called the inner world. But metaphors have a way of solidifying and being too easily accepted by the memory as hard reality. And yet it may be worth while to take this risk and

to scan the preceding chapters dealing with spatial orders for what they may offer by way of genuine analogies or at least of helpful metaphors which could illuminate the *paragone* of our own days, the continued aspiration of the visual arts, both static or kinetic, to rival the miracle of music.

3 *Song and Dance*

Some of the common denominators between the sense of order in its spatial and its temporal manifestations were the subject of the Introduction, where examples were given of the inestimable advantage all organic life derives from the generation of such regularities. It is because we can create orders that we also recognize them and respond to deviations. The match or mismatch between these internal pulsations and external rhythms is reflected in our fluctuating attention, which ranges from automatic assimilation to heightened awareness. The way an impression can fuse with our ongoing rhythms is well illustrated by a 'catching' tune which keeps running in our head as a background to all we are doing and asks to be hummed, almost against our will. Such a compulsion suggests the metaphor of a chemical union—as if the moods and movements of the mind latched on to affinities in the flow of sensory experience. On the other end of the scale there are regularities and rhythms which the mind tries in vain to assimilate because they go 'against the grain'.

What also emerged in the considerations of these effects of the sense of order is the crucial role of hierarchies in the achievement of conscious control. Laughing, sobbing, jumping with joy or stamping in anger are still close to primitive reflexes, but once these repetitious elements have been fitted into larger units which are repeatable in their turn, we approach the creation of patterns in space or in time; the craftsman's skill in the movements of plaiting, weaving or lacemaking can justly be compared with the movements of a dance in which the individual steps are grouped into complex figures to be repeated or varied at will. If proof were needed that there are solid grounds for this comparison it could be found in various country dances which are accompanied by pattern-making. In one of the English Morris dances the regular crossing of swords results in the formation of a star of interlocking blades, which is triumphantly held aloft at the end. In certain maypole dances each of the dancers holds the end of a coloured ribbon attached in the centre and their gyrations result in the weaving of an interlacing canopy, which the second movement of the dance disentangles and dissolves.

But unlike the movements of the craftsman, those of the dancer are basically movements of response. We dance to music, and we could not do so unless we had the capacity to grasp and predict the rhythm of the piece much as dancing in pairs requires sensitivity to the intentions of the partner. I have stressed the importance of forward matching, the construction of internal models which govern our anticipations and also our surprises, by citing the movement of a horseback rider who learns to move in unison with his mount. Dancing embodies more complex hierarchies of movement, but fewer than does design, for the regularities of the dance are partly governed by the laws of nature and the capacities of the human body. Watching somebody jump we expect him to come down—after all he cannot stay up in the air—and the height of his jump will be limited by the strength of his muscles. To be sure the dance, like every art form, is likely to press against the limitations of nature. The skilful dancer will seem to defy nature's laws by feats of strength and balance which surpass our expectation and make us hold our breath. What distinguishes dancing from athletics here is precisely that the performance will fit into a rhythmical sequence building up to a climax or leading away to a point of relaxation. The repetition itself betokens control. There is nothing random, nothing fortuitous in the movement of the great dancer, we can return to watch him again performing his showpiece. Where this

control is most needed is in the interaction of the dancers, the interweaving of configurations which must be well rehearsed and thoroughly mastered.

In all this activity music still occupies a subsidiary though essential position. It serves as guidance and support. The units of movement, the steps, follow a sequence of articulated sounds, which are sometimes enhanced and regulated by the accompaniment of stamping, clapping or percussion. What is needed is noise rather than tones.

It is not unreasonable to link the distillation of noise into tone with the capacities of the human voice, and specifically with the song. It was through its marriage with language, and specifically with poetry, that music achieved its sublimation. It is in language that man has learned to select a restricted number of sounds from the vast array of noises he can produce and to shape them into phonemes, the building blocks of articulate speech. This selectivity is of the utmost importance for any discussion of pattern-making in language and therefore in music. The child first enjoys unselective babbling, the rhythmical utterances of noise which are still close to organic rhythms in laughter or in play. But with this play there also appears the pleasure in increasing mastery, to which Freud in his analysis of verbal jokes attached such importance. Baby language still bears the traces of this mastery emerging from repetition in words such as papa, mama, gee-gee or tata. But here repetition no longer serves the pure pleasure principle. It facilitates and betokens control and intention, much as we found in the function of visual signals.

Not that the adult ever forgets the pleasures of sheer phonetic play. The jingle, the nonsense syllables, the 'hey and a ho and a hey nonino' of Shakespearean songs, are the equivalent in language of the flourish in ornament and in dance. There is a natural transition here to the 'chant' with its tendency to rhythmical repetition as an expression of emphasis and emotion—we need think of nothing more solemn here than the ritualistic chorus 'for he's a jolly good fellow' which sounds quite natural, though it looks odd enough in cold print, particularly if the repetitions are lined up and counted as follows: 'For he's a jolly good fellow (1), for he's a jolly good fellow (2), for he's a jolly good fellow (3), and so say all of us (1), and so say all of us (2), and so say all of us (3), for he's a jolly good fellow (4) and so say all of us (4).

The repeat pattern, the rhythm and the tune of this homely chant may stand for many others. The melody goes up after (3) with an ascending flourish over fe-el-low and descends to the initial baselines for the confirmation of universal assent.

Humming any familiar old tune the reader is likely to recognize the same basic grouping of twice four phrases making for an 'eight bar period'. Nursery songs like 'Baa, baa, blacksheep'. Christmas carols like 'Good King Wenceslas', patriotic ditties like 'Yankee doodle' and marching songs like 'John Brown's body' all conform to this basic structure and so do many more sophisticated songs in strophic form.

4 Nature and Artifice

Where music thus remains wedded to speech and speech-rhythms its freedom is limited to the kind of flourish I have mentioned, which can be carried by a word or syllable without impairing intelligibility. Even so there are the seeds of a conflict here which pervades the whole history of music—which is to be the master? The words or the music? The meaning or the form? The tensions can be productive of much artistic ingenuity, but they also led to violent debates, particularly when they were linked with the perennial issue of 'nature' versus 'artifice', which recurs in the criticism of all the arts.

We have encountered in Chapter I such attacks on the excesses of decoration, on the display of virtuosity in ornament and design. It will be remembered that this debate had its analogue in rhetoric, where the playfulness and bombast of Asiatic oratory were contrasted

with the virtues of plain speaking. Music became particularly vulnerable to the charge when polyphony became a domain of the theorists in the later Middle Ages. As in the case of ornament the excessive intricacy which resulted was attacked on the authority of classical aesthetics.

The Florentine 'reform movement' which led to the evolution of opera in the late sixteenth century is a case in point. Accepting the ancient accounts of the power of music over the emotions at their face value, Vincenzo Galilei in his *Dialogo della Musica Antica e della Moderna*, 1581, enquires why such effects can no longer be observed and blames polyphony for this decline. He rounds on the 'abuses and impertinences' of the *contrapuntisti*, who by their ambition for novelty and their mindless artifice have corrupted the purity of song. Unjust and uncomprehending as his strictures are, we owe to the cause he championed the operatic aria, which, in its turn, was translated into instrumental music by the eighteenth-century symphonists.

Notoriously it was opera, by that time, which seemed ripe for a reform according to classical ideals. Gluck's famous manifesto contained in the Preface to his *Alceste* (1769) echoes the principles we encountered in the Neo-classical opponents of Rococo decoration: 'I . . . thought that my chief endeavour should be to attain a grand simplicity, and consequently I have avoided making a parade of difficulties at the cost of clarity.'

Needless to say, attacks on intricacy and artifice pervade all the arts and *mores* of the eighteenth century, whether we think of the new epistolary style or of Wordsworth's hostility to poetic diction. But just as we noticed in discussing the eighteenth-century reaction against ornament that it stopped far short of a functional style, so the plea for naturalness did not aim at abolishing decorum, let alone art itself, either in poetry or in music. It took a long time for the pendulum to swing so far the other way.

It will be remembered how these tensions between discipline and 'nature' expressed themselves in the writings of Victorian critics, notably in those of Ruskin. The contrast on which he insisted between mechanical perfection and spontaneous expression certainly has its genuine analogy in musical criticism.

Nor need we immediately resort to metaphor in applying to music the issues discussed in Chapter III, *The Challenge of Constraints*. The pleasure in courting admiration by pressing against the limits inherent in the materials, the instruments and even human endurance is common to artistry in all the arts. The virtuosity of the craftsman is here matched by that of the word-smith or the composer. In his classic *European Literature and the Latin Middle Ages* Ernst Robert Curtius gives examples of this kind of *tour de force* in Western poetry—no more appealing to modern taste than Grinling Gibbons' lace cravat carved out of wood (Plate 16). Thus a Greek poet of the sixth century B.C. is said to have written poems in which no 's' appeared, a piece of virtuosity overtopped in late antiquity by a version of the Iliad in each book of which one letter of the alphabet did not occur. Maybe the game was not worth the candle, but both decorative art and poetry know of examples where such obedience to self-imposed rules blossomed into real mastery—it was Nietzsche who spoke of poetry as a dance in chains.

Where the challenge of the medium appears to be unique in music, is in the limitations of its elements. Music, after all, does not consist of noise or even sounds, it rests on the few tones of the scale and its modifications; whether we think of the twelve tones of an octave in Western music or even of the seven octaves which make up the average compass of the keyboard, their number seems small when compared to the range of elements available to the designer, but the number of combinations is a different matter. There exists a form of tonal pattern-making somewhat distinct from music, but instructive as a point of comparison: I refer to the practice of 'ringing the changes'. In this tradition a series of between five and twelve church bells, tuned to the notes of the major scale, are pealed in

succession according to the rules of permutation. I take the example described in Grove's *Dictionary of Music* as the 'elemental basis upon which the science of change-ringing is founded':

```
1 2 3 4 5      5 4 3 2 1
2 1 4 3 5      5 3 4 1 2
2 4 1 5 3      3 5 1 4 2
4 2 5 1 3      3 1 5 2 4
4 5 2 3 1      1 3 2 5 4
               1 2 3 4 5
```

The figure 1 can be seen to advance or 'hunt up' in the first series and to recede again (or course down) in the second. I also learn from the same entry that the number of changes possible on twelve bells is 479,001,600.

Change-ringing is a somewhat extreme example of that enjoyment of permutations which links all the arts with elementary play, combining as it does the pleasures of variety with the pride in ingenuity and control. Both these elements are given scope in Mozart's musical dice game, in which the motifs can be shuffled at random, resulting every time in an acceptable composition. A poetic analogy may be found in the story of the Moghul ruler Babur amusing himself during an illness by writing a couplet in his native Turki and then reorganizing it in five hundred and four different ways. We have seen that the opportunities of displaying similar prowess attracted designers in the 19th and 20th centuries who produced varied sequences of serial designs (Figs. 90, 91). There is more than a loose analogy here with the musical form of variations on a theme, where we find all the resources of the medium exploited—speed, rhythm, volume, pitch, timbre, taken singly or in combination and surprising us by the exponential growth of possibilities, which far outstrips the dimensions of colour and scale in design. But just as in pattern-making we encountered the operation of stringent geometrical laws, allowing the craftsman, for instance, to cover a floor with equal triangles, squares or hexagons (Fig. 70), but not with pentagons, so there are only a limited number of tones which can be sounded simultaneously without producing a discord.

Ultimately, however, these comparisons are more telling for the differences they reveal than for their similarity. For while the geometrical grid itself is a design—albeit an elementary one—the sequence of tones or consonances itself is not a composition. The story was told in 19th-century Vienna of a foreign potentate who said that what he enjoyed most at the opera was the sound of the orchestra before the overture, in other words the tuning. Most of us expect the musical piece to be more selective. We may call it a second-order pattern, an order superimposed on the ordered sounds, much as the Islamic or Peruvian designer may change and vary the geometrical motifs with which he operates (Col. Plates IV, V). It is the interaction of the second (or third) order with the given tonal structure which leads to effects so varied that one might think of the moiré pattern as a comparison (Fig. 108), only to reject it because these fluctuating configurations are not easily predicted and controlled.

It is more appropriate here to remember the feat of counterchange (Figs. 99–105), the skilful contrivance of figures which are identical with the shapes left void as ground between them. The simplest forms are chequerboard or key-patterns, which may perhaps be loosely compared to canons or 'rounds', but the lure of complexity drove both designers and musicians to invent more subtle interlocking motifs. There is a mosaic from Cairo (Fig. 350) which may be said to transcend mere ingenuity. It shows the letters for 'Allah' arranged in such a way that they appear both as figure and ground, as if to proclaim that God is everywhere. There is a touch of sublimity here which may remind us of one of the mighty canons by a master of church music.

We need only try to take this analogy seriously to see how poor it really is. Something happens in such a canon, to say the least it has a beginning and an end. The theme is intoned and other voices join in building up the pattern in ever increasing richness, till the tension finally subsides in the concluding chords. The absence of the time element in design must of necessity limit the effect.

But whatever may be true of pattern-perception, pattern-making happens in time. In discussing procedures in design I have proposed to distinguish between composition and decoration, applying the first term to the establishment of structures, the other to their subsequent elaboration and enrichment. In music the term 'ornamentation' is used precisely in this sense, it does not affect the structure such as the harmonic progression of chords, but it adds flourishes, 'grace-notes' or embellishments. But neither in visual patterns nor in music can the distinction always be upheld. The embellishment of a motif may acquire structural importance, and if we keep our eyes and our ears open we shall find that such methods of hierarchical enrichment as are exemplified in our Fig. 85 can have profound aesthetic effects. They rest, I believe, on a subtle balance between the expected and the surprising. The structures of rhythms and harmonies still correspond to our 'forward matching' but while we are thus reassured we are also delighted by enrichments we could not have anticipated.

What may look at first like mere 'filling in' can turn in classical music into a poignant means of added emphasis, like the insertion of an extra word in a familiar phrase. 'He is a good fellow, a jolly good fellow,' or 'a good fellow, a good good old fellow'; if not 'a good, old, silly fellow'. Which brings us conveniently back to the question how such hierarchies are perceived in any of the arts, discussed in Chapters IV and V of this book.

5 Form, Rhyme and Reason

The burden of this book has been that our sense of order serves us to discover and exploit the regularities pervading our environment, regularities which dovetail with our expectations or sometimes clash with them. Human artifice tends to exhibit more regularities than our natural environment, and human art more than most other forms of artifice. We have seen (Chapter IV) that this prevalence of rules has made it possible to apply to art some of the techniques evolved for the theory of information, which is based on the calculation of probabilities that a certain event will occur within a selected set of possibilities. The amount of 'information' (in the technical sense) will be in inverse proportion to the probability of a signal arriving, so that the fully expected signal will carry no information and will be classified as 'redundant'. It was mentioned that these matters can best be illustrated and explored by means of 'guessing games' which demonstrate the ease or difficulty of completing an incomplete pattern. We may here recall the scholars who play this game in earnest—papyrologists trying to puzzle out a text from the fragmentary evidence preserved on a tattered papyrus. In such a situation a grasp of the rules used by the writer is half the battle. If a legal text follows certain formulas, a few words will suffice for recognition, and if the text is a litany or a chant (like our paradigm) the repeated words will be wholly redundant. What is more interesting is the relation between stringencies and redundancy. If the text is in verse rather than prose the decipherer, like the original poet, has to look for a word which meets the requirements of both meaning and metre, and if by chance the papyrus contains one of the virtuoso pieces of verbal artifice mentioned by Curtius, the scholar has to pit his knowledge of the language against that of the author. Not long ago a few fragments turned up in a papyrus which exhibited such a strange choice of words that the learned reader remembered the trick of writing verse omitting a certain letter of the alphabet. There was no sigma anywhere, and so all words with that letter were ruled out for the reconstruction. We are not all papyrologists, but we are all conversant with the task of reconstructing a text from uncertain fragments. I refer to the effort of reading the faded palimpsest of our memory. It is in trying to remember that we experience the value of 'redundancy', of patterning according to rules. Prose is much harder to recall than verse. It is notorious how hard it is to reconstruct a conversation word for word even after the passage of a few minutes, but a meaningless jingle may lodge itself in the mind on first hearing: 'Till May be out, Ne'er cast a clout.' Few of us are in the habit of referring to our clothes in these terms, nor are we likely to consult the calendar rather than the thermometer in these matters. But the rhyme has preserved the quaint words and the advice in the folk memory and in our own.

Nobody would claim that we needed the theory of information to discover the value of order for memorizing. What it has enabled us to describe is the role of probabilities, of gambling and guessing in our forward matching. It is all-important in listening to speech that we can remember and hold what has gone before sufficiently long to construct the meaning of the sentence, the phrase, the paragraph. We could not relate the predicate to the preceding subject, the adjective to the noun, unless they were simultaneously present in our mind. Listening to speech always confronts us with a series of completion tests—Ne'er cast—what? till May is—what?—and it is here that our attention fluctuates as we are keyed

up for information or relax once we have stored it away. The patterning of speech in any type of chant or poetry reflects and facilitates this alternation.

> In winter, when the fields are white,
> I sing this song for your delight—
>
> In spring, when woods are getting green,
> I'll try to tell you what I mean.
>
> In summer, when the days are long,
> Perhaps you'll understand the song:
>
> In autumn, when the leaves are brown,
> Take pen and ink and write it down.
>
> (Humpty Dumpty's song)

In a way we are cheated of the meaning but we are not left unsatisfied. There is good sense in the condemnation of an utterance as having neither rhyme nor reason. Rhyme, up to a point, can substitute for reason because it narrows our expectation and keeps us active. True, if we can always foretell and never receive a jolt of surprise we fall asleep, a situation wittily summed up by Alexander Pope in his *Essay on Criticism*, where he makes fun of the 'tuneful fools':

> While they ring round the same unvaried chimes
> With sure returns of still expected rhymes;
> Where'er you find 'the cooling western breeze'
> In the next line it 'whispers through the trees'.
> If crystal streams 'with pleasing murmurs creep'
> The reader's threatened (not in vain) with 'sleep'.

It was to avoid this risk that poets such as Byron enjoyed playing with the most outrageous and unexpected rhymes:

> Her favourite science was the mathematical,
> Her noblest virtue was her magnanimity,
> Her wit (she sometimes tried at wit) was Attic all,
> Her serious sayings darken'd to sublimity.
>
> (*Don Juan*, Canto I, XII)

One is entitled to wonder whether future papyrologists would be able to reconstruct the end of the third line if it had been lost, but once we have read it we are likely to remember it, particularly if we followed the poet actively and became keyed up while reading, wondering how he would extricate himself from this self-laid trap.

We have seen that it must be easier to describe these verbal patterns in the terms of information theory than to do the same with visual structures. After all, any language employs a strictly finite set of phonemes, words and grammatical forms, while the designer has unlimited scope in the choice of lines, shapes and colours. But we have also seen that historically this freedom is limited by the conventions of styles, in the choice of motifs and their use in decoration. We become conditioned to certain combinations or 'chunks', we learn what goes with what and to expect a frame for a picture, a border for a rug and margin for a text. Thus architectural elements in particular have their expected terminations in the shape of bases or crowning devices. The façade by Loos which defied this expectation (Plate 2) was characteristically satirized as a house without eyebrows.

It is in music, however, that the interplay between expectation, surprise and fulfilment has become the very stuff of art. Even rhythm alone offers scope for this skill as we are set to

expect simple recurrence as in our chant, or a progression in tempo, volume or complexity. The very restriction of the musical scale enhances the game which was refined step by step in the development of Western music. The introduction of polyphony in mediaeval music led to a crucial resource—known as the cadence or the close—a progression of chords towards a harmonious consonance, which came to be expected, for instance, in the responses sung by the choir during the liturgy. The further enrichment of the system in sixteenth-century polyphony is lucidly described by Donald Tovey in his entry *Harmony* for the 13th edition of the Encyclopedia Britannica.

'Imagine a flux of simultaneous independent melodies, so ordered as to form an artistic texture based not only on the variety of the melodies themselves, but also upon gradations between points of repose and points in which the roughness of the sound is rendered interesting and beautiful by means of the clearness with which the melodic sense in each part indicates the convergence of all towards the next point of repose.'

This periodic convergence towards a point of repose led to the creation of increasingly extended coherent musical structures, to which I shall return. Here we may be satisfied with the analogy of the rhyme and of the forms of termination used by designers. All these methods of forward matching, of betting on the next move, invite comparison with the techniques studied by the theory of information. Attempts have not been lacking to analyse musical styles by these techniques and to measure at least statistically what chances we have with any musical style correctly to predict what comes next. We have seen that the tendency to rhythmical groupings of the material into periods of 'eight bars' allows us a fairly safe bet in simple music for the prediction of a 'close', though we may be less sure how the tune will move to the end. The trouble is that here, as with poetry or design, measurements tend to be more reliable with uninteresting than with interesting works. It could not be otherwise. Tovey once suggested that it was always worth while to play a few bars of a great piece of music and to reflect at which point one became sure that the composer was no fool. Surely it comes when he offers a solution which we could not have thought of and which still fits the structure of the design to perfection. We might say that the demands of continuity and the surprises of discontinuity must be perfectly reconciled, which brings us back to the perceptual analysis of effects as they govern the various media.

6 Elementary Effects

The preceding section with its emphasis on memory and expectation has taken us far from the effects of design discussed in Chapter V. Even in static patterns, however, we discover elementary analogies which are genuine. In music no less than in design there is an even transition from texture to pattern and on to architectural structure depending on our perceptual grasp. Recurrent elements too small to distinguish singly result in the impression of texture, exemplified by such devices as vibrato, tremolo or the trill.

The chapter concerned turned on the notion of 'continuity monitoring', implying that our mental apparatus is set somewhat like a homoeostat indicating 'no change' until a break in continuity demands and arouses attention. There is no need to spell out the application of this principle in music except to recall the many dimensions along which change is possible—the most primitive and superficially effective jolt being volume, whether in the opening or closing chords or in the sudden forte of Haydn's Surprise Symphony certain to arouse even the most somnolent concert-goer. In any medium change can become so frequent and abrupt that it leads to an overloading of the system, an impression of confusion or at least of restlessness, while the right dosage of continuity and change makes for ease of perception experienced as clarity.

In either case training can alter this reaction. Once we have learned to recognize certain

motifs—ornamental or musical—their recurrence will guide our perception. But what is too easily recognizable also soon fails to alert us, so that we find it impossible to attend. Musical compositions lack one effect which we found to be of great relevance to design, the perceptual alternation between figure and ground familiar from the chequerboard. It is true that in listening to repeated sounds such as the ticking of a clock, the dripping of a tap, or the rumbling of a train, we feel compelled to subdivide and shape the flow of identical impressions by projecting alternative rhythms. In music, however, generally it is the performer who sets the accents according to the demands of the score: there is no choice but to follow the auditory patterning.

Neither is there an exact analogy in music to the most important resort of the designer, symmetry and the resultant impression of balance. At any rate the perception of symmetry in music is confined to the brief time span we can hold in our echo memory. We may hear a scale or a chord ascending and then descending to the baseline, we may more intuitively relate the up and down of two corresponding phrases to the speech-melody of question and answer. 'Baa baa blacksheep, have you any wool?—Yes, Sir, Yes, Sir, three bags full.'

The term 'symmetry' or 'architecture' is also used in the description of large-scale symphonic structures with their repeats and recapitulations, but though their effect is based on the same kind of recognition which plays its part in visual symmetry they are not oriented in opposite directions as is the case in design. True, ever since music could be written down, long truly symmetrical sequences could be planned by composers fond of artifice; the device called 'cancricans' (moving backwards like a crab) has been developed and displayed in early and in modern music, but it is certainly much easier to see it on paper than to take it in by ear. An inverted sequence of tones mostly eludes recognition. For naturally music like all the arts of time is relentlessly asymmetrical: it goes from the beginning to its predetermined end and the more cogent its structure, the more it makes us sense this directedness from the start. There would be little point, then, in seeking for further analogies between static design and musical composition were it not for the fact that we found that an element of directedness could even be injected into design. It is the transition from geometrical form to representational motifs which leads to this feeling of orientation—once a motif can be seen to have 'head or tail', or suggest a growing plant, a fluttering ribbon or a hanging tassel, the ground ceases to be neutral and becomes a three-dimensional space.

7 *From Fields of Force to Worlds of Sound*

In Chapter VI, I described the way such motifs singly or together create what I called a 'field of force'. It so happens that this metaphor also fits the characteristic of music I left to the end, I mean tonality. This was the medium which permitted and inspired the greatest creations of Bach, Gluck, Haydn, Mozart, Beethoven and Schubert within the incredibly brief span of a single century. I can think of no parallel here with any other art.

The Western system of tonality may be regarded as a joint product of the laws of acoustics and of the force of habit discussed in Chapter VII. I have referred to this force when mentioning the device of cadence or closure providing a point of repose between harmonic tensions. It appears that it was through a further process of natural selection that certain of these sequences established themselves as preferred forms. Continuing to keep close to safe and accessible authorities, I shall here quote from the entry on *Harmony* by George Dyson in the third edition of Grove's *Dictionary of Music*: 'Once these tonal cadences were accepted as stable harmonic conventions, it was possible to build on them a tonal system. They affected inferentially all neighbouring progressions and they helped to give to a whole movement an acknowledged harmonic direction.'

Here my principal guide and mentor, Sir Donald Tovey, suggested an analogy in the visual arts: 'The nearest parallel to tonality I can find in other arts or senses is perspective. . . . The correctness of the perspective depends upon the painter's having referred all the objects of his picture to one horizon . . . the vanishing-point of all lines being within the picture in the middle of its horizon . . . There are plenty of beautiful pictures that imply a different horizon for each item that can be viewed separately; and while we label the masters of such art primitive, we have outgrown the philistinism that prefers consistent perspective to all decorative merits.' 'A musical composition in classical tonality has a tonic chord, which will normally be the final chord of the whole, and round which all other chords will be grouped in definite relation.'

Admittedly these relations must be heard rather than described. What can be said in words is that the tonic of which Tovey speaks corresponds to the first and last tone in an ordinary scale—the *do* in *do re mi fa sol la si do*. The last tone before the return of the *do* on the octave is called the leading note. It carries with it a strong expectation, in fact a desire for the completion of the scale and return to the tonic, remotely comparable, perhaps, to a recital of the alphabet ending with y rather than z. The story goes that young Mozart could always be got out of bed by someone playing the sequence on the piano as far as the leading note and omitting the tonic. He had to get up to play the missing note. The anecdote splendidly illustrates another aspect of what I have called the Popperian asymmetry. If the sequence had corresponded to the boy's 'forward matching' it would hardly have registered, but the failure to match provided the jolt.

The leading note, which so strongly demands the appearance of the tonic, is part of the chord called the 'dominant'. A movement from tonic to dominant and back again is the kind of alternation familiar to all of us from 'strumming' accompaniments which may strike us as too obvious for our attention, the kind of sequence that has been described as 'musical wallpaper'. Yet most simple chants or tunes of the kind I have mentioned are rarely moving further within the hierarchies of harmonies; at the most they take in the third major chord that can be built on the diatonic scale (the 'subdominant') before they return to base.

In the music of the masters, on the other hand, the three chords mentioned are merely the principal landmark in a system of affinities in which certain harmonies are felt to relate more closely or more remotely to others before or after. Movement away from the tonic is experienced as tension, returning as a home-coming, a resolution, though the composer can and often does contrive to establish intermediate plateaus, temporary resting points, after he has 'modulated' to another key and all but made us forget our point of departure until he allows us once more to discern it in the distance and anticipate its re-appearance with a feeling of 'journey's end'.

One wonders whether Tovey would have accepted the conclusion that his analogy implies no more and no less than that the movement of tones and motifs within the ordered system of harmonic relationships resembles our experience of the external world: our surroundings change in aspect, distance and illumination without losing their identity.

This suggestion may have something in common with Schopenhauer's metaphysical belief that the world of music presents a parallel creation, another manifestation of the Will, such as is Nature. Unfortunately he spoilt his intuition by taking it too far, for instance by identifying the musical scale with the ladder of being, but there are also beautiful insights in his pages. Music for him symbolizes the constant transition of the will from desire to satisfaction: it rapidly generates a new desire, continuously moving along a thousand different paths away from the tonic before the final return. However we choose to describe these effects, there can be no doubt that they relate to our capacity for orientation, the same sense of order which is also engaged in our reaction to our physical environment. There is thus good reason for the romantic assertion that the composer 'opens a whole world before

us'. Admittedly this interpretation does not come within a mile of explaining the effects of tonality, such as the character of the major and minor modes. 'How astounding'—says Schopenhauer rightly—'that the change of a semitone, the entry of the minor third instead of the major, produces in us immediately and inevitably a feeling of anxiety and unease from which we are released with equal immediacy by the major!' Attempts have been made to relate this particular reaction to the experience of relative disorientation connected with this change—we are slightly less safely guided towards the next step. But though the suggestion is interesting it still leaves the values of music unexplained. It remains a fact, as I said, that music can only be described metaphorically. What in English is called 'major' and 'minor' is described synaesthetically in German as *Dur* (hard) and *Moll* (soft). The whole vocabulary of music is soaked in metaphors, whether we speak of 'high' and 'low', 'sharp' and 'flat', crescendo (growing) or allegro (cheerful). We need not apologize, therefore, if we continue to review the operations of the sense of order in decorative art in search for further metaphors. One such metaphor occurred in a passage from Owen Jones quoted in Chapter II. In his discussion of the features which give a grid pattern the desired characteristic of 'repose' he compared the underlying squares to the 'leading form or tonic'. The comparison can be given more substance if we remember the influence which the border and orientation of a grid pattern can have on our reading of the whole (Figs. 143, 144)—the geometric organization perceived is influenced by the initial impression, much as the composer established the tonic by the opening chords.

Geometrical motifs need not be two-dimensional. They can be represented in complex spatial relationships as in such abstract compositions as Cunningham's awkwardly titled 'bent space' (Fig. 351), which uses a chequerboard pattern as a space probe. One might be reminded here of certain forms of 'geometrical' music, in which a simple tonal pattern is sent

around the tonal space as in certain preludes by Bach; yet the great hierarchies of order he explored were only made possible by a departure from natural order: in purely acoustic terms the tones belonging to different keys are not always quite identical. But these differences have been ironed out in the conventional system of 'even temperature', which permits the playing of all modulations on the keyboard. This slight blurring of acoustic distinctions, it turns out, does not destroy the 'field of force'. On the contrary, it allows the composer to extend his range of modulation to other keys and back again without marked discrepancies. The technique is relevant to our topic, because the transition from one key to another is effected across a chord which belongs to both keys but sounds different when it is heard in the context of one rather than the other. This so-called 'enharmonic change' might therefore be compared without too much strain with our old friend, 'Rabbit or duck?' (Fig. 165), particularly since here too the different readings suggest different directions.

I have discussed in Chapter VI in what further ways the introduction of representational elements into decorative design influences our perceptual response. We instinctively place them into a spatial context and gravitational field. The flower rises, the swags hang down heavily. There is something analogous in the experience of chords 'gravitating' towards the tonic, indeed the alternation between tonic and dominant reminds one of a ball bouncing up and down. We have seen, however, that in decoration the field of force can be altered where the organizing pulls between centre and border create their own frame of reference, replacing the normal orientation of the motif. Within such a field the dimensions of up and down are suspended as it were, as they can be within musical space through the device of extended modulation. Remembering the distinctions of Chapter VI we might say that gravitation acts on things rather than on shapes, and I suggest that the 'things' in musical space which correspond most closely to representational motifs are what we identify as melodies. The melody, the tune, which has a definite shape of its own, is grasped as a whole like any of the motifs of decorative art. We have briefly encountered the basic structure of simple tunes in discussing the chant and the song with their tendency to forming two groups of four—the eight bar period which is experienced as a unit, complete in itself but capable of being joined to others.

Once the tonal space was firmly established both theoretically and psychologically, it was ready to accommodate not only geometrical forms piled in 'sequences' but tunes which would lodge in the memory before they were put through the paces of harmonic changes. Even a number of such tunes could be used as thematic material without the listener missing the thrill of recognition in change. They could be broken into snatches, pulled about or interwoven and yet preserve enough of their identity to reveal their derivation, if not at the first hearing at least on closer acquaintance. This, rather than a knowledge of technical terms, is what is meant by understanding a composition and it is on this cumulative enjoyment that the effects of great music largely rest. From the first we delight in the themes, and though we may not be musically schooled we relax and look forward to what is going to happen next. Here also lies one of the main differences between the arts of music and design which was overlooked by writers such as Wornum. It is not only recurrence we expect of music, but change. So deeply is this expectation implanted in us that there is no more effective device for the creation of suspense in classical music than the cessation of change and the repetition of a single sequence of tones or chords. We feel that such a preparation must herald a profound revelation and we are rarely disappointed. There is some analogy here with the resource of 'positional enhancement' I discussed in connection with the field of force, but both the frequency and the impact of the device are hardly commensurate.

The fact must be faced that there is no valid parallel in the art of design to the way the classical composer developed a theme. The variations in colour and context in Peruvian

textiles (Col. Plate IV), striking as they are, are left far behind. If one is to speak of analogies they could only be found in the secular developments of motifs such as were discussed in Chapter VII. The vicissitudes of the palmette scroll as told by Riegl, its transformations and re-interpretations over a thousand years, would be telescoped into a single movement of a symphony. Where the parallels with traditions discussed in the same chapter are less strained is in the role which the force of habit plays in musical as well as other artistic genres. It is the convention which makes departure from the expected expressive and impressive.

The direction of these departures was discussed in Chapter VIII under the heading of style. The history of music appears to justify the pluralistic approach advocated in that section. The invention of perspective in painting for instance preceded the establishment of tonality by some 200 years. Much of the development of music can best be explained as an autonomous sequence, though Gluck's plea for 'simplicity' which I have quoted certainly links up with Neo-classical aesthetics, discussed in Chapter I.

Points of contact are more easily established between music and some of the topics discussed in Chapter IX dealing with symbolism in decoration. Both follow the laws of social decorum. The funeral march is slow and solemn, a military march is rousing and fast. Apart from some emblematic elements (extended in 'programme music') the determining factor in instrumental music is the social context from which the forms derive. The minuet, the hymn, the pastoral, the aria, are all associated with moods which the composer can accept or modify much as the decorator can treat the music room, the boudoir, or the garden house by accepting or flouting conventions.

It is fitting that in this recapitulation we come back to the topic of representation as it is treated in the tenth and last chapter, which centres on the grotesque, the free fantasies of the designer which never lose contact with what I have called 'animation'. We have seen that it matters little who chases whom among the fantastic creatures of the inhabited scroll, nor whether the pursuit is one of love or of aggression. We are involved in a freely created world full of surprises and changes of mood like a musical movement. Our reaction to the flourishes of Dürer (Figs. 301, 302), the grotesques of van Vianen (Fig. 349) or the

Fig. 352. Jean-Baptiste Pillement: pages from the *Cahier de Cartels Chinois.* about 1770

Fig. 353

whimsicalities of Pillement (Fig. 352) has nothing to do with 'meaning' in the conventional sense. They appeal to our sense of balance, our feeling for scale, our search for the familiar in the unfamiliar. In this respect the grotesque comes closer to the condition of music than those abstract repeat patterns which Wornum singled out for comparison, or the colour-music of which the Expressionists dreamt.

It seems to me no accident that the one twentieth-century pioneer who understood the role of representation in the composition of near-abstract configurations was Paul Klee, who was also a musician. Though the pattern came first in his building from elements, he assigned it a title, a direction, a potential weight or scale by taking some element from the visual world. One instance must suffice: the pattern (Fig. 353) looks like a free distribution of elements such as a non-objective artist might enjoy making. It is an incomplete Paul Klee (Fig. 354). In the completed version, which may well have been an afterthought of the artist, the shapes fall into place, our interpretation is guided, we can empathize and feel the thrust of the direction together with its emotional impact. The drawing carries Klee's caption 'beyond and upwards'. It could easily be the title of a piece of music.

It seems to me inescapable that neither the painter nor the musician can simply switch off the field of force without having his resources severely curtailed. He can still create patterns, but he can no longer relate them to our expectations. Much ingenuity and imagination has certainly gone into alternative systems like the creation of serial orders composed of 12 neutral tones, but I remain unconvinced that these experiments have justified the dismantling of one of the greatest inventions of mankind, the tonal system.

One argument often adduced in favour of this and similar radical moves seems to me fallacious on both historical and theoretical grounds. I refer to the claim that the possibilities of the tonal system have by now all been exhausted. Remembering the laws of permutation discussed in relation to snow-crystals (Plates 23, 24) and to change-ringing, we are entitled to doubt this assertion and history confirms our scepticism.

In the year 1770 the great musicologist Charles Burney travelled to Italy to explore the state of music there. Among the composers he met was one Rinaldo da Capua, an old man whose once popular music had gone out of fashion. As such men are apt to be, he was severe on his brother composers. 'He thinks,' Burney reports, 'that they have nothing left to do now, but write themselves and others over again; and that the only chance which they have left for obtaining the reputation of novelty and invention arises either from ignorance or want of memory in the public, as everything, both in melody and modulation, that is worth doing has been often already done.' It was no doubt true that poor Rinaldo could think of nothing novel. But then in 1770 there were certain composers, such as Haydn and Mozart, who could.

There exists a beautiful letter from Mozart to his father in which he talks about three piano concertos he had just completed (1782). 'They are exactly between too hard and too easy. Very brilliant, pleasing to the ear, naturally without lapsing into emptiness, here and there only connoisseurs will find satisfaction, but in such a way that even non-connoisseurs must feel content without knowing why.'

Returning to this topic towards the end of the letter he exclaims: 'Say what you will, that middle position, the true one in all things, is no longer esteemed. In order to gain applause you have to do things which are so easy to understand that any coachman could sing them at once, or so unintelligible that they please precisely because no sensible person can understand them.'

Mozart intimated that he would like to write a book about this subject though not, of course, under his own name. It is an intriguing thought that if he had done so, we might not have spotted the book—but of course he did not. He had more important things to do. If anyone else wanted to try his hand at that book he would first have to explain why Mozart did not want to write music any coachman could sing at once. What is too expected, too redundant, lacks interest. But there is no sense in going to the opposite extreme and writing music which is unintelligible. Even in the 'hard' parts those who do not know the reason, as Mozart says, must feel content. The contentment, one assumes, comes from their having been able to follow the music, however little they have been able to analyse the composer's moves in technical terms.

One of the great innovators of twentieth-century music, Paul Hindemith, described this experience of 'following' music in a form which allows us to look back to the comparison with language. 'While listening to the musical structure, as it unfolds before his ears, he (the listener) is mentally constructing, parallel to it and simultaneously with it, a mirrored image. Registering the composition's components as they reach him, he tries to match them with their corresponding parts of his mental construction. Or he merely surmises the composition's presumable course and compares it with the image of a musical structure which after a former experience he had stored away in his memory.'

Perhaps in his chapter on 'Perceiving Music Intellectually' Hindemith makes the process sound too rational, too much like logic. In stressing the importance of correct anticipations on the part of the listener he does less than justice to the emotional thrill of surprise, the revelation of the next step which provides a convincing continuation we could never have thought of ourselves. As a result he has to make another start in the chapter on 'Perceiving Music Emotionally', where he interestingly suggests the rhythm of our heartbeat as the norm against which we measure the feeling tone of music. But in the experience of music

Fig. 354. Paul Klee:
Drüber und empor. 1931

the two sides can as little be separated as in dance with its yielding and matching movements. Here Lévi-Strauss, in a passage too long to quote adequately, has succeeded better in describing the twin roots of our response to music in such biological rhythms as breathing and in the acquired language of musical culture.

'The musical emotion springs precisely from the fact that at each moment the composer withholds or adds more or less than the listener anticipates on the basis of a pattern that he thinks he can guess, but that he is incapable of wholly divining because of his subjection to a dual periodicity: that of his respiratory system, which is determined by his individual nature, and that of the scale, which is determined by his training. If the composer withholds more than we anticipate, we experience a delicious falling sensation; we feel we have been torn from a stable point on the musical ladder and thrust into the void, but only because the support that is waiting for us was not in the expected place. When the composer withholds less, the opposite occurs: he forces us to perform gymnastic exercises more skilful than our own. Sometimes he moves us, sometimes he forces us to make the movement ourselves, but it always exceeds what we would have thought ourselves capable of achieving alone. Aesthetic enjoyment is made up of this multiplicity of excitements and moments of respite, of expectations disappointed or fulfilled beyond anticipation—'

Like Hindemith and Lévi-Strauss, I believe that this kind of experience cannot be divorced

from our inborn dispositions. The satisfactions we owe to our sense of order lend themselves as metaphors for many escapes from tension, physical and mental, superficial and profound.

8 New Media

New media of temporal pattern-making are concurrently trying to emerge—electronic music and kinetic art. It would be interesting to see how far the tape recorder can rival the capacities of the Kaleidoscope in the form I discussed in Chapter VI, where fragments of the environment as seen through the opening are made to form patterns in multiple mirrors. Can similar tricks be performed with the untreated noises of nature? They can, but one wonders whether this extension of means can compensate for the sacrifice of those constraints and economies which we found to be indispensable for the achievements of music.

It was the inventor of the Kaleidoscope, Sir David Brewster, it will be remembered, who predicted the possibilities of a kinetic art, which was to rival music by substituting colours for tones and exploiting their emotional impact. There is no indication that the great scientist really understood what creates this impact in music. Could a visual music be developed which would not only offer a succession of moods of pleasing Kaleidoscopic patterns but set up a field of force which could lead to that interplay of expectation and fulfilment, of tension and resolution, which is the stuff of music? He would be a bold man who would dare to predict that such an experiment could never succeed. Who, after all, could have predicted Mozart's G Minor Symphony when Western music took its first steps in polyphony? Unfortunately there are few critics or kinetic artists who quite realize the complexity and the challenge of such a task. Many of these witty products seem to me to have less in common with the art of music than with another kinetic art which I have not so far mentioned: I mean fireworks, pyrotechnics. Much skill was once expended on such displays, which caused the crowds to shout ah! and oh! But the exploitation of surprise is not the same as the grasp of a system of relationships. There certainly are kinetic artists who have tried to transcend this pyrotechnic phase. Calder's mobiles are delicately poised on a pivot, the Greek Takis has experimented with magnets periodically switched on and off to produce what he called magnetic ballet, in which the elements are periodically repelled and attracted. Oliver Bevan has effectively experimented with the tension between permanence and change, subjecting a geometrical pattern to gradual shifts of illumination under polarized light and making us watch the emergence and disappearance of new configurations. More systematic methods have been and no doubt will still be devised with the help of computers to programme such machines with the right dosage of the unexpected and the expected, the random and the redundant. Through no fault of their makers, these experiments often lack what—to remain in the jargon—we would have to call 'feed-back'; a systematic criticism which does not feel obliged to hail every innovation but attempts to judge in what way, and how far, the experiment achieved what it set out to do.

The historian is not a critic and should not aspire to be one. All he can try to do is to tell the critic what the perspective of history has taught him. The study of the pattern-maker's craft no less than the study of any other art suggests that what we need is patience. It takes time for a system of conventions to crystallize till every subtle variation counts. Maybe we would be more likely to achieve a new language of form if we were less obsessed with novelty and with change. If we overload the system we lose the support of our sense of order.

Notes

For the full titles of books sometimes cited in a shortened form, see page 389

Preface

p. vii NON-OBJECTIVE ART: See my 'The Vogue of Abstract Art' in *Meditations*.

SLOVAK PEASANT EMBROIDERIES: Rudolf Mrlian (ed.), *Slovak Folk Art* (Prague, 1953), with many fine colour plates.

CHARLES HOLME: *Peasant Art in Austria and Hungary*, The Studio, 1911.

p. viii LOOS: H. Czech and W. Mistelbauer, *Das Looshaus* (Vienna, 1977).

RIEGL: See Otto Pächt, 'Alois Riegl' in *Methodisches zur Kunsthistorischen Praxis* (Munich, 1977). My reservations (which he mentions) were shared by my teacher Julius von Schlosser; see his 'Die Wiener Schule der Kunstgeschichte', *Mitteilungen des Österreichischen Instituts für Geschichtsforschung* (Ergänzungsband) 1934. I have referred to this situation in the Preface to the German translation of my *Meditations* (Vienna, 1973).

KRIS: Our joint 'King Penguin', *Caricature*, was published in 1940; our paper 'The principles of caricature' is reprinted in Ernst Kris, *Psychoanalytic Explorations in Art* (New York, 1952). I have written a memoir on Ernst Kris for the Italian edition of that book, *Ricerche Psicoanalitiche sull'Arte* (Turin, 1967).

p. ix LITERATURE ON THE CRAFTS: The best point of entry is now John Fleming and Hugh Honour, *The Penguin Dictionary of Decorative Arts* (London, 1977). The article 'Ornamentation' in McGraw-Hill, *Encyclopedia of World Art* (New York, 1965) contains a useful bibliography. See also Dietmar Debes, *Das Ornament, Wesen und Geschichte: Ein Schriftenverzeichnis* (Leipzig, 1956), and Donald L. Ehresmann, *Applied and Decorative Arts, a bibliographical guide to basic reference works, histories and handbooks* (Littleton, Colorado, and London, 1977).

Most of the earlier books on ornament are compilations for the use of teachers and craftsmen. The classic of the genre is Owen Jones, *The Grammar of Ornament* (London, 1856) discussed in Chapter II. Alexander Speltz, *The Styles of Ornament* (London, 1910) is a series of 3500 examples arranged in historical order, while Franz S. Meyer, *Handbuch der Ornamentik* (Leipzig, 1888), recently republished in English with an introduction by Tony Birks (London, 1974), contains on its 300 plates both general and functional categories.

For the study of western styles between about 1500 and 1800 the rich anthologies of engraved decorative designs by Berliner and by Jessen are indispensable.

For more systematic treatment of design elements see Chapter III and notes to pp. 73, 74, 92, 93, 211.

p. x DEFINITIONS: K. R. Popper, *The Open Society and its Enemies* (London 1945), Chapter XI, 2, and *Unended Quest* (London, 1976), section 7.

PLATO: *Laws*, 664E–665A (trans. by A. E. Taylor), 1934. I am indebted for this quotation to Dr. I. Grafe.

HOGARTH, *Analysis*, p. 24.

Introduction

p.1 MOTTO: K. R. Popper, *Objective Knowledge*, p. 23.

THE 'BUCKET THEORY': K. R. Popper, 'The Bucket and the Searchlight, Two Theories of Knowledge', in *Objective Knowledge*, appendix. My remark that traces of this approach deriving from Locke survive in much of textbook psychology may seem exaggerated; it can be justified, however, if internal information-processing models of perception are seen in this light, as Ulric Neisser implies in *Cognition*. A similar point is made in his criticism of the model of information storage in Massimo Piattelli-Palmarini, 'L'entrepôt biologique et le démon comparateur', *Mémoires, Nouvelle Revue de Psychanalyse*, 15, Spring 1977, 105–23. In their introduction to part II of the collection of readings from *Scientific American*, *Recent Progress in Perception*, 1976, Richard Held and Whitman Richards comment on the fact that central determinants of perception 'have frequently been ruled out of the purview of science' because 'they do not lend themselves to explanation by the approach from analysis of the stimulus'.

COGNITIVE MAP: Neisser, *Cognition*, pp. 117f.

SENSE OF BALANCE: Gibson, *Senses*, 1966, Chapter IV.

p. 2 EYES: See my 'Illusion and Art' in Gregory and Gombrich, 1973. The most radical conclusions from these observations are drawn by Otto Koenig, *Urmotiv Auge*.

KONRAD LORENZ: *Die Rückseite des Spiegels, Versuch einer Naturgeschichte menschlichen Erkennens* (Munich, 1973), p. 16 (my translation).

GREGORY: *Eye and Brain*, p. 224.

GIBSON: *The Senses*.

NEISSER: *Cognition*, p. 53.

p.3 POPPERIAN ASYMMETRY: E. C. Carterette and Morton P. Friedman, *Handbook of Perception I. Historical and Philosophical Roots of Perception* (1974) is only one of recent surveys of the subject which fail to refer to Popper.

PERCEPTION AS JOLT: I was happy to find that the cyberneticist D. M. MacKay has come to stress the importance of 'negative feedback' or 'disparity signals' in his accounts of perception, as in his contribution to J. C. Eccles (ed.), *Brain and Conscious Experience* (Berlin, 1966), and his 'Ways of Looking at Perception', in W. Wathen-Dunn

(ed.), *Models for the Perception of Speech and Visual Form* (Cambridge, Mass., 1967).

ROBOT: An elaborate version in J. A. Deutsch, *The Structural Basis of Behaviour* (Chicago, 1960), Ch. x.

HOGARTH: See note to p. x.

BATS: Maurice Burton, *The Sixth Sense of Animals* (New York, 1973), pp. 60, 61.

ELECTRIC FISH: Burton as quoted above, pp. 71–2.

p.4 GIBSON: *The Senses.*

GESTALT THEORY: 'The Gestalt explanation of perceptual organization must be regarded as a first stage in an evolving formulation of both problem and solution, neither a closed issue nor a successful theory.' Julian Hochberg in E. C. Carterette, *Handbook*, 1974, p. 204; the passage quoted is the conclusion of a detailed survey of the theory and its present assessment. The most complete and persuasive account of visual perception largely based on this theory is Metzger, *Gesetze*, 1975. The application of this theory to art has been advocated in the writings of Rudolf Arnheim.

ART AND ILLUSION: Chapter VIII, 10, and notes.

GROPING FOR INFORMATION: 'The claim that perception is a continuing process of exploration and information pick-up, which may seem radical for vision, is self-evidently true of touch.' Neisser, *Cognition*, p. 26. The same author reports (p. 58) on an important paper by M. Minsky, 'A framework for representing knowledge', in P. H. Winston (ed.), *The Psychology of Computer Vision* (New York, 1975), stressing the need for anticipatory hypotheses to be built into a computer examining a room. Similar postulates appear in many computer projects which are surveyed in Alan K. Mackworth, 'Model-driven interpretation in intelligent vision systems', *Perception*, 1976, vol. 5, pp. 349–70.

p.5 THE SKY: See my 'The sky is the limit', in Robert B. MacLeod and Herbert L. Pick (eds.), *Perception.*

FAIRY RINGS: The mushrooms spread uniformly to the edge of the soil previously occupied.

p.6 CAMOUFLAGE: Adolf Portmann, *Animal Camouflage* (Ann Arbor, 1959), offers a concise introduction. See also H. E. Hinton, 'Natural Deception' in Gregory and Gombrich, *Illusion.*

COMPUTER EXPERIMENTS: Bela Julesz, 'Experiments in the Visual Perception of Texture', *Scientific American*, April 1975, reprinted in R. Held and W. Richards, 1976.

CONSPICUOUS MARKINGS: Tinbergen, *Instinct*, p. 184.

BOWER BIRD: My description derives from the caption to fig. 5 of Sir Julian Huxley's Introduction to 'A Discussion on Ritualization of Behaviour in Animals and Man', *Philosophical Transactions of the Royal Society of London*, Series B, no. 772, vol. 251, 1966. See also Karl von Frisch, *Animal Architecture* (New York and London), 1974, pp. 238f.

DEFEATING 'NOISE': I should like to suggest that the preference for certain patterns among various species indicated by the experiments of B. Rensch (1958) as reported by D. Morris, *Biology*, p. 160, might be interpreted in similar terms. Maybe there is a survival value in the ease with which potential signals can be distinguished from random noise, visually or auditorily. We know from the researches of von Frisch that bees are programmed to respond to the various patterns of flowers.

p.7 BODY PAINTING: James C. Faris, *Nuba Personal Art* (London, 1972) stresses the aesthetic aspects.

BOAS: *Primitive Art*, p. 31.

EASE OF ASSEMBLY: The beauty of organic form has been frequently celebrated and illustrated since the days of Owen Jones, notably by Ernst Haeckel, *Kunstformen der Natur* (1904), the plates of which have been re-issued by Dover Publications Inc., 1974 (*Art Forms in Nature*). The standard work is D'Arcy Thompson, *On Growth and Form*, 2nd ed. (Cambridge, 1942). See also Peter S. Stevens, *Patterns in Nature* (Harmondsworth, 1974), and René Huyghe, *Formes et Forces de l'atome à Rembrandt* (Paris, 1971).

p.8 CYCLOPEAN WALLS: My Fig. 6 corresponds to the interpretation of this term in Banister Fletcher, *A History of Architecture* (1931), p. 72. Others have identified the term with polygonal masonry.

p.9 PATTERNS FOR PAVIOURS: Many examples in Hiltrud Kier, *Der mittelalterliche Schmuckfussboden* (Düsseldorf, 1970), and *Schmuckfussboden in Renaissance und Barock* (Munich, 1977).

CONSTRUCTION AND PERCEPTION: 'The central assertion is that seeing, hearing, and remembering are all acts of *construction*', Ulric Neisser, *Cognitive Psychology* (New York, 1967) p. 10. The author's subsequent book *Cognition and Reality* modifies this assertion without discarding it altogether.

HOMEOSTAT: W. R. Ashby, *Design for a Brain* (New York, 1952).

p.10 PATTERNS IN TIME: Some bibliographical pointers in the notes to pp. 288, 289.

BÜCHER: *Arbeit und Rhythmus* (Leipzig, 1896).

p.11 ORGANIC RHYTHMS: My remarks are based on a study by Paul Leyhausen, 'Die Entdeckung der relativen Koordination: Ein Beitrag zur Annäherung von Physiologie und Psychologie', in Konrad Lorenz and Paul Leyhausen, *Antriebe tierischen und menschlichen Verhaltens* (Munich, 1968), referring mainly to the researches of E. von Holst, a selection of whose papers are available in English under the title, *The Behavioural Physiology of Animals and Man* (Coral Gables, Fla., 1973).

p.12 CHRISTOPHER ROBIN: A. A. Milne, *When we were very young* (London, 1924). Reprinted by permission of Methuen's Children's Books Ltd, and by permission of E. P. Dutton (© 1924 by E. P. Dutton & Co., Inc., renewed © 1952 by A. A. Milne).

CONGO'S GYMNASTICS: D. Morris, *The Biology of Art*, p. 162.

p.13 CONGO'S DRAWINGS: Morris, pp. 97f.

WASHOE: W. H. Thorpe, *Animal Nature and Human Nature* (London, 1974), pp. 285f.; a popular account is in Eugene Linsley, *Apes, Men and Language* (New York and Harmondsworth, 1976).

CHILD: Helga Eng, *The Psychology of Children's Drawings* (New York, 1931).

p.14 CHINESE TRADITION: *Art and Illusion*, Ch. V, 2.

MADONNA DELLA SEDIA: See my *Norm and Form.*

p.15 THE FRAME: The frame can be seen in Zoffany's painting of the Tribuna of the Uffizi, as illustrated in John Pope-Hennessy, *Raphael* (London and New York, 1970), fig. 23. Since its style excludes a dating

in the later part of the 18th century, it was most likely made around the time when the Grand Ducal collections were first publicly displayed.

I Issues of Taste

p.17 MOTTO: The quotation comes from Browning's *Andrea del Sarto*, but is also listed as an aphorism popular with Ludwig Mies van der Rohe in John Bartlett, *Familiar Quotations*, 14th edition (London, 1968).

OVER-ORNATE: For the absence of this stricture from the Sanskrit tradition see Richard Gombrich, *On being Sanskritic* (Oxford, 1978).

p.18 WILLIAM WATSON: *Style in the Arts of China* (Harmondsworth, 1974), p. 105.

JAPANESE CONTAINERS: Illustrations in Kaisen Iguchi (trans. by J. Clark), *Tea Ceremony* (Osaka, 1975), and in Rand Castile, *The Way of Tea* (New York and Tokyo, 1971).

ALBERTI: *De re aedificatoria*, Book VII, Chapter 10.

VISUAL METAPHORS: See my *Meditations*, pp. 12–29.

p.19 RHETORICAL THEORY: See my 'The Debate on Primitivism in ancient Rhetoric', *Journal of the Warburg and Courtauld Institutes*, 29, 1966, pp. 24–37.

CICERO ON ATTICISM: *Orator*, 78, trans. based on H. M. Hubbell in Loeb Classical Library (London, 1952), pp. 262–3.

p.20 CICERO'S FUNCTIONALISM: *De Oratore*, III, 179, 180, trans. H. Rackham (Loeb Classical Library, London, 1960), II, p. 143.

VITRUVIUS: *On Architecture*, VII, 5, trans. F. Granger (Loeb Classical Library, London, 1934), II, p. 105.

VITRUVIUS POLEMICS: Ludwig Curtius, *Die Wandmalerei Pompejis* (Leipzig, 1929). More recent results and discussions are listed by Dacos, *Domus Aurea*, p. 32.

VITRUVIUS' INFLUENCE: See my *Norm and Form*, pp. 83–6.

p.21 MARQUIS OF MARIGNY: Jean Locquin, *La Peinture d'Histoire en France de 1747 à 1785* (Paris, 1912), pp. 16ff.

COCHIN: For his position and influence see Locquin as quoted above.

p.22 FISKE KIMBALL: *Rococo*.

p.23 WREN: Christopher Wren (junior), *Parentalia* (London, 1750), p. 261. The interiors mentioned are no longer extant.

HOGARTH: *Analysis*, p. 46.

p.24 REIFFSTEIN: See Bauer, *Rocaille*, pp. 63–4.

p.25 KRUBSACIUS: *Gedanken von dem Ursprung, Wachstum und Verfall der Verzierungen in den schönen Künsten* (Leipzig, 1759).

p.26 WINCKELMANN: *Gedanken über die Nachahmung der griechischen Werke* (Dresden, 1755).

AGRIGENTO: *Erläuterung der Gedanken von der Nachahmung der griechischen Werke und Beantwortung des Sendschreibens*, in J. J. Winckelmann, *Sämtliche Werke* (Donaueschingen, 1825), I. The reference is to p. 193. The columns mentioned by Winckelmann are in fact half-columns.

p.27 PIRANESI: *Diverse maniere d'adornare i cammini* (Rome, 1769). For his general position see R. O.

Parks (ed.), *Piranesi*, the catalogue of an exhibition at Smith College, Northampton, Mass., 1961, with contributions by Philip Hofer, Karl Lehmann and Rudolf Wittkower.

p.28 MILIZIA: *Le vite de' più celebri architetti* (Rome, 1768), p. 14.

NILSON: Bauer, *Rocaille*, p. 69.

p.30 GOETHE: *Hermann and Dorothea*, 3 (Thalia: Die Bürger), the translation in the text is my own.

p.31 PERCIER AND FONTAINE: Quotations from the *Discours Préliminaire*, pp. 10–12, and 13–14.

II Ornament as Art

p.33 MOTTO: William Morris, 'The lesser arts', 1877, in H. Jackson (ed.), *William Morris, On Art and Socialism* (London, 1947), p. 26.

ALEXIS DE TOCQUEVILLE: *Democracy in America* (ed. J. P. Mayer and Lerner, trans. G. Lawrence) (London, 1968), vol. II, part I, Chapter XI, p. 600.

PUNCHED CARD: Shirley E. Held, *Weaving, a Handbook for Fiber Craftsmen* (New York and London, 1973), p. 98.

p.34 VICTORIAN BOOKS ON DESIGN: A brief survey in Stuart Durant, 'Ornament in an Industrial Civilisation', *The Architectural Review*, Sept. 1976; further references in the notes to pp. ix, 73.

PUGIN: Phoebe Stanton, *Pugin* (London, 1971).

PUGIN: *The True Principles of Pointed or Christian Architecture* (London, 1841), pp. 25f.

DICKENS: *Hard Times*, Chapter 2.

p.36 PUGIN: *True Principles*, p. 24.

WORNUM: *Analysis*, p. 10.

p.37 SEMPER'S CRITICISMS: *Der Stil*, I, 44. His remarks are borne out by a pamphlet written under the pseudonym Argus (according to the V. and A. catalogue possibly Frederic James Prouting), *To manufacturers, decorators, designers and public generally: a mild remonstrance against the taste-censorship at Marlborough House*, 1853. There are three parts, totalling about 100 pages. Contrary to the title, the pamphlets violently attack 'friend Redgrave', Owen Jones and Sir Henry Cole for their preference for exotic to English designs, the flimsiness of their principles and their rejection of naturalistic standards.

DECORATION VERSUS ILLUSIONISM: See my Walter Neurath Memorial Lecture, *Means and Ends, Reflections on the History of Fresco Painting* (London, 1976), pp. 62f.

WORNUM: *Analysis*, p. 24.

p.38 RUSKIN: Volumes and pages given in the text refer to *The Works of John Ruskin*, ed. by E. T. Cook and Alexander Wedderburn.

p.42 EXPRESSIONIST THEORY: See my 'Expression and Communication' in *Meditations*, pp. 56–69.

BLOUNT: *Arbor Vitae* (London, 1899), p. 17.

p.44 COLLECTIVE MIND: See below, Chapter VIII.

INFLATIONS: See my 'The Logic of Vanity Fair', in *The Philosophy of Karl Popper*.

HEGEL'S INFLUENCE: See Partha Mitter, *Much Maligned Monsters; History of European Reactions to Indian Art* (Oxford, 1977), Chapter IV, 2.

p.46 THOMAS MANN: *Friedrich und die Grosse Koalition* (Berlin, 1915).

WORRINGER: See the author's interesting autobiographical account of the genesis of this seminal book in *Fragen und Gegenfragen* (Munich, 1956), pp. 23–8.

p.47 SEMPER AND POLYCHROMY: See L. D. Ettlinger, *Gottfried Semper und die Antike* (Halle, 1937), pp. 49f.

p.48 BODY DECORATION: G. Semper, *Über die formelle Gesetzmässigkeit des Schmuckes und dessen Bedeutung als Kunstsymbol* (Zürich, 1856), reprinted in *Kleine Schriften* (1884).

WARBURG: See my *Aby Warburg, An Intellectual Biography* (London, 1970).

p.49 TEXTILE DESIGN: Reprinted in *Kleine Schriften* (Berlin, 1884). The passage cited is on p. 97.

IROQUOIS: *Stil* I, 79–80. I have failed to find the precise examples Semper had in mind.

p.50 CHAIRS: *Stil* II, pp. 256–7.

p.54 BIRKHOFF: *Aesthetic Measure* (Cambridge, Mass., 1933).

p.56 JAPANESE INFLUENCE: The best points of entry into the growing literature on this topic are offered by three recent exhibition catalogues: Siegfried Wichmann (ed.), *Weltkulturen und moderne Kunst*, on the occasion of the Munich Olympic Games of 1972; *The Aesthetic Movement and the Cult of Japan*, catalogue of the Fine Art Society Ltd., October 1972, with a bibliography by Stuart Durant; and *Japonisme, Japanese influence on French art 1854–1910*, Cleveland Museum of Art, 1975. As early as 1886, William Anderson in his monumental two-volume *The Pictorial Arts of Japan* (London), gave a brief sketch of the history of this movement. There is also a concise survey in Hugh Honour, *Chinoiserie* (London, 1961), pp. 209ff.

CHESNEAU: Quoted after the English edition (London, 1886), p. 262. There are several such references to the unorthodox principles of Japanese decoration in French literature: J. Bourgoin, *Théorie de l'Ornement* (Paris, 1873), p. 212, is rather condemnatory. Charles Blanc, *L'Art dans la Parure et dans le Vêtement* (Paris, 1874; p. 29 of the English edition, London, 1877), less so. See also Henri Mayeux, *A Manual of Decorative Composition*, English ed. (London, 1894), p. 82.

p.57 DAY: *The Planning of Ornament* included in his collection *Ornamental Design* (London, 1890). My quotations come from the second essay, pp. 10, 19, 30, 31.

p.58 WILDE: 'The Artist as Critic', in *The Works of Oscar Wilde* (London, n.d.), p. 340.

MAURICE DENIS: *Théories* (Paris, 1913).

FENOLLOSA: Michael Sullivan, *The Meeting of Eastern and Western Art* (London, 1973), pp. 118–21.

p.59 FENOLLOSA: The quotation is from p. 759 of this rare periodical, which the New York Public Library helped me to track down.

FENOLLOSA'S DIAGRAM: The diagram is illustrated without giving a source in Walter Beck, *Self-Development in Drawing* (New York and London, 1928), fig. 92. The link between Mondrian and Japanese design is stressed in Decio Gioseffi, *La falsa Prehistoria di Piet Mondriaan* (Trieste, 1957). A diagram in Sir Rutherford Alcock, *Art and Art Industries of Japan* (London, 1878), fig. 7, appears to strengthen Gioseffi's case.

HATTON: *Design, the Making of Patterns* (London, 1902).

LOOS: I quote (and translate) after the German edition *Sämtliche Schriften*, ed. Franz Glück (Vienna, 1962). See also Ludwig Münz and Gustav Künstler, *Adolf Loos, Pioneer of Modern Architecture* (New York and London, 1966).

SULLIVAN: Quoted in N. Pevsner's introduction to the monograph by L. Münz and G. Künstler, p. 19.

CICERO: *Brutus*, 262.

p. 60 LOOS ON ART NOUVEAU: *Schriften*, pp. 167, 65, 276–8.

III *The Challenge of Constraints*

p.63 MOTTO: 'Willst du ins Unendliche schreiten/ Geh nur im Endlichen nach allen Seiten.' J. W. Goethe, 'Sprüche in Reimen; Gott, Gemüth und Welt'.

STRAW STARS: *Neue Strohsterne und Engel*, trans. by R. Albrecht (Freiburg im Breisgau, 1968).

p.64 COCHIN: See Chapter I, p. 21

RIEGL: *Stilfragen* (2nd ed.), p. 13.

p.65 BODY DECORATION: See Introduction, p. 7, and note.

GIBBONS: D. Green, *Grinling Gibbons* (London, 1964).

p.66 KRAFFT: B. Daun, *Peter Vischer und A. Krafft* (Leipzig, 1905), pp. 104f.

WROUGHT IRON: Ferdinand Stuttmann, *Deutsche Schmiedeeisen Kunst* (Munich, 1927–8), 5 vols.; Otto Höver, *Das Eisenwerk, Die Kunstformen des Schmiedeeisens vom Mittelalter bis zum Ausgang des 18 Jahrhunderts* (Tübingen, 1961); Ottfried Kastner, *Schmiedehandwerk im Barock* (Linz, 1971); *Made of Iron*, an exhibition at the University of St. Thomas Art Department, Houston, Texas, September–December 1966; J. Starkie Gardner (revised by W. W. Watts), *Ironworks* (London, Victoria and Albert Museum, 1978), 3 vols.

FILIGREE: T. Risøen and A. Bøe, *Om Filigran* (Oslo, 1959), and the exhibition catalogue *Filigrana, ieri e oggi* (Settimana delle Casse di Risparmio; Genova, 1973).

IVORY: G. C. Williamson, *The Book of Ivory* (London, 1938); H. W. Hegerman, *Elfenbein* (Hanau, 1966).

p.67 PLATO: *Timaeus*, trans. R. G. Bury (Loeb Classical Library, 1952); my quotations come from 53B and 55C.

ANDREAS SPEISER: *Theorie der Gruppen von endlicher Ordnung* (3rd ed. Berlin, 1937); see also Hermann Weyl, *Symmetry* (Princeton, N.J., 1952).

p.70 DOUAT: Bibliographical references in Catalogue Eighty of Marlborough Rare Books Ltd., (London, 1977), no. 187.

Intellectually this remarkable book must be connected with Ramon Lull's *Ars combinatoria*. Thus the sixteenth-century Lullian Bernard de Lavinheta prints on pp. 142–53 of his *Opera Omnia* (Bibliopolis, 1612) all permutations of the sequence BCDT. The long persistence of this tradition in Paris is discussed in the epilogue to J. N. Hillgarth, *Ramon Lull and Lullism in fourteenth-century France* (Oxford, 1971).

p.71 SNOW CRYSTALS: (New York, 1931); reprinted by Dover Publications, New York, 1962.

POSSIBLE SNOW CRYSTALS: Manfred Eigen and Ruthild Winkler, *Das Spiel, Naturgesetze steuern den Zufall* (Munich, 1975), pp. 125 and 196.

p.72 PERUVIAN TEXTILES: Boas, *Primitive Art*, pp. 43f.; J. Alden Mason, *The Ancient Civilizations of Peru* (Harmondsworth, 1957).

p. 73 HISTORICAL STYLES: Apart from the standard handbooks mentioned in note to p. ix of the Preface I should like to list here: George Phillips, *Rudiments of Curvilinear Design* (London, 1839), a somewhat hybrid collection of the author's own compositions in various styles on large plates; Henry Shaw, *The Encyclopedia of Ornament* (London, 1842), reprinted by Academy Editions, 1972; R. Glazier, *A Manual of Historic Ornament* (London, 1899). Many relevant books are also listed in the catalogue of *Victorian Architectural Source Books* from the exhibition *Marble Halls*, London, Victoria and Albert Museum, 1973.

BASIC PRINCIPLES: An early example is a lecture by R. R. Reinagle contained in the information collected by the Committee of the House of Commons, Arts and Manufactures, Session 1836, also summarized in the tome by George Phillips mentioned above, which shows similar ambitions. D. R. Hay, *Original Geometrical Diaper Designs accompanied by an attempt to Develope and Elucidate the True Principles of Ornamental Design as applied to the Decorative Arts* (London, 1844) is noteworthy *i.a.* for its link with Sir David Brewster, the inventor of the Kaleidoscope. A weighty book which would repay study is J. Bourgoin, *Théorie de l'Ornement* (Paris, 1873). The author, known for his detailed studies of Arabic patterns, was a disciple of the philosopher M. Cournot, one of the first to apply mathematical methods to economics. Bourgoin shares Ruskin's horror of Western industrialization and advocates the collection of instances from all over the globe while there is still time, but his own approach is rigidly deductive. Much less ambitious but worth reading for its author is a lecture by William Morris, *Some Hints on Pattern Designing* (1899) listing 'all elementary forms of construction for a recurring pattern' under nine heads. The same year saw the publication of Godfrey Blount, *Arbor Vitae* (London, 1899), a systematic survey starting from the spiral to which I referred in Chapter II. A beautiful French example of the genre is F. Forichon, *L'Ornement Géométrique*; *Combinaisons Géométriques Ornementales* (Paris, 1902), the first volume of a *Cours Méthodique* planned in 5 volumes. An important landmark in the study of the subject is Denman W. Ross, *A Theory of Pure Design, Harmony, Balance, Rhythm* (Boston, 1907), by an influential teacher at Harvard. It anticipates in some respects V. Kandinsky, *Punkt und Linie zur Fläche* (Munich, 1926), which was published as a Bauhaus book and influenced the 'basic course' still followed in many art schools. Claude Humbert, *Ornamental Design, A Sourcebook with 1000 Illustrations* (London, 1970), primarily serves the practical purpose of designers. Further examples on pp. 74, 92, 93 and notes.

BLANC: *L'Art dans la Parure et dans le Vêtement* (Paris, 1874), p. 60. I quote from the English edition (London, 1877), p. 45.

p. 74 'SYMMETRIE': K. Lothar Wolf and Robert Wolff, *Symmetrie, Versuch einer Anweisung zu gestalthaftem Sehen und sinnvollem Gestalten, systematisch dargestellt und an zahlreichen Beispielen erläutert* (Münster, Cologne, 1956).

p.78 VITRUVIUS: Book IV, Chapter 3. The passage is discussed in Alste Horn-Oncker, 'Über das Schickliche', *Abh. der Akademie der Wissenschaften in Göttingen Phil.-Hist. Klasse*, 3, Folge 70, 1967, pp. 51f.

ISLAMIC RUGS: Kurt Erdmann, *Oriental Carpets* (London, 1960). Fritz Hermann, 'Formelemente des orientalischen Knüpfteppichs', *Palette*, no. 27, 1967, suggests that the Islamic procedure reveals a thoroughly different approach from ours to space and time.

p.79 MILADA VILIMKOVÁ: in Paula Fortová-Sámalová, *Das ägyptische Ornament* (Prague, 1963), with an interesting Introduction on the theory of ornament.

p.80 PERIODICITY: There are instructive examples in Claude Bragdon, *Projective Ornament* (Rochester, N.Y., 1915) based on magic squares, and in Keith Albarn et al., *The Language of Pattern* (London, 1974), even though the interpretations of these authors may be contested. Recently, an attractive method of designing grid patterns has been advocated for the use of schools under the name of the *Altair Project*, developed by Ensor R. Holiday in his *Altair Design* books (New York and London, 1976).

p.85 LEONARDO'S KNOTS: Marcel Brion, 'Les Noeuds de Léonard de Vinci et leur signification', *L'art et la Pensée de Léonard de Vinci* (*Etudes d'Art* 8–10, 1953/4) rather vaguely links these compositions with the iconography of the labyrinth. Carlo Pedretti, 'Un "nodo" vinciano inedito', *Raccolta Vinciana* XIX, 1952, pp. 115–16, published an original drawing. For the tradition followed by Leonardo, see Christie, *Pattern Design*, pp. 287f.

MIRZA AKBAR: Some illustrations (redrawn) in Christie, *Pattern Design*. Another pattern book is illustrated in L. I. Remiel's book on Usbekistan architecture (Tashkent, 1961). I owe this reference to Mr J. M. Rogers. For a recent Nigerian example see also David Heathcote, 'Insight into a Creative Process: A rare collection of embroidery drawings from Kano', *Savanna*, vol. I, no. 2, Dec. 1972, pp. 165–74. Some of the procedures used by Islamic designers are convincingly analysed in K. A. C. Creswell, *Early Muslim Architecture* (Oxford, 1932–40), vol I., pp. 139–41, who refers to E. H. Hankin, 'Some Discoveries of the Methods of Design employed in Mohammedan Art', *Journal of the Royal Society of Arts*, LIII, 1905, pp. 461–77, who published further constructions in the *Mathematical Gazette* of 1925, 1934, 1936.

p.86 PHILOSOPHY OF ISLAMIC ART: A recent plea for this approach (not shared by all students of the subject) is Keith Critchlow, *Islamic Patterns, an Analytical and Cosmological Approach*, with a foreword by Seyyed Hossein Nasr (London, 1976). A

Vedic origin is suggested in Keith Albarn *et al., The Language of Pattern.* See also my remarks on p. 225.

p.87 GAMES: W. R. Lethaby, 'Designing Games', a Dryad Handicrafts leaflet (Leicester, 1929), advises such games as a form of training.

UNTOWARD ACCIDENTS: Walter Crane, *Line and Form,* pp. 38f.

p.88 THE DROP: Day, *Ornamental Design,* pp. 34–5.

p.89 ESCHER: It is noteworthy that the artist himself experienced this difficulty to the full; his account is psychologically revealing: 'The border line between two adjacent shapes having a double function, the act of tracing such a line is a complicated business. On either side of it, simultaneously, a recognizability takes shape. But the human eye and mind cannot be busy with two things at the same moment and so there must be a quick and continuous jumping from one side to the other. But this is perhaps the very moving-spring of my perseverance.

'While drawing I sometimes feel as if I were a spiritualist medium, controlled by the creatures which I am conjuring up. It is as if they themselves decide on the shape in which they choose to appear ... they usually are very difficult and obstinate creatures.' Printed in C. H. MacGillavry, *Symmetry Aspects of M. C. Escher's Periodic Drawings* (Utrecht, 1965). For the artist's Islamic sources see Marianne L. Teuber, 'Sources of Ambiguity in the Prints of Maurits C. Escher' in R. Held, *Recent Progress,* pp. 153ff.

p.91 TEXTILE PRINTING: Karl Kasper, *Bunter Traum auf gewebtem Grund* (Berlin, 1938), a somewhat journalistic survey, also includes a useful bibliography.

p.92 FÉLIBIEN: *Des principes de l'architecture, etc.* (Paris, 1676).

MIRROR-REFLECTIONS: At least two books combine the principles of basic design with that of the Kaleidoscope: J. Klinger and H. Anker, *La Ligne Grotesque et ses Variations dans la Décoration Moderne* (Paris, *c.* 1900) and V. Mucha, *Combinaisons Ornementales* (Paris, *c.* 1896); both are described in Catalogue 20 of John Sims and Max Reed, London, as nos. 1931 and 1940.

p.93 OSTWALD: *Die Welt der Form, Entwicklung und Ordnung der gesetzlichschönen Gebilde, gezeichnet und beschrieben von Wilhelm Ostwald,* 4 vols. (Leipzig, 1922–5).

MOIRÉ: Gerald Oster and Yasunori Nishijima, 'Moiré Patterns', *Scientific American,* May 1963; Gerald Oster, 'Optical Art', *Applied Optics,* November 1965; Cyril Barrett, *Op Art* (London, 1970). COMPUTERS: H. W. Franke, *Computer Graphics, Computer Art* (London, 1971); H. W. Franke and G. Jäger, *Apparative Kunst, vom Kaleidoskop zum Komputer* (Cologne, 1973); a survey of 'computer aided design systems' by Rita James is summarized in *The Designer,* December 1976.

IV The Economy of Vision

p.95 MOTTO: Neisser, *Cognition,* p. 39.
GIBSON: *Visual World,* p. ix.
SELECTED SAMPLINGS: 'Perception is inherently

selective', Neisser, *Cognition,* p. 55.

TEXTURE: An early discussion can be found in George Phillips, *Rudiments of Curvilinear Design* (London, 1839?), pp. 48f.

p.96 HOGARTH: 'Wanton Chase', *Analysis,* p. 25; 'letter A', pp. 25–6.

FOVEA: Matthew Kabrisky, *A Proposed Model of Visual Information Processing in the Human Brain* (Urbana Ill., 1966) p. 16: 'An interesting viewpoint of human vision is that we see the world as through a frosted piece of glass capable of transmitting only blurred shadows; however, there is a tiny polished spot in the middle which is clear. The only reason why this does not subjectively bother us or even occur to us is that the clear spot is always where we are 'looking'. Most people are surprised to realise how small the clear spot is, virtually the size of a printed letter held at reading distance. The brain cleverly reconstructs the form and colour of the scene—something which anyone who has ever had a vivid dream will concede as being within its capability—and shifts the clear spot as necessary to fill in data or changing parts of the scene.'

THE IMAGE AS CONSTRUCT: See Ulric Neisser, as quoted under p. 9.

p.98 LEONARDO: *Perdimenti:* J. P. Richter, *The Literary Works of Leonardo da Vinci* (Oxford, 1939), no. 224; the horse: no. 223. Dr I. Grafe has drawn my attention to Ovid's fine description of the fading sight of a departing ship, *Metamorphoses,* XI, 463–71.

p. 99 ET PRINCIPLE: *Art and Illusion,* Chapter VII, 3. John Kennedy, 'Perception, Pictures and the Et-cetera Principle' in R. B. MacLeod and H. L. Pick, *Perception, Essays in Honor of J. J. Gibson* (Ithaca, 1974), erroneously attributes this coinage to Rudolf Arnheim, *Entropy and Art* (Berkeley, 1971), who indeed offers an amusing illustration of the principle.

PROJECTION AND TRANSFORMATION: See my 'The Evidence of Images' in C. Singleton (ed.), *Interpretation* (Baltimore, 1969), pp. 48f.

DE PILES: *Cours de la Peinture par Principes* (Paris, 1708). I quote from the English edition, *Principles of Painting* (London, 1743), pp. 66–7 and 230–1.

p.100 PERIPHERAL VISION: W. Metzger, *Gesetze* (1975), p. 206. Various papers are quoted in the bibliography of I. Bodis-Wollner, 'A distractive effect of peripheral attention on foveal trigram recognition', *Perception,* 1973, 4, p. 413.

p.102 MILIZIA: See Chapter I, p. 28.

p.103 RESEARCH ON READING: E. J. Gibson and H. Levin, *The Psychology of Reading* (Cambridge, Mass., 1975).

INFORMATION THEORY: Colin Cherry, *On Human Communication* (London, 1957).

NEW TOY: R. T. Green and M. C. Courtis, 'Information theory and figure perception: the metaphor that failed', *Acta Psychologica,* 25 (1966), pp. 12–36, partly reprinted in J. Hogg (ed.), *Psychology and the Visual Arts* (Harmondsworth, 1960). A more technical critique is A. C. Staniland, *Patterns of Redundancy, a psychological study* (Cambridge, 1966).

REDUNDANCY: Rudolf Arnheim, *Entropy and Art,*

an *Essay on Disorder and Order* (Berkeley, 1971), p. 19, criticizes the concepts of information theory on these grounds.

p.104 READING AND GUESSING: '. . . Reading is not simply stringing symbols together . . . It is generating hypotheses about the meaning of the pattern of symbols'; Paul A. Kolers, 'Experiments in Reading', *Scientific American*, July 1972. 'Reading is a psycholinguistic guessing game'; Kenneth Goodman as quoted in E. J. Gibson and H. Levin (see above), p. 451, who also point to the limitations of this approach.

p.105 SELECTIVE PATHWAYS: A brief survey in Colin Blakemore, 'The baffled brain', in R. Gregory and E. H. Gombrich (eds.) *Illusion*.

ATTENTION: For sceptical discussions of the traditional distinction between attention and perception see Lloyd Kaufman, *Sight and Mind* (New York, 1974), pp. 19–20, and Neisser, *Cognition*, Chapter 5.

ECOLOGICAL OPTICS: Gibson's project goes much beyond the points mentioned, see 'A Note on Ecological Optics', E. C. Carterette (ed.), *Handbook of Perception* I, pp. 309–12.

ATTNEAVE: *Application of Information Theory to Psychology* (New York, 1959); for critical discussions see above.

p.106 EXPECTED CONTINUITY: 'It is pragmatically true, although not logically necessary, that for the items commonly used in serial pattern tests it is easy to get consensus about the correct continuation. Presumably, the reason for this is that if one sequence is sufficiently "simple" or "more obvious" than others, then almost all persons who find an answer find that one first. But it must be emphasised that this is a psychological, not a logical matter.' H. A. Simon and K. Kotovsky, 'Human acquisition of concepts for sequential patterns', *Psychological Review*, 1963, p. 536.

SKILLS OF PERCEPTION AND MOVEMENT: E. J. Gibson, *Principles of Perceptual Learning and Development* (New York, 1969).

PERCEPTION AND MOVEMENT: The interdependence stressed throughout by Neisser, *Cognition*, forms the subject of the difficult book by Viktor von Weizsäcker, *Der Gestaltkreis, Theorie der Einheit von Wahrnehmen und Bewegen* (Stuttgart, 1947).

ANTICIPATION: Massimo Piattelli-Palmarini, 'Anticipazione' in the new *Enciclopedia* published by Einaudi in Turin offers a wide-ranging discussion of this problem and its philosophical and psychological aspects.

p.107 PHANTOM PERCEPTS: Apart from the chapter referred to in the text, see my *Art and Illusion*, Chapter VII, and 'The Sky is the Limit' in R. B. MacLeod and H. L. Pick (eds.), *Perception*. Neisser, *Cognition*, p. 130, has a section headed 'Images as perceptual anticipations'.

INBORN CAPACITY: 'What babies do know, I believe, is how to find out about their environment and how to organize the information they obtain so it can help them to obtain more. They do not know even this very well, but well enough to begin.' Neisser, *Cognition*, p. 63; see also E. J. Gibson, *Principles of Perceptual Learning and Development* (New York, 1969).

PHANTOM TRIANGLE: The demonstration is due to G. Kanizsa, 'Margini quasi-percettivi in campi con stimulazione omogonea', *Rivista di Psicologia*, 49, 1955. Further discussions in Richard Gregory, 'The Confounded Eye', in *Illusion in Nature and Art*; Lloyd Kaufman, *Sight and Mind*, pp. 477ff; Metzger, *Gesetze*, pp. 430ff. An additional factor is adduced in John P. Frisby and Jeremy Clatworthy, 'Illusory contours: curious cases of simultaneous brightness contrast?', *Perception*, 4/3, 1975. I am more convinced by John M. Kennedy, 'Attention, Brightness and the Constructive Eye', in M. Henle (ed.), *Vision and Artifact* (New York, 1976), that this is basically a case of pictorial perception as I had postulated in *Art and Illusion*, Chapter VII, 2, with reference to paintings, lettering and X-ray photographs, where the phenomenon and its dangers were convincingly demonstrated in G. Spiegler, *Physikalische Grundlagen der Röntgendiagnostik* (Stuttgart, 1957), Chapter VI.

STABILITY: 'If our image of the perceived world is implicitly embodied in our state of organization to cope with it, it may be expected to be naturally *stable* (author's italics). The perception of change will be an updating response triggered only by a *significant degree of mismatch* between the incoming indicators and the internal criteria of evaluation adopted in the light of action currently programmed. . . .' D. M. MacKay, 'Ways of looking at perception', in W. Wathen Dunn, *Models for the Perception of Speech and Visual Form* (Cambridge, Mass., 1967), p. 37. Dr. I. Grafe has drawn my attention to the fact that all this was known to Shakespeare: 'Since things in motion sooner catch the eye than what not stirs' (*Troilus and Cressida*, III, Scene 3).

p.108 FADING PERCEPTS: P. Walker and F. M. Toates, 'Perception as the output of a proportional feedback controller: evidence from the stabilized image', *Perception*, 6/3, 1977, regard the phenomenon as evidence for D. M. MacKay's theory quoted above.

p.111 JULESZ: 'Experiments in the visual perception of texture', *Scientific American*, April 1975 (reprinted in Held, *Recent Progress*).

TEXTURES: Gibson, *Visual World*, especially Chapters 5 and 6.

p.113 PLATO: *Phaedo*, 74 (Loeb Classical Library, p. 257).

FAMILIARITY AND SIMPLICITY: 'I have been emphasizing the importance of simplicity, but it is obvious that familiarity also plays an important role . . . the two factors are hard to disentangle.' Fred Attneave, 'Multistability in Perception', *Scientific American*, December 1971 (reprinted in Held, *Recent Progress*, p. 148).

GESTALT: See Hochberg as quoted under p. 4, and William R. Uttal, *An Auto-correlation Theory of Form Detection* (Hillsdale, N. J., 1975) for a detailed critique.

p.114 PRINCIPLES OF EXCLUSION: Karl R. Popper, *The Logic of Scientific Discovery*, Chapter VI.

KEPLER: Popper, as above, Chapter VI, section 39.

SIMPLICITY: Julian H. Hochberg, *Perception* (Englewood Cliffs, N. J., 1964), p. 88.

PRE-CODED: Ethologists following K. Lorenz speak

of 'Innate release mechanisms'; N. Tinbergen, *Instinct*, pp. 37f.

FEATURE EXTRACTORS: See Blakemore as quoted under p. 105 (selective pathways). Some of the original papers are reprinted in Leonard Uhr (ed.), *Pattern Recognition* (New York, 1966).

HOMING INSECTS: N. Tinbergen: 'Landmark Preference by Homing Philanthus', in *The Animal in its World* (London, 1972).

V Towards an Analysis of Effects

p.117 MOTTO: H. Cantril (ed.), *The Morning Notes of Adelbert Ames Jr.* (New Brunswick, 1960), under 3 August 1943.

PREFERENCES: D. E. Berlyne, *Aesthetics and Psychobiology* (New York, 1971), offers a full survey of the problems and the bibliography.

IMPRESSION OF COMPLEXITY: Erich Raab, *Bildkomplexität, Farbe und ästhetischer Eindruck* (Graz, 1976).

p.118 OSGOOD: Charles E. Osgood, George J. Suci, Percy H. Tannenbaum, *The Measurement of Meaning* (Urbana, Ill., 1957).

p.120 FIRM EXPECTATIONS: See Herbert A. Simon, 'An information-processing explanation of some perceptual phenomena', *British Journal of Psychology*, 58, 1967, pp. 1–12, to which I am altogether much indebted.

p.121 FEWER BREAKS: Lloyd Kaufman, *Sight and Mind, an introduction to visual perception* (New York, 1974), pp. 524–5, appears to come close to my approach when he says: 'A pattern with many different spatial frequencies can appear to be very complicated; but when a few spatial frequencies define the pattern in two dimensions, it might appear to be relatively simple. In this sense there is more information in the complicated pattern than there is in the simple pattern', but he also reminds us how much remains to be discovered.

R. ARNHEIM: loc. cit. p. 34. The argument, which has a long history in *Gestalt* psychology, is also discussed in R. L. Gregory, *Concepts and Mechanisms of Perception* (London, 1974), p. 586.

SCIENCE FICTION: The idea of a 'scanner' is developed in the paper by Herbert A. Simon referred to under p. 120; but his and all other computer models I have seen mentioned, rightly concentrate on the problems of pattern recognition rather than on our subjective reactions to patterns. A detailed survey of such models (much beyond my competence) is Leonard Uhr, *Pattern Recognition, Learning and Thought, Computer-Programmed Models of Higher Mental Processes* (Englewood Cliffs, N.J., 1973).

PLANNING FIXATIONS: 'To reduce random search, eye movements must often be planned from data acquired by the peripheral retina'; Norman H. Mackworth, 'Visual Noise Causes Tunnel Vision', in R. N. Haber (ed.), *Contemporary Theory and Research in Visual Perception* (New York, 1968), p. 434. A similar point is also made by Julian Hochberg, 'The Mind's Eye', in the same collection, p. 323.

p.122 THE EDGE OF THE VISUAL FIELD: Julian Hoch-

berg has introduced the term 'peripheral search guidance' (abbreviated PSG) in this context. He distinguishes it from 'cognitive search guidance' (CSG) where knowledge guides our expectations, as frequently in reading; see Richard A. Monty and John W. Senders (eds.), *Eye Movements and Psychological Processes* (Hillsdale, N.J., 1976), p. 397.

EYE MOVEMENTS: G. T. Buswell, *How people look at pictures* (Chicago, 1935), is the standard work. Its achievements and limitations are discussed in detail in the book quoted in the preceding note.

SEEKING INFORMATION: The salutary warnings in the paper by R. T. Green and M. C. Courtis, 'Information theory and figure perception: the metaphor that failed' (quoted above under p. 103) do not seem to me to invalidate the general observation. Their counter-example of abbreviated cartoons is a particularly complex one, concerned (as the authors emphasize) with meaning, but also with conventionalized representations.

p.123 MONITORING BIOLOGICAL RHYTHMS: The wizardry is even more impressive than indicated in the text. At least one of these instruments (the Delay module of the Cambridge Patient Monitoring System no. 01091) 'can store 4, 8 or 16 seconds of ECG signal such that at the onset of an alarm condition when the recorder is automatically started, the recording commences with the patient's ECG waveform prior to the emergency, thus aiding diagnosis.' In other words it is designed to 'remember' the norm at the onset of the deviation. I owe this information to the cardiologist Dr Adolf Schott.

TEMPLETS: The notion of a template (which proved so important in the biological transmissions of the 'genetic code') has been much discussed in the computer-oriented literature on pattern recognition (Neisser, *Cognitive Psychology*, Chapter 3; Leonard Uhr, *Pattern Recognition*, Chapter 2), but the limitations of this analogy have also become apparent.

HALLUCINATORY PATTERNS: Gerald Oster, 'Phosphenes', *Scientific American*, February 1970; Ronald K. Siegel, 'Hallucinations', *Scientific American*, October 1977.

PSYCHEDELIC: Robert E. L. Masters and J. Houston, *Psychedelic Art* (London, 1968), with bibliography.

DETECTING STRAIGHT LINES: William Uttal, *An Auto-correlation Theory of Form Detection* (Hillsdale, N.J., 1975), pp. 90–91, offers a valuable enumeration of conditions which facilitate or impede this detection.

p.124 W. R. GARNER: 'Good patterns have few alternatives', *American Scientist*, 58, Jan.–Feb. 1970, pp. 34–42.

FROM OUTSIDE IN: The transition from global to focal attention is discussed in Ulric Neisser, *Cognitive Psychology*, (New York, 1967), Chapter 4.

THE DEVIL'S TUNING FORK: First published by D. H. Schuster, 'A new ambiguous figure: a three-stick clevis', *American Journal of Psychology*, 1964, 77, p. 673. John M. Kennedy, *A Psychology of Picture Perception*, pp. 146–8.

TUNING FORK AND EYE MOVEMENT: See my chapter, 'The Evidence of Images', 2, in Charles S. Singleton

(ed.), *Interpretation, Theory and Practice* (Baltimore, 1969), pp. 61f.

IMPOSSIBLE OBJECTS: L. and R. Penrose, 'Impossible objects: a special type of visual illusion', *British Journal of Psychology*, 1958, 49, pp. 31–3, appear to have been the first in the field and to have inspired M. C. Escher; see also Julian Hochberg, 'The representation of things and people', in E. H. Gombrich, J. Hochberg and M. Black, *Art, Perception and Reality* (Baltimore, 1972); R. L. Gregory, 'Perceptual Illusions and Brain Models', *Concepts and Mechanisms of Perception* (London, 1974), p. 368; and Thaddues M. Cowan, 'Organizing the properties of impossible figures', *Perception*, 6/1, 1977.

p.126 SYMMETRY AND REDUNDANCY: Leonard Zusne, *Visual Perception of Form.*

PERCEPTION OF SYMMETRY: Vicky G. Bruce and Michael J. Morgan, 'Violations of symmetry and repetition in visual patterns', *Perception*, 4/3, 1975.

VISUAL SPAN: Norman H. Mackworth, 'Visual Noise Causes Tunnel Vision', as quoted under p. 121, pp. 434–7. As the title indicates, the paper deals with the opposite phenomenon, the narrowing of the visual span by the lack of redundancy.

p.129 GIBSON: *The Senses*, Chapter IX.

p.130 ALTERNATIONS BETWEEN FIGURE AND GROUND: 'The perceptual system entertains first one then the other hypothesis and never comes to a conclusion, for there is no best answer.' R. L. Gregory's comment on the Necker Cube in *Eye and Brain*, p. 12, generally also applies to figure-ground alternations. There is an interesting observation, however, by John Kennedy, *A Psychology of Picture Perception*, p. 92, who reports that seeing the whole area as an object, e.g. (in this case) as a beach ball made of multicoloured leather, tends to still the search for a 'fit'; for now the whole configuration is seen as a figure against the neutral ground of the page. For a full bibliography of the topic, see D. Vickers, 'A cyclic decision model of perceptual alternation', *Perception*, 1972, 1, pp. 31–48; see also Fred Attneave, 'Multistability in Perception', as quoted under p. 113.

p.131 ART AND ILLUSION: Chapter VII, 6.

p.132 MORGENSTERN: *Galgenlieder* (1905). The translation is mine.

p.134 FRASER SPIRAL: Originally published in the *British Journal of Physiology*, 1908. (See Metzger, *Gesetze*, p. 179.)

'OP': Cyril Barrett, *Op Art* (London, 1970), provides a survey of the movement. For the bibliography of relevant psychological research (reaching far back into the nineteenth century) see Nicholas J. Wade, 'Distortions and disappearances of geometrical patterns', *Perception*, 6/4, 1977.

p.137 HOGARTH: *Analysis*, pp. 38–9.

p.138 RAYS: John F. Kennedy, 'Sun figure: an illusory diffuse contour resulting from an arrangement of dots', *Perception*, 5/4, 1976, suggests additional factors.

WHIRLS: Alois R. Hein, *Künstlerische Wirbeltypen* (Vienna, 1929), cites a wide range of examples and bibliography. See also Flinders Petrie, *Decorative Patterns of the Ancient World*, Triquetra: C, Skirls: P, Swastikas: V.

IMAGINARY ROTATION: Irvin Rock, 'The Perception of Disoriented Figures', *Scientific American*, January 1974 (reprinted in Held, *Recent Progress*), which does not, however, discuss the dynamics of vortex figures.

LETTER REVERSALS: E. J. Gibson and H. Levin, *The Psychology of Reading* (Cambridge, Mass., 1975), p. 497.

INTERLACE: Flinders Petrie, *Decorative Patterns of the Ancient World*, Twist, Plait: M.

p.141 AMBIGUOUS CUBES: *Art and Illusion*, fig. 222.

TRANSPARENCY: Metzger, *Gesetze des Sehens*, chapter IX, I. Fabio Metelli, 'The Perception of Transparency', *Scientific American*, April 1974 (reprinted in Held, *Recent Progress*).

p.142 COLOUR: The Library of the Royal College of Art (Kensington Gore, London, SW7) has a large collection of books on colour of which a check-list is available on request, from which I should like to pick out Ralph Evans, *An Introduction to Color* (New York, 1948) and Josef Albers, *Interaction of Color* (New Haven, Conn., 1963). Edwin H. Land, 'The Retinex Theory of Colour Vision', *Scientific American*, December 1977, is another nail in the coffin of the 'bucket theory' of perception.

p.145 LEGIBILITY: 'The most thorough and most recent work on legibility has been done at the National Bureau of Standards (Cornog, Rose and Walkowicz, 1964; Cornog and Rose, 1967). Of the 325 references listed in the 1964 bibliography, 203 are abstracted in the 1967 volume. A tabulation of these 203 studies by the variables investigated reveals the complexity of the topic.' Leonard Zusne, *Visual Perception of Form*, p. 392, where other bibliographical information can be found.

p.148 PLATONIC INTUITION: See my *Symbolic Images*, in the Index under 'Intellectual Intuition'.

VI Shapes and Things

p.149 MOTTO: Richard Gregory, *Eye and Brain*, Chapter 12.

p.151 DRAINED OF MEANING: Gibson, *Visual World*, p. 204 (with further references).

p.154 RUSKIN: *The Two Paths*, pp. 331–3. (See above, Chapter II.)

JACKSON: *Lessons in Decorative Design* (London, 1897) pp. 28f.

p.157 RORSCHACH: 'It stands to reason. . . . that the bilateral symmetry of inkblots should produce more responses of animals and other biological forms than asymmetrical shapes.' L. Zusne, *Visual Perception of Form*, p. 316.

p.160 GIBSON'S AFFORDANCE: Neisser, *Cognition*, p. 72 (with references).

p.163 'CHUNKS' IN PERCEPTION: Herbert A. Simon and Michael Barenfeld, 'Information-Processing Analysis of Perceptual Processes in Problem Solving', *Psychological Review*, 1969, pp. 473–83; 'after 5 seconds' sight of the board, a grand master or a master can reproduce a chess position almost without error.'

PTOLEMY: Accidit etiam in figuris simile huic: videlicet fabricarum quarum parietes habent

equidistantia latera, et liminum ianuarum que sublimia sunt, superiores partes videntur ampliores. Quod accidit ex ymaginatione que fit sensui, quamvis superiora illorum non habeant maiorem strictitatem et propinquitatem quam inferiora. Hoc enim consueverunt homines facere, ut positio sit bene disposita et firma. Mens ergo, quia apparet ei iuxta consuetudinem quod sint ampliora quam visi sint e converso, putat illa vere talia esse, quoniam mens existimat de his que taliter constituuntur, quod habeant equidistantia latera. Nam, cum hec fuerunt recte erecta, sunt super orizontem ad rectos angulos. Res autem que sunt erecte super orizontem ad rectos angulos, sunt equidistantes. Sed, cum non ita se habuerint, ut illa que non habent equidistantia latera, mens putat quod unum de duobus lateribus sit maius quam est. II, 140.

Albert Lejeune, *L'Optique de Claude Ptolémée* (Louvain, 1956).

p.164 STRUCTURE AND ORNAMENTATION: For the antecedents see above, Chapters I and II. The doctrine pervades the *Manual of Design* compiled from the writings and addresses of Richard Redgrave by Gilbert R. Redgrave for the South Kensington Museum in 1876.

PROJECTION OF ACCENTS: Interesting examples in Ilse Lehiste, 'Isochrony reconsidered', *Journal of Phonetics*, 1977, 5, 253–63.

p.165 CAMOUFLAGE: Some historical remarks in L. Zusne, *Visual Perception of Form*, p. 391.

p. 167 EGYPTIAN PLAYFULNESS: Wilhelm Worringer, *Ägyptische Kunst, Probleme ihrer Wertung* (Munich, 1927), explicitly criticized this tendency.

p.168 ARMOURY OF FASHION: René König, *The Restless Image, a Sociology of Fashion* (London, 1973), with basic bibliography; see also my 'Logic of Vanity Fair'.

CHARLES BLANC: *Art in Ornament and Dress*, English translation (London, 1877), pp. 52–3.

VERTICAL AND HORIZONTAL: L. Zusne, *Visual Perception of Form*, p. 165 (with bibliography). More recently: Harvey R. Schiffman and Jack G. Thompson, 'The role of figure orientation and apparent depth in the perception of the horizontal-vertical illusion', *Perception*, 4/1, 1975.

p.169 VITRUVIAN MAN: Inscribed in a square or circle, the figure (familiar from Leonardo's drawing in the Academy in Venice) recalls the gesture of outstretched arms sometimes taught to children as a reply to the question: 'how tall are you?'.

EYE MAKE-UP: Gregory and Gombrich, *Illusion*, p. 203.

HAIRSTYLE: See my chapter, 'The Mask and the Face, the perception of physiognomic likeness in life and art', in E. H. Gombrich, Julian Hochberg and Max Black, *Art, Perception and Reality* (Baltimore, 1972), pp. 1–46.

VII The Force of Habit

p.171 MOTTO: Edward Burnett Tylor, *Primitive Culture* (1871), Chapter I.

EYES: Many examples in Koenig, *Urmotiv Auge*.

p.173 ART AND ARTIFICE: *Art and Illusion*, Chapter III.

ÇATAL HÜYÜK: James Mellaart, 'Çatal Hüyük, a neolithic city in Anatolia', *Proceedings of the British Academy*, LI, 1965, pp. 201–14 (with illustrations).

p.174 RAILWAY COACHES: The relevance of this example for the study of types was stressed by Oscar Montelius, whose illustrations are reproduced in D. Wilson, *The Anglo-Saxons* (London, 1960), p. 14.

p.175 ABSTRACT TERMS: R. B. Onians, *The Origins of European Thought* (Cambridge, 1954).

METAPHOR: See my *Symbolic Images*, pp. 165–8.

FREUDIAN CONTINUITIES: See *Art and Illusion*, Chapter X (quoting William James).

p. 176 SUMMERSON: London, 1963; my quotation below (p. 177) comes from p. 3.

WÖLFFLIN: See below, p. 201.

p.177 RENAISSANCE REFORMS: See my 'From the Revival of Letters to the Reform of Art', in *The Heritage of Apelles* (Oxford, 1976).

EXPRESSIVE MODIFICATION: There is a telling example in Peter Meyer, *Das Ornament in der Kunstgeschichte* (Zürich, 1944) pp. 25–6.

p.179 VASARI: Vasari (ed. G. Milanesi), *Le Vite*, VII, p. 193.

MANUALS FOR CABINET MAKERS: J. V. Schlosser, *La Letteratura Artistica* (Florence, 1956), pp. 412 and 421.

p.180 LORENZ: 'Knowledge, Belief and Freedom', in Paul A. Weiss (ed.), *Hierarchically Organized Systems in Theory and Practice* (New York, 1971), pp. 231–62.

p.181 WARBURG: See my *Aby Warburg, an Intellectual Biography* (London, 1970).

p.182 W. H. GOODYEAR: For his life (1846–1923) and work see A. Johnson and D. Malone (eds.), *Dictionary of American Biography*.

p.183 KUNSTWOLLEN: The debate about the meaning of this term was joined by E. Panofsky, 'Der Begriff des Kunstwollens' (1920), reprinted in his *Aufsätze zu Grundfragen der Kunstwissenschaft* (Berlin, 1967).

p.184 UNDULATING LINES: Flinders Petrie, *Decorative Patterns of the Ancient World* pls. XXIX–XXXII.

GREEK ANECDOTE: Diodorus Siculus, I, 98. The account continues: 'So soon as the artisans agree as to the size of the statue, they separate and proceed to turn out the various sizes assigned to them in such a way that they correspond, and they do it so accurately that the peculiarity of that system excites amazement.' Diodorus of Sicily, with English translation by C. H. Oldfather (Loeb Classical Library, London, 1933), p. 339.

DIFFICULTIES WITH DIAGONALS: David R. Olson, *Cognitive Development, the child's acquisition of diagonality* (New York and London, 1970).

ACANTHUS: Discussions after Riegl include: Hans Möbius, *Die Ornamente der griechischen Grabstelen* (Berlin, 1929); Carl Nordenfalk, 'Bemerkungen zur Entstehung des Akanthusornaments', *Acta Archaeologica* V, 1935; and Roar Hauglid, *Akanthus* (Oslo, 1950). Only the first chapters of this two-volume work deal with the development of the motif outside Norway.

p.187 ARUM DRACUNCULUS: Carus Sterne, *Natur und Kunst* (Berlin, 1891), p. 165.

p.188 BYZANTINE SCROLLS: See my note on 'Bonaventura Berlinghieri's Palmettes', *Journal of the*

Warburg and Courtauld Institutes, XXXIX, 1976, pp. 234–6 with bibliography.

GOTHIC FOLIAGE: Joan Evans, *Pattern*, Figs. 79–101. Lottlisa Behling, *Die Pflanzenwelt der mittelalterlichen Kathedralen* (Cologne, 1964). Denise Jalabert, *La Flore Sculptée des Monuments du Moyen Age en France* (Paris, 1965).

p.189 PEVSNER: *The Leaves of Southwell* (King Penguin Books, London and New York, 1945).

ROCAILLE: Bauer, *Rocaille*, alludes to the continuities between acanthus, palmette and shell and to the relevant bibliography, but concentrates on their differentiation.

p.190 WESTERN SCROLLS AND CHINESE IDIOMS: This interpenetration was the subject of one of the Slade lectures delivered by Otto Kurz at Oxford in 1970/71 under the title 'Islamic Art between East and West'. It is hoped that they will be published.

CLOUD BANDS: These and other motifs are conveniently assembled in Walter A. Hawley, *Oriental Rugs, Antique and Modern* (New York, 1913 and 1970), plate O, p. 291, but the author's discussion in Chapter VI is perfunctory. For the origins of the cloud band in dragon designs see William Willetts, *Foundations of Chinese Art* (London, 1965), pp. 146–7.

'PAISLEY PATTERN': (So called after the imitation of Kashmir shawls in Paisley.) The chapter of Hawley mentioned in the preceding note lists descriptions of the motif as Cone, Palm, Mango, Almond, Riverloop and Pear. Fabio Formento, *Oriental Rugs and Carpets* (London, 1972), p. 69, also mentions the fig but favours the cypress tree. In Ian Bennett (ed.), *The Country Life Book of Rugs and Carpets* (London, 1978), we also read on p. 340 of 'somewhat fanciful' interpretations such as 'the Flame of Zoroastra, the imprint of a fist on wet plaster or the loop in the river Jumna'. Otto Koenig, *Urmotiv Auge*, has no difficulty in seeing in the 'botah' the shape of the human eye. The Indian version, correctly called *būtā* (flower), is discussed in John Irwin, *The Kashmir Shawl* (London, 1973).

p.193 FERDINAND DE SAUSSURE (1857–1913): His *Cours de Linguistique Générale* was published posthumously in 1931.

VIII *The Psychology of Styles*

p.195 MOTTO: 'Wie mir immer eine Furcht ankommt, wenn ich eine ganze Nation oder Zeitfolge durch einige Worte charakterisieren höre—denn welch eine ungeheure Menge von Verschiedenheiten fasset das Wort Nation, oder die mittleren Jahrhunderte, oder die alte und neue Zeit in sich!' Johann Gottfried Herder, *Ideen zur Geschichte und Kritik der Poesie und der bildenden Künste, In Briefen*, 1794–6, no. 38, *Sämtliche Werke* (Stuttgart, 1829), *Zur schönen Literatur und Kunst*, XVI, p. 74.

RIEGL: The article by Barbara Harlow, 'Realignment, Alois Riegl's view of late Roman Art', *Glyph* 3, was not available to me at the time of writing.

WICKHOFF: *Die Wiener Genesis* (Vienna, 1895), published in English as *Roman Art* by E. Strong (London, 1900).

p.196 HILDEBRAND: Adolf von Hildebrand: *Das Problem der Form in der bildenden Kunst* (Strasbourg, 1893), published in English as *The Problem of Form in Painting and Sculpture* (New York, 1907).

p.197 STYLE: See also my entry under that heading in the *International Encyclopedia of the Social Sciences*, 1968, and the chapter 'Kunstwissenschaft' in M. Hürlimann (ed.), *Das Atlantisbuch der Kunst* (Zürich, 1952).

p.199 VIOLLET-LE-DUC: The article is reprinted in H. Damisch (ed.), Viollet-le-Duc, *L'Architecture Raisonnée* (Paris, 1964). (The passage quoted is on p. 169). The best point of entry to the vast oeuvre of the architect is now the catalogue of the exhibition organized by the Caisse Nationale des Monuments Historiques, Paris, 1965.

HEGELIANISM: See my *In Search of Cultural History* (Oxford, 1969), and 'Hegel und die Kunstgeschichte', *Neue Rundschau*, 88, 1977, 2, pp. 202–19.

p.200 SYNOPTIC VISION: See my 'On Physiognomic Perception', in *Meditations*.

p.201 EMPATHY: In a footnote Wölfflin refers to his sources, writings by the influential philosopher R. H. Lotze (1817–81), Robert Vischer, *Das optische Formgefühl* (1872), and others. A few years later the psychologist Theodor Lipps attempted to base the theory of empathy on experimental foundations. In English-speaking countries it mainly gained currency through Bernard Berenson. Peter Gunn, *Vernon Lee (Violet Paget) 1856–1935* (London, 1964), pp. 150–60, discusses Berenson's claims to priority *vis-à-vis* Kit Anstruther-Thomson, who seems to have inspired Vernon Lee, but concedes that the idea was 'in the air' at the time. In 'The Mask and the Face', in *Art, Perception and Reality* (Baltimore, 1972), I have argued against dismissing the theory altogether, without, however, convincing my fellow-author Julian Hochberg.

p.202 Wölfflin, *Renaissance and Baroque*, translated by Kathrin Simon (London, 1964), p. 78.

WÖLFFLIN'S RETRACTIONS: 'Kunstgeschichtliche Grundbegriffe, eine Revision', in *Gedanken zur Kunstgeschichte* (Basle, 1940). Given the frequency with which Wölfflin's *Principles* are assigned as basic reading in art history courses it is depressing that his own second thoughts have never even been translated into English.

p.203 WÖLFFLIN: *Die Kunst der Renaissance in Italien und das Deutsche Formgefühl* (Munich, 1931), p. 6. (The translation in the text is mine.)

GOTHIC 'FORESTS'; P. Frank, *The Gothic Literary Sources and Interpretations through Eight Centuries* (Princeton, 1960).

GIOTTO: Rachel Meoli Toulmin, 'L'Ornamento nella Pittura di Giotto', in *Giotto e il suo tempo* (a Congress of 1967), Rome, 1971, pp. 177–89.

p.204 ROMANESQUE ILLUSIONISM: See my *The Heritage of Apelles* (Oxford, 1976), p. 11.

FOCILLON: For a sympathetic account of his ideas see Jean Bony's introduction to H. Focillon, *The Art of the West in the Middle Ages* (London, 1963), with bibliography.

p.205 FOCILLON: *The Life of Forms in Art*, trans. C. B. Hogan and G. Kubler (New York, 1948), original French edition 1934, p. 18.

FOCILLON'S EXAMPLES: My quotations are from his *Art of the West*, I, pp. 131, 148, and II, pp. 148,152.

p.206 MÉRIMÉE: *Essai sur l'Architecture Religieuse du Moyen Age, Particulièrement en France*, reprinted in P. Josserand (ed.), Prosper Mérimée, *Etudes sur les Arts du Moyen Age* (Paris, 1967). The translation in the text is mine. For the origin of these ideas one might go back to the opening statement of Winckelmann's *History of Ancient Art* (1764): 'The arts depending on design began like all inventions with the necessary: then one looked for beauty and finally there followed the superfluous. These are the three principal phases.'

RUSKIN: ed. Cook and Wedderburn, VIII, pp. 119–21.

p.208 SKILL AND WILL IN LATE ANTIQUITY: Ernst Kitzinger, *Byzantine Art in the Making, main lines of stylistic development in Mediterranean art, 3rd–7th century* (London, 1977), has used precisely the example of decorative sculpture to advocate a return to Riegl's interpretation of stylistic change in the period: 'We must certainly accept a change such as this as wholly 'inner directed', a pure manifestation of the sculptor's own aesthetic preference and intent. There is no content here, no point to be made, no message to be conveyed. No patron can have demanded, let alone generated this innovation. . . . It was a kind of chain reaction among artists with each successive step being predicated on the preceding one. And whatever the motivation was in a specific instance, there is no doubt that the process as a whole has meaning' (p. 79). The author goes on to compare this meaning with the rise of cubism in our century. One hesitates to take issue with so eminent an authority to whom all students of the period owe so very much, but much depends for my own argument on whether or not his evidence is in fact cogent. The tidy evolutionary series of capitals he presents is based on the important book by Rudolf Kautzsch, *Kapitellstudien* (Berlin, 1936), but it appears that Kautzsch himself frequently used his evolutionary hypothesis to date monuments which cannot be otherwise precisely dated; his argument is therefore somewhat circular. No doubt the frequency of certain features increased statistically in the course of time, but such developments, which can be paralleled from many fields, do not justify a teleological 'Lamarckian' interpretation. My own reading of such 'global' trends should become clearer towards the end of this chapter.

p.209 MANY STYLES: For the baroque see Karl Ginhart, 'Die gesetzmässige Entwicklung des österreichischen Barockornamentes', *Kunstgeschichtliche Studien*, ed. Hans Tintelnot, Breslau (Dagobert Frey zum 23. April 1943), which was not available to me. From a different point of view Dwight E. Robinson, 'Style changes: cyclical, inexorable and foreseeable', *Harvard Business Review*, Nov./Dec. 1975, argues for the autonomy of cycles in such fashions as beards.

SPELTZ: *Styles of Ornament*, p. 238.

GOTHIC RIBS: John Fitcher, *The Construction of Gothic Cathedrals: a study of medieval vault erection* (New York, 1961).

p.210 POPPER: *The Poverty of Historicism* (London, 1957), and my 'The Logic of Vanity Fair'.

KUBLER: *The Shape of Time, Remarks on the History of Things* (New Haven, Conn., and London, 1962), p. 68.

p.211 FOCILLON: *The Art of the West*, p. 150.

RICKMAN: *An Attempt to Discriminate the Styles of Architecture in England* (London, 4th ed. 1835), p. 5.

ENGRAVED ORNAMENT: Apart from the collections by Berliner and by Jessen see P. Jessen, *Der Ornamentstich* (Berlin, 1920); *Katalog der Ornamentstichsammlung der staatlichen Kunstbibliothek, Berlin* (Berlin and Leipzig, 1939) and Peter Ward-Jackson, 'Some Main Streams and Tributaries in European Ornament from 1500–1750', *Bulletin of the Victoria and Albert Museum*, III, 1969, nos. 2–4 (also available as a separate publication).

p.212 OXFORD DIVINITY SCHOOLS: H. M. Colvin, *The Sheldonian Theatre and the Divinity School* (Oxford, 1964).

HILDEBRANDT: Bruno Grimschitz, *Johann Lucas von Hildebrandt* (Vienna, 1932), p. 15.

GÖLLER: Adolf Göller, *Zur Ästhetik der Architektur*, 1887.

p.214 LOUIS XIV: 'It seems to me that some things have to be changed, that the themes are too serious and that an element of youthfulness has to be mixed into the project. You will bring me the designs when you wish to . . . there must be childhood spread all round.'

p.215 MOVEMENTS: See my *In Search of Cultural History* (Oxford, 1969), and 'The Renaissance—Period or Movement?' in J. B. Trapp (ed.), *Background to the English Renaissance* (London, 1974).

p.216 AGES AND MYTHS: See my lecture 'The Unrepentant Humanist', *Cornell Revue*, I, Spring 1977, pp. 55–67, where the styles of buildings on Cornell campus are discussed in this light.

IX *Designs as Signs*

p.217 MOTTO: 'Es ist . . . eine der schwierigsten Aufgaben, die Grenzen zwischen Ornament und Symbol auseinanderzuhalten; nach dieser—bisher wenig und fast ausschliesslich vom Dilettantismus verfolgten—Richtung steht dem menschlichen Scharfsinn noch ein überreiches Feld zur Bebauung offen, von dem es heute sehr zweifelhaft scheint, ob es je gelingen wird, dasselbe in halbwegs befriedigender Weise zu bestellen.' Alois Riegl, *Stilfragen*, p. 31.

PORTA DEI BOMBARDIERI: Luigi Simeoni, *Verona* (Verona, 1909), p. 21.

p.218 AGE OF REASON: The extreme in this quest for significance is reached in the Utopian designs by Claude-Nicolas Ledoux, who spoke of an *architecture parlante*. See Hugh Honour, *Neo-Classicism* (Harmondsworth, 1968), p. 139.

LATROBE: T. F. Hamlin, *Benjamin Franklin Latrobe* (New York, 1955).

p.219 WOOD: pp. 191–4.

p.220 SUPERVILLE: Barbara Stafford, '"Medusa" or the Physiognomy of the Earth, Humbert de

Superville's Cosmological Aesthetics', *Journal of the Warburg and Courtauld Institutes*, XXXV, 1972, pp. 308–38.

p.221 DEANE: p. 306.

WARING: p. 58.

p.222 HADDON: pp. 332–3.

p.223 BOAS: *Primitive Art,* pp. 120f.

p.224 T'AO-T'IEH: William Willetts, *Foundations of Chinese Art* (London, 1965), pp. 96f; William Watson, *Style in the Arts of China* (Harmondsworth, 1974), pp. 28f; the most detailed analysis of Chinese bronze decor is due to B. Karlgren, whose studies, mainly published in the *Bulletin of the Museum of Far Eastern Antiquities, Stockholm,* are listed by Willetts on p. 438. For this motif see also pp. 266–7 below.

THUNDER: Herrlee Glessner Creel, *Studies in Early Chinese Culture* (Baltimore, 1937), pp. 236–7.

DIVIDED OPINIONS: Carl Hentze, *Die Sakralbronzen und ihre Bedeutung in der frühchinesischen Kultur* (Antwerp, 1941). His interpretations are accepted by Willy Hartner, 'Studien zur Symbolik der frühchinesischen Bronzen', *Paideuma,* III, 6/7, June 1949. Dietrich Seckel, *Einführung in die Kunst Ostasiens* (Munich, 1960), p. 32, is sympathetic but advises caution. Helmut Brinker, *Bronzen aus dem alten China* (catalogue of an exhibition at the Museum Rietberg, Zürich, 1975/6) writes, 'There are many, far too many, speculations about the meaning of archaic bronze decorations. In this respect the restraint we propose to exercise is certainly not out of place' (p. 22, the translation is mine). William Watson, *Ancient Chinese Bronzes* (London, 1962), p. 42, takes a similar line, while Max Loehr, *Ritual Vessels of Bronze Age China* (the catalogue of an exhibition at Asia House Gallery, 1968), pp. 13–14, is even more emphatic in his rejection of such interpretations.

CLAUDE LÉVI-STRAUSS: 'The Future of Kinship Studies' (The Huxley Memorial Lecture, 1965), *Proceedings of the Royal Anthropological Institute,* 1966, CCCXX, p. 15.

F. D. K. BOSCH: *The Golden Germ, an Introduction to Indian Symbolism* (The Hague, 1960). Mr John Irwin has kindly shown me an English translation of the detailed review of the original Dutch edition by the eminent Sanskritist F. B. J. Kuiper, in *Bijdragen tot de Taal-Land-en Volkenkunde,* dl. 107, 1951. The very respectful and, no doubt, deservedly appreciative tone of his analysis cannot hide the fact that where the validity of so many connections is put in question the layman will do well to regard the methods and conclusions of the book with scepticism.

p.225 ARABESQUE: Ernst Kühnel, *The Arabesque,* transl. Richard Ettinghausen (Graz, 1977), states quite bluntly: 'One would entirely misunderstand the character of the arabesque if one were to attach to it any symbolic function' (p. 8). See also my remarks on p. 86 and note, and on the search for meaning in the 'Paisley pattern', under p. 190.

THE EPHOD: F. J. Dölger, 'Die Glöckchen am Gewande des jüdischen Hohenpriesters nach der Ausdeutung jüdischer, heidnischer, und frühchristlicher Schriftsteller', *Antike und Christentum,* IV, 1934, pp. 233–42. I owe this reference to the kindness of Dr Edith Porada, who refers to archaeological parallels in 'Of deer, bells, and pomegranates', *Iranica Antiqua,* VII, 1967, pp. 99–120.

p.226 PARANG RUSAK: John Irwin and Veronica Murphy, *Batiks* (London, Victoria and Albert Museum, 1969).

ACADEMIC GOWNS: R. D. Venables and R. E. Clifford, M.A., *Academic Dress of the University of Oxford* (Oxford, 1957).

p.227 OTTO KOENIG: *Kultur und Verhaltungsforschung, Einführung in die Kulturethologie,* with a preface by Konrad Lorenz (Munich, 1970).

p.229 DECORUM: The *locus classicus* is Cicero, *Orator,* 70.

FORMALLY LAID TABLE: The 'service'—a number of vessels serving any one meal, all ornamented with the same design—appeared in England around 1730. Gerard Brett, *Dinner is Served, a History of Dining in England, 1400–1900* (London, 1968), p. 132. The famous continental manufactures of Meissen and Sèvres also date from the subsequent decades. Sets of silver dishes etc. existed, of course, in Roman times, but these were not quite uniform.

BERTRAND RUSSELL: *Autobiography, 1872–1914* (London, 1967), p. 56.

'WORK': A detailed explanation by the artist of all the figures and their contribution to the message of the painting is to be found in F. M. Hueffer, *Ford Madox Brown* (London, 1896), pp. 189–95.

p.230 JEANS: In 1974 an exhibition toured American museums of the winners of *Levi's Denim Art Contest.* I quote from the catalogue by Baron Wolman and John Burks (Mill Valley, Ca.): 'The parent generation was turned off at the very thought. Which is doubtless why it felt so good to wear Levi's no matter how tight the crotch and scratchy against the skin. . . . Then, in a pretty dazzling leap, studded Levi's on Fifth Avenue! High Society swells were wearing them now, just like the Hell's Angels. Well, not quite like the Angels. When you're rich you have them pre-bleached and pressed. Bleached Levi's: upward mobility.'

HIDDEN PERSUADERS: The allusion is to the book of that name by Vance Packard (New York, 1956).

p.232 BURGUNDIAN HERALDRY: Florence Deuchler, *Die Burgunderbeute* (Bern, 1963).

p.233 HERALDRY: The bibliography of this subject is extensive, but A. C. Fox-Davies, *Complete Guide to Heraldry* (revised ed. by J. P. Brooke-Little) (London, 1973), keeps the promise of its title. For heraldry in a decorative context see Joan Evans, *Pattern,* Chapter III, and John A. Goodall, *Heraldry in the Victoria and Albert Museum* (London, 1960).

p.236 CHINESE CALLIGRAPHY: Chiang Yee, *Chinese Calligraphy* (London, 1938) and Michael Sullivan, *The Three Perfections, Chinese Painting, Poetry and Calligraphy* (Walter Neurath Memorial Lecture, London, 1974).

ARABIC CALLIGRAPHY: Annemarie Schimmel, *Islamic Calligraphy* (Leiden, 1970), Ernst Kühnel, *Islamische Schriftkunst* (Graz, 1972), and Yasin Hamid Safadi, *Islamic Calligraphy* (London, 1978).

p.237 CUFIC IN WESTERN ART: S. D. T. Spittle, 'Cufic Lettering in Christian Art', *The Archaeological*

Journal, CXI, 1955, pp. 138–52. Richard Etting-hausen, 'Kufesque in Byzantine Greece, the Latin West and the Muslim World', in a Colloquium in Memory of George Carpenter Miles, *American Numismatic Society* (New York, 1976), pp. 28–47, with bibliography.

WESTERN CALLIGRAPHY: Bibliography and many examples in Ernst Lehner, *Alphabets and Ornaments* (London, 1952; reprinted by Dover Publications, New York, 1968).

p.240 MONOGRAMS: Victor Gardthausen, *Das alte Monogramm* (Leipzig, 1924), a scholarly history; Hayward and Blanche Cirker, *Monograms and Alphabetic Devices*, a collection of four nineteenth-century pattern books (Dover Publications, New York, 1970).

p.241 BRACKETS OF TRADE SIGNS: René Creux, *Schilder vor dem Himmel* (Fontainemore, 1962); a few examples in H. R. D'Allemagne, *Decorative Antique Ironwork* (Dover edition, New York, 1968), plates 168–72.

CHINESE COURT ROBES: B. Vuillennier, *Symbolism of Chinese Imperial Ritual Robes* (The China Institute, London, 1939); and *Catalogue of an Exhibition of Imperial Robes and Textiles*, foreword by Alan Priest (Minneapolis Institute of Art, 1943).

CARTOUCHE: O. Zülch, *Entstehung des Ohrmuschel-stils*, Chapter I.

p.243 SYMBOLS IN CARTOUCHES: Philipp Fehl, 'The "stemme" on Bernini's Baldacchino in St. Peter's: a forgotten compliment', *The Burlington Magazine*, July 1976, offers an imaginative suggestion.

PUBLICITY SYMBOLS: Many examples in two books by Walter and Marion Diethelm, *Signet, Signal, Symbol* (Zürich, 1970) and *Form and Communication* (Zürich, 1974).

RELIGIOUS SYMBOLS: Hugo Prinz, *Altorientalische Symbolik* (Berlin, 1915); Count Goblet D.Arviella, *The Migration of Symbols* (Westminster, 1894).

p.244 TREE OF LIFE: According to Genesis II: 9, the Lord planted the tree of life in the midst of the Garden of Eden, which is mentioned again in Revelation XXII. According to legend, the Cross of Christ was fashioned from this *lignum vitae*. The application of the term to a variety of motifs in the religious and decorative art of many ages and regions coincided with the discovery of many comparable myths involving cosmic or sacred trees or pillars, culminating in J. G. Frazer's *Golden Bough* (1890–1915). See Mrs J. H. Philpot, *The Sacred Tree in Religion and Art* (London, 1897); the survey in the article by S. A. Cook, 'Tree Worship', *Encyclopedia Britannica* (13th ed. 1926); and E. O. James, *The Tree of Life, an archaeological survey* (Leiden, 1966). For Indian mythology see Odette Viennot, *Le Culte de l'Arbre dans l'Inde Ancienne* (Paris, 1954); for relevance to Indian art, John Irwin, '"Asokan" Pillars: a reassessment of the evidence', IV, 'Symbolism', *Burlington Magazine*, CXVIII, November 1976.

MESOPOTAMIAN 'TREES OF LIFE': Nel Perrot, *Les Représentations de l'Arbre Sacré sur les Monuments de Mésopotamie et d'Elan* (Paris, 1937). According to Barthel Hrouda, 'Zur Herkunft des Assyrischen Lebensbaumes', *Baghdader Mitteilungen*, 3, 1964, pp.

41–51 (to which Dr Porada has kindly drawn my attention), the motif is not originally a tree, but derived from the Egyptian Papyrus plant.

'TREE OF LIFE' MOTIFS: Many examples in George Lechler, 'The Tree of Life in non-European and Islamic Cultures', *Ars Islamica*, IV, 1937, pp. 369–416. Roger Cook, *The Tree of Life, Symbol of the Centre* (London, 1974), illustrates the range of images which can be subsumed under this designation. My own conclusions come very close to the 'law' formulated by Count Goblet D'Arviella in 1894: 'When an artist wants to bring into prominence, as a symbol, the isolated image of an object which lends itself to symmetrical representation, particularly a tree or pillar, he places on either side two creatures facing one another—giving rise sometimes, in return, to a myth or legend in order to account for the combination.' *The Migration of Symbols* (Westminster, 1894), p. 139. See also p. 270 below.

J. BALTRUŠAITIS: *Art Sumérien et Art Roman* (Paris, 1934).

p. 246 MANDALA IN JUNG: C. G. Jung, 'Concerning Mandala Symbolism' (originally published in German, 1950) in *The Collected Works of C. G. Jung*, vol. 9, part I (New York, 1959), pp. 355–90.

FRIEDA FORDHAM: *An Introduction to Jung's Psychology* (Harmondsworth, 1953), pp. 65–6.

p.247 THE CROSS: For an attempt to list the vast literature, see Rüdiger Schneider Berrenberg, *Kreuz, Kruzifix, eine Bibliographie* (Munich, circulated by the author, 1973).

p.250 HOUSEHOLD CAVALRY: I am indebted for the details to Lt. Col. A. D. Meakin. Here, as always, form and function interact, witness the many similar designs illustrated in Col. Robert H. Rankin, *Military Headdress, a pictorial history of military headgear 1660–1914* (London, 1976).

X The Edge of Chaos

p.251 MOTTO: G. P. Lomazzo, *Rime* (Milan, 1587), as quoted in Zülch, *Ohrmuschelstil*.

MAXIMILIAN'S PRAYER-BOOK: Facsimile editions of the pages decorated by Dürer (and some others) by Karl Giehlow (Vienna, 1907), G. Leidinger (Munich, 1922), and W. Timm (Dresden, 1957). For a general account see E. Panofsky, *The Life and Art of Albrecht Dürer* (Princeton, 1945), pp. 182–90; for a detailed study, Hans Christoph von Tavel, 'Die Randzeichnungen Albrecht Dürers zum Gebetbuch Maximilians', *Münchner Jahrbuch der bildenden Kunst*, III.F. XVI, 1965, pp. 55–120.

DREAMWORK: '... es wär dann Sach, dass einer Traumwerk wollt machen. In solchem mag einer alle Ding durcheinander mischen', *Dürers Schriftlicher Nachlass*, ed. K. Lange and F. Fuhse (Halle a.S., 1893), p. 357 (a parallel passage p. 219).

MAZEROLLES: See H. C. von Tavel as quoted above.

SYMBOLIC MEANINGS: E. Panofsky as quoted above, pp. 189–90. Others are listed in Mathias Mende, *Dürer-Bibliographe* (Wiesbach, 1971), under 3533, 3554, 3555.

p.254 'FULL OF IMAGES': ('Inwendig voller Figur'),

Dürers Schriftlicher Nachlass (as quoted above), pp. 295, 298.

DROLLERY; GROTESQUE: The distinction here proposed has not been traditional in English antiquarian and art-historical writings, where the word Grotesque is used for any monstrous or humorous motif. For the history of the term Grotesque and its original application see Dacos, *Domus Aurea*.

LUTTRELL PSALTER: Complete edition by Eric George Millar (London, 1932).

CANDELABRA MOTIFS: Dacos, *Domus Aurea*, pp. 61–2.

p.255 HORACE: Bibliography in Dacos, *Domus Aurea*, p. 123 (note).

ST. BERNARD: Migne, *Patrologia Latina*, 182, coll. 915/6; a full translation in Elizabeth G. Holt, *A Documentary History of Art*, I, (New York, 1957), pp. 19–22. For the influence of this famous text see Jean Adhémar, *Influences Antiques dans l'Art du Moyen Age Français* (Studies of the Warburg Institute, 7, London, 1939), pp. 270–1; Lillian M. C. Randall, *Images in the Margins of Gothic Manuscripts* (Berkeley and Los Angeles, 1966), pp. 3f; and 'On the aesthetic attitude in Romanesque art' in Meyer Schapiro, *Romanesque Art* (London, 1977). The translation in the text is mine.

p.256 RUSKIN: *Stones of Venice*, III, Chapter 3; *Works* XI, p. 151.

p.257 PEOPLED SCROLLS: J. B. Ward Perkins and J. M. C. Toynbee, 'Peopled scrolls; a hellenistic motif in Imperial art', *Papers of the British School at Rome*, XVIII, 1950, pp. 1–43.

THE GREAT SPHINX: I. E. S. Edwards, *The Pyramids of Egypt* (West Drayton, Middlesex, 1947), p. 107. The relevance of this late inscription is contested by H. Demisch, *Die Sphinx* (Stuttgart, 1977).

GUARDIAN BULLS: H. Frankfort, *The Art and Architecture of the Ancient Orient* (Pelican History of Art, Harmondsworth, 1954), p. 77.

LOEWY: 'Ursprünge der bildenden Kunst', *Almanach der Akademie der Wissenschaften in Wien*, 1930.

p.259 LÉVI-STRAUSS: 'Le Dédoublement de la Représentation dans les Arts de l'Asie et de l'Amérique', originally published in 1944/5, reprinted as Chapter XIII of *Anthropologie Structurale* (Paris, 1958). The translation in the text is mine.

p.260 MEXICAN PARALLELS: My remarks are not intended to exclude a genuine diffusion of the motif as postulated by C. Hentze, *Die Sakralbronzen und ihre Bedeutung in der frühchinesischen Kulturen* (Antwerp, 1941). Even diffusion (if it is accepted as possible across these distances of space and time) would be favoured by psychological dispositions.

LURISTAN: P. R. S. Moorey, *Ancient Bronzes from Luristan* (London, British Museum, 1974).

p.262 FRANKFORT: H. Frankfort, *The Art and Architecture of the Ancient Orient* (Pelican History of Art, Harmondsworth, 1954), p. 211.

KARLGREN: Quoted in Willetts, *Chinese Art*, p. 100.

ZOOMORPHIC STYLES: B. Salin, *Die altgermanische Tierornamentik* (Stockholm, 1904). E. H. Minns, 'The Art of the Northern Nomads', *Proceedings of the British Academy*, 54, 1942; David M. Wilson and Ole Klindt-Jensen, *Viking Art* (London, 1966).

HILDBURGH: Walter Leo Hildburgh, 'Indeterminability and confusion as apotropaic elements in Italy and in Spain', and 'The place of confusion and indeterminability in Mazes and Maze-dances', *Folk-lore*, 56, 1944–5, pp. 134–49, 188–92.

p.265 MEGAW: (Bath, 1970).

ELUSIVE MASK: B. Salin (quoted above) reproduces in his Fig. 593 such a mask resulting from a fusion of animals, referring to it as 'a designer's jest' (*ornamentale Scherze*).

KARL VON DEN STEINEN: *Die Marquesaner und ihre Kunst. Primitive Südseeornamentik*, I: *Tatauierung* (Berlin, 1925).

p.267 WATSON: *Style*, p. 29.

COMPONENTS OF T'AO-T'IEH: Willetts, *Chinese Art*, pp. 96, 97; Carl Hentze, *Die Sakralbronzen*, also identifies the creature's nose with the cicada, symbol of rebirth.

LATER VERSIONS: Willetts, *Chinese Art*, p. 98.

WATSON: *Style*, p. 29, as above.

AZTEC EARTH GODDESS: George Kubler, *The Art and Architecture of America* (Pelican History of Art, Harmondsworth, 1962), p. 59, speaks of the snakes 'as if arising from a headless trunk'. But do they not form the head?

p.268 BOAS ON BRACELET: *Primitive Art*, p. 223.

p.269 BOAS ON BLANKET: *Primitive Art*, p. 214. Bill Holm, *Northwest Coast Indian Art, an analysis of form* (Seattle, 1965), p. 9, remarks on the 'Symbolic ambiguity' revealed in these interpretations without, however, offering an explanation. Otto Koenig, *Urmotiv Auge*, has no hesitation in drawing on these examples of facial masks.

p.270 TREE OF LIFE: See above, p. 244 and notes. Confronting animal heads as terminations frequently occur in late antique and migration period designs, see Hermann Bullinger, *Spätantike Gürtelbeschläge* (Bruges, 1969). But the rarity of their fusion into an elusive mask, which Salin interpreted as a 'jest' (see note to p. 265), may support the avoidance hypothesis. Something was needed to keep them distinct.

DEREGOWSKI: Jan B. Deregowski, 'Illusion and Culture', in Gregory and Gombrich, *Illusion*, especially pp. 182–9.

p.271 SLOMAN: *Bicorporates* (Copenhagen, 1967).

OTTO KURZ: 'Lion Masks with Rings in the West and in the East', *Scripta Hierosolimitana* (Jerusalem, 1973), pp. 22–41.

p.272 KRIS: 'Ego development and the comic', in *Psychoanalytic Explorations in Art* (New York), 1952, Chapter 8, especially p. 213.

p.273 BOOK OF KELLS: *The Book of Kells with a Study of the manuscript* by Françoise Henry (London, 1974), p. 207.

ANIMATION OF INITIALS: Alois Schardt, *Das Initial, Phantasie und Buchstabenmalerei des frühen Mittelalters* (Berlin, 1938); Jürgen Gutbrod, *Die Initiale in Handschriften des achten bis dreizehnten Jahrhunderts* (Stuttgart, 1965); Emile A. van Moé, *La Lettre Ornée dans les manuscrits du VIIIe au XIIe Siècle* (Paris, 1943).

p.274 'THE HAUNTED TANGLEWOOD': T. S. R. Boase, *English Art, 1100–1216* (Oxford History of English Art, Oxford, 1953), p. 89.

p.276 MARGINAL DROLLERIES: L. M. C. Randall, *Images in the Margins of Gothic Manuscripts* (Berkeley and Los Angeles, 1966).

GARGOYLES: J. Baltrušaitis, *Le Moyen Age Fantastique* (Paris, 1955); Lester Burbank Bridaham, *Gargoyles, Chimeras and the Grotesque in French Gothic Sculpture* (New York, 1930); Ronald Sheridan and Anne Ross, *Paganism in the Medieval Church* (New York, 1975).

p.277 MISERICORDS: Dorothy and Henry Kraus, *The Hidden World of Misericords* (London, 1976), concentrates on French examples, with a brief appendix on other regions. See also G. L. Remnant, *A Catalogue of Misericords in Great Britain* (Oxford, 1969); and Hermann Jung, *Närrische Volkskunst, Drollerien und Narrheiten an niederrheinischen Chorgestühlen* (Munich, 1970).

THE MASK IN THE FOLIAGE: Kathleen Basford, *The Green Man* (Ipswich, 1978), who traces this motif from classical times to the eighteenth century, rightly states in her introduction that 'images may pick up many different ideas during the course of time'. Whether or not any of these were originally intended to represent the 'Green Man' as a symbol of revival and regeneration in May Day celebrations, the very belief in this meaning provides a parallel, for instance, to the 'secondary' interpretations of the Chinese *t'ao-t'ieh*. Mr John Piper's remark to the author, mentioned on p. 21, is also worth quoting: 'If one is drawing leaves and branches as a flat, more or less decorative design it seems quite natural to put in two eyes, a nose and a mouth'. Certainly, but what makes it 'natural'?

p.278 REVIVAL OF THE GROTESQUE: I closely follow Dacos, *Domus Aurea*.

p.280 MASTER OF THE DIE: The translation is mine.

p.282 AMBIGUITY IN CARTOUCHES: I follow Zülch, *Ohrmuschelstil*.

VAN VIANEN: J. W. Frederiks, *Dutch Silver* (The Hague, 1952–6).

Epilogue

p.285 MOTTO: T. S. Eliot, *Four Quartets, 'Burnt Norton'*, v (London, Faber and Faber, 1944), p. 12. Reprinted by permission of Faber and Faber Ltd from *Collected Poems 1909–1962* by T. S. Eliot, and by permission of Harcourt Brace Jovanovich, Inc. (© 1943 by T. S. Eliot; renewed, 1971, by Esme Valerie Eliot).

WALTER PATER: 'The School of Giorgione', in *The Renaissance* (London, 1912), p. 135. Pater was clearly aware of the Hegelian system according to which the dominant arts must succeed each other, but while in Hegel poetry is the last of the arts (to be replaced by pure thought) he inverted the sequence.

ISOMORPHIC NOTATION: An instructive comparison between recorded wave-forms and the musical score of some bars of a Mozart trio is illustrated in Charles Taylor, *Sounds of Music* (London, BBC, 1976), Appendix IV.

p.286 RIVALRY: For the history of these rivalries and some parallels see the edition of Leonardo's *Paragone* by Irma A. Richter (Oxford, 1949).

WITTKOWER: *Architectural Principles in the Age of Humanism* (Studies of the Warburg Institute, 19, London, 1949).

HELMHOLTZ: See Charles Taylor as quoted above, pp. 151f.

COLOUR HARMONIES: See F. Schmid, 'The earliest History of the Colour Wheel', in *The Practice of Painting* (London, 1948), pp. 109–18. See also Richard C. Teevan and Robert C. Birney, *Color Vision, an enduring problem in Psychology*, selected readings (Princeton, N.J., 1961). For other titles see notes under p. 142.

ARCIMBOLDO: According to Gregorio Comandini, *Il Figino, overo del Fine della Pittura* (Mantua, 1591), p. 244, he systematically compared colours with musical scales, but we are not told how he demonstrated this affinity.

CASTEL: R. P. Castel, *L'Optique des Couleurs* (Paris, 1740). See the article on him by Albert Wellek in Friedrich Blume (ed.), *Die Musik in Geschichte und Gegenwart* (Berlin, 1952), and the same author's entry on 'Farbenmusik' in the same work, both with bibliographies.

POEM: Antoine Marin Lemierre, *La Peinture, poëme en trois chants* (Amsterdam, 1770), p. 69.

p.287 BREWSTER: See Chapter VI. The quotation comes from Chapter XVII, p. 135, of his *Treatise on the Kaleidoscope*.

SEMPER: *Der Stil*, I, 27.

WATELET: *L'Art de Peindre* (Paris, 1760); the passage is printed in the edition of Lemierre quoted above, p. 68.

p.288 SYNAESTHESIA: Some references in my *Art and Illusion*, Chapter X.

RHYTHM: Eugen Petersen, 'Rhythmus', *Abhandlungen der königl. Gesellschaft der Wissenschaften zu Göttingen, philologisch-historische Klasse*, N. F. Band XVI, no. 5 (Berlin, 1917), pp. 1–104, deals exhaustively with the history of the term and the concept in the ancient world. For more recent work see Paul Fraisse, *Les Structures rythmiques; étude psychologique* (Paris, 1956).

LESSING'S LAOCOON: See my 'Lessing', *Proceedings of the British Academy*, 113, 1958, pp. 133–56.

PERCEPTION OF TIME: Paul Fraisse, *The Psychology of Time*, trans. J. Leith (London, 1964), especially part II, Chapter 3. A bibliography of this vast subject is Irving Zelkind and Joseph Sprug, *Time Research: 1172 Studies* (New York, 1974). For the visual arts see also my 'Moment and Movement in Art', *Journal of the Warburg and Courtauld Institutes*, 27, 1964, pp. 293–306.

ST. AUGUSTINE: *Confessions*, Book XI, 10–31.

METAPHORS: See notes to p. 175.

p.289 DANCE: Roderyk Lange, *The Nature of Dance, An Anthropological Perspective* (London, 1975).

p.290 LANGUAGE: Peter Farb, *Word Play* (New York, 1974), offers a survey of problems and a large bibliography.

p.291 CURTIUS: (London, 1953), pp. 282–3.

p.292 MOZART: It appears that the attribution of this game to Mozart is merely traditional, but his pleasure in permutations is authentic; see Emanuel Winternitz, 'Gnagflow Trazom: An Essay on Mozart's Script, Pastimes and Nonsense Letters',

Journal of the American Musicological Society, XI, 2–3, 1958, pp. 200–16.

BABUR: B. Gascoigne, *The Great Moghuls* (London, 1971), p. 25. For the background see Alfred Liede, *Dichtung als Spiel* (Berlin, 1963), Vol. II, Chapter 21, 'Die Spiele des Orients und die deutschen Spiele'.

RESOURCES OF MUSIC: Herbert A. Simon and Richard K. Sumner, 'Pattern in Music', in B. Kleinmuntz (ed.), *Formal Representation of Human Judgement* (New York, 1968), pp. 219–50.

p.294 PAPYROLOGISTS: Eric G. Turner, *Greek Papyri* (Oxford, 1968).

NO SIGMA: Eric G. Turner, 'Papyrus Bodmer XXVIII: A Satyr-Play on the Confrontation of Heracles and Atlas', *Museum Helveticum*, 33, 1976, Fasc. I, pp. 1–23.

LISTENING TO SPEECH: Striking examples in the classic paper by K. S. Lashley, 'The Problem of Serial Order in Behavior', in Lloyd A. Jeffres (ed.), *Cerebral Mechanisms in Behavior* (New York, 1951).

p.295 HUMPTY DUMPTY'S SONG. From Lewis Carroll, *Through the Looking-Glass*, 1872.

p.296 STYLE AND STATISTICS IN MUSIC: For a survey and a warning see Joel E. Cohen, 'Information Theory and Music', *Behavioral Science*, 7/2, April 1962, pp. 137–62.

TOVEY'S TEST: I have telescoped the final pages of the *Integrity of Music* (Oxford, 1941).

p.297 SYMMETRY IN MUSIC: Donald Tovey, *The Integrity of Music*, p. 104.

SINGLE CENTURY: (1728–1828). The period, which ends with Schubert's death, admittedly does not encompass the earlier masterpieces of Bach and Handel, but the *St. Matthew Passion* and the *Messiah* fall within it.

p.298 TOVEY: *The Integrity of Music*, pp. 47–9.

SCHOPENHAUER: *Die Welt als Wille und Vorstellung* (The World as Will and Idea), I, 3rd Book, s.52. I quote from the 8th edition (Leipzig, 1891).

p.299 SEMITONE: p. 308; the translation is mine.

RELATIVE DISORIENTATION: L. B. Meyer, 'Meaning in Music and Information Theory', *Journal of Aesthetics and Art Criticism*, 15, 1957.

p.300 SUSPENSE THROUGH REPETITION: An example in Beethoven is the twelve pianissimo triplet quavers preceding the emotional climax of the *Cavatina* in his Quartet op. 130.

p.303 RINALDO DA CAPUA: Charles Burney (ed. H. E. Poole), *Music, Men and Manners in France and Italy*, 1770 (London, 1974), p. 154. Burney subsequently glossed this passage of his diary, 'Let Haydn, Mozart and Beethoven answer this assertion.'

MOZART: Letter to his father, 28 December 1782. (The concertos mentioned are K. 413, 414, 415.)

HINDEMITH: *A Composer's World* (Cambridge, Mass., 1952), p. 16.

p.304 LÉVI-STRAUSS: *Le Cru et le Cuit*, translated by John and Doreen Weightman as *The Raw and the Cooked* (London, 1970), p. 17.

p.305 KINETIC ART: Frank Popper, *Origins and Development of Kinetic Art* (London, 1968).

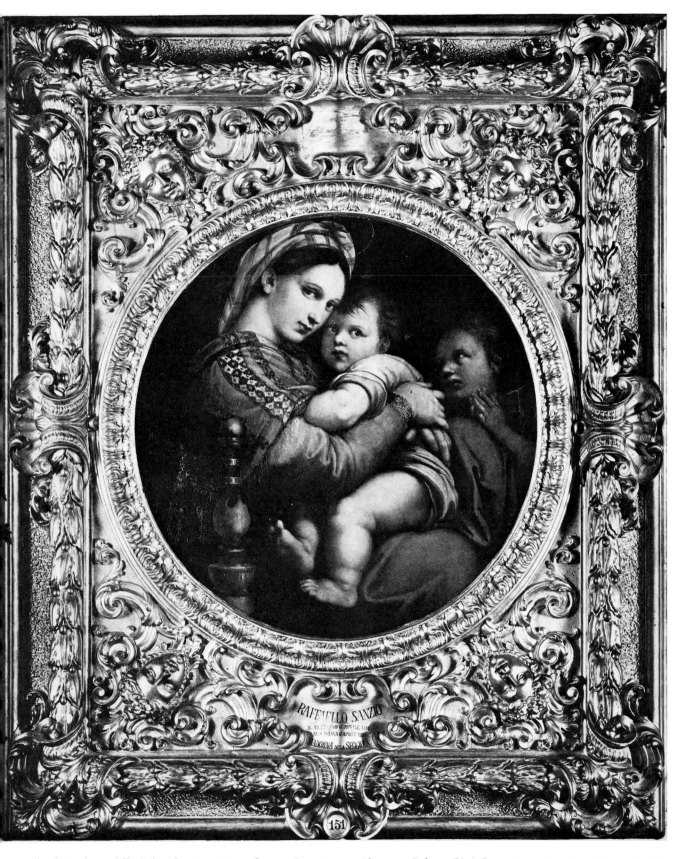

1. Raphael: *Madonna della Sedia,* about 1516, in a frame of about 1700. Florence, Palazzo Pitti. See pp. 14, 75, 125, 156, 160, 164, 167, 189, 242, 284

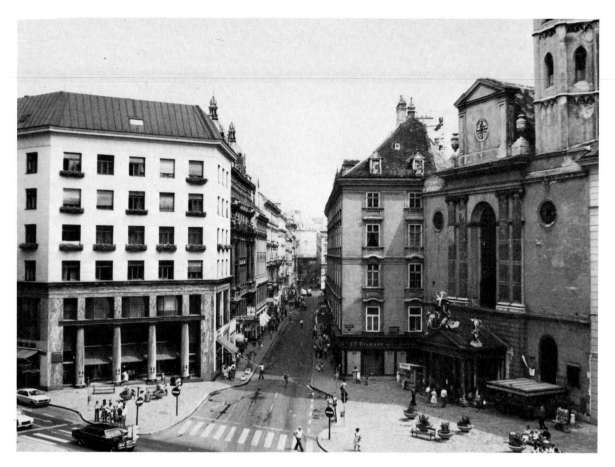

2. The Michaelerplatz, Vienna, with the façade of Goldman and Salatsch by Adolf Loos (begun 1909) on the left, and that of St. Michael's Church (18th century) on the right. See pp.viii,60,164,180,295

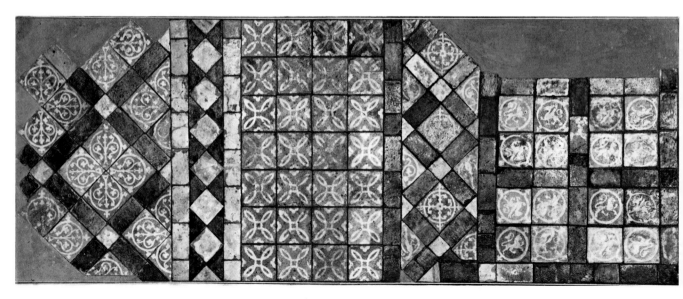

3. Tiled floor from Clarendon Palace. About 1250. London, British Museum. See pp.9,34

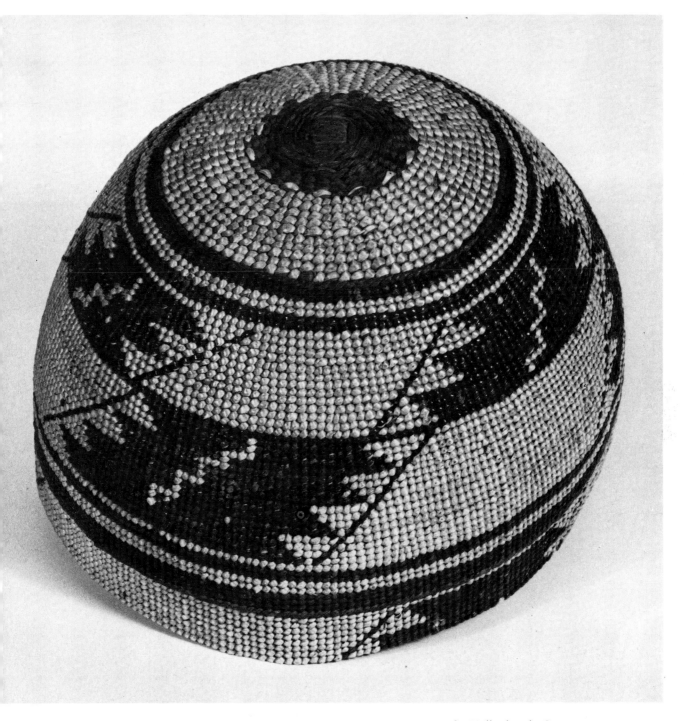

4. Woman's hat from Yurok, Trinidad Bay, Panama. Vienna, Museum für Völkerkunde. See p.11

5. Gateway, Temple of Srirangam, India. 17th century. See pp.17,157

6. Interior of the Cartuja, Granada. 1727–64. See pp.17,164

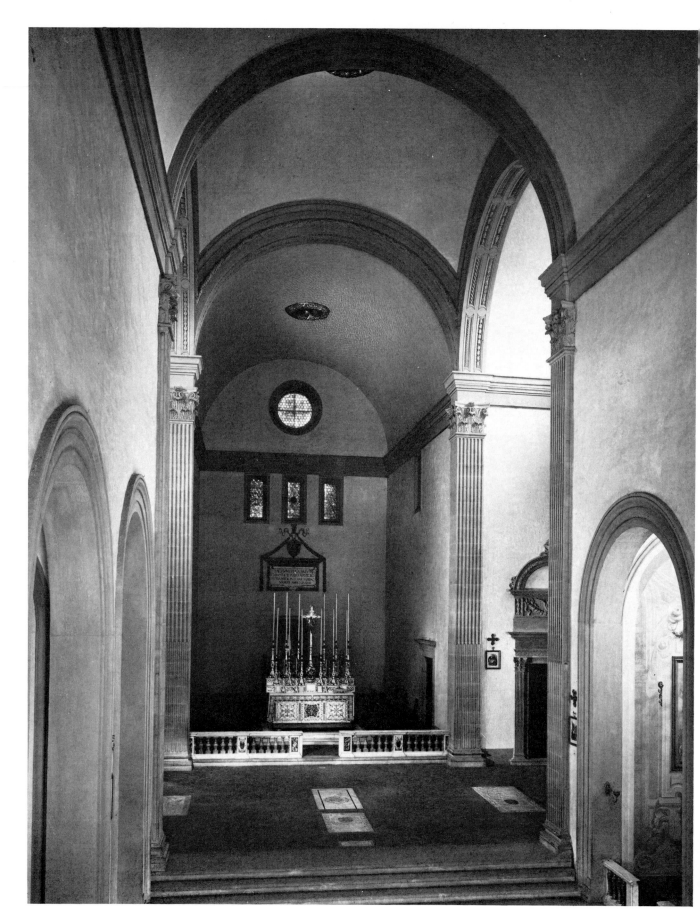

7. Interior of the Badia, Fiesole. 1460–7. See p.18

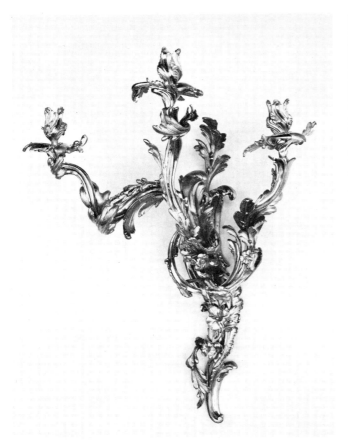

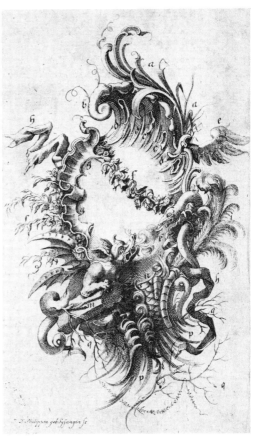

8. Gilded bronze wall light. French, about 1750. New York, Metropolitan Museum of Art, Wrightsman wing. See p.22

9. F.A. Krubsacius: Mock cartouche. 1759. See p.25

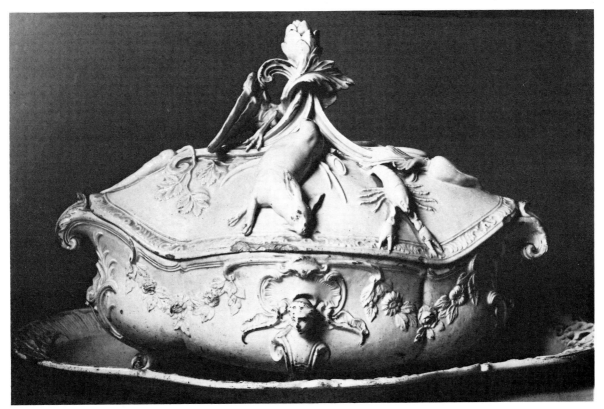

10. Soup tureen. French, middle of the 18th century. Paris, Musée des Arts Décoratifs. See p.21

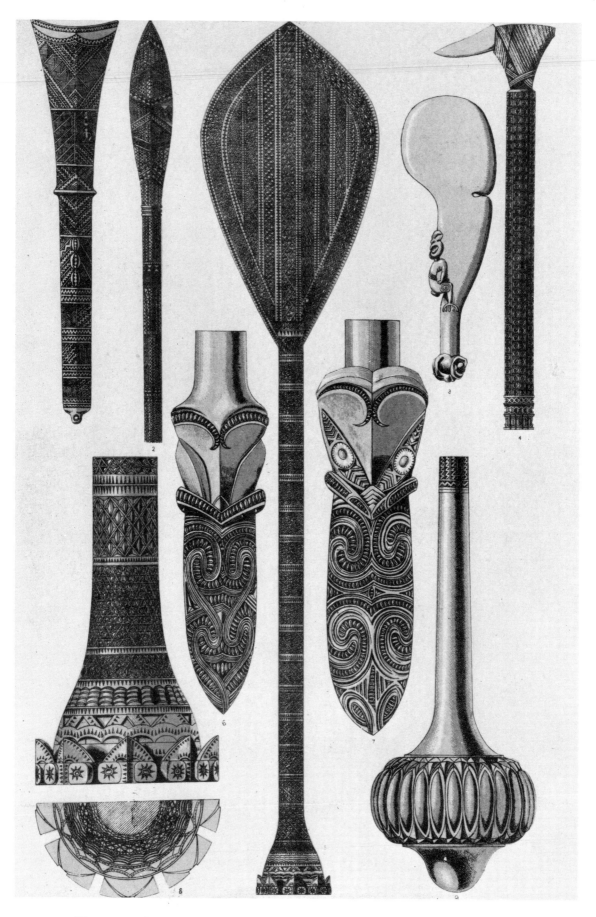

11. 'Ornament of Savage Tribes'. From Owen Jones, *The Grammar of Ornament*, 1856. See p.51

12. H. W. Phillips: *Owen Jones*. 1857. London, Royal Institute of British Architects. See p.51

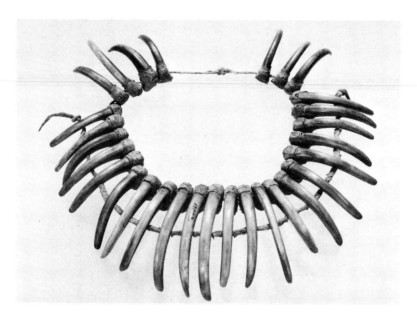

13. Bear claw necklace of the Pawnee Indians. Vienna, Museum für Völkerkunde. See pp.65,258

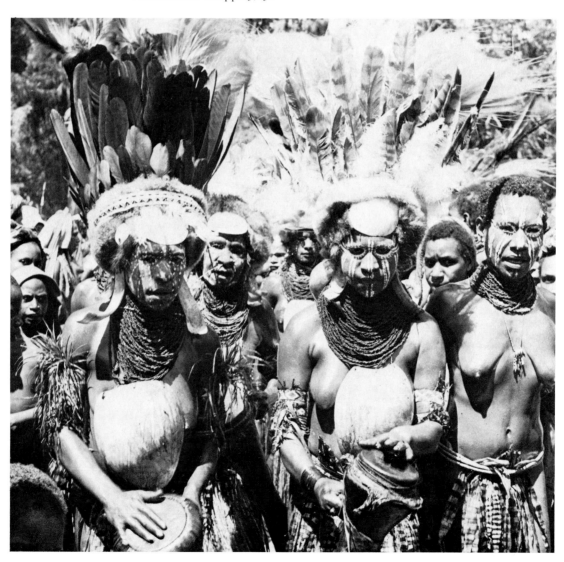

14. Aborigines from Mount Hagen, New Guinea, in festive attire. See pp.48,65,169

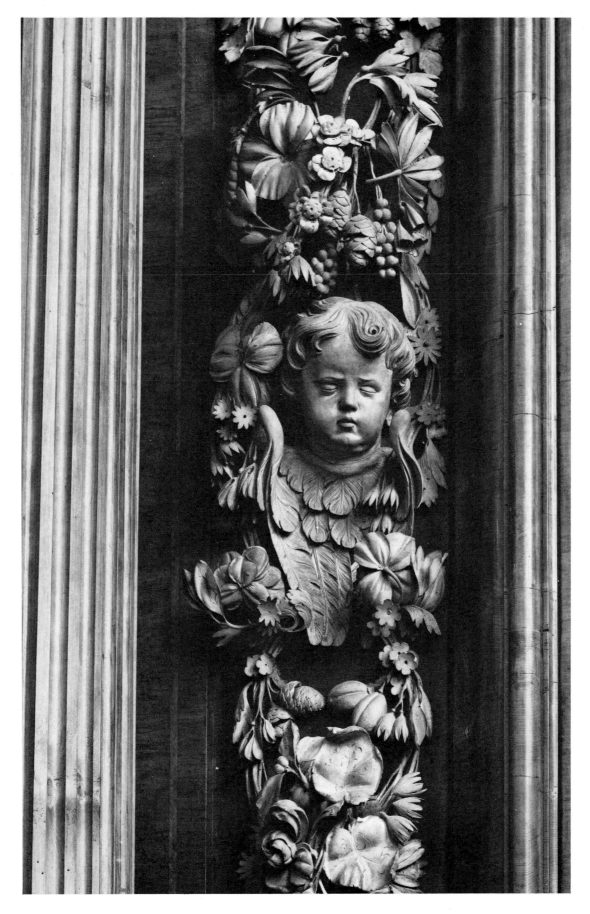

15. Grinling Gibbons: Detail of reredos, Trinity College, Oxford. About 1700. See pp.65,173

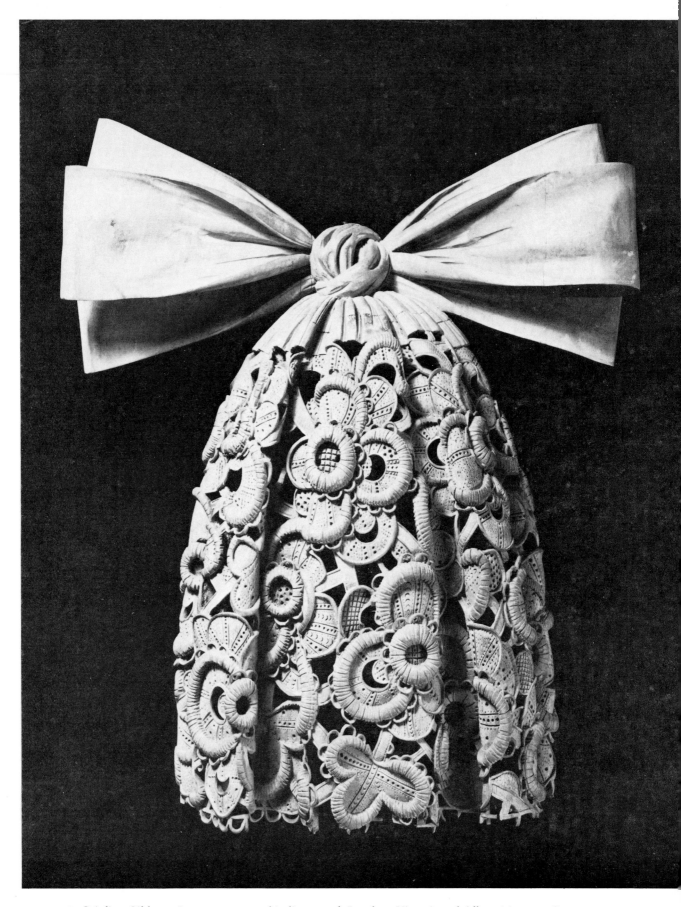

16. Grinling Gibbons: Lace cravat carved in limewood. London, Victoria and Albert Museum. See pp.65,168,291

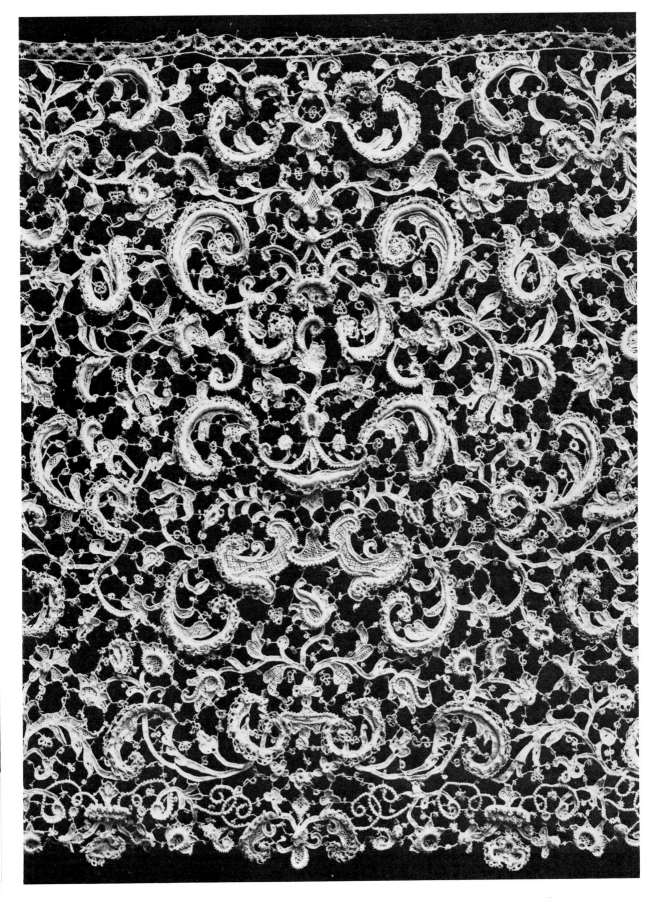

17. Italian needlepoint *(point de neige)*. 17th century. London, Victoria and Albert Museum. See p.65

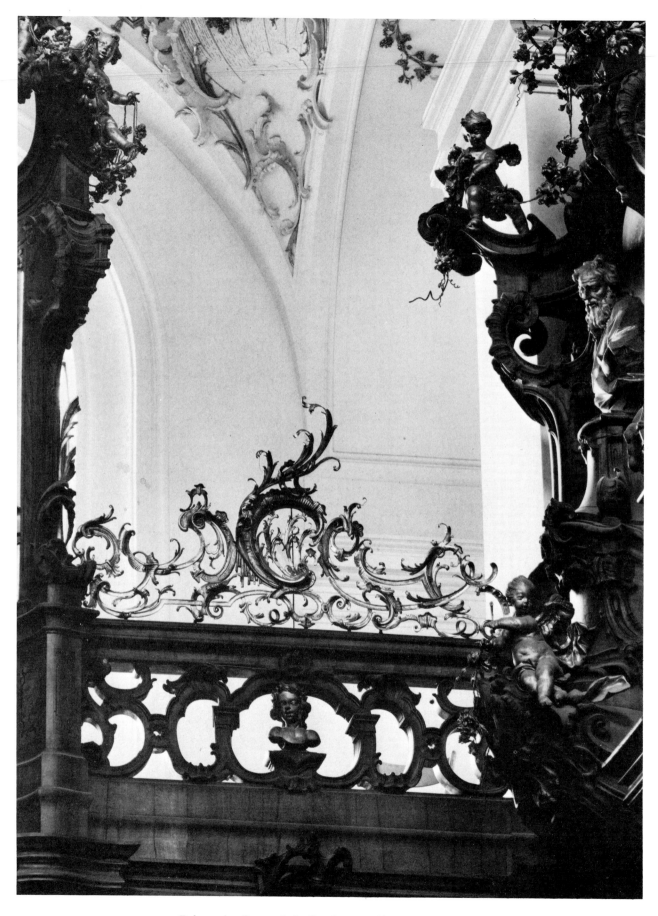

20. Balustrade of organ loft, Ottobeuren. About 1766. See pp.66,75

21. Silver filigree slipper decoration from North Africa.
Stuttgart, Linden Museum. See p.66

22. Ivory armlet from Benin, Nigeria. 16th century. London,
British Museum. See p.66

30. Detail of the decoration in the Salon de Comares, Alhambra, Granada. 14th century. See p.81

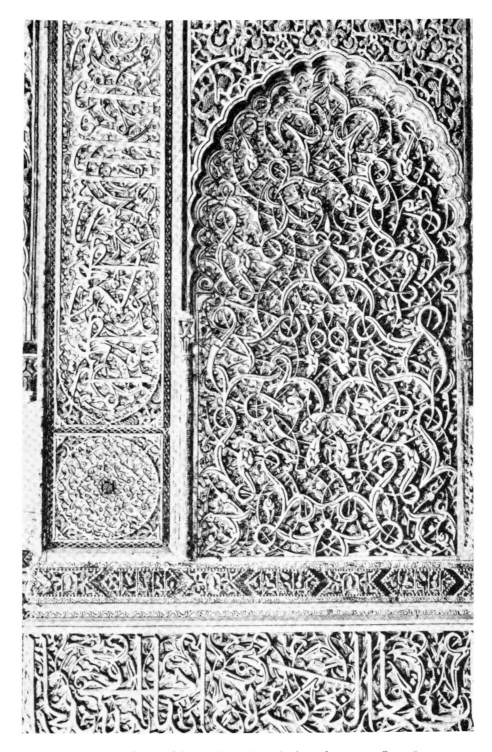

31. Mausoleum of the Saadiens, Marrakesh. 16th century. See p.81

41. Blue and white pilgrim bottle. Chinese, early 15th century. London, Percival David Foundation. See p.159

42. Sutra storage box. Japanese, 17th century. Cornell University, Ithaca, Herbert F. Johnson Museum of Art. See p.140

43. Silver tureen by Boulton and Fothergill. 1773. Birmingham, Assay Office. See pp.165,167

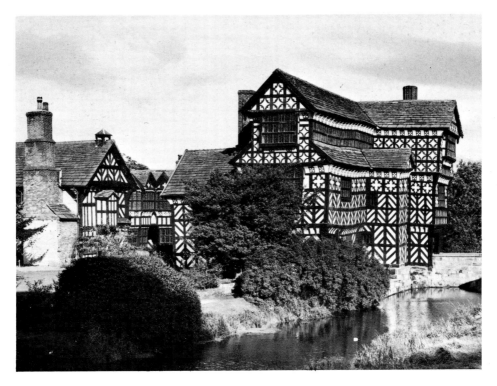

44. Little Moreton Hall, Cheshire. 16th century. See p.164

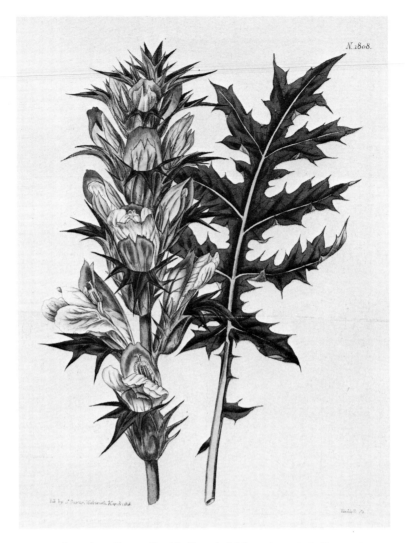

47. Acanthus. From *Curtis's Botanical Magazine*, 1816. See p.184

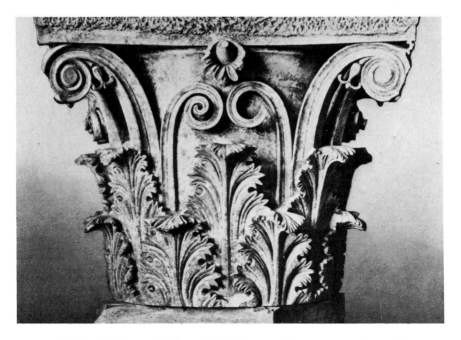

48. Corinthian capital found in Epidaurus. About 300 B.C. See p.184

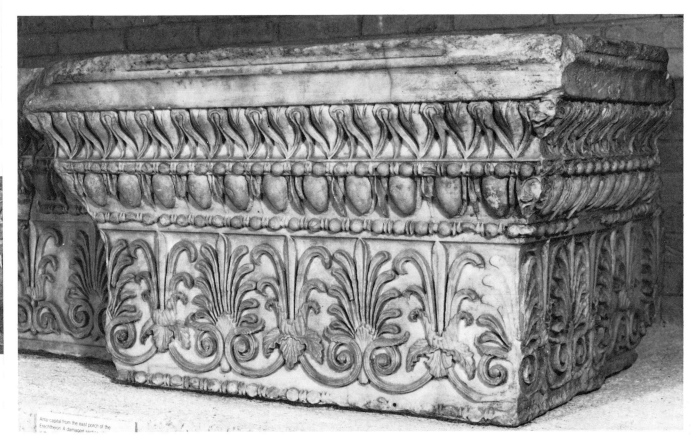

49. Ornamental frieze from the Erechtheion. About 415 B.C. London, British Museum. See pp.185,186,207

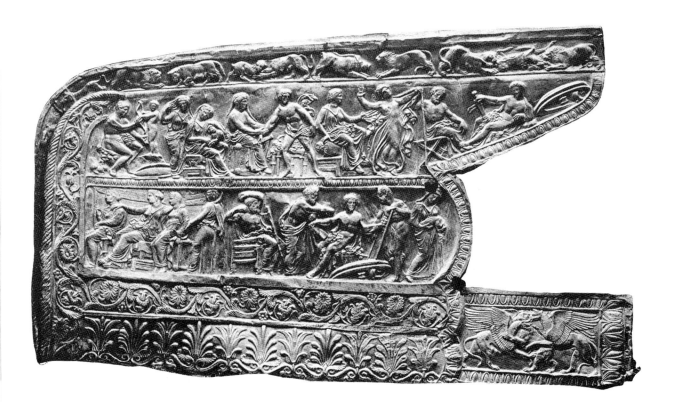

50. Gold quiver. Greek workmanship, late 5th–early 4th century B.C. Rostov-on-Don, Museum. See pp.185,186

64. Lucas Cra 55

65. Vermeer: Detail from *A Young Woman standing at a Virginal*.
About 1670. London, National Gallery. See p.203

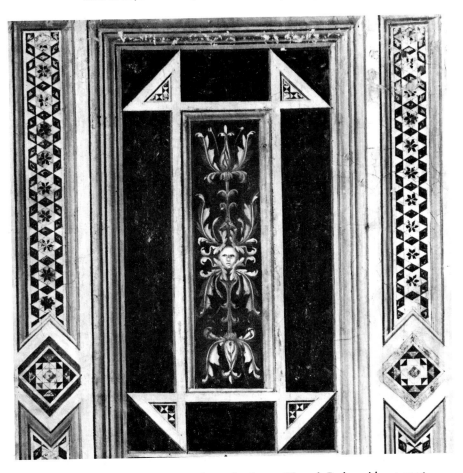

66. Giotto: Decorative panel from the Arena Chapel, Padua. About 1306.
See pp.203,278

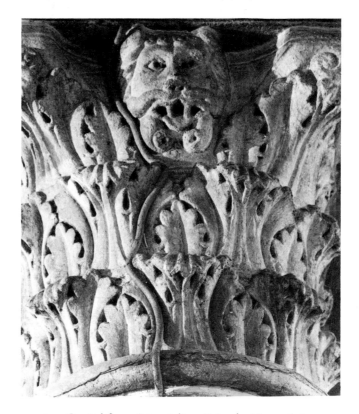

67. Capital from Saint-Julien, Brioude, Haute-Loire.
12th century. See p.205

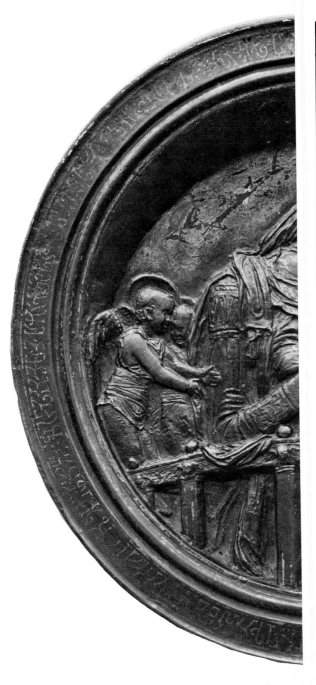

80. Donatello: *Chellini Madonna*. About 1

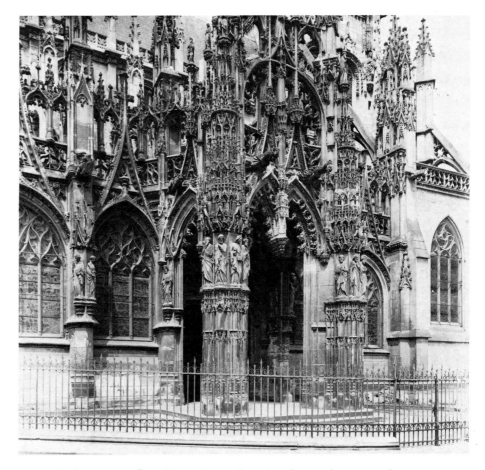

68. Revetment from Notre-Dame, Louviers. Late 15th century. See p.206

78. Bowl with Cufic deco
Metropolitan Museum

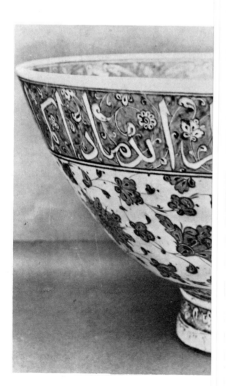

79. Bowl from Isnik, Turke

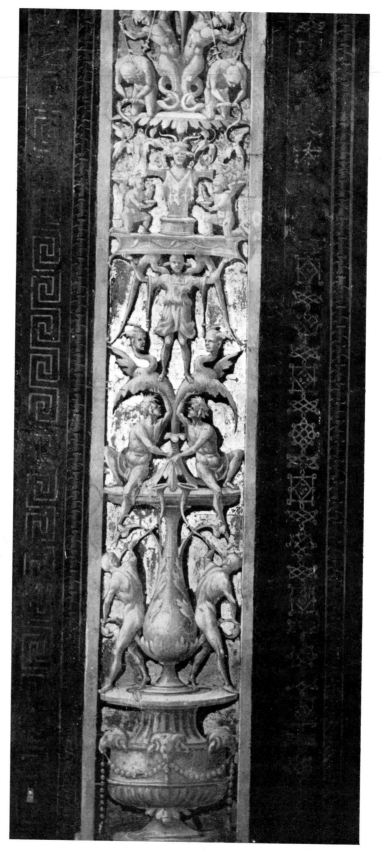

89. Luca Signorelli: Detail of a pilaster from Orvieto Cathedral. 1500–4. See p.279.

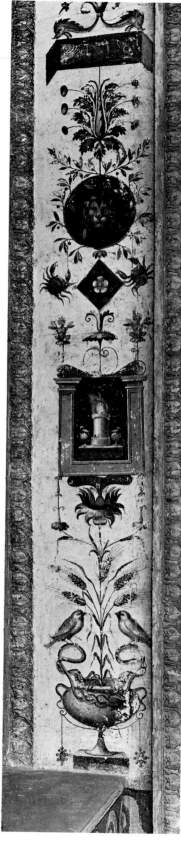

90. Giovanni da Udine: Detail of a pilaster from the Logge Vaticane, Rome. Completed 1519. See p.279

Full Titles of Books
cited elsewhere in a shortened form

BAUER, HERMANN, *Rocaille: Zur Herkunft und zum Wesen eines Ornament-Motivs*, Berlin, 1962.

BERLINER, RUDOLF, *Ornamentale Vorlageblätter*, 4 vols., Leipzig, 1926.

BOAS, FRANZ, *Primitive Art*, Oslo, 1927. Reprinted by Dover Books, New York, 1955.

BLANC, CHARLES, *L'Art dans la Parure et dans le Vêtement*. Paris, 1874. English edition, London 1877.

CARTERETTE, EDWARD C., and FRIEDMAN, MORTON P. (eds.), *Handbook of Perception*, New York and London, 1974 etc.

CHRISTIE, A. H., *Traditional Methods of Pattern Designing*, Oxford, 1910. Second edition, 1929; reprinted by Dover Publications, New York, as *Pattern Design*, 1969.

DACOS, NICOLE, *La Découverte de la Domus Aurea et la Formation des Grotesques à la Renaissance* (Studies of the Warburg Institute, 31), London, 1969.

DAY, LEWIS F., *Ornamental Design*, London, 1890, comprising *The Planning of Ornament* and *The Anatomy of Pattern*.

EVANS, JOAN, *Pattern, a Study of Ornament in Western Europe 1180–1900*, Oxford, 1931.

GIBSON, J. J., *The Perception of the Visual World*, Cambridge, Mass., 1950.

——, *The Senses considered as Perceptual Systems*, New York, 1966.

GOMBRICH, E. H., *Art and Illusion: A Study in the Psychology of Pictorial Representation*, London and New York, 1960.

——, *Meditations on a Hobby Horse and Other Essays on the Theory of Art*, London and New York, 1963.

——, *Norm and Form: Studies in the Art of the Renaissance*, London and New York, 1966.

——, 'The Mask and the Face: Perception of physiognomic likeness in life and in art', in E. H. Gombrich, J. Hochberg and M. Black, *Art, Perception and Reality*, Baltimore, 1972.

——, 'The Logic of Vanity Fair: Alternatives to historicism in the study of fashion, style and taste', in P. A. Schilpp (ed.), *The Philosophy of Karl Popper* (Library of Living Philosophers), La Salle, Illinois, 1974.

——, 'The Sky is the Limit', in R. B. MacLeod and H. L. Pick (eds.), *Perception*, Essays in Honor of James J. Gibson, Ithaca, N.Y., 1975.

GREGORY, R. L., and GOMBRICH, E. H., *Illusion in Nature and Art*, London, 1973.

GREGORY, R. L., *Eye and Brain: The Psychology of Seeing*, London, 1966.

HELD, RICHARD, and RICHARDS, WHITMAN, *Recent Progress in Perception: Readings from Scientific American*, San Francisco, 1976.

HOGARTH, WILLIAM, *The Analysis of Beauty*, written with a view of fixing the fluctuating ideas of taste, London, 1753.

JESSEN, PETER, *Meister des Ornamentstichs* (4 vols.), Berlin, 1923.

JONES, OWEN, *The Grammar of Ornament*, London, 1856.

KENNEDY, JOHN, *A Psychology of Picture Perception, Images and Information*, San Francisco, 1974.

KIMBALL, FISKE, *The Creation of the Rococo*, Phildelphia, 1943.

KOENIG, OTTO, *Urmotiv Auge: Neuentdeckte Grundzüge menschlichen Verhaltens*, Munich, 1975.

MEGAW, J. V. S., *Art of the European Iron Age: A Study of the Elusive Image*, Bath, 1970.

METZGER, W., *Gesetze des Sehens*, Frankfurt am Main, 1975.

NEISSER, ULRIC, *Cognition and Reality: Principles and Implications of Cognitive Psychology*, San Francisco, 1976.

PETRIE, FLINDERS, *Decorative Patterns of the Ancient World*, London, 1930.

POPPER, KARL, *The Logic of Scientific Discovery*, London, 1959.

——, *Objective Knowledge: An Evolutionary Approach*, Oxford, 1972.

RIEGL, ALOIS, *Stilfragen*, Vienna, 1893.

——, *Die Spätrömische Kunstindustrie*, Vienna, 1901.

RUSKIN, JOHN, *Seven Lamps of Architecture* (London, 1849); *The Stones of Venice* (London, 1853); *The Two Paths* (London, 1859). All included in *The Works of John Ruskin*, edited by E. T. Cook and Alexander Wedderburn, 39 vols., London and New York, 1903–12.

SEMPER, GOTTFRIED, *Der Stil in den technischen und tektonischen Künsten* (2 vols.), Frankfurt am Main, 1860 and 1863. 2nd ed., Munich, 1878.

SPELTZ, ALEXANDER, *Der Ornamentstil*, 1904. Translated by R. Phené Spiers as *The Styles of Ornament*, 1910. Reprinted by Dover Publications, New York, 1959.

TINBERGEN, NIKO, *Instinct*, Oxford, 1951.

TOVEY, DONALD, *The Integrity of Music*, Oxford, 1941.

UHR, LEONARD (ed.), *Pattern Recognition: Learning and Thought: Computer-Programmed Models of Higher Mental Processes*, Englewood Cliffs, N.J., 1973.

WATSON, W., *Style in the Arts of China*, Harmondsworth, 1974.

WILLETTS, WILLIAM, *Foundations of Chinese Art*, London, 1965.

WORNUM, R. N., *The Analysis of Ornament*, London, 1856.

ZÜLCH, O., *Entstehung des Ohrmuschelstils*, Heidelberg, 1932.

ZUSNE, LEONARD, *Visual Perception of Form*, New York and London, 1970.

List of Illustrations

Colour Plates

Black and White Plates

Figures in the Text

Introduction

I Issues of Taste

IV The Economy of Vision

V Towards an Analysis of Effects

VI *Shapes and Things*

X *The Edge of Chaos*

Epilogue

The author and publishers are grateful to all those who have supplied photographs and allowed works in their possession, or for which they hold copyright, to be reproduced.

Every student of the subject is indebted to Dover Publications, New York, who in addition to having published reprints of many contributions to the field, state in the books of their Pictorial Archive series: 'Individual items in the book are copyright-free, and may be used (up to 10 items per occasion) without further payment, permission or acknowledgement. You purchase such rights when you buy the book.'

Index